Self-Taught, Outsider
and Folk Art

THIRD EDITION

PORTLAND
PUBLIC LIBRARY

ENRICHING OUR COMMUNITY,
EXPANDING OUR WORLD.

Self-Taught, Outsider and Folk Art

A Guide to American Artists,
Locations and Resources

THIRD EDITION

BETTY-CAROL SELLEN

McFarland & Company, Inc., Publishers
Jefferson, North Carolina

LIBRARY OF CONGRESS CATALOGUING-IN-PUBLICATION DATA

Names: Sellen, Betty-Carol, author.
Title: Self-taught, outsider and folk art : a guide to American artists,
locations and resources / Third Edition / Betty-Carol Sellen.
Description: Third Edition. | Jefferson, North Carolina : McFarland & Company, Inc.,
Publishers, 2016. | Includes bibliographical references and index.
Identifiers: LCCN 2015044770| ISBN 9780786475858 (softcover : acid free paper) ∞
Subjects: LCSH: Folk art—United States—Information services—Directories. |
Outsider art—United States—Information services—Directories. |
Folk artists—United States—Biography.
Classification: LCC NK805 .S46 2016 | DDC 745.025/73—dc23
LC record available at http://lccn.loc.gov/2015044770

BRITISH LIBRARY CATALOGUING DATA ARE AVAILABLE

ISBN (print) 978-0-7864-7585-8
ISBN (ebook) 978-1-4766-2304-7

Printed in the United States of America

Front cover: J. J. Cromer, *Isthmus*, 2014,
mixed media on paper, 10" × 8"

McFarland & Company, Inc., Publishers
Box 611, Jefferson, North Carolina 28640
www.mcfarlandpub.com

TABLE OF CONTENTS

ACKNOWLEDGMENTS

It takes many people to locate the information needed to create a guide to self-taught artists, folk artists, and artists who work outside the mainstream of the art world. Many people contributed and shared information for this book, including artists, gallery owners, museum staff, academics, writers, and collectors. I want to thank them all.

Museums serve many vital purposes for both the novice and the experienced collector. They offer the opportunity to see the art and great stores of information to explore the art and the artists who create it. Many museum people provided invaluable help. Of major significance has been the assistance of Leslie Umberger, curator of folk and self-taught art at the Smithsonian American Art Museum (SAAM)—the premier collection of this art in the United States. She is experienced and knowledgeable about all aspects of this art and gracious with sharing her time and knowledge. In addition to providing a complete and up-to-date list of SAAM's self-taught and outsider art holdings, the most extensive and best-documented in the country, she sent a list of birth and death years for all the twentieth and twenty-first century artists in SAAM's collection and also offered insights into developments in the field. Tammy Stone, administrative coordinator at the Kentucky Folk Art Center in Morehead, provided a list of all artists in the center's permanent collection as well as those participating in Day in the Country, helped me find many artists, looked up birth and death years, and alerted me to some of the center's exhibitions and their catalogs of which I had been unaware.

Staff of other museums who were especially helpful include Heather Winter, Bradley Sumrall, Alice Yelen, Rebecca Hoffberger, Marsha Bol, and Laura Addison. Heather Winter of the Milwaukee Art Museum provided information about the museum's plans to use new technology as a way of providing greater access to the museum's collection. Ogden Museum of Southern Art chief curator Bradley Sumrall described his goal of increasing popular interest in and attraction to Southern art. His exhibitions of the "Richard Gasperi Collection," the exhibition of work by Herbert Singleton, and the show of art from the House of Blues, "When You're Lost, Everything's a Sign," are recent examples of his efforts.

Alice Yelen, senior curator of collections research at the New Orleans Museum of Art, gave me a tour of that museum's huge collection of folk and outsider art. One hopes that the museum leadership will make it more accessible to the public through exhibits and other mechanisms. Rebecca Hoffberger, founder and director of the American Visionary Art Museum, gave me a private tour of AVAM collections and information on plans. Marsha Bol, director of the Museum of International Folk Art (MOIFA) in Santa Fe, introduced me to that institution and to Laura Addison, MOIFA's curator of North American and European Folk Art, who provided a list of American self-taught artists in the collection and responded to numerous queries about specific artists.

Chris Brooks, director of the Folk Pottery Museum of Northeast Georgia, was helpful in finding people and locations. Very helpful also were Jo Farb Hernandez, the director of SPACES, who supplied information about folk art environments, and Rosslyn Schultz, director of the Grassroots Art Center in Lucas, Kansas, who provided descriptions of that center's permanent exhibitions, archives, collections, and plans.

Galleries are another essential component of the self-taught art world. They offer and sell art to collectors, and many gallery owners spend considerable time and effort developing relationships with artists, finding new artists, and supporting artists in their work. Gallery owners who were generous with their time and knowledge of artists were Shari Cavin of the Cavin-Morris Gallery in New York, Jose Zelaya of Arte del Pueblo in Connecticut, Beverly Kaye in Connecticut, Grey Carter—Objects of Art in Virginia, Duff Lindsay of Lindsay Gallery in Ohio, Mike Smith of At Home Gallery in North Carolina, Marcia Weber of Marcia Weber/Art Objects in Alabama, Bonnie Grossman of the Ames Gallery in California, and Jeanine Taylor of Jeanine Taylor Folk Art in Florida. Rey Montez of the Montez Gallery in New Mexico was generous with his time and information about Spanish American folk art, especially the New Mexico traditions of making bultos and retablos.

I also received help from many artists about their own work and that of other artists they know. Minnie Adkins helped with locating many folk artists in Kentucky. Robert Morgan, who lives in Lexington, Kentucky, and makes complex assemblage art, gave me a tour of his home studio filled with his art and the mix of materials used to create it—as young people say, it was "awesome." Pat Juneau and his son Andre were helpful in providing information about themselves, other artists in Louisiana, and local fairs and festivals to which many Louisiana and other nearby artists take their work to sell. Charles Gillam gave me a tour of his folk art environment in Algiers (a district in New Orleans) and described plans for projects along with fellow artist Charles Smith of Illinois.

Collectors are often a great help because they share their experiences and knowledge. In Santa Fe, where I now live, Patty and Arthur Newman have been most especially supportive, introducing me to artists and collectors, telling me about the various museums and exhibitions, and helping me get involved at MOIFA. Leslie Muth, a long-time collector and long-time friend who ran two excellent galleries (one in Houston and then one in Santa Fe) for many years, has introduced us to people who are interested in folk, self-taught and outsider artists and provided information about artists she has carried.

Other collectors who have been of great help to me are Lynne and Jim Browne of North Carolina, Ann Perry Parker, who lives in Wisconsin and New Orleans, and Tom Ray, who lives and works in Richmond, Virginia. Lynne never tired of finding obscure information for me, Ann updated me about the many Wisconsin artists who created folk art environments and the status of those environments, Tom drove me to Newport News to visit the Anderson Johnson Gallery and to the Baron and Ellen Gordon Galleries at Old Dominion University in Norfolk. Another helper was my cousin Nicole Rocha, who lives in Tucson, Arizona, and tracked down an artist for me that I had met at a FASA conference but could not find.

The best helper with this project has been my partner, Marti Burt. She is very skilled at using technology and I am very not! She has contacted many galleries, museums, and artists, gathering information from and about people I had not been able to locate. She kept the project going when I had a most inconvenient hospital stay and recovery. Marti is known nationally and internationally in her own field as an expert in policy research and analysis related to high-risk populations, with a major emphasis on understanding and ending homelessness, but with all her other obligations she has been able to keep this folk art book project going to completion.

INTRODUCTION

This book is about American artists and is for collectors and people who like to read about the art and the artists. As in the previous editions (*20th Century American Folk, Self-Taught, and Outsider Art*, 1993, and the updated *Self-Taught, Outsider, and Folk Art: A Guide to American Artists, Locations and Resources*, 2000), the information is arranged in chapters according to the places where one can buy, view, or learn about the art in this field. These are: galleries, art centers with galleries, private dealers, and artists who sell their own work; fairs and festivals; auctions; museums, libraries, archives and environments; organizations; a selection of books and catalogs published since 2000; and other publications. The final chapter is an alphabetical list of artists with biographical information.

The field has changed dramatically since 2000, when the previous edition was published and all information has been completely updated. Many galleries have closed and only a few new ones have opened. Some galleries have gone virtual, presenting art for sale only on the web. Quite a number of artists sell their own work on their own websites or via Facebook. Many of the recognized masters have died and new people have been discovered.

On a positive note, there has been more attention to the preservation of environments. SPACES has been active, and the John Michael Kohler Foundation has financed the restoration of numerous environments in Wisconsin and some beyond that state. The Louisiana environment created by Kenny Hill in Chauvin is one of the latter. Hill disappeared but his creation is in good shape, attracts many visitors, and is the site of a festival every other year. The Kohler Foundation also sponsors the restoration of Pasaquan, the environment created by St. EOM in Georgia. Paradise Garden, the home of Howard Finster's visionary art environment in Summerville, Georgia, is also looking great and is attracting many visitors, thanks to a new foundation created to assure its preservation. Grandma Prisbrey's Bottle Village can be seen, still standing, with a group working to resolve problems that would then make it possible to enter the site. Other groups are hard at work to assure the continued existence of many other environments, which are listed in the Museums, Libraries, Archives and Environments chapter.

The growth and popularity of auction houses that sell folk art has had a number of effects on the field. With respect to galleries that specialize in representing folk art and artists, the effect seems to have been negative, with fewer galleries overall and some switching from physical spaces to websites only. The growth of this secondary market also changes artist-collector relationships in ways that take some of the pleasure out of collecting folk art for those people for whom meeting and getting to know the artists was a big part of the enjoyment. On the positive side, the auctions make art available to collectors long after specific artists have died or stopped making art, often because people with extensive collections offer some or all of their collection for sale through the auctions.

1

In addition to galleries and auction houses, the Internet has increased access to self-taught and outsider art for both initial sale and resale. Artists maintain their own websites, sell through their Facebook pages, and offer their work for sale through eBay and other on-line sites. The artist descriptions in the Artists chapter usually mention specific galleries or museums where an artist's work may be bought or seen, but anyone interested in acquiring the work of a specific artist would be well-advised to check online sources as well as any listed in this book.

There appears to be concern among some gallery owners that they need to be selling "real art, important art" rather than "'folk art." This attitude has resulted in their pushing the folk and self-taught art aside in favor of European artists, in a field that used to focus on American artists. This phenomenon is most apparent in New York City.

GALLERIES, PRIVATE DEALERS AND ARTISTS WHO SELL THEIR OWN WORK

This chapter describes galleries, private dealers, and other establishments that sell contemporary folk, self-taught, and outsider art. For the most part, gallery descriptions were provided by the proprietors, or taken from their websites if necessary. Galleries are listed alphabetically by state, then by city within state, and finally by the gallery name. Information on private dealers is listed by state after the galleries. Galleries associated with Art Center programs for persons with disabilities are included in this chapter rather than being placed in a chapter of their own. Many galleries have newsletters, blogs, and notifications of exhibits, new artists, and other local news and events, often distributed electronically, through email lists. Consult the gallery listing for contact information for a gallery you are interested in, to see what they have and to sign up.

In addition to galleries and dealers, this age of websites, Facebook, and other social media has prompted some artists to represent themselves and their art, sometimes in addition to being carried by galleries or dealers, sometimes exclusively. When the information could be found, the chapter also provides, by state, a list of artists, alphabetically by name, who sell their own work through websites, Facebook pages, other media connections, and from their own homes or studios. These artists who sell their own work are listed alphabetically by name in each state, following the listings for galleries and private dealers. The reader should refer to the biographies in the Artists chapter, where artists are listed alphabetically by name, to find specific information about their locations and contacting or visiting the artists.

ALABAMA

Studio by the Tracks
301 20th Street South
P.O. Box 101144
Irondale, Alabama 35210
Ila Faye Miller, Director
Phone: 205-951-3317
Email: info@studiobythetracks.org
Web site: www.studiobythetracks.org

Studio by the Tracks, founded in 1989 by the current director, Ila Faye Miller, provides art classes to at-risk children, and people with special needs. Included

are 46 individuals with disabilities, principally adults and teenagers with autism, and a group of homeless men with mental illnesses. Works created in the program become tools that allow the participants not only a creative outlet, but also opportunity to focus on their strengths and interests rather than on their limitations. Many of these individuals attending the studio since its inception and have become career artists who sell their work to collectors. The Studio is located in Irondale, a suburb of Birmingham, in an old refurbished service station next to a railroad track. All students reside in Jefferson County. An annual benefit, "Art from

the Heart," takes place in June. There is also an annual sales event in November. Art may be seen on the Studio's web site and Facebook. At present art is for sale only at these events and sources.

Artists

Micky Barron, Ricky Caldwell, Linda Cooper, Ruth E., Michael Hall, Herman Hatch, Art Horton, John Miller, Michael Moore, Inés Orihuela, Jerry Washington. Also listed on the web site by first name only are Zan, Melvin, Nick, Austin and Ann P., and Kristi

Artisans

P.O. Box 256
Mentone, Alabama 35984
Matt Lippa and Elizabeth Schaaf, owners
Phone: 256-634-4037; 9 a.m.–8 p.m. CST only.
Email: artisans@folkartisans.com
Web site: www.folkartisans.com

Artisans is a mail order and internet gallery of nineteenth and twentieth century American folk art and unusual antiques. Inventory includes tramp art, carvings, quilts, paintings, decorated furniture, "found objects," sculpture, and whirligigs. Artisans specializes in anonymous and unknown artists, with some works by named contemporary outsider artists.

Artists

Florence Berryman, Marilyn Dorsey, Melanie Nelson Finch, Robert E. Gilbert (REG), Lewis Smith

Anton Haardt Gallery

1226 South Hull Street
Montgomery, Alabama 36104
Anton Haardt, Owner
Phone: 334-263-5494
Email: anton@antonart.com
Web site: www.antonart.com

The gallery focuses on folk art from the Deep South with an emphasis on vintage works by Mose Tolliver, Jimmy Lee Sudduth, and others. It is operated by Anton Haardt, an artist herself, who began collecting folk art in the late 1960s. On display but not for sale is her entire collection of Juanita Rogers' mud sculptures. In addition, she displays the only remaining works of Montgomery artist Boosie Jackson, who worked in the 1950s. Anton Haardt photographed Jackson's huge and fantastical environment before it was destroyed. The gallery is open by appointment only. [See also other entry in New Orleans.]

Artists

Loy "The Rhinestone Cowboy" Bowlin, David Butler, Thornton Dial, Sam Doyle, Minnie Evans, Howard Finster, Sybil Gibson, Bessie Harvey, Lonnie Holley, Clementine Hunter, James Harold Jennings, Calvin Livingston, Charlie Lucas, R.A. Miller, B.F. Perkins, Royal Robertson, Juanita Rogers, Mary T. Smith,

Henry Speller, Jimmy Lee Sudduth, James "Son" Thomas, Annie Tolliver, Mose Tolliver, Felix Virgous, Fred Webster, "Artist Chuckie" Williams, Ben Williams

Cotton Belt Gallery

225 South Decatur Street
Montgomery, Alabama 36104
Micki Beth Stiller, Owner
Laura Baldree, Gallery Manager
Phone: 404-290-4027
Email: lbaldree13@gmail.com
Web site: www.cottonbeltart.com

Cotton Belt Gallery is pleased to showcase the art of southern self-taught artists. Originally part of Sweet Gum Gallery, Cotton Belt Gallery was created by Micki Beth Stiller in 1989. Since then she has cultivated personal relationships with many of the artists represented by the gallery. A number of Cotton Belt Gallery's artworks have been included in museum exhibitions. Gallery hours are Monday through Friday from 9 a.m. to 5 p.m. The website includes artists' photographs and additional information.

Artists

Jerry Brown, Richard Burnside, William Dawson, Thornton Dial, Sr., Sybil Gibson, Alyne Harris, Lonnie Holley, Clementine Hunter, M.C. "5¢" Jones, S.L. Jones, Stacy Lambert, Woodie Long, Annie Lucas, R.A. Miller, Reggie Mitchell, Sister Gertrude Morgan, B. F. Perkins, Sarah Rakes, Juanita Rogers, Marie Rogers, Charles Simmons, Bernice Sims, Herbert Singleton, Mary T. Smith, Jimmy Lee Sudduth, Sarah Mary Taylor, Son Ford Thomas, Annie Tolliver, Mose Tolliver, Hubert Walters, Fred Webster, Ruby Williams, Willie Willie, Purvis Young

Marcia Weber/Art Objects

1050 Woodley Road
Montgomery, Alabama 36106
Marcia Weber, Owner/Director
Phone: 334-262-5349
Cell: 334-220-5349
Email: weberart@mindspring.com
Web site: www.marciaweberartobjects.com

This gallery, founded in 1991, is the premier Alabama source for rare and unusual one-of-a-kind works of art created by self-taught artists. A special focus for the gallery is finding unique masterpieces, paintings and sculpture, by genuine contemporary folk artists and by outsider artists especially those from the South. Much of the art is framed with custom archival framing. The informal gallery is open anytime by appointment in a quaint older building with hardwood floors surrounded by huge trees. The gallery is filled with a large inventory of works by many artists from various areas of the United States. A small selection of Haitian

art is also available. The gallery is conveniently located in the Old Cloverdale area of Montgomery just south of downtown near Huntingdon College, one mile from Interstates 65 and 85. The Montgomery gallery has an on-going group exhibition as well as having presented exhibitions in New York, Chicago and Atlanta at shows and museums. Many works from the gallery have been included in books and publications. The gallery website is updated often and provides easy access to view more than a 1000 available works, which can be acquired with a phone call, and as noted above, the gallery is open by appointment. Purchases are shipped promptly within 24 hours of a purchase. The gallery has a satisfaction return policy as well as a layaway plan. Marcia Weber has known and documented many living self-taught artists while actively collecting prime examples of their art for more than thirty years.

Artists

Minnie Adkins, Leroy Almon, Alpha Andrews, Z.B. Armstrong, Hope Atkinson, Michael Banks, Rudolph Valentino Bostic, Ray Brown, Anne Buffum, Richard Burnside, David Butler, Lisa Cain, Ned Cartledge, Tory Casey, Jerry Coker, "Cornbread" (John Anderson), Chuck Crosby, Brenda Davis, Mamie Deschillie, Theresa Disney, Mike Esslinger, Minnie Evans, Howard Finster, Don Gahr, Vic Genaro, Sybil Gibson, Lee Godie, Ted Gordon, Dorethey Gorham, Annie Grgich, Alma Hall, Bertha Halozan, Joseph Hardin, Spencer Herr, Lonnie Holley, Teneco Hunter, James Harold Jennings, M. C. "5c" Jones, Andy Kane, the Rev. J. A. King, Charley Kinney, Jean Lake, Eric Legge, Calvin Livingston, Woodie Long, Peter Loose, Annie Lucas, Charlie Lucas, Erika Marquardt, Lloyd "Hog"

Mattingly, Justin McCarthy, Jake McCord, Frank McGuigan, R. A. Miller, Roy Minshew, Jesse Lee Mitchell, Reginald Mitchell, Roger Mitchell, Ike Morgan, Bennie Morrison, Eddy Mumma, J. B. Murry, Bruce New, Pak Nichols, Matilda Pennic, B.F. Perkins, John Phillips, Elijah Pierce, Sarah Rakes, John Rhodes, Juanita Rogers, Clay Rice, Royal Robertson, Nellie Mae Rowe, Jack Savitsky, William "Sezah," Welmon Sharlhorne, Bernice Sims, Mary T. Smith, Robert E. Smith, Q. J. Stevenson, Jimmy Lee Sudduth, Ionel Talpazan, Wanda Teel, William Thompson, Annie Tolliver, Mose Tolliver, Charles Tolliver, Bill Traylor, Daniel Troppy, Elmira Wade, Inez Nathaniel Walker, Derek Webster, Fred Webster, Della Wells, Myrtice West, Mary Whitfield, Willie White, "Artist" Chuckie Williams, Artis Wright, David Zeldis, Malcah Zeldis and anonymous artists.

Robert Cargo Folk Art Gallery, Tuscaloosa

Robert Cargo's collection of folk art has been donated (after his death) to the Birmingham Museum of Art. See entry under Museums.

Artists Who Sell Their Own Work

Artists are listed here alphabetically; check the Artists chapter for location and contact information.
Bishop "Butch" Anthony
Lonnie Holley
Antjuan Oden
Wally Shoup

ALASKA

Artists Who Sell Their Own Work

Check the Artists chapter for location and contact information.
June Walunga

ARIZONA

John C. Hill—Antique Indian Art Gallery

6292 East First Avenue, Suite 104
Scottsdale, Arizona 85251
John C. Hill, Owner
Jude and Jaimie, Gallery assistants
Phone: 480-946-2910
Email: johnhill98@yahoo.com
Web site: www.johnhillgallery.com

The gallery was established in 1990 with over 40 years of experience in Antique Indian art with an emphasis on the South West and expertise on Hopi Kachinas, antique Indian jewelry, baskets, textiles and pottery. The gallery also specializes in the "Master Outsider Navajo carver" Charlie Willeto (1897–1964) and "New Mexican Outsider" Felipe Benito Archuleta (1910–1992)." Also featured is "Van Gogh of the Desert" painter Martin Dean Coppinger (b. 1934). Housed since 1995 in a Ralph Haver (mid-century

Phoenix architect) building, the gallery is located in the heart of downtown Scottsdale, on the southwest corner of Goldwater Boulevard and Indian School Road. In addition to antique items and those artists named above, the gallery has Mexican folk art and New Mexican religious folk art.

Artists
Felipe Archuleta, Martin Dean Coppinger, Charlie Willeto

Artists Who Sell Their Own Work
Check the Artists chapter for location and contact information.
Francisco "Frank" Franklin

CALIFORNIA

The Ames Gallery
2661 Cedar Street
Berkeley, California 94708
Bonnie Grossman, Director
Sherry Bloom, Gallery Assistant
Phone: 510-845-4949
Email: info@amesgallery.com
Web site: www.amesgallery.com

Established in 1970, The Ames Gallery specializes in the works of contemporary naive, self-taught, visionary, and outsider artists, with a focus on California artists. The gallery also offers exceptional nineteenth and early twentieth century handmade objects including carved canes, tramp art, quilts, whimsies, face jugs, memory jars, and a museum-quality collection of early creatively mended objects, from stapled china to tin-patched wood bowls. The gallery publishes a newsletter, the Ames News, that announces gallery exhibits, additions to the inventory, books, and catalogs, as well as notes of activities throughout the country and a calendar with a focus on pertinent events. The newsletter frequently includes biographies of Gallery artists and essays about issues relevant to the fields of folk art and outsider art. Email or write to be placed on the mailing list.

Artists
Ursula Barnes, Deborah Barrett, Jim Bauer, Dorothy Binger, William Dawson, Dennis Filling, Jack Fitch, Ted Gordon, Wilbert Griffith, Esther Hamerman, Harry Lieberman, Dwight Mackintosh, Alex A. Maldonado, Elijah Pierce, Christopher Dalton Powell, A.G. Rizzoli, Ned Young. Works by Eddie Arning, Georgia Blizzard, Russell Childers, Raymond Coins, Burlon Craig, William Dawson, the Rev. Howard Finster, the Hewell family, James Harold Jennings, David Marshall, Lanier Meaders, and Jon Serl are occasionally available.

First Street Gallery Art Center
250 West First Street, Suite 120
Claremont, California 91711
Rebecca Hamm, Director of Arts
Seth Pringle, Gallery Manager
Phone: 909-626-5455
Email: rhamm@tierradelsol.org
Web site: www.1streetgallery.org

First Street Gallery Art Center is a program of the Tierra del Sol Foundation. It is founded on the proposition that human potential for creativity and artistic expression is not limited by physical or intellectual challenges. Through the cultivation of artistic expression, people with significant challenges can develop creatively and make important contributions to the cultural and economic life of their communities. First Street Gallery Art Center provides professional art training and exhibition resources to approximately fifty adults with developmental disabilities. Staff are all professional artists whose role is to help facilitate art projects and provide guidance when needed. Artists produce work in painting, drawing, printmaking, ceramics, sculpture, and collage. In addition to art-based endeavors, First Street Gallery also provides vital training for community integrated activities, through volunteering and other off-site opportunities. The exhibition schedule includes approximately five shows per year, most of which are dedicated to showing solely client work. First Street Gallery artists also participate in many off-site exhibitions at such venues as The Smithsonian Institution, The Kennedy Center, The Philadelphia Museum of Art, The Berkeley Museum of Art, and ACME Gallery of Los Angeles. The Center operates a professional gallery where every studio artist has an opportunity to display and sell his/her work. Artists earn a 60 percent commission on art sales.

Artists
Douglas Allen, Leul Asfaw, Tony Barnes, John (Jack) Boyer, Katie Bristol, James Cadiz, Evelyn Campos, Teresa Curiel-Gonzalez, Marcelle Desrosiers, Patrick Dwyre, Leon Fuller, Victoria Gutierrez, Herb Herod, Evan Hynes, Jonathan Jackson, Dan Keller, Nikki Kesterson, Quinn Kingerman, Tom Lamb, Chelsea Lenningeer, Michael LeVell, Eric Lue, John Lund, Jackie Marsh, John Maull, Dru McKenzie, Steve Moore, Nathan Murri, Brian Ono, Hector Oviedo, Daniel Padilla,

Grace Perez, John Peterson Aida Pleytez, Kevin Powell, Danilo Quesada, Helen Rae, Hugo Rocha, Narisa Somprasong, Toni Stroman, Jennifer Tomashiro, Michel Tripplet, Kim Willin, Evan Wright, Joe Zaldivar

Sophie's Gallery
109 Rea Avenue
El Cajon, California 92020
Wendy Morris, Art Administrator
Erin Perschbacher, Assistant Art Administrator
Phone: 619-593-2205
Email: sophiesgallery@stmsc.org
Web site: www.stmsc.org

Sophie's Art Gallery, the off-campus art program of St. Madeleine Sophie's Center, provides opportunities for persons with developmental disabilities to express their rich inner lives through a variety of art media. Sophie's Art Gallery features four studios, several gallery spaces and two gift shops where our students show their finished art pieces, have a chance to sell their art and to earn a paycheck. All sales directly benefit the artists. The studio offers a window where community can discover the unique talents and creativity of the Sophie's Center artists. (There is a satellite location at 2825 Dewey Road, Suite 101, San Diego, California 92106).

Artists
John Agostini, Dorothy Biknell, Donna Collins, Timothy Conaway, Kelly Cornell, Terry Esche, Tina Franz, Mitch Gricman, Clayton Hauer, Teri Hawley, Jan Hulet, Bryce Johnson, Camaran Johson, Ian Ketcham, Janet Leenhouts, Jackie Leong, Theresa Ogg, Mark Rimland, Francisco Rojas, Lisa Rowin, Linda Rubin, Anthony Wardlow, and Kristina Woodruff.

The Studio / Cheri Blackerby Gallery
139 Third Street
Eureka, California 95501
John Bensch, Studio Director
Melissa Medina, Assistant
Phone: 707-443-1428
Phone: 707-443-1472
Email: jbensch@thestudioonline.org
Web site: www.thestudioonline.org

Artists
Rachelle Aubrey, Allen Cassidy, Gaylord Divine, Diana Huse, Elizabeth Kordes, Jaimal Kordes, Sean Murphy, Pablo Rahner, William Ruebenack, Geraldine Sadler, Iris Smith, Jerry Spaulding, Elizabeth Thompson, Ken Waldvogel, Dawn Wentworth, Soodie Whitaker, Helena Williams, Heidi Wilson, Jim Wilson

Neighborhood Center of the Arts
200 Litton Drive #212
Grass Valley, California 95945
Amee Medeiros, Executive Director
Amy Sumner, Program Director
Assistant: Christi Coffey
Phone: 530-272-7287
Email: ncadirector@nccn.net
Web site: www.neighborhoodcenterofthearts.org

Neighborhood Center of the Arts is a nonprofit corporation founded in 1984 to provide opportunities for adults with developmental disabilities to increase their independence, to earn income and to achieve integration into the community through their abilities. Our mission is to provide for these possibilities through the arts. The artists exhibit and sell their work in our in-house gallery as well as other regional venues. Work from NCA has been exhibited in galleries throughout the United States and Europe. The Neighborhood Center of the Arts on-site gallery is open to the public Monday—Friday from 9 a.m. to 4 p.m. The Center is located in Grass Valley, situated in the scenic Sierra foothills between Sacramento and Lake Tahoe.

Artists
Sharri Adams, Matt Albin, Jenny Andes, Jenny Barbaria, Cindy Benson, Dan Boling, Maria Brocke, Lisa Brown, Kandy Cain, Meadow Cleary, Colleen Corbett, Shinaeda DeJaneiro, James DelCampo, Debbie Dunham, Mike Dunigan, Jessica Grimes, Danielle Gust, Marlena Hall, Julie Hamilton, Chad Hanson, Danny Harkins, Monica Hargis, Katie Hengesbach, Tiffany Hood, Brittney Innocenti, Shanna James, Wesley James, Paul Johanson, David Jones, John Judd, Karen Kennedy, Sean Krulisky, Kayla Larsen, Robert Lee, Mason Lindsay, Aaron Manful, Spencer McClay, Paul M, Mark Miller, Sheryl Morrisohn, Steve Myers, Natalie Nowak, Kim Pearson, Helen Powell, Beth Rein, Rhiannon Richardson, Robert Riley, Danette Rizonelli, Dan Robinson, Nicole Rogers, Erin Rumsey, Patrick Scudero, Ben Smith, Haley Smith, Robert Snell, Jessie Sterling, Christina Swart, Chucky Tettelaar, Patrick Thomas, Ed Toomes, Roland Viera, Johnny White III, Barbie Wilkins, Debbie Windus

The Good Luck Gallery
945 Chung King Road
Los Angeles, CA 90012
Paige Wery, Owner and Curator
Phone: 213-625-0935
Email: info@thegoodluckgallery.com
Web site: www.thegoodluckgallery.com

The Good Luck Gallery, located in the heart of the Chinatown arts district, is the only gallery in Los Angeles to exclusively showcase self-taught art. Whether it is called Outsider, Folk Art, Naive or Visionary, the emphasis is on artists who are driven by a compulsive need to create and who work beyond the margins of the traditional art world. The gallery opened in 2014. It shows established artists as well as the emerging and

overlooked, covering every form of art—from painting, drawing and sculpture to performance and installations. In addition to regular gallery shows, an online shop features paintings, ceramics, thrift store finds, handmade arts and crafts, as well as zines and literature.

Artists

Jeff Cairnes, Tova Celine, Noah Erenberg, Andrew Frieder, Andrea Joyce Heimer, Harry Steinberg, Elias Telles

Creative Growth Art Center

355 24th Street
Oakland, California 94612
Tom di Maria, Director
Catherine Nguyan, Gallery Manager
Steven Garen, Gallery Assistant
Phone: 510-836-2340x15
Email: info@creativegrowth.org
Website: www.creativegrowth.org

Creative Growth was founded in 1974 to be an arts center for adults with physical, mental and emotional disabilities. Creative Growth is dedicated to the idea that all people, no matter how severely mentally, physically, or emotionally disabled, can gain strength, enjoyment and fulfillment from experiences with the visual arts, and are capable of producing works of high artistic merit. The studio provides professional arts opportunities to adults in a variety of media including fiber arts, wood, painting, ceramics, drawing, print making photography, and video animation. The Creative Growth Gallery exhibition space is dedicated to the art of people with disabilities. Exhibits of art by Creative Growth artists are placed in galleries in other locations locations in the United States and Europe. There were many special art events in the summer of 2014 to mark the 40th anniversary of Creative Growth.

Artists

Luis Aguilera, David Albertsen, Olga Bielma, Terri Bowden, Kerry Damianakes, Carl Hendrikson, John Hiltunen, Susan Janow, Dwight Mackintosh, John Martin, Dan Miller, Donald Mitchell, Aurie Ramirez, Judith Scott, William Scott, Jacob Sockness, Gerone Spruill, William Tyler, Ray Vickers, Merritt Wallace, Ed Walters, George Wilson, Alice Wong, and many more for a total of 150 people

The Folk Tree

217 South Fair Oakes Avenue
Pasadena, California 91105
Rocky Behr, Owner
Gail Mishkin, Gallery Director
Phone: 626-795-8733
Email: rfolktree@aol.com
Web site: www.folktree.com

The Folk Tree is filled with decorative, folk and ethnic art and craft from all over the world. While the store continues to focus on pieces from Mexico, the gallery area also showcases work from the American southwest and elsewhere from around the globe. Rocky Behr says "folk art and crafts of indigenous cultures are the spice of my life." On Folk Tree Tours she takes small groups to share her adventures. The Folk Tree web site is rich in images of pieces available for purchase.

Artists

Among the U.S. artists shown are Marie Romero Cash, Joel Nakamura, Santa Clara Pueblo potters, Hopi Kachina makers, Navajo rug makers and masks by Lomayesva. There also folk arts from Guatemala, Panama, Peru, Mexico, and Russia and once in a while other pieces from New Mexico

NIAD Art Center (National Institute for Art and Disabilities)

551 23rd Street
Richmond, California 94804
Timothy Buckwalter, Gallery Director
Judith Zoon, Assistant
Phone: 503-620-0290
Email: gallery@niadart.org
Web site: www.niad.org

NIAD Art Center began more than 30 years ago. The studio program currently works with more than sixty adult students and operates from 9 to 3 weekdays. Many of the Center's artists show their work in mainstream galleries in the San Francisco Bay Area as well as around the country, Their work is in numerous museums and corporate collections. The Center maintains three exhibition spaces: The Main Gallery, the Annex Space, and. the Storefront. The Main Gallery (1000 square feet) hosts bi-monthly themed exhibitions of work by NIAD artists. The annex Space (250 square feet) hosts special projects by NIAD artists and provides an exhibition area that showcases art from nationally known mainstream or disabled artists. The Storefront (208 square feet) is home to NIAD's seasonal pop-up shops (of objects made by NIAD artists and outside artists not associated with NIAD) as well as an area that showcases unique and amazing series created by NIAD artists. By inviting outside artists to exhibit in its Annex Space and Storefront, NIAD offers a way for its artists to engage with the art of others as well as their own.

Artists

Saul Alegria, Barbara Arbogast, Lois Ann Barnett, Lisa Blevens, Eddie Braught, Mia Brown, Ray Brown, Jeremy Burleson, LaKarla Campbell, Phyllis Carr, Raquel Charles, Deatra Colbert, Arista Dawson, Krista Dean, Julio Del Rio, Lisa Dobel, Adonia Douglas,

Metrius Englin, Luis Estrada, Darlene Farr, Carlos Fernandez, Sylvia Fragoso, Jon Fukul, Felecia Griffin, James Ham, Heather Hamann, Shana Harper, Raven Harper, Peter Harris, Willie Harris, James Hartsell, Shirley How, Harry Ingram, Aisha Ivery, Lacee King, Sara Malpass, David Martin, Erica Martinez, Karen May, Debonaire McCann, Jean McElvane, Ann Meade, Gail Mohr, Marlon Mullen, Tony Pedemonte, Dorothy Porter, Maria Radilla, Dorian Reid, Angela Rogers, Elena Rossi, Alice Sampson, Ellen Smedley, Linda Marie Stewart, Maurice Stradford, Danny Thach, Timothy Thackray, Beverly Trieber, Jonathan Valdivias, Jonathan Velasquez, Vincent Villanueva, Michael Walker, Jessie West, Arstanda "Billy" White, Susan Wise

Primitive Kool Gallery

4944 Newport Avenue
San Diego, California 92107
Paul and Lynne Bolton, Owners
Phone: 619-222-0836
Email: primitivekool@cox.net
Web site: www.primitivekool.com

Primitive Kool Gallery is conveniently located in 'kitchy" Ocean Beach, an eclectic hippie hamlet of San Diego. Adorning the walls of a building that houses a hair salon and The Ocean Beach Playhouse is this fascinating original art available to view every day of the week. What began as an outsider art gallery has become a music inspired outsider and folk art gallery which appeals to music industry collectors and the general public.

Artists

Current artists included in the collection are George Borum, Sainte-James Boudrôt, Charlie Dyer, Howard Finster, Frank McGuinan, Jay Marvin, Missionary Mary Proctor, Aiden Rose, Timm Rye, Herbert Singleton, J.D. Sipe, Lamar Sorrento, Jon Stucky, Jimmy Lee Sudduth, Mose Tolliver. The gallery also includes a collection of Haitian voodoo flags by notable artists including George Valris, Maxon, Roland Rockville, and Yves Telemaque.

Creativity Explored Studio and Gallery

3245 16th Street
San Francisco, California 94103
Amy Taub, Executive Director
Amy Auerbach, Gallery Manager
Phone: 415-863-2108
Email: info@creativityexplored.org
Web site: www.creativityexplored.org

Creativity Explored, a nonprofit visual arts center founded in 1983, advances the value and diversity of artistic expression. Artists with developmental disabilities are provided the means to create, exhibit and sell their art at the Creativity Explored Gallery, on the 'CE' web site and around the world. Gallery artists have studio space, art supplies, technical assistance and exhibition spaces. More than 135 studio artists explore their creativity using media and techniques of their choice including drawing, painting, printmaking, ceramics, fabric arts, assemblage, collage, sculpture, bookmaking, installation art, and video animation. Creativity Explored artists receive assistance from professional artists and have opportunities to visit museums and galleries, gaining exposure to the work of other artists. They receive fifty percent of the proceeds from the sale of their art and forty percent of licensing royalties. Seven annual exhibitions are scheduled in the on-site gallery. Products featuring reproductions of the artists' work are also sold. Creativity Explored, in the vibrant San Francisco Mission District, welcomes artists and art lovers, collectors and the general public to meet, mingle and share their appreciation of art. Creativity Explored maintains an open door policy to visit the studio, attend gallery openings, meet artists, purchase art and donate time and funds to insure that the Creativity Explored program continues.

Artists

Ian Adams, Zachary Adams, Lucinda Addison, Charlie Barthelet, Mary Belknap, Antonio Benjamin, Maria Berrios, Laron Bickerstaff, Andrew Bixler, Alissa Bledsoe, Jennifer Bockelman, Eric Boysaw, Henry Bruns, Pablo Calderon, Toby Calonico, Hanh Chau, Gordon Chin, Ming Choi, Kevin Chu, Anne Connolly, Edana Contreras, Peter Cordova, Charles "Pancho" Cruz, Linda Davenport, Thanh My Diep, Ricardo Estella, Katherine Finn-Garmino, Allura Fong, Christina Marie Fong, Badia Forbes, Vernae Gallaread, Jessenia Garcia, Paul Gee, Melvin Geisenhofer, Hadi Gharffar-Tehrani, Anthony Gomez, Daniel Green, Claus Groeger, Maribel Guzman, Jay Herndon, Nita Hicks, Camille Holvoet, Vincent Jackson, Warren Jee, Valerie Jenkins, Eva Jun, Makeya Kaiser, Kaocrew "Yah" Kakabutra, Olga Kardonskaya, Lakeshia King, Joel Kong, Walter Kresnik, Nina Krietzman, Endora Lau, Tonya Lewis, Andrew Li, Daniel Li, Steven Liu, Michael Bernard Loggins, Hector Lopez, Taneya Lovelace, Merna Lum, Marcus McClure, John Patrick McKenzie, Albert Meyer, Dan Michiels, James Miles, Jason Monzon, Duc Nguyen, Lien Nguyen, James Nielsen, Jose Nunez, Darnell O'Banner, Sara O'Sullivan, Hiroshi Onodera, Nubia Ortega, Bertha Ortega, Selene Perez, Musette Perkins, Richard Pimental, Abel Pineda, Thomas Pringle, Paul Pulizzano, Yolanda Ramirez, Roland Record, Ethel Revita, Emma Reyes, Evelyn Reyes, Jeannette Rideau, Clementina Rivera, Lance Rivers, Kevin Roach, Quintin Rodriguez, Cheryle Rutledge Christina Saavedra, Yukari Sakura, Diane Scaccalosi, Hung Kei Shiu, Ka Wa Shiu, Anne Slater, Calvin Bernard Snow, Ernesto Sosa, Natalie Spring, Weng Ian "Cathy" Tang, Kate Thompson, Thu Mai Tieu, Stella

Tse, Miyuki Tsurukawa, Ana Maria Vidaion, Kathy Wen, Gerald Wiggins, Marilyn Wong, Richard Wright, Ann Yamasaki, Doris Yen, Yang "Buurin" Yu-Zhen, Joe Yuen

Mary Short Gallery

928 East Rose Street
Stockton, California 95202
Margarita Garcia, Gallery Director
Valerie Conboy, Assistant
Phone: 209-948-5759
Email: asc@ddso.org
Web site: www.ddso.org

The Alan Short Center was the first program created by the Developmental Disabilities Service Organization (DDSO). It opened its doors in 1976 and was an early program for adults with disabilities supporting the belief that both the visual and performing arts would encourage self-awareness and personal growth of participants. A gallery was established at the Center and is now a separate entity called the Mary Short Gallery. Two other affiliated DDSO art programs are Short Center North, directed by John Berger—scn @dd.org and Short Center South, directed by Pat Woods—pat.scs@ddso.org. Yvonne E. Soto is President/CEO at the Developmental Disabilities Service Organization. She may be contacted at Yvonne@ddso. org. Addresses and telephone numbers for all three locations may be found on the web at ddso.org/about-us/where-to-find us.

Artists

Helen Bailey, Cookie Braggs, Ken Brown, Jayoti Chand, Brad Dixon, John Ezell, James Geddings, Robert Larson, Geoffrey Lum-Perez, Jerry Malanca, Jose Navarette, David Olson, Rita Rosa Pasillas, Don Roberts, Guadalupe Salcedo, Sarah Werner, Lee Ann Williams are found at the Mary Short Gallery. Artists who work at the other locations may be found on the web.

Just Folk

2346 Lillie Avenue
P.O. Box 578
Summerland, California 93067
Susan Baerwald and Marcy Carsey, Proprietors
Deirdre Gerry and Kathleen Ousley, Managers
Phone: 805-969-7118
Email: reachus@justfolk.com
Web site: www.justfolk.com

The gallery focuses on American folk art, both traditional pieces such as weathervanes, quilts, trade signs, furniture and sculpture, and contemporary self-taught and outsider artists the owners consider part of the American Folk Art world. The 2500 square foot gallery opened in 2007 in a building created for the collection by architect Brian Cearnal. It is barn-like on the first floor and more like a rustic gallery on the second floor. Re-cycled materials were used wherever possible, in the floors, the fixtures and the brick terraces, and solar power keeps the lights on. The gallery has been cited for its architectural beauty, which can be seen on the gallery's website. Art by the self-taught includes a large collection of Bill Traylor paintings that were purchased from a collection in Switzerland unseen in the U.S. for two decades, William Hawkins work, Elijah Pierce carvings, African American quilts and artists from the U.S. This gallery has exhibited self-taught artists since its inception and has had gallery exhibitions, including ones for Bill Traylor, Jim Bloom, Harry Underwood, Thornton and Harold Plople, as well as exhibitions of works by artists of L.A. Goal, Harborview House, and Alpha Resources. Just Folk also has private exhibitions in Los Angeles and lectures on the topic of self-taught artists and folk art frequently at the gallery. The Arts Fund has had a fundraiser at Just Folk that introduced their supporters to outsider art and speaker Brooke Davis Anderson presided. Just Folk exhibits regularly at the Metropolitan Show and the Outsider Art Fair in New York and has participated twice in the Intuit Show in Chicago.

Artists

Jesse Aaron, Ab the Flagman, Minnie and Garland Adkins, Gayleen Aiken, Leroy Almon, David Alvarez, Felipe and Leroy Archuleta, Z.B. Armstrong, Eddie Arning, Ralph AufderHeide, John Bambic. Linvel Barker, Deborah Barrett, Jim Bloom, Aaron Birnbaum, Tubby Brown, Richard Burnside, David Butler, Larry Calkins, Miles Carpenter, Benny Carter, Ned Cartledge, James Castle, Andy Choueke, Clarke Coe, Raymond Coins, Jerry Coker, Jessie and Ronald Cooper, William Dawson, Mamie Deschillie, Uncle Jack Dey, Arthur Dial, Thornton Dial, Sam Doyle, Uncle Pete Dragic, Minnie Evans, Josephus Farmer, Roy Ferdinand, Howard Finster, Sybil Gibson, Charles Gillam, Russell Gillespie, Lee Godie, Ricky Hagedorn, Bertha Halozan, Ray Hamilton, Alyne Harris, Bessie Harvey, William Hawkins, Lonnie Holley, Dan Hot, Clementine Hunter, J.L. Hunter, Black Joe Jackson, James Harold Jennings, Anderson Johnson, S. L. Jones, William LaMirande, Rene LaTour, Tim Lewis, Ronald Lockett, Woodie Long, Charlie Lucas, Willie Massey, Justin McCarthy, Carl McKenzie, Reggie Mitchell, Ike Morgan, Pucho Odio, Earnest Patton, Greg Pelner, B. F. Perkins, Harvey Peterson, Elijah Pierce, Harold Plople, Daniel Pressley, Sarah Rakes, Martín Ramírez, Ron Rodriguez, Sulton Rogers, O.L. Samuels, Jack Savitsky, J. P. Scott, Cher Shaffer, Bernice Sims, Herbert Singleton, Wesley Stewart, Jimmy Lee Sudduth, Big Al Taplet, Mose Tolliver, Inez Nathaniel Walker, Harry Underwood, Melvin Way, Gregory Warmack (aka Mr. Imagination), Fred Webster, Harriet Wiseman, Bohill Wong, Grace and Clarence Woolsey, and Purvis Young

Artists Who Sell Their Own Work
Check the Artists chapter for location and contact information.

Barry Simons (family will continue to sell until there is no more)

CONNECTICUT

Fred Giampietro Gallery
315 Peck Street
New Haven, Connecticut 06513
Phone: 203-777-7760
Email: fred@giampietrogallery.com
Web site: www.giampietrogallery.com

Artists
Morton Bartlett, Danny Huff, Carter Jahn, Larry Lewis

Arte del Pueblo
284 Courtland Avenue, first floor
Stamford, Connecticut 06906
Jose Zelaya, owner
Phone: 203-921-5234
Email: josezelaya@me.com
Web site: www.artedelpueblo.com

Jose Zelaya is known for his excellent collection of art from Haiti and from Jamaica, Grenadines, Bahamas, Mexico, Honduras, Nicaragua, and Europe. In addition he represents several collections of American self-taught art including a collection of art by Mose Tolliver. Recently he has expanded to including American artists. All his artists may be seen on-line at his web site.

Artists
American artists include Felipe Archuleta, Jerry Brown, Burgess Dulaney, Minnie Evans, Bessie Harvey, Charlie Lucas, Justin McCarthy, R.A. Miller, Sister Gertrude Morgan, B.F. Perkins, Royal Robertson, Sulton Rogers, O.L. Samuels, Jack Savitsky, Jimmy Lee Sudduth, Mose Tolliver, Willie White, George Williams, Jim Warren
Other artists include Ras Dizzy (Jamaica), Canute Caliste (Grenadines), Philome Obin and Louisianne St. Fleurent (Haiti).

Beverly Kaye Gallery
15 Lorraine Drive
Woodbridge, Connecticut 06525
Beverly Kaye, owner
Phone: 203-387-5700
Email: beverlyskaye@aol.com
Web site: www.artbrut.com
Blog: www.beverlykayegallery.blogspot.com
Sales Blog: www.ArtbrutAndOutsiderArt.blogspot.com
Facebook: Beverly Kaye Gallery

Beverly Kaye is a private dealer with a focus on uncommon, non-mainstream, outsider, folk and art brut art. The collection also includes Pueblo pottery, photography, and anonymous found art. The annual **Sculpture in the Garden Show**, featuring self-taught artists using recycled and repurposed materials to create unique objects, for both inside and outside the home, is held each June and is open to the public. Children are welcome. The gallery itself is a private space and is opened by appointment.

Artists
Tom Breen, William Brock, Sonny Cardinelli, Pedro Martin DeClet, Joe DeMarco, Moira Fain, Anthony Guyther, Billy Healy, Bill Herzfeld, Alexander Huber, Sandy Mastroni, Howard McAvoy, Corso de Palenzuela, Paul Pitt, Matt Sesow, Gordon Skinner, Ronald Sloan, Marcia Spivak, Anna Stroud, Gerald Thornton, and more

Artists Who Sell Their Own Work
Check the Artists chapter for location and contact information.
Sandy Mastroni

DISTRICT OF COLUMBIA

Art Enables
2204 Rhode Island Avenue, N.E.
Washington, D.C. 20018
Mary Liniger, Executive Director
Beth Baldwin, Arts Coordinator

Phone: 202 554-9455
Email: mliniger@art-enables.org
Email: bbaldwin@art-enables.org
Web site: www.art-enables.org

Art Enables is a 501(c)3 nonprofit gallery and supported program for adult artists with disabilities who live in the metropolitan area. Art Enables mission is to offer these artists the opportunity, environment, materials, and marketing support needed to succeed as professional artists. The artists earn more than money from art sales: they develop pride, recognition for their work, and a sense of belonging. Artists receive a 60 percent commission on their works sold, and are exhibited in the Art Enables Gallery, the online market place, and in external exhibits throughout the area. Art Enables is open Monday–Friday from 9 a.m. to 4 p.m. Visitors are welcome to the studio and art gallery.

Artists

Allison Bell, Calvin "Sunny" Clarke, Mara Clawson, Jackie Coleman, Melissa Cory, Dethaw Cotman, Darnell Curtis, Egbert 'Clem' Evans, Justin Gorman, Deborah Green, Maurice "Mo" Higgs, Payman Jazini, Charmaine Jones, Michael Knox, Toni Lane, Keith Lewis, Paul Lewis, Raymond Lewis, Violet Lucas, Paul McGown, Charles Meissner, Vanessa Monroe, Carl Morrison, Shawn Payne, Max Poznerzon, Jamila Rahimi, Connie Reinwald, Michael Schaff, Chris Schallhorn, Eileen Schofield, John Simpson, Nonja Tiller, Harold Whitlow, Jermaine Williams

Gallery O on H

1354 H Street, N.E.
Washington, D.C. 20002
Mary Ellen Vehlow, Owner
Stephen O. Hessler, Owner
Phone: 202-543-6600
Email: none
Web site: www.galleryoonh.com

Gallery O/H is an alternative arts and culture space that features a selection of local artists (including performance artists) and out-of-the-mainstream and self-taught artists. The building is a converted used car lot and sales office now operated as a gallery and outdoor performance space. The inside traditional setting is one designed to attract persons of many backgrounds or variety of interests and "present a non-intimidating setting to enjoy art for what it is, not what it costs." The self-taught inventory consists of traditional, well-recognized "masters" of the idiom as well as unknown emerging and local artists who are also self-taught. The programming is often coupled with neighborhood or local business events, and often combines visual performance and audio/acoustic music events as well as the art. Gallery O on H has hosted the DC jazz festival "Jazz in the Hood" series every June and a "Music in the Courtyard" series in the summer, which usually includes jazz, blues, and folk, with 'compatible' two and three dimensional art. In 1213 the gallery held the "DC Artists Ball" in connection with President Obama's second Inaugural, which included a collaboration of local art groups, self-taught artists, and a dance performance by "Burning Man" fire performers.

Artists

Allen David Christian, Beatrice Coron, Candy Cummings, Timmie Daugherty, Vanessa German, Charles Gillam, Ted Gordon, "Dr. Bob" Shaffer, Betty Sue Matthews, Greg Mort, Nadine Mort, Mark Swindler, Mars Tokyo, Annie Wellborn, and anonymous artists.

Artists Who Sell Their Own Work

Artists are listed here alphabetically by name; check the Artists chapter for location and contact information.

Frederick Kahler
Matt Sesow

FLORIDA

Gallery on Greene

606 Greene Street
Key West, Florida 33040
Nance Frank, Director/Owner
Karen Wray, Lead Art Consultant
Phone: 305-294-1669
Email: galleryongreene@bellsouth.net
Web site: www.galleryongreene.com

The Gallery on Greene was established in 1996 and has frequent gallery exhibitions. The director, Nance Frank, "conducts her business with personal commitment and a lot of enthusiasm for art and collectors." The gallery focuses on two and three dimensional work from the Florida Keys and Cuba. Art includes art by the self-taught and by internationally recognized artists. Emphasis is on authentic Key West and Cuban art from the 1930s to today

Artists

Jack Baron, Prescilla Coote, Suzie DePoo, George Garcia, Wayne Garcia, Makiki, Mike Rooney, Mario Sanchez, Papito Suarez, William Bradley Thompson, Andy Thurber, Peter Vey, and others

Jeanine Taylor Folk Art

211 East First Street
Sanford, Florida 32771
Jeanine Taylor, Owner
Mary Shaw, Gallery Manager

Phone: 407-323-2774
Email: info@jtfolkart.com
Web site: www.jtfolkart.com

Since 1997, Jeanine Taylor has specialized in contemporary folk art from Florida and the Deep South. Her spacious 5,000 square foot gallery is housed in a 100+year old building in Historic Downtown Sanford, Florida (just 25 minutes northeast of Orlando) and is home to the art of over 50 self-taught artists, as well as 8 local working artist studios. Tayylor insists on celebrating the artist as well as the art by hosting a full schedule of shows, events, and educational programs. Each year, the gallery hosts nationally known artists in the "Folk Artist in Residence" program. The apartments above the gallery have provided hospitality for over 18 visiting artists as well as studio space for long term residency. Ab the Flagman has been a recent artist in residence and Theresa Disney does a two month residency every winter to create a new body of work for the gallery.

Artists

John "Cornbread" Anderson, Butch Anthony, Michael Banks, Chris Beck, Rudolph Valentino Bostic, Benny Carter, Jerry Coker, Ronald Cooper, Michel Delgado, Theresa Disney, Adam Farrington, Roger Ivens (aka Ab the Flagman), Lorraine Gendron, Ken "Blacktop" Gentle, Charles Gillam, Elayne Goodman, Lila Graves, David Hammock, Alyne Harris, Lucy Hannicut, Leonard Jones, Pat Juneau, Mary Klein, Carl Knickerbocker, Ernie Lee, Eric Legge, Trent Manning, Mike Melone, Melissa Menzer, R. A. Miller, Roy Minshew, Reggie Mitchell, Perry Morgan, Anthony Pack, Andrei Palmer, Ed Pribyl, Mary Proctor, Sarah Rakes, Matt Sesow, Cher Shaffer, Jim Shores, Charles Smith, "Frog" Smith, Jimmy Lee Sudduth, Al Taplett, Tres Taylor, Mose Tolliver, Gregory Warmack (aka Mr.

Imagination), Ruby C. Williams, Purvis Young, Kurt Zimmerman

Bruce Shelton-Shelton Gallery

Palm Beach, Florida
Phone: 615-477-6221
Email: sheltongallery@gmail.com
Web site: www.sheltongallery.com

For full description and artist list see gallery entry under Shelton Gallery, Nashville, Tennessee.

Laurie G. Ahner-Galerie Bonheur

2534 Seagrass
Palm City, Florida 34990
Laurie G. Ahner, Owner
Phone: 772-224-2325
Email: gbonheur@aol.com
Web site: www.galeriebonheur.com
By appointment only

For full description and artist list see gallery entry under Galerie Bonheur in St. Louis, Missouri

Artists Who Sell Their Own Work

Artists are listed here alphabetically by name; check the Artists chapter for location and contact information.

Ab the Flagman
Jack Beverland (Mr. B)
Brian Dowdall
Robert Roberg
Bettye Williams
Ruby Williams
Kurt Zimmerman

GEORGIA

Barbara Archer Gallery

Atlanta, Georgia
Barbara Archer, Director
Phone: 404-523-1845
Cell: 404-273-8184
Email: info@barbaraarcher.com
Web site: www.barbaraarcher.com

Barbara Archer Gallery was founded in 1995 to champion and showcase the art of self-taught masters working outside the art-historical mainstream. Since then, the focus evolved to include significant contemporary art in various media and work by select emerging artists, in addition to historically important vernacular art of the 20th century. Archer has worked

closely with major museums, seasoned, and new collectors alike. Barbara Archer Gallery has participated in The Outsider Art Fair in New York City, the National Black Fine Art Show in New York, AAF Contemporary Art Fair in New York; Art London, UK; and Master Drawings London, UK. Museum clients have included the Whitney Museum of American Art, The Philadelphia Museum of Art, The Milwaukee Museum, and The High Museum of Art, among others.

Barbara Archer says "After leaving our gallery's bricks and mortar home in 2013, we continue to cultivate relationships with our artists while welcoming the opportunity to partner with new audiences and venues. As we embark on this exciting new chapter of the Barbara Archer Gallery, our goal remains to offer

innovative and provocative contemporary art. We are available by appointment at 404-523-1845 to show work by artists who may interest you."

Mason Murer Fine Art, Inc.

199 Armour Drive
Atlanta, Georgia 30324
Mark Mason Karelson, Director
Tel: 404-879-1500
Email: info@masonmurer.com
Web site: www.masonmurer.com

Mason Murer Fine Art, "the South's largest art gallery," includes a number of self-taught artists shown in the context of contemporary art.

Artists

Leroy Almon, Sr., Richard Burnside, Ab the Flagman, Archie Byron, Ned Cartledge, Latrice Cooper, Thornton Dial, Sybil Gibson, Paul "The Baltimore Glassman" Darmafall, Bernard Gore, Howard Finster, Willie Jenks, S.L. Jones, R.A. Miller, J.T. McCord, J.B. Murry, Walter Norman, Jr., Andre Palmer, Mary T. Smith, Jimmy Lee Sudduth, Sarah Mary Taylor, Mose Tolliver, Terry Turrell, Fred Webster, Purvis Young

Orange Hill Art

331 Elizabeth Street, NE
Atlanta, Georgia 30307
Robbi Raitt, owner
Tel: 404-401-9255
Email: info@orangehillart.com
Web site: www.orangehillart.com

Orange Hill Art is a gallery specializing in art by folk, outsider and self-taught artists, located in Atlanta's Inman Park. The gallery sells the works of many artists, and regularly mounts both solo and group shows. Recent shows have included solo exhibitions of Archie Byron's work and Scott Griffin's work. O.L. Samuels and John Henry Toney shared the spotlight at another recent exhibition. The gallery takes artwork to sell on consignment, and actively seeks the work of new and established artists to make available to the public. For each artist it represents, the gallery's website provides images of the work for sale along with biographical information. It lists many artists, but does not always have any of their work for sale. As it is clear from the website whether an artist's work is available, and one can see the pieces themselves if any *are* available, it is wise to check the website in advance to see if there is any work for sale by the artist(s) you are looking for. The gallery is open by appointment only.

Main Street Gallery

51 North Main Street
Clayton, Georgia 30525
Jeanne Kronsnoble, owner

Phone: 706-782-2440
Email: mainst2@windstream.net, mail to: Mainst2@windstream.net
Web site: www.mainstreetgallery.net.

Main Street Gallery specializes in contemporary folk and self-taught art, primarily from the Southeast. There are three floors of selling space which makes it possible for the gallery to have one person exhibitions in the upstairs gallery space. The gallery also features regional folk pottery and furniture. Photographs are available.

Artists

Rudolph Valentino Bostic, Tubby Brown, Richard Burnside, Chris Clark, Cornbread, Patrick Davis, Kenny Dickerson, Tommy Durham, Lonnie Holley, Mama Johnson, Clyde Jones, Chris Lewallen, Jake McCord, Andrew Mccall, R.A. Miller, J.L. Nipper, Mary Proctor, Sarah Rakes, O.L. Samuels, Frankie Scarborough, Jay Schuette, Bernice Sims, Buddy Snipes, Jimmy Lee Sudduth, Annie Tolliver, Mose Tolliver, Derek Webster, Della Wells, Purvis Young, and Kurt Zimmerman

James Allen Antiques

1111 Magnolia Bluff Way SW
Darien, Georgia 31305
James Allen, owner
Phone: 912-289-1060
Email: shop@southernpicker.com
Web site: www.southernpicker.com

James Allen is a "Southern picker" who specializes in finding folk art, American furniture, and folk pottery. He now has a shop at this location, which is part of the Darien Outlets Mall.

Around Back at Rocky's Place

3631 Hwy.53 East at Etowah River Road
Dawsonville, Georgia 30534
Robin Blan, owner
Tracey Burnette, owner
Phone: 706-265-6030
Email: aroundbackatrockysplace@hotmail.com
Web site: www.aroundbackatrockysplace.com

Around Back at Rocky's Place is a stopping place for many collectors. About 20 artists are represented; the collection's focus is on Georgia pottery, especially face jugs and the "Best selection by artist John 'Cornbread' Anderson." For nine years the proprietors have had an annual gathering called "Folk Art Family Reunion" during the last weekend in June. Call and you will get a card with detailed driving instructions.

Crocker Pottery

P. O. Box 505
6345 W. County Line Road

Lula, Georgia 30554
Michael Crocker, manager
Phone: 770-869-3160
Email: folkpots@bellsouth.net
Web site: Sells on eBay as "Michael Crocker Folk Pottery"

This Georgia folk pottery center is a source for buying Georgia folk pottery, tours, history, exhibits news and current events in the pottery field. Books and other related items are available. There are kiln openings every two to three months (call for dates) and other special events. The center keeps alive the old traditions of hand-made folk pottery. Michael Crocker, his brothers Dwayne and Melvin, and their mother Pauline produce decorative and utilitarian wares. There are opportunities to see the clay worked and browse the many pieces produced by the Crocker and Meaders family, which are always available Crocker Pottery is open year round Monday–Friday 9 a.m.–5 p.m.

Roots Up Gallery

6 Liberty Street
Savannah, Georgia 31401
Francis Allen and Leslie Lovell, owners
Phone: 912-677-2845
Email: through website
Web site: www.rootsupgallery.com

The Roots Up Gallery opened in May 2014. Allen and Lovell traveled all over the Southeast in the year before opening, collecting all manner of fascinating pieces for their new Roots Up Gallery. Featuring mainly self-taught painters and sculptors, Roots Up is a place that seeks to introduce people to the colorful and meaningful expressions borne in the rural backwoods and under the tin roofs of the South. It's also the only gallery in Savannah dedicated to the genre of folk art. It is located on the parlor (second) level of an historic 1854 mansion, where the art is displayed informally in a setting where the owners offer viewers tea and like to chat about their art and the artists they represent. The gallery's website contains brief bios of all the artists the gallery carries, displays the pieces available from the artist, and sometimes includes videos or still clips of the artists and their art. In addition to self-taught/outsider art, the gallery carries work by some contemporary potters and other trained artists.

Artists

Z. B. Armstrong, Michael Banks, Rudy Bostic, Brian Dowdall, Ab the Flagman, Ken "Blacktop" Gentle, Clementine Hunter, Levent Isik, Charley Kinney, Hazel Kinney, and many others.

Folk America Gallery

P.O. Box 734
Summerville, Georgia 30747

Larry and Jane Schlachter, owners
Phone: 706-857-8095
Email: info@folkamerica.net
Web site: www.folkamerica.net

Folk America is an extension of the Schlachters' private art business of thirty years, which resulted from their passion for collecting folk art in the early 1980s when they first met the Rev. Howard Finster. "The last twenty years have been an adventure, covering a dozen states and well over one hundred thousand miles. It is our desire to share the art we have collected as well as the memories." The gallery is located two miles north of downtown Summerville at 12135 Hwy 27, one mile from Howard Finster's Paradise Garden (which reopened May 6, 2012). Gallery hours are Saturday from 10:00 a.m. until 4:00 p.m. and by appointment.

Artists

Andrea Badami, Georgia Blizzard, Minnie Evans, Howard Finster, Dilmus Hall, B.F Perkins, Mary T. Smith, Jimmy Lee Sudduth, Mose Tolliver, Purvis Young. Register to receive e-mail updates when art is added.

Robert Reeves, Private Dealer

Atlanta, Georgia
Phone: 404-281-3194
Email: southart21@comcast.net
Web site: none

Among the artists and artifacts that Reeves finds and collects are Howard Finster, James Castle, Lewis Smith, Herman Bridgets, vernacular photography, found objects, and anonymous works. The inventory changes often so Reeves should be contacted frequently to see what is available.

John Denton, Private Dealer

Hiawasee, Georgia 30546
Phone: 706-896-4863
Email: jwdenton@windstream.net
Web site: none

Located in the majestic north Georgia mountains, John Denton focuses on twentieth century outsider artists. He carries many R.A. Miller works, works by Nellie Mae Rowe and J. B. Murry, as well as numerous individually numbered works of the Rev. Howard Finster. The Finster collection includes clock boxes from the 1960s, paintings from the late 1970s that have no number, examples form all of the numbered series, and Finster prints. For those not interested in folk art, Denton also handles a wide variety of handmade knives, western art, and many prints by contemporary artists.

Jim Farmer, Private Dealer

The Lorenzo Scott Project
3939 Lavista Road, E435

Tucker, Georgia 30084-5162
Phone: 770-939-8949
Email: jimfarmer@live.com
Web site: none

Artists Who Sell Their Own Work

Artists are listed here alphabetically by name; check the Artists chapter for location and contact information.

Rudolph Valentino "Rudy" Bostic
Fred Budin
Crocker family (potters)
Walter Fleming (potter)
Ken "Blacktop" Gentle
Hewell family (potters)
Peter Loose
Meaders family (potters)
Valton Murray
Indian Joe Williams

ILLINOIS

Arts of Life

2110 West Grand Avenue
Chicago, Illinois 60612
Denise Fisher, Executive Director
Nick Campbell, Program Director
Phone: 312-829-2787
Email: Info@artsoflife.org
Web site: www.artsoflife.org

Arts of Life was founded in 2000. This non-profit art studio provides adults with developmental disabilities a workspace that belongs to and is run by its members. The studio promotes self-respect, personal independence, and artistic skills.

The Arts of Life—Chicago and North Shore

Chicago studio:
 2010 W. Carroll Avenue
 Chicago, Illinois 60612
 Phone: 312-829-2787
North Shore studio:
 1963 Johns Drive
 Glenview, Illinois 60025
 Phone: 847-486-0808
John Sharp, Arts Coordinator
Hilary Marshall, assistant
Email: jsharp@artsoflife.org
Web site: www.artsoflife.org

Arts of Life started as twelve individuals with a passion for artistic expression and a need for an alternative system. Three of the twelve partnered up: a 70-year-old woman with an intellectual disability and a mental illness, a self-taught, unconventional artist, and a professional in the field of developmental disabilities. Nine other people, each with a developmental disability, living in a residential setting soon joined up. The group's shared vision, now a reality, was to create a working, person-centric, artistic community that provided a work environment of equality. The group has four core values—inspiring artistic expression, building community, promoting self-respect, and developing independence. Since its inception it has expanded to include two studios—one in Chicago and one on the North Shore.

Artists—Chicago studio

Pablo Alonzo, Stephanie Andujar, Guy Conners, Lee Draus, Stefan Jarhaj, Carolyn Kelley, David Krueger, Walter Lazard, Bill Lilly, Shannon Mallers, Mike Marino, Christianne Msall, Susan Pasowicz, Tony Perez, Hubert Posey, Elisha Preston, Frances Roberts, Linda Ruzga, Kris Schenkel, Alex Scott, Kathleen Stefanaski, Kelly Stone, Tim Stone, Benjamin Torres, Debbie Vasquez, Robert Verran, Marianne Wehr, Jean Wilson, Joshua Wykes, Christina Zion

Artists—North Shore studio

Emily Aussem, Pouya Bagherian, Ted Gram-Boarini, Russell Copenharve, Danny Frownfelter, Amanda Gantner, Phil Gazzolo, Laura Greenberg, Nikole Heusman, Elise Hylton, David Jonaitis, Hector Jones, Monika Kieca, Sean Kremer, Rebecca Kubica, Evan Madsen, Laura McManus, Erinn Nariss, Montell Payne, Alicia Porter, Brian Reed, Pam Robe, Andrew Sloan, Antonie Smith, Joshua Stern, Rebecca Turner, Chris Viau, Yordan Yanev, Quinn Zenner

Carl Hammer Gallery

740 North Wells Street
Chicago, Illinois 60654
Carl F. Hammer, Director
Phone: 312-266-8512
Email: hammergall@aol.com
Web site: www.hammergallery.com

Carl Hammer presents masterworks by academic and self-taught artists. The Gallery first opened its doors in 1979 and featured select 19th and 20th century American folk art and outsider art of outstanding quality, both historical and contemporary, integrated with works of contemporary mainstream artists. Hammer says "our intent is to present art expression, whether

outsider or 'mainstream,' in which its creation advances a vision of spirit and life evolving from ideas and common life experiences. Hammer says "Today the artists we are proud to go forward with into the 21st century are unique in their own personal visions and means of expression." There is a gallery publication on the web site.

Artists

Self-taught artists in the gallery: Marcus Bontempo, David Butler. Henry Darger, Lee Godie, Jesse Howard, Frank Jones, Bill Traylor, Eugene Von Bruenchenhein, Joseph Yoakum, Albert Zahn.

Karen Lennox Gallery

257 East Delaware Place, No.6
Chicago, IL 60611
Karen Lennox, owner
Phone: 312-787-1477
Email: lennoxgallery@gmail.com
Web site: www.karenlennoxgallery.com

Karen Lennox opened her gallery in 1981, building upon experience in directing a Chicago art gallery in the 1970s. The gallery also has a specialty in works by twentieth century self-taught artists. It also focuses on helping private clients build museum quality collections, emphasizing locating private works by established contemporary artists being sold by previous owners.

Artists

Peter Charlie Besharo, James Castle, Eugene Von Bruenchenhein, Joseph Yoakum

Artists Who Sell Their Own Work

Artists are listed here alphabetically by name; check the Artists chapter for location and contact information.
George Colin
Eileen Doman
Art Paul Schlosser

───── INDIANA ─────

Possum County Folk Art Gallery

30957 Oak Drive
Osceola, Indiana 46561
Sheila Borum owner
Phone: 574-970-5851
Email: shiela@possumcounty.com
Web site: www.possumcounty.com

The gallery, founded in 1997, features folk art and especially blues-related folk art. A special interest is music-themed folk art created by George E. Borum,

also known as MUROB. Sheila Borum and her husband were inspired by Howard Finster—who officiated at their marriage at Paradise Garden—and other folk artists who encouraged them to start a gallery.

Artists

Missionary Mary Proctor, George E. Borum, Tom D., Squeakie Stone, Ernest Lee, Jaybird, George G. Borum, John Taylor, Otto Schneider, Biscuit V, and more.

───── IOWA ─────

The Pardee Collection

P. O. Box 2926
Iowa City, Iowa 52244
Sherry Pardee, owner
Phone: 319-337-2500
Email: sherrypardee@earthlink.net
Web site: www.pardeecollection.com

The Pardee Collection specializes in nontraditional folk and outsider art from the Midwest and Southern United States, as well as art from international sources. Sheree Pardee, the owner, has traveled extensively

around the country for more than 25 years, finding and working with artists. Pardee is herself an interesting and excellent photographer. Available by appointment only.

Artists

John Bambic, Will Branch, "Uncle Pete" Drgac, Les Freswick, Paul Esparza, Emma Gibson, Emitte Hych, David Olson, Stephen J. M. Palmer, Oliver Williams, Jim Work; she also carries vernacular photography.

KENTUCKY

Kentucky Artisan Center at Berea

975 Walnut Meadow Road, I-75 Exit77
Berea, Kentucky 40403
Phone: 859-985-5448
Email: artisancenter-blog@ky.gov
Web site: www.kentuckyartisancenter.ky.gov

The Center describes itself as the folk art and craft capital of Kentucky. Its mission is "to promote economic development, education, and tourism in Kentucky." The shop has work by over 650 artists and artisans in a very handsome 25,000 square foot building that includes a gallery, a gift shop, a café, and a travel information center. The art and craft section is open daily from 9:00 a.m. to 6:00 p.m. The art includes wire horse sculptures by Dacelle Peckler, work by folk art painter, Janet Harding Owens, wood carvings by Lonnie and Twyla Money, 14-inch wood carvings by LaVon Williams, and gourd art by Sally Commack and by Angela Arnett. Also works by Emmy Howeling and Ben Mansur.

Completely Kentucky, Inc.

237 West Broadway
Frankfort, Kentucky 40601
Ann Wingrove, Owner
Melanie Van Houten, Manager
Phone: 502-223-5240
Email: info@completelykentucky.com
Web site: www.completelykentucky.com

This gallery/shop sells only items made in Kentucky, including three-dimensional works, fine crafts, and food. There are functional, decorative, traditional, and contemporary pieces. The works of over six hundred artists are sold, with about sixteen folk artists including Minnie Adkins, Lonnie and Twyla Money, Jennifer Zingge, Bobby Peck, and P.J. Campbell.

Peaceful Valley Folk Art Shop

720 Right Newcombe Creek Road
Isonville, KY 41149
Minnie Adkins and Family, Owners
Phone: 606-738-5779
Email: none
Web site: none

Minnie Adkins, Isonville's premier folk art carver, opened this gallery with her family in 2014 to showcase local artists and provide a year-round opportunity for herself and others to display and market their work. Artists attending said that it was almost like the "Day in the Country" used to be.

Artists
Minnie Adkins, Wanda Barker, Donna Boggs, Sharon Boggs, JoAnn Butts, Becky Campbell, Brent Colling-

worth, Ron Gevedon, Jimmy Lewis, Tim Lewis, Pam Meade, Elsa Salyers, and Dolly and Guy Skaggs

Ann Tower Gallery

141 East Main Street
Lexington, Kentucky 40507
Ann Tower, Director
Phone: 859-425-1188
Email: anntowergallery@gmail.com
Web site: www.anntowergallery.com

The Ann Tower Gallery features work by many of Kentucky's best artists who have achieved national and international acclaim. The gallery also represents some of the most prominent self-taught Kentucky artists. Self-taught artists included are Minnie Adkins, Joan Dance, JoAnn Butts, Lonnie and Twyla Money, Dolly and Guy Skaggs, Leon Kassapides, and Janice Harding Owens.

Clark Art & Antiques

801 Winchester Road
Lexington, Kentucky 40505
Tom Clark, Owner
Phone: 859-361-2147
Email: clarkartandantiques@gmail.com
Web site: none. On Facebook

Tom Clark has one of the largest collections of works by folk and self-taught Kentucky artists to be found anywhere for sale. It has everything from art, antiques to flea market finds to well-known folk artists, stained glass and more. It is a wonderful place for browsing and for adding to one's personal collection.

Artists
Minnie Adkins, Bill Baker, the Coopers, Robert Cox, Burlon, Craig, Denzil Goodpaster, Harry Jennings, Tim Lewis, Cher Shaffer, Donald Tolson, LaVon Williams, the Moneys

Institute 193

193 North Limestone Street
Lexington, Kentucky 40507
Phillip March Jones, Director
Kelly Colasanti
Phone: 859-229-0454
Email: phillip@institute193.org
Web site: www.institute193.org

Institute 193 focuses on folk and outsider art, and also carries some mainstream artists. It is a not-for-profit gallery established with the intent to promote the art.

Artists

Howard Finster, Mike Goodlett, Lonnie Holley, John Martin, Massengill family, Robert Morgan, Charles Williams

CRAFT(s) Gallery

572 South 4th Street
Louisville, Kentucky 40202
David McGuire, Owner
Karen Welch, Owner
Phone: 502-584-7636
Email: david@craftslouisville.com
Web site: www.craftslouisville.com/cms/

CRAFT(s) Gallery is a traditional and contemporary art gallery founded by Karen Welch and David McGuire in summer, 2013. It features fine artisan craft by local and national artists. Call to find out which self-taught artists are available.

Artists

Minnie Adkins, Marvin Finn, Denzil Goodpaster, Joshua Huettig, Harry Jennings, Edd Lambdin, Larry McKee, Carl McKenzie, Lonnie and Twyla Money

Studioworks/Zoomgroup

2008 Eastern Parkway
Louisville, Kentucky 40204
Heather Drury, Manager
Phone: 502-581-0658
Web site: www.zoomgroup.org/studioworks

StudioWorks is a non-profit art gallery and studio benefiting adults with developmental disabilities. The artists can choose from a variety of art making processes and materials. Central to the program are drawing and painting, but ceramic sculpture, jewelry making, collage, photography, and fiber arts are also available. The program respects the idea that artists with developmental disabilities are capable of significant individual expression.

All the art available at StudioWorks is made by the artists who participate in the program, which encourages sales and artists receive 80 percent of the price of all sold work. The remaining 20 percent goes back into the program for art materials. The program receives its funding primarily through Medicaid waivers, which provide the artists with a choice of activities that can enrich their lives.

Staff consists of five professionally trained artists who interact with member artists daily as they teach new techniques and provide support. Visiting artists are welcome, to provide workshops or presentations of their own original artworks. The visiting artist program helps expand member artists' frame of reference for what is possible through art. StudioWorks also holds art exhibits and looks for exhibition opportunities outside its own space as well. Framing all of the

program's activities is the inclusive idea of belonging to and participating with the larger community.

Larry Hackley, Private Dealer

P.O. Box 909
Richmond, KY 40476
Phone: 859-986-0780
Email: larryhackley@yahoo.com
Web site: none

Larry Hackley is a "picker" concentrating on Kentucky artists, but also including other southern artists. Once the owner of Hackley Gallery in Winchester, Kentucky, he moved, first to Berea and then to Richmond and began selling from his home.

Artists

Minnie Adkins, Eddie Arning, Steve Ashby, James Bright Bailey, Elisha Baker, Linvel Barker, Cyril Billiot, Minnie Black, Homer Bowlin, Jerry Brown, Lewis Brown, Robert Brown, G.F. Cole, Golmon Crabtree, Burlon Craig, William Dawson, "Creative" G.C. DePrie, Alva Gene Dexhimer, Howard Finster, Homer Green, John Garrou, Lee Godie, Denzil Goodpastor, Earl Gray, Gary Higgins, Dilmus Hall, T.A. Hay, Jessie Howard, Harry Jennings, Wes Jones, Rothel King, Charley Kinney, Hazel Kinney, Noah Kinney, Lewis Lamb, Arlie Lambdin, Edd Lambdin, Jim Lewis, Leroy Lewis, Tim Lewis, Willie Massey, Larry McKee, Carl McKenzie, Lanier Meaders, R.A. Miller, Ike Morgan, Sister Gertrude Morgan, Earnest Patton, R.W. Rawlings, "Popeye" Reed, Marie Rogers, Wilhelm Schimmel, Mary T. Smith, Jimmy Lee Sudduth, Sarah Mary Taylor, Mose Tolliver, Donny Tolson, Edgar Tolson, Inez Nathaniel Walker, Southern folk pottery, African-American quilts, Southern carved walking sticks, anonymous 19th and 20th century works

Artists Who Sell Their Own Work

Artists are listed here alphabetically by name; check the Artists chapter for location and contact information.

Minnie Adkins
Bill Barker
Fred and Bonnie Burkes
Jo Ann Butts
Carolyn Hall
Barbara Keeton
Bob Kemplin
Ben Mansur
Lenville Maxwell
Janice Harding Owens
Dacelle Peckler
Deborah Evans Perry
Thaddeus Pinkney
Ruby Queen
Donald Lee "Donny" Tolson

—————— LOUISIANA ——————

Gilley's Gallery

8750 Florida Boulevard
Baton Rouge, Louisiana 70815
Eric Gilley, Director
Marie Gilley
Phone: 225-922-9225
Cell: 225-921-3346
Email: outsider@ea*Phone:* net
Web site: www.gilleysgallery.com

Open since 1978, Gilley's Gallery features self-taught Southeastern outsider artists, especially those from Louisiana such as Clementine Hunter, Sister Gertrude Morgan and David Butler. With a special focus on the work of Clementine Hunter, Gilley's houses one of the largest gallery collections of her available work. The gallery has regular hours and is also opened by appointment. Photographs will be sent upon request.

Artists

David Butler, Edward "Chaka" Butler Lanoux, "Chief" Willey, Clementine Hunter, Donald McLaws, Sister Gertrude Morgan, Sarah Rakes, Mary T. Smith, Jimmy Lee Sudduth, Willie White, Willi/Willie

Houmas House Plantation and Gardens

40136 Louisiana Hwy 942
Darrow, Louisiana 70725
Phone: 225-473-9380
Email: none
Web site: www.bellacalla.com/craig-black-artist and on Facebook (cbartist1)

In addition to the attraction of a beautiful restored River Road plantation and a good restaurant, Houmas House has the art and studio of self-taught artist Craig Black. In addition to being the grounds keeper at Houmas House, he has painted murals in the entry halls a "history" of the location—hunting dogs and birds among the fields of sugar cane, Roseate Spoonbills, buildings, and other local scenes. Black has his art studio in the old guard cottage, where he makes wood carvings from driftwood he finds along the banks of the Mississippi, paintings in acrylics, murals with many layers of glazing, and clay sculptured figures and spooky figures made from burlap coffee bags soaked in paint. If a visitor comes at the "right" time there may be an invitation to visit Craig's "Sculptured Home" in Gonzales, Louisiana.

Framer Dave's

512 Mississippi Street
Donaldsonville, Louisiana 70341

Framer Dave, Frame Shop Owner
Artist in Residence, Alvin Batiste
Phone: 225-473-8536
Email: framerdave69@yahoo.com
Web site: www.alvinbatiste.com

The walls of this frame shop are covered with sometimes as many as 200 art pieces by Batiste. His subjects cover local scenes and events from south Louisiana and scenes he imagines about New York.

Algiers Folk Art Zone

207 Le Boeuf Street
New Orleans, Louisiana 70114
Charles Gillam, Sr., Director
Phone: 504-261-6231
Email: gillamfolkart@yahoo.com
Web site: none. On Facebook

In addition to his own painted wood carvings of subjects closely related to Louisiana and to African American culture this place is an environment, a gallery, and the site of an annual folk art event every fall usually in October. There are portraits of Blues men, a mural of a New Orleans second-line. and carved heads of New Orleans musicians are everywhere. Gillam makes use any and all found objects and materials to create his art—discarded wood and metal, vintage covers of vinyl recordings, it all becomes a wonderful sight and homage to the great African and American cultural art and icons. Gillam also has a booth and sells his art work at the New Orleans Jazz and Heritage Festival.

Anton Haardt Gallery

2714 Coliseum Street
New Orleans, Louisiana 70130
Anton Haardt, Owner and Director
Phone: 504-891-9080
Cell: 504-8971172
Email: anton3@earthlink.net
Web site: www.antonart.com

This gallery has a large collection of folk art from the Deep South, focusing on vintage works by Mose Tolliver, Jimmy Lee Sudduth and others. Ms. Haardt has the entire collection of the mud sculptures of Juanita Rogers. The gallery publishes a newsletter (see description under the Montgomery, Alabama, gallery location), and will send photographs to interested collectors. Open by appointment only. There is another Anton Haardt Gallery that opens for special exhibitions at 2858 Magazine Street, New Orleans, Louisiana 70115. It is best to check the gallery website for information. These two galleries house the largest collections of folk art for sale in New Orleans. It is best to

call in advance. In 2005 Ms. Haardt wrote *Mose T A to Z: The Folk Art of Mose Tolliver*, a splendid book of colorful art and essays.

Artists

Loy "The Rhinestone Cowboy" Bowlin, David Butler, Thornton Dial, Sr., Sam Doyle, Minnie Evans, Howard Finster, Sybil Gibson, Bessie Harvey, Lonnie Holley, Clementine Hunter, James Harold Jennings, Calvin Livingston, Charlie Lucas, R.A. Miller, B.F. Perkins, Royal Robertson, Juanita Rogers, Mary T. Smith, Henry Speller, Jimmy Lee Sudduth, James "Son" Thomas, Annie Tolliver, Mose Tolliver, Felix Virgous, Willie White, Ben Williams, "Artist Chuckie" Williams

Barristers Gallery

2331 St. Claude Avenue
New Orleans, Louisiana 70117
Andy P. Antippas, Owner and Director
Phone: 504-710-4506
Email: andyantippas@gmail.com
Web site: www.barristersgallery.com

Barristers Gallery is one of the twenty-five galleries of SCAD NOLA (St.Claude Arts District), all of which are open the second Saturday of every month. Barristers is also open by appointment. The gallery exhibits the work of trained and untrained Outsider artists, local and international.

Artists

Ryan Burn, Lillian Butter, Bruce Davenport, Keith Duncan, Roy Ferdinand, Jr., Richard Fitzgerald, Sallie Ann Glassman, Anne Marie Grgich, Scott Guinon, Susan Ireland, Mario Mesa, "Dr. Bob" Schaffer, Herbert Singleton, Myrtle Van Damitz III, Wally Warren, Peter Wood

Coq Rouge Gallery

905 Cadiz
New Orleans, Louisiana 70115
Patricia Low, Owner/Artist
Phone: 504-266-0440
Email: coqrougegallery@gmail.com
Web site: none

This gallery, located on the corner of Cadiz and Magazine, has a large and varied collection of art and artists of different backgrounds, some schooled and some self-taught. Its main focus is on things local to the New Orleans area and created by hand. The owner selects artists, and each piece from an artist, because she loves the piece and can see in it a "gumbo of where the artist is from what has influence them, and where they are now." She feels that "art should create a conversation, it should evoke memories, and it should make you happy."

Artists

Kerry Fitts, Emma French Connelly, Linda Corley, Patricia Low, Claudia Mc Grane, Dottee "Dot-Tee" Ratliff.

Kako Gallery

536 Royal Street
New Orleans, Louisiana 70130
Owner/Director Catherine Koe
Assistant Linda Lesperance
Phone: 504-565-5445
Email: kakogallery@aol.com
Web site: www.kakogallery.com

This gallery, just a few steps from Jackson Square, offers many different styles of art from local artists, including a few folk art paintings and carvings by Charles Gillam and paintings by self-taught artist Gary Harrington.

LeMieux Galleries

332 Julia Street
New Orleans, Louisiana 70130
Denise Berthieume Owner/Director
Phone: 504-522-5988
Email: mail@lemieuxgalleries.com
Web site: www.lemieuxgalleries.com

LeMieux Galleries represent important contemporary artists and one self-taught artist, Leslie Staub, who is also included and displayed in the House of Blues art collection in New Orleans. Staub's art has appeared in many exhibitions and in original book paintings.

Raven Arts Gallery

1621 Clio Street
New Orleans, Louisiana 70130
Regenia A. Perry, Ph.D, Owner/Director
Phone: 504-729-0036
Email: none
Web site: none

The Raven Arts Gallery is a "A Collector's Gallery." It is a showcase for the private collection of art historian Regenia Perry, a museum quality collection of artwork and textiles acquired during Perry's extensive travels in the United States and Africa. Perry has served as curator and co-curator of exhibitions at the Metropolitan Museum of Art, Corcoran Museum of Art and the Dallas Museum of Art and is the author of numerous books, exhibition catalogs, and articles in the areas of African and African American academic and self-taught art. The Raven Arts Gallery space is organized into four galleries: The African Gallery with a focus on West and Central African artworks; The Rene Stout Gallery with mixed media and three dimensional works influenced by Stout's fascination with Kongo Minkisi

(power figures); the gallery of six decades of Harlem photographs of James Van Der Zee; and The Ruth Mae McCrane Gallery features the story telling paintings, at once sophisticated and naïve, of this Houston painter whose colorful multi-figured scenes are bursting with movement and detail. One-hour private tours of the collection and/or sales are available by appointment. Reservations are required and limited to 12 persons. Call 504-729-0036 to make reservations.

Artists

F. L. "Doc" Spellman, Luster Willis, Johnny W. Banks, Ruth Mae McCrane, Vivian Ellis, Roy Ferdinand are other artists in the gallery's collections.

Artists Who Sell Their Own Work

Artists are listed here alphabetically by name; check the Artists chapter for location and contact information.

Ivy Billiot
Craig Black
Bruce Brice (family will continue to sell until no more available)
Lorraine Gendron
Charles Gillam
Pat Juneau
Claudia McGrane
Mary Ann Pecot de Boisblanc
Dot-Tee Ratliff
"Dr. Bob" Shaffer
Welmon Sharlhorne
Carol Thibodeaux
Louis Vuittonet

MAINE

Spindleworks

7 Lincoln Street
Brunswick, Maine 04011
Liz McGhee, Program Manager
Phone: 207-725-8820
Email: emcghee@iaofmaine.org
Web site: www.spindleworks.org

Spindleworks is a nonprofit arts center for adults with developmental disabilities, founded in 1978 primarily as a weaving program. Now, over 40 artists work in a variety of mediums, including painting and drawing, photography, ceramics and woodworking, weaving, and other fiber and fabric arts. In addition, the artists write poetry and stories, and express themselves through acting and other performing arts. Their work has been exhibited both locally and nationally, and they are well known and respected members of Maine's artistic community. As well as studios open to the public, there is a store and onsite gallery which mounts shows throughout the year. Member artists receive 75 percent from sales of their artwork. Through exhibits, community events, theatrical performances and volunteering, Spindleworks aims to break down stereo-types of people with disabilities and educate the public about their talents and strengths.

Artists

Robin Albert, Dana Albright, Angela Alderete, Kevin Babine, Jeanette Baribeau, Nancy Bassett, Emma Becker, Diane Black, Earl Black, Caroline Boylston, James Burrillm Tracy Cabral, Melissa Capuano, Barbara Carter, Betty Carter, Kelly Caton, Kimberly Christensen, Bonita Davis, Kimberly Devries, Heather Desjardins, Samuel Eberhart, Jennell Edson, Donald Freeman, James Gallagher, Skylar Goldwaite, Joshua Jones, John Joyce, Theresa Labrecque, Anna McDougal, Karen McGann, Loralei McGinn, Grace McKenna, Mitchell Pfeifle, Danielle Philippon, Jimmy Reed, Justin Reed, Michelle Rice, Thomas Ridlon, Nancy Scott, Terri Snape, Micah Webbert, Kelly Weingart, Lloyd Whitcomb, Emilie Williams, Kaley Willette, Helen Warren.

Artists Who Sell Their Own Work

Artists are listed here alphabetically by name; check the Artists chapter for location and contact information.
Rodney Richard, Jr.
L.C. Van Savage

MARYLAND

Make Studio

3500 Parkdale Avenue
Building 1, #16
Baltimore, Maryland 21211
Jill Scheibler, Director, Programming and Operations
Stefan Bauschmid, Director, Creative and Studio
Phone: 443-627-3502
Email: info@make-studio.org
Web site: www.make-studio.org

Make Studio's mission is to provide multimodal visual arts programming opportunities to adults with

disabilities in a supportive and inclusive environment, including sales and exhibition opportunities. Make Studio is motivated by a consideration of quality of life for and a celebration of the whole person, believing that providing avenues for communication, connection, and empowerment to artists with disabilities benefits the individual and the community

Artists

Gregory Bannister, Bradley Jacobs, Tony Labate, Charlie Linkins, Bess Lumsden, Zach Manuel, Louis Middleton, Jr., Cristina Patterson, Kareem Samuels, Gary Schmedes, Margie Smeller, Jarek Sparaco, Hal Stebbing, Rachel Tuchman, Tyrone Weedon, Jermaine "Jerry" Williams

Arundel Lodge

2600 Solomons Island Road
Edgewater, Maryland 21037
Katerina Evans, Art Program & Gallery director
Phone: 443-433-5961
Email: Kevans@arundellodge.org
Web site: www.openeyegallery.org

Arundel Lodge is a visual arts program for people with mental disabilities that helps its members explore the road to wellness. Artists of Arundel Lodge create paintings, fiber arts, and mixed media art, which the lodge exhibits several times a year to promote sales. "Arundal Lodge partners with individuals and families to improve their behavioral health through recovery related services." Arundel Lodge sponsors its own exhibitions and also has artists invited to exhibit with Art Enables in Washington, D.C.

Artists selected to be included in Art Enables 2012 show "Outsider Art Inside the Beltway," a juried show were Daniel Barclay, Marisa Bolan, Colin Lacey, Leah Loebner, Christian McCarroll, Rhona Mclaughlin, and Margaret O'Brien.

Artists Who Sell Their Own Work

Artists are listed here alphabetically by name; check the Artists chapter for location and contact information.
Dee Harget
Tom Steck

MASSACHUSETTS

Harriet G. Finkelstein, Private Dealer

Boston, MA 02118
Phone: 857-544-6055
Email: ohharriet@gmail.com
Web site: none

Finkelstein sells art from her private collection, as well as art that comes to her attention, or that she acquires. People visit her home to see the work, by appointment only. In addition to contemporary American self-taught art, Finkelstein also sells Haitian art.

Artists

William Dawson, Sam Doyle, William Hawkins, Elijah Pierce, Martín Ramírez, Bill Traylor, George Widener, Purvis Young

Gateway Arts Gallery

60–62 Harvard Street
Brookline, Massachusetts 02445
Rae Edelson, Director
Stephen De Fronzo, Artistic Director
Phone: 617-734-1577
Email: gatewayarts@vinfen.org
Web site: www.gatewayarts.org

The gallery exhibits the art of Gateway program clients. Shows may be group or solo exhibitions. They are all curated and have themes. All of the art at the shows is for sale and prices range from $60 to $1500. Art works include both two-dimensional and three-dimensional pieces. There is also a crafts store connected to the gallery and both the crafts store and gallery are on the program site. There are the works of more than sixty artists to draw upon, most of whom are self taught and intuitive artists and all the artists have some sort of disability—from mental retardation, autism, and head injury, to mental illness. The Gateway Arts Gallery is non-profit and state funded. The artists receive sixty percent of the selling price of their work. There is a large mailing list and very well-attended gallery openings.

Artists

Ronde Allen, Cathy Anderson, Yasmin Arshad, John Colby, Mari Colvina, Larry Edmiston, Charles Ellsby, Joe Howe, Robert Kirshner, Anita Lombardi, Joanne O'Donnell, Gilberto Palacios, Sanders Paul, Ruby Pearl, Rebecca Bella Rich, Carmella Salvucci, Roger Swike, Bohill Wong.

MICHIGAN

Hill Gallery
407 West Brown Street
Birmingham, Michigan 48009
Timothy Hill, Director
Pamela Hill, Director
Phone: 248-540-9288
Email: info@hillgallery.com
Web site: www.hillgallery.com

The Hill Gallery, directed by Timothy and Pamela Hill, opened in Birmingham, Michigan in 1981. In addition to 20th century fine art, the gallery has continuously offered exceptional examples of American folk art, concentrating on the power and mystery of folk sculpture, mostly from the 19th but some from the 20th century. Much of the early work was done by anonymous artists.

Artists
Tom Charlton, Bill Traylor

Judith Racht Gallery
13689 Prairie Road
Harbert, Michigan 49115
Judith Racht, owner
Phone: 269-469-1080
Email: judith_racht@yahoo.com
Web site: www.judithrachtgallery.wordpress.com

Judith Racht opens her gallery from Memorial Day to Labor Day; in the winter she is open Saturdays and Sundays only from 11 a.m. to 5 p.m. She shows self-taught and folk art along with contemporary art and sculpture. Anonymous pieces are included, too.

Artists
Lee Godie, Jimmy Lee Sudduth, Derek Webster, Purvis Young

Ridgefield Gallery
525 N Brandt Road
Ortonville, Michigan 48462
Ken and Donna Fadeley, Owners
Phone: 248-627-2205
Email: dmfadeley@aol.com
Web site: none

Ridgefield Gallery opened officially in 2000 in its permanent location in our 1860's barn in Ortonville, MI. Owners Ken and Donna Fadeley have collected the work of contemporary folk/self-taught artists for over 30 years. Trained as a sculptor Ken was initially drawn to the artists themselves trying to understand their compulsion and need to create. We have traveled extensively meeting most of the artists whose work we collected. The first was Edgar Tolson in 1970 while Ken was a graduate student at the University of Kentucky. The Gallery offers the work of many folk and self-taught artists, Southern Pottery and contemporary Split Oak baskets. Since 2001 the gallery also offers hand carved Paper-Mache molds called Takaans that the Fadeleys have collected and traveled to the Philippines to purchase. These wonderful carvings are now appreciated and collected for their unique aesthetic qualities and history. Other Services include custom bases and stands in both steel and wood and custom mounts for art objects.

The gallery is located about 65 miles north of Detroit and is open by appointment most days. Just call for an appointment (248) 627-2205.

Artists
Eddie Arning, Linvel Barker, Burlon Craig, Creative G. C. DePree, Howard Finster, Denzil Goodpaster, Tim Lewis, Ben Miller, Donnie Tolson, Miles Smith Inez Nathaniel Walker, and many others.

MISSISSIPPI

The Attic Gallery
1101 Washington Street
Vicksburg, Mississippi 39183
Lesley Silver, owner
Phone: 601-638-9221
Email: atticgal@aol.com
Web site: www.atticgal.net

The Attic Gallery focuses on Southern, three-dimensional work but with other forms such as paintings, too. The emphasis is on primitive, outsider, and folk art with a few others including trained artists and the craftspeople Elayne Goodman and Kennith Humphrey. The Gallery mounts an annual theme show. Photographs are sent on request.

Artists
"Poor Julia" Allen, Butch Anthony, David Baum, Chris Clark, Elwin Hudson, Lucy Hunnicutt, Pat Juneau, Shar Johnson, Chris Kirsch, Chris London, Frank McGuigan, J.E. Pitts, Mary Proctor, "Dr. Bob" Shaffer, Earl Simmons, Artis Wright.

Artists Who Sell Their Own Work
Artists are listed here alphabetically by name; check the Artists chapter for location and contact information.
Tab Boren (potter)
Zelle Manning
Earl Wayne Simmons

MISSOURI

Galerie Bonheur

7507 Wellington Way, 1 west
St. Louis, Missouri 63105
Laurie Carmody Ahner, Director and Owner
Yoko Kiyoi, Assistant
Phone: 314-409-6057
Phone: 314-303-6040 (Yoko)
Email: gbonheur@aol.com
Web site: www.galeriebonheur.com

Galerie Bonheur started in 1980 when Lauri Carmody Ahner began collecting and selling Haitian folk art. This continues to be an important part of the gallery, along with additional artworks from other Caribbean countries and folk art from Poland, Romania, Hungary, and Russia. The focus has also always been on quality folk art from the United States as well, including the work of Milton Bond, Justin McCarthy, Jack Savitsky and more recently Mary Whitfield, Harriet Wiseman, John Barton, Craig Norton Paul Graubard, Janice Kennedy, and many others. The gallery has presented many exhibits, including the work of Mary Whitfield at the Black History Museum in St. Louis in 2007. Open by appointment only.

Other locations, all open by appointment only, are: Stuart, Florida 772-224-2325 and Santa Fe, New Mexico 505-983-6439.

Artists

John Barton, Milton Bond, Amos Ferguson, Janice Kennedy, Justin McCarthy, Craig Norton, Jack Savitsky, Mary Whitfield, Harriet Wiseman, "Haitian old masters," and numerous international folk and self-taught artists from around the world.

NEW MEXICO

Amanecer Gallery

897 Camino Los Abuelos
Galisteo, New Mexico 87540
Phone: 505-466-8967
Email: Annacardenas1@hughes.net
Web site: none

This gallery offers the paintings of Freddie Cardenas as well as the micaceous pottery of Anna Cardenas. Freddie is a self-taught artist who started painting several years ago after retiring from his job as Superintendent of the New Mexico Public Schools. He currently works with the Bureau of Indian Education. Freddie paints landscapes, in oil and acrylics, from around the Galisteo Basin and other New Mexican villages. He enjoys using bright colors, sunflowers, clouds and whimsical characters in most of his paintings. Photos can be sent upon request. Call to arrange a visit.

Garcia Gallery

1325 State Road 75
Peñasco, New Mexico 87553
Lorrie and Andrew Garcia, Owners
Phone: 575-587-2968
Email: lorriegarcia85@hotmail.com
Web site: www.highroadnewmexico.com

This gallery features bultos and retablos—carvings and paintings, respectively, of religious figures—by Lorrie Garcia, a high school teacher who began making art after she retired. Andrew, also a retired teacher, makes outstanding carved wooden furniture in old New Mexico styles. The gallery displays both of their work.

Case Trading Post Museum Shop/Wheelwright Museum of the American Indian

P.O. Box 5153
704 Camino Lejo, Museum Hill
Santa Fe, New Mexico 87502
Ken Williams, Case Trading Post Manager
Phone: 505-982-4636, ext. 110
Phone: 800-607-4636
Email: casetradingpost@wheelwright.org
Web site: www.wheelwright.org/casetradingpost

The Case Trading Post Museum Shop offers regional Native American art by recognized masters and emerging talent. The informed sales staff can help the first time buyer or seasoned collector choose pottery, jewelry, rugs, kachina dolls, Navajo folk art, baskets, books, and more. Purchases support Native American artists and the museum's programs.

Artists

Johnson Antonio, Sheila Antonio, Elsie Benally, Delbert Buck, Jonathan Cage, Silas Claw, Mamie Deschillie, Louise Goodman, Hathale family, Herbert family, Edith Herbert John, Harrison Juan, Gregory Lomayesva, Manygoats family, Samuel Manymules, Pete family, Dennis Pioche, Florence Riggs, Fay Tso family, Willeto family, Rose Williams family

Davis Mather Folk Art Gallery

141 Lincoln Avenue
Santa Fe, New Mexico 87501
Davis Mather, owner

Phone: 505-983-1660
Email: Folkart@newmexico.com
Web site: www.davismatherfolkartgallery.com

This is the first folk art shop in Santa Fe and has been open at the same location for 19 years. It began by selling the best of animals made by Felipe Archuleta. The present focus of the gallery is New Mexican wood carvings; Navajo chickens, roosters, crows, turkeys, animals from cardboard, songbirds, mud toys and pictorial rugs; and some Latin American, Mexican, and "unpredictable art," such as the brightly colored and carved snakes of trained artist Paul Lutonsky.

Artists
Felipe Archuleta, Josephina Augilar, Harold Bayer, Fransisco Chacon, Jimbo Davila, Dareen Herbert, Moises Jimenez, Paul Lutonsky, Joe Ortega

The Rainbow Man

107 East Palace Avenue
Santa Fe, New Mexico 87501
Bob Kapoun and Marianne Kapoun, Owners
Phone: 505-982-8706
Email: rainbomn@aol.com
Web site: www.therainbowman.com

The Rainbow Man, a gallery since 1945, specializes in unusual regional folk art by Native Americans and by Hispanic self-taught artists. The gallery also features the mosaic shell jewelry of the well-known self taught jeweler Angie Reano Owen. Included in the gallery is the traditional and non-traditional folk art of the indigenous tribes of Mexico. Photographs of Edward Curtis

Artists
Felipe Archuleta, Leroy Archuleta, Marie R. Cash, Gregory Lomayesva, Ron Archuleta Rodriguez

Montez Gallery

132 County Road 75
P.O. Box 408
Truchas, New Mexico 87578
Rey Montez, owner
Phone: 505-689-1082
Email: santafeheaven@peoplepc.com
Web site: www.montezsantafe.com

In 2014, owner Rey Montez celebrated the 25th anniversary of Montez Gallery, first located in his hometown of Santa Fe and now in Truchas, New Mexico, on the high road to Taos. The gallery represents the art work of more than 150 local families in northern New Mexico and southern Colorado and carries traditional and contemporary Spanish arts and has a large collection of santos—saints in "bulto" (three-dimensional) and "retablo" (two-dimensional) forms, as well as furniture, both contemporary and antique, made in northern New Mexico. Montez also offers an appraisal service. Montez is very knowledgeable about the art traditions of New Mexico and willing to share this with visitors to his gallery.

Artists
Fernando Bimonte, Frank Brito, Sr., Charlie Carrillo, Grace Maria Garcia Dobson, Leon Fernandez Hernandez, Al and Gil Florence, Goldie Garcia, Lydia Garcia, Nicolas Herrera, Father John Battista Juliani, Chris Maya, George Lopez, Ricardo Lopez, The Madrid Family, Antonio R. Martinez, Eluid Levi Martinez, Rey Martinez, Irene Medina, Marilyn and John Moyes, Ben Ortega, Miguel Perez, Carlos Rael, Gerald Rebolloso, Jose Guadalupe Hernandez Reyna, Alfredo Rodriguez, Michael Salazar, Ellen Santistevan, Julie Florence Thibodeaux, Horacio Valdez, Frank Zamora.

Laurie Ahner, Private Dealer

Santa Fe, New Mexico
Phone: 314-409-6057
Email: gbonheur@aol.com
Web site: www.galeriebonheur.com

Artists available are listed under Gallerie Bonheur in St. Louis, Missouri. Laurie is often in New Mexico, and may be reached through the contact information above.

Artists Who Sell Their Own Work

Artists are listed here alphabetically by name; check the Artists chapter for location and contact information.
Freddie Cardenas
Arán Carriaga
Maria Romero Cash
Lorrie Garcia
Dorothy Holland
Kelly Moore
Ron Archuleta Rodriguez
Rosemary Sparno
Harold Willeto

NEW YORK

Steven S. Powers

360 Court Street, #28
Brooklyn, New York 11231
Steven S. Powers, Owner

Phone: 718-625-1715
Email: Steve@stevenspowers.com
Web site: www.stevenspowers.com

This is a Brooklyn gallery specializing in American folk art and woodlands sculpture.

Artists

Charles Hutson, George E. Morgan, James W. Washington, Jr., and nineteenth and twentieth century pieces by anonymous artists.

The Gallery at HAI

33–02 Skillman Avenue
Long Island City, New York 11101
Phone: 212-575-7696
Quimetta Perle, Director
Email: qperle@hainyc.org
Web site: www.hainyc.org

The Visual Arts Workshop Program of HAI started in the 1970s. The initials originally stood for Hospital Audiences, Inc., and the program provided opportunities for people with mental disabilities to go places and see things. The name has been changed to Healing Arts Initiative to reflect its current focus on providing guidance, structure, support, and art supplies for participants with chronic mental illness, developmental disabilities, and artists living in nursing homes. The Gallery at HAI was founded in 1998 to provide exhibition space for HAI artists. It regularly mounts exhibitions to display its artists' work.

Artists

Everette Ball, Julius Caesar Bustamante, Derrick Alexis Coard, Martha Cruz, Ray Hamilton, Jose Lopez, Gaetana Menna, Lady Shalimar Montague, Angela Rogers, Rodney Thornblad, Laura Anne Walker, Melvin Way, and others

American Primitive Gallery

49 East 78th Street, Suite 2B
New York, New York 10075
Aarne Anton, owner
Tina Anton
Phone: 212-628-1530
Email: american.primitive@verizon.net
Web site: www.americanprimitive.com

The American Primitive Gallery focuses on American self-taught, outsider, and folk art. The gallery represents numerous artists and has a diverse, challenging inventory of paintings and sculpture. In addition to well-known artists, the gallery mounts regular exhibitions that feature new discoveries. The gallery also offers antique American folk art and Americana from the nineteenth and twentieth centuries.

Artists

Eugene Andolsek, Clyde Angel, Charles Benefiel, Hawkins Bolden, J.J. Cromer, Ted Ludwiczak, Daniel Martin Diaz, Frederick Hastings, Raymond Materson, Lewis Smith, Jimmy Lee Sudduth, Ionel Talpazon, "Son" Thomas, Terry Turrell, James Wong

Andrew Edlin Gallery

134 10th Avenue
New York, New York 10011
Phone: 212-206-9723
Andrew Edlin, Owner
Becca Hoffman
Email: ae@edlingallery.com
Web site: www.edlingallery.com

The Andrew Edlin Gallery, located in an "arts" building in Chelsea, specializes in outsider and contemporary art.

Artists

John Byam, Henry Darger, Thornton Dial, Ralph Fasanella, Brent Green, Martín Ramírez, Charles Steffen, Eugene Von Bruenchenhein

Cavin-Morris

210 Eleventh Avenue, Suite 201
New York, New York 10001
Shari Cavin and Randall Morris, owners
Phone: 212-226-3768
Email: ShariCavin@gmail.com
Email: info@cavinmorris.com
Web site: www.cavinmorris.com

Cavin-Morris looks to self-taught artists for work that is unique, honest, and category-defying. Regardless of personal biography, the visual power of the artists' works is paramount. The gallery shows the work of emerging artists as well as that of established masters.

Artists

Chelo Amezcua, Emery Blagdon, Peter Charlie Bocharo, James Castle, Bessie Harvey, Estate of J.B. Murray, John Podhorsky, Martín Ramírez, Anthony Joseph Salvatore, Kevin Sampson, Jon Serl, Gregory Van Maanen, P.M. Wentworth, Joseph Yoakum, Anna Zemankova, and self-taught artists from the Caribbean, Europe, Australia, and Asia.

Fountain Gallery

703 Ninth Avenue at 48th Street
New York, NY 10019
Phone: 212-262-2756
Email: no email. Contact through website or by phone.
Web site: www.fountaingallerynyc.com

Founded in 2000 as a not for profit exhibition space, the gallery sells original artworks and collaborates with "a wide network of artists, curators, and cultural institutions." Included in the program are emerging and established, trained and self-taught artists. Artist listed are self-taught or largely self-taught.

Artists

Anthony Ballard, Tony Cece, Justine Hall, Gary

Brent Hilsen, Mercedes Kelly, Dick Lubinsky, Glenn Moosnick, Eloise Ockert, Gail Shamchenko

Galerie St. Etienne

24 West 57th Street, Suite 802
New York, New York 10019
Hildegard Bachert
Jane Kallir
Phone: 212-245-6734
Email: gallery@gseart.com
Web site: www.gseart.com

Paintings and works on paper. American and European folk art mostly from the 1940s and 1950s. The American artists are listed below. The gallery also carries Haitian art including such masters as Rigaud Benoit, La Fortune Felix and Prospere Pierre-Louis, and contemporary European outsider artists such as Michel Nedjar and the artists of Gugging.

Artists
Henry Darger, Minnie Evans, Morris Hirshfield, John Kane, Mary Ann Robertson "Grandma" Moses, Joseph Pickett, Horace Pippin

Hirschl & Adler Modern

730 Fifth Avenue
New York, NY 10019
Shelley Farmer
Phone: 212-535-8810
Email: modern@hirschlandadler.com
Web site: www.hirschlandadler.com

Hirschl & Adler is a gallery specializing in American and European paintings, watercolors, drawings, and sculpture. Most of its offerings come from the eighteenth through early twentieth century. However, a relatively new component of the gallery if Hirschl & Adler Modern, which handles a few self-taught and outsider artists among many other contemporary painters, sculptors, and other trained artists.

Artists
James Edward Deeds, Jr., Bill Traylor, Frank Walter, David Zeldis

Luise Ross Gallery

547 West 27th Street #504
New York, New York 10001
Luise Ross, owner
Phone: 212-343-2161
Email: ross.gallery@juno.com
Web site: www.luiserossgallery.com

Since 1982, the Luise Ross Gallery has exhibited the work of self-taught artists. In addition to frequent gallery exhibitions—three or four a year devoted to self taught artists—gallery staff have also organized exhibitions for public and university museums. The gallery published a scholarly compendium of Bill Traylor's exhibition history, bibliography, and public collections in 1991. One of the gallery's most recent shows was an exhibition of the work of the late Gayleen Aiken.

Artists
Gayleen Aiken, Thomas Burleson, Harris Diamant, Oscar Escobar, Minnie Evans, Lonnie Holley, Bill Traylor

Marion Harris

1225 Park Avenue
New York, New York 10128
Marion Harris, Owner
Tessa, Assistant
Phone: 212-348-9688
Cell: 860-604-6677
Email: info@marion-harris.com
Web site: www.marion-harris.com
By appointment only

Marion Harris is a recognized resource for contemporary self-taught art, as well as for art and antiques dating from 200 BC to the present. Her motto is "Where Classic Meets Curious."

Artists
Morton Bartlett, Jerry, Coker, Conner Brothers, James Edward Deeds, Jr., Carlos DeMedeiros, A.W. Gimbi, Andrei Palmer, Malcom McKesson, Denzel Goodpaster, Edgar Tolson, Frank Walter, David Zeldis

Pure Vision Arts

114 West 17th Street, 3rd Floor
New York, New York 10011
Pamela Rogers, Director
Phone: 212-366-4263
Cell: 646-265-0659
Email: purevisionarts@shield.org
Web site: www.purevisionarts.com

Pure Vision Arts is Manhattan's only studio and exhibition space for beginning and established artists with autism and other developmental disabilities. It is a program of the Shield Institute, a non-profit organization that serves as a resource center for artists and art collectors and others interested in promoting inclusion and accessibility in the arts for people with disabilities.

Artists
Nicole Appel, Oscar Azmitia, Susan Brown, Christopher Chronopoulos, Chase Ferguson, Barry Khan, Leon McCutcheon, Walter Mika, Jessica Park, Eric Sadowsky

Ricco/Maresca Gallery

529 West 20th Street, 3rd floor
New York, New York 10011
Frank Maresca and Roger Ricco, Owners

Eleanore Weber, Gallery Director
Phone: 212-637-4819
Email: info@riccomaresca.com
Web site: www.riccomaresca,com

Ricco/Maresca was founded in 1979, at a location on Broome Street in Soho. After several moves it arrived at its current Chelsea location in 1997. Ricco/Maresca has championed and showcased the art of self-taught masters working outside the art-historical mainstream. The gallery focuses both on significant contemporary art in various media and on historically important American art since 1900.

Artists

Eddie Arning, Henry Darger, Thornton Dial, Sam Doyle, William Edmondson, Ken Grimes, William Hawkins, Laura Craig McNellis, Martín Ramírez, Judith Scott, Bill Traylor, George Widener, Joseph Yoakum

Stephen Romano, Private Dealer

New York, New York
Phone: 646-709-4725
Email: rmanostephen@gmail.com
Web site: www.romanoart.com

Stephen Romano is a private dealer located in Manhattan. He specializes in self-taught and visionary masterworks and emerging contemporary artists. He is available by appointment only.

Artists

Morton Bartlett, Peter Charlie Besharo, Calvin and Ruby Black ("Possum Trot"), William Blanley, David Butler, James Castle, Janko Domsik, Sam Doyle, William Hawkins, Frank Jones, Sister Gertrude Morgan, Elijah Pierce, Judith Scott, Jeff Soto, Joseph Yoakum, Carlo Zinelli

Artists Who Sell Their Own Work

Artists are listed here alphabetically by name; check the Artists chapter for location and contact information.
Ron Berman
Morgan Monceaux
Karen Partelow
Anne Strasberg

——— NORTH CAROLINA ———

American Folk Art & Framing

64 Biltmore Avenue
Asheville, North Carolina 28801
Phone: 704-251-1904
Email: folkart@amerifolk.com
Web site: www.amerifolk.com

American Folk Art & Framing is a gallery that integrates contemporary folk art and craft with American folk art and antique furniture. "We celebrate the handmade and illustrate centuries of creativity. Some highlights in the gallery include works by Rudolph Valentino Bostic and most of the traditional folk and utilitarian potters of North Carolina."

Artists

Ellie Ali, Kent Ambler, Butch Anthony, Michael Banks, Rudolpy Valentino Bostic, Cornbread, Sarah Hatch, Spencer Herr, Lucy Hunnicutt, Ron Irwin, Woodie Long, Christine Longoria, Karl Mullen, Jim Gary Philips, Ruth Robinson, Darrell Loy Scott, Liz Sullivan

Art Cellar Gallery

920 Shawnee Avenue/Highway 184
Banner Elk, North Carolina 28604
Mike McKay and Pamela Bundy McKay, owners
Liz Brown, Gallery Director
Phone: 828-898-5175
Email: info@artcellaronline.com
Web site: www.artcellaronline.com

This is a fine art gallery, with an eclectic mix of art treasures, nestled in the North Carolina mountains. The gallery features trained Appalachian mountain painters and specializes in contemporary Southern folk art and outsider art, along with Catawba Valley face jugs and other North Carolina folk pottery. It is the exclusive dealer for memory painter Arlee Mains, an Appalachian mountain native. The gallery presents monthly exhibitions May through October. Call for winter hours. Photographs are sent on request.

Artists

AB the Flagman, Howard Finster, Roy Finster, Ray Fisher, Sybil Gibson, James Harold Jennings, Anderson Johnson, S.L. Jones, Woodie Long, Charlie Lucas, Arlee Mains, Joe McFall, Mark Casey Milestone, R.A. Miller, Jack Savitsky, Bernice Sims, Jimmy Lee Sudduth, "Wiili" Bobolink Summer

At Home Gallery

2802 Shady Lawn Drive
Greensboro, North Carolina 27408
Mike Smith, Owner
Phone: 336-908-2915
Email: athome05@earthlink.net
Web site: none

The At Home Gallery has an annual open house featuring some of the country's leading self-taught artists and potters, with an emphasis on North Carolina art and pottery. The gallery also carries a few African art pieces, and work by some trained artists. The gallery is open all year round by appointment (call 338-908-2915). The owner also does art appraisals. In 2014 Mike Smith was celebrating his 21st year in the art business.

Artists

Alan Bisbort, Georgia Blizzard, Benny Carter, William Fields, Howard Finster, Billy Ray Hussey, James Harold Jennings, S.L. Jones, Phillip Long, Willie Massey, Carl McKenzie, R.A. Miller, Charles Moore, Ike Morgan, Stephen Douglas Price, William Pumphrey, Sarah Rakes, Royal Robertson, Chris Roulhac, Will Sears, Matt Sesow, Vollis Simpson, Bernice Sims, Dylan Smith, Jerry Smith, Mary T. Smith, Jimmy Lee Sudduth, Mose Tolliver, Alex Young, Jeff Zenick, and more. Fine artists include Mike Northuis, Anne Kesler Shields, and more.

The Enrichment Center—An Affiliated Chapter of The Arc

1006 South Marshall Street
Winston-Salem, North Carolina 27101
Valerie Vizena, Director
Phone: 336-777-0076
Email: vvizena@enrichmentarc.org
Web site: www.enrichmentarc.org

The Enrichment Center is an arts-based program for adults with intellectual and developmental disabilities. The Center's visual arts program includes painting, drawing, pottery, three-dimensional multi-media, and photography. The Center's artists, known collectively as the Artists of Gateway Studios, work in the tradition of Outsider Art, with individual pieces ranging from realistic to abstract. The artists exhibit and sell their work in The Enrichment Center's Gateway Gallery as well as in local, regional and, occasionally, national and international venues. Call (336) 837-6832 for gallery hours.

Artists

Some of the many artists who work with The Enrichment Center are: Victoria Allen, Tim Befus, Paul Blanton, Trip Collins, Chris Cuthrell, Timmy Gordon, Marcie Haley, Meredith Lamy, Adam Lefevre, Walker Lewis, Jr., Jonathan Lindsay, Julie Mack, Kenneth McMahan, Levon Moore, Noelle Nichols, Kevin Raby, Diana Robbins, Sharon Robinson, Mimi Waldrep, Corey Williams, Valarie Williams, John Zakon

Ginger Young, Private Dealer

Chapel Hill, North Carolina 27514
Ginger Young, owner
Phone: 919-428-0511
Email: gingerart@aol.com
Web site: www.gingeryoung.com

Ginger Young had a gallery for more than twenty years, and now works as a private dealer. She specializes in works by self-taught artists from the southeastern United States. Her collection includes over 700 paintings, drawings, sculptures, and assemblages by more than sixty contemporary self-taught artists. She is available by appointment.

Artists

Chris Beck, Kacey Carneal, Raymond Coins, Grahame Eggleston, Howard Finster, Sybil Gibson, James Harold Jennings, M.C. "5¢" Jones, Peter Loose, Mattie Lou O'Kelley, Sarah Rakes, Nellie Mae Rowe, O.L. Samuels, Steve Shepard, James Arthur Snipes, Jimmy Lee Sudduth, Mose Tolliver.

Artists Who Sell Their Own Work

Artists are listed here alphabetically by name; check the Artists chapter for location and contact information.

Steve Abee (potter)
Craig family (potters)
Albert Hodge
Billy Ray Hussey (potter)
Kale family (potters)
Carolyn Mae Lassiter
Charles Lisk (potter)
Sam McMillan
Mark Casey Milestone
Ricky Needham

OHIO

Thunder Sky Inc. Gallery

4573 Hamilton Avenue
Cincinnati, Ohio 45223
Phone: 513-823-8914
Email: info@raymondthundersky.org
Web site: www.raymondthundersky.org

Thunder-Sky, Inc. was founded to preserve the legacy of Raymond Thunder-Sky through exhibits and programs, and to provide an exhibition space, workspace, and ongoing support for other unconventional artists in the area. Exhibitions include "Deep in Thought: Paintings by Mark Betcher and Scott Car-

ney," "Unrealized and Unforeseen, "Monsters of the World," "World Domination," and "New Clownville Amusement Park: Constructing Raymond's Perfect World." A lot of Cincinnatians remember a man dressed in a clown collar and construction hat, walking the Cincinnati streets with a toolbox in tow, a serious expression on his face. He did this for many years, mystifying folks as to what he was up to. The man's name was Raymond Thunder-Sky. And what he was doing was drawing demolition and construction sites throughout Cincinnati and other parts of the region. Raymond, a Native American with a rich family history, passed away in 2004, leaving behind over 2,000 drawings, and a vast array of clown costumes, construction hats, and toolboxes. His work is now collected internationally, and has been in gallery and museum exhibits across the world.

Artists

Antonio Adams, Mark Betcher, Emily Brandehoff, Scott Carney, Andrew Cole, Eric Deller, Tony Dotson, Dale Jackson, David Earl Johnson, Yohana Junker, Robert McFate, Katherine Michael, Mike Weber, among others

Visionaries and Voices

3841 Spring Grove Avenue
Cincinnati, Ohio 45223
Kieth Banner and Bill Ross, Co-Founders
Phone: 513-861-4333
Email: Kiethb@buttlermrdd.org
Web site: www.visionariesandvoices.com

Visionaries and Voices, a nonprofit studio/gallery, was created specifically to provide a home base for artists living with a disability to grow and succeed. The program began as a grassroots effort among social workers impressed by the art created at home by people with disabilities, who made connections with local galleries to bring this art before the public. The resulting shows created enough momentum to help establish a studio and gallery specifically for the artist and so they had to leave the Essex Studio. The gallery's current location provides about 2500 square feet that includes a store-front gallery dedicated to contemporary folk and outsider art.

Artists

Rob Bolubasz, Kathy Brannigan, Courttney Cooper, Tripp Higgins, Andrea Hostick, Deondre Hyde, Dale Jackson, Romando (Manny) Love, Barb Riddle, Annie Titchener, and many more.

Bingham's Antiques

12801 Larchmere Boulevard
Cleveland, Ohio 44120
Sherrie Chicatelli
Phone: 216-721-1711

Email: ashleyantiques@gmail.com
Web site: none specifically for folk art

The gallery has a few self-taught and outsider artists, with an emphasis on Ohio folk art. It also offers tramp art and other anonymous art. The gallery has regular hours and is open by appointment.

Artists

Okey Canfield, Chief Gray Eagle, Beni Kosh, "Popeye" Reed

Hawk Galleries

153 East Main Street, #1
Columbus, Ohio 43215
Tom Hawk, Owner
Phone: 614-225-9595
Email: tom@hawkgalleries.com
Web site: www.hawkgalleries.com

The Hawk Galleries are known primarily for their representation of trained artists working in glass, and also handle sculpture, paintings, and jewelry. In 2014, while attending "A Day in the Country" at Morehead State University, Morehead, Kentucky, gallery owner Tom Hawk was so taken by the woodcarving art of Minnie Adkins and her northeastern Kentucky colleagues that he bought lots of art from lots of people, and has extended his gallery's focus to include Kentucky folk art.

Keny Galleries

300 East Beck Street
Columbus, Ohio 43206
Timothy C. Keny, Owner
Phone: 614-464-1228
Email: inquiry@kenygalleries.com
Web site: www.kenygalleries.com

The gallery presents both fine and folk art and tries to select folk art that qualifies as fine art, too. The gallery is open regular hours and by appointment. Photographs are sent upon request. In 2014 there was an exhibition devoted to the art of Elijah Pierce, "Parables and Politics and Elijah Pierce's Art."

Artists

Ralph Bell, James Castle, William Hawkins, Elijah Pierce, E. Popeye Reed, Bill Traylor, LaVon Van Williams, Jr.

Lindsay Gallery

986 North High Street
Columbus, Ohio 43201
Duff Lindsay, owner
Phone: 614-291-1973
Email: lindsaygallery@hotmail.com
Web site: www.lindsaygallery.com

Lindsay Gallery specializes in contemporary self-taught American folk and outsider art. In October 2014 Duff Lindsay hosted at his gallery the Folk Art Society of America at its annul conference and presented an exhibition of work by Ohio folk and self-taught artists "from yesterday and today."

Artists

Mike Egan, Joseph Garlock, Amber Groome, William Hawkins, Andrea Joyce Heimer, Donald Henry, Lonnie Holley, Morris Jackson, Bill Miller, Joey Monsoon, Karl Mullen, Paul Patton, Wallace Peck, the Rev. Samuel David Phillips, Ashley D. Pierce, Elijah Pierce, Janis Price, Popeye Reed, Stephen Sabo, Anthony Joseph Salvatore, Harry Underwood

R.A.W. Gallery
112 E. Main Street

Columbus, Ohio 43215
Phone: 614-221-1430
Email: George@rawgallery.us
Web site: www.rawgallery.us

The R.A.W. Gallery does a lot of things, from exhibiting the work of emerging artists to drag shows. Columbus folk artist Levent Isik's work is often featured for sale here.

Artists Who Sell Their Own Work
Artists are listed here alphabetically by name; check the Artists chapter for location and contact information.
Mike Egan
Tom Hay
Levent Isik
Jay Schuette

OREGON

Art from the Heart
3505 NE Broadway
Portland, Oregon 97232
Brian Hall, Manager
Phone: 503-528-0744
Email: emilyco@albertinakerr.org
Web site: www.artfromtheheartpdx.com

Art from the Heart is an art center and gallery for adults with developmental disabilities that began in 1995. It strives to foster each artist's creative growth, build positive relationships within the community, and promote an awareness of the cultural contributions from people of all abilities. The gallery features work in fine art and craft in watercolor, drawing, acrylic, handbound books, fiber arts, printmaking, ceramics, cards, woodwork, mosaic, and mixed media. The gallery hosts two art openings each year featuring new works by each artist in the studio. In 2011 Art from the Heart was absorbed into a larger agency, Albertina Kerr Centers, whose mission is to strengthen Oregon families and communities by helping children and adults with developmental disabilities and mental health challenges, empowering them to live richer lives.

Artists

Shea Arnold, Carol Bell, Rachel Borkan, Jessica Boyer, Terrie Bush, Chrissy Chapman, Jason Dunn, Job Erickson, Heidi Frisbie, Charlie Gillespie, Justin Gilroy, Michael Griffin, Aaron Hobson, Jenna Hoisington, Terry Holt, Aaron Hutchinson, P.J. Kalhar, Phillip Klover, Pat Lemen, Andrew Louie, David Marquoit, Bion Mason, Virgil Neff, Amy Osborn, Rachel Parsons, Derwin Pike, Deanna Poulson, Amy Protz, Fred Risk, Geneva Sizemore, Ashley Sith, Rebecca Smouze, Amanda Stewart, Rose Stevens, Richard Taccogna, Brian Teters

Artists Who Sell Their Own Work
Check the Artists chapter for location and contact information.
Annie Grgich

PENNSYLVANIA

HUSTONTOWN
860 Path Valley Road
Fort Loudon, Pennsylvania 17224
Gene Beecher
Phone: 717-369-5248

Email: GEJA@embarqmail.com
Web site: none

HUSTONTOWN is both an Internet gallery (always open) and a physical gallery (open by appoint-

ment) featuring nineteenth and twentieth century folk and self-taught arts and crafts, anonymous and signed works, and folk photography.

Artists

Gene Beecher, Paul "The Baltimore Glassman" Darmafall, Mama Johnson, Kellianne O'Brien, Karen O'Lone-Hahn, Ed Ott, Morrow Paddock, "Popeye" Reed, David Roth, Daniel Toepfer, Ruby C. Williams

Robert Cargo Folk Art Gallery

Paoli, Pennsylvania.

Robert Cargo's daughter, who was offering works from his collection at this location, has donated his collection of folk art to the Birmingham Museum of Art. See entry under Museums.

Fleisher/Ollman Gallery

1216 Arch Street-5A
Philadelphia, Pennsylvania 19107
Alex Baker, Director
Phone: 215-545-7562
Cell: 215-219-1055
Email: info@fleisher-ollmangallery.com
Email: alex@fleisher-ollmangallery.com
Web site: www.fleisherollman.com

Over its six decades, Fleisher/Ollman has established a reputation as one of the premiere sources for self-taught art, defining the field and helping to develop major collections of this once-marginalized group of artists. It was among the first to mount major exhibitions of work by Henry Darger, Sister Gertrude Morgan, Bill Traylor, and Martín Ramírez, and published early catalogs on James Castle, William Edmondson, and Joseph Yoakum. In recent years, the gallery's emphasis has shifted to include the exhibition of contemporary artists whose work resonates with the self-taught. This revised mission has become particularly relevant as the art world becomes increasingly engaged with the material that we have championed for so long. In addition to our contemporary interests, we continue to showcase the most significant American vernacular artists of the 20th century, including the exclusive representation of Felipe Jesus Consalvos and the Philadelphia Wireman.

Artists

Eddie Arning, Peter Attie Besharo, James Castle, Felipe Jesus Consalvos, Alan Constable, Sam Doyle, William Edmondson, Howard Finster, William Hawkins, Frank Jones, Julian Martin, Justin McCarthy, Philadelphia Wireman, Elijah Pierce, Martín Ramírez, Edgar Tolson, Bill Traylor, Eugene Von Bruenchenhein, P.M. Wentworth, Joseph Yoakum, Purvis Young

Outside In

Resources for Human Development (RHD)
Philadelphia, Pennsylvania
Kevin Roberts, Administrator
Phone: 215-951-0300 ext. 3714
Email: kroberts@outsideingallery.org
Web site: www.outsideingallery.org

Outside In is a "virtual" gallery managed by Resources for Human Development (RHD) for the clients who participate in its arts programs. RHD is a comprehensive nonprofit social service organization with headquarters in Philadelphia. Founded in 1970, RHD currently oversees and supports more than 160 locally managed human service programs in 14 states, serving people with mental and developmental disabilities and substance use disorders. In 2014 RHD ran eight arts programs in various locations around the country, with plans to open several more in the coming years. One of its programs, Outside the Lines (see description above, at Boston, Massachusetts), has a gallery of its own where the public can see and purchase art made by RHD clients, but the others do not. Instead, the various programs select the best work of their artists and submit it for inclusion on the website, www.outsideingallery.org. The website displays about 150 pieces at any given time, providing information about the artist when one clicks on a particular image. The website accommodates the work of many artists, in a constantly changing array. Anyone interested in visiting any of the programs or seeing more work by a particular artist may contact Kevin Roberts at RHD (215-951-0300, ext. 3714) to be put in touch with the appropriate program.

Outsider Folk Art/George Viener, Private Dealer

Wyomissing, Pennsylvania 19610
Phone: 571-442-8184
Cell: 610-780-4178
Email: George@outsiderfolkart.com
Web site: www.outsiderfolkart.com

Artists available are listed under Outsider Folk Art in Leesburg, Virginia.

Artists Who Sell Their Own Work

Artists are listed here alphabetically by name; check the Artists chapter for location and contact information.

James Leonard
Karen O'Lone-Hahn
Mary Michael Shelley
Robert Sholties

RHODE ISLAND

George Jacobs Self-Taught Art, Private Dealer

P.O. Box 476
Newport, Rhode Island 02840
George Jacobs, Owner
Phone: 401 847-0991
Email: selftaughtart@aol.com
Web site: www.self-taughtart.com

George Jacobs has been a folk art gallery owner and dealer, first in Winston-Salem, North Carolina (1986–1999) and now in Newport, Rhode Island. In Winston-Salem he presented numerous exhibitions featuring many of the South's most celebrated self-taught artists. In 1999 Jacobs moved to Newport, Rhode Island, where he continues to work in the field as an independent dealer. The vernacular art he offers comes from the Southeast United States and embodies visual tra-

ditions of the same cultural groups whose musical traditions created such forms as the blues and Old Time music. He has exhibited at the Outsider Art Fair and the Metro Show in New York City, Intuit in Chicago, and Folk Fest in Atlanta. Jacobs encourages people to contact him about their interests, whether buying or selling.

Artists

Georgia Blizzard, Richard Burnside, David Butler, Sam Doyle, St. EOM, Minnie Evans, Roy Ferdinand, Howard Finster, Sybil Gibson, Martha Grunenwaldt, Riet van Halder, Bessie Harvey, Lonnie Holley, James Harold Jennings, S.L. Jones, Woodie Long, Sister Gertrude Morgan, Eddy Mumma, J. B. Murry, Leroy Person, Melissa Polhamus, Sarah Rakes, Royal Robertson, Nellie Mae Rowe, Jon Serl, Herbert Singleton, Mary T. Smith, Henry Speller, Jimmy Lee Sudduth, Mose Tolliver, Bill Traylor, Jerry Wagner, Purvis Young

SOUTH CAROLINA

Mary Praytor Gallery

26 South Main Street
Greenville, South Carolina 29601
Mary Praytor, Owner
Phone: 864-235-1800
Email: marypraytor@gmail.com
Web site: www.marypraytorgallery.com

The Mary Praytor Gallery has been at its present location offers a collection of contemporary art by nationally and internationally known artists. Included are many Southern folk artists and a few trained artists who do primitive-style work. Photographs will be sent on request and the gallery is open regular hours as well as by appointment. It also offers a finder service for specific artworks.

Artists

Herron Briggs, Raymond Coins, H.A. Brown, Richard Burnside, Howard Finster, Michael Finster, James Harold Jennings, Clyde Jones, Charlie Lyons, R.A. Miller

Red Piano Too Art Gallery

853 Sea Island Parkway
St. Helena Island, South Carolina 29920
Mary Mack, Owner
Phone: 843-838-2241
Email: redpianotoo@islc.net
Web site: www.redpianotoo.com

The Red Piano Too Gallery is located in a 2,400 sq. foot building which was originally built about 1940 to serve as the Community Cooperative. African-American landowners and farmers founded the Cooperative after studying land use and agricultural techniques at Penn School, the only school for freed former slaves that survived reconstruction. Its purpose was to provide a market for the Island's agricultural products, and to provide, at a reasonable price, materials and supplies to area farmers. It was the first agricultural Co-operative of its kind in South Carolina. The structure was renovated in 1999.

Artists

Nellie Ashford, Henrimae Bell, Dan Ciesielski, James Conner, Al Davis, James Denmark, Charles Desassure, Brian Dowdall, Diane Britton Dunham, Sam Doyle, Amiri Gueka Farris, Allen Fireall, Cassandra Gillens, Johnnie Griner, Serena Hall, Alyne Harris, Howard Hunt, Shirley Hunter, Leonard Jones, Arianne King-Comer, Ernest Lee, Mary Inabinett Mack (owner, painter), Jake McCord, Carol McGill, Shaviance Mitchell, Julia C. Neal, Nolia, Ken Page, Jonathan Green Posters, "Missionary" Mary Proctor, Alfreda Robinson, Tami Kutz Robertson, Elayne Scott, "Georgia" Kyle Shiver, the Rev. Johnnie Simmons, Lin Sippel, Geraldine Smith, Saundra "Renee" Smith, Kathleen Pearson Strong, Jimmy Lee Sudduth, Irene Tison, Mose Tolliver, Margaret Warfield, Della Wells, William "Jay" Wilkie

Louanne LaRoche, Private Dealer

Bluffton, South Carolina 29910
Phone: 843-757-5826
Email: lclaroche@earthlink.net
Web site: www.larochecollections.com

This is the collection of a private dealer, based upon more than thirty years of collecting as the former owner of the Red Piano Gallery. The focus is on Southern self-taught art.

Artists

Z.B. Armstrong, Jerry Coker, Mamie Deschillie, Sam Doyle, Sybil Gibson, Ralph Griffin, James Harold

Jennings, Leonard Jones, Jake McCord, R.A. Miller, B.F. Perkins, "Missionary" Mary Proctor, Lorenzo Scott, Jimmy Lee Sudduth, Malcah Zeldis.

Artists Who Sell Their Own Work

Artists are listed here alphabetically by name; check the Artists chapter for location and contact information.
Richard Burnside
James "Squeakie" Stone
William Thomas Thompson

TENNESSEE

Bell Buckle Crafts

14 Railroad Square
Bell Buckle, Tennessee 37020
Anne White-Scruggs, Owner
Phone: 931-389-9371
Email: none
Web site: none

Bell Buckle was an old railroad town that nearly died during the Depression. Then some people started a restoration project. Anne White-Scruggs' shop was the first to open, in the old bank building. She carries a variety of works, including handmade furniture, crafts, and art.

Artists

Homer Green, J.L. Nipper, Bama Pierce

The Arts Company

215 Fifth Avenue North
Nashville, Tennessee 37219
Anne Brown, Owner
Phone: 615-254-2040
Email: art@theartscompany.com
Web site: www.theartscompany.com

The Arts Company is a "full-service arts resource in the heart of the downtown business district." The art in the gallery includes photography, painting, sculpture, outsider art, and "the unexpected fun part." The outsider focus is on Southern regional artists and at least one room in the gallery is always devoted to outsider art. The gallery has regularly scheduled hours Monday through Saturday and is open on the third Sunday of every month for the Third Sunday Art Matinee, when new work and artists' receptions are held. A mailing list is maintained and interesting invitations are sent each month.

Artists

Minnie Adkins, Jessie Cooper, Ronald Cooper, Thornton Dial, Sr., Howard Finster, Bob Gray, Lonnie

and Twyla Money, Roy Pace, Frank Pickle, Lamar Sorrento, Daniel Strausser, Vannoy Streeter, Tres Taylor, Tom and Judy Touchstone, Purvis Young, and Gee's Bend quilters.

Shelton Gallery

5133 Harding Road
B-10-PMB-392
Nashville, Tennessee 37205
Bruce Shelton, Owner
Vicky Pierce, Assistant
Phone: 615-477-6221
Email: sheltongal@aol.com
Web site: www.sheltongallery.com

Shelton Gallery is focused on antique walking sticks, silver, paintings, and other collectables. Shelton specializes in Southern self-taught folk, outsider, and visionary art. He has represented artists Helen LaFrance and Tim Lewis in major exhibitions at the Tennessee State Museum and Vanderbilt University. The gallery is open a regular schedule and by appointment. He also operates as a private dealer in Palm Beach, Florida.

Artists

Minnie Adkins, Linvel Barker, Jerry Brown, Roy Ferdinand, Jr., Howard Finster, Denzil Goodpaster, Homer Green, Helen La France, Tim Lewis, Jesse Mitchell, Braxton Ponder, Dow Pugh, Royal Robertson, Marie Rogers, Sulton Rogers, Herbert Singleton, Jimmy Lee Sudduth, Mose Tolliver, Troy Webb, Bobby Williford, and nineteenth and twentieth century works by anonymous artists.

Angela Usrey, Private Dealer

Chattanooga, Tennessee
Phone: 423-280-7182
Email: angelaishome@gmail.com
Web site: www.hillgallery.com

Usrey offers works of American outsider art, primarily Southern, after closing the Tanner-Hill Gallery. She will send photographs and slides on request.

Artists

Thornton Dial, T. A. Hay, Kevin McCarthy, Stephanie Wilde

Artists Who Sell Their Own Work

Artists are listed here alphabetically by name; check the Artists chapter for location and contact information.

Jo Nease Krause

Lamar Sorrento

TEXAS

Garde Rail Gallery

4411 Spicewood Springs Road #1403
Austin, Texas 78759
Karen Light, Director
Phone: 206-355-7353
Email: gallery@garde-rail.com
Web site: www.garde-rail.com

Garde Rail specializes in outsider art from the United States and beyond. It represents Gregory Blackstock. The gallery is open by appointment only.

Artists

Gregory Blackstock, Holly Farrell, Rebecca Shapiro, Terry Turrell

Imagine Art

2830 Real Street
Austin, Texas 78722
Debbie Kizer, Founder and Executive Director
Phone: 512-524-1840
Email: info@imagineart.net
Web site: www.imagineart.net

Located in a converted warehouse in the creative hotbed neighborhood of east Austin, Imagine Art is an art center founded in 1997 to serve artists with disabilities, both mental and physical. It offers its more than 40 artists fine art studio space with supplies and artistic direction, a gallery with professional development, recovery groups and life coaching, and a community garden with daily meals. Imagine Art presents the work of its artists in bi-monthly exhibits, where work in many media including pastels, graphite, watercolor, wood, ceramics, fused glass, and mixed media are presented. Visitors are welcome to view the gallery during business hours, 9 a.m.–4 p.m. Monday through Friday.

Artists

Margo Adkins, Tien Ban hike Burns, Debbie Cantu, Cathy Carr, Angelique Catero, Elana Connor Catherine Corff, Nicole Corchiato, Richmond Freeman, Carol Gonzalez, Louis Hailson, Scott Harbour, Larin Harp, Donald Hein, James Hernandez, James Johnson, Thomas Kemper, Ramin Mandavi, Sylviann Murray, Laura Alisha Meyers-Doughty, James Nelson, Scott Pozen, Delilia Price, Lui Reader, Kelly Reider, Laura

Riley, Ben Rivera, Billy Rohleder, Elias Sofikitis, Kathleen Staas, Lydia Drey Ward, Nancy West, Dennis Williams, Kim Witt, Ebony Young, Jennifer Zamecnik.

Yard Dog Folk Art

1510 South Congress Avenue
Austin, Texas 78704
Randy Franklin, owner
Phone: 512-912-1613
Email: yarddogart@gmail.com
Web site: www.yarddog.com

Yard Dog focuses on folk and outsider art of the American South. Included are works in a variety of media including paintings, drawings and three-dimensional works. The gallery publishes a newsletter and sends photographs upon request.

Artists

Eddie Arning, Paul Darmafall ("Baltimore Glassman"), Uncle Pete Drgac, Scott Griffin, Jennifer Harrison, Andrea Heimer, Clementine Hunter, James Harold Jennings, Daniel Johnston, M.C. "5¢" Jones, Bill Miller, Reggie Mitchell, Ike Morgan, Morris Ben Newman, Royal Robertson, Sulton Rogers, Lamar Sorrento, Jimmy Lee Sudduth, Mose Tolliver, "Artist" Chuckie Williams, Purvis Young.

Valley House Gallery

6616 Spring Valley Road
Dallas, Texas 75240
Kevin and Cheryl Vogel, Owners
Phone: 972-239-2441
Email: kvogel@valleyhouse.com
Web site: www.valleyhouse.com

The gallery represents many contemporary artists and also carries nineteenth and early twentieth century American and European fine art. Many of the contemporary artists represented by Valley House Gallery have ties to the south, southwest, or Texas and focus on representational work in a broad variety of media. The gallery works to further these artists' careers by taking their work to major art fairs, arranging for museum exhibitions, and exhibiting their work at the gallery in one-person or group shows.

Artists

Teri Fitzpatrick, Valton Tyler, Bob Stuth-Wade, Velox Ward, Clara McDonald Williamson

San Angel Folk Art
220 Blue Star
San Antonio, Texas 78204
Richard Henry Lee, owner
Phone: 210-226-6688
Email: info@sanangelfolkart.com
Web site: www.sanangelfolkart.com

After a decade spent traveling throughout Mexico and Latin America, meeting folk artists and collecting their works, Richard Henry ("Hank") Lee opened San Angel Folk Art Gallery in San Antonio in 1989. With degrees in both business and visual arts, he sought to create a gallery that supported the vast field of visual folk arts by curating and showing some of the most accomplished folk artists of the day. Shortly after opening San Angel Folk Art gallery, Hank began to feature the work of local artists and artists in the immediate Southwest. As time passed, San Angel Folk Art expanded its collection to include artists from the greater southern and southwestern United States as well as Latin American, Europe and Africa.

American Artists

Shane Campbell, Kieth Davis, Nicholas Herrera, Arthur Lopez, Chris Maya, Bill Miller, Jeri Moe, J. L. Nipper, the Rev. Samuel Perkins, Alfredo Rodriguez, Isaac Smith, Hubert Walters, Derek Webster

Webb Gallery
209–211 West Franklin
Waxahachie, Texas 75165
Bruce and Julie Webb, Owners
Phone: 972-938-8085
Email: webbart@sbcglobal.net
Web site: www.webbartgallery.com

Founded in 1987, Webb Gallery began as a collection based on the owners' interest in old handmade items, fraternal lodge items, tramp art, memory jugs and quilts. In 1989 the focus changed to contemporary art including many self-taught artist's work. The large gallery space has exhibits of artwork that change every 3 months, along with the glimpses of the huge inventory and an ever-changing array of antique pieces.

Artists

Z.B. Armstrong, John W. Banks, Hector Alonzo Benavides, Carl Block, Hawkins Bolden, Tom Burleson, William S. Burroughs, Carl Dixon, Uncle Pete Drgac, Burgess Dulaney, Ralph Griffin, Mark Cole Greene, Daniel Higgs, Robert Howell, the Rev. J. L. Hunter, M.C. "5¢" Jones, S.L. Jones, Ida Mae Kingsbury, George P. Kornegay, Joe Light, Helen Burkhart Mayfield, Ike Morgan, J. B. Murry, Carl Nash, Michel Nedjar, Royal Robertson, Xmeah ShaElaRe'El, Mary T. Smith, Jimmy Lee Sudduth, the Rev. Johnnie Swearingen, James "Son" Thomas, L.T. Thomas, Mose Tolliver, Willard "The Texas Kid" Watson, Derek Webster, George White, "Artist Chuckie" Williams, Willie Wayne Young

Artists Who Sell Their Own Work
Artists are listed here alphabetically by name; check the Artists chapter for location and contact information.

Lisa Cain
Jim Clark
Kevin "King" Orth
Mary Frances Robinson
Matt Tumlinson

UTAH

Twin Rocks Trading Post
P. O. Box 330
913 E. Navajo Twins Drive
Bluff, Utah 84512
Barry and Steve Simpson, owners
Phone: 435-672-2341
Phone: 800-526-3448 (toll free)
Email: theteam@twinrocks.com
Web site: www.twinrocks.com, then click on "folk art"

Twin Rocks Trading Post offers a wealth of Native American craft and art, including basketry, rugs, jewelry, and pottery. The Trading Post also represents many Navajo folk artists—Navajos who make art outside of tribal traditions and inspired by their own ideas. The Twin Rocks Trading Post is located beneath the Navajo Twins geologic formation in the historic pioneer town of Bluff, Utah.

Artists

Johnson Antonio, Ray Growler, Leland Holliday, Marvin Jim, Ray Lansing, Dennis Ross, Leonard and Emily Tsosie, Robin Willeto, Harold Willeto, Matthew Yellowman

—— VERMONT ——

G.R.A.C.E./Grass Roots Art & Community Effort
P.O. Box 960
59 Mill Street
Hardwick, Vermont 05843
Carol Putnam, Director
Kathy Stark, Exhibitions Director
Phone: 802-472-6857
Email: grace@vtlink.net
Web site: www.graceart.org

This gallery sells and exhibits artwork produced through the G.R.A.C.E. workshop program since its opening in 1983. It also features three-dimensional work from all over the United States, has a large collection of North Carolina face jugs, and offers art by internationally recognized self-taught artists such as Howard Finster and Henry Darger as well as lesser-known and emerging artists. The exhibition program is offered at non-traditional sites across the region in-cluding storefronts, libraries, and church halls. An exhibit in the Pine Forest is a staple of the annual Bread and Puppet Circus in Glover, where thousands pass through each year to view dozens of artists' work. The artwork is of high quality and largely two-dimensional. G.R.A.C.E. artists receive 65 percent of the sales price, with the remaining 35 percent helping to support the program.

Artists
Gayleen Aiken, Elaine Baldwin, Joel Bertelson, Larry Bissonnette, Ken Bridges, Patrick Brooks, Merrill Densmore, T. J. Goodrich, Jill Harvey, Dot Kibbee, David Matthews, and James Nace, among others

Artists Who Sell Their Own Work
Check the Artists chapter for location and contact information.
Edmond Menard

—— VIRGINIA ——

j fergeson gallery
311 North Main Street
Farmville, Virginia 23901
Jarrod Fergeson, Owner
Phone: 434-391-1006
Email: jarrod@jfergesongallery.com
Web site: www.jfergesongallery.com

The j fergeson gallery in Farmville brings together the work of nationally recognized and local artists in the gallery space as well as in the carefully curated gift shop. It features contemporary painting, ceramics, sculpture and photography, also carrying a few self-taught artists. The range of work promises to introduce gallery visitors to artists and craftspeople they might not otherwise encounter.

Artists
Eldridge Bagley, Dorothy Bowman, and on occasion William H. Clarke

Outsider Folk Art
Leesburg, VA 20176
George and Sue Viener, Owners
Emily Branch, Gallery Director`
Phone: 610-939-1737
Cell: 610-780-4178
Email: George@outsiderfolkart.com
Web site: www.outsiderfolkart.com

George and Sue Viener have collected Americana and self-taught art for over 40 years, participating in the Outsider Art Fair in New York City and various shows over the years at Intuit in Chicago as well as mounting shows of their own at their former gallery, Goggleworks, in Reading, Pennsylvania. After their move from Pennsylvania to Virginia, the Vieners now offer art from their collection through this new "virtual" gallery.

Artists
Gerald Andersen, Charles Auchincloss, Nina Bidault, Jim Bloom, Mildred Borras, Chris Callahan, Teresa Cline, Aloïse Corbaz, Thornton Dial, Will Espey, William Edmondson, Howard Finster, Theodore "Ted" Gordon, Bessie Harvey, Imperio (Prison Artist), Danielle Jacqui, Edward Kingsbury III, Lalena Lamson, Jerry Leonard (Prison Artist), Ted Ludwiczak, Justin McCarthy, Mariama McCarthy, David "Big Dutch" Nally, Alison Silva, Hugo Sperger, Sybil Roe Thompson, Mildred Tice, Philip Virgil, Floretta Emma Warfel, Chuckie Williams, Harriet Wiseman, Edward Woltemate, Jr., Frank Wyso, Michael Wysochansky, Purvis Young, Carlo Zinelli, Domenico Zindato

Grey Carter/Objects of Art
1126 Duchess Drive
McLean, Virginia 22102
Grey Carter, Director

Linda Ortega, Assistant
Phone: 703-734-0533
Email: info@greyart.com
Web site: www.greyart.com

Grey Carter's house is his gallery, where the art on the walls and objects around the house are for sale. Carter has been collecting and representing self-taught, visionary and outsider art for over forty years, compiling a collection of works that represent some of the finest available. From well-established and highly regarded masters to new artists more recently discovered Carter offers a wide range of paintings, drawings, sculptures, and works that defy categorization. He is available by appointment, and also holds several open houses a year for prospective buyers.

Artists
J.J. Cromer, Paul Lancaster, Charlie Lucas, Justin McCarthy, Mark Casey Milestone, Jack Savitsky, Shane Van Pelt

Raven Arts
3404 Moss Side Avenue
Richmond, Virginia 23222
Regenia A. Perry, Owner
Phone: 804-228-8223
Email: none
Web site: none

Specializes in lectures, rental exhibitions, consulting, appraisals, workshops, and sales of African-American folk art. Best to call ahead; much of Perry's art for sale is located at her New Orleans Gallery, so try there also.

Artists
Leroy Almon, Sr., John Banks, William Dawson, Sam Doyle, Minnie Evans, Josephus Farmer, Roy Ferdinand, Jr., Bessie Harvey, Clementine Hunter, John L. Hunter, Mr. Imagination, John Landry, Deacon Eddie Moore, Leslie Payne, Royal Robertson, Juanita Rogers, Nellie Mae Rowe, Willie Stokes, Jimmy Lee Sudduth, Mose Tolliver, Inez Nathaniel Walker, Derek Webster, Luster Willis

The Gallery at Folk Art Net
7919 Williamson Road

Roanoke, Virginia 24019
Bill Jones, Owner
Phone: 800-476-5781
Email: info@folkartnet.com
Web site: none

The Gallery is located in an old log cabin, whose rooms are filled with art and antiques. The Gallery offers many pieces by self-taught artists, most of whom are located no more than 100 miles from Roanoke. Many are recent discoveries made by the gallery owner. The proprietor does not maintain a website, but can be visited or called to find out what he has. He will send photographs to aid in purchases. He also sells art and antiques for other people on commission, using Ebay.

Artists
Tom Baldwin, Benny Carter, Patricia Hayden, Kenneth Lee Meyers, Anne Moon, Sally Nolen, Phyllis "Por Phyl" Long, Dave Ramey, Dave Rawlings, Charles Simmons, George Wright

Barry M. Cohen, Private Dealer
Alexandria, Virginia
Email: landmark@cox.net
Web site: none

Folk, outsider, erotic folk art, and objects by recognized as well as anonymous artists. The emphasis is on quality painting and personal vision. This rich collection includes multiple pieces by painter Caroline Goe, Justin McCarthy, Charles Rabin, John Schreiner, Marcus Staples, Jr., Popeye Reed and a large collection of art from Nova Scotia and anonymous artists.

Artists Who Sell Their Own Work
Artists are listed here alphabetically by name; check the Artists chapter for location and contact information.
Kasey Snydor Carneal
Jay Cherrix
William H. Clarke
J. J. Cromer
Everett Mayo
"Queena" Stovall (work still available)

WASHINGTON

Dos Folkies Gallery: Outsider–Self-Taught–Art Brut
PO Box 84
Chimacum, Washington 98325
Dave Russell & Jenell DeMatteo, Owners
Phone: none listed

Email: info@dosfolkies.com
Email: mydawggy@hotmail.com
Web site: www.dosfolkies.com

Dos Folkies is a virtual gallery. The web site starts with a detailed mission statement about the Gallery's commitment to supporting the works of the self-taught

artists and artists with disabilities. There is information on the backgrounds and experiences of the proprietors and a colorful web site that presents the artists works available for purchase.

Artists: Michael Banks, Richard Burnside, Penny-Cannon, Ken Gentle (aka "Blacktop"), Lonnie Holley, Janet Jacobson, Willie Jenks, Eric Legge, Charlie Lucas, R. A. Miller, Missionary Mary Proctor, Craig Rogers, Dave Russell, James "Buddy" Snipes, Jimmy Lee Sud-

duth. Annie Tolliver, Mose Tolliver, John Henry Toney, Annie Wellborn, Carter Wellborn, Myrtice West, Ruby Williams.

Artists Who Sell Their Own Work

Check the Artists chapter for location and contact information.

Dennis Chastain

——————— WEST VIRGINIA ———————

Artists Who Sell Their Own Work

Check the Artists chapter for location and contact information.

Earl Gray

——————— WISCONSIN ———————

Dean Jensen Gallery

759 North Water Street
Milwaukee, Wisconsin 53202
Dean Jensen, Owner
Phone: 414-278-7100
Email: deanjensonart@sbcglobal.net
Web site: www.deanjensegallery.com

The Dean Jensen Gallery was established in 1987. While there is always some outsider art on view here, the Dean Jensen Gallery also regularly presents exhibitions by nationally and internationally prominent mainstream painters and photographers. The gallery handles both American and European self-taught artists (the American artists are listed below), and mounts exhibitions of their work about twice a year. The gallery has also built up a reputation for its inventory of antique tattoo flash—original tattoo drawings

that were once displayed as advertisements in tattoo parlors.

Artists

Eileen Doman, Howard Finster, Sister Gertrude Morgan, Philadelphia Wireman, Carter Todd, Bill Traylor, Eugene Von Bruenchenhein

Artists Who Sell Their Own Work

Artists are listed here alphabetically by name; check the Artists chapter for location and contact information.

Paul Bobrowitz
Clarence Powell
Rudy Rotter (family will continue to sell until no more available)
Mona Webb

FAIRS AND FESTIVALS

The Fairs and Festivals listed are generally highly organized gatherings at which numerous galleries and artists set up booths and sell their wares over several days. Some are devoted to self-taught and outsider art, others include them in a larger event. Some, such as the Angola Prison Rodeo, feature works from a single source—in this case, Angola Prison inmates. Entries are arranged in alphabetical order by state and then city within state.

ALABAMA

Arts and Crafts Festival

Information available from:
Eastern Shore Chamber of Commerce
Fairhope, Alabama 36532
Phone: 334-928-6307
Web site: www.fairhopealabama.net/ArtsCraftsFestival.html

The sixty-first Arts and Crafts Festival in this Gulf Coast town took place during March 2014. Lorraine Gendron, of Hahnville, Louisiana, and Brian Dowdall of Cocoa Beach, Florida, are two self-taught artists who have been included in this festival.

Kentuck Festival

Information available from:
Kentuck Museum
503 Main Avenue
Northport, Alabama 35476
Phone: 205-758-1257
Email: kentuck@kentuck.org
Web site: www.kentuck.org
Miah Michaelsen, Executive Director

The Kentuck Festival of the Arts is an annual event that takes place on the third weekend of October. The festival "celebrates the Deep South with presentations of its visionary folk art, traditional and contemporary crafts, legendary music, and regional food." Artists who have attended over the years have included AB the Flagman, Butch Anthony, Jack Beverland, Jerry Brown, Brian Dowdall, Howard Finster, Roy Finster, Lorraine Gendron, Lonnie Holley, Chris Lewallen, Woodie Long, Annie Lucas, Charlie Lucas, Sam McMillan, Virgil Perry, Sarah Rakes, Euple and Titus Riley, Bernice Sims, James "Buddy" Snipes, Jimmy Lee Sudduth, Michael "Catfishman" Suter, Annie Tolliver, Mose Tolliver, Daniel Troppy, Myrtice West, "Indian Joe" Williams, Artis Wright, and Sharon Yavis.

DISTRICT OF COLUMBIA

Outsider Art Inside the Beltway

Information available from:
Art Enables
2204 Rhode Island Avenue, NE
Washington, D.C. 20018
Phone: 202-554-9455
Web site: www.art-enables.org

Art Enables is a Washington, D.C.-based art center for people with mental disabilities. Since 2006 it has hosted a juried show featuring its own artists and those who participate in other art centers around the country, including Creativity Explored in San Francisco, Spindleworks in Brunswick, Maine, Pure Vision Arts in New York City, First Street Gallery in Clare-

mont, California, and others. These artists make distinctive art that comes from the heart—all are self-taught. Visitors may enjoy and collect some truly remarkable art. The show is usually mounted for five to six weeks (e.g., the 2014 show ran from October 11 through November 21); Art Enables is metro-accessible, close to the Rhode Island Avenue Station of the Red Line.

GEORGIA

Folk Fest

Information available from:
 Steve Slotin
 5967 Blackberry Lane
 Buford, Georgia 30518
 Phone: 770-932-1000
 Fax: 770-932-0506
 E-mail: slotin@slotinfolkart.com
 Web site: www.slotinfolkart.com/folkfest
Fest location:
 1700 Jeurgens Court
 Norcross, Georgia (I-85 & Indian Trail Rd. Exit 101)

Folk Fest takes place in Norcross, a north Atlanta suburb, during the third weekend in August. Started by Steve Slotin in 1994, it includes an opportunity to meet many artists and to purchase art from the nearly 100 galleries and dealers who sell their wares in a friendly, welcoming atmosphere.

Southern Folk Expressions

Information available from:
 The Hambidge Center
 P.O. Box 339
 Rabun Gap, Georgia 30568
 Phone: 706-746-5718
 Web site: www.hambidge.org/the-festival.html

This annual celebration, taking place in the North Georgia mountains during mid–July to early August, is sponsored by The Hambidge Center and two local galleries that feature self-taught artists—Timpson Creek Gallery and Main Street Gallery. The celebration includes folk artists' receptions, barbecue and bluegrass music, slide shows and book signings, kiln openings and pottery sales. Among the many artists who have been included are AB the Flagman, Carl Block, Rudolph Valentino Bostic, Tubby Brown, Kacey Carneal, Benny Carter, Wesley Carter, Chris Clark, Rodney Hardee, Alyne Harris, Lonnie Holley, Roy Minshew, Ben Owen III, Jay Schuette, and William Thomas Thompson, to name a few.

Finster Fest

Information available from:
 Email: info@paradisegardenfoundation.org
 Web site: www.finsterfest.com
Fest location:
 Dowdy Park
 Summerville, GA

Recently, the Paradise Garden Foundation was started to restore, preserve, and maintain the world-famous environment, Paradise Garden, that Howard Finster created in Summerville. The festival began in 1992 as "Howard Finster Day," drawing artists and crafts people from many parts of the country to display and sell their wares. It has continued and grown since that time, becoming Finster Fest under the auspices of the Paradise Garden Foundation. It takes place in late spring (check website for exact dates) and is the Foundation's annual fundraising event. It is one of the Southeast's most popular folk art and music festivals. A few of the artists who come are self-taught, including Wallace Knox Wilkinson, Jr., Paul Jastram, and James Schroeder.

KENTUCKY

A Day in the Country

Information available from:
 Kentucky Folk Art Center
 102 West First Street
 Morehead, Kentucky 40351
 Phone: 606-783-2204
 Web site: www.kyfolkart.org
 Tammy Stone, Administrative Coordinator

This annual event was started by folk artist Minnie Adkins to introduce her many talented neighbors in eastern Kentucky to folk art collectors—Tim Lewis, Jim Lewis, Jr. Lewis, Linvel Barker, Hazel Kinney, Charles Keeton, and Carolyn Hall, to name just a few. The event became so popular (and hot) that it was moved to a large, air-conditioned space in downtown Morehead. "A Day In the Country" is one of the largest annual gatherings of folk artists in America. At this event, more than 50 folk artists from Kentucky and other states present their work for sale directly to the public. In 2014 participating artists included Greg Adkins, Minnie Adkins, Steve Armstrong, Bill

Barker, Bebo, Tammy Booher, Maryanne Boylan, Jo Ann Butts, Rebecca Campbell, Brent Collingsworth, Erick Dobson, Tony Dotson, Nancy Gillum, Earl Gray, Joshua Huettig, Levent Isik, William Keith, Jo Neace Krause, Tim Lewis, Glen and Merline Maynard, Janice Miller, Lonnie and Twyla Money, Bruce New, Janice Harding Owens, Thaddeus Pickney, Guy and Janet Purcell, Terry Ratliff, Guy and Dolly Skaggs, Joyce Skaggs, Charles Spellman, Eileen Stockham, LaVon Van Williams and many others. It is a friendly event with lots of art and opportunities to meet the artists.

Annual Minnie Adkins Day Festival

Little Sandy Lodge
1916 Kentucky Highway 32
Sandy Hook, Kentucky 41171
Phone: 606-548-2095
Web site: www.kentuckymonthly.com/events/elliott-county-minnie-adkins-day

Elliott County's first "Minnie Adkins Day Festival" took placed in 2014 and henceforth will be officially designated the Annual Minnie Adkins Day by Elliott County officials. It will take place on the third Saturday in July every year in Sandy Hook, Elliott County, Kentucky. The event is a celebration of all local artists in the region. People came from "all over" at the first time gathering to honor artist Minnie Adkins for her promoting the region's art and crafts. The second Minnie Adkins Day was held on July 18, 2015. Food, fun, and music are promised, along with the art.

———— LOUISIANA ————

Angola Prison Rodeo

Information available from:
 Louisiana State Penitentiary
 Angola, Louisiana 70712
 Phone: 225-655-2133 or 225-655-2607
 Email: info@angolarodeo.com
 Web site: www.angolarodeo.com

The Angola Prison Rodeo has been held for more than forty years. It occurs on one weekend in April and every Sunday in October. It includes regular rodeo events, music, food, and other attractions. The attraction most relevant to those interested self-taught art is the Hobbycraft area, "an all-day, full-blown arts and crafts festival, complete with entertainment and food" (per website). All artworks and crafts available for sale are made by prison inmates, some of whom have become quite well known for their art. Entry to the Hobbycraft area is included in the Rodeo ticket price, but in case the Rodeo is sold out, which often happens, people who want to see or buy the art can still buy a ticket that admits them to the Hobbycraft area only. Proceeds from the Angola Prison Rodeo cover rodeo expenses and supplement the Louisiana State Penitentiary Inmates Welfare Fund, which provides inmate recreational and educational supplies.

Melrose Arts and Crafts Festival

Information available from:
 Melrose Plantation
 3633 Hwy 119
 Natchitoches, Louisiana 71452
 Phone: 318-581-8042
 Phone: 800-259-1714 (toll free)

This event usually takes place in early May. More than 100 artists and crafts persons from throughout the South come to the historic Melrose Plantation to display their arts and crafts—including paintings, pottery, wooden sculpture, and "unique yard art." Clementine Hunter began here, painting the people, the life, and scenes of Cane River. Her paintings are on display at the plantation.

New Orleans Jazz and Heritage Festival

Information available from:
 New Orleans Jazz and Heritage Festival
 2200 Royal Street
 New Orleans, Louisiana 70117
 Phone: 504-944-0010
 Web site: www.nofazzfest.com

This festival, held the last weekend in April and the first weekend in May, has a folk art section as well as contemporary and African/African-American crafts. Folk artists who frequently exhibit their work are Ivy Billiot, "Dr. Bob" Shaffer, Charles Gillam, and Pat Juneau. Pine needle basket makers from several Louisiana native groups—Coushatta, Choctau, and Houma—display their wares, and Isleños (a community of people from the Canary Islands who settled in Louisiana), especially the Perez family, offer their miniature boats and bird carvings. Each artist comes for only one of the two Jazzfest weekends, so check the website to see when each will be there.

Palmer Park Arts Market

Arts Council of New Orleans, Louisiana
Phone: 504-218-8869 504-523-1465
Web site: www.artscouncilofneworleans.org
Gene Meneray, Director, Artist Services

The Art Council of New Orleans sponsors "An Open-Air Festival of Creativity" in Palmer Park on the last weekend of every month. Palmer Park is located at the intersection of Claiborne Avenue and Carrollton Avenue, at the uptown terminus of the St. Charles Avenue streetcar, and is thus very easy to reach. The event features over 100 local artists and craft people, live music, creative activities for kids, and good local food. A few of the many artists included are Lorraine Gendron, who creates Mississippi mud sculptures related to Louisiana culture and wood figures of local musicians; Pat Juneau, who makes colorful yard art metal pieces; Carol Thibodeaux, who does gourd art, Cajun 'stained glass,' and bird houses; Blayne Gothard, Shutter-Fish; Mitch Landry, who makes metal art sculptures of "fish, flora, fauna, fowl"; and Hannah Cohen, who makes shadow boxes of New Orleans customs, scenes, and most especially local musicians.

MICHIGAN

Outsiders Outside

Information available from:
Judith Racht Gallery
13707 Prairie Road
Harbert, Michigan 49115
Phone: 616-469-1080

In the Midwest, Judith Racht sponsors a "self-taught visionary and folk art" fair—Outsiders Outside in Harbert, Michigan. (She used to sponsor a second fair, Outsiders Inside, in Chicago, but does not do that one any more.) The fair includes dealers and galleries from all regions of the United States. Many Midwest galleries exhibit at this fair and nowhere else.

NEW YORK

Outsider Art Fair

Information available from:
Email: info@outsiderartfair.com
Web site: www.outsiderartfair.com

The Outsider Art Fair has been held in New York for more than two decades. It was held at the Puck Building for many years, and included lectures and other events arranged by the (then) Museum of American Folk Art. Many galleries from various parts of the world come to display and sell art; the Fair offers the opportunity for many interested in outsider, self-taught and folk art to network and catch up on happenings in the outsider art world. Ownership of the Outsider Art Fair changed a few years ago, since which time it has changed venues and even months of the year several times. In 2016 it was held in January at the Pavilion on West 18th Street. In addition, emphasis has shifted somewhat away from American self-taught artists and toward European ones.

NORTH CAROLINA

Mint Museum Annual Potters Market Invitational

Information available from:
2730 Randolph Road
Charlotte, NC 28207
Phone: 704-337-2000
Web site: www.mintmuseum.org

This event takes place on the lawn of the Mint Museum, gathering potters in the rich tradition of North Carolina pottery for an annual event that offers collectors access to their latest works. Every year, hundreds of pottery enthusiasts line up hours in advance of the opening to gain access to the day's best treasures. Fifty outstanding North Carolina potters are invited to these markets, which are presented by the Delhom Service League, the ceramics affiliate of the Mint Museum, promoting ceramic arts and education. The entry fee includes admission to the Mint Museum Randolph. Proceeds support the Mint Museum's decorative arts collection. The 10th annual Market Invitational happened on Saturday, September 6, 2014.

Catawba Valley Pottery and Antiques Festival

Information available from:
Hickory Metro Convention Center
I-40, Exit 125
Hickory, North Carolina 28603
Phone: 828-324-7294 or 828-322-3943
Email: info@CatawbaValleyPotteryFestival.org
Web site: www.catawbavalleypotteryfestival.org

More than 110 vendors come to this festival, held in March every year. The event features Antique Southern traditional pottery, contemporary pottery, folk art, lectures, and exhibits. It is sponsored by the Catawba County Historical Association and the North Carolina Pottery Center. Tickets must be purchased in advance—check the website for specific dates and details on ticket purchase.

Fearrington Folk Art Show

Information available from:
 Fearrington Barn at Fearrington Village
 U.S. 51-501 North
 Pittsboro, North Carolina 27312
 Phone: 919-542-4000
 Phone: 800-277-0130 (toll free)
 Web site: www.fearrington.com

This annual event, which takes place over two days of a February weekend, is an exhibition and sale of diverse artwork from self-taught Southern artists who are influenced by the spirit of folk art, naïve art, and outsider art. Featured artwork includes whimsical painting, fantastical robots, sculptures, pottery and more. Some of the artists included in the show: Ab the Flagman, Brian Dowdall, Sam McMillan, Tres Taylor,

and more than thirty others. On the Friday before the show opens, there is a special Collector's Preview that offers the collector the opportunity to visit and have more in-depth conversations with the artists and purchase their work. All sales proceeds benefit the artists directly; Fearrington takes no commission from the artists, nor does it charge a booth fee to the artists selected for the show. Ticket prices are just $5 per person at the door.

Lake Norman Folk Art Festival

Information available from:
 3630 Drum Campground Road
 Sherrills Ford, North Carolina 28673
 Phone: 828-327-8576
 Web site: www.LakeNormanFolkArtFestival.com

This festival is held the first Saturday in October and includes activities for the entire family. There is a juried folk art sale with artists from North Carolina and beyond. In 2014, artists included Minnie Adkins, Theresa Disney, Cher Shaffer, Jim Shores, Sarah Rakes, A.V. Smith, Mike Esslinger, and Sam Ezell. Potters, traditional and innovative, are included. The festival is sponsored by the Hickory Museum of Art, which is also the home of the Huffman Folk Art Collection.

AUCTIONS

Auctions are a source for purchases, and potentially allow one to buy works by artists who are no longer producing but were collected by others long ago. Auction dates and what is for sale are announced in advertisements in art publications and on websites of auction houses. They are also a good resource if you want to sell all or part of your collection. On the Internet, eBay has become an important presence and source for folk art at auction. The following eight companies or organizations have regular auctions in the field. All maintain websites where a person can see the art to be auctioned, and all now incorporate online bidding as part of their auctions. Except for the FASA auction, which takes place in a different city every year concurrent with the FASA annual conference, they are listed alphabetically by state.

The Folk Art Society of America at Longwood Center for the Visual Arts (FASA@LCVA)

129 N. Main Street
Farmville, Virginia 23901
Phone: 434-395-2206

Email: fasa@folkart.org
Web site: www.folkart.org
Rachel Ivers, Director of LCVA
Jill Manning, Assistant

The Folk Art Society of America was founded in 1987 by fourteen Richmond-based people who shared an interest in folk art and artists. The Society now has members from all over the United States and several foreign countries. In 2014 it merged with Longwood College and was renamed The Folk Art Society of America at Longwood Center for the Visual Arts. The goals of the organization are to discover, promote, study, document, and preserve folk art, folk artists, and folk art environments. FASA holds an annual meeting, usually in early October, in a different city each year. One evening of the meeting is devoted to an auction of art donated by FASA members, which raises money for the organization's various functions. Attendance at the meeting is not required to participate in the auction, which can be accessed on line. Bidding may also be done on line.

Also see entry for FASA at LCVA under Organizations and Other Publications.

CALIFORNIA

Hewlett's Antique Auctions

P.O. Box 87
13286 Jefferson Street
LeGrand, California
Phone: 209-389-4542
Email: hewlettsdirect@sbcglobal.net
Web site: www.hewlettsauctions.com
Buster Hewlett, Auctioneer

Hewlett's Antique Auctions is a family-owned and operated business selling almost anything, including folk art. For over forty years it has been auctioning, selling, or buying single items and whole estates, from sources all over the United States. Hewlett's is located in central California, off of U.S. 99 between Madera and Merced.

GEORGIA

Slotin Folk Art Auction

112 East Shadburn Avenue

Buford, Georgia 30518
Phone: 770-532-1115

Phone: 404-403-4244
Email: auction@slotinfolkart.com
Web site: www.slotinfolkart.com
Steve Slotin, Auctioneer

Slotin Folk Art auctions take place twice a year, the second weekend in November, and the following spring. The art at auction is "strictly folk art, covers the entire range of material, including single pieces and whole collections." Auctions take place over two days, and may be attended in person or on line. Catalogs in color illustrate every item for sale and are sent one month before the auction. Catalogs cost $20 to $25, and sales results are sent after the auction.

NEW YORK

Christie's
20 Rockefeller Plaza
New York, New York 10020
Phone: 212-636-2230 (direct to relevant department)
Web site: www.christies.com

Christie's has offered superb examples of American Folk Art since its first sales of Americana in 1979. In recent years, the auction house has expanded its focus in this area, including enhanced staffing to bring Outsider Art to the sale roster, earning exceptional prices and presenting established self-taught artists to collectors worldwide. Christie's publishes full-color, thoroughly researched catalogues. Information on each work to be auctioned, including condition reports, images, and academic essays, is available online prior to a sale. Past sale results and catalogues may also be accessed through the website.

Sotheby's
1334 York Avenue
New York, New York 10021
Phone: 212-606-7130 (direct to relevant department)
Web site: http://www.sothebys.com/en/departments/american-furniture-decorative-art-folk-art.html

Sotheby's has a Department of American Furniture, Decorative Art, and Folk Art. Nancy Druckman is the director. Sotheby's limits its representation to "artists who have established track records, people who have already come to the attention of galleries and serious collectors." Information about upcoming auctions is available on the web site, as are catalogs and results of past auctions. Published catalogs contain illustrations for every piece to be auctioned, and include information about the artist. Catalog purchasers receive information about sales after the auction. Prices for catalogs vary.

NORTH CAROLINA

North Carolina Pottery Center
Information available at:
 P.O. Box 531
 233 East Avenue
 Seagrove, NC 27341
 Phone: 335-873-8430
 Web site: www.ncpotterycenter.org
Auction location:
 Leland Little Auction & Estate Sales
 620 Cornerstone Court
 Hillsborough, NC

The 15th pottery auction sponsored by the North Carolina Pottery Center took place in August 2014, and included both a live auction and a silent auction. There is also the opportunity to participate by phone and as an absentee bidder. Offerings are available for viewing at www.llauctions.com. Leland Little holds many auctions in addition to the one sponsored by the Pottery Center, including other auctions devoted to work by southern pottery.

Also see entry for the Society under Organizations and Other Publications.

Southern Folk Pottery Collectors Society
220 Washington Street
Bennett, NC 27208
Phone: 336-581-42446
Email: sfpcs@rtmc.net
Web site: http://www.southernfolkpotterysociety.com/

Southern Folk Pottery Collectors Society had its first "Absentee Auction" March 31, 1993, and still holds them regularly, via auction catalogs and online bidding. Auctioned items include pottery from many Southern states, with pieces from individual potteries and from important collections. Each auction is preceded by a fully illustrated catalog, available on the Society's web site, with information and references about the pieces and biographies of the potters. Catalog price is around $15 plus shipping. Post-sale results are also available on the web site.

Also see entry for the Society under Museums and Organizations.

PENNSYLVANIA

Material Culture

4700 Wissahickon Avenue
Philadelphia, Pennsylvania 19144
Phone: 215-438-4700 (Auction Department)
Phone: 215-849-8030 (Store)
Email: info@materialculture.com
Web site: www.materialculture.com

Material Culture, established in 1993, offers a 60,000 square foot emporium of constantly changing art, antiques, crafts, furnishings, and architectural elements from around the world. It also uses this space to sponsors all manner of exhibitions and events. Material Culture holds frequent auctions that, taken as a whole, cover the range of goods it sells. At least once a year, sometimes more often, the auction focuses on folk, self-taught, and outsider art. One auction in 2014 offered folk, self-taught, and outsider art exclusively; another in that year offered a combination along with fine art. Other years had similar mixes. Material Culture displays the art for sale at each auction on its website well in advance. In addition, one can always browse the store, but allow lots of time.

TENNESSEE

Kimball M. Sterling, Inc.

125 West Market Street
Johnson City, Tennessee 37604
Phone: 423-928-1471
Email: kimballsterling@earthlink.net
Web site: www.outsiderartauctions.com
Kimball Sterling, Auctioneer

Kimball Sterling auctions folk art, estates, antiques, and a wide array of collectables. His company, which has been running auctions for more than a quarter of a century, is particularly well-known for its antique canes and walking sticks collection. Kimball Sterling, an expert in Southern outsider art, was the fourth auctioneer in the country and the first in the Southern United States to conduct live internet auctions. Some auctions are specifically for self-taught and outsider art. Full-color catalogs are available; some are charged for, some are not. Sterling introduces new artists at each auction, and for these people there is information in the catalog.

MUSEUMS, LIBRARIES, ARCHIVES AND ENVIRONMENTS

Descriptive material and information about artists in collections was, for the most part, provided by the museums. It is best to call ahead to see if the work one wishes to see is on view or may be seen by special arrangement, and to determine days and hours the collections are open. Museums are arranged alphabetically by state, then by city within state, and then by the name of the institution, if a city has more than one museum. If available, the entries provide a website and email contact information. We have not included links through Facebook, Twitter, or YouTube in the museum descriptions, but you can connect with these links through museum websites if they have them. Folk art environments that are extant and may be visited as of the time this book is published are listed for the state where they are located, following the museum listings for that state. If no environments are listed for a state, either none ever existed or they no longer exist.

See also Other Resources at the end of this chapter.

ALABAMA

Birmingham Museum of Art
2000 Reverend Abraham Woods Jr. Blvd.
Birmingham, AL 35203
Phone: 205-254-2565
Email: webinfo@artsbma.org
Web site: www.artsbma.org
Gail Andrews, Director
Emily Hanna, Curator, Arts of Africa and the Americas

This museum houses a permanent collection of more than 17,000 works including European, American, Asian, and traditional art from the twelfth century to the present. The museum has a number of folk artists, primarily but not exclusively from the Southeast. The exhibition "Pictured in My Mind" was at the museum February 4 through April 7, 1996. "Story" quilters Yvonne Wells and Nora Ezell are represented in the collection. Many works of self-taught artists now in the collection were a gift from the family of Robert Cargo, gallery owner and collector late of Tuscaloosa, Alabama, who donated his collection to the museum shortly after his death.

Self-Taught Artists in the Collection
Minnie and Garland Adkins, Leroy Almon, Z.B. Armstrong, John Barnard, Jerry Brown, Richard Burnside, David Butler, Raymond Coins, Jerry Coker, Calvin Cooper, Ronald Cooper, William Dawson, Thornton Dial, Sr., Charlie Dieter, Burgess Dulaney, William Edmondson, Nora Ezell, Roy Ferdinand, Howard Finster, Albert Freeman, Lorraine Gendron, Sybil Gibson, John and Larry Gilley, Denzil Goodpaster, Ted Gordon, Ralph Griffin, Carolyn Hall, Joseph Hardin, Bessie Harvey, Herman Hayes, Clarence Hewitt, Troy Hicks, Lonnie Holley, Clementine Hunter, J.L. Hunter, Billy Ray Hussey, Alvin Jarrett, James Harold Jennings, M.C. "Five-Cent" Jones, S.L. Jones, Charley Kinney, Junior Lewis, Joe Light, Rebecca Light, Ronald Lockett, Charlie Lucas, Sam Martin, Tim Martin, Willie Massey, Thomas May, Justin McCarthy, Columbus McGriff, Carl McKenzie, R.A. Miller, Sister Gertrude Morgan, Ike Morgan, Emma Lee Moss, Mark Anthony Mulligan, J.B. Murry, Larry Nevil, B.F. Perkins, "Old Ironsides" Pry, Tim Reed, Ernest "Popeye" Reed, Sandra Rice, Titus and Euple Riley, Royal Robertson, Juanita Rogers, Sulton Rogers, Jack Savitsky, Inez Shell, Bernice Sims, Herbert Singleton, John Ray Smith, Mary T. Smith, Robert Smith, Donna Sophronia-Sims, Georgia Speller, Henry Speller, Jewell Starday, Vannoy Streeter, Jimmy Lee Sudduth, Sarah Mary Taylor, Son Ford Thomas, Mose Tolliver, Felix Virgous, Hubert Walters, Derek Webster, Fred Webster, Yvonne Wells, Myrtice West, Willie

White, "Artist Chuckie" Williams, George Williams, Jeff Williams, Sharon Yavis

Fayette Art Museum

Fayette Civic Center
530 North Temple Avenue
Fayette, Alabama 35555
Phone: 205-932-8727
Email: fayetteartmuseum@yahoo.com
Web site: http://fayetteartmuseum.vpweb.com
Anne Perry-Uhlman, Director

The Fayette Art Museum was founded in 1969 by Fayette City Council and Jack Black, who was the Museum's Director for 35 years. It began with the gift from Lois Wilson, a Fayette native, of her art collection, which ultimately totaled 2,600 pieces of her own art on found objects and of other artists' work. The museum is located in Fayette Civic Center, originally the Fayette Grammar School, built in the 1930's and restored in 1982. There are now over 4000 pieces in the permanent collection with over 500 running feet of display space on the main floor of the Civic Center and 6 folk art galleries downstairs.

Self-Taught Artists in the Collection

Sybil Gibson, Lonnie Holley, Jessie LaVon, Douglas Odom, Moses Odom, B.F. Perkins, Margarette Scruggs, Jimmy Lee Sudduth, Wanda Teel, Mose Tolliver, Fred Webster, Willie White, Bernard Wright, Purvis Young, and other folk and mainstream artists

Mobile Museum of Art

Mailing Address:
 P.O. Box 8426
 Mobile, Alabama 36689
Location:
 4850 Museum Drive
 Mobile, Alabama 36608
Phone: 251-208-5200
Email: prichelson@mobilemuseumofart.com
Web site: www.mobilemuseumofart.com
Deborah Velders, Director
Paul Richelson, Chief Curator

The museum's collections include Southern furniture, nineteenth and twentieth century painting, decorative arts, contemporary American crafts, and European, Asian, and African art. It includes works by a number of folk and self-taught artists. The museum does not usually mount exhibitions specifically focused on self-taught artists, but they are included in exhibitions for which they are relevant (e.g., an exhibition of African-American artists), and new acquisitions by self-taught artists are displayed along with other new acquisitions.

Self-Taught Artists in the Collection

Archie Byron, L.W. Crawford, Willie Elliott, Jr., "Sir" Chesley Harris, Theodore Hill, S.L. Jones, Mosea Light, Charlie Lucas, Sidney Lugger, Robert Marino, Cheever Meaders, Lanier Meaders, Sam Rawls, Earl Simmons, Q.J. Stephenson, Jimmy Lee Sudduth, Mose Tolliver, Yvonne Wells, Jeff Williams

Montgomery Museum of Fine Arts

P.O. Box 230819
One Museum Drive
Montgomery, Alabama 36123
Phone: 334-244-5700
Email: info@mmfa.org
Web site: www.mmfa.org
Mark M. Johnson, Director
Margaret Lynne Ausfeld, Senior Curator of Art

The Museum's collection of works by self-taught and folk artists was founded with the gift of thirty drawings by the Montgomery artist Bill Traylor from Charles and Eugenia Shannon in 1982. It was in this same year that the work of this group of artists, primarily active in the mid-to-late 20th century, came to prominence, and their work began to be collected and interpreted within the larger canon of American art. Subsequently the Museum has acquired a substantial collection of work by self-taught artists from both the State of Alabama and the Southeastern United States.

Works by folk artists are included in various permanent collection exhibitions throughout the year. The acquisition of works by Southern folk artists for the permanent collection is a collecting priority of the museum. The museum has had numerous exhibitions with a self-taught artist focus, including "The Hemphill Collection of American Folk Art," "Amish Quilts," "Southern Folk Images," "Charlie Lucas," "Made in Alabama," "Yvonne Wells Quilts," "Mose T," and "Whirligigs and Weathervanes."

Self-Taught Artists in the Collection

Jesse Aaron, Thornton Dial, Sr., Sam Doyle, Sybil Gibson, Clementine Hunter, Charlie Lucas, Elijah Pierce, Mary Proctor, Bernice Sims, Mose Tolliver, Bill Traylor, Fred Webster, and others. Also included are works by Yvonne Wells and several other quilters.

Existing Environments

Environments are listed here alphabetically by the name(s) of the people who created them; check the Artists chapter for location and contact information.
 W.C. Rice—Cross Garden
 Joseph Zoettl—Ave Maria Grotto

ALASKA

Alaska State Museum
395 Whittier Street
Juneau, Alaska 99801
Phone: 907-465-4826 (Curator of Collections)
Email: shendrikson@educ.state.ak.us
Addison Field, Chief Curator
Steve Henrikson, Curator of Collections

The Alaska State Museum is a general museum, with collections featuring the ethnography, history and art of Alaska. Within the art collection, there are a number of Eskimo artists who are self-taught, and whose works depict everyday Eskimo life, and, in some cases, mythological scenes, such as in the work of Kive-

toruk Moses. "While we don't regard these artists as folk or outsider artists, they may fall under your definitions." The museum has a body of work from Eskimo artists Kivetoruk Moses, George Ahgupuk, Milo Minock and Florence Malewotkuk, among others.

The museum closed temporarily on February 28, 2014, and will reopen in the new State Library, Archives and Museum (SLAM) building in May 2016. The new 118,000 square-foot facility will still be at its same location, 395 Whittier Street, where a gift store, cafeteria, auditorium, classroom, reading room, museum galleries, research room, historical library, and state archives will all be under one roof.

ARIZONA

Heard Museum: Native Cultures and Art
Main museum:
 2301 North Central Avenue
 Phoenix, Arizona 85004
 Phone: 602-252-8848
Heard Museum West
 16126 North Civic Center Plaza
 Surprise, Arizona 85374
 Phone: 623-344-2200
Heard Museum North
 34505 North Scottsdale Road
 Scottsdale, Arizona 85262
 Phone: 480-488-9817
Email: contact@heard.org
Web site: www.heard.org

Since its founding in 1923 by Dwight and Maie Heard, the Heard Museum has grown in size and

stature. The Heard Museum is internationally known for its collections, educational programming, and festivals. Something big happens almost every month, including the Heard Museum Guild Indian Fair and Market in March—featuring more than 600 of the top American Indian artists—and the Spanish Market in November—presenting the work of over 70 Hispanic artists from Arizona and New Mexico. Many of the artists at Heard Museum events are self-taught. Museum shops at all three locations offer a wide selection of traditional and contemporary artwork purchased directly from American Indian artists.

Existing Environments
Environment is listed by the name of the person who created it; check the Artists chapter for location and contact information.
Bruce Gulley—Mystery Castle

ARKANSAS

Arkansas Arts Center
P.O. Box 2137
MacArthur Park, 9th and Commerce Streets
Little Rock, Arkansas 72203
Phone: 501-372-4000
Email: info@arkansasartscenter.org
Web site: www.arkarts.com
Todd Herman, Director
Brian Lang, Curator

The Arkansas Arts Center's permanent collection includes drawings and sculpture by folk/outsider

artists. The works are not always on exhibit, but may be viewed by appointment. An exhibition of art by Eddie Kendrick, planned in collaboration with the New Orleans Museum of Art, was held at the Arkansas Art Center in the fall of 1998.

Self-Taught Artists in the Collection
Ulysses Davis, William Edmondson, Minnie Evans, Lee Godie, Ted Gordon, William Hawkins, Clementine Hunter, S.L. Jones, Eddie Kendrick, Sister Gertrude Morgan, O.L. Samuels, Bill Traylor

CALIFORNIA

Oakland Museum of California
1000 Oak Street
Oakland, California 94607
Phone: 888-OAKMUSE (625-6873) (toll-free)
Web site: www.museumca.org
Lori Fogarty, Director and CEO
Christina Linden, Associate Curator of Painting and
 Sculpture

The Oakland Museum is an internationally acclaimed
regional museum of California, offering visitors an op-
portunity to view the state in microcosm. Permanent
and changing exhibitions, collections, and programs
deal exclusively with the California theme, presenting
the ecology, history, artistic expression, and cultural
diversity of the state. There are permanent and special
exhibits of the work of the state's most highly regarded
painters, sculptors, photographers, and craftspeople.

Self-Taught Artists in the Collection
John Abduljaami, Peter Allegaert, Ursula Barnes,
Dalbert Castro, Urania Cummings, John Ehn, Robert
Gilkerson, Ted Gordon, Louis J. Henrich, George F.
Knapp, Alex A. Maldonado, Felix Angel Mathews,
Louis Monza, John H. Newmarker, Ruth Renick, John
Roeder, Theodore Santoro, Judith Scott, Barry Sim-
ons, Smith of Visalia, Peter Thompson, Carrie Van
Wie, and collections of anonymous prison and tramp
art.

Existing Environments
Environments are listed here alphabetically by the
name(s) of the people who created them; check the
Artists chapter for location and contact information.
 Art Beal—Nitt Witt Ridge
 John Ehn—Old Trapper's Lodge
 Baldasare Forestiere—Underground Gardens
 Tressa Prisbrey—Bottle Village
 Simon Rodia—Watts Towers
 Romano Gabriel—Wooden Sculpture Garden

DISTRICT OF COLUMBIA

National Museum of the American Indian
4th St & Independence Ave SW
Washington, D.C. 20560
Phone: 202-633-6644
Web site: www.nmai.si.edu

The National Museum of the American Indian
(NMAI) has one of the most extensive collections of
Native American arts and artifacts in the world—ap-
proximately 266,000 catalog records (825,000 items)
representing over 12,000 years of history and more
than 1,200 indigenous cultures throughout the Amer-
icas. Ranging from ancient Paleo-Indian points to con-
temporary fine arts, the collections include works of
aesthetic, religious, and historical significance as well
as articles produced for everyday use. Current holdings
include all major culture areas of the Western Hemi-
sphere, representing virtually all tribes in the United
States, most of those of Canada, and a significant num-
ber of cultures from Middle and South America and
the Caribbean. Approximately 68 percent of the object
collections originate in the United States, with 3.5 per-
cent from Canada, 10 percent from Mexico and Cen-
tral America, 11 percent from South America, and 6
percent from the Caribbean. Overall, 55 percent of the
collection is archaeological, 43 percent ethnographic,
and 2 percent modern and contemporary arts. The lat-
ter include Native Americans who are considered self-
taught or folk artists. The museum mounts exhibits of
the work of contemporary artists from time to time.

Phillips Collection
1600 21st Street, N.W.
Washington, D.C. 20009
Phone: 202-387-2151
Web site: www.phillipscollection.org
Director: Jay Gates
Eliza Rathbone, Chief Curator
Elizabeth Hutton Turner, Curator

The Phillips Collection includes nineteenth and
twentieth century European and American artworks
including paintings, works on paper, sculpture, and
photography. Included are works by Anna Mary Rob-
ertson "Grandma" Moses, John Kane, and Horace Pip-
pin

Smithsonian American Art Museum
Smithsonian Institution
Eighth and F Streets, N.W. (accessible entry at Eighth
 and G Streets, NW)
Washington, D.C. 20560
Phone: 202-633-8383 (Curatorial office)
Email: umbergerl@si.edu
Web site: www.americanart.si.edu
Leslie Umberger, Curator of Folk and Self-Taught Art

The Smithsonian American Art Museum (SAAM) is the nation's art collection, dedicated to the understanding, appreciation, and enjoyment of the art of a citizen democracy. SAAM celebrates the extraordinary creativity of our country's artists, whose works collectively reflect the history of the United States and connect us to the experiences of its people. The more than 42,000 works included in the collection are significant works of art from all periods and media that exemplify the excellence of diverse artistic traditions across the country.

SAAM has long championed works that were overlooked by many collectors, museums, and art historians. The museum was one of the first general museums to recognize the importance of the work of folk and self-taught artists and to have such material on view at all times. Over the past decade the Smithsonian American Art Museum's collection of work by folk and self-taught artists has grown exponentially. This collection commenced at American Art when the 180 component *Throne of the Third Heaven of the Nations' Millennium General Assembly*, by James Hampton, was discovered in a Washington, D.C. Carriage house and subsequently gifted to the museum. This spiritual sculpture is a collection highlight and among the most popular works at the museum, which sees over one million visitors every year.

In 1986 the museum acquired a group of over 400 works by untrained and often unknown artists from Herbert Waide Hemphill, Junior. Substantial acquisitions were also made possible by Charles and Janet Rosenak in the 1980s and 1990s. Since then, curatorial acquisitions and gifts by various patrons have resulted in a sector of the American Art collection comprising over 1,000 works. Important recent acquisitions include 54 works by James Castle and some 100 multimedia works by a D.C. artist who went by the pseudonym of Mingering Mike. Such veins increase the breadth and raise the profile of this internationally recognized collection. Leslie Umberger joined the museum staff as its Curator of Folk and Self-Taught Art in 2012. The museum mounts special exhibitions of self-taught artists, in addition to maintaining galleries in which it displays works from its permanent collection. For example, during May through October 2014, it presented "Ralph Fasanella: Lest We Forget" on the 100th anniversary of the artist's birth. The museum is responsible for several publications with relevance to folk art: *Made with Passion: The Hemphill Folk Art Collection; Afro-American Art: 20th Century Selections; Hispanic American Art* and *Free Within Ourselves: African-American Artists in the Collection of the National Museum of American Art* by Regenia Perry.

SAAM and the National Portrait Gallery share space in the Old Patent Office Building, which also houses the Library. The building sits between F and G Streets and Seventh and Ninth Streets, NW, with entrances on either F or G at Eighth. The latter is wheelchair ac-

cessible. The Guard Office will direct you to the library, whose direct telephone number is 202-633-8230. The library is a research collection and is open to the public. The collection includes 45,000 cataloged volumes, principally on American art, history, and biography. Auction catalogs, periodicals and serials, scrapbooks, microforms, and uncatalogued art ephemera in 300 file drawers make up the remainder of the collection. Emphasis is on painting, graphic art, and sculpture, with a growing concern for photography and decorative arts.

Membership in the Smithsonian American Art Museum provides various benefits including a quarterly newsletter, preview announcements of lectures and symposia and a discount in the museum shop and bookstore. Membership provides a discount on subscriptions to the museum's publication, *American Art*.

Selected Self-Taught Artists in the Collection (in Addition to Works of the Eighteenth and Nineteenth Centuries, and Anonymous Works)

Mary Adams, Aghassi George Aghassian, Gayleen Aiken, Ross Allen, Consuelo Gonzalez Amezcua, Tobias Anaya, Jeremy Anderson, Stephen Anderson, Johnson Antonio, Felipe Archuleta, Leroy Archuleta, Anna Armstrong, Eddie Arning, Steve Ashby, Andrea Badami, S. C. Baker, John W. Banks, Franklin Lafayette ("Fate") Becham, Peter "Charlie" Besharo, Patsy Billups, Calvin and Ruby Black, Prophet William J. Blackmon, William Blayney, Georgia Blizzard, Alexander Bogardy, the Rev. Maceptaw Bogun, Mary Borkowski, Frank Brito, Evan Javan Brown, Sr., Robert Brown, Russell "Smokey" Brown, Brown's Pottery, Delbert Buck, Charlie Burnham, Richard Burnside, Charles Butler, David Butler, Archie Byron, Fred Campbell, Elizabeth W. Capron, Miles B. Carpenter, James Castle, Annie D. Celletti, R. M. Chalmers, Henry Ray Clark, Silas and Bertha Claw, Rex Clawson, Alice Cling, Joe Clingan, "Professor" John H. Coates, Clark Coe, Raymond Coins, Jim Colclough, Helen Cordero, Wilbur A. Corwin, David Courlander, Burlon Craig, "Tattoo Jack" Cripe, Michael and Melvin Crocker, Earl Cunningham, Frances Currey, Matilda Damon, Henry Darger, William Dawson, Mamie Deschillie, John "Uncle Jack" Dey, Charles Dieter, Irving Dominick, Sam Doyle, William Edmondson, Penny Emerson, Minnie Evans, Josephus Farmer, Albina Felski, "Cedar Creek Charlie" Fields, Howard Finster, Walter Flax, Marshall B. Fleming, Peter Oliver Foss, J.O.J. Frost, Harold Garrison, Victor Joseph Gatto, John Gerdes, Russell Gillespie, Lee Godie, Louise Goodman, William O. Golding, Ted Gordon, Helen Greyeyes, Ray Growler, Esther Hamerman, James Hampton, Joseph Hardin, Perkins Harnly, Otesia Harper, Bessie Harvey, John Harvey, Hathale family, William Hawkins, Woody Herbert, Nicholas Herrera, Lonnie Holley, Jesse Howard, Charles W. Howe, Robert How-

ell, Clementine Hunter, Yvonne Jacquette, Lawrence Jacquez, Anderson Johnson, Frank Jones, M.C. "5¢" Jones, S.L. Jones, Josephine Joy, Edward A. Kay, Myra Tso Kaye, Frederick Kahler, Lavern Kelley, Leon Kennedy, O.W. "Pappy" Kitchens, Gustav Klumpp, Benniah C. Layden, Lawrence Lebduska, John Lenthall, James Leonard, Alicia Eugenia Ligon, George Lopez, Jose Dolores Lopez, Herman Luce, Dwight Mackintosh, Noel Mahaffey, Alexander Maldonado, Betty Manygoats, Gregorio Marzan, Alberta Nofchissey Mason, Justin McCarthy, Christine McHorse, John W. McLoughlin, Jr., John McCluhan, Eric Calvin McDonald, Fred McLain, Cheever Meaders, Lanier Meaders, Cora Meek, Ben Miller, Lewis Miller, Peter Minchell, Mingering Mike, Ethel Wright Mohamed, Jose Mondragon, Louis Monza, Sister Gertrude Morgan, Ike Morgan, Mr. Imagination (Gregory Warmack), J.B. Murry, Hisi Quotskuyva Nampeyo, Louis Naranjo, Lowell Nesbitt, Linda Nez, Louise Nez, Mattie Lou O'Kelley, Jose Benito Ortega, Angela Palladino, Donald Paterson, Leslie Payne, John Perates, Fannie Pete, Julia Pete, Oscar Peterson, Elijah Pierce, Dennis Pioche, Horace Pippin, Carl Piwinski, John Podhorsky, Tom Polacca, Steven Polaha, Daniel Pressley, "Old Ironsides" Pry, "Butch" Quinn, William Queor, Martin Ramirez, Enrique Rendon, Max Reyher, Florence Riggs, Samuel Anderson Robb, Robert Roberg, Royal Robertson, Juanita Rogers, Sulton Rogers, Max Romain, Rod Rosebrook, Nellie Mae Rowe, Ellis Ruley, Ida Sahmie, Jean Sahmie, Rachel Sahmie, Anthony Joseph Salvatore, O.L. Samuels, Jack Savitsky, Clarence Schmidt, "Butch" Irvin Schramm, James P. Scott, Jon Serl, Xmeah ShaEla'ReEl, Welmon Sharlhorne, Louis Simon, Herbert Singleton, Mary T. Smith, Miles Smith, Simon Sparrow, Henry Speller, Lorenzo Spencer, Hugo Sperger, Leonard L. St. Clair, St. EOM (Eddie Owens Martin), Q.J. Stephenson, Ervin Stewart, Clarence Stringfield, Jimmy Lee Sudduth, James "Son" Thomas, Mose Tolliver, Edgar Tolson, Bill Traylor, Faye Tso, Horacio Valdez, Lonnie Vigil, John Vivolo, Eugene Von Bruenchenhein, Inez Nathaniel Walker, Derek Webster, P.M. Wentworth, George W. White, Jr., Lizzie Wilkerson, Charlie Willeto, Harold Willeto, Leonard Willeto, George Williams, Lorraine Williams, Rose Williams, Sue Williams, Luster Willis, Augustus Aaron Wilson, Jimmy Wilson, Jane "In Vain" Winkelman, Tom Yazzie, Joseph Yoakum, Edmond Youngbauer, Malcah Zeldis

Smithsonian Institution—Archives of American Art

8th and F Streets, N.W.
Washington, D.C. 20560
Phone: 202-633-7940
Email: kirwinl@si.edu
Web site: www.aaa.si.edu
Liza Kirwin, Deputy Director

The Archives today is the world's pre-eminent and most widely used research center dedicated to collecting, preserving, and providing access to primary sources that document the history of the visual arts in America. Its vast holdings—more than 20 million letters, diaries and scrapbooks of artists, dealers, and collectors; manuscripts of critics and scholars; business and financial records of museums, galleries, schools, and associations; photographs of art world figures and events; sketches and sketchbooks; rare printed material; film, audio and video recordings; art publications; and the largest collection of oral histories anywhere on the subject of art—are a vital resource to anyone interested in American culture over the past 200 years.

The archives holds the papers—letters, writings, business records, photographs and the like—of folk art collectors such as Herbert Waide Hemphill, Jr., J. Stuart Halliday, James and Beth Arient, Jean Lipman, Edward Lamson Henry, Ann Oppenhimer, and Chuck and Jan Rosenak; dealers such as Edith Halpert, Robert Carlin, and Jeff and Jane Camp; curator and art administrator Holger Cahill; and artists Eddie Arning, Howard Finster, Horace Pippin, Grandma Moses, James Hampton, and others.

The Archives also houses papers of trained artists who collected material about American folk art such as John Geldersma, James Auer, Andy Nasisse, Judith McWillie, William Volkerz, Charles Sheeler, Whitney Halstead, and Nathan Lerner.

Among the Archives' collections are hundreds of photographs of artists; a wealth of rare printed material, as well as tape-recorded interviews with Leroy and Felipe Archuleta, Steven Ashby, Minnie Black, Miles B. Carpenter, Ned Cartledge, Chief Rolling Mountain Thunder, Jim Colclough, "Cedar Creek Charlie" Fields, William Dawson, Sam Doyle, Howard Finster, Michael B. Fleming, Joseph Furey, Carlton Garrett, Emil Gehrke, Robert Gilkerson, Lee Godie, Denzil Goodpaster, Ted Gordon, Dilmus Hall, Irene Hall, Jesse Howard, S.L. Jones, Eddie Owens Martin (aka St. EOM), Columbus McGriff, Carl McKenzie, R.A. Miller, Dow Pugh, Herman Rusch, "Popeye" Reed, Jack Savitsky, Fred Smith, Mary T. Smith, Robert E. Smith, Simon Sparrow, Jimmy Lee Sudduth, Mose Tolliver, Edgar Tolson, Horacio Valdez, Willard Watson, Malcah Zeldis, and others.

Liza Kirwin, Southeast Regional Collector of the archives, notes the special problems of collecting primary materials from artists who are either illiterate or do not save their papers. She says, "We seek artists' spoken words and observations, slides, photographs, and videotapes." Among these types of materials, in addition to those noted above, are: John Geldersma's slides of David Butler, his works of art and his home, 1974–1980; James Auer's photographs of Fred Smith; and slides of Howard Finster, by Ann F. Oppenhimer. The Archives also holds the papers of collectors Chuck

and Jan Rosenak consisting of their research files from their three books on twentieth century folk art.

Millions of items are available for study at the archives and at the regional centers in New York City, Detroit, Boston, and San Marino, California. The collection is available to all interested people. Some collections, frequently those of living persons, may have restrictions, and the use of collections of papers not filmed requires advance appointments, so it is recommended that anyone wishing to use the archives call in advance.

Researchers may view microfilmed collections and oral histories through interlibrary loan with an academic or public library. Unfilmed collections are only accessible by appointment at the office where they reside. Reference Services staff at the archives will supply a list of documents available and delineate the access to them.

Existing Environments

Environment is listed by the name of the person who created it; check the Artists chapter for location and contact information.

Donald G. Morgan—Jamaica

—— FLORIDA ——

East Martello Museum

3501 South Roosevelt Boulevard
Key West, Florida 33040
Phone: 305-296-3913
Web site: www.kwahs.org/visit/fort-east-martello
Michael F. Gieda, Executive Director
Cori Convertito, Curator

The museum is a nonprofit facility operated by the Key West Art and Historical Society (KWAHS) located in a Civil War battery built in 1862. Among folk exhibits on display are the Stanley Papio Collection (inventive sculptures incorporating auto parts and metal scraps into shiny creatures) and the largest collection of wood-carvings, paintings and drawings by the internationally known Cuban-American artist Mario Sanchez. Mario Sanchez images are also available on line.

The Mennello Museum of American Folk Art

900 East Princeton Street
Orlando, Florida 32803
Phone: 407-246-4278
Web site: www.menellomuseum.com

Frank Holt, Director
Robert Melanson, Librarian

The Mennello Museum of American Folk Art opened November 22, 1998. It was founded with a gift by Marilyn and Michael Mennello of their collection of American folk art to the city of Orlando. The opening museum collection includes works by Florida painter Earl Cunningham, and works by John Gerdes, Jacob Kass, Paul Marco, Gary Yost, and Virgil Norberg. Archival materials, letters, journals, and photographs are part of the Mennello gift. The museum is located in a renovated building and has two gallery spaces, a sculpture garden, and a museum shop. It is situated in a six-acre park overlooking a little lake and adjacent to the Orlando Museum of Art and the new Orlando Science Center. In addition to the permanent collection, the museum will host traveling exhibitions.

Existing Environments

Environments are listed here alphabetically by the name(s) of the people who created them; check the Artists chapter for location and contact information.

Sal Kapunan—Taoist Environment
Edward Leedskalnin—Coral Castle
Moses House

—— GEORGIA ——

Georgia Museum of Art

University of Georgia, East Campus
90 Carlton Street
Athens, Georgia 30602
Phone: 706-542-4662
Web site: www.georgiamuseum.org/art/collections/
self-taught-artists

Founded by Alfred Heber Holbrook in 1945, the Georgia Museum of Art has long offered its audiences a world-class art experience. As both an academic museum and the state's official art museum, it serves not only the University of Georgia population, but also the owners of its permanent collection—the citizens of Georgia—through award-winning exhibitions, publications and programming.

Works by self-taught artists are a recent emphasis of the Georgia Museum of Art's collecting philosophy. Major gifts by collectors Gordon W. Bailey, Carl Mullis, and Ronald and June Shelp have served as the basis

of several exhibitions with accompanying award-winning publications, including "Amazing Grace: Self-Taught Artists from the Mullis Collection" and "Lord Love You: Works by R.A. Miller from the Mullis Collection." Several large works are on display in the museum's permanent collection galleries.

Self-Taught Artists in the Collection

Minnie Adkins, Andrea Badami, Thornton Dial, Sr., Howard Finster, Denzil Goodpaster, Joe Light, Charlie Lucas, R.A. Miller, Royal Robertson, Sulton Rogers, O.L. Samuels, Mary T. Smith, Jimmy Lee Sudduth, Mose Tolliver, Purvis Young

High Museum

1280 Peachtree Street, N.E.
Atlanta, Georgia 30309
Phone: 404-733-4444 (general)
Web site: http://www.high.org/Art/Permanent-Collection/Folk-Art.aspx

The High is dedicated to supporting and collecting works by Southern artists. In 1994, the museum established a department of folk art, distinguishing itself as the first general museum in North America to have a full-time curator devoted to folk and self-taught art. A $2.5 million gift received in August 2014 from Merrie and Dan Boone endows a permanent, full-time curatorial position to lead the department—The Merrie and Dan Boone Curator of Folk and Self-Taught Art—and will be used to support and expand the museum's folk and self-taught art initiatives.

The original nucleus of the museum's folk art holdings was the T. Marshall Hahn Collection, donated in 1996, plus Judith Alexander's gift of 130 works by Atlanta artist Nellie Mae Rowe. Other artists the High has collected in depth in this field include the Rev. Howard Finster, Bill Traylor, Thornton Dial, Sr., Ulysses Davis, Sam Doyle, William Hawkins, Mattie Lou O'Kelley, and Louis Monza. The collection of almost 800 objects also boasts superb examples by renowned artists from beyond the South, such as Henry Darger, Martín Ramírez, and Joseph Yoakum. The permanent collection of the High Museum of Art also includes European and American prints, paintings, sculpture, decorative arts, and photography.

Self-Taught Artists in the Collection

Leroy Almon, Sr., Linda Anderson, Filipe Archuleta, Eddie Arning, Calvin and Ruby Black, Richard Burnside, David Butler, Ned Cartledge, James Castle, Raymond Coins, Ferdinand Cooper, Karolina Danek, Henry Darger, Ulysses Davis, Thornton Dial, Sr., Sam Doyle, William Edmondson, Minnie Evans, the Rev. Howard Finster, Carlton Garrett, Ted Gordon, Dilmus Hall, Bessie Harvey, William Hawkins, Lonnie Holley, Clementine Hunter, Frank Jones, Charley Kinney, Tim Lewis, Ronald Lockett, Charlie Lucas, Dwight Mackintosh, Lanier Meaders, Louis Monza, Sister Gertrude

Morgan, J.B. Murry, Mattie Lou O'Kelley, John Perates, Elijah Pierce, Martin Ramirez, Royal Robertson, Juanita Rogers, Nellie Mae Rowe, Lorenzo Scott, Herbert Singleton, Mary T. Smith, Henry Speller, Charles Steffen, Jimmy Lee Sudduth, Mose Tolliver, Edgar Tolson, Bill Traylor, Eugene Von Breunchenhein, Inez Nathaniel Walker, Lizzie Wilkerson, Knox Wilkinson, Jr., Charlie Willeto, Joseph Yoakum

Morris Museum of Art

1 Tenth Street
Augusta, Georgia 30901
Phone: 706-724-7501
Email: mormuse@themorris.org
Web site: www.themorris.org/ourcollection/selftaught.html
Kevin Grogan, Director and Curator

The Morris Museum of Art, located on the Riverwalk in downtown Augusta, is home to a broad-based survey collection of Southern art. As a museum dedicated to exhibiting and exploring the art and artists of the South, the Morris preserves and enhances a cultural legacy. The collection includes holdings of nearly 5,000 paintings, works on paper, photographs, and sculptures dating from the late-eighteenth century to the present. It holds a strong collection of work by contemporary Southern self-taught artists. In addition to the permanent collection galleries, the museum hosts eight to ten temporary special exhibitions every year. The museum also houses the *Center for the Study of Southern Art*, a reference and research library that includes archives pertaining to more than 1,000 artists who have worked in the South. It is open to the public with a regular schedule of hours and by appointment.

A series of galleries showcase the extensive collection. The exhibition begins with the antebellum period and continues through galleries devoted to such themes as Civil War art, the Black presence in Southern art, Southern impressionism, early twentieth century painting and contemporary work. The museum also features changing exhibitions. The museum store offers exhibition catalogs, art books and unique gift items. The museum publishes many exhibition catalogs. There are approximately 2,500 works in the permanent collection, with about eighty-eight self-taught works at this time. Special exhibitions featuring self-taught artists have been "The Dot Man: George Andrews of Madison, Ga." (September 7–December 31, 1994); "Nellie Mae Rowe" (March 21–May 19, 1996); and, "Self-Taught Artists in the South: Selections from the Permanent Collection" (Summer 1996–Fall 1996).

Self-Taught Artists in the Collection

George Andrews, Z.B. Armstrong, Ralph W. Brewer, Richard Burnside, Buzz Busby, Willie M. Chambers, Minnie Evans, Howard Finster, William O. Golding, T.A. Hay, Lonnie Holley, Walter Tiree Hudson,

Clementine Hunter, James Harold Jennings, Charley Kinney, Joe Louis Light, Charlie Lucas, Zelle Manning, Willie Massey, Jake McCord, Carl McKenzie, R.A. Miller, Ricky Miller, Sister Gertrude Morgan, B.F. Perkins, Mary Proctor, Margaret Ramsey, Popeye Reed, Margaret Ross, Nellie Mae Rowe, Lorenzo Scott, Mary T. Smith, Sotherland, Jimmy Lee Sudduth, Eugene A Thompson, Mose Tolliver, Bill Traylor, Willie White, Ken Woodall

Columbus Museum

1251 Wynnton Road
Columbus, Georgia 31906
Phone: 706-748-2562
Email: information@columbusmuseum.com
Web site: www.columbusmuseum.com
Tom Butler, Director

The museum houses a collection that features objects from the Deep South, particularly Georgia, Alabama, and northern Florida. The Columbus Museum has engaged in collecting the work of self-taught art since the 1980s. The St. EOM collection, formerly housed by the museum, has been returned to the Marion County Historical Society to be used at the restoration of the Pasaquan site. The museum has an extensive collection of nineteenth and early twentieth century quilts made in the region.

Self-Taught Artists in the Collection

Butch Anthony, Carl Brown, Burlon Craig, Minnie Evans, Thomas Jefferson Flanagan, D.X. Gordy, Herman Hayes, S.L. Jones, Lanier Meaders, Jessie DuBose Rhoads, Tom Stafford, Mose Tolliver, Edgar Tolson, Herman Wadsworth, Fred Webster, Dennis Wills

Hudgens Center for the Arts

6400 Sugarloaf Parkway, Building 300
Duluth, Georgia 30097
Phone: 770-623-6200
Email: info@thehudgens.org
Web site: www.thehudgens.org
Teresa Osborn, Director

The Hudgens is a community art center, offering exhibitions, classes, and events to members of the local community. It has several exhibitions going at any given time, with exhibitions changing quarterly. In the past four years it has mounted two exhibitions devoted in whole or in part to self-taught artists. In fall 2014, it presented and exhibition, "Blurred Lines: Contemporary Self-Taught Meets the Masters," which, on the self-taught side, included Eddie Arning, Richard Burnside, Thornton Dial, Sr., Ab the Flagman, Sybil Gibson, Madge Gill, Lee Godie, Lonnie Holley, Toby Ivey, Charles Kinney, J.B. Murry, Nellie Mae Rowe, Henry Speller, Jimmy Lee Sudduth, and Purvis Young, all on loan for the length of the exhibition. If thinking of vis-

iting, it would be best to call ahead or check the website to see whether any works by self-taught artists are on display.

Museum of Arts and Sciences

4182 Forsyth Road
Macon, Georgia 31210
Phone: 478-477-3232
Email: info@masmacon.com
Web site: www.masmacon.com
Susan Welch, Executive Director

The Museum's permanent collection—acquired over 55+ years—reveals a focus on art by Southern painters, Georgia folk pottery and contemporary traditions, and gifts to the Museum by regional collectors. Folk art objects in the permanent collection are almost exclusively works by traditional Georgia potters: Lanier Meaders, Edwin Meaders, Cleater Meaders, Marie Rogers, Mike Merritt, Bill Merritt, D.X. Gordy, Chester Hewell and his sons Matthew and Nathaniel. They include traditional forms, face jugs and "whimsies." The museum organized an exhibition on folk pottery in 1989 entitled "Georgia Clay: Pottery of the Folk Tradition." An illustrated catalog was published. Other folk art exhibitions have included the work of Nellie Mae Rowe, Maude Wahlman's "Afro-American Quilts," and one guest-curated by Marie Cochran entitled "Visionary Artists."

Folk Pottery Museum of Northeast Georgia

P. O. Box 460
Sautee-Nacoochee Center
Georgia Highway 255 N
Sautee-Nacoochee, Georgia 30571
Phone: 706-878-3300
Email: cbrooks@snca.org
Web site: www.folkpotterymuseum.com
Chris Brooks, Director

The Folk Pottery Museum of Northeast Georgia showcases, the handcraft skills of one of the South's premier grassroots art forms, and explores the historical importance and changing role of folk pottery in southern life. Folk potter Michael Crocker helped to assemble the core collection for the museum, with Dr. John Burrison, the curator. Burrison is also the author of *Brothers in* Clay, the definitive work on Georgia folk pottery. The Museum offers exhibits of folk pottery including face jugs, and educational tours. Demonstrations of pottery making can be arranged for interested groups (request in advance). The museum offers pottery for sale by the area's premier folk pottery families—Craven, Crocker, Ferguson, Hewell, and Meaders.

King-Tisdell Cottage Foundation, Inc.
502 East Harris Street
Savannah, Georgia 31401
Phone: 912-234-8000

The Foundation administers the Beach Institute, the King-Tisdell Cottage, and the Negro Heritage Trail Tour. The Beach Institute, which historically served as the first school built for African-American children in Savannah after the Civil War, is now used as an African-American cultural center. The Institute is located at 502 East Harris Street and houses the Foundation's precious collection of over 230 woodcarvings by the nationally acclaimed self-taught artist Ulysses Davis. National recognition began for Davis in 1978 when several of his sculptures were shown at the Library of Congress. In 1988 the Foundation presented "Wooden Souls," a documentary of the work of Ulysses Davis, with photo documentation by Roland L.

Freeman. On February 23, 1992, a year-long exhibition of the Ulysses Davis Collection, sponsored by the Foundation, opened at the Savannah History Museum. Most recently, Davis' work was part of the 1996 Summer Cultural Olympics exhibited in Savannah and is permanently housed at the Institute. If one is interested in visiting any one of the three sites, please call the Foundation.

Existing Environments
Environments are listed here alphabetically by the name(s) of the people who created them; check the Artists chapter for location and contact information.
E. M. Bailey—Bailey's Sculpture Garden
Howard Finster—Paradise Garden and Howard Finster Vision House Museum
Harold Rittenberry, Jr.—Home and Garden
St. EOM—Pasaquan

ILLINOIS

Tarble Arts Center
Eastern Illinois University
2010 Ninth Street
Charleston, Illinois 61920
Phone: 217-581-2787
Email: tarble@eiu.edu
Web site: www.eiu.edu/~tarble
Michael Watts, Director

The collections at the Tarble Arts Center include the Tarble Arts Center Folk Arts Collection and Archives. Eastern Illinois University started to collect Illinois folk arts in 1976, through the College of Fine Arts. "The impetus for the Folk Arts Collection came from three surveys of contemporary folk artists living in east central and southeastern Illinois, conducted in 1976 and 1985." The Folk Arts Collection, survey data, and archival materials were passed from the College of Fine Arts and the Paul T. Sargent Gallery to the Tarble Arts Center when it opened in 1982. The collection has been added to through gifts and grants, and works by Illinois artists continue to be sought for the collection, especially contemporary works from artists living in east-central and southeastern Illinois. Sub-collections include the *Ferd Metten Collection* (carvings and assemblages), the *Buzzard Textile Collection, Famous Black American Dolls by I. Roberta Bell*, the *First Lady Doll Collection by Leta C. Whitacre*, and the *Burl Ives Cane Collection*. Notable artists represented in the collection include *Jennie Cell (paintings), Cora Meek (embroidered quilts and rugs), Lee Godie (drawing), and Arthur Walker (carvings and assemblages).*

Self-Taught Artists in the Collection
Jennie Cell, Lee Godie, Ferd Metten, Cora Meek, Arthur Walker

The Art Institute of Chicago
Michigan Avenue and Adams Street
Chicago, Illinois 60603
Phone: 312-443-3600
Email: none provided; email contact available within website
Web site: www.artic.edu
Douglas Druick, President and Eloise W. Martin Director

In the Department of Prints and Drawings, the Art Institute houses numerous drawings by Joseph Yoakum, a few drawings by Henry Darger, and two works by Minnie Evans. Its Galleries of American Arts has a carved and painted wood turkey by Leroy Ortega, two miniature Mardi Gras floats made of beads by John Landry, a whirligig by Frank Memkus, a small sculpture by Albert Zahn, a tramp art cathedral clock case from Wisconsin, and several important ceramic pieces of Jugtown pottery from North Carolina. The 20th Century Painting and Sculpture Department has in its collection a Grandma Moses, "Making Apple Butter," 1958, and a Horace Pippin, "Cabin in the Cotton," before 1937. The Art Institute "doesn't often collect twentieth century folk art."

The Roger Brown Study Collection of the School of the Art Institute of Chicago is the result of a gift in

1996 from Roger Brown (the late artist and collector) of his extensive collection of art, books, slides, architectural drawings, sketchbooks, correspondence, video tapes, and other archival materials for use as an artist's study collection. The collection, installed throughout the artist's former home, contains over 1,000 works in a variety of media and from diverse categories, including an exceptional array of works by self-taught artists; American and ethnographic folk art; works by Chicago Imagists and other contemporary artists; objects from American material and popular culture; costumes and textiles; furniture; books, travel souvenirs and ephemera. The outstanding assemblage of objects reflects Brown's personal artistic vision and his insightful responses to the visual, material world around him in a city that has been home to many outstanding self-taught artists and a center for the recognition and study of these artists. The collection is primarily a resource of The School of the Art Institute of Chicago, and is open by appointment only. Send inquiries to Lisa Stone, Curator, The Roger Brown Study Collection, 1926 Halsted Street, Chicago, Illinois 60614.

The Art Institute of Chicago has the unpublished manuscript about Joseph Yoakum by Whitney Halstead. People doing research may use this material on the premises, with prior arrangements. The archivist is Bart Ryckbosch, 312-443-4777.

Intuit: The Center for Intuitive and Outsider Art

756 North Milwaukee Avenue
Chicago, Illinois 60622
Phone: 312-243-9088
Email: intuit@art.org
Web site: www.art.org
Deborah Kerr, Executive Director

Established in 1991, Intuit: The Center for Intuitive and Outsider Art (Intuit) is the only nonprofit organization in the United States that is dedicated solely to presenting self-taught and outsider art. Intuit recently incorporated permanent display space into its Milwaukee Avenue headquarters, where it shows items from the more than 1,100 works of art in its permanent collection, as well as to mount special exhibitions. Recent exhibitions include "Welcome to the World of Mr. Imagination" (January 9 through April 25, 2015), "Past Perfect: the Art of Eileen Doman" (July 11 through September 27, 2014), and "Collective Soul: Outsider Art from Chicago Collections" (September 9 through December 31, 2014. Intuit also offers resources for scholars and students; a *Permanent Collection* with holdings of more than 1,100 works of art; the *Henry Darger Room Collection*; the *Robert A. Roth Study Center*, a non-circulating collection with a primary focus in the fields of outsider and contemporary self-taught

art; and *educational programming* for people of all interest levels and backgrounds.

See also entries for Intuit under Organizations and Other Publications.

Museum of Contemporary Art

220 East Chicago Avenue
Chicago, Illinois 60611
Phone: 312-280-2660
Email: none provided
Web site: www.mcachicago.org
Madeleine Grynsztejn, Pritzker Director
Lynne Warren, Curator

The Museum of Contemporary Art has shown outsider or folk art a number of times in its history, particularly as it relates to the Chicago art movement known as Imagism. The Museum owns several works by Henry Darger, Lee Godie, and Joseph Yoakum. The work of these and other Chicago-based self-taught artists, such as Mr. Imagination, is explored in the catalog for the major Museum of Contemporary Art exhibition "Art in Chicago, 1945–1995."

Rockford Art Museum

Riverfront Museum Park
711 North Main Street
Rockford, Illinois 61103
Phone: 815-968-2787
Email: info@rockfordartmuseum.org
Web site: www.rockfordartmuseum.org/outsider?start =30
Linda Dennis, Executive Director
Carrie Johnson, Curator

The major part of the collection of self-taught art at the Rockford Art Museum came as a result of the donation by James Hager of 109 works from his collection of African-American self-taught artists. Since then, additional works have been added to the collection.

Self-Taught Artists in the Collection

Leroy Almon, Sr., Stephen Anderson, Hugh Argraves, Z.B. Armstrong, E.M. Bailey, Hawkins Bolden, Richard Burnside, Archie Byron, L.W. Crawford, Arthur Dial, Mattie Dial, Richard Dial, Thornton Dial, Sr., Thornton Dial, Jr., Sam Doyle, Howard Finster, Ralph Griffin, Dilmus Hall, Alyne Harris, Bessie Harvey, Matt Herbig, Theodore Hill, Stephen Hodder, Lonnie Holley, Jim Julin, Joe Light, Rosie Lee Light, Ronald Lockett, Charlie Lucas, A.J. Mohammed, J.B. Murry, B.F. Perkins, Royal Robertson, Lorenzo Scott, Mary T. Smith, Georgia Speller, Henry Speller, Jimmy Lee Sudduth, James "Son" Thomas, Mose Tolliver, Felix Virgous, Charles Williams, Luster Willis, Purvis Young

Existing Environments

Environment is listed by the name of the person who created it; check the Artists chapter for location and contact information.

Charles Smith—African American Heritage Museum and Black Veterans Archive (#1)

IOWA

Existing Environments

Environment is listed alphabetically by the name of the person who created it; check the Artists chapter for location and contact information.

Paul Dobberstein—Grotto of the Redemption

KANSAS

Grassroots Art Center

P.O. Box 304
213 South Main Street
Lucas, Kansas 67648
Phone: 785-525-6118
Email: grassroots@wctiweb.com
Web site: www.grassrootsart.net
Rosslyn Schultz, Director

This is a center with a focus on the visionary art of the Midwest. The collection consists entirely of work by self-taught, grassroots, or outsider artists including limestone sculpture by Inez Marshall (1907–1984); cement sculpture embellished with broken glass by Ed Root (1866–1960); wood sculpture by Glenn Stark (b. 1918); mosaic wall painting by Leroy Wilson (1912–1991). Two more local grassroots artists, S.P. Dinsmoor (1843–1932) and Florence Deeble (b. 1900) are represented by photographs of their work which is located elsewhere in Lucas. The museum consists of two buildings, one devoted mostly to the work of Marshall and the other to the work of Root. At present the museum has between fifteen to twenty pieces of Ed Root's work and with the completion of the building project, sixty more will be added. A third building is under construction and will have a variety of functions and installations, including the amazing metal creations of Myron T. Liggett of Mullinville, Kansas.

Existing Environments

Environments are listed here alphabetically by the name(s) of the people who created them; check the Artists chapter for location and contact information.

Florence Deeble—Rock Garden and Miniatures
S.P. Dinsmoor—Garden of Eden
Myron "M.T." Liggett—Yard environment
Inez Marshall—Continental Sculpture Garden
Ed Root—Environment

KENTUCKY

Kentucky Museum/Western Kentucky University

1414 Kentucky Street
Bowling Green, Kentucky 42101
Phone: 270-745-2592
Email: kymus@wku.edu
Web site: www.wku.edu/kentuckymuseum
Brian Bjorkman, Director
Sandy Staebell, Registrar/Collections

The Kentucky Museum has a collection titled "Handmade Harvest: Traditional Crafts of Tobacco Farmers." It was assembled in 1987 by the museum staff for an exhibition with the same name. There are a few works that qualify as art, including puppets and paintings by Helen La France, carved figures and canes by Homer Bowlin, carved figures and a snake cane by Ed and Pansy Cress, a figure and tobacco truck by Noah Kinney, stone figures by William McClure, carvings by Charlie Lewis, and a painted gourd by Sally Commack. There is also a fox figure by Hal McClure. The general museum collection also includes several carvings, a diorama and a painting by Unto Jarvi. Contact the museum Registrar/Collections Curator at 270-745-6260 or sandy.staebell@wku.edu to arrange access to objects not on exhibit ("prior appointment strongly suggested").

Kentucky Museum of Art and Craft

715 West Main Street
Louisville, Kentucky 40202
Phone: 502-589-0102
Email: none given
Web site: www.kmacmuseum.org
Aldy Millikin, Executive Director and Chief Curator
Joey Yates, Associate Curator

Founded in 1981, the Kentucky Museum of Art and Craft (formerly Art and Craft Foundation) was started as a way to build interest in the state's rich craft heritage, which lead to a collection of American Folk Art from the region. Its mission is to support and promote excellence in art, craft, applied arts and design. The Museum features contemporary art that explores craft emphasizing the techniques, materials and process of creative expression. Our goal is to educate and inspire while promoting a better understanding of art and craft through exhibitions, collaborations, outreach and the permanent collection. Alliances are forged within Kentucky, regionally, nationally, and internationally in order to participate in a broader conversation about art and its role in society. The Museum regularly mounts exhibitions of the work of self-taught artists. One recent exhibition featured Elijah Pierce; a second one displayed the work of two artists from Creative Growth, a California art center for people with disabilities—Dan Miller and Judith Scott. It also mounts exhibitions around a particular theme that include work by contemporary trained and self-taught artists. One example was "Storytelling as Craft," which included Denzil Goodpaster, Edgar Tolson as well as contemporary trained artists.

Self-Taught Artists in the Collection

Minnie and Garland Adkins, Wayne Ferguson, Marvin Finn, Tim Hall, Mack Hodge, Russel Hulsey, Noah Kinney, Sherman Lambdin, Tim Lewis, Lloyd "Hog" Mattingley, Carl McKenzie, R.A. Miller, Lonnie and Twyla Money, J. Olaf Nelson, Earnest Patton, Debbie Evans Perry, Tom Sternal, Wayne Thornberry

Kentucky Folk Art Center

102 West First Street
Morehead, Kentucky 40351
Phone: 606-783-2204
Email: tathompson@moreheadstate.edu
Web site: www.kyfolkart.org
Matt Collinsworth, Director
Taral Ashton Thompson, Curator
Tammy Stone, Administrative Coordinator

The Folk Art Center at Morehead State University is permanently housed in a renovated warehouse. It includes exhibition space, an auditorium, and a museum shop that may be accessed by the web. The upper level has a gallery for changing exhibitions and/conservation space for the collection. The library/archive has a collection of books and periodicals about folk art that are available during regular hours. A major exhibition in 1998 was "African-American Folk Art in Kentucky." In 2004 an exhibition was "Country Girls, Self-Taught Women Artists," and included artists Minnie Adkins, Joan Dance, Grace Kelly Laster, Janice Harding Owens, Marjorie Sauer, Cher Shaffer, and Genevieve Wilson. KFAC sponsors several annual events including A Day in the Country Folk Art Show and Sale the first Saturday in June (see "Fairs and Festivals" for details). It is possible to become a Friend of the Kentucky Folk Art Center; check the website or contact the Center for information. The Center publishes a quarterly e-newsletter (see Other Publications). As of 2015, because it is running out of room and wants to concentrate on Kentucky artists, the Center is beginning to sell works by other artists. Thus in coming years it may not still have works by non-Kentuckians listed below.

Self-Taught Artists in the Collection

Garland Adkins, Minnie Adkins, Mabel Alfrey, Elisha Baker, Lillian Barker, Linvel Barker, Minnie Black, James Allen Bloomfield, Willis Bond, Marie Braden, Dale Brown, Donnie Brown, Barbara Burton, Omer Campbell, Bob Cassady, Benny Catron, Brent Collingsworth, Calvin Cooper, Courtney Cooper, Harry Cooper, Ronald and Jessie Cooper, Ruthie Cooper, Tim Cooper, Martin Cox, Paul Cox, Robert Cox, Joan Dance, William Dawson, Johnnie Eldridge, John Fairchild, Michael Farmer, Marvin Finn, Howard Finster, George Floyd, Marvin Francis, Sybil Gibson, John Gilley, Larry Gilley, Denzil Goodpaster, Ralph Griffin, Carolyn Hall, Dilmus Hall, Larry Hamm, Gary Hargis, T.A. Hay, Mack Hodge, Debbie Horton, Lucy Horton, Andrew Hostick, Irene Huff, Sam Ingram, Unto Jarvi, Harry Jennings, Arlie Johnson, Norma Keaton, Noah Keaton, Charley Kinney, Hazel Kinney, Noah Kinney, Jo Neace Krause, Helen LaFrance, Roddie Leath, Connie Lewis, Erma Lewis, Jimmy Lewis, Junior Lewis, Leroy Lewis, Richard Lewis, Tim Lewis, Richard Livesay, David Lucas, John Mason, Willie Massey, Lenville Maxwell, Hagan McGee, Zephra May-Miller, Thomas May, Carl McKenzie, Janice Miller, Milford Miller, R.A. Miller, William Miller and Rick Bryant, Kendal Mitchell, Mark Mollet, Lonnie and Twyla Money, Earl Moore, Sr., Jerome Moore, Robert Morgan, Robbie Mueller, Mark Anthony Mulligan, Janice Harding Owens, Nolan Parsons, Jody Partin, Earnest Patton, Eugene Peck, Jack Pennington, B.F. Perkins, Gilbert Perrin, Deborah Evans Perry, Nan Phelps, Jim Gary Phillips, Thaddeus Pinkney, Monica Pipia, Darwood Potts, Bobby Quinlan, Willie Rascoe, Tim Ratliff, Red Reffit, Delmer Reynolds, Russell Rice, J.C. Rose, Joy Rose, Jack Savitsky, Guy and Dollie Skaggs, Joe Simpson, Elijah Smith, Mary T. Smith, Charles Spellman, Hugo Sperger, Leslie Stapleton, Q.J. Stephenson, Jimmy Lee Sudduth, Sarah Mary Taylor,

Mazie Thomas, Mose Tolliver, Donny Tolson, Edgar Tolson, Benny Wells, Charles Williams, LaVon Van Williams, Linda Williams, Russell Williams, Larry, Willet, Luster Willis, Genevieve Wilson, William Wombles, Don Young, Purvis Young, Tom Young.

Owensboro Museum of Fine Art

901 Frederica Street
Owensboro, Kentucky 42301
Phone: 502-685-3181
Email: info@omfa.us
Web site: www.omfa.us
Mary Bryan Hood, Director

The principal direction of the permanent collection of the Owensboro Museum of Fine Art is American and European fine and decorative arts from the 16th century to the present. A special feature of the collection, the result of the museum's mission to document the cultural history of Kentucky and the region, is a definitive collection of works by self-taught artists. The collection's mission has been expanded to include the Appalachian region. This collection has been enriched by major gifts of more than 700 works from important private collections, including the O'Appalachia Collection of Ramona Lampell and the comprehensive collection of folk and outsider art from the late Dr. William G. Ward. The museum annually organizes major exhibitions by artists working in the naive genre and publishes catalogs and papers on their works. These have included "Kentucky Spirit," "Unschooled Talent," "The Naive Approach," "Folk Art in Kentucky Collections," "Art from the Heart," and a 2008 documentary on major American collections, "Crossroads: Spirituality in American Folk Traditions." The museum has a library of documentaries and photographs of the artists represented in its folk art collection and its gift shop specializes in works by these artists. More than 1500 two-dimensional and three-dimensional pieces now comprise the museum's holdings of works in this genre.

Self-Taught Artists in the Collection

Garland Linville Adkins, Minnie Evon Adkins, Linda Vandiver Bailey, Lillian Faye Fannin Barker, Edgar Bell, Glen Bell, Donny Bivins, Jean Black, Minnie Lincks Black, Roger Blair, Joseph G. Boarman, L. O. Bolick, Rex Booth, Robin Brewer, Pat Brothers, Carl Brown, Jean M. Buchanan, Connie Carlton, Don Cash, Marie Romero Cash, Mary Anderson Cayce, Elmer K Cecil, Lestel Childress, Maurice Clayton, Raymond Coins, Sally Commack, Calvin Cooper, Jessie Farris Cooper, L. D. Cooper, Ronald Everett Cooper, Liz Davis, Evan Decker, Audie Denison, Sam Drake, Everett Druien, Johnnie Eldridge, Balarmino Esquibel, Debbie Evans, Michael W. Farmer, Don Ferrell, Marvin Finn, Howard Finster, Cyril Gillet, John Gilley, the Rev. Fred Glover, Clefford Goad, Denzil Goodpaster, Dee Gregory, Dennis Gregory, Monica Sosaya Halford, Carolyn Hall, Dilmus Hall, Gary Lawton Hargis, Thomas Andrew Hay, the Rev. Herman Hayes, Jennifer Heller, Renee Hicklin, Unto Jarvi, James Harold Jennings, Anita Romero Jones, Mary Olive Jones, S.L. Jones, Charles Keaton, Charley Kinney, Hazel Bateman Kinney, Noah Kinney, Corbain Kirby, Terri Kuegel, Don Lacy, Edd Lambdin, Shirley Lambdin, Bonnie Brannin Lander, Bev Lewis, Connie Lewis, Jimmy Lewis, Junior Lewis, Leroy Lewis, Luke Lewis, Tim Lewis, Maryann Lomayear, Krissa Maria Lopez, Peter Lopez, Rosemarie Lopez, William E. Low, Charlie Lucas, David Nabor Lucero, Frankie Nazario Lucero, Lloyd "Hog" Mattingly, Tom May, Carl McKenzie, Thomas O. Miller, William Miller, Ruth Mitchell, Sedalia Montgomery, Charles Morgan, Jacqueline Nelson, John Olaf Nelson, R. Newell, Helen LaFrance Orr, Cami Ortiz, Sabanita Lopez Ortiz, Earnest Patton, Benjamin F. Perkins, Bernadette Pino, Bonnie Prus, Tim Ratliff, Russell Rice, S.A. Richards, Doug Ridley, Paula Rodriguez, Max Romain, Margaret Lavinia Hudson Ross, Margery L. Settle, Cher Shaffer, Gabriel Shaffer, Erwin Lex Shipley, Robert M. Short, Oda Shouse, Jr., Herbert Singleton, Tim Sizemore, Donna R. Smith, Theresa Mattingly Smith, Oscar Spencer, Hugo Sperger, Jimmy Lee Sudduth, Luis Eligio Tapia, Mose Tolliver, Edgar Tolson, George V. Triplett III, Otis Earl Walker, Melvin Wathen, Annie G. Wellborn, Genevieve Wilson, Nina Wireman

LOUISIANA

Alexandria Museum of Art

P.O. Box 1028
933 Second Street
Alexandria, Louisiana 71309
Phone: 318-443-3458
Email: info@themuseum.org
Web site: www.themuseum.org
Catherine M. Pears, Executive Director
Megan Valentine, Curator and Registrar

The museum has the North Louisiana Folk Art Collection that was featured at the 1984 World's Fair in New Orleans. Most of the arts and crafts included represent traditional works. The museum has a gallery devoted to exhibitions of works by regional artists and local collections in central Louisiana. The Bolton Study Room and Library holds a collection of over 2,000 art related books and periodicals. It is open to the public by appointment. There is also a museum

store and a cafe. Self-taught artists represented in the permanent collection are David Allen and Clementine Hunter.

Louisiana State Penitentiary Museum

LSP
General Delivery
Angola, Louisiana 70712
Phone: 225-655-2592
Web site: bottom of page at http://angolamuseum.
 org/?q=RodeoHistory
Marsha Lindsey, Museum Director

The Louisiana State Penitentiary has an extensive arts program for inmates; the Museum displays some art pieces made by inmates, including Henry Bridgewater, along with information about the history of the prison at Angola and the surrounding area. It is operated by the Louisiana State Penitentiary Museum Foundation, a non-profit organization. The Museum is open to the public Monday through Friday, 8:00 a.m. to 4:30 p.m., and on Saturday from 8:00 a.m. to 4:00 p.m. There is no admission fee to visit the museum; donations are accepted.

Also see entry in Fairs and Festivals for inmate arts and crafts for sale during the Angola Prison Rodeo.

Louisiana Art and Science Museum

100 South River Road
Baton Rouge, Louisiana 70802
Phone: 225-344-5272
Email: LASM@lasm.org
Web site: www.lasm.org
Carol S. Gikas, President and Executive Director
Elizabeth Weinstein, Museum Curator
Lexi Guillory, Collections Manager

The museum has in its permanent collection approximately seventy paintings by artist Clementine Hunter. In the summer of 1991, the museum hosted an exhibition, "Outsider Art," which included Louisiana artists Heleodoro Cantu, Jessie Coates, and Marion Conner.

Rural Life Museum

Louisiana State University
P.O. Box 80498
4560 Essen Lane
Baton Rouge, Louisiana 70809
Phone: 225-765-2437
Email: dfloyd@lsu.edu
Web site: http://sites01.lsu.edu/wp/rurallife
David Floyd, Director

The Rural Life Museum of Louisiana's collection of artifacts and antiques has developed around the plantation home of Steele Burden and his family, which

was given to LSU. Many of the objects were gathered from around the Louisiana countryside by Burden; the beautiful landscaping is also the result of his long years of work. Burden, who died in 1995, worked on his ceramic sculpture in a corner of the museum—the corner has been preserved just as he left it. This self-taught artist's works are found in the homes of many collectors. There is a permanent display of his work at the museum, along with his own collection of folk art which includes Clementine Hunter, Knute Heldner, Don Wright, Allen Crochet, the Vargus wax dolls of African-American figures, and many more. The museum now has regular hours of opening, daily from 8:30 to 5:00.

Paul and Lulu Hilliard University Art Museum

University of Southwestern Louisiana
PO Drawer 42571
Girard Park Drivee
Lafayette, Louisiana 70504
Phone: 337-482-0811
Email: none given, email available within website
Web site: www.museum.louisiana.edu
LouAnne Greenwald, Director

The museum's permanent collection is located at 101 Girard Park Drive. Founded July 1, 1983, the museum has among its objects the Louisiana Art Collection of nineteenth and twentieth century artists, "both academic and outsider." The outsider artists include Clementine Hunter (three works), David Butler (one work), Milton Fletcher (one work), and Royal Robertson (four works). The exhibition "Baking in the Sun" circulated from USL to other museums. The catalog prepared for the exhibition won a prize in 1988 for excellence in art publishing. In 2015 the museum hosted the exhibition "Clementine Hunter: A Sketchbook," first mounted by the Ogden Museum of Southern Art.

House of Blues

225 Decatur Street
New Orleans, LA 70116
Phone: 504-310-4999
Web site: www.houseofblues.com/NewOrleans

The House of Blues is a music venue and restaurant with branches in 12 cities as of 2014, including New Orleans, Boston, Chicago, Cleveland, Anaheim, Los Angeles, San Diego, Dallas, Houston, Las Vegas, Orlando, and Myrtle Beach. They are listed here as a museum because they all display art by self-taught and outsider artists on their restaurant walls, some more and some less. The New Orleans location probably has the most—eating in the restaurant is a visual treat.

Self-Taught Artists on Display at the New Orleans House of Blues

Leroy Almon, Prophet William Blackmon, Jon Bok, Richard Burnside, Paul Darmafall ("Baltimore Glassman"), the Rev. Howard Finster, Sybil Gibson, Homer Green, Lonnie Holley, L. V. Hull, James Harold Jennings, Willie Jinks, M. C. "5¢" Jones, Albert King, Roland Knox, Gregory Kowaclewski, Jake McCord, Ruth Mae McCrane, Sam McMillan, R. A. Miller, Reggie Mitchell, Eddie Mumma, J. L. Nipper, B. F. Perkins, Missionary Mary Proctor, William Rice, Royal Robertson, Lorenzo Scott, "Dr. Bob" Shaffer, Earl Simmons, Herbert Singleton, Mary T. Smith, James "Buddy" Snipes, Leslie Staub, Jimmy Lee Sudduth, "Big Al" Taplet, James "Son Ford" Thomas, Annie Tolliver, Mose Tolliver, Hubert Walters, Willie White, "Artist Chuckie" Williams

New Orleans Museum of Art

P.O. Box 19123, NOLA 70179
One Collins Diboll Circle, City Park
New Orleans, Louisiana 70124
Phone: 504-658-4100
Email: yelen@noma.org
Web site: www.noma.org
Susan M. Taylor, Director
 Alice Yelen, Senior Curator of Collections Research

The museum collection contains arts of the Americas, pre–Columbian to the present; photography; African and Asian art; thirteenth through nineteenth century European painting; and decorative arts. A folk art collection is being developed.

The museum has sponsored a number of exhibitions including one of David Butler works and others which have featured Clementine Hunter, Sister Gertrude Morgan, William Edmundson, Eddie Kendrick, Charles Hutson, Bruce Brice, and O.W. "Pappy" Kitchens. A major exhibition, "Passionate Visions of the American South: Self-Taught Artists from 1940 to the Present," was presented in 1993 at the Museum and then traveled nationally. In 1998 there was an exhibition of sculpture by William Edmondson. Recent exhibitions include "Hard Truths: The Art of Thornton Dial," in 2012.

Self-Taught Artists in the Collection

Z.B Armstrong, Eddie Arning, Robyn Beverland, Ivy Billiot, Sainte-James Boudrôt, Bruce Brice, David Butler, Miles B. Carpenter, Raymond Coins, Earl Cunningham, Paul "The Baltimore Glassman" Darmafall, William Dawson, "Uncle Jack" Dey, Thornton Dial, Sr., William Edmondson, Vivian Ellis, Antonio Esteves, Roy Ferdinand, Jr., Howard Finster, Mike Frolich, Victor Joseph Gatto, Reginald Gee, Sybil Gibson, Martin Green, Ralph Griffin, Alyne Harris, William Hawkins, Lonnie Holley, Clementine Hunter, Charles W. Hutson, James Harold Jennings, Willie Jinks, Clyde Jones,

Frank Jones, Eddie Kendrick, Charley Kinney, Gustav Klumpp, O.W. "Pappy" Kitchens, May Kugler, Ronnie Landfield, Nilo Lanza, Edwin Larson, Joe Light, Charlie Lucas, Willie Massey, Justin McCarthy, R.A. Miller, Ike Morgan, Sister Gertrude Morgan, Nan Phelps, "Butch" Quinn, Mattie Lou O'Kelley, B.F. Perkins, Elijah Pierce, "Old Ironsides" Pry, "Popeye" Reed, Royal Robertson, Sulton Rogers, Nellie Mae Rowe, St. EOM, J.P. Scott, Jon Serl, Bernice Sims, Herbert Singleton, Mary T. Smith, Marion Souchon, Jimmy Lee Sudduth, the Rev. Johnny Swearingen, Willie Tarver, Charles Tolliver, Mose Tolliver, Gregory Van Maanen, Hubert Walters, Willie White, "Chief" Willey, Wesley Willis, Purvis Young

Ogden Museum of Southern Art

925 Camp Street
New Orleans, Louisiana 70130
Phone: 504-539-9600 (general)
Phone: 504-539-9621 (curatorial)
Web site: www.ogdenmuseum.org
Bradley Sumrall, Chief Curator

The mission of the Ogden Museum of Southern Art is to broaden the knowledge, understanding, interpretation, and appreciation of the visual arts and culture of the American South through its events, permanent collections, changing exhibitions, educational programs, publications, and research. The Ogden began with a gift from Roger Ogden, which forms the heart of today's collection. Since that beginning, the Collection has grown through the generosity of donors from across the United States, most recently the Richard Gasperi Collection. Recent exhibitions include "Herbert Singleton" (Fall 2014), "When You're Lost, Everything's a Sign: Self-Taught Art from the House of Blues Collection" (opened on April 25, 2013), "The Richard Gasperi Collection: Self-Taught, Outsider, and Visionary Art" (October 4, 2014, through February 22, 2015), featuring works by Charles Hutson, Elayne Goodman, Thornton Dial, the Rev. Howard Finster, Clementine Hunter, Nellie Mae Rowe, Welmon Sharlhorne, George Andrews, and others. A book, *Clementine Hunter: A Sketchbook*, accompanied this exhibition, displaying early sketches by Hunter that had not previously been available.

Self-Taught Twentieth Century Artists in the Collection

George Anderson, David Butler, Patrick Davis, Thornton Dial, Sr., Minnie Evans, Roy Ferdinand, Howard Finster, Michael Frolich, Theora Hamblett, Bessie Harvey, Lonnie Holley, Clementine Hunter, Charles Hutson, Zelle Manning, Sister Gertrude Morgan, J.P. Scott, Sulton Rogers, Royal Robertson, Herbert Singleton, Leslie Staub, Jimmy Lee Sudduth, "Son" Ford Thomas, Mose Tolliver, Willie White, Purvis Young, and others.

Meadows Museum of Art

Centenary College
2911 Centenary Boulevard
Shreveport, Louisiana 71104
Phone: 318-869-5169
Email: lnicolet@centenary.edu
Web site: http://www.centenary.edu/meadows
Dr. Lisa Nicoletti, Head of Collections and Research

The Meadows Museum of Art opened its doors in 1967 and originally housed 350 paintings, watercolors and drawings by the French Academic artist Jean Despujols. Since that time, the Museum has added significantly to its permanent collection, which now includes 1,500 works reflecting a variety of world cultures and traditions. It has significant holdings of tribal artifacts and Inuit sculptures and prints.

Self-Taught Artists in the Collection

David Butler, Howard Finster, Clementine Hunter, J.B. Murry, Juanita Rogers, Mose Tolliver, Mary T. Smith, James "Son" Thomas. Also, Magale Library Gallery at Centenary has Milton Fletcher in its collection.

Existing Environments

Environments are listed here alphabetically by the name(s) of the people who created them; check the Artists chapter for location and contact information.
Charles Gillam—Algiers Folk Art Zone
Kenny Hill—Chauvin Sculpture Garden
Charles Smith—African American Heritage Museums and Black Veterans Archives (II and III)

—————— MARYLAND ——————

American Visionary Art Museum

Baltimore Inner Harbor
800 Key Highway
Baltimore, Maryland 21230
Phone: 410-244-1900
Web site: www.avam.org
Rebecca Hoffberger, Director
George Geary, Director of Exhibitions

The American Visionary Art Museum (AVAM) is dedicated to the study, collection, preservation, and exhibition of visionary art and to increasing the public's awareness and understanding of this artistic expression. Visionary art as defined for the purposes of AVAM refers to art produced by self-taught individuals, whose works arise from an intensity of personal vision.

AVAM mounts major exhibitions each year (usually) running from October through August of the next year, each organized around a theme and involving works gathered from around the county (i.e., mostly not in AVAM's permanent collection). The initial exhibition in 1995, "The Tree of Life," included 400 works created from wood and tree byproducts. It was followed by "Wind in My Hair," the second exhibition, in 1996, which honored the human desire to break free of earthly ties. Other exhibitions have included The End Is Near: Visions of Apocalypse, Millennium, and Utopia," "Love: Error and Eros," "We Are Not Alone. Angels and Other Aliens," "All Faiths Beautiful," "Art, Science, and Philosophy," "All Things Round: Galaxies, Eyeballs, and Karma," "The Art of Storytelling," and "The Visionary Experience: Saint Francis to Finster," Smaller exhibitions are also mounted, including ones focused on a single artist (e.g., one called "Out of this World" featured many works by Eugene Von Breunchenhein on the 100th anniversary of his birth). The latest, at the time of this writing is "The Visionary Experience: Saint Francis to Finster " from October 4, 1014–August 30, 2015, curated by film maker and book writer Jodi Wille and AVAM founder and director Rebecca Alban Hoffberger.

The museum includes six galleries for exhibitions, including on on its first floor where works from the permanent collection are displayed on a rotating basis. Also at AVAM are tall sculpture barn, a museum shop, a giant whirligig made by Vollis Simpson, a central sculpture garden, and a wildflower sculpture garden. Permanent collections include the entire archive of Dr. Otto Billig, consisting of his large private library, research papers, and over 1,200 pieces of art; the Adamson Travelling Collection of Great Britain; the Light-Saraf Film Archive; BBC Films on Outsider Artists archive; and other materials. AVAM is working on making its entire permanent collection available on its website, including images of the work and artist biographies. Check website for progress. The museum building includes restaurant space, which has gone through several changes since the museum opened. Currently slated to open in 2015 is Encantada, the latest restaurant venture.

Some of the Self-Taught Artists in the Permanent Collection

Joseph Abrams, Antonio Alberti, Eddie Arning, Ho Baron, Robert Benson, Deborah Berger, Calvin and Ruby Black, Hawkins Bolden, Frank Bruno, Fred Carter, Allen Christian, Loring Cornish, J.J. Cromer, Abraham Lincoln Criss, Paul "The Baltimore Glassman" Darmafall, Patrick Davis, Charles Dellschau, Thornton Dial, Sr., Brian Dowdall, Axel Erlandson,

the Rev. Howard Finster, Ted Gordon, Gerald Hawkes, Eric Holmes, James Harold Jennings, Clyde Jones, Frank Jones, Nancy Josephson, Leonard Knight, Nor- bert Kox, Malcolm McKesson, and Martin Ramirez, J.P. Scott, Judith Scott, Vollis Simpson, James "Son" Thomas, Gregory Warmack ("Mr. Imagination")

MASSACHUSETTS

Existing Environments

Environment is listed by the name of the person who created it; check the Artists chapter for location and contact information.

Elis Stenman—The Paper House

MICHIGAN

Existing Environments

Environment is listed by the name of the person who created it; check the Artists chapter for location and contact information.

Mae Mast—Environment

MINNESOTA

Existing Environments

Environment is listed by the name of the person who created it; check the Artists chapter for location and contact information.

Jack Ellsworth—Ellsworth Rock Garden

MISSISSIPPI

The Ethel Wright Mohamed Stitchery Museum

"Mama's Dream World"
307 Central Avenue
Belzoni, Mississippi 39038
Phone: 601-247-3633
Carol Mohamed Ivy, Curator
Email: hwilson493@aol.com
Web site: www.mamasdreamworld.com

Ethel Wright Mohamed is often called Mississippi's Grandma Moses of stitchery. She used beautiful and intricate stitches to tell the stories of her family's life on fabric. "Through this unique and beautiful "painting with thread" she has given us a view into the history of the Mississippi Delta's way of life. She called her work 'memory pictures.'" The museum is in her former home. Her work is represented in the Smithsonian Institution.

Delta Blues Museum

P.O. Box 280
114 Delta Avenue
Clarksdale, Mississippi 38614
Phone: 601-627-6820
Email: dbmuseum@clarksdale.com
Web site: www.deltabluesmuseum.org
Shelley Ritter, Director

The Delta Blues Museum is a division of the Carnegie Public Library in Clarksdale, and was founded by librarian Sid F. Graves. The museum is dedicated to blues artists, with hundreds of related photographs, recordings, and memorabilia. The collection contains works by B.B. King and a life-size figure of Muddy Waters (wearing clothes donated by Waters' widow Marva Morganfield). The collection includes six James "Son" Thomas pieces—five animals and one skull. The Delta Blues Museum Gift Shop sells postcards featuring pho-

tographs of grassroots environmentalists by Tom Rankin.

Museum of the Mississippi Delta (formerly Cottonlandia Museum)

1608 Hwy. 82 West
Greenwood, Mississippi 38930
Phone: 601-453-0925
Robin Seage, Executive Director
Web site: www.museumofthemississippidelta.org

This is a small regional history museum with an active arts department. The art collection encompasses painting, sculpture, photography, watercolor, ceramics, mixed media, pencil, and pen and ink, displayed in one gallery and along the museum's hallways. It has a strong collection of Mississippi artists, in part because of a juried fine arts competition and also because of the support shown to local and Delta artists. There are original woodcuts by Lalla Walker Lewis, as well as paintings by Saul Haymond, Theora Hamblett and a newer artist from Clarksdale, W. Earl Robinson.

Mississippi Museum of Art

380 S. Lamar Street
Jackson, Mississippi 39201
Phone: 601-960-1515
Email: rward@msmuseumart.org
Web site: www.msmuseumart.org
Betsy Bradley, Director
Roger Ward, Deputy Director and Chief Curator

The museum has a collection of nineteenth and twentieth century American, Southern and Mississippi art, including more than 170 outsider art objects made by artists in the southeastern United States. These include works by artists Annie Dennis, Howard Finster, Earl Simmons, Jimmie Lee Sudduth, Sarah Mary Taylor and Mose Tolliver, which are important parts of the collection. It also has English paintings from mid–eighteenth century to early–nineteenth century; Japanese, Chinese, Oceanic, Native American, Pre-Columbian; and contemporary art.

Self-Taught Artists in the Collection

Leroy Archuleta, Nathaniel Barrow, Willie Barton, Cyril Billiot, Ivy Billiot, Loy "Rhinestone Cowboy" Bowlin, Eula Crabtree, Annie Dennis, Burgess Dulaney, Roy Ferdinand, Jr., Russell Gillespie, Theora Hamblett, Otesia Harper, James C. Howard, John L. Hunter, James Harold Jennings, M.C. "5¢" Jones, O.W. "Pappy" Kitchens, Nilo Lanza, Tim Lewis, A.J. Mohammed, Ethel Wright Mohammed, Deacon Eddie Moore, B.F. Perkins, Helen Pickle, Royal Robertson, Ron Rodriguez, Juanita Rogers, Sulton Rogers, Welmon Sharlhorne, Joseph Sharlow, Earl Simmons, Herbert Singleton, Henry Speller, Jimmy Lee Sudduth, Sarah Mary Taylor, James "Son" Thomas, Fred Webster, George Williams, Luster Willis

The Old Capitol Museum of Mississippi History

P.O. Box 571, Jackson 39205
100 S. State Street
Jackson, Mississippi 39201
Phone: 601-576-6920
Email: none given
Web site: www.mdah.state.ms.us/oldcap
Lauren Miller, Director

The Old Capitol Museum, accredited since 1972 by the American Association of Museums, is a division of the Mississippi Department of Archives and History. The collection began in 1902, and now numbers approximately 10,000 cataloged items. There is a significant collection of swamp cane baskets woven by Mississippi Choctaw.

Artists in the Collection

Willie Barton, Loy "Rhinestone Cowboy" Bowlin, Eula Crabtree, Burgess Dulaney, James Howard, O.W. "Pappy" Kitchens, Paul Lebetard, Ethel Wright Mohamed, Alice Mosely, A.J. Mohammed, Matthew Renna, Sulton Rogers, Earl Simmons, Mary T. Smith, Henry Speller, James "Son" Thomas, Decell Williams, George Williams, Luster Willis

Lauren Rogers Museum of Art

P.O. Box 1108
565 North Fifth Avenue (at Seventh Street)
Laurel, Mississippi 39441
Phone: 601-649-6374
Web site: www.lrma.org
George Bassi, Director

The Lauren Rogers Museum has one Theora Hamblett painting. It has a religious theme, was painted in 1969 in oil on canvas, is called "Transfiguration," and was a gift of the Betty Parsons Foundation. Another painting in the collection is one by Anna Mary Robertson "Grandma" Moses entitled "The Daughter's Homecoming." A third painting, a gift of the artist, is Oliver Winslow's "Lauren Rogers Museum."

University of Mississippi

University Museums
University, Mississippi 38677
Phone: 601-232-7073
Email: museums@olemiss.edu
Web site: www.olemiss.edu/depts/u_museum
Bonnie J. Krause, Director

The University museums in Oxford have an extensive collection concentrating on Mississippi folk artists, both black and white. These include the following: over 400 paintings by Theora Hamblett, portraying children's games, home memories, dreams, and

visions; Sulton Rogers, wood-carvings including figures, animals, canes, etc.; Clementine Hunter, paintings; James "Son" Thomas, ceramics; Luster Willis, paintings and wood-carvings; and Jimmy Lee Sudduth, paintings. There are also quilts by Pecolia Warner, Minnie Watson, and Amanda Gordon.

Existing Environments
Environment is listed by the name of the person who created it; check the Artists chapter for location and contact information.

Loy "Rhinestone Cowboy" Bowlin—house and yard (now at Kohler Art Center in Wisconsin)

MISSOURI

Existing Environments
Environment is listed by the name of the person who created it; check the Artists chapter for location and contact information.

Bronislaus Luszcz—Black Madonna Shrine

NEBRASKA

Flatwater Folk Art Museum
Mailing address:
 P.O. Box 7
 Brownville, Nebraska 68321
Location:
 609 Main Street
 Brownville, Nebraska 68321
Email: flatwater1@windstream.net
Phone: 402-825-4371
George Neubert, Owner and Director

The Flatwater Folk Art Museum is a project of the Flatwater Art Foundation. Located in the 1854 historic frontier river town on the Missouri River and housed in a renovated 1884 American Prairie Gothic building, the collection of the Flatwater Folk Art Museum, its exhibitions and folk-life programs, illuminate and document valued aspects of American culture through the aesthetics of daily life. The museum displays feature a broad spectrum of intriguing artifacts ranging from historic traditional folk art and crafts, naive expressions, to contemporary "outsider" art. The folk art collection includes paintings to pottery; toys to trade signs; quilts and samplers to silhouettes; scrimshaw to ship models; carousel horses; wood-carvings; hunting and fishing decoys to game boards; retablos and Santos; windmill weights, whirligigs and weather vanes. The museum will continue to collect and display traditional folk art such as quilts, samplers and weather vanes along with naive expressions in painting, sculpture and ceramics, commercial art, and outsider art.

Self-Taught Artists in the Collection
Hawkins Bolden, Shane Campbell, Ron Cooper, the Rev. Howard Finster, the Rev. J. L. Hunter, R.A. Miller, Herbert Singleton, Mose Tolliver, Willie White, "Artist Chuckie" Williams, and others.

NEW JERSEY

Newark Museum
P.O. Box 540
49 Washington Street
Newark, New Jersey 07107
Phone: 973-596-6550
Phone: 800-MUSEUM
Email: americanart@newarkmuseum.org
Web site: www.newarkmuseum.org
Steven Kem, Director and CEO
Ulysses Grant Dietz, Chief Curator and Curator of
 Decorative Arts

The Newark Museum has "one of the premier folk art collections in America, which it makes a point of displaying continuously. The museum was the first in America to mount an exhibition of folk art, in 1930 and again in 1931. Both were organized by Holgar Cahill." Many twentieth century pieces have been added during the last ten years, including "an important John Scholl sculpture."

Self-Taught Artists in the Collection
Bill Traylor, William Edmondson, David Butler, Minnie Evans, Joseph Pickett, Eddie Arning, Willie

Wayne Young, Thornton Dial, Sr., the Philadelphia Wireman, William Hawkins, Hawkins Bolden, Purvis Young, and others

Noyes Museum of Art of Stockton College

733 E. Lilly Lake Road
Oceanville, New Jersey, 08231
Phone: 609-652-8848
Email: publicrelations@noyesmuseum.org
Web site: www.noyesmuseum.org
Michael Cagno, Executive Director
Dorrie Papademetriou, Curator of Collections and Exhibitions

The Noyes Museum of Art presents thoughtful and engaging art exhibitions in a peaceful natural setting. South Jersey's only fine arts museum, the Noyes Museum displays a growing collection of American fine art, craft, and folk art, including vintage bird decoys. In 2010 the Noyes Museum formed a partnership with Stockton College and expanded its name. The museum's ten to twelve exhibitions each year include outstanding travelling exhibitions and works by leading American and New Jersey artists. The museum has an educational program and a library. Exhibitions have included "Twentieth Century Self-Taught Artists from the Mid-Atlantic Region" (April 10 to June 19, 1994); "Drawing Outside the Lines: Works on Paper by Outsider Artists" (July 2 to September 17, 1995); "Angels, Cherubs and Putti: The Artists' Muses" which included artists Chelo Amezcua, Minnie Evans, R.A. Miller, Sister Gertrude Morgan, Purvis Young, and Lino Zerda (November 9, 1996, to January 5, 1997); "For the Love of Art: Folk Carvings by South Jersey Artist Albert Hoffman" (June 28 to September 21, 1997); "Mindscapes: Extending the Limits of Reality" (October 5, 1997, to January 4, 1998) which included work by Robert Sholties. "An Inner Journey: Paintings by Michael J. Ryan" also took place in 1997, and a retrospective of the works of Justin McCarthy in 1999. A 2014 exhibition was "Detour: Self-Taught Artists" (May 16 to September 21, 2014).

Self-Taught Artists in the Collection
Minnie Evans, Victor Joseph Gatto, Albert Hoffman, Michael J. Ryan, David Zeldis, Malcah Zeldis

NEW MEXICO

Albuquerque Museum of Art

P.O. Box 1293
2000 Mountain Road, N.W.
Albuquerque, New Mexico 87104
Phone: 505-242-4600
Email: cwright@cabq.gov
Web site: www.cabq.gov/culturalservices/albuquerque-museum
Cathy Wright, Museum Director

The Albuquerque Museum has in its permanent art collection numerous examples of naive art, which have been the basis for a number of exhibitions. In addition, the following carvers listed in the catalog *Santos, Statues, and Sculpture: Contemporary Woodcarving from New Mexico*, plus additional acquisitions, belong to the Albuquerque Museum.

Self-Taught Artists in the Collection
Leroy Archuleta, Patrocinio Barela, Frank Brito, Gloria Lopez Cordova, Frances Graves, Alonzo Jimenez, Eurgencio and Orlinda Lopez, Felix A. Lopez, Jose Benjamin Lopez, Lusito Lujan, Nora Naranjo Morse, Zoraida and Eulogio Ortega, Marco A. Oviedo, Claudio Salazar, Horacio Valdez

Dalley Open Air Windmill Museum

109 W. First Street
Portales, New Mexico 88130
Phone: 575-356-5307
Web site: http://www.rooseveltcounty.com/?page_id=1931

Bill and Alta Dalley collected windmills for more than 30 years. They considered themselves a husband-and-wife windmill search-and-rescue team, retrieving what had once been working windmills and relocating them to their yard in Portales. They would dive the back roads to hunt for windmills, searching for abandoned homesteads, farms, watering homes, and similar places where they might discover a forgotten windmill. After getting permission, they would move the windmill to their home, repair and paint it, and hoist it up in their backyard with all the others. The count having reached 80, some of which Bill made himself, the Dalleys donated their collection to Roosevelt County, and it has been moved from their backyard to the county fairgrounds. The county plans to expand the site into a xeriscaped park complete with walking paths. Some windmills "hold exalted positions" around town, such as the one by the courthouse and another at a community bank. The windmills can be seen through a fence without prior arrangements, or you can call the county manager's office if you want to enter and walk around.

Museum of International Folk Art

P.O. Box 2087
706 Camino Lejo

Santa Fe, New Mexico 87504
Phone: 505-476-1200 (main number)
Phone: 505-476-1224 (Laura Addison direct line)
Email. Laura.addison@state.nm.us
Web site: www.internationalfolkart.org
Marsha Bol, Director
Laura M. Addison, Curator of North American and
 European Folk Art

The Museum of International Folk Art, located at 706 Camino Lejo on Museum Hill, two miles southeast of the Santa Fe Plaza, contains a visual feast. Most often noted for the Girard Foundation collection of over 100,000 objects from one hundred countries, the museum also has extensive collections of Southwestern folk art and self-taught artists. It has a significant collection, growing all the time, of art by self-taught artists living in the United States. A recent exhibition, "Wooden Menagerie: Made in New Mexico" (April 6, 2014, through February 15, 2015), featured many works by Felipe Archuleta and the relatives, neighbors, and friends who worked with him.

Self-Taught American Artists in the Collection
 Lionel Adams, Felipe Archuleta, Leroy Archuleta, Leroy Almon, Sr., Max Alvarez, Tobias Anaya, Johnson Antonio, Charles Balth, Patrocinio Barela, James Bauer, Harold Bayer, Frank Brito, Sr., Jerry Brown, David Butler, Miles B. Carpenter, Ned Cartledge, Marie Romero Cash, Russell Childers, Jim Colclough, Helen Cordero, Burlon Craig, Mamie Deschillie, "Uncle Jack" Dey, Frank Demaray, J. Evans, Amos Ferguson, Marvin Finn, Howard Finster, Robert Gallegos, Carlton Garrett, Gedewon, Herman Hayes, Clementine Hunter, Billie Hutt, Alonzo Jimenez, Clyde Jones, S.L. Jones, Lavern Kelley, Tella Kitchen, Gustav Klumpp, Harry Lieberman, Lanier Meaders, R.A. Miller, Mr. Imagination, Sister Gertrude Morgan, Elijah Pierce, Mattie Lou O'Kelley, Martín Ramírez, Jose M. Rivera, Marie Rogers, Rodney Rosebrook, Nellie Mae Rowe, Martin Saldaña, Dan Sansone, "Pop" Shaffer, Antoinette Schwob, Miles Smith, Barbara Strawser, Vannoy Streeter, Clarence Stringfield, Edgar Tolson, Alfred "Charlie" Willeto, Inez Nathaniel Walker, Willard Watson, "Chief" Willey, Joseph Yoakum, Anna Zemánková, Larry Zingale

Wheelwright Museum of the American Indian

Mailing address:
 PO Box 5153
 Santa Fe, New Mexico 87502
Location:
 704 Camino Lejo
 Santa Fe, New Mexico 87505

Phone: 505-982-4636
Email: info@wheelwright.org
Web site: www.wheelwright.org
Jonathan Batkin, Director
Cheri Falkenstein-Doyle, Curator

The Wheelwright Museum of the American Indian offers unique exhibitions of contemporary and historic Native American art. It is famous for its focus on little-known genres and for solo shows by living Native American artists. Every exhibition is original to the Wheelwright, bringing visitors new research, fresh perspectives, and rich, lively visual expression. The origins of the museum go back to the 1920s and early 1930s, when Mary Cabot Wheelwright and Hastiin Klah, a Navajo ceremonial singer, began their long association. Hastiin Klah was worried that much of Navajo culture would be lost in the U.S. government's longstanding policy of forced assimilation; he and Wheelwright began collecting and recording, using oral histories, oral and written renditions of traditional ceremonial songs, photographs of sand paintings used in ceremonies, and many cultural artifacts. By the mid-1930s it became obvious that they would need a museum to house what they had collected and produced. Its intent was to offer the public a sense of the beauty, dignity, and profound logic of Navajo religion. The museum had two names before becoming the Wheelwright, both reflecting its Navajo focus. It assumed its current name after it repatriated numerous ceremonial objects to the Navajo Nation during the 1960s and 1970s, while still retaining its extensive collections and archives that document Navajo art and culture from 1850 on, along with an expanded focus that includes all Native American arts and cultures. For the past 10–15 years its collecting focus has been on Native American jewelry; the museum's first exhibition focused on this collection opened on June 6, 2015, in just-completed new exhibition space. The Wheelwright does not focus on outsider art, but its permanent collection does include a number of Native American artists who fall within that genre.

Self-Taught American Artists in the Collection
 Johnson Antonio, Delbert Buck, Della Cruz, Mamie Deschellie, Gregory Lomayesva, Nora Naranjo-Morse, Charlie Willeto, Willeto family

Existing Environments

Environments are listed here alphabetically by the name(s) of the people who created them; check the Artists chapter for location and contact information.
 Bill and Alta Dalley—Open Air Windmill Museum
 "Pop" Shaffer—Shaffer Hotel and Rancho Bonito

NEW YORK

Fenimore House Museum

P.O. Box 800
5798 State Route 80 (Lake Road)
Cooperstown, New York 13326
Phone: 607-547-1400
Email: info_fenimore@nysha.org
Web site: www.fenimoreartmuseum.org
Paul S. D'Ambrosio, President and CEO
Erin Richardson, Director of Collections

Fenimore House is the museum of the New York State Historical Association. The folk art collection is nationally known, though more for its nineteenth than its twentieth century pieces. In recent years, however, an aggressive effort has been made to increase the twentieth century folk art holdings. The collection is national in scope.

Self-Taught Artists in the Collection

Eddie Arning, David Butler, Karolina Danek, William Edmondson, Ralph Fasanella, Howard Finster, Bessie Harvey, William Hawkins, Edwin Johnson, Lavern Kelley, James C. Litz, Emily Lunde, Gregorio Marzan, Frank Moran, Grandma Moses, Janet Munro, Philadelphia Wireman, Sulton Rogers, Joseph Schoell, John Scholl, Jon Serl, Mary Shelley, Queena Stovall, Jimmy Lee Sudduth, Mose Tolliver, Edgar Tolson, Annie Wellborn, Isidor "Pop" Wiener, Purvis Young, Malcah Zeldis

American Folk Art Museum

1865 Broadway, 11th Floor (mailing address)
Two Lincoln Square/Columbus Avenue between 65th and 66th Street (location)
New York, New York 10023
Phone: 212-595-9533
Email: info@folkartmuseum.org
Web site: http://www.folkartmuseum.org
Anne-Imelda Radice, Director
Stacy C. Hollander, Chief Curator

The American Folk Art Museum has had numerous name changes, each reflecting a change in its sense of its mission and direction. It began in 1961 as the Museum of Early American Folk Art. In 1966 the name changed to the Museum of American Folk Art, and the exhibitions and acquisitions began to reflect "every aspect of American folk art," with increasing interest in art of the 20th century. In 2001 the museum chose its current name, American Folk Art Museum. This

latter name change has caused some controversy, as the museum's focus has expanded to include the work of European artists and artists from other countries.

The permanent collection consists of over 4,000 objects representative of all ages and aspects of American folk art. A recent exhibition (December 2014) featured works by Ralph Fasanella donated to the museum by his family: The exhibition, "Ralph Fasanella: Lest We Forget," includes the artist's depictions of the plight of the working class in postwar America. There is a museum shop adjacent to the Eva and Morris Feld Gallery.

Self-Taught Artists in the Collection

The museum has moved large parts of its art, library materials, and archives to space in Queens, where it is less accessible than formerly. Check with the museum to learn which artists are currently on display.

Metropolitan Museum of Art

1000 5th Avenue (at 82nd Street)
New York, NY 10028
Phone: 212-535-7710
Email: info@metmuseum.org
Web site: www.metmuseum.org

The Metropolitan Museum of Art is not usually found in a book about finding and seeing American folk art. This has changed since the Souls Grown Deep Foundation presented the museum with a gift of 57 works of art. The Foundation is included in the Winter 2015 issue of *Folk Art Messenger*.

Self-Taught Artists in the Collection

Thornton Dial, Sr., Lonnie Holley, Joe Light, Ronald Lockett, Jim Minter, J.B. Murry, Missionary Mary Proctor, Nellie Mae Rowe, Emmer Sewell, Mary T. Smith, Georgia Speller, Henry Speller, Mose Tolliver, Purvis Young

Existing Environments

Environments are listed here alphabetically by the name(s) of the people who created them; check the Artists chapter for location and contact information.

Ted Ludwiczak Easter Island on the Hudson
Veronica Terrillion Environment

NORTH CAROLINA

Asheville Art Museum

Mailing address:
 P.O. Box 1717
 Asheville, North Carolina, 28802
Location:
 2 South Pack Square
 Asheville, North Carolina 28801
Phone: 828-253-3227
Email: ashevilleart@main.nc.us
Web site: www.ashevilleart.org
Pamela L. Myers, Director
Frank E. Thomson, III, Curator

The Asheville Art Museum has an ever-growing collection of outsider, self-taught and folk art, currently housing over sixty artists across two and three-dimensional works. The collection includes Mary Lee Bendolph, Thorton Dial, Minnie Evans, Howard Finster, George Widener and Western North Carolina artists McKendree Robbins Long, Clyde Jones, Raymond Coins, and Russell Gillespie. The museum owns over 100 works by Buncombe County folk potteries including George Donkel Pottery, Burlon Craig, Walter B. Stephen, Oscar L. Bachelder, Penland Stone Pottery, Brown's Pottery, Lee Smith Pottery, and others.

Self-Taught Artists in the Collection

Minnie Adkins, Alpha Andrews, Oscar L. Bachelder, Andrea Badami, Mary Lee Bendolph, Biltmore Industries, Georgia Blizzard, Donald Boone, Arthur Bradburn, Herman Bridgets, Glenn Brown, Brown Brothers Pottery, Elliot Buckner, J.R. Cheek Pottery, Raymond Coins, Ronald Cooper, Burlon Craig, Harold Crowell, May Ritchie Deschamps, Thornton Dial, Sr., Kate Clayton (Granny) Donaldson, David Donkel, George Donkel Pottery, Sam Doyle, Jack Eichbaum, Winton Eugene, Evan's Pottery, Howard Finster, Michael Finster, Roy Finster, Russell Gillespie, Ben Hall, Alyne Harris, Bessie Harvey, Mark Hewitt, Lonnie Holley, Samuel Wilson Jacobs, Harry Jenkins, Anderson Johnson, Clyde Jones, Frank Jones, Jugtown Pottery, Lankford Pottery, McKendree Robbins Long, Charlie Lucas, James Marbutt, William Marion, Wade Martin, R.A. Miller, Louis Monza, J. L. Nipper, North State Pottery, Mattie Lou O'Kelley, Vernon Owen, Jimmy Parham, Penland Stone Pottery, Missionary Mary Proctor, Sulton Rogers, Lorenzo Scott, Bernice Sims, Lee Smith Pottery, Walter B. Stephen, James Henry Stone, Jimmy Lee Sudduth, William Thomas Thompson, Throckmorten Pottery, Mose Tolliver, B.R. Trull, Deacon Trust, Hubert Walters, Lillian Webb, Derek Webster, Myrtice West, George Widener, Pauline Wills, Yoder & McClure "Jug Factory," Purvis Young

Ackland Art Museum/University of North Carolina

Mailing Address:
 Campus Box 3400
 Chapel Hill, North Carolina 27599
Location:
 101 S. Columbia Street
 Chapel Hill, North Carolina 27599
Phone: 919-966-5736
Email: ackland@email.unc.edu
Web site: www.ackland.org
Peter Nisbet, Chief Curator and Interim Director

The Ackland Museum has a collection of North Carolina art, including a large collection of ceramic pieces. There are approximately sixty jars, plates, and pitchers, and two grave markers. Represented are Burlon Craig, Charles B. and Enoch S. Craven, David Donkel, Nicholas Fox, Henry H. and Royal P. Heavner, the Jugtown ware potters, Ben Owen, Samuel Propst, Luther Richie, Daniel and James Seagle, and the Webster School potters. There are two face jugs and a snake jug by Burlon Craig, a sculpture, "Hare," by Claude Richardson, Jr., and three wood sculptures by Edgar Alexander McKillop. There is also a sculpture by Raymond Coins, and one drawing and one painting by Minnie Evans.

Mint Museum of Art

2730 Randolph Road
Charlotte, North Carolina 28207
Phone: 704-337-2000
Email: info@mintmuseum.org
Web site: http://www.mintmuseum.org
Kathleen V. Jameson, President and CEO
Brian Gallagher, Curator of Decorative Arts
Michele Leopold, Chief Registrar

The Mint Museum's major attraction to people interested in self-taught and folk art is its focus on American ceramics in its extensive collection of artworks and its library's collection of documents. The ceramics collection numbers over 3,000 pieces encompassing works by Native American potters, particularly those of the southwestern United States; folk potters east of the Mississippi, with an emphasis on those from North Carolina and the southeastern United States; and decorative pottery and porcelain, including art pottery, from the Colonial period to the present. In 1983 the museum received as a gift/purchase the North Carolina pottery collection of Dorothy and Walter Auman of Seagrove. Well-known potters and descendants of potters, the Aumans spent over thirty years searching out early pieces of North Carolina pottery.

Eventually they amassed a collection of some 1,900 pieces, covering all periods and types of North Carolina pottery, from eighteenth century shards to contemporary, traditional pieces. Also in the museum is the Daisy Wade Bridges Collection, which includes Native American pottery, art pottery and North Carolina pottery.

The Delhom-Gambrell Library of the Mint Museum of Art has extensive literature on the subject of American pottery and porcelain. In addition to the many objects she brought to the museum, Daisy Wade Bridges also donated books, catalogs, journals and slides, which make research and understanding of the collection possible. The library is open to all by appointment with the librarian at 704-337-2023.

Hickory Museum of Art

P.O. Box 2572
243 Third Avenue NE
Hickory, North Carolina 28601
Phone: 828-327-8576
Email: none
Web site: www.hickoryart.org
Lisë C. Swensson, Executive Director
 Kate Worm, Collections Curator Assistant

The Hickory Museum of Art was founded in 1944 to collect, foster and preserve American art. Eight works were collected that year, and today, 70 years later, the Museum has approximately 1,500 art objects in its collection. It has a strong commitment to including self-taught artists, with over 250 holdings in Southern regional self-taught art. Most of these works are on view in the Museum's long-term interactive exhibition that takes up the entire third floor, "Discover Folk Art: Unique Visions by Southern Self-Taught Artists." This is an immersive introduction to the world of Southern contemporary folk art, organized into five themes: Introduction, Beliefs, Memories, Nature, and Collecting.

Self-Taught Artists in the Collection
"Ab the Flagman," Leroy Almon, Tammy Leigh Brooks, Richard Burnside, Miles Carpenter, Wanda Clark, Raymond Coins, Abraham Lincoln Criss, Marie Elem, Minnie Evans, Sam Ezell, Howard Finster, Michael Finster, Russell Gillespie, Theresa Gloster, Larry Heath, Albert Hodge, Clementine Hunter, James Harold Jennings, Joe McFall, Sam "The Dot Man" McMillan, R.A. Miller, and Sister Gertrude Morgan, Minnie Reinhardt, Lorenzo Scott, Q.J. Stephenson, Arie Reinhardt Taylor, Mose Tolliver, Hubert Walters, Myrtice West, George Williams, Jeff Williams, and more.

Gregg Museum of Art and Design

North Carolina State University
Campus Box 7306

Raleigh, North Carolina 27695
Phone: 919-515-3503
Roger Manley, Curator
Web site: www.ncsu.edu/gregg

The Gregg Museum of Art & Design (formerly the N.C. State Gallery of Art & Design) has been in temporary quarters at 516 Brickhaven Drive, Suite 200, since May 2013, while its new space at the historic chancellor's residence at 1903 Hillsborough Street is being developed. Check the website for its whereabouts. Normally, the museum offers exhibitions and collections focusing on decorative and applied arts, ceramics, textiles, and folk and self-taught art. The largest holding—among the largest bodies of work by a single self-taught artist held by any institution in the world—is the Annie Hooper bequest. This consists of nearly 3,000 figures comprising more than 200 biblical tableaux made from painted driftwood, cement, putty, and seashells. Individual sculptures by Hooper range in height from 6 to 48 inches. This work was displayed in its entirety at a major exhibition and symposium in 1995, but is currently in storage; it may, however, be viewed by appointment.

Self-Taught Artists in the Collection
Georgia Blizzard, Vernon Burwell, Betty Carter, Annie Hooper, James Harold Jennings, Clyde Jones, Vollis Simpson

Small Museum of Folk Art

East Street
Pittsboro, North Carolina 27312
Phone: none yet
Email: none yet
Website: none yet

The Small Museum of Folk Art was under development as this book went to press. It will house the folk art collection of Jim Massey, who spent decades collecting the art of Howard Finster, Clyde Jones, Sam McMillan, R.A. Miller, Jimmy Lee Sudduth, and many other artists whom Massey knew personally and whose work he sometimes received as gifts and sometimes commissioned. Fund-raising is under way to assure that the project reaches completion.

North Carolina Museum of Art

Mailing address:
 4630 Mail Service Center
 Raleigh, North Carolina 27699-4630
Location:
 2110 Blue Ridge Road
 Raleigh, North Carolina 27607
Phone: 919-839-6262
Email: info@ncartmuseum.org
Web site: www.ncartmuseum.org
Lawrence J. Wheeler, Director

Linda Dougherty, Chief Curator and Curator of Contemporary Art

The museum occasionally exhibits "outsider" artists. Art in the permanent collection consists of seven works on paper by Minnie Evans, and "a wonderful painting by a North Carolina self-taught artist, Lena Bulluck Davis."

Southern Folk Pottery Collectors Society/Shop and Museum

1828 North Howard Mill Road
Robbins, North Carolina 27325
Phone: 910-464-3961
Web site: www.southernfolkpotterysociety.com
Contact Person: Billy Ray Hussey

The shop and museum opened in 1991 in an area where there are nearly ninety active potteries. The museum has a display of Southern folk art pottery, which changes quarterly, from the eighteenth century to the present. The shop carries a select offering of "folk pottery by all the major traditional Southern potters." The society conducts biannual absentee auctions and exhibitions accompanied by an illustrated reference catalog. There is also a reference library at the museum, including several video productions on the subject of Southern folk pottery. There are regular weekday hours (check website) or call for an appointment.

Also see entries for the Society under Auctions and Organizations.

St. James Place Folk Art Museum

Location of museum:
 U.S. Highway 64
 Robersonville, North Carolina 27871
Location of Library:
 119 South Main Street
 Robersonville, North Carolina 27871
Phone: 252-508-0342 (library)

The St. James Place Folk Art Museum was a private folk art museum housed in the restored Robersonville Primitive Baptist Church located on U.S. Highway 64, 39 miles west of Rocky Mount and 20 miles north of Greenville on N.C. Highway 903. This pristine example of late clapboard Gothic revival architecture was built in 1910 and added to the *National Register of Historic Places* in 2005. For more than a decade it served as a museum for folk art, antique decoys, and art pottery from the personal collection of Dr. Everette James, Jr., a native of Robersonville. Dr. James moved most of his collection to the Carl Van Vechten Gallery of Fine Arts at Fisk University in Nashville. What remains in the Primitive Baptist Church is quilts—more than 100 North Carolina quilts, including 42 African-American examples. The church, with its quilts, can be accessed by going to the Robersonville Library, 119

S. Main Street, during the times it is open (M-F, 9–5; Saturday, 9–12) and asking for the key to the church. You do not have to call in advance. While there, you might want to check out several pieces of folk art pottery that Dr. James donated to the library.

Robert Lynch Collection of Outsider Art

North Carolina Wesleyan College
3400 North Wesleyan Boulevard
Rocky Mount, North Carolina 27804
Phone: 252-985-5268
Web site: http://www.ncwc.edu/arts/lynch.php

The Four Sisters Gallery, in the Pearsall Building at North Carolina Wesleyan University, is a gallery for contemporary self-taught art. It includes pieces from the Robert Lynch Collection, plus more recent acquisitions. The works of the Robert Lynch Collection may be viewed (in five parts) on this Gallery's website at http://www.ncwc.edu/arts/four-sisters.php.

Self-Taught Artists in the Collection

Donald Boone, William Boyd, Herman Bridgets, Vernon Burwell, Alan Cooper, Henry Davis, Jr., Nevin Evans, Clyde Jones, Tezelle Kenyon, Pauline Meinstereiffel, William Owens, Leroy Person, Vollis Simpson, Q.J. Stephenson, Arliss Watford, Jeff Williams

North Carolina Pottery Center

P.O. Box 531
235 East Street
Seagrove, North Carolina 27341
Phone: 336-873-8430
Email: info@ncpotterycenter.org
Web site: www.ncpotterycenter.org
Lindsey Lambert, Executive Director

The North Carolina Pottery Center is a museum and educational center devoted to preserving the history and ongoing tradition of North Carolina pottery. The center has a library for use by the staff, potters and the public. Memberships in the center are available and a newsletter is published. In the center there is a space in the lobby that supplies information on the location of potteries, special events and festivals, exhibits and kiln openings, and other information for the use of visitors to the area. The pottery collection at the center includes North Carolina pottery from the late eighteenth century to the present. Exhibitions extend the number of potters whose work may be seen at the Center. Its website offers a directory of potters associated with the Center.

Face Jug Makers Currently Represented in the Collection

Brown family, Burlon Craig, M.L. Owens, R. Emmitt Albright, Louis D. Brown, Albert Hodge, Joe Reinhardt

Cameron Art Museum

(formerly St. John's Museum of Art)
3201 South 17th Street
Wilmington, North Carolina 28412
Phone: 910-395-5999
Web site: www.cameronartmuseum.org
Deborah Velders, Director

The museum collection includes American paintings, works on paper, and sculpture. The focus is on North Carolina art, including over 150 pieces of Jugtown pottery. Recently renovated, the museum is a complex of three architecturally distinct buildings with a common-walled sculpture garden. In addition to the permanent installations, the museum schedules ten to twelve temporary exhibitions each year, and there is a commitment to educational programs. The museum has a significant collection of the work of Minnie Evans, who lived in Wilmington and was a friend to the museum. The film "The Angel That Stands by Me" was filmed in great part at the museum. There are eleven works of art by Minnie Evans in the permanent collection. In addition the museum has two pieces of sculpture, a giraffe and a horse, by Clyde Jones, and a newly acquired whirligig by Vollis Simpson.

Diggs Gallery at Winston-Salem State University

601 S. Martin Luther King Jr. Drive
Winston-Salem, North Carolina 27110
Phone: 336-750-2000
Email: diggsinfo@wssu.edu
Web site: www.wssu.edu/diggs
Belinda Tate, Director/Curator

The Diggs Gallery is home to one of the South's leading showcases dedicated to African and African-American art. In 2007 the gallery was identified as one of the top 10 African American galleries in the nation, and was also identified by the Smithsonian as one of the nation's best regional facilities for exploring contemporary African art. Diggs Gallery is the major cultural center at the university, offering ten to fifteen exhibitions each year (half of which are curated and originate from WSSU). The 6,000 square foot gallery hosts educational programs throughout the year. Exhibitions, publications and programs address a broad range of artistic expression, including self-taught artists, with a special concentration on African and African-American art. Diggs Gallery does not have a permanent collection.

Past exhibitions highlighting self-taught work: Ashe: Improvisation & Recycling in African American Visionary Art (1993); Minnie Evans: Artist (1993); Selected Work by George Andrews: The Dot Man (1996); Hubert Walters (1997). In 1999 there were three exhibitions on Southern, African-American wood-carvers: Arliss Watford; Daniel Pressley; and Vestor Lowe. Two recent exhibitions have been "Ascension" (June 19, 2004–April 2, 2005) and "Ascension II" (January 12–March 22, 2008), examining the legacy of self-taught African-American artists in North Carolina.

Existing Environments

Environments are listed here alphabetically by the name(s) of the people who created them; check the Artists chapter for location and contact information.

Clyde Jones—Haw River Crossing
Sal Kapunan—Taoist Environment
Vollis Simpson—Whirligig Park
Q.J. Stephenson—Occoneechee Trapper's Lodge
Henry Warren—Shangri-La

NEVADA

Existing Environments

Environment is listed by the name of the person who created it; check the Artists chapter for location and contact information.

Chief Rolling Mountain Thunder—Rolling Thunder Monument

OHIO

Akron Art Museum

1 S. High Street
Akron, Ohio 44308
Phone: 330-376-9185
Email: mail@akronartmuseum.org
Web site: www.akronartmuseum.org
Mark Masuoka, Executive Director and CEO
Janice Driesbach, Chief Curator

The permanent collection contains regional, national, and international paintings, sculpture, photo

graphs, and prints from 1850 to the present. In 1987 the museum began actively collecting contemporary folk art, and now has 130 objects in its collection. Since 2000 it has mounted several exhibitions featuring self-taught artists, including "Perilous Beauty: The Drawings of David Zeldis" (May 25–August 11, 2002); "Memorial Tribute to McMoore" (November 11, 2009 to January 18, 2010); "Stranger in Paradise: The Works of Reverend Howard Finster" (February 25–June 3, 2012); and "Butch Anthony: Vita Post Mortum" (November 6, 2014–January 25, 2015).

Self-Taught Artists in the Collection

Butch Anthony, David Butler, Miles B. Carpenter, Earl Cunningham, John William "Uncle Jack" Dey, Gerald C. "Creative" DePrie, Minnie Evans, Howard Finster, Preston Geter, William Hawkins, Lola Isroff, S.L. Jones, Eddie Lee Kendrick, Birdie Lusch, Vivian Maier, W.D. "Crazy Mac" McCaffrey, Justin McCarthy, Alfred McMoore, Sister Gertrude Morgan, Charles Orloff, Elijah Pierce, "Popeye" Reed, Anthony Joseph Salvatore, Jon Serl, Simon Sparrow, Christopher Steele, Mose Tolliver, Eugene Von Bruenchenhein, Philadelphia Wireman, Joseph Yoakum, Purvis Young, David Zeldis, Malcah Zeldis

Cincinnati Art Museum

953 Eden Park Drive
Cincinnati, Ohio 45202
Phone: 513-721-2787
Email: info@cincyart.org
Web site: www.cincinnatiartmuseum.org
Cameron Kitchen, Director
Julie Aronson, Curator of American Paintings, Sculpture, and Drawings

The museum has a folk art gallery, with almost all of the pieces dated prior to the twentieth century. There are two paintings by Nan Phelps and two large landscapes which are dated to the early twentieth century and signed "L.A. Roberts." One of these paintings usually hangs in the folk art gallery, "though we know nothing about the artist." The Department of Prints, Drawings, and Photographs has two oil pastels by Eddie Arning—"Girl in Blue with White Birds," ca. 1972, and "Crusading for a Great Love of Life," ca. 1971—both gifts of Mr. and Mrs. Alexander Sackton.

Columbus Museum of Art

480 East Broad Street
Columbus, Ohio 43215
Phone: 614-221-6801
Email: info@ccmaohio.org
Web site: www.columbusmuseum.org
Nannette V. Maciejunes, Executive Director
M. Melissa Wolfe, Curator of American Art

The first chartered art museum in Ohio, the Columbus Museum of Art was established in 1878. Along with mainstream art reflecting the history of western culture, it is also recognized for extraordinary regional collections, such as the largest public collection of woodcarvings by Columbus folk artist Elijah Pierce. It also houses the works of other self-taught artists of the region. It has mounted exhibitions devoted to the work single artists, including Elijah Pierce and William Hawkins. Group shows include the recent "Counterpoint: Works by Folk and Self-taught Artists at the Columbus Museum of Art" and "New Traditions/Non-Traditions: Contemporary Art in Ohio." The latter blended work of 13 self-taught artists with that of contemporary trained artists.

Self-Taught Artists in the Collection

Fred Alton, Ralph Bell, Mary Borkowski, William Hawkins, Tim Lewis, Walter O. Mayo, Tonita (Quah Ah) Peña, John Perates, Elijah Pierce, "Popeye" Reed, Anthony Salvatore, Edgar Tolson, Inez Nathaniel Walker

Miami University Art Museum

801 S. Patterson Avenue
Oxford, Ohio 45056
Phone: 513-529-2232
Email: artmuseum@miamioh.edu
Web site: www.miamioh.edu/cca/art-museum
Robert S. Wicks, Director
Jason E. Shaiman, Curator of Exhibitions

The Miami University Art Museum is a public institution dedicated to the exhibition, interpretation, and preservation of works of art. The museum serves both the university community and the general public. The art museum houses five galleries of changing exhibitions and a growing permanent collection of more than 16,000 pieces.

Self-Taught Artists in the Collection

Rick Borg, Charlie Dieter, Lee Godie, William Hawkins, Clementine Hunter, Frank Jones, S.L. Jones, Harry Lieberman, Mary Merrill, Michael Nakoneczny, Judith Neville, Elijah Pierce, "Old Ironsides" Pry, Sophy Regensburg, Anthony Joseph Salvatore, Inez Nathaniel Walker

Southern Ohio Museum and Cultural Center

P.O. Box 990
825 Gallia Street
Portsmouth, Ohio 45662
Phone: 740-354-5629
Email: info@somacc.com
Web site: www.somacc.com
Mark Chepp, Executive Director
Sarah Johnson, Senior Curator

The museum has a commitment to showing outsider art rather than having a permanent collection of it. Temporary exhibitions have included "Mountain

Harmonies" which featured the works of Charley Kinney, Noah Kinney, and Hazel Kinney; and "Local Visions," curated by Adrian Swain, featuring outsider artists from northeastern Kentucky. In the fall of 1998 the museum hosted an exhibition, "African American Folk Art From Kentucky" and an installation, "O'Leary, Have You Lost Your Mind?" by Kentucky-born Cincinnati artist O'Leary Bacon. In 1999–2000 the museum mounted an exhibition pairing several Ohio fine artists with folk artists from northeast Kentucky. The permanent collection includes three pieces of "outsider art": "Parting the Red Sea" by Hazel Kinney, "Wild Booger" by Charley Kinney, and "Speckled Rooster" by Noah Kinney.

Springfield Museum of Art

107 Cliff Park Road
Springfield, Ohio 45501
Phone: 937-325-4673
Email: smoa@springfieldart.net
Web site: www.springfieldart.museum
Ann Fortesque, Director

The Springfield Museum of Art collects American art, with a sub-focus upon the work of regional and Ohio artists. Folk art in the collection includes works by Elijah Pierce, William Hawkins, Ralph Bell and Anthony Joseph Salvatore. The Museum has held numerous exhibitions featuring folk art, including: "Local Visions: Folk Art From Northeast Kentucky"; "An Unexpected Orthodoxy: The Paintings of Lorenzo Scott"; "Ralph Bell: Art As Life Force"; and "Masterworks of 20th Century African-American Arts." A recent exhibition was "Compelled: Folk Art and Vision" (Fall 2014-Spring 2015).

Self-Taught Artists in the Collection

Ralph Bell, Mary Borkowski, Smoky Brown, James Castle, Levent Isik, Tamara Jaeger, Mary Frances Merrill, J. B. Murry, Elijah Pierce, Aminah Robinson, Charlie Willeto, Purvis Young

Existing Environments

Environments are listed here alphabetically by the name(s) of the people who created them; check the Artists chapter for location and contact information.
James Batchelor—Odd Garden
Brice Baughman—The Statues
Ben Hartman –Hartman Rock Gardens

OKLAHOMA

Existing Environments

Environment is listed by the name of the person who created it; check the Artists chapter for location and contact information.

Ed Galloway—Totem Pole Park

OREGON

Existing Environments

Environments are listed here alphabetically by the name(s) of the people who created them; check the Artists chapter for location and contact information.

Rasmus Peterson — Peterson's Rock Garden
William "Wibb" Ward — Bear Park

PENNSYLVANIA

Lehigh University Art Galleries

420 E Packer Avenue
Bethlehem, Pennsylvania 18015
Phone: 610-758-3615
Web site: www.luag.org
Ricardo Viera, Director and Curator
Mark Wonsidler, Coordinator of Exhibitions and Collections

The museum focuses on contemporary art, with an eclectic permanent collection. It has sponsored exhibitions of folk and outsider art. It is assembling a major collection, including videos and other documentary materials, of Howard Finster and members of his family including Beverly Finster, Michael Finster, K. Allen Wilson, and Chuck Cox. Minnie Adkins, R.A. Miller, and Hugo Sperger are also represented in the museum's collection.

Philadelphia Museum of Art

2600 Benjamin Franklin Parkway
Philadelphia, Pennsylvania 19130
Phone: 215-763-8100
Email: amartinfo@philamuseum.org
Web site: www.philamuseum.org
Timothy Rub, Director and CEO
Ann Percy, Curator of Drawings

The Philadelphia Museum of Art, founded in 1876, is one of the largest and most varied museums in the United States. It recently began developing its holdings of works by self-taught artists, an endeavor in which it has been greatly aided by a substantial gift of over 200 pieces from the Jill and Sheldon Bonovitz Collec-

tion. These works were the subject of a 2013 exhibition, "Great and Mighty Things." Other exhibitions featuring self-taught artists will be held from time to time.

Self-Taught Artists in the Collection

Felipe Archuleta, Eddie Arning, Emery Blagdon, David Butler, Miles B. Carpenter, James Castle, Bruno Del Favero, Sam Doyle, William Edmondson, Howard Finster, Lee Godie, Consuelo Gonzalez Amezcua, William Hawkins, S. L. Jones, Justin McCarthy, Sister Gertrude Morgan, Elijah Pierce, Martin Ramirez, Ellis Ruley, Jon Serl, Herbert Singleton, Simon Sparrow, Bill Traylor, Eugene Von Bruenchenhein, George Widener, Joseph Yoakum, Purvis, Young

SOUTH CAROLINA

The South Carolina State Museum

P.O. Box 100107
301 Gervais Street
Columbia, South Carolina 29202
Phone: 803-898-4921
Email: webmaster@scmuseum.org
Web site: www.museum.state.sc.us
Paul Matheny, Chief Curator of Art

The South Carolina State Museum is one of the most comprehensive museums in the southeast. The collections include objects of art, natural history, science and technology, and cultural history. Each discipline has an entire floor dedicated to the exhibits, focusing on its objects, and telling the story of that discipline in relation to South Carolina. The museum has been involved with two important folk art exhibitions in recent years: "Worth Keeping: Found Artists of the Carolinas," which was curated by Tom Stanley at the Columbia Museum of Art in 1981, and "Still Worth Keeping: Communities, Preservation and Self-Taught Artists," in 1997–1998. The museum has a store, and museum members receive discounts.

Self-Taught Artists in the Collection

Sam Doyle; miniature scrap metal machines of Walter Streetmyer; photographs of the L.C. Carson site plus a wood relief, "Fantasy" by Carson; Herron Briggs' scrap wood, scrap metal, fan blade and other found material airplane whirligigs; Dan Robert Miller's wood-carvings; a Pearl Fryar topiary piece; "City Within A City," a painting of Charleston Harbor by Marion Hamilton; Gene Merritt; and John Schwarz. There is a collection of photographs of environments from the book project *Self-Made Worlds: Visionary Folk Art Environments.*

Existing Environments

Environments are listed here alphabetically by the name(s) of the people who created them; check the Artists chapter for location and contact information.

L.C. Carson—Concrete City
Pearl Fryar—Topiary Garden

TENNESSEE

Austin Peay State University

P.O. Box 4677
Department of Art
Clarksville, Tennessee 37044
Phone: 931-221-7333
Email: dickinsm@apsu.edu
Michael Dickins, Director of Galleries

The Margaret Fort Trahern Gallery collection contains several painted cement sculptures by Tanner Wickham—"Sargeant York" and two "Sleeping Dogs."

The Mabel Larson Gallery is used to display items from the Department of Art's permanent collection, on a rotating basis. During fall semester 2014, the Larson Gallery displayed many items of folk art recently acquired through several donations. These include several William Edmondson stone carvings.

Museum of Appalachia

Physical location:
2819 Andersonville Highway

Clinton, Tennessee 37716
Phone: 865-494-7680
Mailing address:
P.O. Box 1189
Norris, Tennessee 37828
Email: museum@museumofappalachia.org
Web site: www.museumofappalachia.org
John Rice Irwin, Founder and Director
Elaine Irwin Meyer, Executive Director

Mr. John Rice Irwin, native of Tennessee, gathers Appalachian artifacts and installs them at the 75-acre Museum of Appalachia, located 15 miles north of Knoxville on Highway 1-75, exit 22. There is a schoolhouse and a church, several homes, a barn, a blacksmith shop—and many furnishings from the past. He not only collects the pieces, he collects the people's stories as well. There are craftspeople and artisans on hand at the annual Tennessee Fall Homecoming in October. The Museum of Appalachia also has a folk art collection, a gift shop, and a restaurant.

The Museum of Appalachia is part of Smithsonian Affiliations, a national outreach program that develops long-term, collaborative partnerships with museums, educational, and cultural organizations to enrich communities with Smithsonian resources. There are more than 180 Smithsonian Affiliates in more than 40 states, Puerto Rico and Panama. It is affiliated with the Smithsonian Institution.

Self-Taught Artists in the Collection
Troy Webb and his extended family of carvers; Minnie Black, creator of gourd creatures; Fred Carter of southwestern Virginia coal mining country, "Cedar Creek Charlie" Fields, who painted his house and almost everything in it with polka dots; Dow Pugh, whose carvings are on display; and others. There are special collections on display, one of handmade walking canes and another of carved figures. The Museum of Appalachia is "open during daylight hours the year 'round."

Knoxville Museum of Art
1050 World's Fair Park Drive
Knoxville, Tennessee 37916
Phone: 865-525-6101
Email: info@knoxart.org
Web site: www.knoxart.org
David L. Butler, Executive Director
Stephen Wicks, Curator of Art

The Knoxville Museum of Art opened in March 1990. During the 1990s it mounted several exhibitions of folk/self-taught/outsider art, including "O, Appalachia," April 2–June 7, 1991; "Fond Recollections of William Russell Briscoe," May 10–June 7, 1991, a 1992 exhibition of Mexican folk art from the Nelson A. Rockefeller Collection; "Patchwork Souvenirs of the 1933 Chicago World's Fair" (more than 39 award-winning quilts from the 1933 national competition),

May 3–July 21, 1996; and, "Awakening the Spirits: Art by Bessie Harvey," April 4, 1997–March 22, 1998, the first-ever retrospective museum exhibition of one of East Tennessee's most heralded self-taught artists.

The Museum's present focus is on contemporary international art and the art of East Tennessee. The Museum has a collection of works by Bessie Harvey, but they are not always on display. There is a permanent gallery of the history of art in East Tennessee, featuring artists working from 1850 to 1950. Works by Bessie Harvey may often be seen in that gallery, and periodically in another gallery, devoted to contemporary art. It is advisable to call ahead if you want to see Harvey's work, to be sure it will be on display during your visit.

Carl Van Vechten Gallery of Fine Arts
1000 17th Avenue North
Fisk University
Nashville, Tennessee 37208
Phone: 615-329-8720
Web site: http://www.fisk.edu/services-resources/fisk-university-galleries/the-carl-van-vechten-gallery
Kevin Grogan, Director

The Carl Van Vechten Gallery of Fine Arts has a collection of non-traditional folk art and outsider art. The collection, based upon a gift from A. Everette James, is titled "The James Collection at Fisk."

Self-Taught Artists in the Collection
Z.B. Armstrong, W.A. Cooper, Sam Doyle, Alvin Jarrett, Anderson Johnson, Eric Calvin McDonald, Sister Gertrude Morgan, Vannoy Streeter, Wesley Stewart, Sarah Mary Taylor, Mose Tolliver

Cheekwood Museum of Art
1200 Forrest Park Drive
Nashville, Tennessee 37205
Phone: 615-356-8000
Phone: 877-356-8150 (toll-free)
Email: info@cheekwood.org
Web site: www.cheekwood.org
Jane O. McLeod, President and CEO
Jochen Wierich, Chief Curator of Art

Cheekwood Museum of Art was founded on the holdings of the Nashville Museum of art in 1959, and has been expanding since then. With respect to self-taught art, the acquisition of seven more limestone sculptures by Nashville artist William Edmondson means the Cheekwood now has the largest collection of this artist's work (Newark Museum has the second largest). The museum has 20 pieces. The four most important of these are "Bess and Joe"; "Eve," "Girl with Cape," and "Reclining Man." These were displayed in an exhibition, "William Edmondson: The Hand and the Spirit," in 2013. 2014 saw a major exhibition, "William Edmondson and Friends," that featured 30 of Ed

mondson's sculptures accompanied by 20 works of people who feel they have been influenced by him, including Thornton Dial, Sr., and Lonnie Holley. The web site has information on "Bess and Joe" in the "On-Line Collection."

Cheekwood organized the first traveling retrospective on William Edmondson and the first catalog on the artist since 1981.

Existing Environments

Environments are listed here alphabetically by the name(s) of the people who created them; check the Artists chapter for location and contact information.

Chris Little

Billy Tripp—Mindfields

Enoch Tanner Wickham—Memorials

TEXAS

Art Museum of Southeast Texas

500 Main Street

Beaumont, Texas 77701

Phone: 409-832-3432

Email: info@amset.org

Web site: www.amset.org

Lynn P. Castle, Executive Director and Curator of Exhibitions and Collections

The museum has a permanent collection of works by self-taught artists, and often has a small exhibition of these works on view. The museum tries to have at least one major folk art exhibition each year.

The extensive collection of the environmental works of Felix "Fox" Harris has had "a tumultuous history" at the museum since Harris's death in 1985. Pieces have gone through numerous installation locations, de-installations due to threats of inclement weather and subsequent long-term storage. Finally in August 2007, AMSET unveiled *Somethin' Out of Nothin': The Works of Felix "Fox" Harris*, a semi-permanent gallery and resting place for these Beaumont treasures. The exhibition gallery contains 26 of Harris's totem-like structures, photographs of his home and environment, and other material related to his life. The museum mounts other exhibitions of self-taught artists from time to time, including one for "Sarah Mary Taylor: Yazoo City Quilter." In 2014 it spotlighted the carvings of Sulton Rogers.

Self-Taught Artists in the Collection

Josefina Aguilar, Irene Aguilar, Leroy Archuleta, Freddy Avila, Cyril Billiot, Ivy Billiot, Loy "The Rhinestone Cowboy" Bowlin, Earl Cabaniss, Alfonso Castillo, Floyd O. Clark, Ennis Craft, Jr., Patrick Davis, Mamie Deschillie, Roy Ferdinand, Jr., Felix "Fox" Harris, John L. Hunter, James Harold Jennings, Beatrice Jimenez, M.C. "5¢" Jones, S.L. Jones, Edd Lambdin, Junior Lewis, Deacon Eddie Moore, Paul Moseley, Marcia Muth, Rosalie Pinto, Royal Robertson, Ronnie Rodriguez, Sulton Rogers, Xmeah ShaEla'ReEl, Welmon Sharlhorne, Isaac Smith, Tom Tarrer, James "Son" Thomas, Daniel Troppy, Hubert Walters, Velox Ward, Willard "The Texas Kid" Watson, Fred Webster, Onis Woodard

African American Museum of Dallas

P.O. Box 150153

3536 Grand Avenue at Fair Park

Dallas, Texas 75315

Phone: 214-565-9026

Email: info@aamdallas.org

Web site: www.aamdallas.org

Harry Robinson, Jr., Director

The African American Museum was founded in 1974 as a part of the Special Collections at Bishop College, a Historically Black College that closed in 1988. The Museum has operated independently since 1979. The $7 million edifice was funded through private donations and a 1985 Dallas City bond election that provided $1.2 million for the construction of the new facility. The African American Museum is the only one of its kind in the Southwestern Region devoted to the preservation and display of African American artistic, cultural and historical materials. It has one of the largest African American Folk Art collections in the United States, which began with a gift from Mr. and Mrs. Billy R. Allen. Other donors to the collection were Dr. Warren & Sylvia Lowe, Dr. Bobby Alexander, and Phillip Vaccaro. The Folk Art collection is housed in the Sam and Ruth Bussey Gallery on the Museum's first floor.

A rich heritage of African American Art and history is housed in four vaulted galleries, augmented by a research library. Visitors can also experience living black culture through the museum's educational and entertaining programs presented in the educational plaza, which includes a theatre and classrooms.

Self-Taught Artists in the Collection

John W. Banks, Nathaniel Barrow, Calvin J. Berry, Cyril Billiot, Hawkins Bolden, David Butler, Roy Ferdinand, Milton A. Fletcher, Ralph Griffin, Dilmus Hall, Lonnie Holley, Robert Howell, Clementine Hunter, John L. Hunter, Frank Jones, M.C. "5¢" Jones, Harvey Lowe, Sam McMillan, Sister Gertrude Morgan, Royal Robertson, Sulton Rogers, J.P. Scott, Cherry ShaEla'ReEl, Xmeah ShaEla'-ReEl, Welmon Sharlhorne, Joseph Sharlow, Earl Simmons, Daniel Simon, Herbert Singleton, Ed Smith, Johnny Ray Smith, Georgia

Speller, Jimmy Lee Sudduth, Johnnie Swearingen, L.T. Thomas, Mose Tolliver, Hubert Walters, Willard "Texas Kid" Watson, Derek Webster, George White, "Artist Chuckie" Williams, George Williams, Jeff Williams, Wesley Willis

The Menil Collection

1515 Sul Ross
Houston, Texas 77006
Phone: 713-525-9400
Email: info@menil.org
Web site: www.menil.org
Josef Helfenstein, Director

The Menil Collection opened in 1987 to house, preserve, and exhibit the art collection of Houston residents John and Dominique de Menil. Considered one of the most important privately assembled collections of the twentieth century, the Menil Collection included, in 2014, approximately 17,000 paintings, sculptures, prints, drawings, photographs, and rare books; masterpieces from antiquity, the Byzantine world, and the tribal cultures of Africa, Oceania, and the American Pacific Northwest. The twentieth century are particularly well represented. The Menil Collection includes a library and a bookstore.

Self-Taught Artists in the Collection

Felipe Archuleta, Howard Finster, Johnny Swearingen, Henry Ray Clark, Charles A.A. Dellschau, Earnest C. Hewitt, Frank Jones, Forrest Bess, Jeff McKissack, and Bill Traylor, among others

The San Antonio Museum of Art

200 W Jones Avenue
San Antonio, Texas 78215
Phone: 210-978-8100
Email: info@samuseum.org
Web site: www.samuseum.org
Katie Luber, Director

The San Antonio Museum of Art is housed in the historic Lone Star Brewery complex along the banks of the San Antonio River. The Museum has over 85,000 square feet of exhibition space and more than 23,000 art objects in its collection. The mission of the Museum is to collect, preserve, exhibit, and interpret significant works of art representing a broad range of history and world cultures. The museum's collections are encyclopedic, with endowed curatorships in Asian Art, Art of the Ancient Mediterranean World, American Art, Latin American Art, and Contemporary Art.

The Museum's strongest folk art collections are in Spanish and Latin American art, with approximately 6,000 objects from the collections of Peter P. Cecere, Robert K. Winn, and Nelson A. Rockefeller.

The Museum's American folk art collections consist mainly of 19th and early 20th century Texas furniture, utilitarian pottery, and other objects. Among the artists in the American folk art collection are paintings and drawings by Eddie Arning (1898–1993), Bill Traylor (1853–1949), and John W. Banks (b. 1912). Artists represented in the American folk sculpture collection are New Mexicans Felipe Archuleta (1910–1991), José Mondragon (1931–1989), Sabanita López Ortiz (nd), Alex Sandoval (1898–1989), and Jerry Sandoval (nd), and a number of anonymous artists. Texans Dionisio Rodriguez (1891–1955), José Varela (1907–1996), Eliseo Alvarado (1911–2001), and a number of anonymous folk artists are also well-represented.

The Museum owns a collection approximately 50 works by German/Texan self-taught folk artist C.A.A. Dellschau (1833–1923). Most of these are folio size mixed media works from the end of the 19th century or the earliest part of the 20th century.

Existing Environments

Environments are listed here alphabetically by the name(s) of the people who created them; check the Artists chapter for location and contact information.

Robert Harper — The Fan Man
Ida Mae Kingsbury (art is now in Lucas, KS)
Jeff McKissack — The Orange Show
John Milkovisch — Beer Can House
Samuel Mirelez
Cleveland Turner — The Flower Man

UTAH

Existing Environments

Environment is listed by the name of the person who created it; check the Artists chapter for location and contact information.

Thomas Battersley Childs — Gilgal Gardens

VIRGINIA

Longwood Center for the Visual Arts

129 N. Main Street

Farmville, Virginia 23901
Phone: 434-395-2206

Email: fasa@folkart.org
Web site: http://www.folkart.org
Rachel Ivers, Director of LCVA
Jill Manning, Assistant

The Longwood Center for the Visual Arts is part of Longwood College in Farmville. The Center mounts a continuously changing array of exhibitions and is committed to devoting two exhibitions a year to folk and self-taught art. These may be traveling exhibitions, such as the recent on featuring the art of Mr. Imagination, curated and originally shown at the American Folk Art Museum. Or they may be exhibitions developed by the center. The Longwood Center recently received a large gift of folk, self-taught, and outsider art and related materials from the Ann and William Oppenheimer Collection, which will play a part in many future exhibitions. A library and resource center will opened in 2015 to make these materials available to interested parties, including over 1000 books and archival materials pertaining to folk and self-taught art.

Meadow Farm Museum

3400 Mountain Road
Glen Allen, VA 23060
Phone: 804-501-2130
Email: henrec@co.henrico.va.us
Web site: www.henricohistoricalsociety.org/brookland.
 meadowfarm.html

The museum, part of Henrico County's Division of Recreation and Parks, is located in a 150-acre park in Glen Allen, Virginia, and includes a nineteenth century farmhouse and outbuildings. Staff demonstrate traditional folk life skills throughout the year. Folk art exhibitions occur on an annual basis in the exhibition gallery. The museum includes a library and an archival collection containing books, catalogs, periodicals, research files, and slides on many contemporary folk artists, with an emphasis on the work of Virginia folk artists. There is a collection of video tapes (VHS) on the following artists: Ann Murfee Allen, Edward Ambrose, Eldridge Bagley, Abe Criss, Anderson Johnson, Selma Keith, Marion Line, Oscar Spencer.

The collection and archives are open to the public by appointment. Call ahead for information on exhibitions, museum hours, and access to the farmhouse.

Self-Taught Twentieth-Century Artists in the Collection

Edward Ambrose, Norman Amos, Eldridge Bagley, Patsy Billups, Georgia Blizzard, Abe Criss, Alpha Frise, Lonnie Holley, James Harold Jennings, Anderson Johnson, S.L. Jones, Jacob Jones Kass, Selma Keith, Marion Line, John Mason, Eugene Poore, Elmer Smith, Oscar Spencer, Jimmy Lee Suddath, Mose Tolliver

Anderson Johnson Gallery at the Downing-Gross Cultural Arts Center

2410 Wickham Avenue
Newport News, Virginia 23607
Phone: 757-525-7372
Email: mkayaselcuk@nngov.com
Mary Kayaselcuk, Historic Site Coordinator

This museum is devoted to the work of Anderson Johnson, the son of a Lunenburg County sharecropper. At the age of eight, while hoeing his father's cornfield, he was struck by a life-changing vision of angels. Baptized at the age of 12 by Bishop C.M. "Sweet Daddy" Grace, he began his ministry and became an attraction on the revival circuit. In the ensuing years, Johnson traveled throughout the United States, teaching himself to draw, play piano and guitar and preach the gospel. In mid-life, God instructed him to settle in Newport News. In his home at 1224 Ivy Avenue, he established his house of worship, the Faith Mission. To attract passersby so that he might bring them to Jesus, he adorned both the exterior and interior with folk art paintings. Some were life-size wall murals; most were done on cardboard and other scrap materials. His milieu was a mystical realm populated with thousands of faces—portraits of U.S. presidents, women, figures from the Bible, celebrities, animals and foremost, angels. In 1987, the city of Newport News purchased his home for an urban renewal project. Prior to demolition, the murals and other significant pieces were removed so that they might become part of a permanent exhibition highlighting his story. Using over 600 pieces of visual art and architectural salvage, the gallery at Downing-Gross Cultural Arts Center recreates vignettes from the Faith Mission. The theater offers an orientation film "Bound for the Promised Land' which incorporates footage of Johnson at praise in sermon and song. You are invited to enter the world of Anderson Johnson—his Zion—to view the man and his work on his own terms.

Baron and Ellin Gordon Galleries at Old Dominion University

4509 Monarch Way
Norfolk, Virginia 23508
Phone: 757-683-6271
Email: raustin@odu.edu
Web site: www.odu.edu/gordongalleries
Robert Wojtowicz, Director
Ramona Austin, Curator

The Baron and Ellin Gordon Art Galleries, as a part of the College of Arts and Letters at Old Dominion University, promotes the advancement of knowledge through research and scholarship in the arts and seeks to develop a respect for the dignity and worth of the

individual, a capacity for critical reasoning and a genuine desire for learning in the campus and regional community. It fosters the extension of the boundaries of knowledge and is committed to the preservation and dissemination of a rich cultural heritage through exhibitions, lectures and seminars, classes, guided tours and special programs.

In 2007 Baron and Ellin Gordon donated 375 folk art works by self-taught artists from their collection. The university relocated its galleries in 2007 to a new state-of-the-art 15,000-square-foot facility located at 4509 Monarch Way on the east side of campus. The Baron and Ellin Gordon Self-Taught Art Gallery showcases self-taught art and its relation to contemporary art with shows, drawing on the permanent collection and loans to the galleries.

Self-Taught Artists in the Collection
Levent Isik, Kent Michael Smith, Ronald Stone, Derek Webster

Anderson Gallery
Virginia Commonwealth University
907 ½ West Franklin Street
Richmond, Virginia 23284
Phone: 804-828-1522
Email: ???
Web site: www.arts.vcu.edu/andersongallery
Ashley Kistler, Gallery Director
Tracy Garland, Collections Specialist

The Anderson Gallery has an extensive permanent collection and within it a small but growing collection of contemporary self-taught art; it has supported this field over the years with various exhibitions. Among these have been: "What It Is: Black American Folk Art from the Collection of Regenia Perry," October 6–27, 1982; "Under the Cloak of Justice: The Work of Ned Cartledge," January 21–March 6, 1994; and "Ruth Clide Proffitt: An Unrecognized Artist," June 26–September 27, 1998.

Self-Taught Artists in the Collection
William Edmondson, Howard Finster, Sister Gertrude Morgan, Ruth Clide Proffitt

Virginia Union University Museum
1500 North Lombard Street
Richmond, Virginia 23222
Phone: 804-257-5660
Web site: http://www.vuu.edu/vuu_museum/folk_art.aspx

The Sellman Collection of African American Folk Art at Virginia Union University's museum is a vibrant and fascinating part of its collection. Given to the Museum by Dr. and Mrs. James Sellman, the collection consists of the works of over ten important vernacular artists, most notably Mose Tolliver and Thornton Dial.

The collection contains a wide variety of water colors, oil paintings, and three dimensional works. On display in 2014 were nearly fifty of Thornton Dial's paintings. VUU also owns extensive collections of African and Oceanic art.

Self-Taught Artists in the Collection
Hawkins Bolden, L.W. Crawford, Arthur Dial, Thornton Dial, Jr., Thornton Dial, Sr., Ralph Griffin, Theodore Hill, Lonnie Holley, Joe Light, Mary T. Smith, Henry Speller, Annie Tolliver, Mose Tolliver, Felix Virgous

Taubman Museum of Art
(formerly Art Museum of Western Virginia/Center in the Square)
110 Salem Avenue SE
Roanoke, Virginia 24011
Phone: 540-342-5760
Della Watkins, Director
Amy Moorefield, Director of Exhibitions
Email: amoorefield@taubmanmuseum.org
Web site: www.taubmanmuseum.org

The Art Museum of Western Virginia was established in 1951 and has, among other objects, a small collection of folk/outsider art including more than seventeen pieces by Howard Finster, two pieces by Leroy Almon, Sr., three pieces each by Mose Tolliver, Fred Webster, and B.F. Perkins, and face jugs by Burlon Craig. The museum has a commitment to "expanding this collection, exhibiting works of this nature regularly and also sharing the works in our collection with other institutions."

Self-Taught Artists in the Collection
Garland Adkins, Minnie Adkins, Leroy Almon, Sr., Richard Burnside, Ronald Cooper, Burlon Craig, Howard Finster, James Harold Jennings, S.L. Jones, Jacob James Kass, B.F. Perkins, Eugene Poore, Oscar Spencer, Hugo Sperger, Mose Tolliver, Fred Webster, Purvis Young

Miles B. Carpenter Folk Art Museum
201 Hunter Street
Waverly, Virginia 23890
Phone: 804-834-3327
Shirley S. Yancey, Director

The Museum, Miles Carpenter's white frame house, is located on Route 460 in Waverly, Virginia, between Petersburg and Suffolk. It was founded in 1986. The Museum collects artifacts, photographs, slides, and newspaper clippings about the wood carver's life and art. The museum houses and displays the largest single collection of Carpenter's artworks, comprising over 200 pieces. A docent is available when the museum is open, and offers guided tours. The museum does not have a website, but maintains an active Facebook page.

This is also the site for the First Peanut Museum in the USA.

Abby Aldrich Rockefeller Folk Art Center

326 Francis Street, West
Williamsburg, Virginia 23185
Phone: 888-965-7254 (toll-free)
Web site: www.colonialwilliamsburg.com/do/art-museums/rockefeller-museum
Carolyn J. Weekley, Director of Museums

The Folk Art Center opened its new facilities on May 1, 1992. The 19,000 square foot space includes nine exhibition galleries, administrative offices, a library, research facilities and a gift shop. The archival collection includes all types of materials from earliest times to the present. Access to the library and to the archives requires an appointment. Started in 1957 to house the collection of Abby Aldrich Rockefeller, there are now 3,000 objects from the eighteenth, nineteenth, and twentieth centuries.

Self-Taught Twentieth-Century Artists in the Collection
 Eddie Arning, Miles Carpenter, Steve W. Harley, Karol Kozlowski, Benniah G. Layden, Lawrence Lebduska, Edgar A. McKillop, Martin Ramirez, Irwin Weil; also tramp art, American quilts.

WASHINGTON

Washington State Historical Society

1911 Pacific Avenue
Tacoma, Washington 98403
Phone: 253-798-5925
Email: lynette.miller@wshs.wa.gov
Web site: www.washingtonhistory.org

The collection of the Historical Society consists of paintings, several of which date to the late nineteenth century. One exception is the Ronald Debs Ginther collection of watercolors painted 1929–1935, which depict Depression scenes in the Pacific Northwest.

Self-taught painter Ginther was once a member of the Industrial Workers of the World (IWW). An appointment is required to view this collection.

Existing Environments
 Environments are listed here alphabetically by the name(s) of the people who created them; check the Artists chapter for location and contact information.
 Emil and Veva Gehrke—Windmills
 Milton Walker—Walker Rock Garden

WEST VIRGINIA

Huntington Museum of Art

2033 McCoy Road
Huntington, West Virginia 25701
Phone: 304-529-2701
Web site: www.hmoa.org
Margaret Mary Layne, Director

The Huntington has many important collections including its famous glass collection; American, French and English paintings and graphics; decorative arts; and several other categories, including regional art. There is a first-rate collection of decorated powder horns and over 350 folk canes. The museum also houses a collection of pre–twentieth-century folk art. The collection of contemporary folk art focuses on works from Appalachia. Some especially powerful pieces are a boat with six people fishing by Willie Massey; a concrete sculpture, "The Death of Dr. Crawford," and "Crucifixion" by Dilmus Hall; a "Tower of Babel" under construction with workers carrying bricks up the sides of the tower, by Herman Hayes. "The Girl Band" by Noah Kinney and the "dancing puppets" of Charley Kinney are in the Huntington collection. There are twenty major pieces by artist Evan Decker including a life-sized horse and his famous "Cardinal Cage." In 2014 the museum presented the exhibition, "Self-taught, Outsider, Visionary: Highlights from the Folk Art Collection," which featured works from its more than 200 outstanding examples of paintings, drawings, sculpture, textiles and "eccentric" or vernacular furniture by self-taught artists. The bulk of this rich collection is made up of works created by artists from Kentucky, West Virginia, and other Southern Appalachian states, most of which the museum acquired in the 1980s and 1990s, but works are still being added to this collection. A number of these artists, including Evan Decker, S.L. Jones, Minnie Adkins, and Charley and Noah Kinney, are represented by a large numbers of objects.

Self-Taught Twentieth-Century Artists in the Collection
 Minnie and Garland Adkins, Linvel Barker, Minnie

Black, Jessie Cooper, Paul "Baltimore Glassman" Darmafall, Evan Decker, G.C. "Creative" DePrie, Carlton Garrett, Earl Gray, Dilmus Hall, T.A. Hay, Herman Hayes, Anderson Johnson, S.L. Jones, Charley Kinney, Noah Kinney, Edd Lambdin, Leroy Lewis, Tim Lewis, Willie Massey, Carl McKenzie, Paul Patton, Bobby Quinlan, "Butch" Quinn, Arnold "Spark Plug" Sparks, Nina Sparks, Jimmy Lee Sudduth, Donny Tolson, Edgar Tolson

Art Collection/Marshall University Graduate College

100 Angus E. Payton Drive
South Charleston, West Virginia 25303
Phone: 304-746-2038
Web site: www.marshall.edu/SCHAS/art-collection/
works-by-artist

The Marshall University Graduate College Art collection was established to enhance the aesthetic environment, to provide people with an opportunity to view and enjoy art, and to provide an opportunity for the exhibition of the talents of outstanding West Virginia artists. The collection embraces a wide variety of media including, but not limited to, photography, print making, sculpture, painting, and wood-carving. Two self-taught West Virginia artists included in the collection are Earl Gray and Herman Hayes. Works are hung in buildings all around the campus; the website allows you to locate works by artist, then giving their location, or works by location, then giving the artists whose works are in that building.

Museum/Oglebay Institute

Route 88
Wheeling, West Virginia 26003
Phone: 304-242-7272
Web site: www.oionline.com
Christin Byrum, Director
Lindsay Davis, Curator

The museum has a permanent collection that includes paintings by many artists important to the heritage of the area. Included in this collection are two paintings by Patrick J. Sullivan.

WISCONSIN

Global Arts (Rudy Rotter's Sculptures)

2402 Franklin Street
Manitowoc, Wisconsin 54220
Phone: 920-242-0717
Web site: www.globalarts.biz

Rudy Rotter was a local dentist-turned-sculptor who went on to become the most prolific artist in Wisconsin history. Rotter died in 2001, leaving behind a museum and studio (improvised out of this well-worn warehouse) and an estimated 17,000 works; some 11,000 of which were housed in this museum during his lifetime. With his death in 2001, the museum closed, but all of his work has been preserved. Global Arts maintains, conserves, and manages the collection, and displays it at a warehouse at the above address, where it can be seen by appointment (call first to arrange). Some pieces may also be for sale.

Milwaukee Art Museum

700 North Art Museum Drive
Milwaukee, Wisconsin 53202
Phone: 414-224-3200
Email: mam@mam.org
Web site: www.mam.org
Daniel Keegan, Director
Heather L. Winter, Librarian/Archivist

The Milwaukee Art Museum, in its magnificent lakeside setting, has a substantial folk art collection. The twentieth century holdings increased significantly with the 1989 acquisition of the Michael and Julie Hall Collection of American Folk Art and the more recent acquisition of the Anthony Petullo Collection, which includes European as well as American self-taught artists. In the future the collection will be permanently installed in a separate space dedicated to American folk art. The museum also has numerous pieces from the Possum Trot environment of Calvin and Ruby Black and an extensive collection of works by Edgar Tolson. It has face jugs by E.J. Brown, Bob Brown, and Burlon Craig; walking sticks by Ben Miller, Denzil Goodpaster, and others; and also many anonymous pieces in each category above. The museum also has one of the largest collections of Haitian art in the country, as well as a growing collection of American and European outsider art.

Self-Taught Twentieth-Century Artists in the Collection

Fred Alten, Consuelo Amezcua, Felipe Archuleta, Eddie Arning, Calvin and Ruby Black, William J. Blackmon, William Alvin Blayney, James Bloomfield, Freddie Brice, Cleveland Brown, Matthew Brzostoski, Richard Burnside, Vernon Burwell, David Butler, Miles B. Carpenter, James Castle, Anna D. Celletti, Raymond Coins, Gloria Lopez Cordova, James Crane, Henry

Darger, Sanford Darling, Ulysses Davis, Vestie Davis, William Dawson, Thornton Dial, Sr., Sam Doyle, Burgess Dulany, Minnie Evans, Josephus Farmer, Ralph Fasanella, Howard Finster, Victor Joseph Gatto, Lee Godie, Denzil Goodpaster, Ted Gordon, Anne Grgich, Dilmus Hall, Bertha Halozan, Ray Hamilton, James Hampton, Bessie Harvey, William Hawkins, Morris Hirshfield, Albert Hoffman, Lonnie Holley, Jesse Howard, Clementine Hunter, J.C. Huntington, Jerry Iverson, Anderson Johnson, Clyde Jones, Frank Jones, S.L. Jones, L. M. Kalas, John Kane, Charley Kinney, Lawrence Lebduska, Michael Lenk, Abraham Levin, Jim Lewis, Tim Lewis, Harry Lieberman, Dwight Mackintosh, Justin McCarthy, Carl McKensie, Lanier Meaders, Oscar de Mejo, Anna Louisa Miller, Ben Miller, R. A. Miller, Sister Gertrude Morgan, Ike Morgan, "Grandma" Moses, Mark Anthony Mulligan, Eddie Mumma, J.B. Murry, William Oleksa, Jose Benito Ortega, Earnest Patton, John Perates, B. F. Perkins, Elijah Pierce, Stephan Polaha, Stephen Poleskie, John Poppin, Daniel Pressley, "Old Ironsides" Pry, Martin Ramirez, Earnest "Popeye" Reed, J. Richardson, Royal Roberston, Juanita Rogers, Nellie Mae Rowe, Anthony Joseph Salvatore, Theodore Santoro, Jack Savitsky, Antoinette Schwob, James Scott, Jon Serl, Bernice Sims, Drosses P. Skyllas, Mary T. Smith, Simon Sparrow, Henry Speller, Oscar Spencer, Hugo Sperger, Quinton Stephenson, Clarence Stringfield, Jimmy Lee Sudduth, Luis Tapia, Sarah Mary Taylor, Carter Todd, Mose Tolliver, Edgar Tolson, Bill Traylor, Gregory Van Maanen, Eugene Von Bruenchenhein, Inez Nathaniel Walker, Gregory Warmack ("Mr. Imagination"), Derek Webster, "Chief" Willey, Clarence and Grace Woolsey, Joseph Yoakum, Albert Zahn

John Michael Kohler Arts Center

P.O. Box 489
608 New York Avenue
Sheboygan, Wisconsin 53082
Phone: 920-458-6144
Web site: www.jmkac.org
Ruth DeYoung Kohler, Director

The John Michael Kohler Arts Center was established in 1967 with the mission of encouraging and supporting innovative exploration in the arts. Since the 1970s, the Arts Center has been involved in the preservation, study, and exhibition of work by vernacular artists and has worked closely with Kohler Foundation, Inc. (KFI—see Organizations) to preserve the objects and environments they have made. Artist-environment builders transform their homes, yards, or other aspects of their personal surroundings into multifaceted works of art that, in vernacular ways, embody and express the locale—time, era, place—in which each of them lived and worked. The artists' locales, histories, ways of learning, and reasons for art-making are widely varied, though they share in having

a powerful connection to home-as-art-environment; each expresses the ineffable qualities of place according to nativist understandings and insights.

Along with in-depth work to preserve art environments came the realization that not all of them could be retained on their original site. The Arts Center adopted as the primary thrust of its collecting efforts acquiring and caring for large bodies of inter-related objects from dismantled art-environments, following the conviction that objects made as elements of an art environment relate to one another and bolster overall meaning in a way that isolated components do not. Each painting, sculpture, drawing, or photograph was initially envisioned, by the artist, as an element of a comprehensive and dynamic installation and, furthermore, her or his home. The Arts Center strives to maintain and convey the connectivity of art objects created in this specific way and offer, through documentation of the original art-environment and carefully researched exhibitions and publications, expansive views into the lives of artists situated within a tapestry of artistic and cultural heritage. Often hundreds of a single artist's work are preserved and presented together at the museum.

Arts center memberships are available and help support the extensive arts programming. Members receive many benefits including free or reduced admissions to many events; discounts to attend classes and take part in trips; a discount in the museum shops; and a subscription to the bimonthly newsletter and other mailings. Write to the center for information and application.

The John Michael Kohler Arts Center has an outstanding volunteer organization called Friends of Art with over 600 active participants. The purpose of the Friends of Art is to support and supplement the programs of the center and to promote a public awareness of the programs. Friends of Art participate in nearly every aspect of the arts center. There is a docent program which contributes nearly 350 hours of volunteer time annually. Hundreds of volunteers contribute to the success of annual special events, to workshops and classes, mailings, clerical office work and much more. Volunteers range from young teens to senior adults. People living near this museum/arts center have an unusual opportunity to contribute to this community resource.

The Kohler Foundation, Inc. is a separate organization and has been involved in many site preservation projects within the state.

American Artists Whose Environments Are Represented in the Collection

Levi Fisher Ames, Jacob Baker, Emery Blagdon, Loy Allen "Rhinestone Cowboy" Bowlin, David Butler, John Ehn, Nick Engelbert, Tom Every, Ernest Hupenden, Peter Jodacy, Mary Nohl, Frank Oebser, Carl Peterson, Clarence M. Powell, Sam Rodia, Herman

Rusch, Dr. Charles Smith, Fred Smith, James Tellen, Eugene Von Bruenchenhein, Stella Waitzkin, Albert Zahn

Museum of Woodcarving

Highway 63 North
P.O. Box 371
Shell Lake, Wisconsin 54871
Phone: 715-468-7100
Maria McKay, Director
Web site: http://www.roadsideamerica.com/story/2252

This museum houses the work of one man, Joseph T. Barta, who carved one hundred life-sized figures and over four hundred miniatures, most of these pieces are here and attract many visitors. It is open May 1 through October 31, daily from 9 a.m. to 6 p.m.

Existing Environments

Environments are listed here alphabetically by the name(s) of the people who created them; check the Artists chapter for location and contact information.

Nick Engelbert—Grandview
Tom Every—Dr. Evermor and Foreverton
Ernest Hupenden—Painted Forest
Mary Nohl—Yard art
Frank Oebser—Little Program
Herman Rusch—Prairie Moon Sculpture Garden and Museum
Fred Smith—Concrete Park
James Tellen—Woodland Sculpture Garden
Father Phillip J. Wagner—Grotto and Wonder Cave
Paul and Matilda Wegner—Grotto
Father Mathias Wernerus—Holy Ghost Park/Dickeyville Grotto
Clyde Wynia—Jurustic Park

OTHER RESOURCES

The **University of Georgia Art Department** has a folk art archive, including material on Dilmus Hall.

The **Library and Archives of the University of Kentucky** houses the University of Kentucky Oral History program which includes sixty tapes of interviews with participants from the field of folk art collected by Julie Ardery. Among these are interviews with Russell Bowman, Carl Hammer, Chuck Rosenack, Herbert Hemphill, Rick Bell, John Ollman, Minnie Adkins, Carl McKenzie, Donny Tolson and many others. A list is included in the bibliography section of Ms. Ardery's book, *The Temptation: Edgar Tolson and the Genesis of Twentieth Century Folk Art* (University of North Carolina Press, 1998). The Folk Art Society of America has a library and archives.

The **Jean and Alexander Heard Library at Vanderbilt University** has, in its Special Collections and University Archives, "Self-taught Artist Resources" (S.T.A.R.), which started with records and materials donated by Dan Prince. Prince donated more than 40 cubic feet of photographs, slides, artists' biographies and other supporting papers. There are plans to develop a national repository for documents about American self-taught art in order to become a center for research in the field. The contact person is Marice Wolfe. *Phone:* 615-322-2807; *Fax:* 615-343-9832.

Additional resources for research are the libraries of museums that have folk art collections, some of which were noted above, and/or have curated exhibitions in this field.

ORGANIZATIONS

Organizations supply opportunities for camaraderie with those who share an interest in folk art, programs for learning about and seeing folk art and artists, and in some cases the chance to work on projects of interest that enhance the appreciation of this field and its creative work.

The organizations described have a variety of purposes and memberships. The first two organizations listed, the Folk Art Society of America at Longwood Center for the Visual Arts and Intuit: The Center for Intuitive and Outsider Art, are membership groups with a national base. The next four organizations are membership-based with local or regional interests. Next on the list are organizations devoted to the education, development, and/or protection of folk art environments. The last six organizations are mostly cultural in focus or sponsor publications or other activities of interest to those who enjoy contemporary folk, self-taught, and outsider art.

The Folk Art Society of America at Longwood Center for the Visual Arts (FASA@LCVA)

FASA Office contact information:
P.O. 17041
Richmond, Virginia 23226
Email: fasa@folkart.org
Web site: www.folkart.org
LCVA location and contact information:
129 N. Main Street
Farmville, Virginia 23901
Phone: 434-395-2207
Web site: http://lcva.longwood.edu/collections/folk-art
Rachel Ivers, Director of LCVA
Jill Manning, Assistant

The Folk Art Society of America was founded in 1987 by fourteen Richmond-based people who shared an interest in folk art and artists. The Society now has members from all over the United States and several foreign countries. In 2014 it merged with Longwood College and was renamed The Folk Art Society of America at Longwood Center for the Visual Arts. Its goals continue to be to discover, promote, study, document, and preserve folk art, folk artists, and folk art environments. With the merger, the functions that were once performed exclusively by the Society have been split. Longwood Center now houses the FASA archives and research library, comprising FASA's collection of books, exhibition catalogs, videotapes, slides, photographs, and primary source materials. Call 434-395-2207 in advance for an appointment. FASA continues to produce the *Folk Art Messenger*, a three-times-a-year publication that features news and articles about artists, exhibitions, publications, and a calendar of events. FASA will produce its annual conference and associated auction in 2015, after which Longwood Center will take on the task of conference and auction organizing for 2016 and beyond. The conference has been held in a different city each year; recent conferences have visited Richmond, Washington, Santa Fe, New Orleans, Los Angeles, Chicago, Atlanta, Milwaukee, Columbus, Phoenix, Houston, Lexington, and Memphis. FASA continues to answer the email, maintain the website, and handle membership, benefits of which include a subscription to the newsletter, advance registration for the annual conference, access to the library, discounts on folk art books, and opportunities to participate in a wide variety of folk art related programs and activities. There are many levels of membership available and an application for membership will be sent upon request. FASA also maintains a very active Facebook page, which can be reached directly

or through the FASA website. For membership, *Folk Art Messenger*, and the 2015 conference, contact FASA through the P.O. Box, the email, or the website given for FASA. To reach Longwood Center, use the phone number or website given for LCVA.

Also see entries for FASA at LCVA under Auctions and Other Publications.

Intuit: The Center for Intuitive and Outsider Art

756 North Milwaukee Avenue
Chicago, Illinois 60622
Phone: 312-243-9088
Email: intuit@art.org
Web site: www.art.org
Deborah Kerr, Executive Director

Established in 1991, Intuit: The Center for Intuitive and Outsider Art (Intuit), is the only nonprofit organization in the United States that is dedicated solely to presenting self-taught and outsider art—with important *exhibitions*; resources for scholars and students; a *Permanent Collection* with holdings of more than 1,100 works of art; the *Henry Darger Room Collection*; the *Robert A. Roth Study Center*, a non-circulating collection with a primary focus in the fields of outsider and contemporary self-taught art; and *educational programming* for people of all interest levels and backgrounds.

Intuit recently incorporated gallery space in which to display works in its permanent collection, as well as to mount special exhibitions. The organization sponsors many events, including exhibitions, tours to environments, lectures, visits to collectors and their collections. Members receive a subscription to *The Outsider*, discounts on books and merchandise, discounts on house tour events, invitations to exhibitions and other events, invitations to study tours, and use of the study center. There is a sales shop at the organization headquarters that offers members a ten percent discount. Available are hard to find outsider art books, "exclusive T-shirts and quirky gifts found nowhere else in Chicago." Several categories of membership are available.

Also see entries for Intuit under Museums and Other Publications.

Friends of Folk Art/Museum of International Folk Art

P.O. Box 2065
Museum of New Mexico Foundation
Santa Fe, New Mexico 87504
Phone: 505-982-6366
Phone: 888-553-6663 (toll free)
Web site: www.museumfoundation.org/friends-folk-art

The Friends of Folk Art is an educational, social, and membership group affiliated with the Museum of International Folk Art. The emphasis is on "folk art, food, friendship, and old-fashioned fun." Proceeds from the Friends of Folk Art benefit programs of the Museum of International Folk Art. The cost of membership in the Friends of Folk art is $100 per year for individuals and $150 for couples. Memberships run for one year from date of purchase. All members must first be members of the Museum of New Mexico Foundation, which one can join through its website, https://secure.museumfoundation.org/join.

North Carolina Folk Art Society

c/o Susan Rhyne
P. O. Box 730
Ellenboro, North Carolina 28040

The North Carolina Folk Art Society was established in 1988 to study and promote the understanding and appreciation of folk art, and to disseminate information on folk artisans and folk art. It meets four times a year, in conjunction with exhibits and other events when possible. Southern traditional (decorative material culture) and contemporary (outsider, visionary, naive) folk art are treated equally. Education and social interaction are the goals of the society. The organization publishes an annual newsletter, *VOICES*, one of the best newsletters, with excellent articles and a calendar of events. *VOICES* is available as part of the membership or by separate order. Memberships are: $20 for individuals; $30 for a family.

Also see entry under Auctions and Other Publications.

Southern Folk Pottery Collectors Society

220 Washington Street
Bennett, North Carolina 27208
Phone: 336-581-42446
Email: sfpcs@rtmc.net
Web site: www.southernfolkpotterysociety.com
Contact Person: Billy Ray Hussey

This is an organization for the collector of Southern folk pottery, with the following benefits: "To acquire unique pieces made exclusively for society members; a first chance to acquire pieces from the society's own collection, at discounted prices; a periodic newsletter with informative articles on the potters and their wares and descriptions of society offerings; a biannual absentee auction catalog available at members' discounted prices; and opportunities to visit potters and witness the creation of folk pottery." In November 1991 the society opened a shop/museum, now in Bennett, North Carolina. Annual membership in the Society is $25.

Also see entries for the Society under Auctions, Museums and Other Publications.

Lucas Arts and Humanities Council, Inc.

P. O. Box 304
213 South Main Street
Lucas, Kansas 67648
Phone: 785-525-6118
Email: grassroots@wtciweb.com
Web site: www.grassrootsart.net
Rosslyn Schultz, Director

Membership in this organization, which is designated a tax exempt, non-profit corporation, supports the activities of the Grassroots Art Center. The Center is a focal point for grassroots art and artists, documenting yard environments throughout the Midwest for the past twenty years. It has inherited much of the art and other materials from the now closed museum of the Kansas Grassroots Art Association. Displays on the Center grounds include the cars and motorcycles that Herman Divers created out of pull-tabs from soda cans, the concrete sculptures of Ed Root, and limestone carvings by Inez Marshall. The Center also provides directions to environmental art that remains in place throughout the Midwest. Memberships are $20 for a single annual membership and $30 for a family annual membership. Higher-level memberships are also available. Checks are payable to LAHC and mailed to the address above.

SPACES—Saving and Preserving Arts and Cultural Environments

9053 Soquel Drive, Suite 205
Aptos, California 95003
Phone: 831-662-2907
Email: info@spacesarchives.org
Web site: www.spacesarchives.org
Jo Farb Hernandez, Director

SPACES is a nonprofit 501 (c) (3) public benefit organization that was incorporated in 1978 for the purposes of identifying, documenting, and advocating for the preservation of large-scale art environments. Founding director Seymour Rosen conceived of SPACES as a national (and, later, an international) organization. Currently operating out of offices in northern California, it boasts an archives of approximately 25,000 photographs as well as numerous books, articles, audio and video tapes/DVDs, and artists' documents. In addition, SPACES maintains databases on sites, bibliographic material, exhibitions, and relevant events.

SPACES has served as an international resource to state arts and humanities councils, museums, universities, public radio and television stations, state historic preservation offices, and grass roots organizations in their local and regional efforts to document, research, and preserve the phenomena of art environments:

hundreds of researchers request information annually from SPACES' archival collections.

SPACES staff have developed materials to help local communities answer the appropriate questions for art historical, humanistic, sociological, and preservation concerns; have written feature articles on the subject for national and international magazines and journals; have spoken at national and international conferences of arts organizations, folklorists, preservationists and museum personnel; have guest-curated exhibitions for museum and university galleries; and have supplied documentation for films, videos, articles, books, and other dissemination projects by independent researchers and scholars.

Paradise Garden Foundation

200 North Lewis Street
Summerville, Georgia 30747
Phone: 706-808-0800
Email: info@paradisegardenfoundation.org
Web site: www.paradisegardenfoundation.org
Jordan H. Poole, Executive Director

The Paradise Garden Foundation came into existence because it was clear that local support and local commitment was going to be key to the success of restoring and maintaining the Garden. The Foundation's mission is to preserve, maintain, and showcase the Rev. Howard Finster's visionary artistic site, Paradise Garden. The Foundation's primary goal is to serve as a social, cultural, educational, and artistic nexus for the benefit of Chattooga County and the Northwest Georgia region. The Foundation has revived the annual Finster Fest, which began in 1992 (see Fairs and Festivals). Paradise Garden Foundation will foster regional economic development via tourism, public service, and creative enterprise, each of which adheres to Finster's vision for his garden. Paradise Garden Foundation will report directly to the Commissioner of Chattooga County under an operating agreement between the county and the Foundation.

Support for the Foundation as a member or a gift donor provides critical resources to restore the Garden and continue Finster's vision to see all touched by art. Memberships, which can be done through the website, are $50 for families, $35 for individuals, and $15 for a students.

Pasaquan—Pasaquan Preservation Society/Kohler Foundation

P. O. Box 564
Buena Vista, Georgia 31803
Phone: 229-649-9444
Email: landofpasaquan@gmail.com
Web site: http://pasaquan.blogspot.com

Since St. EOM's death and until recently, Pasaquan was owned by the Pasaquan Preservation Society, a

private, not-for-profit, 501(c)(3) organization. In June of 2014 Pasaquan Preservation Society deeded Pasaquan to The Kohler Foundation for complete restoration. At the end of the restoration process Pasaquan will go to Columbus State University. To learn more about the site, visit the website (above) or see Tom Patterson's biography, *St. EOM in the Land of Pasaquan*, and Eyeball Productions' video program, *The Pasaquoyan*.

The PEC Foundation
P.O. Box 95
Blanchardville, Wisconsin 53516
Phone: 608-967-2140
Fax: 608-967-2307
Email: ricky-r@mhtc.net
Web site: www.nicksgrandview.com/The_PEC_Foundation.html
Bob Negronida, President

The Pecatonica Educational Charitable Foundation, Inc. is the organization that operates "Grandview," a sculpture environment created by self-taught artist Nick Englebert. It makes the historic site available for the general public and to the community for educational and social events. The PEC Foundation became the recipient of the folk art site from the Kohler Foundation after the latter had restored the site. Volunteers from PEC guide touring groups and maintain the site. PEC publishes a newsletter, *Grand Views.*

Pecatonica Educational Charitable Foundation is a mouthful. One of the reasons the name was chosen is that the first part forms the acronym PEC—which is short for Pecatonica and used by the local school district and many others in the area. The Pecatonica River is a thread that ties the communities together.

The PEC Foundation is a volunteer group of local citizens and community leaders. It started in 1997 by serving the southwest Wisconsin communities of Hollandale and Blanchardville but over the last decade has become a regional arts/cultural organization.

Grandview and its many projects thrive because of the large number of volunteers who help as hosts, teachers, gardeners, techie and maintenance folks or whatever is needed. People interested in volunteering should contact a board member or use the information in the "Contacts" section of the web site. Gifts to the PEC Foundation/Grandview are tax deductible to the extent allowed by law.

Preserve Bottle Village Committee
P.O. Box 1412
Simi Valley, California 93062
Phone: 805 231 2497 (ask for Barbara)
Email: bottlevillage@gmail.com
Web site: www.bottlevillage.com

The Preserve Bottle Village Committee was formed in July 1979 to acquire and restore the privately owned historic property known as Grandma Prisbrey's Bottle Village, at 4595 Cochrane Street in Simi Valley. The organization has fought hard to preserve this truly wonderful folk art environment from developers. In the intervening decades, dedicated members have been responsible for ensuring the protection of Bottle Village, raising funds to continue preservation efforts, pay property taxes, meet government demands for engineering studies, and care for the grounds. The long-term objective of the organization is to allow public access on a regular basis to the fully improved and restored Bottle Village.

In 2012, the organization initiated a comprehensive restoration approach for the entire one-third acre site and its historic components. Archival materials are being inventoried, historical records and studies are being researched, qualified experts are being contacted, fundraising is underway, and the site is being maintained and secured. New members are welcome; contact the Committee using the information above.

Friends of Fred Smith
Normal Building, Room 217
104 South Eyder Street
Phillips, Wisconsin 54555
Phone: 715-339-7282
Email: www.friendsoffredsmith.org
Web site: http://www.friendsoffredsmith.org

From 1948 until 1964 retired lumberjack Fred Smith spent most of his time building sculptures of embellished concrete on his property south of Phillips, in the heart of Wisconsin's North Woods. The result was, as he called it, the Wisconsin Concrete Park. Friends of Fred Smith, Inc. is a not-for-profit arts organization formed to maintain and preserve the sculptures, landscape, and historic Smith house. Tax deductible membership/donations are available at a variety of levels. Call or write for a membership application. There are also opportunities for those who would like to be active volunteers. A newsletter and other mailings are sent to members. The book *The Art of Fred Smith* (new edition, 1997) by Lisa Stone and Jim Zanzi may be ordered by sending a check to the Friends at the address above.

The Orange Show Center for Visionary Art
2402 Munger Street
Houston, Texas 77023
Phone: 713 926 6368
Email: Lynette@orangeshow.org
Web site: www.orangeshow.org
Lynette Wallace, Director

The Orange Show was once a private vision, made concrete through years of solitary labor by a Houston postman, Jeff McKissack. Since the mid–1980s it has become a monument and a beacon, a center for the study of folk art environments and a community gathering place where people come to experience and celebrate the creative process.

Education programs—field trips and mural projects, visionary art workshops and Art Car collaborations—are held for more than 10,000 people a year. Lectures, demonstrations and films present the work of other self-taught and visionary artists to a large audience. Local self-taught artists and environments such as the Beer Can House, the Flower Man's house, and Ida Kingsbury are documented. Smither Park, a half-acre of land adjoining the Orange Show property, is maintained in memory of John H. Smither, a long-time supporter and collector of folk art and a former member of the Orange Show Center Board. The park has sculptures and artists are building mosaic walks. Smither Park has its own website, www.smitherpark.org.

Art Car Weekend brings it all together in a four-day celebration of the drive to create. Now more than two decades old, this is the oldest and largest Art Car event in the country, bringing together great contemporary artists, self-taught artists, and lots of "ordinary" folks to exhibit extraordinary mobile works of art.

The Orange Show Foundation is funded through contributions and grants. Memberships are encouraged and include the quarterly *The Orange Show Newsletter*, with information about folk art environments, the many activities and programs sponsored by The Orange Show Foundation, artists, and additions to the library. Members also receive program discounts.

The Orange Show Folk Art Library has a collection of books, periodicals, articles, photographs, and primary materials concerning folk and self-taught art in Houston and in other locations. There is a state-by-state site directory. The library is open to the public during the Foundation's regular business hours. It is helpful if one calls ahead for an appointment.

Thunder Mountain Monument

P.O. Box 162
Imlay, Nevada 89418
Phone: 702-538-7402
Email: dvanzant@frontier.com
Web site: www.thundermountainmonument.com
Contact Person: Dan Van Zant

Those interested in helping to preserve the folk art environment of the late Chief Rolling Mountain Thunder (Frank Dean Van Zant) are asked to send money to Dan Van Zant at the above address. The need for care and maintenance is great and requires generous donations. The site "is here and thriving." It is open and welcomes visitors, but by appointment only. The monument is located on Highway I-80, southwest of Winnemucca, Nevada.

Painted Screen Society of Baltimore, Inc.

P.O. Box 12122
Baltimore, Maryland 21281
Email: paintedscreens@verizon.net
Web site: www.paintedscreens.org
Elaine Eff, Director

The Painted Screen Society was founded in 1985 to preserve and promote screen painting and related row house arts in Baltimore's neighborhoods. The Society sponsors workshops, lectures, films, and more. Membership supports the goal of creating a permanent facility for teaching and exhibiting Baltimore's unique community tradition. The Society has now produced two films on DVD, *The Screen Painters*, about the artists and their art, and *How to Paint a Baltimore Screen* which may be ordered from the Society, which also sells t-shirts with painted screen motifs. A new book is also available, *The Painted Screens of Baltimore: an Urban Folk Art Revealed*, by Elaine Eff, published by the University of Mississippi Press. In addition to receiving information, members may volunteer for all sorts of projects. Membership is $10.

Center for Southern Folklore

112 Main Street
Memphis, Tennessee 38103
Phone: 901-525-3655
Email: info@southernfolklore.com
Web site: www.southernfolklore.com
Judy Peiser, Co-Founder, Executive Producer
Billy D. Featherstone, Executive Director

The Center for Southern Folklore is a private non-profit organization dedicated to preserving and presenting the music, culture, arts, and rhythms of the South. The center is a showplace for folk arts, music, and photography. Open seven days a week, the center presents media and live performances, concerts, cultural tours, and festivals. The center's annual festival, the Memphis Music and Heritage Festival, is a three day folklife celebration held on Labor Day weekend on Beale Street. A major multimedia archives is maintained. Memberships in support of the Center are available at various levels.

Folk Art Center/Southern Highland Handicraft Guild

P.O. Box 9545
Milepost 382, Blue Ridge Parkway
Asheville, North Carolina

Phone: 828-298-7928
Email: send email from website
Web site: www.southernhighlandguild.com
Ruth T. Summers, Executive Director
Andrew Glasgow, Director of Programs and Collections

The Folk Art Center, located on the Blue Ridge Parkway at Milepost 382, opened its beautiful 30,500 square foot building in 1980. It is operated by the Southern Highland Handicraft Guild (the Guild was founded in 1930 to preserve and encourage crafts culture in the Southern Appalachians). The Center schedules many special exhibitions, programs, workshops, and demonstrations. It houses the Allanstand Craft Shop, museum space, and an excellent library. Although the stated focus is on traditional mountain crafts as well as contemporary American crafts, some works displayed fit the contemporary folk art category—especially those of wood-carvers and sculptors. So do many of the books and other materials in the library. To keep abreast of exhibition schedules and other programs, people are encouraged to become a sponsor of the Folk Art Center; which involves a donation of anything from $25 on up. Sponsorship carries with it free tickets to the Center's bi-annual Craft fairs, a subscription to its newsletter, and discounts on purchases from its shops (for donations of $250 or more).

Appalshop

91 Madison Avenue
Whitesburg, Kentucky 41858
Phone: 606-633-0108
Email: info@appalshop.org
Web site: www.appalshop.com
Contact Persons: Elizabeth Barret (Director) and Caroline Rubens

Appalshop is a cooperative organization of media artists who produce films, television programs, theater, radio, audio recordings, and photography. It has its own radio station production and office space. The work of the people of Appalshop, which began in a downtown Whitesburg storefront, "gives the people of Appalachia a chance to speak for themselves." Appalshop's focus is on material culture, but a few of the projects are of interest to folk art people, for example the video of Minnie Black and her gourd band, another on Jerry Brown's pottery, and a film about Chester Cornett, "Handcarved."

Kohler Foundation, Inc.

725 X Woodlake Road
Kohler, Wisconsin 53044
Phone: 414-458-1972
Web site: www.kohlerfoundation.org/preservation
Terri Yoho, Executive Director
Dan Smith, Senior Preservation Coordinator
Susan Kelly, Preservation Coordinator

Kohler Foundation, Inc., located in Kohler, Wisconsin and established in 1940, has long supported the arts and education. The work of Kohler Foundation encompasses five major areas of concentration: art preservation, grants, scholarships, a performing arts series (the Distinguished Guest Series), and the management of the Waelderhaus, an historic home.

The preservation part of the foundation's work is committed to preserving culture as exemplified in numerous art sites it has funded. In the past, preservation efforts were focused on Wisconsin. However, the Foundation has recently committed itself to expand its preservation efforts nationwide. The Foundation has initiated and completed many restorations in Wisconsin, including: The Painted Forest at Valton; the Concrete Park in Phillips; Mecikalski Stovewood Building at Jennings; Wegner Grotto at Catarac; and, its most recent site, Prairie Moon Sculpture garden and museum at Cochran. Two art sites being preserved currently are Nick Engelbert's Grandview in Hollandale [this site has been turned over to the PEC Foundation] and a sculpture garden and small park created by James A. Tellen, Sr., in Sheboygan. Sites being preserved elsewhere include Kenny Hill's environment in Chauvin, Louisiana and St. EOM's Pasaquan in Columbus, Georgia.

Alire, Diane. *The Cross Garden.* **Albuquerque, NM: New Grounds Gallery, 2006.**

This slim volume contains 26 photos by Diane Alire out of the hundreds she took of W. C. Rice's Cross Garden, a folk art environment in Prattville, Alabama. Alire supplies a brief introduction describing her 20-year project to document the garden, which she discovered in 1984 in Prattville, a 15-minute drive from where she grew up in Montgomery. The environment includes thousands of crosses erected and painted by W.C. Rice, a self-ordained minister who, like Howard Finster, devoted most of his life to preaching through his art.

Allen, Margaret Day. *When the Spirit Speaks: Self-Taught Art in the South.* **Atglen, PA: Shiffer, 2015.**

Margaret Day Allen is an avid collector of self-taught art, who shares her passion in this book. She introduces the reader to 32 self-taught artists from the Southeastern United States. Some are well known, while others have not been recognized beyond their immediate neighborhoods. What they all have in common is a strong determination to make art, which they have pursued, often to the amazement of their family and friends. Some began making art in response to a personal crisis such as an accident that ended their working life, or to a vision or inspiration to make holy art. Others had a lifelong interest in making art but could not act on that interest until they had time to do so after retirement. None had formal art training, and many remained unaware of the formal art world for much or all of their art-making life.

Andera, Margaret, and Lisa Stone. *Accidental Genius: Art from the Anthony Petullo Collection.* **Milwaukee, WI: The Milwaukee Art Museum, and DelMonico, 2012.**

This book, the second since 2000 to focus on the Petullo Collection, was published in conjunction with an exhibition celebrating a gift to the Milwaukee Art Museum of over 300 works by self-taught American and European artists collected by Anthony Petullo over the course of three decades. It includes an introduction by Jane Kallir discussing Art Brut and "Out-

sider" Art, an essay by Lisa Stone discussing the collection, elaborate color plates of the collection, and biographies of the artists. About one-third of the artists are Americans—the rest are mostly European, with some from other parts of the world. See also Jane Kallir, *Self-Taught and Outsider Art: The Anthony Petullo Collection* (2001) below.

Awalt, Barbe, and Paul Rhetts. *Nicholas Herrera: Visions of My Heart.* **Albuquerque. NM: LPD, 2003.**

Herrera is a New Mexico carver and maker of santeros. This book describes his life and work in chronological periods, from his early carving, drawing, and creating (he began as a child) through later influences, the most dramatic of which was a car accident that nearly killed him and subsequently determined the course of the rest of his artistic and religious life. The authors discuss the ways that family, local history, and the church influence and interact in his work. It includes hundreds of color photographs, some black and white ones, and 29 drawings by the artist. Essays on Herrera's work are provided by Charlie Carrillo, Cathy Wright, and Chuck Rosenak.

Bonesteel, Michael. *Henry Darger: Art and Selected Writings.* **New York: Rizzoli, 2000.**

This book offers the first comprehensive view of Darger's art and writings. Representations of over 100 of Darger's artworks are included, as well as 15 examples of his writing. Darger wrote about his imaginary world, in which the forces of good and evil battled over the enslavement of children, depictions of which were the focus of his drawings and painting. The author provides an introduction to Darger's work and examines his difficult childhood, strong religious faith, and doubt, which together shaped his work.

Bryant, Jen. *A Splash of Red: The Life and Art of Horace Pippin.* **New York: Alfred A. Knopf, 2013.**

This book, written for children, tells the story of Horace Pippin's life—his family and his town, how he started making art (from the time he could hold a piece

of charcoal), how he came to paint, and how he sold his art in local storefronts. It ends with his recognition by the local artists' club in West Chester, Pennsylvania, the judgment of N.C. Wyeth that his work was "very good," and that he should have his own art show—after 40 years of working on his own. Illustrations by Melissa Sweet depict scenes from Pippin's life; the inside back cover shows several examples of Pippin's art and a map of cities where it can be seen.

Burrison, John A. *From Mud to Jug: The Folk Potters and Pottery of Northeast Georgia.* **Athens: University of Georgia Press, 2010.**

Burrison wrote an earlier book, *Brothers in Clay,* that examined the folk pottery traditions of north Georgia, including the families and communities that began it and have carried it on through generations. In *From Mud to Jug,* Burrison extends his earlier study. He interviews active potters and their families, describing the influences that made this part of Georgia such a center of folk pottery and what keeps it going today. He also explores in greater depth the roots and historical developments of the folk pottery tradition in this area. He includes many photographs of artists, their working environments, and the pottery they make, from practical vessels to whimsical face jugs. He also describes the Folk Pottery Museum in Sautee-Nacoochee, devoted to preserving and displaying the works of this region, which opened between the first and second books.

Cain, Lisa. *Art of the Spirit: The Culture of the Rural South, Self-Taught Artist Lisa Cain.* **Bloomington, IN: AuthorHouse, 2011.**

Lisa Cain, a self-taught African-American artist, grew up in rural Canton, Mississippi. She is a memory painter, depicting scenes from her childhood relating to work, play, food, family, social life, and the houses, churches, and businesses of the town itself. Her work has been exhibited in galleries across the United States. This book presents some of her paintings along with narratives in which she explains the origins of her images and celebrates the character of individuals of the rural South that she feels "were proud, brilliant, fearless, hard-working and strong and who loved each other, loved God and who valued the land and nature.

Carlano, Annie, ed. *Vernacular Visionaries: International Outsider Art.* **New Haven, CT: Yale University Press/Museum of International Folk Art, Santa Fe, NM, 2003.**

This book was published to accompany the exhibition of the same name at the Museum of International Folk Art, October 31, 2003, through August 29, 2004. It features extensive documentation of the work of seven artists from around the world, of which three are American — William Hawkins, Charlie Willeto, and Martin Ramírez (who, while technically Mexican, has long been counted as an American artist). Each chap-

ter is devoted to a single artist and includes an introductory and interpretive essay. John Beardsley writes about William Hawkins, Randall Morris about Martín Ramírez, and Susan Brown McGreevy about Charlie Willeto. Other artists featured in the book include Gedewon (France). Nek Chand (India), Hung Tung (Taiwan), Anna Zemankova (Moravia), and Carlo (Italy). Annie Carlano wrote the introduction and John Beardsley contributed an interpretive essay, "Imagining the Outsider."

Carter, Gray. *Paul Lancaster: Immersed in Nature.* **Chicago: Pegboard, 2009**

Paul Lancaster has no formal training in either painting or poetry-writing, yet he does both. His paintings, intended to actualize the visions he sees in his mind, include dense, layered landscapes of every season, often but not always including human figures. When he does indoor scenes, even still lifes, he brings the imagery of nature inside. Grey Carter, who has known Lancaster for decades and represents him in his gallery, wrote a biographical essay for this book, illustrated with early and later photographs of Lancaster as well as examples of his art. Also included are brief essays on Lancaster's work by Susan W. Knowles and N. J. Girardot. The book includes numerous color plates that show the range of his vision; many are accompanied by one of Lancaster's poems.

Clarke, Georgine, ed. *Alabama Masters: Artists and Their Work.* **Montgomery: Alabama State Council on the Arts, 2008.**

This is a catalog from the exhibition of the same name, which was first displayed at the Julie Collins Smith Museum of Fine Art at Auburn University in early 2007, and then traveled. The exhibition was designed to showcase the more recent generations of Alabama artists, with self-taught artists included along with those who have had formal training and orient toward "the art world." A two-page spread for each artist includes a short bio sketch, a brief description of his or her work, and two or more color reproductions. Self-taught artists in the exhibition and catalog include Thornton Dial, Sr., Lonnie Holley, Charlie Lucas, Charles Smith, Jimmy Lee Sudduth, Bill Traylor, plus Nora Ezell, Yvonne Wells, and the quilters of Gee's Bend. Gail Andrews, director of the Birmingham Museum of Art, wrote the introduction.

Collinsworth, Matt, ed. *Krause and Spellmann: Scenes from a Lost America.* **Morehead, KY: Morehead State University, 2011.**

This exhibition catalog reproduces 30 of Jo Nease Krause's paintings and 23 by Charles Spellman. Adrian Swain provides an extensive essay containing biographical information obtained through interviews with the artists, and interpretations of their art and the rural environments that have shaped their perceptions, memories, and art.

Collinsworth, Matt, ed. *Minnie Adkins: Against the Grain.* **Morehead, KY: Morehead State University, 2006/2015.**

The 2015 version of this exhibition catalog contains an original essay by Adrian Swain and revised essays and text by Matt Collinsworth. It updates the catalog prepared for the 2006 exhibition.

Collinsworth, Matt, ed. *Robert Morgan: The Age of Discovery.* **Morehead, KY: Morehead State University, 2011.**

Robert Morgan creates strange, incredible, sculptures using a great variety of found objects. This book contains many images of his work, along with an introduction by Collinsworth and an essay by Adrian Swain, interspersed among the color plates, that traces the development of Morgan's art and places it in his biographical and cultural context.

Congdon, Kristin G., and Tina Bucuvalas. *Just Above the Water: Florida Folk Art.* **Jackson: University Press of Mississippi, 2006.**

This book focuses exclusively on Florida's many self-taught artists, whose work reflects the traditions of many diverse communities. It includes profiles of over seventy artists, including Missionary Mary Proctor, Mario Sanchez, Nicholas Toth, Ruby C. Williams, and Purvis Young. The media in which these artists have worked include painting and sculpture, but also assemblages of found objects, basketry, leatherwork, and other means of expression. Communities represented include Hispanic, Native American, African American, Jewish, and others, from the Georgia border to the tip of the everglades and the Keys. See also Gary Monroe's *Extraordinary Interpretations,* described below.

Crawley, Susan Mitchell. *The Life and Art of Jimmy Lee Sudduth.* **Montgomery, AL: Montgomery Museum of Fine Arts, 2005.**

This book was published in conjunction with an exhibition of the same name at the Montgomery Museum of Fine Arts, held from January 15 through March 27, 2005. Following Margaret Lynne Ausfeld's introduction, Susan Crawley's essay describes the breadth of Sudduth's appeal; the range of his subject matter and media (painting with clay and mud house paint and other paints), found object sculpture, working on and with any materials he could find; his other interests, especially his music; and his integration into his community and the strength he drew from it. Many color plates illustrate the scope of Sudduth's work.

Creative Growth Art Center. *One Is Adam, One Is Superman: The Outsider Artists of Creative Growth.* **San Francisco: Chronicle, 2004.**

This book is devoted to the participants in Oakland, California's Creative Growth Art Center and the art they make. Leon Borenstein's photographs center the

pages devoted to each artist, accompanied by examples of their work and either a quote from the artist or a brief description.

Crown, Carol, ed. *Coming Home: Self-Taught Artists, the Bible, and the American South.* **Memphis and Oxford: The Art Museum of the University of Memphis and the University Press of Mississippi, 2004.**

This catalog accompanied a traveling exhibition of the same name organized by the Art Museum of the University of Memphis. It examines the Bible's influence on 70 contemporary folk artists, including Howard Finster, Sister Gertrude Morgan, William Edmondson, Clementine Hunter, Elijah Pierce, and Myrtice West. Essays by Crown and eight additional scholars discuss the role of evangelical religion in the American South and the ways it affected to work of these artists, placing them in the context of contemporary American art and history, literature, and music. The book is illustrated with many works of art (the exhibition itself contained 125 works), and includes biographical sketches of about half of the artists in the exhibition.

Crown, Carol, and Charles Russell. *The Sacred and Profane: Voice and Vision in Southern Self-Taught Art.* **Jackson: University Press of Mississippi, 2007.**

This book provides a cultural and historical analysis of southern self-taught art. It concentrates on the cultural contexts in which the artists live(d) and made their art, as well as on the lives and works of representative artists. It also examines how they have been received in the larger world of mainstream art, and the influences they have had on trained artists. The South's complex cultural, religious, racial, and political history provides the context in which the artists discussed in this book lived and worked. The authors trace how this context, as it presents itself for each artist, working in different milieus, supplies the subject matter that the artists express. They show how the artists draw from the different elements of the context, often combining images and ideas drawn from one element with those of another. They are particularly interested in southern artists' efforts to find personally fulfilling forms of aesthetic expression that give vision and voice to the simultaneous demands of the sacred and the profane dimensions of existence. Religion is a particularly potent element of the Southern context, and extremely important for many self-taught Southern artists. Essays by Charles Reagan Wilson and Frédéric Allmel discuss the range of religious artistic creations, while studies of Howard Finster, Myrtice West, Anderson Johnson, and Eddie Martin (St. EOM) illuminate the intensely personal religious experience of particular artists. The works of some artists, such as Nellie Mae Rowe and Clementine Hunter, address both the sacred and the profane dimensions of their lives, while the art of Bill Traylor, George Andrews, and Thornton

Dial focuses more on the individual artist's social observations and personal responses to their times and the history of the South.

Crown, Carol, and Cheryl Rivers, eds. *Folk Art.* **Vol. 23 of** *The New Encyclopedia of Southern Culture.* **Chapel Hill: University of North Carolina Press, 2013.**

This is, indeed, an encyclopedia. After brief introductions by the series editor and the volume editors, it contains brief essays by academic experts on many topics, arranged alphabetically, from African American Expressions and Art Cars to Visionary Art and Whirligigs, Weathervanes, and Whimseys. These are followed by more than 200 pages of brief artist biographies, each written by a person familiar with the artist's work; Southern artists from the 18th through the 21st centuries are included.

Customs House Museum & Cultural Center. *Time Made Real: The Carvings of Tim Lewis.* **Clarksville, TN: The Customs House Museum & Cultural Center, 2008.**

This book depicts the carvings of Tim Lewis on display during an exhibition at the Customs House Museum from July 12 through October 31, 2008, which subsequently traveled to the Columbus Museum of Art (November 14, 2008, through February 22, 2009), the Mennello Museum of American Art (April 15 through June 30, 2009), and the Kentucky Folk Art Center (October 1 through December 10, 2009). It includes essays about Lewis's own work by Lee Kogan; his personal history by Frank Holt; the larger context of stone carving by Michael D. Hall; and the context of the mountains where he lived and their folk art tradition by Dan Prince. The book also includes biographical information about Lewis and other publications that discuss his work.

DePasse, Derrel B. *Traveling the Rainbow: The Life and Art of Joseph. E. Yoakum.* **New York and Oxford, MS: Museum of American Folk Art and the University Press of Mississippi, 2001.**

Joseph Yoakum created intricate and highly symbolic imaginary landscapes in his paintings, drawing on his dual heritage as African-American and Native American, and on his highly original life experiences as a railroad man, a soldier in World War I, a member of the Ringling Brothers Circus, and other employment in many parts of America and in Europe. DePasse presents the results of meticulous research that confirms the reality of the many stories that Yoakum told about his life and art—stories that many had previously doubted but that DePasse shows to have been largely based on fact. Illustrated.

Eff, Elaine. *The Painted Screens of Baltimore: An Urban Folk Art Revealed.* **Oxford: University Press of Mississippi, 2013.**

Certain Baltimore neighborhoods are well-known for their painted screen doors and window screens. While depicting pleasant scenes to the outside world, they let in the breeze, keep out the flies, and prevent outsiders from seeing inside—all vital functions in the crowded neighborhoods where this art evolved. Elaine Eff has a long history of involvement with the screens, their artists, and the Painted Screen Society of Baltimore. In this book she describes the tradition and its history, interviews living artists about their own work and that of the artists who preceded them, the influences the screens have had on the neighborhood and its residents, and what the future may look like. The book contains many color examples of the screens themselves, of the artists and their families, and the surrounding neighborhood.

Fageley, William. *Tools of Her Ministry: The Art of Sister Gertrude Morgan.* **New York: American Folk Art Museum and Rizzoli, 2004.**

Fageley, the former assistant director for art and curator of contemporary self-taught art at the New Orleans Museum of Art, spent decades of his professional life, following the career and development of Sister Gertrude Morgan, New Orleans' prolific artist and gospel minister. He organized the exhibition documented in this catalogue, which was displayed at the American Folk Art Museum from February 25 through September 26, 2004, the New Orleans Museum of Art from November 13, 2004, through January 16, 2005, and Intuit in Chicago from February 11 through May 28, 2005. Fageley provides details of the artist's life, discusses her work, and reveals her inspirations, all accompanied by 120 color and black and white photographs. The book includes essays by Jason Berry and Helen M. Shannon, a foreword by Gerard C. Wertkin, and a chronology and bibliography of the artist's life and work.

Farr, Sheila. *James Martin: Art Rustler at the Rivoli.* **La Connor, WA: Museum for Northwest Art, 2001.**

James Martin is not strictly a self-taught artist, having attended art classes early in his career and started by imitating other artists. But as he evolved, he returned to themes and techniques of his high school years, taking inspiration from the burlesque and vaudeville shows he loved to watch. Galleries and exhibitions focused on self-taught art frequently included his work, and collectors of folk art eagerly sought his paintings. This book describing his career and including color plates of his work is therefore included in this review of recent books on self-taught art.

Fine, Gary Alan. *Everyday Genius: Self-Taught Art and the Culture of Authenticity.* **Chicago: University of Chicago Press, 2004.**

This book examines the growth of interest in and recognition of art by individuals without formal train-

ing and the interplay of their creativity and the world of galleries, auctions, and dealers who have increasingly inserted themselves as middlemen between the artists and buyers/collectors. It discusses the authenticity so central to the artists' worlds and how it is affected by discovery and inclusion in the larger marketplace of art.

Fountain Gallery. *Fountain Gallery—More Than a Gallery: A Movement.* **New York, Fountain Gallery, 2010.**

On the occasion of its tenth year, the Fountain Gallery produced this catalogue to commemorate its achievements and honor 21 of the artists whose work it has featured over the years. Each artist's pages include a photograph, an example of his or her work, a description of the work and brief history of the person's involvement with art, and a quote from the artist. All participants in Fountain Gallery have a mental illness of one variety or another, but it does not stop them from making powerful art.

Gendron, Lorraine. *Louisiana Folk Artists.* **Lafayette: University of Louisiana at Lafayette Press, 2009.**

This book documents the many themes of Gendron's work. It includes a foreword by Betty-Carol Sellen, interviews of the artist by Nina Wilson, and four chapters on various themes and subjects present in Gendron's art. The chapter "Historical Reflections" includes Gendron's large paintings of the 1811 slave revolt in Louisiana, "the largest slave uprising in U.S. history." Gendron donated all of her paintings of this event to the River Road Historical Society; they are on permanent display at Destrahan Plantation, the site of the trials that followed the revolt. Illustrations in the book depict these paintings. Other chapters include "Cultural Reflections," "Spiritual Reflections," and "Family, Friends, Home, and More."

Gengarelly, Tony, and Adria A. Weatherbee. *Exploring Nirvana: The Art of Jessica Park.* **North Adams: Massachusetts College of Liberal Arts, 2008.**

Jessica Park was born in 1958 in North Adams, Massachusetts. She has been autistic all of her life, and has never been able to live independently. She began drawing very early, and by at least age 6 was creating works to which she gave titles. Houses, churches, and prominent buildings are favorite subjects, featuring prominently among the hundreds of works she has produced to date. These incorporate extraordinary detail with bright, varied colors that, while not "accurate," seem incredibly "real." This book focuses on the interplay between Park's autism and her art. One chapter by her mother, Clara Claiborne Park, describes how Jessy increasingly responded to the opportunity to create art from the age of two and a half, when she was responding to little else. A chapter by Emmanuelle Dalmas-

Glass describes her evolution as an artist. A foreword by Oliver Sachs describes her "life of the mind" and "how at least some of what might be called the defects or strangenesses of autism can also become singular strengths." Twenty-six of her paintings are presented in color plates, along with the story of how and why they were created. The book ends with lists of solo and group exhibitions that have included Park's work, a chronology of her art, and a selected bibliography of writing about her.

Georgia Museum of Art. *Amazing Grace: Self-Taught Artists from the Mullis Collection.* **Athens: Georgia Museum of Art, 2007.**

This book was published in conjunction with an exhibition of the same name featuring the works of 59 artists, mostly from the south, mounted by the Georgia Museum of Art from September 29, 2007, through January 6, 2008. It includes the exhibition catalog and short biographies of the artists represented, written by Paul Manoguerra, the museum's Curator of American Art, who organized the exhibition. It also includes a foreword from the museum's director, notes on being a collector by Carl Mullis, and an essay by Carol Crown, Professor of Art History at the University of Memphis, on the themes of the sacred, secular, and nature found in the art on display.

Georgia Museum of Art. *Lord Love You: Works by R.A. Miller from the Mullis Collection.* **Athens: Georgia Museum of Art, University of Georgia, 2009.**

An exhibition at the Georgia Museum of Art, University of Georgia, in Athens, Georgia, August 8–October 24, 2009. In addition to illustrations of R.A. Miller's art, the catalog includes an essay by Paul Manoguerra on American Visual Culture and interviews with Carl Mullis and Durwood Pepper.

Gershon, Pete. *Painting the Town Orange: The Stories Behind Houston's Visionary Art Environments.* **Charleston, SC: History, 2014.**

Houston, Texas is many things to many people; among its claims to fame are a surprising number of folk art environments, created in the city's out of the way corners by people who spent lifetimes realizing their own special vision of beauty. These include The Orange Show by Jeff McKissack, the Beer Can House by John Milkivisch, The Flower Man's House by Cleveland Turner, Notsuoh by Jim Pirtle, and Zocalo/TempleO by Nestor Topchy. This book tells the stories behind each of these environments and includes pictures, including 14 pages of color plates. Also discussed are the Houston area's "lost environments"—creations similar to those that survived, but which no longer exist.

Haardt, Anton. *Mose T A to Z: The Folk Art of Mose Tolliver.* **Montgomery, AL: Saturno, 2005.**

This book, by collector and gallery owner Anton Haardt, documents the life and art of Mose Tolliver. In 2005, at the time to book was published, Tolliver was the last surviving artist included in the groundbreaking Corcoran exhibition, *Black Folk Art in America: 1930–1980*. Haardt details Tolliver's art career, which began after a work-related accident left him unable to continue to work. She traces his development as an artist and his increasing recognition, from the time he hung his paintings on a tree in front of his house to sell for one dollar to his recognitions as one of the most prominent of southern folk artists. A foreword by Lee Kogan and an introduction by Dr. Regenia Perry help situate Tolliver in the world of twentieth-century folk art.

Hall, Michael D. *Legacy in Wood: Elijah Pierce at the Columbus Museum of Art*. Columbus, OH: Columbus Museum of Art, 2013.

This book offers several essays on Elijah Pierce and a chronology of his life and work. His art is displayed in color plates accompanied by brief descriptions and notes, organized around the themes he most liked. These include parables and moral lessons, American history and folklore, domestic and exotic animals, sermons and bible stories, signs and symbols, everyday people and celebrities, meditations on life and love, tableaux and genre scenes, and memories and autobiography. The essays, which cover different aspects of Pierce's life, work, and importance, were contributed by Carolyn Jones Allport, E. J. Connell, Joseph Copeland, Kojo Kamau, and Nannettee V. Maciejunes. The book ends with suggestions for further reading about Pierce.

Hendershot, Mary Kennedy. *An Old Man Has Visions*. Madison, TN: Monroe Area Council for the Arts, 2005.

James Bunch, a Tennessee woodcarver, is the subject of this book. Bunch was, at the time of writing, the oldest, and many said best, living artist in Tennessee (he was about 99 then, and died a few years later). Bunch was a woodcarver and a preacher, who worked as a farmer, lumberjack, gravedigger, carpenter, and dam-builder during the course of a life lived in poverty in eastern Tennessee (he said he often did not make more than a dollar a day). Using only a pocketknife and the occasional handsaw and working from memory, James Bunch created a remarkable collection following his retirement in 1980 to care for his ailing wife, Harriet. Dr. Robert Cogswell, Director of Folk Life for the Tennessee Arts Commission, has described Mr. Bunch as "the best living folk artist in the state of Tennessee." This book owes its exceptional quality to the collaboration of Tennessee artists who worked on the project, including noted photographers Charles Brooks and Don Dudenbostel and graphic designer Laurel Breyen. The book includes and introduction by Dr. Cogswell and a reflective essay by Keith Hender

shot, a graduate of Bennington College in Vermont. The Bunch collection is on display at the Museum of Appalachia in Norris, Tennessee. Included in the collection is the life-sized motorcycle, "The Chiper," carved over a three-year period during the 1980s.

High Museum of Art. *Bill Traylor: Drawings from the Collections of the High Museum of Art and the Montgomery Museum of Fine Arts*. Atlanta: High Museum of Art, 2012.

This book accompanied the exhibition of the same name mounted at the High Museum from February 5 through May 15, 2012; at the Frist Center for the Visual Arts in Nashville from May 25 through September 3, 2012, and at the Mingel International Museum in San Diego from February 9 through May 12, 2013. In addition to more than 70 color plates of Traylor drawings, the volume contains essays commenting on the art and the artist by Margaret Lynne Ausfeld, Fred Barron and Jeffrey Wolf. Susan Mitchell Crawley and Leslie H. Paisley contribute two additional essays, one focused on Traylor's working materials and methods, and the other explaining the care and maintenance needed for fragile works on paper such as those Bill Traylor created.

High Museum of Art. *Let It Shine: Self-Taught Art from the T. Marshall Hahn Collection*. Atlanta: High Museum of Art/University Press of Mississippi, 2001.

This elaborately illustrated book accompanied the exhibition of the same name held at the High Museum of Art from June 23 to September 2, 2001. It contains the exhibition catalogue, written by Susan Mitchell Crawley, along with essays by Lynne E. Spriggs on Hahn's collecting life; Joanne Cubbs on geographical impacts on self-taught art from the south; and Lynda Roscoe Hartigan on the pleasures of collecting folk art in the south. Crawley also contributed brief artist biographies, each accompanied by one of the artist's works, and there is a checklist of the entire collection as donated to the High Museum.

Hirasuna, Delphine. *The Art of Gaman: Arts and Crafts from the Japanese American Internment Camps, 1942–1946*. New York: Random House, 2005.

"Gaman" is the Japanese word for "accept what is with patience and dignity." In the years 1942–1946, Japanese Americans on the west coast had a lot to "accept," as more than 120,000 of them were forcibly removed from their homes with only what they could carry and interned in camps far from their homes, on the premise that they constituted a threat to national security. During their internment they did many things, including create art, largely self-taught. The author's parents were so interned. The book includes a preface by the author, a chapter on the camps themselves, a chapter on the art, produced from discarded

and indigenous raw materials found in the camps, and a chapter on the years after. Many pieces from the camps were the focus of an exhibition that began at the Smithsonian American Art Museum and traveled to several other museums around the country.

Hunter, Clementine. *Clementine Hunter: A Sketchbook.* **New Orleans, LA: Ogden Museum of Southern Art, 2015.**

Clementine Hunter is probably Louisiana's best-known memory painter, depicting the life of the Care River plantation world she lived in during the early part of the 20th century. The sketchbook contains the first works of art she painted—26 works never seen before—that were exhibited in a recent show at the Ogden of the Richard Gasperi collection. Gasperi provides an introduction to this book.

Journey of Hope: Artwork from The Living Museum, a Space for Art and Healing. **Queens, NY: Otsuka America Pharmaceutical, 2002.**

This book documents the work of artists confined to the Creedmoor Psychiatric Center in Queens Village who had the opportunity to make art in Building 75—a huge, initially abandoned, structure that became known as "The Living Museum." The book contains handsome color plates of the art and portraits of the artists, along with an essay on the origins and development of The Living Museum by Janos Marton.

Kallir, Jane. *Self-Taught and Outsider Art: The Anthony Petullo Collection.* **Urbana: University of Illinois Press, 2001.**

This is one of two books since 2000 to feature the collection of self-taught and outsider art donated to the Milwaukee Art Museum by Anthony Petullo, a Milwaukee businessman and avid collector for over thirty years. Jane Kallir wrote the introduction to this work, which discusses this art in the larger context of art collecting, categorization, and valuation, describing how critical approaches have changed to such an extent that self-taught and outsider art can be embraced within the larger framework. She also describes Petullo's art collecting career, his motivation, and his broad focus. The book also contains brief artist biographies and histories of exhibitions for each artist. See also Andrea and Lisa Stone, *Accidental Genius: Art from the Anthony Petullo Collection* (2012), above.

Kentucky Folk Art Center. *Linvel Barker: Works from the Collection of Rita Biesiot.* **Morehead: Kentucky Folk Art Center, 2012.**

In 2012 the Kentucky Folk Art Center mounted an exhibition of Linvel Barker's carvings on loan from the extensive collection of Rita Biesiot. Adrian Swain provides an interpretive essay describing Barker's evolution as a carver and his unique style and approach to carving. Examples of Barker's earliest works (two roosters) and all of his signature animals—horses, cows, buffalo, cats, dogs, sheep, giraffes, pigs, and squirrels.

Kogan, Lee. *Painted Saws: Jacob Kass.* **New York: American Folk Art Museum, 2002.**

This exhibition catalogue accompanied an exhibition of Kass's work on display at the American Folk Art Museum from July 20 through December 1, 2002. Kogan describes Kass's life, which involved art from the start. In his working life he made elaborate signs for commercial vehicles in Brooklyn, where he lived. After retirement he began painting on discarded metal objects, especially saws, and changed his subject matter to scenes of rural and urban life, often depicting people at work. The author describes how Kass's life, values, and environments influenced his art (He spent time in Vermont and Florida as well as in Brooklyn. Photographs of the saws reveal the meticulous detail of the work. There is also an exhibition checklist and a selected bibliography.

Krug, Don, and Ann Parker. *Miracles of the Spirit: Folk, Art, and Stories from Wisconsin.* **Oxford: University Press of Mississippi, 2005.**

This book explores the broad range of recent Wisconsin artists whose work has developed "outside the mainstream" of academic and museum-based art. These artists follow their own visions, creating everything from paintings, sculptures, assemblages of found objects, and collages to entire outdoor environments. The book is organized geographically within the state's several regions, with each region being introduced through its history and cultural traditions. Color and black and white plates illustrate the art and portray the artists, while interviews with the artists reveal their motivations and perceptions of their art and its place in their lives. In the final chapters, the authors place Wisconsin's rich visual culture into regional, national, and international contexts.

Laffal, Florence, and Julius Laffal. *American Self-Taught Art: An Illustrated Analysis of 20th Century Artists and Trends with 1,319 Capsule Biographies.* **Jefferson, NC: McFarland, 2003.**

The authors, avid folk art collectors for decades and the publishers/editors of *Folk Art Finder* from 1980 to 2000, provide a comprehensive examination of self-taught artists working in the twentieth century. The first chapter discusses the history of interest in the art and the evolution of various terms to represent it, including folk, self-taught, outsider, naïve, vernacular, and others. They report on a database they created to describe folk artists, and summarize their analysis. They use the database to examine the validity of certain assumptions about the people considered to be folk artists—for example, that all are poorly educated or illiterate—and find that some such key generalizations are not entirely true—for instance, one in five of the more than 1,300 artists they examine had

education beyond high school, including advanced degrees, while only about one in three had seven or fewer years of education. They provide short biographies of 1,319 artists (chapter 3) and examples (chapter 4) of work grouped in various ways, such as "assemblages," "wood carving," "rural focus," "social protest," and "environments." The book includes a foreword by Tom Patterson.

Lehigh University. *Revealing the Masterworks: The Finster Cosmology.* **Bethlehem, PA: Lehigh University, 2004.**

This exhibition catalogue accompanied a show of the same name held at Lehigh University from September 29 through December 19, 2004. Edited by Norman Girardot, Ricardo Viera, and Diane LaBelle, the catalogue analyzed Finster's art (over 47,000 pieces) and, selecting a highly focused group of pieces, takes a serious look at the artistic breadth of what he accomplished, his motivations and the messages he sought to convey, and the cultural-religious interconnections of his work. Girardot is a professor of religion, and brings his considerable scholarly talents to this task without using overly technical language. He spent a lot of time with Finster in the 15 years before the artist's death, and hosted him as a guest at Lehigh University twice. He combines the knowledge gained through his personal acquaintance with the artist, his academic area of expertise (history of religions combined with visual cultures), and the input of many others in the field, to bring Finster into the mainstream of criticism focused on the intersection of art and religion.

Lindsay Gallery. *Stephen Sabo: Whittler, Tinkerer... Artist.* **Columbus, OH: Lindsay Gallery, 2012.**

This short book contains many photographs of Sabo's work, together with a short biography written by Amy Weirick, based on conversations with the Sabo family and friends. Sabo was a carver, depicting scenes and creatures from his environment — some very simple and some quite complex. The book illustrates examples of each.

Longwood Center for the Visual Arts. *Three-Ring Circus: Highlights from the William and Ann Oppenhimer Folk Art Collection.* **Farmville, VA: Longwood Center for the Visual Arts, 2011.**

This volume accompanied an exhibition by the same name held at Longwood Center for the Visual Arts from September 9, 2011, through January 6, 2012. The exhibition commemorated the gift to Longwood Center for the Visual Arts of the William and Ann Oppenhimer Folk Art Collection. The volume includes an explanation by the Oppenhimers of why they chose Longwood for their bequest, and overview of the collection by Kathy Johnson Bowles, director of LCVA, and chapters featuring the art itself, organized around

the themes of "We the People," "Animal Kingdom," and "Tent Revival." The volume ends with a selected bibliography related to the art in the exhibition.

Ludwig, Kelly. *Detour Art: Outsider, Folk Art, and Visionary Environments Coast to Coast—Art and Photographs from the Collection of Kelly Ludwig.* **Kansas City, MO: Kansas City Star, 2007.**

This book offers images and descriptions of art, artists, and environments from the back roads of the whole United States. Many of the artists represented made their art in the relative isolation of rural America. Some use(d) paint (e.g., Mose Tolliver, Mary T. Smith, Jimmy Lee Sudduth), some carve(d) wood or stone or shaped clay (e.g., Minnie Evans, Linvel Barker, Burgess Dulaney), some made constructions (e.g., James Harold Jennings), and some made extensive folk art environments (e.g., S.P. Dinsmoor, Howard Finster, Kenny Hill). All are "worth a detour" to visit them, if they are still alive, or their environments.

Maizels, John. *Fantasy Worlds.* **Cologne, Germany: Taschen, 2007.**

This book describes environments, some created by trained artists and some by individuals without formal art training who started small and just kept going. Environments in Europe, America, Asia, and Africa are represented. The text describing the environments, which is provided in English, German, and French, was written by John Maizels. Deidi von Schaewen created the extensive photographic documentation. Angelika Taschen edited the volume.

Manger, Barbara, and Janine Smith. *Mary Nohl Inside and Outside: Biography of the Artist.* **Madison: University of Wisconsin Press, 2009.**

This book describes the evolution of Mary Nohl's environment — her house and yard in a suburb of Milwaukee near Lake Michigan — along with developments in her life and how the two intertwined. Nohl left plenty of material to work with, including diaries, letters, photographs, and other publications, all of which were examined in the course of completing this book. Nohl was not, technically, a self-taught artist, having gone to the Art Institute of Chicago and taught art for a number of years to public school students. Resources provided by her parents allowed her to spend most of her life making art rather than teaching it. This book details the many media she worked in and how she blended them into the environment she created. She spent over 40 years of her life creating a space that reflected her concerns and sensibilities, going far beyond any formal training and following her own vision in the manner of outsider artists creating unique environments in many places and times. Nohl willed her property to the John Michael Kohler Art Center as a way to assure that it would be preserved and made available to the public.

Mason, Lauris. *Missionary Mary Proctor: The Doors.* **Antioch, CA: Fine Arts, 2014.**

This is the first book devoted completely to the work of Missionary Mary Proctor. It includes illustrations of sixty-six of the doors and large panels that she paints with vivid colors and adorns with numerous found objects. The book contains essays on her work and extensive lists of exhibitions, museums, galleries, and private collections that have exhibited or contain her works, along with books, exhibition catalogs, articles, archives, and a dissertation that include information about her and her art.

Mason, Randy, Michael Murphy, and Don Mayberger. *Rare Visions & Roadside Revelations.* **Kansas City, MO: Kansas City Star, 2002.**

The authors are hosts of a travel series on KCPT, Kansas City's public television station. The book documents numerous folk art environments from Alabama to Colorado that the authors visited in the course of 24 road trips. Each segment includes pictures of the environments visited, brief descriptions of how they came to be, and, for some, conversations with the people who created these special places.

McDonough, Yona Zeldis. *Sisters in Strength: American Women Who Made a Difference.* **New York: Henry Holt, 2000.**

This book honors 11 outstanding women whom the author and her mother, well-known folk artist Malcah Zeldis, believe have shaped history through their courage, steadfastness in their beliefs and commitments, and ability to triumph over adversity, including that posed by their gender in their chosen fields. They are Pocohontas, Harriet Tubman, Elizabeth Cady Stanton and Susan B. Anthony, Clara Barton, Emily Dickenson, Mary Cassatt, Helen Keller, Eleanor Roosevelt, Amelia Earhart, and Margaret Mead. Malcah Zeldis' illustrations of the women and their achievements contribute immensely to the book's charm and its appeal for young readers.

Monroe, Gary. *Extraordinary Interpretations: Florida's Self-Taught Artists.* **Gainesville: University Press of Florida, 2003.**

This book covers over 60 self-taught Florida artists, including Woody Long, Brian Dowdall, Alyne Harris, Mary Proctor, O.L. Samuels, Purvis Young, and others both well-known and unknown except to a few. For each, Monroe explores the motivating factors that prompt the artist to make their art, the distinctive features of their work, and where it might fit in the sometimes-fluid concepts of naïve, outsider, visionary, and folk art. The book depicts the artists' work and includes photographs of the artists. See also Congdon and Bucuvalas' *Just Above the Water*, described above.

Monroe, Gary. *Harold Newton: The Original Highwayman.* **Gainesville: University Press of Florida, 2007.**

This book starts with Monroe's essay on Newton that includes a vividly detailed biography of the artist, largely based on reminiscences from Newton's fellow artists, friends and family. Monroe also examines Newton's technique and the significance of his legacy, which Monroe argues was defined by artist's ability to portray Florida as a vigorous and fertile Promised Land. The book contains 165 illustrations. Monroe also comments on the capriciousness of the art market; while Newton's work was little known throughout his career, it has become highly collectible in the 21st century. This is an excellent, beautifully illustrated introduction to a dynamic painter that sparks the viewer's interest in Newton and his fellow highwaymen, all of whom took to painting and to the road because the combination offered more scope for earning money in the era of Jim Crow. For those interested in more information about the highwaymen, Monroe has also written *Mary Ann Carroll: First Lady of the Highwaymen* (Gainesville: University Press of Florida, 2014).

Monroe, Gary. *The Highwaymen: Florida's African-American Landscape Painters.* **Gainesville: University Press of Florida, 2001.**

Monroe tells the story of the Highwaymen, 25 African-American Florida men and 1 woman who, in the 1950s, painted whimsical, dreamy, romanticized Florida landscapes that they sold all over the state's east coast, door-to-door and in restaurants and businesses of all types. Their paintings, containing lots of water, palm trees, and dramatic skies, were extremely popular at the time and allowed them to escape the abysmal working conditions in Florida's citrus groves and packing houses. The book contains reminiscences of some of the artists, plus 63 color reproductions of their work.

Moore, Kelly. *Absurdity Is My Friend.* **Santa Fe, NM: Eat Everything. 2011.**

This book, by self-taught artist Kelly Moore, includes numerous examples of his painting and equally numerous examples of his somewhat stream of consciousness poetry and commentary. Also included are photographs of Moore's shed at the Tusuque Flea Market, from which he sells his art, wild horses, and Moore himself.

Moses, Kathy, with Bruce Shelton. *Helen LaFrance: Folk Art Memories.* **Nashville, TN: S&S, 2011.**

Illustrated with many reproductions of the artist's work and photographs of her home and local community, this book tells the story of Helen LaFrance's life and artistic work. Separate chapters present and discuss her art, each one focusing on one of her most frequent themes—everyday life (work, play, farm, school, community), church life (bible study, choir

practice, picnics, baptisms, and funerals), familiar landscapes and architecture, and memorable events/special occasions, and visionary paintings. In addition, the author discussed LaFrance in the context of memory painting in general, of her own life and her local environment, and her technique.

Museo Nacional Centro de Art Reina Sofía. *Martín Ramírez: Reframing Confinement.* **Madrid, Spain: Meseo Nacional/Presel, 2010.**

Along with many color plates of the artist's work, this book contains essays and critical commentary about Ramírez' life, his confinement and the ways he was treated, his worldview, and his place in the world of art. Contributors include Lynne Cooke, Brooke Davis Anderson, Victor M. Espinosa, James Lawrence, Tarmo Pasto, Roger Cardinal, Roberta Smith, Phyllis Kind, Peter Schjeldahl, and Hal Foster. The book ends with a list of works, a chronology, a history of exhibitions that have featured Ramírez' work, and a bibliography of monographs, books, exhibition catalogs, and periodicals that discuss his life and work.

Museum of Fine Arts, Houston. *Thornton Dial in the 21st Century.* **Atlanta, GA: Tinwood, 2005.**

Lavishly illustrated with photographs of Dial's work, this substantial book presents essays by established scholars discussing Dial's most recent work and placing it in the context of his earlier oeuvre, aided by many quotations and interpretations from Dial himself. Contributors include William Arnett, who has supported and promoted Dial's work for decades, John Beardsley, Alvia J. Wardlaw and Jane Livingston, Joanne Cubbs, Mark Lawrence McPhail, Eugene Metcalf, Jr., Paul Arnett, Amiri Baraka, Bernard L. Herman, Amei Wallach, Richard R. Brettell, and Thomas McEvilley. These contributors, most of whom have written about Dial's work in other publications, explore new theories and update old ones in their discussion of the importance of this artist and his work.

Museum of New Mexico. *Collective Willeto: The Visionary Carvings of a Navajo Artist.* **Santa Fe: Museum of New Mexico Press, 2002.**

Charlie Willeto was among the first Navajos to carve nontraditional figures, making him a trailblazer for other Navajos who wanted to realize their own visions of people, animals, and the natural world. His work is widely exhibited, widely collected, available for examination in numerous museum collections, and influential within and beyond his tribe. Lee Kogan contributes the longest interpretive essay in the book, comparing Willeto's work to that of other important folk artists and trying to understand some of the cultural and symbolic components of his work. Short essays are also provided by Shonto Begay, Walter Hopps, Greg LaChapelle, and John and Stephanie Smither. Some are personal recollections of meeting Willeto and/or Willeto family members, or first encountering

his art. One tries to connect Willeto's work to "the collective unconscious." The book is illustrated with 100 excellent color photographs, and there is a bibliography.

Norris, Mike, and Minnie Adkins. *Sonny the Monkey.* **Morley, MO: Joey, 2012.**

This is a children's picture book, with words and music (it includes a CD) by Mike Norris and illustrations by Minnie Adkins. Many pages include pictures of some of Minnie's signature animals, such as the bear and the fox. *Bright Blue Rooster* is another children's book by the same author/illustrator team.

North Carolina Wesleyan College. *African-American Quilts: 60 Historic Textiles from the Farmer-James Collection.* **Rocky Mount, NC: North Carolina Wesleyan College, 2003.**

This catalogue accompanied the exhibition of the same name held initially at the Four Sisters Gallery of North Carolina Wesleyan College in 2003 that later traveled to other sites through 2004. It includes over 100 color photographs of the collection, along with essays by Nancy Jane Farmer and A. Everette James, Jr., Anita Holloway, and Elsa Barkley Brown. Everett Mayo Adelman offers an introduction. The quilts in the exhibition were made in North Carolina between 1860 and 1950 and collected by Farmer and James in the decade leading up to the exhibition. The essays place the quilts in their cultural context, as well as the context of history and quilting.

Padgelek, Mary. *In the Hand of the Holy Spirit: The Visionary Art of J.B. Murray.* **Macon, GA: Mercer University Press, 2000.**

From the age of seventy to eighty, J.B. Murry followed a call from God to paint. He believed that God guided his hand as he produced hundreds of "spirit paintings" to spread his message. Mary Padgelek tells the story of how Murry, an illiterate farm worker in rural Georgia, created art that became known and collected around the world. She analyzes his art and his spiritual message, and the influence it has had on twentieth century art.

Patton, Paul W. *Rix Mills Remembered: An Appalachian Boyhood.* **Kent, OH: Kent State University Press, 2003.**

Patton grew up in Rix Mills, Ohio, a small village in the southeastern corner of the state. In his later years he painted more than 500 pictures of his town, as he remembered it, but complete with a detailed map of its main street, houses (with family names attached, and shops, churches, and mills. His book contains reproductions of 100 of his paintings, accompanied by his reminiscences of life in the town when he was a boy. His paintings of winter landscapes are some of his most dramatic works.

Percy, Ann, ed. *James Castle: A Retrospective.* **Philadelphia: Philadelphia Museum of Art, 2008.**

This book contains the catalog accompanying the exhibition of the same name mounted at the Philadelphia Museum of Art from October 14, 2008, through January 4, 2009. It also includes illustrated essays by Ann Percy, Jacqueline Crist, Jeffrey Wolf, Brendan Greaves, and Nancy Ash and Scott Homolka. In addition, Beth Ann Price, Ken Sutherland, Daniel Kirby, and Maarten van Bommel write about a scientific study of James Castle's art. The book also includes a chronology of Castle's work, a history of exhibitions featuring his work, family documents, and a bibliography.

Percy, Ann, ed., with Cara Zimmerman. *Great and Mighty Things: Outsider Art from the Jill and Sheldon Bonovitz Collection.* **Philadelphia: Philadelphia Museum of Art, 2013.**

This book contains the catalog accompanying the exhibition of the same name mounted at the Philadelphia Museum of Art from March 3 through June 9, 2013, along with numerous other contributions. It includes hundreds of color plates displaying the art of the collection, plus a number of essays. The editors report a conversation about collecting with the donors; Francesco Clemente, Lynne Cooke, Joanne Cubbs, Bernard L. Herman, and Cara Zimmerman provide essays, and Ken Sutherland and Beth A. Price offer an appendix discussing the approach to studying the works in the Bonovitz collection scientifically.

Raw Vision. *Raw Vision Sourcebook: The Essential Guide to Outsider Art, Art Brut, Contemporary Folk Art & Visionary Art from Around the World.* **Radlett, Herts, UK: Raw Vision, 2002, 2009.**

These two books include information on American outsider art since 1900, along with a major emphasis on European outsider artists, as might be expected of a book published in Great Britain and oriented toward the continent. The 2009 edition updates the earlier one. They both contain short reviews of works discussing the art of the insane and publications focusing on visionary environments, along with an unannotated list of other notable publications. They each have a section of biographical sketches for about 50 artists, with some different ones in each edition. Each edition has a section listing galleries, by country, that carry outsider art; and sections on relevant publications, organizations, and websites.

Rexer, Lyle. *How to Look at Outsider Art.* **New York: Harry N. Abrams, 2005.**

Matters of nomenclature abound with respect to folk, self-taught, and outsider art, with many attempts to "define" and differentiate among the numerous terms that are sometimes applied to these works. Terms include vernacular, visionary, self-taught, outsider, naïve, primitive, and art Brut, among others.

Rexer takes up the challenge of discussing what makes the work of contemporary artists without formal art training "outsider" art, noting along the way that many artists now considered great, such as Van Gogh, Picasso, and Kathe Kollwitz, were in their time considered "primitive, gauche, ugly, and strange." He has a case to make for factors that lead to classifying an artist as an outsider, which include being self-taught, responding to inner visions or missions, not orienting toward the world of formal art, and (for the most part), working in a flat, two-dimensional perspective. In his explorations he includes American self-taught artists, but also about as many artists from countries other than the United States. Those who are intrigued with efforts to categorize and differentiate this art will find much food for thought in this book, whether or not you come away with the feeling that Rexer has "solved" the definitional problem or the feeling that the lines between categories, and even the categories themselves, will never be hard and fast. See also Colin Rhodes, *Outsider Art.*

Rhodes, Colin. *Outsider Art: Spontaneous Alternatives.* **London: Thames & Hudson, 2000.**

This book addresses the question of what we mean by outsider art. Taking its examples from both American and European artists, it has chapters on Art Brut, Art by the Insane, Alternative Worlds, Self-Taught Visionaries, and "Other Positions." Rhodes is interested in people who "do not fit into the official category of the professional artist," but still produce a great deal of art. They are "the creative patternmakers par excellence, often producing interesting and powerful bodies of work that find their way, through various means, into public view. Here their artistic production takes on a life that distances it—often emphatically separating it—from its producer." He identifies such art as Outsider Art and explores its characteristics and history. See also Lyle Rexer, *How to Look at Outsider Art.*

Rivers, Cheryl, ed. *Donald Mitchell: Right Here, Right Now.* **Oakland, CA: Creative Growth Art Center, 2004.**

This book contains dozens of reproductions of Mitchell's art, along with essays by Tom di Maria, Lucienne Peiry, Frank Maresca, Lyle Rexer, and Colin Rhodes. Each discusses Mitchell's work from his or her own perspective.

Rosenak, Chuck, and Jan Rosenak. *Navajo Folk Art.* **Tucson, AZ: Rio Nuevo, 2008.**

This book updates an earlier one by the same authors, *Navajo Folk Art: The People Speak,* published in 1994. It expands on the themes articulated in the first book, adding new photographs and including more than 25 artists that the authors encountered after the first book came out. The book reflects the many years that the Rosenaks spent meeting and getting to know the artists and collecting their work (much of which

they gifted to the Smithsonian American Art Museum to assure that it receives the recognition it deserves).

Russell, Charles. *Groundwaters: A Century of Art by Self-Taught and Outsider Artists.* **London: Prestel, 2011.**

The author examines the work of twelve artists in detail, discussing each artist's life and times and the context of his or her work. Each section includes numerous color plates of the artist's work. Six of the twelve are American artists—Morris Hirshfield, Bill Traylor, Henry Darger, Martín Ramírez, Howard Finster, and Thornton Dial, Sr. The others are Adolf Wölfli, Madge Gill, Aloïse Corbaz, August Walla, Nek Chand, and Michel Nedjar. An introduction and conclusion draw together the various themes discussed during presentations of each artist.

Sellen, Betty-Carol, with Cynthia Johanson. *Outsider, Self-Taught, and Folk Art Annotated Bibliography: Publications and Films of the 20th Century.* **Jefferson, NC: McFarland, 2002.**

This book is a companion volume to Sellen and Johanson, 2000. Together they make up the second edition of Sellen and Johanson's groundbreaking *20th Century American Folk, Self-Taught, and Outsider Art* (New York: Neal-Schuman Publishers, Inc., 1993). Because the amount of bibliographical material had grown significantly since 1993, the 2nd edition was divided into two volumes; this annotated bibliography is the second volume of the 2nd edition. It provides an exhaustive annotated bibliography of books, exhibition catalogs, journal articles, newspaper articles, films, and videos published in the 20th century that have American folk, self-taught, and outsider artists and the art itself as their focus.

Sellen, Betty-Carol. *Art Centers: American Studios and Galleries for Artists with Developmental or Mental Disabilities.* **Jefferson, NC: McFarland, 2008.**

This book is devoted to the special world of Art Centers—programs that, as Sellen says in her Introduction, "support their members with structure, guidance from art mentors, a safe place to work, supplies so they can do their art," and, of great importance, exposure to collectors and the chance to sell their art through their galleries, exhibitions, and websites. These programs differ from numerous art therapy programs in their emphasis on the art rather than on the disability, and on providing commercial outlets for their members' creativity. The book's first section contains descriptions of 40 Art Centers, listed alphabetically by state and city, and lists the artists who worked there at the time. Images of art by Center artists accompany each entry. This section is followed by one containing brief artist biographies. A brief introductory essay on the essential nature of creativity in everyone is extracted from Florence Ludins Katz and Elias

Katz's book, *Art and Disabilities: Establishing the Creative Art Center for People with Disabilities* (1990), with their permission. The Katzes are often considered the pioneers of the Art Centers movement.

Sims, Bernice. *The Struggle: My Life and Legacy.* **Castroville, TX: Black Rose Writing, 2014.**

Bernice Sims, who died toward the end of 2014, was eighty-seven when she wrote this book, telling her story to LaVender Shedrick Williams, who assembled the final version. Her attitude, "Live life until you run out of life," is Sims' inspiring belief. Sims was born during The Great Depression, became a protester during the Civil Rights era, and raised six children as a young single mother. She has written of her struggles to offer hope and encouragement to future generations. This book, written from her Pensacola, Florida nursing home room, shares Sims' life growing up poor in segregated Alabama and how she overcame countless obstacles to become a widely-known a memory painter. She hoped that *The Struggle* would inspire readers of all ages to press through their own struggles, recognize opportunities, and to follow their dreams.

Siwek, Daniel. *House of Blues: A Backstage Pass to the Artists, Music, & Legends.* **San Raphael, CA: Insight, 2013.**

The House of Blues is "a live music institution," with performance space in 12 cities in 2014 (the number has changed over the years). It also is a living museum of folk, self-taught, and outsider art, with over 6,000 pieces in its collection, displayed in many of its venues, of which the most extensive display is in New Orleans. This book focuses mostly on the musical artists who perform at the House of Blues, including photographs of performances and interviews with the musicians. But most of Chapter 6 is devoted to "Visual Blues." The chapter provides images of some of the art than hangs in the House of Blues, along with brief interviews with the artists whose work is included.

Speer, Richard. *Matt Lamb: The Art of Success.* **Hoboken, NJ: John Wiley, 2005.**

Matt Lamb was a successful Chicago businessman who never gave art a thought until diagnosed at the age of 51 with a fatal illness—which turned out to be a mistake, at least from the medical point of view. Not, however, from the point of view of self-expression. Feeling that he wanted to paint, he walked into an art store and asked the clerk to "give me whatever you think I need." Thus began more than 20 years of painting, exhibiting, and increasing recognition as an artist. Speer spent a year getting to know the artist, and in this book tells the story of his life change and its consequences, accompanied by 33 photographs of the artist and his work.

Umberger, Leslie, ed. *Sublime Spaces and Visionary Worlds: Built Environments of Vernacular Artists.* **Princeton, NJ: Princeton Architectural, 2007.**

The John Michael Kohler Arts Center in Sheboygan, Wisconsin, has undertaken the mission to preserve environments created by self-taught and visionary artists, which this colorful and inspiring book present for the first time. It features the work of twenty-two vernacular artists whose locales, personal histories, and reasons for art-making vary widely but who all share a powerful connection to home-as-art environments. Featured projects range from art environments that remain intact, such as Simon Rodia's Watts Towers in California, to sites lost over the years such as Emery Blagdon's six hundred elaborate "Healing Machines," made of copper, aluminum, tinfoil, magnets, ribbons, farm machinery parts, painted light bulbs, beads, coffee can lids, and more. From the "Original Rhinestone Cowboy" Loy Bowlin's wall-to-wall glitter-and-foil living room to the concrete bestiary of the "witch of Fox Point," Mary Nohl, each artist and project is described in detail through a wealth of visuals and text. Essays by Umberger, Erika Doss, Ruth Kohler, Lisa Stone and Jane Bianco discuss the environments, the motivations of the artists, and the drive to preserve them.

West, Bruce. *The True Gospel Preached Here.* Oxford: University Press of Mississippi, 2014.

West records in words and pictures his meeting with the Reverend Dennis at his creation, "Margaret's Grocery," in Vicksburg, Mississippi, shortly before Dennis died. Reviewer John Foster calls this book one of the best photo-documentaries of a folk art environment in the field of self-taught art.

Whitney Museum of American Art. *The Quilts of Gee's Bend.* Atlanta: Tinwood, 2002.

This catalogue accompanied the exhibition of the same name held at the Whitney from late 2002 through early 2003. The women of Gee's Bend have been quilting since before slavery ended, applying their unique visions of color and pattern to create quilts like no others. They use color and pattern in idiosyncratically inspired ways, which the 162 color photographs in this book amply illustrate. Essays by John Beardsley, William Arnett, Paul Arnett, and Jane Livingston describe the geography and history of Gee's Bend that have made it a unique cultural location, and the relation of the quilts to the history of American art—likening many to the work of famous abstract artists. A very large proportion of the catalogue is devoted to the quilters themselves, describing their quilts and their stories and illustrating them with photographs of the quilts, the artists, and their environment. The book ends with a bibliography of selected works documenting and describing the quilters of Gee's Bend, and an index.

Windham, Ben. *Charlie Lucas: Tin Man.* Tuscaloosa: University of Alabama Press, 2009.

Georgine Clarke, Visual Arts Program Manager for the Alabama State Council on the Arts, wrote the introduction to this book, which describes Lucas' working environment, his approach to creating is sculptures, and his place in the context of Alabama culture. Much of the book is devoted to Windham's interviews with Lucas, providing a running commentary on his personal history, the places he has lived, the motivations behind his art, and his techniques and evolution as an artist. The book ends with a list of selected exhibitions and publications that feature Charlie Lucas, grants and fellowships he has received, and programs in which he has been an artist-in-residence.

Yau, John. *James Castle: The Common Place.* New York: Knoedler, 2000.

This is the catalog accompanying an exhibition of James Castle's work held November 15, 2000, through January 13, 2001, at the J. Crist Gallery in Boise, Idaho. It contains an essay on Castle's work by John Yau and plates of the art that appeared in the exhibition, along with photographs of Castle, his house, and other structures in his environment. The plates are in color, but as the works were created using "soot and spit on found paper," as most are described, they appear mostly as shades of black and brown, on white or cream-colored background.

OTHER PUBLICATIONS

This chapter contains a list of publications of interest to those who collect, sell, or study contemporary folk and outsider art. The publications may be obtained by subscription, by membership, or by contribution to a sponsoring organization. A few publications are free for the asking. Listed first are the three most comprehensive publications in the field of folk and outsider art: *Folk Art Messenger, The Outsider,* and *Raw Vision.* Publications from organizations and institutions that are devoted wholly or in part to this art follow. A few of the art periodicals that mention contemporary folk and outsider art with enough frequency to encourage the reader to check them on a regular basis are *Maine Antique Digest, Antiques Monthly, Antiques and the Arts Weekly, Antiques West;* art periodicals such as *Art & Antiques, Art and Auction, Art in America, Art Papers,* and *New Art Examiner.* Many other publications occasionally include articles on self-taught, folk, and outsider art; most are indexed in the on-line publication Art Abstracts, for the interested collector to search out for themselves. Gallery and Art Center newsletters are noted in their respective entries. A few popular magazines have articles on folk art from time to time—among them are *Country Living, Elle Decor, Metropolitan Home,* and *Southern Living.* In addition to the publications described in this chapter, many galleries have newsletters, blogs, and notifications of exhibits, new artists, and other local news and events. These are usually distributed electronically, through email lists. Consult the Galleries chapter to find out how to contact a gallery you are interested in, through their websites, email, or by phone to see what they have and to sign up.

Two comprehensive publications—*Folk Art* and *Folk Art Finder*—along with eight local or special-purpose ones have ended since the second edition of this book in 2000, and no new ones have begun.

Folk Art Messenger

The Folk Art Society of America
P.O. Box 17041
Richmond, Virginia 23226
Phone: 434-395-2207
Web site: www.folkart.org/fam/folk-art-messenger
Ann Oppenhimer, Editor

The *Folk Art Messenger* is published three times a year by the Folk Art Society of America. A subscription is included with a membership in the organization. It has been published since the fall of 1987 and includes feature articles, news reports, book reviews, book lists, an exhibition calendar, detailed articles about deceased artists and important members of the Society, reports about the organization's activities including details about annual meeting programs, and much more. All articles include color and black and white images.

The Outsider

Intuit: The Center for Intuitive and Outsider Art
756 North Milwaukee Avenue
Chicago, Illinois 60622
Phone: 312-243-9088

Web site: www.art.org/publications-store/the-outsider
Janet Franz, Editor

The Outsider is published twice a year by its parent organization, Intuit: The Center for Intuitive and Outsider Art, and is included as part of the membership. *The Outsider*, Volume 1, Issue 1, first appeared in Summer 1996. It was preceded by the publication *In'tuit*, offered by the same organization, which began in Spring 1992. The publication includes news of the organization, book reviews, exhibition reviews, articles about artists, and a calendar of events. There are frequent articles on art environments and at least two articles by Jim Swislow on "outsider and folk art on the web." Black and white illustrations of high quality are included.

Raw Vision

Raw Vision Ltd. [U.S. Office]
163 Amsterdam Avenue, #203
New York, New York 10023
Phone: 212-714-8381
E-mail: rawvision@btinternet.com
Web site: www.rawvision.com
John Maizels, Publisher

Raw Vision is an "International Journal of Intuitive and Visionary art." It is published quarterly in London. This periodical includes in-depth articles about outsider art and artists, obituaries, book reviews and exhibition reviews with many color photo-graphs. There is a "Raw News" section that provides information country by country. The U.S. subscription rate is $38 for a one year personal subscription. Individual copies are about $12 each in bookstores.

Visions: American Visionary Art Museum

American Visionary Art Museum
800 Key Highway
Baltimore, Maryland 21230
Phone: 410-244-1900
Web site: www.avam.org

This publication appears in conjunction with or shortly after each of the museum's major exhibitions. It serves as both an exhibition catalog and a news and information letter for the museum. Volume 20, the latest issue, was published in conjunction with the exhibition "St. Francis and Finster" in 2015. In addition to detailed information on the "current" exhibition there are articles on folk and outsider art, and information about happenings at AVAM and what activities and exhibits are planned for the future. Illustrations are included. Receipt of *Visions* is part of membership in AVAM.

Folk Art News

Kentucky Folk Art Center

102 West First Street
Morehead, Kentucky 40351
Phone: 606-783-2204
Matt Collinsworth, Editor

This newsletter is once again being published quarterly by the Kentucky Folk Art Center, after a long hiatus. It is distributed by email and features information about the center, its programs and projects, exhibitions, services, collections, and profiles of artists. One can subscribe by requesting to be on the Center's email list—send a request to tod.barker@moreheadstate.edu.

Grand Views

PEC Foundation, Inc.
P.O. Box 95
Blanchardville, Wisconsin 53516
Rick Rolfsmeyer, Editor

Grand Views is the newsletter of the Pecatonica Educational Charitable Foundation and the Friends of Grandview. The PEC Foundation operates Grandview, the historic folk art environment of immigrant farmer Nick Engelbert, which it took over after restoration by the Kohler Foundation. Donations to the foundation are tax-deductible, make you a "friend," and will get you the newsletter.

The Orange Show Newsletter

The Orange Show Foundation
2402 Munger
Houston, Texas 77023
Phone: 713-926-6368
Web site: www.orangeshow.org

The newsletter of the Orange Show is a benefit of organization membership. Or, one can sign up to receive the newsletter by clicking a link at the bottom right-hand corner of the organization's website. It provides information about Houston folk art sites, Orange Show programs and events, book reviews and library acquisitions. Illustrations.

Journal of the CPA Prison Arts Program

Community Partners in Action
Prison Arts Program
Mailing address:
 110 Bartholomew Avenue, Suite 3010
 Hartford, Connecticut 06106
Program location:
 3580 Main Street; Building 11
 Hartford, Connecticut 06106
Phone: 860-722-9450
Email: cpaprisonarts@gmail.com
Web site: www.cpa-ct.org/prisonarts
Jeffrey Greene, Editor and Program Manager

The Prison Arts Program was established in 1978. It promotes self-examination and self-esteem to people incarcerated in several of Connecticut's correctional facilities through participation in visual arts classes, exhibitions and publications, and brings the talent and creativity of the prison population to the community at large. The Journal of the Prison Arts Program has been in publication since 1987. The Journal expands the reach of the CPA's Arts Program by sharing inmate art and writing with a larger community and gives inmates an opportunity to convey their invaluable knowledge and experience concerning a wide range of artistic, intellectual and social issues. Illustrations are in black and white. The price for an issue is $5.00.

North Carolina Pottery Center Newsletter

North Carolina Pottery Center
P.O. Box 531
Seagrove, North Carolina 27341
Phone: 336-873-8430
Web site: info@ncpotterycenter.org

The *North Carolina Pottery Center Newsletter* is an e-newsletter. It is available to center members and, on request, to interested individuals. The newsletter includes information on the center and the development of its facilities and services, meetings, exhibitions and festivals, accessions to the growing pottery collection, and directions to visit potters.

Pasaquoyan Visions

The Pasaquan Preservation Society
P.O. Box 5675
Columbus, Georgia 31906

Pasaquoyan Visions is published quarterly by The Pasaquan Preservation Society, a division of the Marion County Historical Society. It contains news from and about St. EOM's Pasaquan, an amazing colorful art environment.

Southern Folk Pottery Collectors Society

Southern Folk Pottery Collectors Society
220 Washington Street
Bennett, North Carolina 27208

Phone: 336-581-42446
Email: sfpcs@rtmc.net
Web site: www.southernfolkpotterysociety.com

This quarterly newsletter is a benefit of membership in the Society and is aimed at collectors. It is included in the membership dues of $25 per year. Articles focus on "definitions," potters and their wares, activities at the Society shop and museum in Robbins, North Carolina, and collecting matters in general. Black and white illustrations are included.

The Southern Register

Center for the Study of Southern Culture
University of Mississippi
University, Mississippi 38677
Email to receive newsletter: jgthomas@olemiss.edu
Web site: southernstudies.olemiss.edu/publications/southern-register

The Southern Register is the quarterly newsletter of the Center for the Study of Southern Culture and is available to those who join the organization, Friends of the Center, and those who request it. The newsletter reports on projects, conferences, and other activities sponsored by the Center. It notes relevant conferences at other institutions and reviews books. It includes brief articles, of which contemporary folk art has sometimes been the topic. The newsletter provides ordering information for books, video cassettes, and other items carried by the Center, which always has titles related to folk art.

VOICES: The Newsletter of the North Carolina Folk Art Society

c/o Susan Rhyne
P. O. Box 730
Ellenboro, North Carolina 28040

This newsletter is published once per year and is part of the membership privileges of the society, or it may be purchased separately for $7.00 per issue. Members write the articles which are about collecting experiences, visits to artists, artists' biographies, and other relevant matters. It includes a calendar of events of interest to members, book reviews, and black and white photographs, usually of artists. It lives up to its stated purpose of being "entertaining."

ARTISTS

Twentieth and twenty-first century self-taught artists who paint, sculpt, carve, draw, make assemblages, create art environments, and make pottery face jugs or other pots that serve as a surface for a sculptured form are listed in alphabetical order. Decoys, quilts, and other pottery are excluded because each of these has a separate and extensive literature of its own, too vast to include here. "Anonymous" artists are usually excluded. Artists are included if it is possible to see their art in at least one of the following ways: galleries carry it; museums have it in their collections; or artists show their own work or sell it themselves through their own websites or Facebook pages.

Some new artists may not stand the test of time, but they are listed for the consideration of collectors and others in the field. In a few cases artists are included who have slipped out of sight but there is some evidence that they are still working, and an inspired dealer or collector might find them. Grassroots art sites/environments are included if they may be visited or if they have been well-documented and illustrated.

Information about the artists comes from gallery owners, museum curators, collectors, published sources, and from personal visits to the artists. Individual entries do not contain all the references to the artists included in this book. To locate all references, especially gallery representation and inclusion in museum collections, consult the index.

Biographical entries are deliberately brief and serve mostly the purpose of identification. In some cases longer entries have been provided, especially if published information on an artist is scarce or nonexistent. If an address or telephone number is listed, it is because the artist requested that it be included. Quite a few self-taught artists now sell their own work through websites, Facebook pages, other media connections, and from their own homes or studios. When this information could be found, it appears in these biographical descriptions. In addition, for those wishing to locate artists by geography, a list of artists who sell their own work is included in the chapter "Galleries, Private Dealers and Artists Who Sell Their Own Work," by state and then alphabetically by name, following the entries for galleries and private dealers. In the same way, folk art environments that may be visited are included in the chapter "Museums, Libraries, Archives and Environments," by state and then alphabetically by name, following the museum and archive entries.

For references to artists and illustrations in published sources such as books, exhibition catalogs, periodicals, newspapers, and films and videos, one should consult the separate outsider art bibliography, *Outsider, Self-Taught and Folk Art Annotated Bibliography: Publications and Films of the 20th Century*, by Betty-Carol Sellen and Cynthia Johanson (Jefferson, NC: McFarland, 2000).

Aaron, Jesse (1887–1979)

Jesse Aaron, wood sculptor, was born in Lake City, Florida. He left school in the first grade and started working to help support his eleven younger brothers and sisters. He worked at many jobs and then retired in the 1960s to care for his disabled wife. After many failed attempts to find work and care for his wife, "he prayed for help and said God replied and told him to 'make art.'" Aaron used a chainsaw to make his wood sculpture. His figures have a crude and appealing look. His work has appeared at auction sales and was included in the exhibition "Passionate Visions of the American South."

AB the Flagman (b. 1964)

Roger Lee Ivens, better known as AB the Flagman grew up in in Atlanta, Georgia and now lives in Sanford, Florida. AB's fascination with the flag started at an early age. Born into a military family, he was heartbroken at age seven when his father died. Buried with a military ceremony, the flag on his father's coffin took on special meaning to AB and frequently became the iconic center of his art. His first work experience was as a singer in Baptist churches in North Georgia. He worked as a carpenter and spent after-hours making art from leftover scraps of wood. He also was singing with various bands. After a serious accident in the spring of 1995, when he severed a couple of fingers on the right hand, AB began working full time on his art. His scrap wood collages of patriotic subjects, most often painted, are captivating. His work is available at Jeanine Taylor Folk Art in Miami and Garde Rail Gallery in Austin. He often takes it the annual Kentucky Festival in Alabama to sell, and also sells through his Facebook page.

Abduljaami, John (b. 1941)

Born in Shawnee, Oklahoma, John Abduljaami is a wood sculptor and lives in Oakland, California. His works, typically made of redwood, eucalyptus, or black walnut, vary in size from very small to quite large, with the larger pieces being the most frequent. He works with huge pieces of wood, which he shapes with an ax and chisel and finishes with regular house paint. Images may be an eagle larger than life, a rooster, a moose, or a totem of the smiling faces of his four children. Abduljaami received a certificate of valor for his heroic efforts during the Loma Prieta earthquake. While largely unknown in the rest of the country, his pieces have been exhibited throughout the San Francisco Bay area, including at the Oakland Museum of California. A video featuring Abduljaami is available on YouTube (www.youtube.com/watch?v=IYaFUTqazHO).

Abee, Steve (b. 1968)

Inspired by potters Burlon Craig and Charlie Lisk, Steven Abee had his first sale of pottery in April 1994.

He lives in Lenoir, North Carolina. Using traditional methods, Steven mixes his glazes, digs his own clay, and fires his clay in a groundhog wood-fired kiln. He makes distinctive face jugs, snake jugs, roosters, traditional forms and figures, featuring his dark slip, alkaline, and clear-glass glazes, and his distinctive multicolored swirls. He has a studio in Lenoir and his pottery is sold there (and other North Carolina places too).

Abrams, Joseph (1906–1998)

Joseph Abrams lived in Miami Beach, Florida. Abrams started making hats out of newspaper when he was eighty. He used to sit all day on a sheetless bed and makes paper hats; hats nothing like those that children make. The hats were made with newspaper, painted with watercolors, acrylics, poster paints—whatever he could find. Abrams had stopped working just before his death because of ill health. One of his creations is in the permanent collection of the American Visionary Art Museum in Baltimore. His art was included in the exhibition, "The Passionate Eye: Florida Self-Taught Art," in 1994.

Adams, Antonio

Antonio Adams works on his art at Visionaries and Voices in Cincinnati with much encouragement from his mother, who is herself an artist. Antonio Adams is learning disabled and a most talented artist. He paints portraits—he is partial to pop stars—murals, and wood and painted wooden robot figures. Adams and Thunder-Sky were the first artists at V&V. Now there are many more.

Adkins, Garland (1928–1997)

Among the best-known artists in Kentucky, Garland Adkins and wife Minnie had reputations for skilled animal carving. Garland helped Minnie with the carvings, which Minnie painted. He roughed out and dried the pieces in a wood fueled "smoke-house." The well known horse image was carved and finished entirely by Garland. Everyone grieved when Garland died in November 1997 after a long illness. The Kentucky Folk Art Center in Morehead featured the artistic couple in the exhibition "Something Big: The Art of Minnie and Garland Adkins." In 1988 a gallery at the Kentucky Folk Art Center in Morehead was named after Garland and Minnie.

Adkins, J.R. (1907–1973)

Adkins began to paint in 1969 when the pain of arthritis forced him to retire. His painting, which is illustrated in Jay Johnson and William C. Ketchum, Jr., *American Folk Art of the Twentieth Century* and in Herbert W. Hemphill, Jr., and Julia Weissman, *Twentieth Century American Folk Art and Artists*, varies from hu

morous to the historical to landscapes. His work is in the collection of the American Folk Art Museum in New York.

Adkins, Minnie (b. 1934)

Minnie Adkins learned to carve when she was a child. She is known for her wonderful carvings of red foxes, black bears, possums, tigers, and roosters. Her figures are smoothly carved and painted, with distinctive faces. Minnie also carves and paints scenes from the Bible. At the Appalachian Celebration in 1994, Minnie Adkins was presented with the Appalachian Treasures Award. In 1998 she and artist husband Garland were awarded honorary doctoral degrees from Morehead State University. Minnie's carved and painted works illustrate the book *Bright Blue Rooster (Down on the Farm)*, by Mike Norris and also *Sonny the Monkey*. A third book, *Mommy Goose Rhymes* is being published by the University of Kentucky Press. For several years Minnie and Garland sponsored a picnic, "A Day in the Country," at their home in Isonville, Kentucky, which featured talented local artists with art for sale. This very popular event continues to be held the first Saturday in June but has moved to the Kentucky Folk Art Center in Morehead.

In 1999 Adkins remarried. Herman Peters, her new husband, was born in Isonville in 1922, but spent most of his adult life in Ohio, where he worked as a pipefitter. Returning to Isonville after retirement and being widowed, he became a close friend of Minnie Adkins, who was herself recently widowed. The two soon married. Peters teased his new wife that anything she carved in wood, he could make in iron. He made good on this claim, producing large metal sculptures similar to many of Minnie's carved animals. He is perhaps best known for his 5–6 feet tall blue roosters, following Minnie's design, he also made cows and horses. Peters died in 2008. His work is in the permanent collection of the Kentucky Folk Art Center, including an enormous blue rooster at the museum's entrance.

In 2014 Elliott County officials established a local event to honor Minnie Adkins in her home county, "Minnie Adkins Day." It took place on the third Saturday in July 2014 and is now planned to be an annual event. The next "Minnie Adkins Day" was scheduled for July 18, 2015, at The Little Sandy Lodge (606-738-5515) in Elliott County, Kentucky, on Route 7 and 32. There will be an arts and crafts market at the celebration featuring many local artists. Adkins also sells her work from her home (606-738-5779).

Aghassian, George (1904–1985)

Aghassian came to the United States in 1921 from Armenia, to study architecture. He never got to go to school, but when he started drawing in the 1970s while recovering from an illness, his works reflected his interest in architecture. His art was included in the 1997 exhibition, "Flying Free."

Aiken, Gayleen (1934–2005)

Aiken lived in her hometown of Barre, Vermont. She started painting as a child and used words and pictures to tell the story of her life and the life she wished she had led, portraying the adventures of her 24 imaginary Raimbilli cousins and the rooms of the imaginary house where they lived, in great detail. She was part of the G.R.A.C.E. program in Vermont. Her art is included in the exhibition "Flying Free," in a book *Moonlight and Music: The Enchanted World of Gayleen Aiken* by Gayleen Aiken and Rachel Klein (Henry Abrams, 1995), and in an award-winning film (now available in video format), *Gayleen*, by Jay Craven, which may be purchased from G.R.A.C.E. Her art is in the permanent collection of the Abby Aldrich Rockefeller Folk Art Center, the Smithsonian American Art Museum, and the American Folk Art Museum. Luise Ross Gallery in New York City mounted an exhibition of Aiken's art in 2013.

Albright, Jory (b. 1950)

"Albright is a man of imagination and interpretation and the Southern Alleghenies Museum of Art wants you to see it." The museum's latest exhibition, "Jory Albright, Mindful Travels," was on view through January 9, 2014. The exhibit included more than 40 of the artist's pictorial narratives, showing both fictional and nonfictional people and places. Albright lives in Altoona, Pennsylvania. In high school he started painting with watercolors and played guitar in a rock band. He worked on the Pennsylvania railroad for about two years. In 1972 he turned his apartment into an art studio. He paints with oils on canvas now, and makes his own frames. Jory is a self-trained and self-taught artist. He has taken his experience and views, mixed in with what he has learned visually, and created a genre that is part folk, part illustration. He paints "dandies, landscapes, and railroads." He has traveled and has recorded this in his paintings. His work is in the permanent collections of the Southern Alleghenies Museum of Art and the Railroaders' Memorial Museum in Altoona. He is represented by 321 Gallery in Hollidaysburg, Pennsylvania (www.321gallery.net; 814-317-5045).

Albritton, Sarah (b. 1926)

Albritton is a lifelong resident of Ruston, Louisiana. She and her husband had a well-known Louisiana restaurant, Sarah's Kitchen. In 1993, along with bankers, lawyers, and mayors, she started painting when asked to be part of a "celebrity fundraiser" for the North Central Louisiana Arts Council. She began a series of paintings of her early childhood memories

and she hasn't stopped. Albritton often paints painful personal memories or images reflecting complex issues such as efforts to triumph over racism, hunger, and hardship. The Arts Council reported in 2015 that Albritton is still painting.

Alexander, Jim (b. 1950)

Alexander was born in Wolfe County, Kentucky. He carved quite a bit when he was about ten or twelve, making toy knives and swords for himself. He also watched Edgar Tolson carve and tried to imitate him. He attended a one-room schoolhouse and looked forward to the weekly visit of the bookmobile. He and his best friend would each check out the limit of five books, and then trade. This gave him the opportunity, which he took, to read ten books a week. Jim especially liked fiction, science fiction, and "how to" books of all kinds. He put aside carving while in his teens. He graduated from high school and lived for a while in Ohio and Michigan. Then Jim returned to eastern Kentucky, began working in the building trades, married, and now works at a sawmill. He became serious again about carving, a couple of years ago. He carves animals and human figures. His preferred wood is basswood, which he then paints, sometimes realistically and sometimes fancifully. Subjects have included a longhorn cow, a polar bear, and a tableau of "Eve with the Serpent."

Alfonso, Geraldo *see* Makiki

Alfrey, Mabel (1912–1998)

Alfrey lived in Morehead, Kentucky. She was an elementary school teacher for many years and moved to Ohio at one point in her life to be a school principal. She worked in oils and created bold semi-expressionistic paintings with a variety of subject matter. Her work is in the Kentucky Folk Art Center in Morehead.

Allee, Norma (b. 1934)

Allee was born July 1, 1934, in Indianapolis, Indiana. She showed artistic talent as a child, but any possibility of pursuing her love for painting was pushed aside when she was widowed and had two young children to raise. After both children were grown, she bought paints, brushes, canvas, and a pile of "how to" books. She found the best "teacher" was to really, really look at the subject. After a few quick paintings, she painted her first and last painting of flowers in her mother's memory — her mother had wanted her to grow up to be a painter of flowers and landscapes — and put a brass plate on it saying "My Mother's Flowers." She soon started to do formal portraits, then tried other styles and subjects. Norma would be most likely described

as a creator of primitive paintings. She now lives in New Orleans, Louisiana.

Allen, Ann Murfee (1923–1995)

Allen was born in Emporia, Virginia, and lived for many years in Richmond. Allen started painting in about 1967. It has been said about her that she was as much an historian as she was a painter. Her subjects came from her reading, especially newspaper articles, and from history. She liked to do research on historical topics and then paint them. She also painted memories of her own community. Her work may be seen at the Meadow Farm Museum in Virginia. She was included in the exhibition "Folk Art: The Common Wealth of Virginia" in 1996. Also in 1996 there was an exhibition "Ann Murfee Allen, Painter of Memories: A Retrospective, 1967–1994" at Meadow Farm Museum in Glen Allen, Virginia.

Almon, Leroy, Sr. (1938–1997)

Almon lived in Tallapoosa, Georgia, and was a carver who used hand chisels and pocketknives to carve bas-relief wood, which he then painted. His subject matter was usually religious. He often portrayed people battling Satan. The evil temptations of contemporary life, famous historical subjects, and the trials of racism appeared in his polychrome reliefs. He lived and worked in Columbus, Ohio, as a Coca-Cola salesman and there came under the influence of master carver Elijah Pierce. 1982, he returned to his hometown of Tallapoosa to create art on his own. Leroy Almon's work is in many private collections, galleries, and is in several museum collections including the Rockford Art Museum in Illinois; the Art Museum of Western Virginia in Roanoke; the Museum of International Folk Art in Santa Fe; and the High Museum in Atlanta. In April 1997, at the age of 59, he died of a heart attack, leaving a wife and two sons. His work has been in many exhibitions including "Black History and Artistry," in 1993, and "Flying Free," in 1997.

Alten, Fred (1871–1945)

Alten is known for his carvings of all kinds of animals, many of which he displayed in cages. He kept his art a secret during his life. Alten's work has been exhibited frequently, and has been included in books, often with illustrations. Museums that include his work are the American Folk Art Museum and the Milwaukee Art Museum.

Althauser, Tim (b. 1957)

Tim Althauser has spent his life in the Southwest, where he began as a lumberman and then built log cabins. At the age of 38 he suffered a severe brain hemorrhage, after which he had to learn to walk all over again,

and to take care of himself. He also began to teach himself to paint. His subject matter arises directly out of his earlier work—he paints trees, mostly aspens, from the bottom up. "He captures the liberated feeling you get when you're out in nature, gazing up at the sky and listening to the breeze in the leaves; you would think he has spent his entire life staring up at trees, and he has," says Steve Cieslawski, director of The William and Joseph Gallery, a Santa Fe gallery that gave Althauser a major exhibit of his art in 2014.

Alvarez, David (1953–2010)

Alvarez was raised in Oakland, California, and moved to Santa Fe, New Mexico in 1979. He spent several years carving under the direction of Felipe Archuleta before he developed his own style. His work is illustrated in Wendy Lavitt's *Animals in American Folk Art*. He is in the collection of the American Folk Art Museum.

Alvarez, Max (b. 1952)

Max Alvarez was born in San Francisco and raised in Oakland, as was his brother David. He moved to Santa Fe in 1979. He started carving as a hobby and now does it full time. Alvarez works with cottonwood that he gathers himself. He carves animals such as pigs, coyotes, roosters, bears, squirrels, and skunks, as well as African animals. One collector believes Max Alvarez is "the most versatile of the New Mexico carvers and can do any animal." His work is in the American Folk Art Museum and the Museum of International Folk Art.

Ambrose, Edward (1913–1999)

Ambrose was born in Strasburg, Virginia, and lived in Stephens City. Ambrose was a carpenter for 55 years. He carved and painted wood sculptures. He made a wide range of subjects but his political caricatures were said to be his best work. His favorite wood was basswood, which he used a pocketknife to carve. His artwork was included in the exhibition "Folk Art: The Common Wealth of Virginia," in 1996.

Amezcua, Chelo (1903–1975)

Consuelo "Chelo" Gonzalez Amezcua was born in Piedras Negras, Mexico, and grew up in Del Rio, Texas, the youngest of six children. She began drawing at an early age, but received little encouragement for her art and little education of any kind. Amezcua left school after the sixth grade, but remained an avid reader of Greek and Egyptian mythology and Spanish literature. She worked at a dime store selling candy, and in her spare time created art. Amezcua used her own imagination and any readily available material to make her art. Colored ballpoint pens and heavy cardboard were frequent choices. Her distinctive drawings are intricately patterned with long flowing lines. Her work has been called "romantic and unrestrained artistic creation." She also wrote poetry and did delicately incised carvings in stone. Her work is in the permanent collection of the Milwaukee Art Museum and was exhibited in "Spirited Journeys: Self-Taught Texas Artists of the Twentieth Century." She was part of a 2015 exhibition of the visionary experience at the American Visionary Art Museum in Baltimore.

Anaya, Tobias (1908–1988)

Anaya lived and worked all his life in the beautiful little town of Galisteo, New Mexico. Anaya made small, unpainted sculptures from wood and other found objects. He started making art when his mother, whom he had cared for, died and he was very lonely. His art is in the collection of the Smithsonian American Art Museum and the Museum of International Folk Art. He died in Galisteo.

Anderson, Cathy (1966–1995)

Cathy Anderson's prolific body of work consists of watercolor drawings, paintings, and ceramic sculpture. Her work is figurative with architectural elements. She enjoyed experimenting with color and creating spatial illusions with an intuitive form of perspective drawing. Some of her artwork seems based in memories, some represented present situations, others appeared to be playful musings that incorporated appealing images and ideas. Anderson was a person with autism; staff at the Gateway Gallery in Brookline reflected that her observational skills made it possible for her to move ahead in her ability to function in society, and these same powers of observation were applied in her art, too. In her work she found ways to communicate that she could not do verbally. "She found her voice in art." Gateway had a memorial exhibition 1996. Anderson's art was exhibited in New York, Boston, Pennsylvania, Washington, D.C., and London and is in private collections.

Anderson, Linda (b. 1941)

Anderson comes from Floyd County, Georgia. She is the fourth of five children born to a tenant farming family. She left school at age thirteen and became a carpenter. She quit working outside the home to care for a daughter who needed her help. Anderson believes her painting comes from God as an answer to a prayer for help: "Beautiful pictures started to appear in my head." Anderson paints with oil on linen or oil crayons on sandpaper. She also does woodcarving. Her subject matter comes from her own experiences. Her work was included in the exhibition "Georgia Folk Art," in 1991, and "Womenfolk" at Wesleyan College in Macon, Georgia, in 1998.

Anderson, Stephen Warde (b. 1953)

Anderson lives in Rockford, Illinois. He started painting in 1976 after he was discharged from the Navy. He makes his own "canvas" and paints for his art. His paintings are "pointillistic," and his most popular themes are perfect women, goddesses or otherwise, from the past. His art is in the collections of the Smithsonian American Art Museum and the Rockford Art Museum.

Andrews, Alpha (b. 1932)

Alpha Andrews is from rural north Georgia. The daughter of a sharecropper, she picked cotton as a child to help support the family. Married at nineteen, she had five children and soon after became a widow. One of the children required special care; the rest she managed to support and encourage through college. After years of community service on a volunteer basis, she became an ordained minister. Andrews has the distinction of being the only white woman invited to preach in black churches. She started painting in 1983, was discovered by an Atlanta gallery owner, and sold a few paintings. She stopped for a while because of family responsibilities, and then in 1990 started again after a disabling car accident. Andrews is best known for her scenes of Southern life. Her later paintings include psychic visions she has always had, but never revealed outside the family. She was included in the exhibition "Georgia Folk Art," in 1991.

Andrews, George (1911–1997)

George Andrews was born in Plainview, Georgia, and lived there until 1953. He was a sharecropper and the father of ten children. His older children eventually moved to cities, as did his wife and younger children in 1953. George Andrews then moved to Madison, Georgia, in Morgan County, an area where he had always lived. He started painting when he was a little boy. He painted his house and most of the objects in it, turning his home into a total art environment. He did some paintings in later years, oil and enamel on canvas-board furnished by his mainstream artist son Benny. The two artists shared an exhibition that opened in Memphis in the fall of 1990 and traveled to six other cities: "Folk: The Art of Benny and George Andrews." The catalog had illustrations of George's work. "The Dot Man: George Andrews of Madison, Georgia" was the name of an exhibition featuring his work in 1994 at the Morris Museum of Art in Augusta. There is a book/catalog featuring his art, with the same title, which includes a detailed biography of his life and his family. The Barbara Archer Gallery in Atlanta gave him a solo exhibition in 2004. His art is represented in the permanent collections of the Morris Museum and the Ogden Museum of Art in New Orleans.

Angel, Clyde (1920–2006)

Clyde Angel [Vernon Clyde Willits] was born in Beaver Island, Iowa, and was a "highway wanderer" who made his art from scrap metal he picked up along the road, often tin cans and rusty car parts. He was a recluse who lived somewhere in Iowa and did not want to know people or interact with society. Angel said people could know him from his art. He learned rudimentary welding techniques from a welder/fireman who became a friend and who allowed Angel to use his tools. He made two-dimensional and three-dimensional figures of imaginary women, men, and animals. His art was appreciated; but his insistence on remaining anonymous was not. This stand he took did not make it easy for those who admired his work to support him, as the art world demands the proper credentials and a face to go with them. Some, such as gallery owners Judy Saslow and Sherry Pardee, understood his need to let the work speak for itself. (Information provided by his son, Skip Willits.)

Anthony, Bishop "Butch" (b. 1964)

Butch Anthony lives in Seale, Alabama, and is a "jack-of-all-trades," being especially skilled in carpentry. He built the log cabin where he lives. Anthony spends most of his time around the woods and creeks. He consequently has a large collection of shark teeth, arrowheads and other artifacts. He has been drawing since he was a boy and started painting about 1994. He started by painting on cardboard boxes and now paints on canvas, tin, boards, and plywood. Some of his paintings depict his own past experiences, while others offer a humorous commentary on modern life. Butch also creates large and small sculptures out of tin, wire, wood, and cast-off materials. His work was included in the exhibition "In Our Own Backyard: The Folk Art and Expressions of the Chattahoochee Valley" at the Columbus Museum in Columbus, Georgia, in 1996. Butch Anthony lives at 41 Poorhouse Road in Seale, Alabama.

Antonio, Johnson (b. 1931)

Johnson Antonio lives in the Lake Valley area in New Mexico. Although it is not part of the Navajo tradition to carve, Antonio started when he was in his fifties. He carves "for money to support his family and out of the desire to communicate to others the spirit of his people and their animals." Antonio whittles dried logs with a pocketknife and paints the figures with watercolors and gouache. His work is in the collections of the Smithsonian American Art Museum, the Museum of International Folk Art, and Wheelwright Museum of the American Indian in Santa Fe.

Antonio, Sheila (b. 1961)

Sheila Antonio was born March 28, 1961, and

resides in the Bisti area in New Mexico. She went to school through the eleventh grade. She makes small, colorful, and often humorous bead-covered forms that capture the Navajo way of life in a contemporary style.

Archuleta, Felipe (1910–1991)

Many describe Felipe Archuleta as "the best of the New Mexican carvers" and as an "important link between the sacred *santero* tradition and a contemporary art form." He is written about and exhibited frequently. The essay by Christine and Davis Mather in the catalog *Lions and Tigers and Bears, Oh My!* is a detailed source of information about Archuleta. Felipe Archuleta is in the collections of the Smithsonian American Art Museum, American Folk Art Museum, and the Museum of International Folk Art. He is the featured artist in the long-running "Wooden Menagerie" exhibition at the Museum of International Folk Art in Santa Fe. Felipe was born in Santa Cruz, New Mexico and died in Tesuque.

Archuleta, Leroy Ramon (1949–2002)

Leroy Archuleta was born in Tesuque, New Mexico, and worked in Denver, Colorado for many years until he tired of life in the big city and returned home. In 1973 he started working with his father Felipe. He used cottonwood from fallen trees, a chainsaw, and small tools, as did his father, to make his wooden animals. His art illustrates the book *Leroy's Zoo* (Black Belt Press, 1997), which accompanied a traveling exhibition of the same name. Leroy shared his studio and his knowledge of wood carving with his nephew Ron Rodriguez. His work is in the collections of the Albuquerque Museum, The American Folk Art Museum, the Smithsonian American Art Museum, and others. His art was included in the exhibition "Flying Free" in 1997 and "Wooden Menagerie" at the Museum of International Folk Art in 2014. Leroy died in Tesuque.

Armstrong, Steve (b. 1945)

Armstrong is a self-taught artist from Lexington, Kentucky. He works primarily in wood, making sculptures such as canes, whirligigs, and other more complex works with moving pieces. Armstrong is a graduate of the University of Kentucky. For years, he worked at other occupations before becoming a full-time artist. His work is in the permanent collection of the Kentucky Folk Art Center.

Armstrong, Z.B. (1911–1993)

Zebedee "Z.B." Armstrong lived in Thomson, Georgia. He fashioned wood and other found objects into elaborate calendars and other constructions, usually painted white and patterned all over with a grid of red and black using magic markers. He made the calendars to predict the date of the end of the world. He spent his last years in a nursing home, no longer able to do his art. His work appeared in "Passionate Visions of the American South" in 1993. In 1997 a whole room of his work was part of the exhibition "The End Is Near" at the American Visionary Art Museum in Baltimore. Several galleries carry his work, which is also in museum collections.

Arning, Eddie (1898–1993)

Arning was raised on a farm in Germania, Texas a community near Austin, Texas. In 1934 he was committed to a mental institution where he remained for about thirty years. He was then released to a nursing home in 1964. It was there that he began to draw when offered material by an art teacher. At first Arning drew only animals; then he began to make drawings based upon newspaper stories, magazine photographs, advertisements, and other examples of popular culture. In 1973, when he was released from the nursing home and went to live with his sister, he stopped drawing. He has been written about frequently. His work is included in many museums and was included in the exhibition "Passionate Visions of the American South" in 1993. In 1997, the High Museum in Atlanta, Georgia, mounted an exhibition, "Abstract Realities: The Art of Eddie Arning." He died in McGregor, Texas.

"Artist Chuckie" *see* Williams

Ashby, Steve (1904–1980)

Steve Ashby made figures of plywood and other found objects. His work has been written about extensively and is in the collections of the Milwaukee Art Museum, the of American Folk Art Museum, and the Smithsonian American Art Museum. His work has been included in many exhibitions including "Black Folk Art in America 1930–1980" at the Corcoran Museum in Washington, D.C., and "Passionate Visions of the American South" at the New Orleans Museum of Art in 1993. He was born and died in Delaplane, Virginia.

Atkinson, Hope Joyce (1946–2012)

Hope Atkinson was born December 10, 1946, in Wisconsin. She was one of nine children. Hope was only four years old when her mother left home. Her father tried to keep the family together but couldn't and she ended up in foster care. When Atkinson was 16 she got a license to work on ore boats on the Great Lakes, which she did for many years. She eventually got her own small boat and traveled the waters of Lake Superior daily until a horrible accident nearly took her life. After months in the hospital, she went home to a Spartan barn on the shore of Lake Superior where she

lived, with no running water and heat from her wood cook stove. When Atkinson was lonely she began to create "friends" from papier mâché and found objects. Her colorful work revolves around spiritual themes mixed with a wry sense of humor and strong social awareness. Many works are autobiographical in nature and are combined into elaborate groupings. Hope received housing in Alabama (from Marcia Weber, her art dealer), when Lake Superior was too cold to stay in the winter. Marcia Weber/Art Objects still has some of her work for sales. Her studio in Cornucopia, Wisconsin is now a summer artists' workshop.

Aulisio, Joseph P. (1910–1973)

Aulisio was born in Old Forge, Pennsylvania, and later lived in Stroudsburg. He painted portraits of family and friends and landscapes. The majority of his works remain with his family. His art may be seen in many published sources, including the *Museum of American Folk Art Encyclopedia of Twentieth-Century American Folk Art and Artists.*

Ave Maria Grotto *see* Zoettl, Joseph

Bacon, O'Leary (b. 1944)

O'Leary Bacon was born in Louisville, Kentucky. She graduated from Kentucky State University, earned a master's degree in social work from Loyola University in Chicago, and worked for 26 years as a social worker. She then gave it up to paint her autobiographical art depicting African American experiences. She moved to Cincinnati in 1992, and continues to make colorful and powerful paintings. She works in a variety of media including oils, encaustics, pastels, acrylics, colored pencil and wood, all of which she has taught herself to use. Her narrative paintings are mostly about people. Her frames are usually handmade "to complete the composition." Ms. Bacon is exhibited frequently in galleries, was included in the exhibition "African-American Folk Art in Kentucky" in 1998, and is active in Cincinnati. Recent exhibitions have been "Journeys to Freedom," an exploration of what it means to be free, "A Tear and A Smile" at the YWCA Women's Art Gallery in 2004, and "Empty Chairs, Painted Windows," in 2005, about domestic violence, shown at the Cincinnati YWCA Women's Art Gallery."

Badami, Andrea (1913–2002)

Badami was born in Omaha, Nebraska. When he was five, his family returned to Corleone, Italy. After going back and forth to Italy many times, serving in the Italian army in the war, being captured by the British, and living seven years as a prisoner of war in England. He returned to Omaha to stay in 1946, where he worked for the Union Pacific Railroad until retirement in 1978. At that point he moved to Tucson, Ari-

zona. He began painting after seeing some paintings in an art gallery. He painted scenes from his difficult early years, and reflected a religious and social philosophy that Badami had difficulty expressing in English. He started showing his paintings while still in Omaha, after taking some to the Joselyn Museum where the exhibitions manager recognized his talent. His art is in the collections of the American Folk Art Museum and the Smithsonian American Art Museum.

Bagley, Eldridge (b. 1945)

Bagley is from Lunenburg County, Virginia, and he paints scenes of the rural county where he lives, generally giving them a certain twist. It has been said, "His more recent oil-on-Masonite or canvas paintings often make personal statements or comments on society." His work appeared in the exhibition "Folk Art: The Common Wealth of Virginia," in 1996. In 2011 he received an Award of Distinction from the Folk Art Society of America at its annual conference.

Bagshaw, Margarete (b. 1964)

Self-taught artist Bagshaw is a third generation artist in a family of famous Santa Clara/Tewa women painters. She has developed her own path and identity. Her early work was the muted tones of pastels but now her canvases burst with color, action, shapes, textures and light. She has pushed the boundaries of Indian art and "has emerged as a defiantly independent voice for Native women artists" according to a writer in the 2012 Summer Guide of the Museum of Indian Arts & Culture in Santa Fe. Golden Dawn Gallery in Santa Fe carries her work along with the art of her mother, Helen Hardin and grandmother, Pablita Velarde, all of which the gallery shows together.

Bailey, E.M. (1903–1987) "Bailey's Sculpture Garden"—Atlanta, Georgia

E.M. Bailey was born and grew up in rural Georgia near Indian Spring. He moved to Atlanta in 1916 and stayed there for the rest of his life. In a small yard next to his home, Bailey built a collection of monuments and shrines. Working chiefly with plaster or cement, he built figurative sculptures and vase forms, often embellished with paint. The garden was located at 396 Rockwell, S.W., in Atlanta. It is no longer there, but rumor has it that the sculpture was saved by collectors. One of his works is in the Rockford Art Museum in Rockford, Illinois.

Bailey, James Bright (1908–1993)

Bailey lived most of his life in Marshfield Township, North Carolina. He started carving after he had to retire at age 59 as a result of exposure to asbestos. Bailey made colorful sculpture, including trucks, and

many carvings of small freestanding figures using his favorite wood, maple, from his backyard, and small tools. He had to stop carving in the early 1980s because of increasing ill health. His art was included in the exhibition "Worth Keeping" in South Carolina and in the exhibition "Signs and Wonders: Outsider Art Inside North Carolina."

Baker, Elisha (b. 1922—no further information available)

Baker is a disabled sawmill worker who lives in Pineville, Kentucky. He made his first cane over thirty years ago for his own use. The canes usually have, according to Larry Hackley, "his unique braced handle." Recent works are more colorful than his earlier ones. He uses cedar, cherry, and walnut and carves with a pocketknife. Most of his canes have a head at the top; recent ones may feature a full figure. The shaft is carved and painted with decorative patterns, often with a cage of marbles under the head. The heads may be of religious figures such as Jesus, Roman soldiers, and King Herod, or such popular figures as Elvis, Dolly Parton, and Daniel Boone. His work is in the permanent collection of the Kentucky Folk Art Center in Morehead, Kentucky. Attempts to contact or determine whether Baker is still alive have failed.

Baker, Ernest "Dude" (b. 1920—no further information available)

Baker was born in Roger's Chapel, Powell County, Kentucky, and now lives in Slade. Baker had eight brothers and four sisters and his father ran a country store. He quit school after the eighth grade because he "found it too confining." He worked in a sawmill and on the railroad. Born partially sighted, Baker is now legally blind. "Dude" Baker, his wife, his brother, and his wife's brother were well-known for their church music played on the local radio station. Baker sang and played the harmonica. In 1989 his wife of 38 years died. He had been devoted to caring for her during her illness from two strokes. After her death, when, he says, he was "beside himself with grief," his long-time friend and neighbor, Carl McKenzie, convinced him to try his hand at carving to occupy his time and his mind. Baker says he tried a long time to make a walking stick with a snake before he succeeded. He now carves canes and a variety of human figures—"families," bathing beauties, birds, and animals. His work shows a definite McKenzie influence but has its own appeal. He believes he is "supposed to do" what his mentor showed him, but as time passes he is developing more images of his own. His work has found its way into the homes of collectors. His home is behind the "rest stop" at the beginning of the entrance to Natural Bridge State Park. Attempts to contact or determine whether Baker is still alive have failed.

Baker, Samuel Colwell (1874–1964)

Baker was born in Shenandoah, Iowa. He painted "naive paintings," with oil on canvas. His subjects were landscapes and religious themes. His work was included in the book *Religious Folk Art in America* by Dewhurst. His work is also in the book *Twentieth-Century American Folk Art and Artists* by Hemphill and Weissman and in the permanent collection of the University of Nebraska Art Galleries.

Baker, Thomas King (1911–1972)

Thomas King Baker was born in Pittsburgh to a doctor and his wife. He was one of six children. The family moved to Kansas City, Missouri, in 1918. Thomas liked to make pictures from an early age but received no encouragement from his family. He grew up to be a successful businessman, a lover of music and literature, a "socialite and fun-loving friend." When he died in 1972, "Baker quietly left a remarkable body of artworks created in the seclusion of his basement over a twenty-five year period." The executor for another Kansas City painter found the works and eventually located the widow of Tom Baker to learn the story of his life. In 1953, his wife had bought him a $2.00 set of paints, and after that he would return home from work and disappear into the basement to paint. In 1972 he became ill with a progressive numbness and paralysis, especially in his hands, and could paint no longer. The detailed story of Baker's life and the discovery of his art is found in the exhibition catalog *The Art of Thomas King Baker* published by the Albrecht-Kemper Museum of Art in St. Joseph, Missouri, in 1997.

Baldwin, Elaine

Elaine Baldwin was born in Vermont and has lived in Morrisville for over twenty years. She has several hobbies, including taking care of her four poodles, and all types of art and crafts. She enjoys traveling and recently returned from a trip to Montana. She looks forward to the winter season because she enjoys sledding. Elaine attended the G.R.A.C.E. weekly workshops at Brooklyn Street Center in Morrisville for many years, working often with watercolors, but markers were her favorite medium. G.R.A.C.E. still carries her art.

Baltimore Glassman *see* Darmafall, Paul "The Baltimore Glassman"

Bambic, John (b. 1922)

John Ivan Bambic was raised in the Yugoslav Republic of Slovenia, where he grew up next to a blacksmith's shop. He was apprenticed to a butcher and he also farmed. After World War II he was sent to a relocation camp. He met his future wife there, and they emigrated to the United States in 1950 and settled in

Milwaukee. Before his retirement, he worked in a tannery for thirty years. His detailed and elaborately painted whirligigs reflect his working life: a shoemaker hammers a shoe, a farmer feeds his chickens, a butcher cuts a leg of beef. The carvings spin into motion at the slightest breeze. The exhibition "A Slovenian Tradition: The Whirligigs of John Bambic" was at the John Michael Kohler Arts Center in 1995. His work was included in the American Visionary Art Museum show "Wind In My Hair."Folk Art dealer Sherry Pardee carries his work.

Banks, John Willard (1912–1988)

Banks was born in Cottonwood, Texas and lived most of his adult life in San Antonio, Texas. His interest in drawing, which he had enjoyed as a child, was revived after a long hospital stay. He painted the history of black life in rural southern Texas. He used ballpoint pen, crayon, and markers, on cardboard mostly. His work is in the permanent collection of the San Antonio Museum of Art and the Smithsonian American Art Museum. He was included in the exhibition "Tree of Life" at the American Visionary Art Museum in Baltimore and in "Spirited Journeys: Self-Taught Texas Artists of the Twentieth Century."

Banks, Michael (1972)

Banks was born and grew up in a housing project in northern Alabama, raised by a single mother. He drew from a very early age, with his mother encouraging him to make his art. He was beginning to be recognized when, in 1992, his mother died and he stopped making art for the next five years, while suffering from depression. In 1997 he started again, painting and also experimenting with new techniques, including using found objects and building materials in his pieces. When he is making art, he says, he is totally absorbed, and the work just emerged. He often doesn't realize what he is creating until it is finished. His work has been widely recognized; in 2005 the now-closed Hurn Museum in Savannah gave him a solo show, and he has been featured in the pages of *Southern Living*. In early 2015 the Roots Up Gallery in Savannah mounted an exhibition of 22 of his paintings, and carries his work for sale. In addition to the Roots Up Gallery, his art is also available through Marcia Weber/Art Objects in Montgomery and Jeanine Taylor Folk Art in Miami.

Barkas, Walter (1938–1995)

Walter Barkas was born in New York City. He had a life of rich experience: studies at the University of California at Berkeley, Peace Corps work in Nigeria, lived among the Mayans in Mexico, drove a taxi in Seattle, taught at a community college, and worked in construction and logging. In his last years he lived in

a cabin in the woods, which he built with basic hand tools. His life-sized animal sculptures, created in collaboration with his wife, Rivkah Sweedler (b. 1946), were quite exceptional. It was said in an announcement for his memorial service that "Walter was committed to living lightly and simply, and he could find the most amazing, artistic uses for other peoples' 'throw-aways.' He was a master of recycling, turning old plastic bottles into delightful masks, and downed trees into donkeys and dogs and goats and birds." He also made wonderful stories about his critters, woodcuts, and paintings.

Barker, Bill (b. 1941)

Bill Barker lives with his wife in West Liberty, Kentucky, and works for the state highway department. He was born and raised in the area, but after graduating from high school he went to Indiana for twelve years where he worked in the steel mills. He returned to Kentucky in 1974. In about 1994 he started carving his "space chickens" and other figures out of pine knots. In addition to the chickens he makes salamanders, bugs, stick men, and lizards—or whatever else comes to his mind. He paints his whimsical figures in very bright colors, often with dots or other patterns. His work is found at Morehead and other galleries. He also sells his work at The Day in the Country in Morehead.

Barker, Lillian Faye (1930–1997)

Lillian Barker was born in Roscoe, Kentucky, and lived in eastern Kentucky with her carver husband, Linvel Barker, and helped him with the fine sanding of his pieces. She made some of the small animals on her own. Lillian also taught herself to paint, using acrylics and canvas-board. Her subjects were stories from the Old Testament. She was killed in an automobile accident on an icy road in 1997. Her art is in the collections of Owensboro Museum of Fine Art and the Kentucky Folk Art Center in Morehead.

Barker, Linvel (1929–2003)

Linvel Barker was born in Crockett, Kentucky. For thirty years he worked in an Indiana steel mill. His wife Lillian worked in Indiana, too, for an auto parts manufacturer. After retirement they moved back to Kentucky, to Isonville. Barker had a hard time with retirement, and neighbor Minnie Adkins suggested he try his hand at carving. He eventually gave in and tried it; the results were magnificent. His animal carvings have an elegance of design not often found in folk art and the finely finished surface adds to their beauty. Woods used are linwood, poplar, and buckeye, which is two toned. Barker stopped carving after the death of his wife. Galleries and museums have his work in their collections. The Barkers' art was included in the exhibition "Flying Free" in 1997. Larry Hackley has his art for sale.

Barnard, John (b. 1955)

John Barnard was born in Pittsburgh, Pennsylvania. He took no special interest in art until his late teens, when he began to practice drawing and painting. He believes that he began to develop his distinctive style after moving to Savannah, Georgia, in 1976. He now paints about ten hours per week. He is a completely self-taught artist who "does not match the usual stereotype," said his dealer, the late Robert Cargo. He is, according to Cargo, "a superbly educated metallurgical engineer but has no training in art." He had a fifteen-year accumulation of drawings that he had shown to no one except his family until he brought them to Robert Cargo in Alabama. He works primarily in gouache and watercolors, and occasionally pencil with a little color. The artist says, "My primary subject is the human body, sometimes in relationship to animals, most often cow-like figures. The vast majority of my paintings are female nudes of one sort or another. I also have an interest in portraits. In general, I work on a small scale, almost always on paper."

Barnes, Ursula (1872–1958)

Ursula Barnes was born in Germany and moved to San Francisco, California, c. 1891. She had an interesting and colorful life and traveled extensively. She was a dancer on the New York stage, the wife of an itinerant evangelist, a Hollywood actress a parlor maid in Chicago, and a pastry cook in San Francisco. Very few people, including her family, knew that she painted until her canvases were found at the time of her death. She completed only 30 or so paintings, using the world of the theater as the inspiration for her work. Her paintings are filled with melodrama, with fanciful costumed characters and lots of motion. She is recognized most often for her painting "Cat and a Ball on a Waterfall," which gave the name to and illustrated the cover for an exhibition "Cat And A Ball On A Waterfall: 200 Years of California Folk Painting and Sculpture," in Oakland in 1986. Recently a selection of her work has turned up in a private collection and some of her art is available at the Ames Gallery in Berkeley.

Barnett, Lois Ann (b. 1961)

Lois Barnett is from San Pablo, California, and has been working at the National Institute of Art and Disabilities since 1988. She has very limited vision "yet she makes artwork that is a pleasure to behold." Her subject matter is landscape and also birds, butterflies, and flowers. "She builds her work up with many small strokes in bands of colors, blending together at their borders giving the work an ephemeral quality." She uses very bold colors and is not bound by convention. Her work has been exhibited frequently and she is popular with collectors.

Baron, Jack (1926–2005)

Jack Baron was born in Rockaway Beach, Queens, New York. He went to high school and college in New York, served in the U.S. Navy, and worked as a department store window trimmer. He moved to Key West in 1977, where he began painting. In Florida, Baron was a well-known and well-regarded self-taught artist. He had numerous gallery exhibitions and his paintings are in many private collections. His paintings are described as "having a few solid forms interspersed with shapes filled with small dots of vibrant contrasting color." His subjects—people, places, and cats—always relate to Key West. His professional and personal papers are deposited with The Amistad Research Center in New Orleans, Louisiana. The Joy Gallery in Key West held an exhibition of Baron's work as recently as 2014, and the Gingerbread Square Gallery on Duval Street in Key West carries his work.

Barrett, Deborah (b. 1946)

Barrett is a native of Michigan, where she studied creative writing at Wayne State University. She moved to the San Francisco Bay Area in the early 1980s, went to New York for a while, and settled permanently in San Francisco in 1994. Barrett began to make art as a child, creating toys for herself, and much later for her son. Much of her art is figural, containing elements of the early toys as she assembles a variety of materials for her collages and assemblages. She works with pencil, ink, paint, found paper, scraps of fabric and leather, and old journal pages. She also uses wood, wire, wax, and plaster to construct three-dimensional figures of many sorts. Her work has been shown in New York, Los Angeles, Portland, and Seattle, as well as many parts of the Bay Area. The Ames Gallery in Berkeley carries her work.

Barta, Joseph Thomas (1904–1972)

Joseph Thomas Barta was born in Illinois, went to college there, and became a coach and teacher. He also did a lot of traveling. He started carving full-time when he was just over age 40. He built a museum to house his collection of about 500 small carvings of people and animals. He also built many life-sized figures to portray the story of Christianity. It is still possible to visit his collection at the Museum of Woodcarving in Shell Lake, Wisconsin. See the chapter on Museums for details.

Bartlett, Morton (1909-1992)

Morton Bartlett was born in Chicago, attended Harvard University, and was a self-taught sculptor and photographer. His life's work was a "family" he invented in sculptures and in photographs. His work was discovered just after his death. It consisted of 3 boy and 12 girl figures, about half life-size, each taking about a

year to complete. He made extensive wardrobes for each, and also created additional heads, numerous sketches, scores of outfits, and took over 200 photographs. The work took almost three decades to complete, from 1936 to 1963. He then packed it away, not to be found until after his death. *Family Found: The Lifetime Obsession of Self-taught Artist, Morton Bartlett,* containing biographical information and information about his art was published by Marion Harris in 1994. His work is in private collections and in the Musée l'Art Brut in Lausanne, France.

Batchelor, James (b. 1914)—"Odd Garden"—Cincinnati, Ohio

Batchelor's garden was referred to in a newspaper article as "yard-art mosaic that's a little bit Mardi Gras, a little bit Looney Toons, a little bit roadside Americana." It is filled with vegetables planted in painted barrels, silk flowers, a stuffed goat chained to a bowling ball, a "life-sized, voodoo-doll-looking woman" that had to be moved to the backyard when men talking to her got angry when she wouldn't answer back. There is also a Batchelor family "Walk of Fame" with a star-studded square for his late wife (who didn't like the garden) and each of their nine children. People brought him things to add to his garden all the time and he was pleased that people drove by to take a look. Batchelor's house is located at 761 Wayne Court, in the Walnut Hills neighborhood of Cincinnati, Ohio. In 2014 The Folk Art Society of America visited the site at the end of the 2014 annual conference and reported its excellent condition. A more extensive description is available at http://www.weirdus.com/states/ohio/personalized_properties/james_batchelor/index.php.

Batiste, Alvin J. (b. 1962)

Alvin Batiste was born March 16, 1962, in the small community of Donaldsonville, Louisiana. He started drawing at the age of three, encouraged by his mother. Not until Batiste was in his early thirties, inspired by art shows he saw on public television, did he decide to try his own hand at acrylics. Again his mother encouraged him and he began painting on anything he could find: washtubs, cardboard boxes, slate, just about anything. Batiste has had no training, just an instinctive nature to paint what he sees and feels. His work reflects his small town, his African American culture, and some of the images he sees on television. He worked for a long time at Rossie's Custom Framing, where he had his "studio," where the proprietor Sandra Imbraguglio supplied him with canvas and paint. He now makes his art at "Framer Dave's" in Donaldsonville. His work is in collections in the United States and Europe.

Bauer, Jim (b. 1954)

Jim Bauer was born in Portland, Oregon. His father was in the military and the family traveled from base to base. Bauer attended junior college in California, has been an auto mechanic, a researcher at Kaiser Aluminum, and a dealer of aluminum kettles, teapots and other objects at flea markets, thrift stores, and recycling depots looking for aluminum objects he can use in his art, which can include coffee pots, irons, and sprinkler heads. Many include electric lights and one includes a working telephone. Obviously an "aluminum enthusiast," he makes his art in an Airstream trailer. He began making sculptures when he saw a piece of art he wanted but could not afford. He started making robot-like fanciful figures from cast-off kitchen utensils. "They have a futuristic look, but a nostalgic quality," according to an art critic in *The New York Times.* He was included in the exhibition "Wind in My Hair" at the American Visionary Art Museum in Baltimore in 1996. Bauer lives in Alameda, California. His work is carried by American Primitive Gallery in New York and the Ames Gallery in Berkeley.

Baughman, Brice (1874–1954)—"The Statues"—Zanesville, Ohio

Baughman was from Black Run, Ohio. He was a stonecarver who created sandstone monuments and sculptural pieces in the deep wood of his farm near Jackson Township in Muskingun County, Ohio. He taught himself to carve animals and people from the hard rock there; a massive sandstone formation with only a shallow covering of soil. He made his first statue in 1898, that of President William McKinley. Baughman, two sons, and a nephew cleared the ground around the statues and scattered picnic tables amongst them. The day the last statue was dedicated, more than 3,000 cars passed through the park to see the site. The sculptures are still there, as described in a 2008 book by Neil Zurcher, *Ohio Oddities.* But the land passed through several owners following Baughman's death; they mostly left the statues alone, and they "are now just a collection of one man's artwork scattered across an overgrown woods in central Ohio."

Baum, David

The following information about artist David Baum comes from the proprietor of the Attic Gallery in Vicksburg, Mississippi, who met him in New Orleans: "Some might call him a vagabond or a wanderer. A less romantic answer would be that he is homeless, a street person. But the unarguable fact is he's an artist. We met David in Jackson Square in New Orleans when we stopped to admire his paintings ... tourists weren't buying. The work was a little too intense and uncompromising." He was given their business card. He sent paintings to the gallery as he was leaving New Orleans, from his mother's home in Idaho, and then from his new home in Kingman, Arizona, where he was washing

dishes to get by. "David is driven to paint. It is what he does well. But for religious reasons he wonders if it is wrong to glorify himself by painting. As a compromise he augmented his signature with a cross." He turned up later in Vicksburg and for a time was painting local scenes and local faces, "but they also show evidence of his inner struggles. After seven months in Vicksburg, he moved on. The last we heard he was back in Kingman."

Beal, Art (1886–1992)—"Nitt Witt Ridge"—Cambria, California

Art Beal built winding stairways, paths, arches, walls, rooms, patios, fences, and other structures on a hillside using shells, concrete, rock, and countless found objects. Beal, who "hated it when people did not double the 't' in 'Nitt' and 'Witt,'" collected everything written about the site and wrote in the correct spelling. The Art Beal Foundation is actively at work to restore the site and open it to the public; see the chapter on organizations for details. This site is located at 881 Hillcrest, just off Main Street in Cambria, and part of the site is visible from the street. Art Beal was living in a nursing home at the time of his death. Beal is included in Seymour Rosen's book, *In Celebration of Ourselves* (California Living Books, 1979). A 2002 book by Kathy Strong, *Southern California: Off the Beaten Path* (Grove Pequot Press) features Nitt Witt Ridge as one of the places the author considers definitely worth a visit.

Beavers, Geneva (1913–1997)

Geneva Beavers was raised on a large farm, the youngest of twelve children, near Durham, North Carolina. She lived in Chesapeake, Virginia, for more than forty years. Mrs. Beavers started painting in 1974 after her son was killed in a motorcycle accident. As a child she liked to draw, but both her mother and her teacher told her it was "a waste of time." Mrs. Beavers did both painting and plaster sculpture. In her paintings she liked bright colors with figures outlined in black and with lots of patterning. For her sculpture her husband built armatures for her and she would slowly add layers of plaster. In both painting and sculpture her favorite subjects were animals, "not real ones, kind of distorted, but even the children recognize what they are." Her art was included in the exhibition "Folk Art: The Common Wealth of Virginia" in 1996 and in the exhibition "Flying Free" in Williamsburg in 1997.

Beebe, Robert (b. 1931)

Robert Beebe was born in Banks, Oregon. He spent three years in the army in Germany, restored old houses and taught German for twelve years before returning to the United States. In 1959 he started drawing and painting as much as he could. In around 1988 he started doing his art full-time. He works mostly with acrylics on paper and favors mysterious animals, people, creatures, and landscapes. He lives with his cat in the village of Idyllwild, in California.

Beecher, Gene (1909-1996)

Gene Beecher was born in Houston, Texas, and later lived in New Haven, Connecticut, and Cleveland, Ohio. He lived in Lakeland, Florida at the time of his death. Most of his life he was a musician with his own dance band. He took up painting after he retired and moved to Florida. Beecher "started with a blank canvas, selects colors he likes, placed them randomly, then began to create figures by defining negative spaces and outlining areas." His medium was acrylic on assorted flat surfaces and the primary subject matter is the emotional and psychological response of people in human interaction. Two of his paintings were included in the exhibition "Contemporary Folk Art: A View from the Outside" in 1995. HUSTONTOWN, in Fort Loudon, Pennsylvania, run by his son, has his father's work for sale.

Bell, Dwight Joseph (1918–2004)

Bell was born in Possum Hollow, Virginia, on July 20, 1918, and lived in Staunton in an assisted care facility. He was injured at birth and could not learn to read or write. His sister Lena says, "He was smart and gifted in so many other ways." He did drawings from memories and from looking at pictures. The images in his drawings include houses drawn with clean, precise lines, every brick in place; long trains with passengers; and gardens filled with brightly colored whirligigs. He used to make airplanes and whirligigs, dogs, cats—most anything anyone would want—from found wood and paint. Bell always lived with his mother, and when she died in 1977 "he was a lost soul" and quit working. Then he started again in the 1990s. Bell was included in the exhibition "Outsider Art: An Exploration of Chicago Collections" in 1996.

Bell, Ralph (1913–1995)

Ralph Bell was a remarkable artist who lived in Columbus, Ohio. He was taken from his home at age nine and lived in a state institution for sixty years. In the last years of his life he lived in a residential facility. Bell had cerebral palsy and could not walk or use his arms. He used a special helmet-like apparatus with an attached brush to paint colorful works at the United Cerebral Palsy Center where he made his art. He was an inspiration to everyone there. He created a painting device similar to his own for children with disabilities. Bell was a person of warmth and humor and also an extremely talented artist. His works are colorful and the images command attention. In a rather abstract background one finds an occasional flower, human fig-

ures, and cunning animals. Often the people are painted with no arms; "since Ralph could not use his, they seemed rather unimportant to him." In 1993 his work was part of the exhibition "Raw Spirit" at Northern Kentucky University.

Bello, Francisco (b. 1961)

Francisco Bello was born in Cuba and moved to the United States with his family when he was six years old. The people at the National Institute of Art and Disabilities, where he used to makes his art, say that Bello seemed very shy, "but when given a pencil, pen or brush and encouraged to put his images on paper, he is a dynamo of expressive emotion." His images are most often groups of people, but sometimes the paintings have no clear object. In 1995 he moved to Florida. His work has been included in several exhibitions, including at the American Visionary Art Museum in Baltimore.

Benavides, Hector Alonzo (1952– 2005)

Benavides was born in Laredo, Texas, and grew up on the family ranch in Hebbronville, where he lived until his father died in 1970. He studied successfully to become an optician. Benavides first began drawing his signature "squares, dots and lines" when he was in elementary school. Benavides devoted himself totally to his art in 1983. He worked in isolation, sleeping days and working all night. He boasted of being obsessive-compulsive, a quality reflected in his art. He continued drawing and used his art to cope with his emotions. From a distance his work looks like intricately woven cloth. His religion influenced his work as did his moods. All his work was dedicated to his mother, who offered consistent encouragement. His art was included in the 1998 exhibition, "Spirited Journeys: Self-Taught Texas Artists of the Twentieth Century."

Benefiel, Charles (b. 1967)

Charles Benefiel was raised in Santa Monica and Venice, California. As a teenager he found himself struggling with alcohol and drug addiction. By the age of eighteen he was homeless, living in abandoned houses on what is known as "the circuit," the routes between Los Angeles and Seattle frequented by runaways. After six years of attempting rehabilitation, Benefiel quit all substances cold. As a child, he had found refuge in art, sometimes creating detailed drawings on paper the size of a postage stamp. As an adult he returned to drawing obsessively in stipple to relieve his anxieties. Progressing in private, the drawings became larger and even more detailed until achieving a sort of "photo surrealist" quality, requiring months of almost non-stop drawing to complete. By the summer of 1993, Benefiel had taken refuge in the mountains of

New Mexico, living in a one-room shack, where he could continue his art as an obsessive form of personal healing. Eventually he went to a mental health center where he was diagnosed with "obsessive compulsive disorder." His art is available at American Primitive Gallery in New York City.

Berryman, Florence (1899–1992)

Berryman made over 1,000 drawings, ranging across many subjects. No one, it seems, including her surviving relatives, knew that she had been a prolific artist. She numbered her paintings and made several "series," though no complete set had been identified. Most are drawn in pencil and wax crayon on the backs of old letters, calling cards and handbills dating from before World War I. "There are portraits and self-portraits, street scenes, and sketches of Edwardian families at home. We are shown African-American servants working, children playing, couples courting, dining, dancing, and traveling by Tin Lizzie and paddle-wheel steamer. The line is deft and certain in every example, with particular attention to style in dress. There are also a number of fantastic images and sinister ones, too, and "one remarkable sequence of twenty-two drawings depicts a woman's struggle with a disease and hallucinations." This information and further research that followed comes from John Witek, who discovered more than 1,000 of Berryman's drawings at an outdoor antiques market in Kutztown, Pennsylvania. His research identified the father as successful cartoonist Clifford Berryman, originally from Kentucky. Berryman, who created his work in a studio, never brought it home. He had encouraged his son to follow in his footsteps, but not his daughter Florence who, in addition to being a *woman*, was deaf as the result of a bout with scarlet fever as a child. She never married and spent her entire life in her father's home.

Besharo, Peter "Charlie" Attie (1899– 1960)

Besharo immigrated to rural Pennsylvania from Syria early in the century. None of his neighbors knew about his art until it was discovered after his death. His work has been written about and exhibited many times. Besharo was also known as "Charlie."

Beverland, Jack "Mr. B" (b. 1939)

Jack "Mr. B" Beverland was born in Idaho Falls, Idaho, and now lives in Tampa, Florida. His father died when he was eight years old and he, his mother, and his brother, moved to Pinellas County, Florida. Beverland worked in a chain store for 32 years. In 1991 the job was eliminated and he was forced to retire. Losing his job plus health problems made him a very angry man. His family helped him through these trying times and eventually he turned to art as therapy. His earliest

paintings reflected his rage and frustration: "Money Talks," "Life Is a Bitch," and "Alone." The people in the early paintings were often faceless. Eventually he conquered his anger and his subject matter is now simpler and more peaceful. He sells his own work through his website, www.mr-b-folkartist.com.

Beverland, Robyn (1958–1998)

Robyn "The Beaver" Beverland lived in Oldsmar, Florida, in a house next door to his parents. Robyn enjoyed helping his parents in their yard and even more he enjoyed the pleasure he gave to people with his paintings. He had a very rare disease called Wolfrand Syndrome, which had left him blind in one eye and only partially sighted in the other. He also had diabetes and a mild case of cerebral palsy. Yet he was a cheerful person whose world was his family, his Bible, and his art. He painted "from his own mind's experiences" and used house paint and plywood or cardboard. One of his most often repeated images was one of several faces of different colors called "We Are All One." After several bouts with pneumonia, "The Beaver" spent his last months on a respirator and died August 20, 1998.

Beyale, Sandy (b. 1971)

Beyale resides near Tsaya, New Mexico. He makes figurative carvings from cottonwood and paints them in very bright colors with acrylics. His figures of people are carved in traditional dress and with traditional hairstyles, frequently engaged in contemporary activities. He has taught his father, Bob Beyale, to carve too. His life and art are written about in *The People Speak: Navajo Folk Art* by Chuck and Jan Rosenak.

Billiot, Cyril (1911–2000)

Cyril Billiot, one of nine children, grew up in Terrebonne Parish, Louisiana, in a French-speaking family, and was of Houma Indian descent. He never went to school but learned to read, write, and speak English from friends and coworkers in the sugarcane fields. Mr. Billiott said he started carving at age ten by "watching the old folks carving and making baskets." His earliest works were gunstocks made for neighbors and small pirogues and alligators made from wood. He used to sell these by the side of the road in his younger days. Billiot preferred carving tupelo wood, and painted his carvings. He made a variety of animals and other figures including roosters, tigers, elephants, angels, Adam and Eve, the Statue of Liberty, and Uncle Sam. He got his inspiration from pictures in books and magazines. He added images to his repertoire for his own pleasure, and not because collectors forced him to do so. His work is easy to distinguish from that of his son Ivy because of it appealing roughness. Ivy carves with a refined smoothness, his animals are more realistic, and he uses taxidermy and doll eyes, whereas Cyril painted the faces of his carved figures. By 1997 Cyril mostly stopped working, in part because of increasing age-related ill-health and in part because he was so deeply saddened by the untimely loss of his daughter Evelyn, with whom he lived in Houma.

Billiot, Ivy (b. 1948)

Ivy Billiot, the youngest child of carver Cyril Billiot, was born in Grand Caillou, Louisiana. He has been carving full-time for more than twenty-five years. Ivy makes a large wooden ark with many small carved and painted animals and a few life-sized ones too, such as a large black bear and a life-sized alligator. His bird carvings with accurate painting are exquisite. Ivy's work is finely finished, more so than the work of his father, Cyril. Materials he uses include tupelo wood, paint, and craft store eyes. Ivy welcomes visitors, but a call in advance is appreciated: 985-868-3984. He lives in Houma, Louisiana. He also sells his art at the New Orleans Jazz and Heritage Festival and from his house.

Billups, Kata (b. 1958)

Kata Billups was born in Charleston, West Virginia, went to art school for a time but rejected it as heartless. She considers Howard Finster her mentor. She began her well-known series of Elvis paintings, in which she incorporates her own life with his, after a visit to Graceland in 1987. One of her dealers describes her art as "kitsch," and says "it brings a smile to people's faces and is hanging on many Hollywood celebrities' walls." Billups now lives in Mt. Pleasant, South Carolina.

Billups, Patsy (1910–1998)

Patsy Billups lived in Saluda, Virginia. She was known for marker, pencil, crayon, watercolor, and ink drawings on paper. Her usual images were birds, animals, churches, and hex signs. Toward the end of her life she lived in a nursing home in Saluda and was no longer able to draw. She was included in the exhibition "Virginia Originals" in 1994 and in "Folk Art: The Common Wealth of Virginia" in 1996.

Bimonte, Fernando (b. 1955)

Bimonte was born in Uruguay and lives in La Cienega, New Mexico. He discovered New Mexican art after travels in Spain, Italy, Mexico, and the United States. His grandfather was a sculptor. He makes contemporary retablos using inventive and innovative materials. Bimonte is written about in the Rosenaks' *Contemporary Santeras y Santeros* (Northland Publishing, 1998) and is represented by Montez Gallery in Santa Fe.

Binger, Dorothy (1926–2007)

Dorothy Binger was born in San Francisco in 1926.

She held clerical jobs before becoming a painter in the 1980s, using first watercolors and later acrylics. Some of her paintings are part collage, often uniting the paint with unconventional materials. Her painted figures are intensified by her use of ballpoint pen. In a conversation with gallery owner Bonnie Grossman, Dorothy Binger said she was "deeply interested in women's social relationships within this world and their clothing reflects this interest, and has special meaning." She has been quoted as saying she "sometimes feels she knows the people who inhabit her paintings," but she had no conscious desire to represent any specific person. The people in her paintings are players in a spiritual longing for understanding and completion, "because this was Dorothy's quest." Her work was included in the exhibition, "Tree of Life," at the American Visionary Art Museum in Baltimore in 1995–1996. The Ames Gallery in Berkeley, California, represents the artist.

Bingler, William R., Jr. (b. 1922)

W.R. "Peanut" Bingler, Jr., was born in Charlottesville, Virginia, one of eight children. He left school as a teenager to help his family when his father became disabled. He fought in World War II, came home, and married. He and his wife raised five children. In 1955 he took over the maintenance department of the Martha Jefferson Hospital. There, in the 1960s, Bingler traded overtime work for access to equipment and began to make his sculptures out of found objects. He was included in the exhibitions "Tree of Life" and "Wind in My Hair" in 1996 at the American Visionary Art Museum.

Birckett-Mann, Lattie J. (1872–1965)

Lattie Birckett-Mann was born in Fairfield, Illinois, on June 10, 1872. She grew up there and in 1919 she moved to Chicago. Birckett-Mann started painting in 1952 when she was 80 years old and completed about sixty paintings in her lifetime. She died July 3, 1965. Birckett-Mann was a memory painter and she was included in the exhibition "Outsider Art: An Exploration of Chicago Collections," at the Chicago Cultural Center in 1996–1997.

Birnbaum, Aaron (1897–1998)

Aaron Birnbaum came to the United States from the Ukraine as a teenager. He made his living as a tailor's apprentice and eventually had his own dress making company. He took up painting when he was around seventy, after his wife died, and with the encouragement of his daughter, Lorraine. He painted on paper, wood, glass or tin, and created scenes from his memories, views of the streets of New York, and artistic commentary on the human condition. His one hundredth birthday was celebrated at the Museum of American Folk Art. He was able to work until 1996

when he had a disabling stroke and had to move to a nursing home. A friend recalls him saying at the time, "I wish I had the same strength I had when I was ninety." Gallery owner Kerry Schuss said Birnbaum maintained his sense of humor to the end. Birnbaum died August 7, 1998, at the age of 103.

Bissonnette, Larry (b. 1957)

Larry Bissonnette is a self-taught artist who lives in Winooski, Vermont. Because of a learning disability he missed out on any formal education. He was a resident of the Brandon Training School from ages eight to 21. After years in residential programs for the developmentally disabled, he now lives with his parents where he makes complex collages and "stacks of paintings." There was a one-man exhibition of his works at the Francis Colburn Gallery, University of Vermont, in 1994. G.R.A.C.E in Vermont carries his work.

Black, Calvin (1903–1972) and Ruby Black (1915–1982) "Possum Trot"—Yermo, California

Calvin Black was born in Tennessee and Ruby was born in Georgia. Calvin had stated working for the family circus as a teenager, learning ventriloquism. For health reasons, Calvin and Ruby settled in the California desert in 1953, where they opened a rock shop. To attract customers they created the Fantasy Doll Show and Bird Cage Theater with a wind-driven merry-go-round, with dolls built by Calvin and dressed by Ruby. Calvin used his skills as a ventriloquist with the dolls. "Possum Trot" existed from the mid–1950s until the 1980s, when Ruby Black died. This dismantled site exists only in books now, but many art encyclopedias, articles, and photographs memorialize it. Light and Saraf made a film about the site, and some pieces are in museum collections. Individual pieces from the site are sometimes available in galleries or turn up at an auction.

Black, Craig (b. 1954)

Craig Black is from Gary, Indiana. As a boy he traveled with his family, first to Beaumont, Texas, and then to Baton Rouge, Louisiana, where he eventually met his wife, Linda, and married in 1973. In 1976 they moved to the gatehouse at Houmas House, an historic plantation on the Mississippi River, where he is the caretaker and grounds keeper. Linda had a gallery called Southern Tangent and when it closed she too went to work at the plantation. Linda Black is now deceased. Craig Black still resides at Houmas House, where he has a studio space and three dogs to keep him company. He says, "you will seldom find one of my paintings that doesn't have dog hairs on the surface." He has been painting for a long time and uses layers and layers of paint to "create his fantasies and

give dimension to his work." The frames "grow" right out of the paintings and incorporate found objects like pieces of wood, tree branches, a turtle shell; whatever fits the theme and mood. Some of his canvases were painted to illustrate a science fiction novel he has not yet completed. A critic said of his work, "His detailed tapestry style and flair for elaborate fantasies are gifts for every eye and every soul regardless of its own natural desires." He also works with clay and especially enjoys having found "the three-dimensional qualities I've wanted in my work." He paints his sculptured fantasy pieces with acrylics and also makes figures from Mississippi River driftwood. Black sells his art from his studio at the Houmas House plantation, and through his Facebook page.

Black Madonna Shrine *see* Luszcz, Bronislaus

Black, Minnie (1899–1996)

Minnie Black came from Laurel County, Kentucky. She created wonderful objects, mostly fantasy animals and other creatures, from the gourds she grew on her property. She often "encouraged" the gourds to grow in a certain way, to be useful for the objects she made from them. She displayed these objects in her Gourd Museum next door to her house. She had hoped that the museum would remain after her death, but it was sold, and the collection too. Black also made musical instruments using her gourds and formed a band of senior citizens. Minnie Black is often written about and her work maybe seen in museums. The Kentucky Folk Art Center in Morehead presented an exhibition of her work, "Oh My Gourd," in 1994.

Blackmon, "Prophet" William J. (1921–2010)

"Prophet" William Joshua Blackmon was the seventh son born to Dan and Gussie Blackmon of Albion, Michigan. After completing the eleventh grade he went to work with his father for the New York Central Railroad, labored briefly at an iron foundry, and joined the army, serving for two years in the South Pacific at the end of World War II. Following his discharge, he became a self-proclaimed "hitchhiking man of God," living hand-to-mouth and preaching door-to-door across much of the Upper Midwest. He began to sense that he could discern and cure physical ailments and foresee future events in the lives of others. In the mid–1970s he moved to Milwaukee, Wisconsin, where he established his first "Revival Center and Shoe Repair Shop." Blackmon's paintings evolved from handmade signs that marked his frequently shifting places of work and worship. The chance selling of one sign led to more elaborate paintings with religious themes sold to support his ministry. A significant traveling exhibi-

tion, "Signs of Inspiration: The Art of Prophet William J. Blackmon," opened at the Haggerty Museum of Art in Milwaukee in the fall of 1999, and was accompanied by "a substantial exhibition catalog examining his life and career" by Jeffrey Hayes. His work is in the permanent collections of the Milwaukee Museum of Art, the Minnesota Museum of American Art, and the Smithsonian American Art Museum. Paul Phelps of Oconomowoc, Wisconsin (262-567-9310) was helping Blackmon sell his work, and may still have some pieces for sale.

Blagdon, Emery (1907–1986) "The Healing Machines"

Emery Blagdon was a native of north-central Nebraska. He was a hobo and then a farmer. He started making art when he was nearing fifty and constructed what he called his "healing machines," a project that he worked on for thirty years. Dan Drydon, who met Emery in 1975 and wrote about him, described his work: "When I entered his shed/studio, my vision was in shock. Lights danced on the thousands of bits of foil and wire and ribbon. It was as if the universe had come into the dark little shed and all the stars were contained in the great mass." When he died, Blagdon left nearly a hundred paintings and over 600 sculptures, which were purchased at auction by Drydon, Don Christensen, and Trace Rosel. These have been shown as a traveling exhibit since 1989. Intuit, in Chicago, sponsored "The Healing Machines of Emery Blagdon" at the East and West Galleries in Chicago in 1992. There was an installation of over 600 pieces in the exhibition, "Self-Taught Artists of the Twentieth Century: An American Anthology," in 1998–1999, sponsored by the American Folk Art Museum in New York. One of his "machines" is in the collection of the John Michael Kohler Arts Center in Sheboygan, Wisconsin. Blagdon is one of the artists featured in Leslie Umberger's book, *Sublime Spaces and Visionary Worlds: Built Environments of Vernacular Artists* (Princeton Architectural Press, 2007).

Blayney, William Alvin (1917–1986)

Blayney was a self-taught painter who grew up in Pittsburgh and later moved west. In 1957, while still in Pittsburgh, he began painting religious paintings that have been called a "remarkable personal vision." Blayney died in Thomas, Oklahoma. His art is in the Smithsonian American Art Museum.

Blevens, Lisa (b. 1968)

Lisa Blevins creates decorative drawings, densely patterned with color and myriad small shapes—hearts, flowers, circles, triangles, sometimes suggesting radiating stars or suns. Blevens works on her art at NIAD in Richmond, California, two days every week. For

three other days she bags groceries at a supermarket. Blevens started at NIAD in January 1996 at age 28. She suffers from mild cerebral palsy and lives with her family.

Blizzard, Georgia (1919–2002)

Georgia Blizzard was born in Saltville, Virginia, and lived in the southwestern Virginia town of Chilhowie, near Glade Springs. At the age of eight she began making dolls out of clay dug from a creek near her home. She continued to make objects in this medium, which she would "burn" in a cinder-block-enclosed circle of fire. In the late 1950s she began to make objects for her daughter Mary to sell from a little shop on their property—pots with stories that had a deep meaning. Her hand-built pots are finely molded and detailed. Her work is in the permanent collections of the Smithsonian American Art Museum, the Abby Aldrich Rockefeller Folk Art Museum in Williamsburg, Virginia; and the High Museum in Atlanta, among others.

Block, Andrew (1879–1969)

Andrew Block was born in Denmark and migrated to the United States, eventually settling in Solvang, California. He started painting when he was in his seventies and from then on painted night and day. He documented the Danish community in Solvang and also painted his memories of Denmark, historical scenes, biblical stories, and seafaring activities. His work was included in the 1995 exhibition "Working Folk" at the now closed San Francisco Craft and Folk Art Museum.

Blocksma, Dewey (b. 1943)

Blocksma was born in Amarillo, Texas, and is a self-taught artist who now lives in Grand Rapids, Michigan. In 1979 he left the medical profession to devote full-time to his art. He has been labeled an "outsider." His mixed-media assemblages were included in the exhibition "Primal Portraits" at the San Francisco Craft and Folk Art Museum in 1990. He constructs mysterious figures made from a wide variety of bits of junk.

Bloom, Jim (b. 1968)

Jim Bloom was born in Allentown, but now lives in Philadelphia. Bloom intended to be a writer but turned to art when a disabling accident made it impossible for him to sit still for long. He turned his creativity to art and was discovered by HAI. He is represented by George and Sue Viener of Outsider Folk Art in Leesburg, Virginia, and by Just Folk in Summerland, California. Bloom makes collage-like works with whatever materials are at hand. Current gallery representatives say "Bloom intends to create works that need no explanation; ideas that stand on their own and need no explanation."

Bloomfield, James Allen (b. 1945)

James Allen Bloomfield was born in Cincinnati, Ohio, spent some time in Chicago, but has been most of his life in Kentucky. His first artistic expression as a child was to copy his father's artwork. His father died when James was eight. Then he painted as he wished from age 21 to 25. One day a friend criticized his work and he burned it all. Before that creative period, and after, Bloomfield crisscrossed the country in a variety of jobs and all those experiences are reflected now in his carvings and paintings. This self-taught artist enjoys creating pieces from his environment—clay is dug from his backyard to make pottery; a carburetor melted down, using a homemade bellows, becomes a metal sculpture; and a grapevine from the woods becomes the neck of a five-foot-tall blue heron carving. The themes of the art center around religion, minority rights, the environment and life's struggles.

Bobo, Wesley

Bobo lives on U.S. Highway 61 near Greenville, Mississippi. In his yard one can see two dinosaurs made from scrap metal with orange eyes that were formerly lights on a school bus. He makes the scrap metal creatures in a shed behind his house. Bobo never learned to read or write, and he makes his own tools. A written source noted that some of his creatures may be seen at the Department of Archives and History in Jackson, Mississippi.

Bobrowitz, Paul (b. 1951)

Bobrowitz was "born in a Milwaukee hospital and immediately went home to Brookfield," where he grew up. He now lives in Merton, Wisconsin, northwest of Milwaukee. Bobrowitz sculpts objects from all types of metal—stainless steel, corten, aluminum, bronze, and copper. He does "monumental pieces" and small sculptures for the interested collector. In his own yard there are 300 pieces of sculpture. He started out making images of birds and people. Now he has become more abstract. Depending on the material he has used, he may paint or polish the finished piece. Others he prefers to allow to rust. Many of his sculptures have movement, either from the wind or implied by the stance of the figures. He prefers to elicit joy and happiness from his viewers, though they can inspire sober contemplation, too. He wants no violence or anger to be expressed in his work. A recent sculpture represents a sun rising from a horizon, with its rays being human figures. The West Bend Art Museum in Wisconsin gave him a one-man show in 1991. Paul Bobrowitz receives visitors at N93-W29174 Woodchuck Way in Town of Merton, Wisconsin. Tel: 262-538-1495. He maintains a website at www.bobrowitzsculpture.com.

Bogardy, Alexander (1901–1992)

Bogardy was born in Hungary (Or Baltimore, Mary-

land, as some of his relatives insisted) and lived most of his adult life in Washington, D.C. Bogardy identified himself as a Hungarian Gypsy, though his family denied it. He was a featherweight boxer and fought as "The Baltimore Kid." He played the violin and was a cosmetologist. He wrote a book, *Hair and Its Social Importance*, which may be found at the Library of Congress, in which he speaks of hair as "an organ of the body and directly connected to spiritual roots." He paid careful attention to the depiction of hair in his paintings. Described as "a quiet man and a devout Catholic," his paintings on canvas have an almost exclusively religious orientation, and are somewhat "architectural." The themes are often taken from the Bible. He took a class in mechanical drawing in order to illustrate ships for the Department of the Navy. His paintings reflect this in that his buildings are rendered with perfection while his figures and animals seem to float in the air. He started painting in the late 1960s and worked for only about a decade. Bogardy died in a nursing home in June of 1992. His art was is included in the St. James Place Folk Art Museum in Robersonville, North Carolina. The collection is now at the Carl Van Vechten Gallery of Fine Arts in Nashville Tennessee.

Bolan, Marisa

Marisa Bolan is an artist at the Arundel Lodge in Maryland. Each year Arundel Lodge honors an artist whose art inspires others in this program for people who have many challenges. She was chosen to be that artist in 2012. She shares her process of creating her art: "Art just goes with my emotions. A canvas is never finished. Sometimes I open my eyes and then capture what I see on the canvas."

Bolden, Hawkins (1914–2005)

Bolden lived in Memphis, Tennessee. A twin, he believed a head injury caused by his brother led to his eventual blindness. In the 1960s he began making sculptures—mask-like images with faces punched into such objects as frying pans, traffic signs, and cooking pots. He also made life-sized figures from found objects including metal, clothing, and carpet strips. His work was included in the exhibition "Passionate Visions of the American South."

Borkowski, Mary (1916–2008)

Mary Borkowski was born March 28, 1916, in Sulphur Lick Springs, Ohio, where her family operated a bed and breakfast. She married twice and worked many years as a waitress. She "tells stories with needles and thread." Many of the stories are about her experiences and the experiences of those around her. She made thread paintings using her own technique. Borkowski also painted on Masonite or canvas with acrylics. Borkowski was included in the exhibition "Wind

in My Hair" at the American Visionary Art Museum in 1996. She lived in Dayton, Ohio, where she died.

Bostic, Rudolph Valentino ("Rudy") (b. 1941)

Bostic produces vibrant mythical and biblical images, usually painted in enamel or house paint on cardboard. Bostic was born in Savannah, Georgia. As a young boy, without many commercial toys, he made things to entertain himself. At about age seventeen he was asked to paint some pictures for a church. He did this, using cardboard and house paint because they were the only affordable materials available. He still prefers the smooth surface of cardboard to use for his paintings. He paints biblical images and also images of popular culture that he sees on television. His work is available through Marcia Weber/Art Objects in Montgomery, Main Street Gallery in Clayton, Georgia, and from his own website (www.rudolphbostic.com). It is in the permanent collections of the Smithsonian American Art Museum, the American Folk Art Museum, and the High Museum, among others.

Boudrôt, Sainte-James (b. 1948)

A native of New Orleans, Boudrôt creates a form of obituary art so pure in conception and execution it is difficult to convince collectors that it is not a traditional New Orleans folk art. Using obituary notices collected for many years from the pages of New Orleans newspapers, Boudrôt uses them, along with relevant Christian symbolism, to create a usually tripartite memorial with visual imagery and words about the deceased. All of this is painted in bright colors on the wooden panels of discarded shipping crates, chairs, or other flat pieces of wood. Self-taught Boudrôt, who is also A.J. Boudreaux—an art dealer and former attorney—thinks of his works as "compositions," not art. His work for sale is available at Primitive Kool Gallery in San Diego.

Bowlin, Loy (1909–1995)—"The Rhinestone Cowboy"—McComb, Mississippi

The Rhinestone Cowboy lived in a small white frame house just outside of McComb. From a distance it could not look more ordinary. Step through the front door and you were dazzled. There was color everywhere, and it just shines with glitter, rhinestones, foil, and other objects that reflect light, all arranged in beautiful paper cutouts and painted squares and rectangles with intricate patterns. The furniture was painted and decorated too, as was the car in the garage. Bowlin, in his younger days, dressed in sequined and glitter-covered clothing and drove his matching Cadillac around town. Bowlin didn't like to remove pieces from

his house or walls, but he did create "extras" to sell. After his death the site was moved to the Kohler Art Center. There are color photographs in the book *Self-Made Worlds: Visionary Folk Art Environments* (Aperture, 1997), and in Leslie Umberger's book, *Sublime Spaces and Visionary Worlds: Built Environments of Vernacular Artists* (Princeton Architectural Press, 2007).

Boyer, John "Jack" (b. 1931)

John "Jack" Boyer uses vivid oil pastels, prismacolors, and tempera to describe complex architectural landscapes. Influenced by his father, whom he says "made buildings," Jack's work often depicts houses and structures as diverse as the White House or Egyptian pyramids. Boyer's human characters exhibit similar features yet are distinguishable by their costumes: heads-of-state, religious icons, pharaohs, characters from horror movies—detailed and boldly colorful. Boris Karloff and Lon Chaney and their screen characters are favorites. Jack was born on the East Coast and is a client of the First Street Gallery in Claremont, California, where he has been making art since 1993. He has been creating art for most of his sixty-plus years. The gallery gave Jack his first one-person exhibit November 19, 1998–January 8, 1999. The exhibit featured 21 paintings and drawings created since 1993.

Boyle, Frank (b. 1933)

Frank "Preacher" Boyle was born in Memphis, Tennessee. After high school he worked for years at many famous places such as the Peabody Hotel in Memphis, the Palmer House in Chicago, and the Beverly Wilshire in Los Angeles. Then he went on to work in Las Vegas, Nevada, where he got involved with alcohol and drugs. He says he finally realized that he "could either die like a dog or get my head together and "I learned if you are coming off drugs and alcohol you had better have a goal." For Boyle, the goal became to help other substance abusers and the means became his art. He returned to Memphis in 1986 and began a low-key ministry. Then he started his bottle art, painting bottles with bright pattern and design and with faces. These have caught the eye of collectors, and Boyle says in response, "All my creations are a gift to me from God. If you give the right thing, God'll give it back."

Boyle, Willie (1939–1997)

Willie Boyle was born in New Orleans, Louisiana. He lived during his youth in St. Roch in the Eighth Ward and attended Shaw Grammar School. In the 1960s he used to hang around a club called Bourbon House on Bourbon and St. Peter in the French Quarter in the years before the area was taken over by tourists. "It was a hangout for writers and artists, and I really liked being around artists." He spent time in Angola Penitentiary "related to heroin use," said Boyle, and it

was there that he started making art. Boyle carved walking sticks; welded found objects into sculpture; and also made drawings that remind some people of the work of Minnie Evans. He lived with his wife in Arabi, a community just downriver from New Orleans, at the time of his death from cancer, February 14, 1997. His work turns up occasionally in New Orleans galleries.

Braden, Marie (b. 1960)

Braden is a self-taught artist from Paris, Kentucky. She still lives in Kentucky, close to Morehead. Braden is a painter who works with oils. Her work is expressive of her personal inner concerns. It may be seen at Morehead at the Kentucky Folk Art Center.

Bradley, Alan Wayne "Haint" (b. 1947)

Bradley was born in Tennessee and travelled around for many years before settling down in eastern Tennessee. He creates intricate multi-layered pieces of designs that are built up layer upon layer, using one to eight boxes for each and fitting them together to create textured shadow boxes from recycled material. Haint says his works are spiritual in nature and symbolize God's creation. He was working at Rising Fawn Folk Art Gallery and Sculpture Garden with Jimmy Hedges.

Brandau, Adam (1910–1998)

Adam Brandau, a retired metal worker, was born in Troy, Ohio, and lived in Jackson. He learned his metalworking skills from his father, a "tinner," and from his own years spent as a tinsmith in a factory. He began to make metal men and women in earnest in 1992 after his retirement. Brandau used found materials of wood and tin to create his figures—humans, birds, animals, and airplanes; some of them twelve feet tall. First he would draw the figures freehand, then make the figures out of heavy metal, paint, and vinyl. He used discarded ductwork, auto body parts, and other items discarded as junk. His figures were made by soldering, not welding. Brandau spray painted the figures and sometimes finished them with black auto lacquer. His earliest pieces were airplane whirligigs and a wind-driven Ferris wheel. His later pieces were mostly figurative. He was one of two artists, the other being Carl McKenzie, featured in the exhibition "In Their Own Time" at the Riffe Gallery in Columbus, Ohio, in 1996.

Breen, Tom

A large, whiskered man who is "maybe around age 65," Tom Breen lives in his truck in various northeastern states, wherever his truck is parked. The art dealer who carries his work meets him at the antiques fair in Brimfield, Connecticut, where he has a space and sells mostly broken pieces. To pass the time there he sits in the back of his truck and fashions humorous pieces

out of whatever broken antiques he has at hand. Often the pieces represent "old girlfriends—a form of revenge." He also makes giant fish decoys and signage. Beverly Kaye in Woodbridge carries his work.

Brice, Bruce (1942–2014)

Bruce Brice lived in his home town of New Orleans. Self-taught, he began his artistic career as an art gallery assistant, and soon started selling his own paintings in 1969, hanging them on the fence at Jackson Square, the perfect location for attention from tourists from across the nation and around the world. Brice was the first artist commissioned to make the official poster for the New Orleans Jazz and Heritage Festival (Jazzfest), in 1970. This iconic poster depicted different aspects of Jazzfest—its music, food, Mardi Gras Indians, and more. The print was free and appeared all over the city. Brice sold his art from a special booth at Jazzfest for the next 45 years, until his death, the only artist to participate from the beginning. Brice's paintings captured the colorful, multi-dimensional life of African Americans in New Orleans' most storied cultural neighborhoods. Brice enjoyed painting scenes like a map and blending elements in a pastoral yet dynamic setting. His work included political statements about segregation and the marginalization of African American Musicians, artisan, and culture-bearers, all of which he placed on top of a precise, kinetic background. His style was rooted in Haitian rara and had a Caribbean aura, yet was definitely New Orleans. Brice loved New Orleans and put its unique attractions into everything he painted: brass bands, the Jazz and Heritage Festival, jazz funerals, Mardi Gras Indians, New Orleans architecture. The 2015 Jazzfest was the last one at which his work was available, posthumously. Many details about Bruce Brice and his life and work appear in publications. His family continues to sell his art through his website, www.brucebrice.com, or by calling at 504-949-4294. His work is in the permanent collection of the New Orleans Museum of Art.

Brice, Freddie (b. 1920)

Freddie Brice was born in Charleston, South Carolina. His father left the family while he was still quite young and his mother went to work in a cotton mill. After her death, he was raised by an aunt and uncle. In 1929, he moved to New York City. He worked at a variety of jobs and spent time in jail and mental institutions. At one time he worked painting ships in the Brooklyn shipyards. Brice was introduced to painting in the 1980s while attending a day program in a psychiatric center. His images are most often animals, room interiors, watches, and clocks, for which he mostly uses a black-and-white color scheme. As contemporary labels go, he is probably an "outsider." Brice's work was included in the exhibition "Flying Free" in 1997.

Bridges, Joan (1934–2012)

Joan Marie Evans Bridges was born in Natchez, Mississippi and lived in Pineville, Louisiana, near Alexandria, until her death. Her mother died when she was three years old, and her father, who was a riverboat captain, eventually put Joan and her four sisters in an orphanage in Natchez, Mississippi. Earlier they had been cared for by a woman named Annie who was very supportive of Joan. Joan's art was frequently in memory of her "dear Annie." She suffered from depression for many years and painted to work herself out of it. The wax medium she used was derived from candle wax, blended with crayons of various colors. Her technique of painting with melted wax provided a translucent relief of colors and layers. Some of her works are more abstract designs than figurative. Many of her paintings include her poetry. Gilley's Gallery in Baton Rouge still carries her work.

Bridgewater, Henry (1925–2001)

Bridgewater was a man with "a life sentence and no possibility of parole" at the Louisiana State Prison in Angola. He was born in New Roads, Louisiana, and was a carver of great skill. An example of his work seen in a private collection was of a large horse-pulled carriage with many people on board. The faces on the people and even the horses were quite brilliantly executed. He is best known for his lamp bases with such images as cowboys, movie stars, singers, and other popular figures. His work was sold at the annual Angola Prison Rodeo, and now turns up at auctions and in private collections.

Brito, Frank, Jr. (b. 1943)

Frank Brito, Jr. (b. 1943) makes humorous saints and animal carvings which are "among the best." He is retired now and frequently works in his father's shop. Montez Gallery in Truchas, New Mexico has their work.

Brito, Frank, Sr. (1922–2005)

Brito senior said heart surgery added years to his life and the opportunity to add years of carving to his life. Frank Brito, Sr., was born in Albuquerque and died in Santa Fe. His work is included in many collections including the Smithsonian American Art Museum and the Museum of International Folk Art. His work is described as "more innovative than many of the santeros." He also carved small animals.

Brock, Charles (1925–1993)

Charles Brock was a Mississippi wood-carver of considerable talent. He carved many varies of birds, fish, and snakes. Brock's carvings evinced great artistry. There are many examples in private collections in Mississippi and Louisiana.

Broussard, Regina (b. 1943)

Regina Broussard lives in Oakland, California. She has became a client of the Creative Growth Art Center in 1978. "Her art has been the means to communicate a very personal narrative of women and squirrels in a park-like world." A staff member suggested that the ever-present squirrels became important to the artist after an initial visit to a park, and may represent "running freely" to her. "Watching Regina draw, one is aware of her calm confidence in graphic representation. Her pen defines the contours of objects as seen from her internal world, a world which is colorful, inviting, full of food and free of gravity."

Brown, Betty (b. 1939)

Betty Brown of Fairfield, Kentucky, was born in Louisville on June 30, 1939. She moved with her family to Fairfield when she was age six. Her husband is a farmer and they have five children. Brown is retired from her job and works part-time now, has two dogs and a cat, and spends spare time cleaning, cutting, and painting gourds. She got started painting gourds when a friend gave her one, and not knowing what to do with it she painted the friend's house on it and gave it back. Not only did the friend like it, so did everyone else who saw it. Brown says, "It has been fun ever since, painting gourds of all shapes and sizes." Most of her gourds are painted scenery on the outside with cutout openings in the gourds to show a miniature setting inside. She has been showing gourds at the Kentucky Gourd Show since it started. Mrs. Brown will paint a person's home if a picture is sent to her.

Brown, Ken

Ken Brown, who is in his early fifties, has been painting at the Alan Short Center for the developmentally disabled in Stockton, California for more than twenty years. He uses prismacolor on paper and "paints fine detail in an abstract sense."

Brown, Oscar (1933–1995)

Oscar Brown was born in Brooklyn, New York. He lived with his mother, was particularly close to his sister, and had a large extended family in Brooklyn and North Carolina. Brown began attending a mental health outpatient clinic in 1985, and there came into contact with HAI. Brown painted every day. "He worked quickly and intuitively, applying short, deft strokes across the page. He often used watercolors or oil pastels on black paper, embellishing the images with silver or gold metallic markers. Though he occasionally painted African faces or birds from his imagination, the majority of his works are abstract." His work is illustrated in the catalog for the exhibit of HAI artists that was mounted at Capital Cities/ABC in New York City in 1996.

Brown, Ree (1926–2014)

Ree Brown was born in Utah and graduated from Utah State University in 1950. He moved to Seattle in 1967. Brown was trained as an accountant and worked for many years in the office of a large oil company "but gave that up years ago." Brown said he was always interested in art, but never tried it until the late 1970s. He started by copying well-known painters, then began drawing on his own. He worked in tempera and oils, drawing animals and groups of people. He liked to look at people and draw them while sitting in a public place, "but they don't look like anybody," he said about the finished paintings. In the 1990s he began sculpting small pieces, especially human heads, that are charming and a little mysterious.

Brown, Rutherford "Tubby" (1929–2003)

Tubby Brown was born in Jefferson, Georgia, and graduated from the University of Georgia in 1950. He served in the army during the Korean War and was stationed in Hawaii. Upon his return to Georgia, he and his brother ran a grocery business for 35 years. Brown said that he dreamed at night what he will build. He created assemblages and other works of painted wood and tin. His work is simple, colorful and fanciful, and often based on the Bible. He made a Noah's Ark that was very well done and popular with collectors. Betty Brown, his wife, contributed by painting his assemblages.

Brown, Smokey (1919–2005)

Smokey Brown was born in Dayton, Ohio. As a young man he was an apprentice to his grandfather, who was an ornamental plasterer. Later he worked as a stone carver, muralist, sign painter, and cartoonist. He also worked in carnivals that, it is said, influenced his work. He started art classes at Wilberforce, but dropped out. In 1978, after retiring from General Motors, he moved to Columbus to take advantage of the arts program for senior citizens offered by the Columbus Parks and Recreation Department. From then on he began to make his art full time. Brown was friends with artist William Hawkins and they were often exhibited together. His work offers social commentary about "the darker side of humanity" and encourages people to avoid being controlled by drugs and alcohol, to protect rather than abuse children, and not to oppress one another. Brown, whom others classify as a folk artist, called himself an "urban street artist." He made masks, mixed media paintings, and collages. His art was included in the exhibition "Raw Spirit" at Northern Kentucky University in 1993 and in "People, Places and Things: An African American Perspective," at the Columbus Museum of Art, also in 1993.

Browne, Berkeley (b. 1949)

E. Berkeley Browne (real name: Ellyn Bone) was born in Northern California and spent much of her childhood in the Gold Rush region of the Sierra Nevada mountains. A self-taught artist, her fascination with the old mining camps and decaying cemeteries of that area, intertwined with family history, is the inspiration for her work, which combines childhood memories with found objects. Browne creates unusual sculptures, collages, and dioramas. The "Buffalo Gals" series, whimsical papier mâché cowgirls dancing merrily in their own environments, combine with cast-offs to display Browne's romantic impressions of the Old West. Her "Story Boxes" are small time capsules filled with photographs, charms, and tokens connecting to the artist's past. Her found-object wall sculptures are abstractions that often depict women who find themselves, as the artist states, "lost, found, and recycled." Browne lived in the New England area for a time and now lives again in northern California and does a lot to rescue abandoned animals.

Bruno, Frank (b. 1925)

Frank Bruno was born in Douglas, Arizona. In 1980 he inherited the 29-room Avenue Hotel in Douglas where he now lives, keeping the rooms just as they were when his mother died. He taught himself to paint while working as a brakeman for the Southern Pacific Railroad. After World War II he had a short career in the military, and in the 1960s he worked as a commercial artist in the civil defense office at the Pentagon in Washington, D.C. He had many jobs, many "returns" to his home, and made many attempts "to be an artist." He paints warnings to his countrymen to "follow a renewed spiritual relationship with God, "lest we fall victim to the sword." The Bible is the source for his work. His medium is oil on canvas, linen, and pressboard, and sometimes he will under-paint with acrylics. His work was in the exhibition "The End Is Near," at the American Visionary Art Museum in 1997.

Buck, Delbert (b. 1976)

Buck is a Navajo carver who lives near Farmington, New Mexico. The Buck family herds sheep and goats. Delbert has seven brothers and sisters. He makes humorous figures from found objects combined with carvings of animals, people, and vehicles, which are all brightly painted. His work has been included in several Southwestern gallery shows, and is in the permanent collection of the Wheelwright Museum.

Budde, Craig (1909-2003)

Craig Budde moved from Sioux Falls, South Dakota, to Lodi, California, in 1963, where he worked as a newspaper linotype operator for the *News Sentinel*. For many years he spent a portion of his "retirement" creating in private what he called his knickknacks—pieces ranging from small wooden plaques decorated with garage sale jewelry to carved and drawn portraits of women he said were a figment of his fancy. He had hundreds of these carvings of women displayed throughout his house, fashioned in scrap wood, about 3" by 3" in size. Although each face is similar, each portrait is different, featuring a variety of hairstyles, hats, jewelry, and paint colors. A shy man, Mr. Budde had no idea who inspired the portraits he created, but admitted that he couldn't seem to draw anything else. His work was in the exhibition "Face to Face: Portraits by Craig Budde and Ted Gordon," curated by John Turner, at the former Craft and Folk Art Museum in San Francisco in 1998.

Budin, Fred

Budin was born, raised, and educated in New York City, a place, he says, "with too many people crowded into too small a space." He started painting at an early age, and says drawing helped him escape from the crowds and noise. But since he drew on the blank pages in published books, his parents discouraged him. Due to a learning disability and lack of opportunities, his dream of becoming an industrial designer never happened. He studied math and science and received a degree in engineering from New York Institute of Technology (BSIE). He continued drawing but never showed them to anyone. In 1989 while working with an Atlanta artist on an engineering project, he asked her about painting and showed her some of his work, and he offered to teach him to paint. He now paints in oil on canvas, and sometimes attaches found objects. He begins his paintings in the middle of the canvas and spreads them out to encompass the boundaries. Budin's subject matter is often about people with physical, economic or mental (including drug use) disabilities, in addition to painting about his surrounding world. He says he paints now "not for himself but for those who will come after me, to show them my world." Budin is a VSA Member Artist and has represented the disabled artists of Georgia in Washington, D.C., New York, and Atlanta). Amnesty International has used his work to promote peace and the U.S. government purchased his painting of a one-legged homeless man to hang in Federal plaza in New York. Budin, who now lives in Atlanta, sells his work through his website, www.fredbudin.com; one may also contact him via email through his website.

Bunch, James Walter (1916–2012)

James Walter Bunch was born in eastern Kentucky and came with his family to Tennessee as a child. His father died before he was born, and he was raised by his grandparents. Times were hard, and Bunch had little time for school. He was a Baptist preacher, serving as pastor to a number of churches in addition to

working as a farmer, logger, gravedigger, carpenter, and dam-builder. Bunch whittled for many years, but began carving in earnest in 1979, when he stopped working to care for his sick wife. He carved from memory, both tiny wooden scenes set in bottles to a full-scale wooden model of a motorcycle. He is the subject of *An Old Man Has Visions*, a presentation of his life and art, by Robert Cogswell (Madison, TN, Monroe Area Council for the Arts, 2005; 70 illustrations—see description in Selected Books). (Dates for birth and death varied in sources).

Burden, Steele (1900–1995)

Steele Burden lived in Baton Rouge on the grounds of the Rural Life Museum of Louisiana State University in Baton Rouge. The site was part of Burden's ancestral home, which he gave to the University along with donors Ione Burden, his sister, and Mrs. Pike Burden, his widowed sister-in-law. The artifacts in the various buildings on the grounds are the result of Burden's travels about the state to seek them out. Burden was a landscape gardener at LSU, and in the process of his work he met artist Paul Cox. Cox would go out and find clay and suggest Burden try his hand at sculpting. Burden tried it, and continued to make the figures and paint them until the end of his life. The glaze he used resulted in a white crackle finish. He did not do his own firing. He made about 300 different images, many containing political commentary such as his figures of politicians called, "Pigs at the Trough." He painted too—"just dabbles," he said. He liked to do swamp scenes; "there is something intriguing about the swamp, the cypress," he said. A collection of his work may be seen at the Rural Life Museum and his "studio space" has been left as it was at the time of his death.

Burkes, Fred (b. 1956)\Burkes, Bonnie (b. 1957)

Fred Burkes was born in Woodburn, Oregon on June 9, 1956, and soon moved with his family to Kentucky where he has lived ever since. Bonnie Burkes was born November 4, 1957, in West Liberty, near where they now live in Morgan County. They have seven children. Fred is a former long distance truck driver but does his woodcarving full time now. His preferred material being linwood. Bonnie paints the works with acrylics. They create birdhouses and animals but Fred's preference is for carving human figures.

Minnie Adkins inspired and encouraged the Burkes to start making their carvings. One really fine piece they have done is a replica of the Kentucky-Ohio bridge, with a hand carved truck crossing on it, and "welcome" signs for each of the states painted on either end of the bridge. The Burkes sell their work directly, so call them at 606-522-3739.

Burman, Ron (b. 1965)

Ron Burman was born March 15, 1965, in Philadelphia, Pennsylvania, and moved with his family to Jacksonville, Florida, in 1976. He says he started dragging things out of trash bins and bringing them home with him in the first grade, in spite of his mother's objections. Burman moved to New York City in 1989. Now he spends some time every day listening to music and painting on whatever he can find on the streets of New York's East Village. He has also lived on a Kibbutz in Israel and traveled throughout Europe, all of which have influenced his art. His unique paintings and found-object collages are popular with collectors. He sells his art through his website, www.ronburman.com.

Burns, Herman V. (b. 1935)

Herman V. Burns is a Kentucky self-taught painter whose work was discovered and acquired early on by collector Bill Glennon and other discerning collectors. His art was introduced to a wider audience through an exhibition at the Kentucky Museum of Art and Craft in Louisville that coincided with the annual conference of the Folk Art Society of America. Lee Kogan assisted in this exhibition, as did Michael Noland. "The paintings capture the beauty of the flora and the fauna of Kentucky. A catalog, "Herman V. Burns—A Kentucky Painter," published by the Kentucky Museum of Art and Craft in 2007, provides information about the life and hard times of the painter and many color illustrations of his art.

Burnside, Richard (b. 1944)

Richard Burnside was born in Baltimore, Maryland, but moved with his mother, two sisters, and four brothers to Anderson County, South Carolina, when he was five years old. He lived in Charlotte, North Carolina, for a number of years after serving in the army and now resides again in South Carolina, in Pendleton. In 1976 he began to paint. Burnside paints on found objects such as paper bags, plywood, gourds, and pieces of furniture, using whatever paint he can find. One of his most well-known images, recurring frequently, is of a rather round flat face. He also paints snakes, tigers, turtles, and other figures. He was included in the exhibition "Flying Free" in 1997. His work is included in the permanent collections of many museums, including the Smithsonian American Art Museum; the High, Morris, and other Georgia museums, the Rockford Art Museum, and the Taubman Museum of Art in Roanoke. Many galleries carry his work, including Cotton Belt and Marcia Weber/Art Objects in Montgomery, Just Folk in Summerland, California, and Main Street Gallery in Clayton, Georgia. He also maintains a Facebook page through which he sells art.

Burwell, Vernon (1916–1990)

Vernon Burwell was born in Rocky Mount, North

Carolina, the son of sharecroppers. Orphaned at age thirteen, he moved from one family to another. He married in 1942, and worked for the railroads. He had to retire in 1975 because of eye problems, caused by diabetes, that were eventually remedied. Burwell began making cement sculpture in his carport attached to the house in order to have something to do after retirement. The year or two before his own death, Burwell did not work very much on his art, because he was so saddened by the illness and death of a daughter. Burwell is known for his cement and painted sculpture of cats, tigers, people (often busts), and political figures. Sometimes they are life-sized and other times they are smaller. His work is in private collections and in museums.

Busby, Lloyd "Buzz" (1906–1992)

Busby was a barber who lived in Calera, Alabama. His house was near the highway and he put many of the art objects he created in his yard, including wooden people, all of whom had names, which passersby could see and admire. His art was created from wood and mixed media. He sold some smaller pieces, often jointed wooden human figures with smiling but not "cute" faces. His work is included in the book *Revelations: Alabama's Visionary Folk Artists*.

Bustamante, Julius Caesar (1958–2013)

Bustamante was a native West Indian of the Arawak/Caribe nation, who was born in Curaçao and raised in Spanish Harlem. He served in the U.S. Army for seven years, in two theatres of engagement, and received several medals. He said that military discipline helped him cope with everyday life. Bustamante started drawing when he was diagnosed with post-traumatic stress syndrome in 2000, and made pastel and pencil drawings until he died. "Art," he said, "soothes my state of mind." Loving a challenge, he saw art as a way to show others that disabilities do not disable. His travels to several countries and world perspective appear in the many multicultural elements in his art. He drew stories of ancient civilizations and their relationship to the present. Bustamante worked at HAI, Inc., which still sells his art through The Gallery at HAI.

Butler, Charles (1902–1978)

Charles Butler was born in Montgomery, Alabama, and spent most of his adult life in western Florida, working in local hotels. Late in life, with no training and with tools he made himself, he started carving. He carved historical figures, landscapes, and Bible stories in wood relief. Some works appear sparse and others are filled with detail. He completed about a hundred pieces before he died.

Butler, David (1898–1997)

David Butler was born in Good Hope, Louisiana, October 2, 1898, and lived in Patterson, Louisiana. He is one of the most famous of the twentieth century folk artists and is known for the tin sculptures, intricately cut out and painted, with which he decorated his yard and house. Butler has been the subject of many articles and papers, and his work has appeared in numerous gallery and museum exhibitions. David Butler was one of the artists featured in the 1982 exhibition "Black Folk Art in America 1930–1980." His work is in the permanent collections of the New Orleans Museum of Art, the American Folk Art Museum, the Akron Art Museum, the Museum of International Folk Art, and many others. In 2014 there was a major exhibition of the personal collection of former New Orleans art dealer Richard Gasperi at the Ogden Museum of Southern Art in New Orleans that included numerous works by David Butler.

Butler, Edward "Chaka" (b. 1941)

Butler also goes by the name of Edward Butler Lanoux, but is widely known by his nickname, "Chaka." Butler is from Plaquemines Parish, but now lives in Baton Rouge. He carves bas-reliefs of important black people and heroes. His desire to sell or not changes from day to day and week to week. Gilley's Gallery in Baton Rouge carries his work, and is the best source for seeing and acquiring it as the artist himself does not always receive visitors.

Butts, Jo Ann (b. 1950)

Jo Ann Butts carves and paints large, whimsical, brightly painted farm animals and a few wild ones too. She sells her art at Day in the Country, held at Morehead State University every June, and a few other places. She will sell via mail too: 108 Simmons Loop Road, Sandy Hook, Kentucky 41171, or you can call her at 606-738-9839 or email her at joannbutts@yahoo.com.

Byrne, Edward Patrick (1877–1974)

Byrne started painting in a Missouri retirement home at age 89 and kept on until the last year of his life at age 97. The walls of his room were covered with his paintings. Earlier in his life he had painted designs on his living room walls and on the outbuildings of his farm, and made and painted many birdhouses. In addition to other images, he was known for his abstract and futuristic architectural paintings. He was included in the American Folk Art Museum exhibition "A Place for Us" in 1996.

Byron, Archie (1928–2005)

Byron was born and raised in Atlanta, Georgia. He joined the navy, then later came back to Atlanta and

finished high school. Byron went to trade school, worked as a bricklayer, and then for the Fulton County sheriff's department. He founded the first black detective agency in the United States, and was a member of the Atlanta City Council. His earliest art pieces were root sculptures. Later he started with a flat piece of wood, mixed sawdust and glue, and used his hands and a knife to form his molded pieces. The result was a "relief surface." Once they dried he painted them with an airbrush. He also made some freestanding figures that represented "religion, sexuality, ancestry." His art was included in the exhibition "Passionate Visions of the American South."

Cain, Lisa (1962)

Lisa Cain was born in Canton, Mississippi and grew up in this small country town. She is highly educated, with a degree in neuroscience and an appointment at the University of Texas Medical Branch at Galveston, but her art is self-taught. She paints pictures of her childhood, including church scenes, farm life, baptismal pictures, and pictures depicting grandparents in positive roles, reflecting her own formative relationship with her grandmother. Her work has been in numerous shows and exhibitions and can be found at Marcia Weber/Art Objects in Montgomery, Alabama, The Attic Gallery in Vicksburg, Mississippi, and numerous other galleries, and in the Fayette Art Museum. She sometimes has a booth at Folk Fest in Atlanta, and sells her own art through her website, www.lisacain.org or by email (lisacain@wt.net). She can be contacted by phone at 409-539-0870. She has written *The Art of the Spirit: The Culture of the Rural South.*

Calkins, Larry (b. 1955)

Larry Calkins was raised in a small logging town on the Oregon coast and now lives with his wife on a farm in Issaquah, Washington. "Larry's art often reflects on the conditions of his upbringing in a close-knit but isolated community." In his art, he explores his family history as a metaphor for the transient nature of life. Recurring images, numbers, and dates signify life-altering events. These often delicate assemblages, reminiscent of artifacts, take the form of books, dresses, wagons, and other objects.

Campbell, Shane (b. 1954)

Shane Campbell was born in New Hampshire and grew up in Tennessee. He has been carving most of his life. In 1996 he abruptly quit his job of 21 years with a "Fortune 500" company and moved his family from Connecticut to East Tennessee. He had a need to create and decided it was "now or never." His father, Jack Campbell, was also a folk artist for whom each carving was a form of self-expression, an extension of himself, his heart, his soul — and Shane feels the same

way. His work is both traditional and unique. Shane carves figurative pieces such as Uncle Sam, Lady Liberty, and blues singers. He now lives in Hixon, Tennessee. Campbell's work has been featured at the Outsider Art Fair, the Kentucky Arts Fair, and Folkfest, and is in the permanent collections of the Chicago and Orlando House of Blues, the Mennello Folk Art Museum in Orlando, the Milwaukee Museum of Art, and the Santa Barbara Maritime Museum. His work has also been included in exhibitions at the American Visionary Museum. San Angel Folk Art in San Antonio carries his work.

Canfield, Okey (1907–1995)

Okey Canfield was born in Elkins, West Virginia. He worked as a coal miner, factory worker, outdoorsman, gunsmith, cockfighter, stringed instrument maker, ballad writer, and singer. In 1931 he and his wife Opal Marie moved to Ohio to work there, and this is where he started whittling his birds. Many of his birds were the domestic species he knew as a hunter. He also carved penguins, whooping cranes, parrots, and an occasional spider or snake. He made-do with found materials but was particular about which materials were appropriate to which species. He was a prolific artist who produced over a thousand carvings. Canfield died in October 1995, in Ravenna, Ohio.

Cantu, Heleodoro (1935–d. 1980s)

Cantu was born in Baton Rouge, Louisiana, and lived there all his life. His grandfather owned a hot tamale business, built houses, and also sculpted in his spare time. The elder Cantu had moved his family and tamale business from Monterrey, Mexico, to Baton Rouge in 1915. In 1926 he sold the business and moved back to Mexico. Cantu's father ran away from Mexico and returned to Louisiana to marry his sweetheart in Baton Rouge. Heleodoro Cantu did not begin painting or carving until 1970, when he was recovering from open-heart surgery. For his sculpture he used the very fine green, rust red, and coppery wires from inside television sets. He made flowers, hummingbirds, butterflies, trees, dancing human figures — all delicate and rather abstract. His paintings were of local scenes, small towns, and bayous that are not at all sentimental. They are most frequently based on childhood memories. He demonstrated a great ability to capture the special light in southern Louisiana. His last works are large carved pieces made from birch, cedar, and hickory — trunks blown over during hurricanes. The themes of these larger pieces are religious. Cantu died in the 1980s in Baton Rouge after a long illness.

Cardenas, Freddie

Cardenas started painting several years ago after retiring from the New Mexico Public Schools as Super

intendent. He currently works with the Bureau of Indian Education and drives to Jemez everyday as Principal. Freddie paints landscapes from around the Galisteo Basin and other New Mexico villages. He paints in oil and acrylic mediums. He enjoys using bright colors, sunflowers, clouds and whimsical characters in most of his paintings. He sells his art through the Amanecer Gallery at 897 Camino Los Abuelos, Galisteo, New Mexico 87540. You can reach him at 505-466-8967 or annacardenas1@hughes.net.

Carneal, Kacey Sydnor (b. 1935)

Kasey Carneal was born in Richmond and now lives in Gloucester, Virginia. In January 1985 she made the decision to paint full-time. She has documented the Severn River farming and fishing community where she lives. She has a small studio on the property where she paints six to seven hours every day. She works in oil on wood, canvas, or Masonite. In most of her works, the frame is an extension of the canvas. Dr. Donald Kuspit, author, teacher and lecturer, has been quoted as saying, "her work looks simplistic, but it is very, very complex." Her paintings are filled with color, energy and rhythm. Ruth Latter, art critic for the *Daily* Progress, states that Carneal is "far more talented and original than Grandma Moses ... [and] is rapidly becoming one of the most sought-after painters working in an unsophisticated yet distinctive mode of expression." Carneal's work has been in many juried shows in 52 cities, 23 states, and the Netherlands. A recent one occurred in June and July 2014 at the Charles H. Taylor Art Center in Hampton, Virginia. Her paintings hang in several medical centers including the National Children's Hospital in Costa Rica and the University of Virginia Children's Hospital. Ginger Young sells Carneal's work, and Carneal also sells her own work (www.tidewaterwomen.com/blogs/art-beat/kacey-sydnor-carneal-self-taught-artist) or call her at 804-693-3804.

Carpenter, Miles B. (1889–1985)

Carpenter was born in Brownstown, Pennsylvania but moved to Waverly, Virginia, as a child. He worked in a sawmill and after retiring operated an icehouse. He carved a little before retirement, but took up carving seriously after his wife died in 1966. He made "root monsters" and humorous carvings of human figures, many of which he painted in latex house paint. His work may be seen in a number of publications and museums. The Miles B. Carpenter Home and Museum in Waverly, Virginia, has about sixty pieces of Carpenter's art. He was included in the exhibition "Folk Art: The Common Wealth of Virginia." He died In Petersburg, Virginia.

Carriaga, Arán

Carriaga lives in Albuquerque, New Mexico. He began carving at the age of nine, when he wanted a bicycle and his mother said the family could not afford it and that he would have to save for two bicycles, one for himself and one for his sister. Carriaga was determined to get a bike, so he went to the local sawmill and asked the men to save soft scrap wood for him. He began carving Frankensteins and selling them for $10 each. Two months later he brought his mother enough money to pay for two bikes. He kept carving, but always Frankensteins. It was not until he met Master Santero Alcario Otero that he began making santeros. He met Otero at a flea market where they had adjacent booths, and they hit it off. Otero asked him to try carving a bulto and gave him some guidance. Otero approved of Carriaga's first effort and told him to carve a second one on his own. Upon seeing the second one, Otero declared "you've graduated" and the two carved together for the next twelve years. Carriaga entered his second bulto in the New Mexico State Fair Hispanic Arts division and won a Blue Ribbon. He talked with the judges, who encouraged him and helped him to enter the Santa Fe Spanish Market, where he still sells his work today. He maintains a Facebook page and also sells from his home at 1335 15th Street, NW in Albuquerque. In addition to having a booth at the Santa Fe Spanish Market, he sells at the San Felipe de Neri Santero Market in Old Town, Albuquerque and his work can be found at Grey Dog Trading in Albuquerque. Carriaga is a member of the Santa Fe Spanish Colonial Arts Society.

Carroll, Mary Ann

The only woman in a group of traveling Florida painters called "The Highwaymen" (see entry under "The Highwaymen"), Carroll supported herself and her six children selling her art. Gary Monroe wrote about her in *Mary Ann Carroll: First Lady of the Highwaymen* (Gainesville: University Press of Florida, 2014).

Carson, L.C. (1913–1998)— "Concrete City"—Orangeburg, South Carolina

Carson, a contractor for 47 years, was inspired to create his Concrete City after a visit to Ave Maria Grotto in Cullman, Alabama. Carson created his own versions of buildings from around the world, such as the Parthenon, the Sphinx, and the Coliseum. Using common construction materials, he built a well-landscaped site for 33 waist-high structures. As Carson was no longer able to care for his creation, he donated it shortly before his death to the South Carolina State Museum in Columbia, where many of his small buildings can be seen by visitors. The site is documented in *Weird Carolinas* (2007) and *South Carolina Curiosities* (2011).

Carter, Binford "Benny" Taylor, Jr. (1943–2014)

Carter was born in High Point, North Carolina, and lived in Madison, North Carolina. He filled his yard with colorful birdhouses, totems, and sculptural configurations—all made of found objects. Unlike many artists, he said he had no interest at all in art when he was young, but later painted up to twenty hours a day. He worked for many years as a supervisor at a metal products plant, and only began painting when he was laid off from his job. He made paintings, decorative birdhouses, clocks totems, metal sculptures, and other works, often including found objects in his pieces. A visit to New York City when he was young, and visits since then, made a strong and lasting impression that inspired many detailed and colorful paintings rich with architectural detail and complexity. His work has been in exhibitions at the American Visionary Art Museum in Baltimore, Montgomery Museum of Fine Art, and several university museums.

Carter, Fred (1911–1992)

Carter was a self-taught artist from Clintwood, Virginia. He moved there from his birthplace in Dickinson County to work in his uncle's store. Carter became a successful businessman, builder, landscape architect, and nurseryman. He began to paint and carve wood when he was fifty years old. He had also become a collector of Appalachian artifacts. Much of his work expresses his anger at the destruction of the environment and injustices against people. Paintings and sculpture range from abstract to realistic.

Casey, Joseph Sylvester (1900–1987)

Casey was born in Blackwell, Missouri, and moved to South Bend, Indiana, in 1921 where he worked at the Studebaker and Bendix plants until retirement. He filled his home with images of childhood memories and scenic landscapes, and few friends or others in the community knew that he was a painter. Entirely self-taught, Casey painted with watercolors and acrylics. An African American painter, the people fishing and at leisure are always white. His art was included in the exhibition "The Intuitive Edge: Midwest Folk and Outsider Art" at the South Bend Regional Museum of Art in 1996.

Cash, Marie Romero

Cash is a native-born Hispanic raised in Santa Fe, New Mexico, where her parents were prominent traditional tin-work artists. She has become a leading authority on the Santero tradition. She distinguishes herself and her art by bringing together her extensive familiarity with traditional art forms and an enthusiasm for exploring and innovating in the santaros she makes. She has written a number of books on the art

of Santeros. She sells her art at the annual Spanish Market in Santa Fe, New Mexico, and through her website, www.marieromerocash.com.

Castle, James (1899–1977)

James Castle was born in Garden Valley, Idaho, a remote town about fifty miles from Boise. "Born profoundly deaf, he never learned to sign, finger-spell, or speak. His family took care of him. He made art every day of his life from found materials and observed the world around him." His drawings were made of soot, saliva, and a sharpened stick. Castle made numerous drawings and three-dimensional constructions. He made books for which he sewed the bindings and filled every page with his intricate pictures. He was "discovered" when his niece brought the art to the attention of Boise gallery owner Jacqueline Crist. In 1997 the Chicago organization Intuit presented a one-person exhibition of his work. Among other institutions, James Castle's work is in the Boise Art Museum, the University of Oregon Museum of Art, and Henry Art Gallery at the University of Washington in Seattle. A catalog, *A Silent Voice: Drawings and Constructions of James Castle*, was published by the Fleisher/Ollman Gallery, of Philadelphia, in 1998.

Castro, Dalbert (b. 1934)

Born in 1934 near the ancient village of Holakcu, Auburn, Placer County, California, Dalbert Castro's childhood was spent among tribal elders, from whom he learned the traditional legends and stories of the Maidu people. His grandfather, Jim Dick, was the last Maidu chief or headman of the area, and Castro's late wife, Betty Murray Castro, was well known for her storytelling abilities and knowledge of the Maidu language and history. Castro did not start painting until 1973 when, after serving in the U.S. Navy, working in the logging industry and for a firm making clay pipes, he found himself unemployed. His wife suggested he start painting. Skeptical and without any instruction, he took her advice. Castro is often identified as a folk artist who creates a kind of "naive" art, but he continues to grow as an artist and interpreter of his people and has come to be well recognized. His Nisenan Maidu background is rich in the mythology and regional flavor of the Sacramento Valley and foothills, which he captures in his paintings. He has exhibited at the Oakland Museum of California, the Crocker Art Museum in Sacramento, Chaw'se Regional Park's invitational show at Pine Grove, Amador County, at Pacific Western Traders in Folsom, and elsewhere. He was one of eight artists featured by the California Historical Society in its special Fall 1992 issue of *California History*, entirely devoted to Indians of California. His work was exhibited in "Cat and a Ball on a Waterfall" and is included in the published catalog. The Oakland Museum holds an important collection of Castro's

work, which will be the subject of a future exhibition there. It is also available through Pacific Western Traders in Folsom, California.

Cayce, Mary Anderson (1910–1996)

Cayce was born in Owensboro, Kentucky, where she lived her entire life. As a young child she watched in fascination while her Stockholm-born father carved wood sprites. Her own bas-relief and free-standing sculptured forms were modeled from clay and gypsum and then painted with acrylics. Environments containing dozens of pieces were her favorite format. Her works are in the Owensboro Museum.

Cell, Jennie (1905–1988)

Jennie Cell was born in Charleston, Illinois. Her art focused on subjects involving rural life. Beginning her painting career at age fifty, Cell was frequently quoted as saying that she painted "what I remember, not what I see." One art critic called her "one of the very few true American primitive painters." Her work can be seen in the permanent collections of the Tarble Arts Center and the Smithsonian American Art Museum.

Chastain, Dennis (b. 1943)

Chastain grew up in Salem, Oregon, and now lives in Forks, Washington. He makes a living as a chainsaw sculptor, with skill and far more originality than most. He started carving in about 1988 and is quite well known in the Forks area of the Olympic Peninsula. His work may be seen at the Forks Timber Museum (www.forks-web.com/fg/timbermuseum.htm, 360-374-9663).

Cherrix, Jay (b. 1945)

Jay Cherrix has held a variety of jobs, from meat cutter to owner of a kayak rental shop. He is the grandson of a famed carver of duck decoys, Ira Hudson (1873–1949). He watched his grandfather work when he was a little boy but did not start carving for himself until 1987. His carvings of people, fish, and birds are more stylized and less representational than Hudson's. Jay captures the form and grace of his subjects, and his egrets and "phoenix birds" resemble modern sculpture. Jay Cherrix lives in Chincoteague, Virginia, where he sells his art from his studio and shop.

Chief Rolling Mountain Thunder (1911–1989)—"Rolling Thunder Monument"—Imley, Nevada

The Chief, formerly known as Frank Van Zandt, built a monument to the American Indian in the Nevada desert. It has been described in many publications, and there is a Light-Saraf film about the site. There is a support group, and tours may be arranged

(see the chapter on organizations). Rolling Thunder Monument is located just off Highway I-80 at exit 145 about thirty miles southwest of Winnemucca, Nevada. To see the site, call Mike Flansaas at 702-538-7402.

Childers, Russell (1915–1998)

From Oregon, Russell Childers' carvings reflect the sorrow-filled memories of his childhood—he was committed to a state institution when he was only ten years old. His severely ill mother failed in all her efforts to have him returned to her during the last days of her life. Childers remained locked up as a deaf-mute for 38 years. In the 1960s a mandatory review of long-term patients revealed that he was neither deaf nor mute. He was released to foster care and given remedial assistance. Childers carved maple and oak into delicate figures. His self-portraits and early family scenes have been described as "strong and heartbreaking."

Childs, Thomas Battersley—(1888–1963)—Gilgal Gardens—Salt Lake City, Utah

Childs created this site to honor the founder of the Mormon religion. Childs was a stonemason by profession. He created a Sphinx with the face of Joseph Smith, a spectacular granite ark, a three-foot locust of rock, an enormous stone heart, and a 20-foot tall, sword-carrying giant from King Nebuchadnezzar's Dream. There are also dozens of engraved plaques with phrases from the Book of Mormon and the Bible. The site is located behind the Chuck-A-Rama Restaurant. It is hoped that it is still there; developers were "threatening." It is documented in Lisa Thompson's *Gilgal Garden, an Historic Sculpture Garden Created by Thomas B. Child, Jr.*, and numerous journal and newspaper articles. There was a group trying to save the site with this e-mail address: trent.harris@mcc.utah.edu.

Chilton, James (b. 1938)

James Chilton loves to walk and to make art. Many of his color drawings depict scenes he sees rambling about the Bay area. Other inspirations are television, newspapers, and photographs. His pictures are detailed and structured with areas of dense color separated by white ground. Some of his art demonstrates a deep concern with entrapment, such as a piece depicting a forest fire, pictures with barred windows, a series on the burning of the Branch-Davidian Compound in Waco, Texas. Other works suggest a joy in exploring and recording the world around him as he sees it. Chilton was confined for 22 years to an institution for the developmentally disabled. He now lives in a board-and-care home. Chilton began his artistic career in 1975 at Creative Growth in Oakland and has been at NIAD since 1990.

Church, Guy (b. 1945)

Church comes from Madison, Wisconsin, but has lived in Memphis, Tennessee for at least 20 years. He uses pencils to make his art, only rarely adding a touch of color. His images are often lonely-looking, with single figures against wide settings. One image, which he calls "Eat Your Beans," shows a boy with a helmet of highly controlled hair, sitting at a table with a plate of food in front of him and a black, hiding, expression on his face, backed by an amorphous body, head out of the frame, arm pointing accusingly at the plate—rather chilling. Church has been homeless off and on for many years, picking up odd jobs and continuing to make art. During that time a doctor in Memphis bought many of Church's drawings as the artist produced them. This collector has now gifted some of them to the Brooks Museum in Memphis, which retains them in its permanent collection. As of this writing, Church has been residing in the house of an elderly woman in Memphis whom he helps with chores; since living inside he has increased his production of art and is working on bigger paper. Tops Gallery in Memphis (www.topsgallery.com) carries his work now, and the owner, Matt Ducklo, has gotten to know Church very well. In December 2014 the gallery included four of Church's pieces in a group show, and local reviewers singled out Church's work as the most interesting pieces in the show. Ducklo plans to give Church a solo show in September 2015.

Church, Willard (b. 1929)

Willard Church was born in Ronceverte, West Virginia. He worked at a number of jobs, his last one at a liquor store. He retired in 1990, and he and his wife spent the year after that traveling and staying with each of their six children. Then they returned, living in the rural countryside near Ronceverte in a trailer on top of a hill. Church painted using automobile paint on Masonite. He used different kinds of automobile paint, sometimes on the same painting, because when the two different paints meet it "creates interesting actions." He also likes a lot of texture and so used a paintbrush only occasionally. He preferred to use blades, feathers, and leaves. Some subjects for his art came from perusing the encyclopedia, while others were inspired by the land and towns around him. Church is deceased, date not found.

Clark, Chris (1958–2011)

Chris Clark was born in Birmingham, Alabama. He graduated from high school and started college but dropped out and joined the army. He married while stationed in Germany and had a daughter. After his time in the service was up, he returned to Birmingham. He started to paint, which he had always wanted to do, when he started to lose his sight and found out that he had severe diabetes. He kept on making art and went

from painting on found boards to painting on quilts with a mixture of fabric dye and paint, then coated with polyurethane. Although his family did not approve of what he does to quilts, he was very popular with art collectors.

Clark, Floyd O. *see* Clark, Mildred Foster

Clark, Henry Ray (1936–2006)

Henry Ray Clark was born in Bartlett, Texas, and has lived since then in Houston and in the Texas State Prison in Huntsville. He dropped out of school after the seventh grade and became a street person, where he earned his nickname, the "Magnificent Pretty Boy." He made elaborate patterned drawings that have been referred to as "kaleidoscopic." He painted obsessively when in prison and was discovered at a prison art show in 1989. It seems his painting stops whenever he is back on the streets. Clark was paroled in 1991 and in 1994 opened a hamburger stand which he decorated with his art. His freedom was short-lived and by 1996 he was back in prison. His art was included in the exhibition, "Spirited Journeys: Self-Taught Texas Artists of the Twentieth Century." He died in Houston.

Clark, Jim (b. 1938)—Weathervanes and Whirligigs—Fort Worth, Texas

Clark was born in California, but due to his father's occupation in the Air Force, he lived all over and, if anywhere was "home," it was North Carolina. Clark himself is career Air Force, being a member of the second class to graduate from the Air Force Academy with a degree in aeronautical engineering. He was a fighter pilot, then worked in the defense industry as an engineer after retiring from the Air Force. Clark has been carving wooden objects since first grade; as a boy scout, he made individual, unique, wooden slides for uniform neckerchiefs for 70 members of his boy scout troop. He began carving "Americana" in the early 1970s, being inspired by old weathervanes and other folk art objects in one of the towns where he was stationed. He made "old" weathervanes for outdoor use and then began making smaller versions for indoors. He still makes weathervanes, whirligigs, and small decorative items from found wood and rusty metal. His yard in Ft. Worth, Texas is full of his creations, and worth a visit. One can email Clark and his wife at folkart@airmail.net to arrange a visit. Classics on Main in Salado, Texas, carries his work.

Clark, Larry (b. 1954)

Larry Clark was born in Lafayette, Louisiana, and raised by his grandmother in Franklin. He suffered a serious illness as a child, and spent eight years in a hos

pital. It was at this time that he started drawing, trying to express the feelings that were overwhelming him. With the help of his art and the spirit of his grandmother, he was able to overcome his despair and become more constructive. Clark left Louisiana for San Francisco in 1987. His art was discovered at an art program for the poor and or homeless. With few exceptions, Larry Clark's paintings depict the agonies resulting from racial hatred and are set in the South. He "wants to let young blacks know where their roots are in America, because there are so many who think their roots are in Africa."

Clark, Mildred Foster (1923–1980)/ Clark, Floyd O. (1913–1985)

The Clarks lived in Jefferson, Texas, and collaborated on making art for about twelve years. Floyd Clark started out making frames with rubber tire strips and other found objects for Mildred's paintings. Then he started his own paintings, naive in style, of cats, angels, watermelons, flowers, and animals. Mildred Clark painted as a child, applying the pigment to the same sacks she used. Their work was included in the exhibition "Eyes of Texas" in 1980, and Mildred died soon after.

Clark, William (b. 1956)

William "Robot Man" Clark was born in Atlantic City, New Jersey, and is the second of five children of a Seventh Day Adventist pastor. His father taught him to be an auto mechanic, and he then opened a shop of his own. When Clark lost his license to drive because of several speeding tickets, "he was devastated" and frustrated by the enforced inactivity. To fill his time, he started to make complex robot figures from junk. After he got his license back, he attached the robots to his cars and took them on the road. Clark lives in Williamstown, New Jersey, where he spends time at flea markets trading parts, finding raw materials and selling robots.

Clarke, Brennan (b. 1971)

Brennan Clarke's drawings and paintings, like one titled "Exploding Universe," are charged with energy and color. Using felt pen, colored pencil or paint, he creates complex and sophisticated graphic designs, sometimes incorporating small drawings based on logos or cartoons. In others, cars, trucks, and planes all seem to move in a field of aerial or multiple perspectives. He also makes prints, enjoys painting on fabrics, and devises innovative techniques such as "drawing" with the point of a bottle opener and coloring the paper's surface to create a relief drawing. Clarke says he makes up pictures as he works, usually with his earphones tuned to jazz, rock, or rap. Clarke started working at NIAD in 1994.

Clarke, William H. (b. 1950)

William Clarke was born and raised in Blackstone, Virginia, a small town of about 2,500 people. His art reflects his African-American community and the lives of the people who live there. A self-taught artist, he has been drawing since the age of six. He works mostly with oil pastels and religion is a central part of his work. Mr. Clarke believes his talent is a gift from God. His art has been included in many exhibits and in the 1999 Heart of Virginia Festival in Farmville he took first place, winning the Visual Arts Award. His art has been included in an exhibition at the University of South Carolina's McKissick Museum in 2000 and two exhibitions at j. fergeson Gallery in Farmville, Virginia, the latest in 2011. In addition to being included in many local gallery shows, he sells his own work through his Facebook page and YouTube, and can be reached at his home at clarkecandraw@aol.com.

Claw, Silas (1913–2002)/ Claw, Bertha (b. 1926)

Silas and Bertha Claw resided in Arizona, where it is assumed that Bertha still lives. They made pottery that is traditional in form but to which the Claws appliqued colorful pictorial designs to the pot surface pots. Two nieces helped them to sand and paint their ware. According to Chuck and Jan Rosenak in *The People Speak: Navajo Folk Art*, the Claws are "among the most popular of the contemporary Navajo potters." Their work is available from Adobe Gallery in Santa Fe, Territorial Indian Arts and Antiques in Scottsdale, Arizona, among other outlets.

Clay, St. Patrick (1917–1996)

The Rev. St. Patrick Clay lived in Columbus, Ohio, where he was the assistant minister of a Baptist church there. He worked at one time in coal mines. Clay made walking sticks and assemblages from found objects inspired by his visions. Some of the materials he used included foam rubber, toothpicks, and wood, which he then painted. His work was included in the exhibition "New Traditions/ Non-Traditions: Contemporary Folk Art in Ohio" in 1990. There are two photographs of his work in *American Folk Art Canes* by George Meyer.

Coe, Clarke W. (1847–1919)— Killingsworth Images— Killingsworth, Connecticut

Coe built a unique water-powered environment for his grandchildren. It consisted of movable life-sized figures. The site no longer exists. There are pieces in the Killingsworth Historical Society and the Museum of American Folk Art. There is detailed information in the *Museum of American Folk Art Encyclopedia of Twentieth-Century Folk Art and Artists.*

Coins, Raymond (1904–1998)

Raymond Coins was born in Stuart, Virginia, and moved when he was about ten years old to an area near Winston-Salem, North Carolina. After retiring in 1976 as a farmer and as a worker for local tobacco companies, he made wood and stone carvings of human and animal figures, some in bas-relief. Some of his figures were "dressed" by his wife. His earliest works were such familiar objects as arrowheads and the like but soon he became less representational and "developed a more reduced style."

Coker, Jerry (b. 1938)

Coker was born in Dewitt, Arkansas, but has lived most of his life in Florida, now in Gainesville. He started painting in the 1970s and is entirely self-taught. "Jerry paints with acrylic on board. His paintings are colorful and tend to be impressionistic." He also makes tin masks. Jeanine Taylor Folk Art, Marcia Weber/Art Objects, and Just Folk are galleries that carry his work.

Colandrea, "Rocco" (b. 1945)

Ron "Rocco" Colandrea was born in Newport News, Virginia, and reared in Nyack, New York. Most everyone familiar with the Haverstraw, New York, area has passed by or eaten at "Rocco" Colandrea's hot dog truck. He parks on Route 9-W, overlooking Haverstraw Bay on the Hudson River. His family has been there for sixty years. Rocco wanted to go to school to study art, but coming from a large family he had to work most days after school with his father on the hot dog truck. He went on to having a pizzeria and from there to owning a few restaurants. Now he is back at the hog dog truck. Between customers, Colandrea creates fantastical sculptures using small pieces of slate embedded in and embellished with a variety of found objects. His work was included in an exhibit at the Arts Alliance of Haverstraw called "Blue Collar Art," February 28–March 16, 1999. The director of the Alliance, Alice Jane Bryant, describes his figurative pieces as having "spirit, and humor." In addition to his figurative pieces, often animals behaving like humans, he does wall pieces using found objects. One of his large pieces is on permanent display at the Bear Mountain Inn in the Catskill Mountains of New York.

Colbert, Deatra (b. 1964)

Deatra was born in Ohio and moved with her family to Richmond, California, as a child. Her favorite subjects for her artwork are athletes and television actors. They are strewn and garlanded with flowers, small arbitrary forms and wavy lines, with words and names associated with sports or television. Some of her paintings were made at a time when she was absorbed with maps. She started working at NIAD in 1994. Her art was included in the exhibition, "Visions from the Left

Coast: California Self-Taught and Visionary Art," in Santa Barbara, California.

Colclough, Jim (1900–1986)

Jim Colclough was born and raised in Oklahoma. He moved to Westport, California, when he retired, around 1961 and took up woodcarving. He carved wooden pieces from soggy logs found on the beach at Fort Bragg, California; almost life-size figures, which represented both ordinary people and political characters. These figures often expressed his views, making fun of authority figures and society. His carved figures were sometimes jointed and nearly always painted. Colclough's art is in the collection of the Smithsonian American Art Museum.

Cole, Sandy

The niece of G.F. Cole, "an accomplished but often ignored potter of Lee County, North Carolina," Sandy worked with her uncle beginning in the late 1980s and up until his death in 1991. In 1992, she and her husband, Kevin Brown, opened a shop of their own called North Cole Pottery. Sandy's face jugs are finely modeled with expressive faces. Kevin's face jugs have a unique quality of their own.

Colin, George (1929–2014)

George Colin lived with his wife, Winnie, in Salisbury, Illinois. The son of a family of French immigrants, he worked as a flour bagger for Pillsbury Mills and started making art at age 50. With a home full of his colorful creations, his yard is filled with sculptures, mostly of wood and paint. Colin worked with pastels, oils, watercolors, and charcoal to create paintings and drawings. George Colin's art is described as wild and primitive; it has featured in exhibitions at the Smithsonian American Art Museum and the American Folk Art Museum in New York City. It sold in the Springfield area initially, then in Chicago galleries and internationally. His work features Illinois farm scenes, nature, abstracts and a range of eclectic subjects rendered in bright pastels on paper. A couple of years before his death, he took up the harmonica. His art was included in the exhibition "Outsider Art: An Exploration of Chicago Collections." His work is available from the Art Stop Gallery in La Grange, Illinois. During Colin's lifetime he and his wife sold his art from his studio, which she may still be doing. In addition, there is a Facebook page for George Colin Art Gallery.

Collins, Scott (b. 1950)

Collins was born in Hickory Grove, South Carolina, on Christmas Day. After high school, he moved to Gastonia, North Carolina, where he worked in a gas station, operated heavy equipment, and repaired appliances. In 1995 he started making figures out of wire,

One of the first was an eagle. When a stranger offered good money for it, he started making more figures, some of which have been purchased to grace public places. Collins thinks of his work as a hobby and does not think of himself as an artist. His work was included in the exhibition "Wind in My Hair" in 1996 at the American Visionary Art Museum.

Connelly, Emma French

Connelly is originally from Tennessee and now lives in New Orleans. Most of her work is in fiber arts, but she is not afraid to try something new. She makes art dolls, meticulously sewing and decorating them until they are "perfectly imperfect." Connelly "is never afraid to try something new," says gallery owner Patricia Low. Her work is sold at Coq Rouge in uptown New Orleans.

Conner, Claude W. (b. 1939)

C.W. Conner, as he is called, is a self-taught artist who has worked with painting, drawing, and woodcarving for about thirty years. His art reflects his beginnings in the rural South—he was born in Walton County, Georgia—and his later life in and around Atlanta. He uses conventional art materials and also barn wood, tin roofing material, and house paint. He paints and draws a wide variety of subjects including women's faces, country scenes of people doing work and chores, figures, animals, and many others. He also makes carved walking sticks. Conner lives in Ellijay, Georgia, and his work is included in galleries.

Connor, Michael (b. 1957)

Mike Connor was born in Suffern, New York, October 23, 1957, and grew up in Stony Point, New York. He is an electrician by trade and lives in New York State. Connor has worked in New York City as a lighting technician, and has traveled all over the United States as a journeyman electrician with the International Brotherhood of Electrical Workers. He is also a self-taught artist who paints in acrylics on wood panels and is a "political artist" who focuses on the rights of workers. A major theme of his art is workers' relationships and treatment by their bosses and labor unions. He was part of an exhibition titled "Blue Collar Art" at the Arts Alliance of Haverstraw, in Haverstraw, New York in 1999.

Cooper, Calvin (1921–2011)

Calvin Cooper lived in Wallingford, Kentucky, not far from where he was born. A retired highway department worker, he found the subjects of his woodcarvings in the shapes and the forms of small trees and branches in the woods around his home. He worked the natural shape to create sculpture with a distinctly personal style and reveal his sense of humor. Cooper's

subject matter was varied and included natural themes, realistic scenes, and fantastic and imaginative creatures such as his well-known brightly painted polka-dotted roosters. His work is in the museum at the Kentucky Folk Art Center in Morehead.

Cooper, Richard P. (b. 1938)

The Rev. Richard P. Cooper was born in Pittsburgh but has spent most of his life in Pennsylvania farm country. A Lutheran minister, he made his first painting, a farm scene filled with childhood memories, in 1975. His subjects are mostly religion and rural life and he paints with oil on canvas. Cooper hasn't a lot of time to paint, so his production is low. His work is in the John Judkyn Memorial Museum, in Bath, England, and Pennsylvania's Johnstown Museum.

Cooper, Ronald (1931–2012) and Jessie Cooper (1932–2013)

The Coopers lived in Flemingsburg, Kentucky. Jessie and Ronald were raised in northeastern Kentucky. They married when she was 16 and he was 17 and ran a country store for a number of years. Work in the store and raising their four children led Jessie to put aside her early interest in art. A series of unfortunate events resulted in their leaving the store and moving to Ohio, where Ronald worked in a factory and Jessie as a checker in a supermarket. Ronald suffered subsequent ill health and a crippling car accident. Making art turned out to be therapeutic for both Ronald and Jessie. Jessie Cooper painted, often on pieces of furniture and other found objects. She sometimes created a three-dimensional scene in a dresser drawer or chest. Focusing primarily on religious subject matter, Jessie's work also dealt with autobiographical subjects and social commentary. Ronald Cooper's subjects had more to do with "fire and brimstone." Ronald sculpted figures and other objects from lumber and found wood, which he then painted in bright thick paint. His subject matter was predominantly biblical; many pieces feature snakes or devils.

Cooper, Ruthie (b. 1968)

Ruthie Cooper lives in Flemingsburg, Kentucky, and makes brightly painted figurative assemblages, creatures and devil-like constructions from animal bones. She is married to folk artist Tim Cooper and is the daughter-in-law of Ronald and Jessie.

Cooper, Tim (b. 1957)

Tim Cooper lives in Flemingsburg, Kentucky, and creates animals, insects, and devil figures, which he constructs out of wood, vinyl, metal, other found materials, and then paints. Cooper has recently added angels, motorcyclists, and "pop" culture figures to his

wood sculptured forms. For a while he stopped making art, but has started once again. He is the son of Jessie and Ronald Cooper.

Cordero, Helen (1915–1994)

Cordero lived at Cochiti Pueblo in New Mexico. She was the creator of the contemporary storyteller doll that first appeared in 1964. Her work was inspired by memories of her grandfather, and she had said that when her two oldest children were killed one year apart, working helped her with the loss. The Museum of International Folk Art has a large collection of her storyteller dolls. Storyteller dolls are now made by around 200 people, and some of them are very good.

Corley, Linda

Linda Corley is from Houma, Louisiana. She has only been painting for a couple of years, beginning this new passion late in life. Her work usually tells a story of childhood memories." Most of her pieces have a quality about them, as if they have a soul." She is represented in the Coq Rouge Gallery in New Orleans

Cotton, Walter F. (1892–1978)

Walter F. Cotton was the son of a man who had been a slave. He grew up on a farm near Mexia, Texas. He picked cotton, served in World War I, worked as a railroad mail sorter, and then studied to become a schoolteacher. He began painting in the 1930s, inspired by paintings he saw in a Catholic church. Cotton painted religious and historic scenes, and portraits. His historic scenes were done from a desire to preserve the history of African-Americans for future generations. Cotton's first paintings were done with melted crayons on cardboard or wood. Later he painted on canvas panels with oil paints. Cotton's art is included in the exhibition "Spirited Journeys: Self-Taught Texas Artists of the Twentieth Century."

Cox, Paul (b. 1928)

Cox was born in Mauk Ridge, Kentucky, attended school through the fourth grade, and still lives there. He worked for the county road department most of his life. Cox has been involved in making art of one kind or another since he was about seven, but gave away most of his work to family and friends up to about 1989, when his work first came to the attention of the Kentucky Folk Art Center. At that time the Center bought four animal sculptures from Cox for its permanent collection. These objects were sculpted out of clay that Cox had gathered from road cuts near his home. He shaped the clay, then painted it, but never fired the pieces. His clay sculptures and the wooden carved animals he began to make later demonstrate a strong natural sense of form. In addition to being in

the Center's permanent collection, his work is often available through the Center's Museum Store.

Coyle, Carlos Cortez (1871–1962)

Coyle was born in Kentucky and went to a high school run by Berea College. He moved around enough that several states claim him as "their" artist. After his retirement in 1948 he moved to his last home, in Florida. Coyle is written about frequently. In the spring of 1996 the Kentucky Folk Art Center in Morehead mounted an exhibition called "The Mystery of Carlos Cortez Coyle." The art department at Berea College has a collection of his work, and mounted an exhibition in 2014.

Crabtree, Golmon (b. 1934)

Crabtree is Kentucky born and raised and one of several "bird handle" carvers from the south central part of Kentucky. He is a carpenter and maintenance man for a school and also drives the school bus. He makes canes, small wooden toys, picture frames, and small figures of people and animals. Crabtree carves with a pocket knife and uses cedar and various tropical woods salvaged from pallets made in South America. He uses paint for accents and shellacs his carvings. In addition to canes with bird handles, Crabtree's images include figures of Indians, Daniel Boone, Dolly Parton, and snakes and other creatures.

Craft, Ennis, Jr. (1946–1999)

Craft was born in Pineville, Louisiana, on October 1, 1946. He always loved art and started drawing as a child. In the third grade he invented a cartoon character, "Captain Rogan," and wanted very much to be taken seriously for this work. His art dealer has several of his comic books and comic strips in stock. They are many pages long, some with color covers, and all are in comic book or comic strip format. The strips have six black-and-white drawings, and one color set for Sundays. He dropped out of school in the tenth grade, then got his G.E.D., attended Louisiana State University for three months, and dropped out. He worked at a cleaning place, on offshore oil rigs for five years, and worked for an investigator all around the country. He started using oils to paint and said he enjoys doing it, and especially liked it when people were impressed enough to buy his work.

Craig, Burlon (1914–2002)

Burlon Craig was born in Hickory, North Carolina, and was probably the best known of the Catawba Valley potters. He began working in pottery when he was fourteen, when he became an apprentice to a western North Carolina potter. He went into the navy in 1942 and when he returned he bought a farm near Vale, North Carolina. He follows a tradition that began

in the nineteenth century, using old-time methods every step of the way. In 1984 Craig won a National Heritage Fellowship. The face of a Burlon Craig face jug has protruding eyes, wide eyebrows that meet at the bridge of the nose, and a grin filled with square teeth cut from china plates. Burlon Craig is featured in the book *Catawba Clay: Contemporary Southern Face Jug Makers*, by Barry G. Huffman. There is also information in the same book about the pottery of Burlon's son, Don Craig (b. 1945), and his grandson Dwayne Craig (b. 1973). Don makes swirl face jugs, and snake designs. You may call him at 828-245-1003.

Crawford, L.W (b. 1942)

Crawford is from Whitehall, Alabama, a small town near Montgomery. He started to make various objects—boats, churches, houses, crosses, picture frames—with matchsticks when he "first went to the penitentiary" in 1962. Later, after he got out, he started making large art objects. Then he went back to prison again but has been released now. Collectors have sought his work, especially his crosses. It is hoped that his work will reappear in Montgomery area galleries. He was included in the 1991 publication "Outsider Artists in Alabama," and "Outside the Main Stream" at the High Museum in 1988.

Creese, Michael F. (b. 1945)

Creese lived in Syracuse, New York, until he moved to San Antonio, Texas, in 1968. He says about himself, "As a self-taught artist, I work with acrylics because of its quick drying and its bright colors. I create happy scenes of life as I see it." Creese has won several awards for his art, including one at a Black Heritage Show in 1988. He works as a letter carrier for the post office.

Criss, Abraham Lincoln (1914–2000)

Abe Criss was born in Cumberland, Virginia and lived there a long time on land that belonged to his family. He worked much of his life as a master cabinetmaker and furniture refinisher. He began to carve after retirement. He filled his yard with a wonderful wooden "zoo" of his many animal creatures. Criss made wooden figures of people and animals that he carved and assembled in a somewhat fantastical mode. The work also has some painted detail. He had his first exhibition, *The Bench and the Bench Maker*, at the University of Richmond in 1987. His work is in the collection of Meadow Farm Museum in Glen Allen, VA; Longwood (VA) Center for the Visual Arts, and the Art Museum of Western Virginia in Roanoke. It has been in several exhibitions, including at the American Visionary Art Museum in Baltimore. When Criss moved to New Jersey toward the end of his life to be closer to his daughter, he started doing more drawing than carving.

Crocker, Michael (b. 1956) and Crocker, Melvin (b. 1959)

These brothers were born in Lula, Georgia, and still live there. They are north Georgia potters who run the Crocker Pottery. They are the sons of a farming family and took up pottery on their own as adults. They make face jugs in a contemporary manner by making a pot from a mold and adding the face later.

Cromer, J. J. (b. 1967)

J.J. Cromer was born in Princeton, West Virginia and grew up in Tazewell, Virginia. Except for his college years, he has lived in the same area of southwest Virginia most of his life. He has a bachelor's degree in history and two masters' degrees, one in English and the other in library science. He works as a librarian. He showed an ability to make art in childhood, but was not encouraged in that direction as a child. Although his mother did support his creative drive, his father wanted him to be a doctor or lawyer. Soon after he married, he began to draw incessantly, while watching TV in the evenings, until the pastime gave way to obsession and drawing developed into painting. His paintings, which sometimes include cutouts from other media, are sometimes witty, sometimes satirical, and sometimes sad. They are very colorful and very intricate, filled with flowing shapes and repetitive images, often of small stylized shapes that look a bit like teeth and a bit like clothespins, with faces but without arms. Cromer had his first exhibitions in 1999, and has gone on from there, with a solo exhibition at the Staniar Gallery, Washington and Lee University, in 2008, and other shows. Grey Carter: Objects of Art in McLean, Virginia carries his work, as do an increasing number of other galleries. In addition, Cromer maintains his own website (www.jjcromer.com) and Facebook page, through which he sells his own art. His work is in the permanent collections of Intuit: the Center for Intuitive and Outsider Art in Chicago and the American Visionary Art Museum in Baltimore.

Crosby, Chuck (1957–1994)

Chuck Crosby was a self-taught outsider artist born in New Orleans, Louisiana, May 21, 1957. He had created compulsively since he was a child and became depressed when a severe nerve injury left his painting arm useless. After much practice he got the other arm to take over and thus regained his ability to paint and draw. Crosby discovered he had AIDS in the early 1980s and started painting constantly, except during periods when he was too sick. He painted from his imagination and from life experiences. His style was unique and included repetitive images inspired by his dreams and fears. Some of the human subjects in his paintings were friends of his, including the frequently portrayed "Big Lady" and "Little Man." He painted on any surface available—furniture, bottles, gourds, and

canvas—with acrylics. At times the artist wrote a framing narrative of words along the borders of his paintings. Chuck had been looking forward to the exhibition of his work at the Arthur Roger Gallery in New Orleans, but died before he could see it, at age 37 on July 15, 1994. A few pieces of work are available from Marcia Weber/Art Objects in Montgomery, Alabama.

Cuffie, Curtis (1955–2002)

Cuffie was born in South Carolina and moved to New York City with his family at the age of 15. From 1985 to 1996 he lived as a homeless street person on the Lower East Side. He collected thousands of objects from the streets that he used to make sculptural installations on city streets and sidewalks, often accompanying them with ad hoc performances voicing his own poetry. His work was exhibited at the American Visionary Art Museum in Baltimore and in New York galleries such as American Primitive Gallery. He was able to leave the streets eventually, and was working at Cooper Union when he died.

Cunningham, Earl (1893–1977)

Earl Cunningham was born in Edgecomb, Maine. While working as a self-employed shopkeeper and self-taught artist, he visited Florida for the first time in 1924. After a long time of traveling the East Coast—supporting himself as a seaman, chicken farmer and junk dealer—Cunningham settled in St. Augustine, Florida, where he opened an antiques shop, the "Over-Fork Gallery," in 1949. He painted brilliant colored landscapes and scenes of idyllic harbors. He is the subject of a book, *Earl Cunningham: Painting an American Eden*, by Robert Hobbs, who describes Cunningham as "hearing a dual siren song—the itinerant way of life and creativity." Cunningham wanted to build a museum to keep his paintings but they were dispersed after his death. Marilyn and Michael Mennello found Cunningham's work and are credited with saving it. Cunningham's art is in the permanent collections of many museums. The paintings in the Mennello's personal collection have been given as the core gift to the new Mennello Museum of American Folk Art in Orlando, which opened in November 1998.

Dance, Joan (b. 1940)

Joan Dance was born in Paducah, Kentucky, where she still lives. For years before she started painting, Ms. Dance wrote poetry. She started painting in 1964 when she felt compelled to draw her church. She then drew more churches, eventually adding people to the paintings. Then she added paintings of children, children's games, and other scenes. Joan Dance is a self-taught painter who does everyday scenes that are crisply linear and boldly colored. There was an exhibition of her work at the Kentucky Folk Art Center in Morehead in

January 1997. Her work is in the permanent collection of the Kentucky Folk Art Center and she was featured in the 1998 exhibition "African-American Folk Art in Kentucky." Her work is available at Ann Tower Gallery in Lexington and is in the permanent collection of the Kentucky Folk Art Center in Morehead, Kentucky.

Darger, Henry (1892–1973)

Henry Darger was born and lived in Chicago. His childhood was spent in an orphanage and a home for the feeble-minded. When he died, his room was discovered to contain over 15,000 pages of text and 2,000 drawings. The length of his "art life," according to John MacGregor, who has written extensively about Darger, was "from 1962 to 1972." Darger's work is the story of a universe torn by warring forces of good and evil; innocent children led by the "virtuous Vivian sisters" struggling to escape ruthless adult males. In the winter of 1997, The American Folk Art Museum in New York presented the exhibition "Henry Darger: The Unreality of Being" which attracted much critical attention. Much of his work is in the permanent collection of Intuit: the Center for Intuitive and Outsider Art, in Chicago, which has a Henry Darger Room.

Darmafall, Paul "The Baltimore Glassman" (1925–2003)

Paul "The Baltimore Glassman" Darmafall was born September 25, 1925, in Moundsville, West Virginia. His mother and father were from Poland. His father was a coal miner who died when Paul was ten years old. He had six brothers and sisters. He enlisted in the navy when he was sixteen and participated in major battles in World War II. Darmafall moved to Baltimore in the mid-1950s. He worked as a grinder at Bethlehem Steel and then as a bricklayer, working on several important Baltimore buildings. He retired in 1976 and spent his time fishing, riding his bike to historic sites, taking photographs, and reading. He began making his mixed media messages in about 1983. He first worked on the sidewalk along a busy stretch of highway. Later he had a workspace at Kubus Studio and Gallery in Baltimore. Paul's works are messages that represent his ideas about life; he enjoyed explaining them to people. The art incorporates broken glass, found objects, and glitter. He first traced a drawing, then painted over the design and added found objects, and finally printed his messages onto the piece. Glassman's art was informed by a life of hardship, honest work, and "personal isolation because of his singular world view." There was an exhibition of his work at the American Visionary Art Museum in the summer of 1999.

Davila, Richard Luis "Jimbo" (b. 1955)

"Jimbo" Davila lives in El Rancho, New Mexico. He

was born in Valley Forge, Pennsylvania, and did not come to New Mexico until after he had dropped out of college in Arizona. He worked with Felipe Archuleta for a number of years, and then began carving on his own. He was first known for his brightly carved and colored snakes. Now he is making other figures. Davis Mather Folk Art Gallery in Santa Fe carries his work, which is also in the permanent collection of the American Folk Art Museum and was included in the recent exhibition "Wooden Menagerie: Made in New Mexico" at the Museum of International Folk Art (April 6, 2014, through February 15, 2015).

Davis, Keith (b. 1955)

Davis was born in Loveland, Texas. He began painting at the age of 10, after recovering from a nearly fatal case of juvenile hemolytic anemia, which kept him bed-ridden for months. As his father walked him through the waiting room towards the doors of the Lubbock hospital, Davis was captivated by three doctors' portraits, each painted in oil. Overwhelmed by the beauty and near-photographic quality of the each work, he aspired to make art "just as beautiful." Davis first trained and worked as a paramedic for nearly a decade in West Texas. In 1982, he moved to Austin, where he worked as a barber for twenty years, painting in his off hours. His first shows were in Austin area restaurants almost a decade ago. Since then, he's painted and shown his work steadily and, in 2003, became a painter full-time. Completely self-taught, Davis is a prolific and accomplished painter. He draws his subjects from his life, or from popular culture (musicals, westerns), and his imagination; in addition, his work is at times three-dimensional. Currently, he is working on three-dimensional painted sculptures rendered in wood and paint. San Angel Folk Art in San Antonio carries his work.

Davis, Patrick (b. 1943)

A native of Guyana, Patrick Davis moved to Houston, Texas, in 1979. He makes sculpted characters— mostly men, some women, a few dogs—that are long, thin, have "an attitude," and often have their tongues sticking out. The dogs are painted white. The human characters have brightly patterned "clothing" that result from the artist's use of the pages of the *National Geographic* and other such magazines. Some recent figures have fabric garments, too. The basic interior structure of the earlier figures came from computer punch cards, pressboard, and filament tape. The figures, barefoot or with shoes, may be dressed in flowing robes or suits and ties—nearly always with hats. A critic has said of them, "they have the fluidity of dancers." Once he learned to make a stronger armature, Davis began making larger figures. Some of his newer female forms are quite beautiful and some recent creations are tableaux with several figures. Main Street Gallery in Clayton,

Georgia carries his work, which is also in the permanent collections of the Ogden Museum of Southern Art, the American Visionary Art Museum, and the Art Museum of Southeast Texas.

Davis, Ulysses (1914–1990)

Davis lived in Savannah, Georgia, for more than forty years and operated a barbershop. Between customers and after working hours, he decorated his shop with carved figures from wood. His themes were religious, patriotic, and historical. He also carved some animals and made carved and painted wood reliefs. Davis has been written about and exhibited frequently. The King-Tisdale Cottage Foundation on East Harris in Savannah has 230 of his woodcarvings. Although Davis sold few of his works, there are some in private collections and pieces are occasionally available. Washington, D.C., photographer Roland Freeman has taken excellent photographs of Davis and his work, which is in the permanent collections of the High Museum in Atlanta, the Milwaukee Art Museum, and the Arkansas Arts Center.

Davis, Vestie (1903–1978)

Davis was born in Hillsboro, Maryland, and left home at an early age to join the navy. Eventually he settled in New York and worked as a newsstand manager, circus barker, concession stand operator at Coney Island, and an embalmer. His paintings were discovered at the outdoor art show in Washington Square in New York's Greenwich Village. His paintings were either done on location or from photographs. Often he sketched them first on paper in pencil or crayon. Davis is known for his colorful, detailed paintings of New York. The permanent collections of the Milwaukee Art Museum and the American Folk Art Museum include his work.

Dawson, William R. (1901–1990)

A prominent self-taught wood sculptor and painter, Dawson began sculpting after his retirement. He used scrap wood, sometimes adding chicken bones and paint. His heads and totem-like carvings depict strong facial features. Toward the end of his life he took to painting more. Dawson is featured in many exhibition catalogs and museum collections, including The Smithsonian American Art Museum and Archives of American Art, the New Orleans Museum of Art, and the Kentucky Folk Art Center.

Day, Frank L. (1902–1976)

Day was born in Berry Creek, California. He was a Maidu and learned traditional legends and facts about his people. He traveled a lot as a young man and then settled in California. He had to retire after an automobile accident and this revived his interest in painting.

Using oil on cardboard and canvasboard, he painted the history of his people and their myths and traditions. His work appears in *Twentieth-Century Folk Art and Artists* by Hemphill and Weissman and in other publications.

Decker, Evan (1912–1981)

Decker was born in Wayne County, Kentucky, and lived in Delta, Kentucky, until his death. A farmer, carpenter, and builder all his life, he was a cowboy in his heart. His place was named "Home on the Range." Decker was fascinated with the West, which dominated his artistic life. Mostly a sculptor, he started painting toward the end of his life. He created over 100 pieces, including a life-sized horse on which he used to sit and sing cowboy songs to his family. He created tableaux, animals, birds in trees, and added pieces to beautifully crafted furniture. Forty-two pieces of his work are in the Huntington Museum in West Virginia. A catalog illustrating his work, based upon an exhibition at Berea College, is *When, The Skies, Not, Cloudy, All, Day: The Art of Evan Decker.*

DeClet, Pedro Martin (b. 1963)

Pedro Martin DeClet was born in Brooklyn, New York, and was raised in New Haven, Connecticut. His mother is Puerto Rican and he doesn't know his father. His family is upwardly mobile and his siblings all well-educated. He strayed away, he says, "walked out the front door and walked in the wrong direction." He did not go to school, got into a lot of trouble, and ended up in prison. He was in solitary for two years. Eventually he was brought to Jeff Green's prison art classes. At first he wasn't cooperative, but finally found himself. His paintings were included in twenty prison art shows. While in prison he read everything he could get his hands on in art, literature, and philosophy. Now the artist lives in the country with his mother and paints all the time, and also has begun to make small sculptures. Nearly everything he does is a self-portrait. He helped build a neighbor's barn and now has a studio space there. His work is represented by Beverly Kaye in Connecticut.

Deeble, Florence (1900–2000)— "Rock Garden & Miniatures"— Lucas, Kansas

Florence Deeble was a schoolteacher. She and her roommate Christine Klontz first built a rock garden in Norton, Kansas. After they retired in the 1960s, they moved to Lucas. Deeble, who made this project on her own, began with a lily pond and went on to create concrete miniatures of remembered landscapes seen while traveling, including Mt. Rushmore. During her lifetime, Deeble enjoyed having people see the yard art and garden. Her garden at 129 Fairview in Lucas,

Kansas has been preserved since her death (the house itself has been taken over by another outsider artist, Mri Pilar, who has a passion for Barbie dolls and aluminum foil). The site may be visited by stopping first at the Kansas Grassroots Art Center, which maintains photographs of the garden. One may also see Deeble's garden and other folk art environments in and near Lucas, Kansas on the Center's tours.

Del Favero, Bruno (1910–1995)

Bruno Del Favero was born March 14, 1910, in Princeton, Michigan. At the age of five he accompanied his family when they returned to Lozzo Cadore, Italy. At seventeen he came back to America and settled in Greenwich, Connecticut. Bruno worked as a carpenter with house builders, and built his own first home where all five of his children were raised. After many years he retired from construction work and became a gardener/chauffeur. At this time he became interested in painting. He began experimenting with oil and acrylic paints. Many of his paintings were inspired by the beautiful landscapes surrounding the Dolomite Mountains near Venice where he grew up. He loved to wake up early and paint the scenery from his past. In an interview in the *Greenwich Time* in October 1988 he was quoted as saying, "When I was about to retire, it didn't take long to decide what I would be happy doing … this is the best time of my life. There is so much to paint." Cavin-Morris in New York represents the artist.

Dellschau, Charles A. A. (1830–1923)

Dellschau was born in Germany and immigrated to Texas in 1850. He married and had a family but his wife died, and he was left to raise the children, whom he ignored as much as possible. He was a butcher by trade. When he retired he spent his time alone in an attic, painting books of flying machines and inventing a society, the Sonora Aero Club, whose exploits he painted. Twelve scrapbooks of his work were salvaged from a 1960 fire at a Houston house where he once lived. His watercolors and collage images are said to recall illuminated manuscripts. His books of art were nearly lost; a few are in the Menil Collection in Houston. He was included in the exhibition "Wind in My Hair" in 1996 at the American Visionary Art Museum. His art was the subject of a recent (March 21, 2013) article in *Atlantic* Magazine.

Dennis, H. D. (c. 1916–2012)— "Margaret's Grocery"—Vicksburg, Mississippi

The Rev. H.D. Dennis promised Margaret Rogers he would transform her humble country store if she would marry him, which she did in 1986. He definitely transformed it. It was covered inside and out with

religious messages with a gentle lift, unlike the site created by W.C. Rice at his cross garden. Here people were welcomed by a kind and positive spirit. There were colorful constructions everywhere and all-inclusive welcome signs. Preservation of the site, located on Business Route Highway 61, five miles north of Clay Street (the center of Vicksburg), was in the hands of the Cool Springs M. B. Church, but in 2010 the church found itself unable to maintain the property. The site can now be seen in the book *The True Gospel Preached Here* by Bruce West.

Densmore, Merrill (b. c1945)

Merrill Densmore was born in the Northeast Kingdom of Vermont. He now lives in St. Johnsbury, Vermont. The artist started to paint by using "paint by numbers" and drawing with crayons. He has been using acrylic paint and working with the G.R.A.C.E. program since 1994. Densmore's work has been exhibited in numerous shows in Vermont as well as outside the region. One of his favorite subjects is the Vermont landscape. He uses bold color patterns to fill his paintings with clouds, mountains, cows, houses, and sheep. He is continually experimenting with new techniques.

DePrie, "Creative" G. C. (1935–1999)

Gerald "Creative" DePrie lived in Huntington, West Virginia. DePrie was a barber for a time and served in the navy. DePrie always said, "I believe I am out in the future, and I am psychic," and "my art is influenced by omens, and the fact that you can only live in the future, not the past or the present." DePrie suffered from a heart condition and "nerves" and so spent most of his time on his art. As for technique, he said "the pencil moves and I follow it." DePrie's most frequent subjects in his art are human figures and architecture. When he drew the human figure, he drew it nude and then added the clothes. He was fascinated with nursery rhymes, with a strange and sometimes unsettling twist on the traditional; *Alice in Wonderland*; and ancient places, Egypt in particular. Of Egypt he said, "I know about it, I don't know why. I've been there I think." DePrie died suddenly, from his heart ailment, in May of 1999. His art is widely collected. Larry Hackley (Richmond, Kentucky) carries his work and it is in the permanent collection of the Huntington Museum of Art.

Deschillie, Mamie (1920–2010)

Mamie Deschillie was born in Burnham, New Mexico, and lived in Fruitland, New Mexico. She was said to be a fine weaver and a traditional person. Her art is very imaginative and unique, especially the collages. In the last decade or two of her life she started making clay dolls and dressing them in scraps, as her mother had done. Then she started making the cutouts and collages that have become greatly admired by folk art collectors. Detailed information about her appears in *The People Speak: Navajo Folk Art* by Chuck and Jan Rosenak. Several galleries or dealers carry her art, including Marcia Weber/Art Objects, Case Trading Post at the Wheelwright Museum in Santa Fe, and private dealers Leslie Muth and Louanne LaRoche. Her work is in the permanent collections of the Smithsonian American Art Museum, the Museum of International Folk Art, and the Art Museum of Southeast Texas.

Dexhimer, Alva Gene (1931–1984)

Dexhimer was born in Clarksburg, Missouri, and died in Syracuse, Morgan County, Missouri, living on the edge of the Ozarks. He could neither read nor write, but filled his art with copied words. Handicapped by a farm accident as a boy of seven, he passed time by making objects for his own amusement and for passersby on the county road in front of his house. He had all kinds of bric-a-brac, found-object creations and whirligigs in the yard. In a back shed were his paintings, hundreds of them. These paintings, copied from the mass media, a tradition among folk artists, but transformed by his stubborn sensibility, were done on whatever he could find, with house paint from Wal-Mart or donations. In the newsletter *ENVISION* (July 1997) there is a detailed and interesting article about the artist and his work by Alex Primm, who knew him. Dexhimer's work was in an exhibition "Deliberate Lives: A Celebration of Three Missouri Masters" in 1984. A show featuring his work, "Alva Gene Dexhimer: Missouri Maverick," was held at MAM Collections in Missoula, Montana in late 2011.

Dey, "Uncle Jack" (1912–1978)

John William "Uncle Jack" Dey was born in what is now Hampton, Virginia. At eighteen he moved to Maine to work as a lumberjack and trapper. Four years later he moved to Richmond, Virginia, where he was first a barber and then a policeman. He was a popular figure with neighborhood children who brought their bicycles to "Uncle Jack" for repair. In 1955 Dey "began to display psychological problems" and was forced to retire from the police department, at age 43. He started to paint to escape boredom. He created paintings from his experiences and his dreams. Dey painted with enamel on board in flat, bright colors.

Dial, Arthur (b. 1930)

Arthur Dial was born in rural Alabama. In 1940 he moved with his elder half-brother Thornton to Bessemer, Alabama. Dial spent most of his working life at a company called U.S. Pipe. The artist was inspired by the artistry of his older brother and began to create his own art out of materials familiar to him from his job. He has been working on his art most of the time since

he retired in the mid–1990s. He was included in the exhibitions "Souls Grown Deep: African-American Vernacular Art of the South" and "Wrestling with History."

Dial, Richard (b. 1955)

Richard Dial, second son of Thornton Dial, Sr., worked as a machinist for Pullman-Standard Company in Alabama and established a wrought iron furniture company in 1984. He has created one series that is both furniture and art. His chair sculpture was included in the exhibition "Souls Grown Deep: African-American Vernacular Art of the South," in Atlanta in 1996.

Dial, Thornton, Jr. (b. 1953)

Dial creates "compelling painting/assemblages" that deal with racial issues and with relationships to nature." A lot of biographical material is available for Dial Jr., at www.soulsgrowndeep.org, but nothing about where to buy or see his work.

Dial, Thornton, Sr. (b. 1928)

Thorton Dial was born in Emmelle, Alabama, a rural and farming area in the western part of the state. After the third grade he left school to do such work as assisting at a local ice house and digging sweet potatoes. When Dial was ten, his mother had the chance to marry so long as she agreed to give up Thornton and his half-brother Arthur. The boys first went to live with their grandmother Martha James Bell, and then after her death three years later they moved to Bessemer, a highly industrial area near Birmingham. There they lived with their great aunt Sarah Dial Lockett to whom Thorton has been devoted. In 1951 Thornton married Clara Mae Murrow and they had three sons and two daughters. Dial worked very hard all his life to support his family. His main employment for 33 years was with Pullman-Standard, though he often had to work at more than one job at a time. During most of his life, Thornton Dial has made things. About 1987 Dial began to consider himself an artist. He is a painter and sculptor whose themes are relationships—between the races, men and women, God and humankind. In the spring of 1997, Virginia Union University in Richmond presented an exhibition of thirty water colors, paintings, and mixed-media pieces by Dial from its collection, "Thornton Dial: The Tiger Looking In." The brochure published for this exhibition contains an essay by Robert Hobbs with his views on Dial's life and the symbolism in his art. A major exhibition of his large assemblages, "Hard Truths: The Art of Thornton Dial," was on display at the Indianapolis Museum of Art, High Museum of Art (Atlanta), New Orleans Museum of Art, and the Mint Museum (Charlotte, North Carolina) from fall 2011 through fall 2012. A smaller exhibition took place at 333 Montezuma Gallery in Santa Fe in 2014, in which Dial's work was displayed along with that of Lonnie Holley.

Dieter, Charlie (1922–1986)

Dieter was born in Little Gap, Pennsylvania, and lived in Weatherly. He spent most of his life taking care of his mother. At age 47, when his mother died, Dieter went into a nursing home. He lived, it is said, "in his own private reality," which he drew upon for his paintings. Dieter is known for his delicate, childlike drawings of familiar places, friends, animals, and a band from his real and his imaginary worlds. He became part of the folk art circle promoted by Sterling Strauser, along with "Old Ironsides" Pry and Justin McCarthy.

Dinsmoor, S. P. (1843–1932)—"The Garden of Eden"—Lucas, Kansas

Samuel Perry Dinsmoor was born in Coolville, Ohio, and died in Lucas. He was a Civil War veteran and a strong supporter of the Populist political movement in the 1890s. He spent thirty years building the Garden of Eden site, populating it with numerous concrete figures representing social commentary and Bible stories. There are many illustrations and writings about this site, which is still open at 305 E. Second Street in Lucas from March through October every year. Specific hours and details about visiting can be found at www.garden-of-eden-lucas-kansas.org or by calling 785-525-6395. The Grassroots Art Center, also in Lucas, maintains photographs of the site.

Dixon, Carl (b. 1960)

Carl Dixon is a wood-carver from Jackson, Mississippi. He started carving in 1978 as a hobby while working as a brick mason. No longer able to make a living in Jackson, Dixon moved to Houston, Texas, in 1980. Dixon is very religious and this determines the themes and stories portrayed in his work. He first draws the picture on paper, then carves the scene on wood. He uses a combination of power tools and hand tools. His art was included in the exhibition, "Spirited Journeys: Self Taught Texas Artists of the Twentieth Century." The Kloesch Haus Gallery in Houston carries his work.

Dobberstein, Paul M. (1872–1954)—"Grotto of the Redemption"—West Bend, Iowa

This is the earliest of the many Midwestern grottoes. Father Dobberstein began work on it in 1912 and continued until his death in 1954. He built nine contiguous grottos illustrating the Redemption—from the Fall of Man to the Resurrection. He also built smaller grottos and memorials in other locations in Iowa, Wisconsin, and further afield. The structures are

encrusted with natural materials such as rocks, polished stones, and shells. The Grotto of the Redemption is open for guided tours from June to mid–October and at other times by appointment. The grotto is located two blocks off Iowa State Highway 15A at the north end of West Bend. Call 515-887-2371 or visit the website www.westbendgrotto.com.

Doc Atomic (b. 1962)

Doc Atomic was born in New York and has lived in New Mexico for more than twenty years. He has a degree in engineering, and is a self-taught artist. He has won prizes for his art cars in Houston, and one of them was exhibited at the International Museum of Folk Art in Santa Fe. The artist likes to explore future imaginary worlds and creates "strange sculptures from electronic components, computer parts and fragments of scientific instruments that he collects." Doc Atomic was included in the exhibition, "Art Outsider et Folk Art des Collections de Chicago," which opened in September 1998 in Paris. Judy A. Saslow Gallery in Chicago represents the artist.

"Dr. Evermor" see Every, Tom

Doman, Eileen (b. 1954)

Eileen Doman was born in Chicago and now lives in Genoa, Illinois. She is a self-taught artist who began painting at 38. A former beautician and telephone operator, she had long felt the desire to paint. After a few attempts at floral still life, she began painting from old family photographs. She was struck by the intensity of emotion she felt when she looked at them and wanted to capture this same feeling in her paintings. Doman's work has been exhibited in galleries in New York and California. Her work has been displayed at the Outsider Art Fair in New York. She sells from her Facebook page.

Dominguez, Anthony (b. 1960)

Dominguez was born in Fort Worth, Texas. He once worked as a sign painter and maintained a home. He gave it all up, "shed worldly attachments," and lives on the streets of New York wherever he can find shelter for the night. His earliest white-on-black works were drawn on black cloth using bleach from a clean needle program. In recent years he has worked on a larger scale, and his art is filled with irony and black humor. "Skeletonized" figures dance between life and death. Images are created with white paint applied to black fabric, often with a squeezable bottle. His past work as a sign painter may be the source of written messages and symbols incorporated into his work. His signature is a small pictogram of a stick figure opening a door marked by a heart. He has been exhibited by American Primitive Gallery in New York and other places.

Dowdall, Brian (b. 1948)

Brian Dowdall grew up in the small mining town of Anaconda, near the mountains in Montana. After years of hitchhiking, sleeping in forests in the country and abandoned buildings in cities, Dowdall settled in Florida. An art dealer describes his work as "chunky, awkward, mysterious animals painted on cardboard with acrylics." Dowdall calls them "animal spirit paintings" and says that he chooses colors from "the sun, moon and fire and the earth, trees and water." His painted menagerie includes alligators, armadillos, dogs, cats, elephants, possums, and snakes. He considers animals his true friends. Roots Up Gallery in Savannah and Red Piano Too Gallery on St. Helena Island, South Carolina, carry his work, which is also appears in the permanent collection of the American Visionary Art Museum. In addition, he sells from his own website, www.briandowdallvisionary.com.

Doyle, Sam (1906–1985)

Doyle was born on St. Helena Island, South Carolina, where he attended Penn School, the first school for freed slaves. He lived in an area with a long and sustained African and African-American history and culture. His paintings depict people from his island, including both legendary and local characters. He is well-known and written about frequently. Many galleries carry his work, which may also be found in the permanent collections of the Smithsonian American Art Museum and Archives of American Art, the American Folk Art Museum, the Milwaukee, Philadelphia, and Ashville Art Museums, as well as other museum collections.

Drake, Sam (b. 1957)

Sam Drake was born in Owensboro and lives in Greenville, Kentucky. A carver, he uses basswood and whatever scraps he can find. He paints his completed carvings with acrylics. His work is in the Owensboro Museum collection.

Drgac, Peter Paul "Uncle Pete" (1883–1976)

Drgac was born in New Tabor, a Czech farming community in Texas. Drgac and his wife had their own grocery and bakery in two Texas locations. After retirement, he became known for growing spectacular flower and vegetable gardens. He loved children and received the nickname "Uncle Pete" from his nieces and nephews. He did not start to paint until after the death of his wife following many years of marriage. At the age of 65 he developed a passion for painting. He decorated every surface around him and began to make paintings on posterboard. He drew objects, animals, and plant forms in a flat stylized way. He used enamel paint. Leslie Muth of Santa Fe was the first to introduce

his work to the public and still has some of his art for sale, as does The Pardee Collection in Iowa.

Driver, Vanzant (b. 1957)

Driver was born in Taft, Texas, just north of Corpus Christi. He finished high school and went to junior college in Laredo with an athletic scholarship. He moved to Houston in 1978, worked on an oil rig, married, and divorced. Shortly after his divorce, the fingers of his right hand were crushed under 600 pounds of steel. He eventually regained the use of his hand, which he considered a miracle. After being laid off a construction job, he began to work full-time on his glass sculptures. With broken automobile windshield glass and other glass he created beautiful small churches that were quite fragile. The Menil Collection has his work in the permanent collection and he was included in the 1998 exhibition, "Spirited Journeys: Self-Taught Texas Artists of the Twentieth Century."

Dulaney, Burgess (1914–2002)

Dulaney lived in Fulton, in Itawamba County, a rural area of northern Mississippi. He produced sculpture from red clay. Although his work is thought by some to resemble pre–Columbian figures, he knew nothing of that art. He never traveled and lived just a few feet from the log cabin where he was born. He was the second-to-youngest of eleven children. He made all sorts of animals including lions, camels, bears, boar hogs, and sheep as well as snakes and haunting human forms. His work was included in the exhibition "Baking in the Sun." He didn't work as much in later life because of failing health, but he still did what he could, digging mud from a local mud hole, working in his kitchen or on the porch, and just letting them dry.

Edlin, Paul (b. 1931)

Paul Edlin retired from years of clerical work and has put together an unusual body of art from things usually discarded. He incorporates stamps into paintings and "paints" with colored bits of stamps. For over twenty years Paul has been experimenting and meticulously cutting, composing, and pasting postage stamps. The pictures from the early 1980s were intimately scaled with larger stamp images pieced together to make pictorial compositions. Paint was an important part of the early pictures. Later works are enlarged pictures with stamps cut into smaller and smaller pieces. The stamps became obsessive and intricate mosaics. He has spent months on a single picture, lifting the tiny bits of cut stamps with a pin to create a pointillist colored image that could be complex pictures with abstracted or naively pictorial compositions. Edlin's work has been exhibited at the American Visionary Art Museum in the exhibition "Eros and Error: Love Profane and Divine" in 1998. American

Primitive Gallery represents Edlin, and gave him a solo exhibition, "Paul Edlin: Family Business," in 2014. Andrew Edlin, owner of American Primitive and nephew of Paul Edlin, traces his interest in outsider art to his uncle, who ran galleries in addition to producing his own art.

Edmondson, William (1870–1951)

Edmondson was born near Nashville, Tennessee. He started carving around 1932, inspired by a vision. One of the most highly regarded self-taught artists, he carved gravestones, freestanding figurative sculpture, and garden ornaments using discarded blocks of limestone, and tools made from railroad spokes. Animals, biblical subjects, and secular figures were his dominant images. He is written about frequently and is in museum collections including the Smithsonian American Art Museum and the Milwaukee Art Museum.

Egan, Mike (b. 1978)

Pittsburgh artist Mike Egan paints skeletons and skulls. He first became interested in this subject matter while drawing cartoons and skateboard graphics as a kid. Egan went on to study printmaking in college, but after graduation he lost access to printmaking tools and taught himself to paint. He went back to school to become a licensed embalmer and funeral director. Continuing to paint, Egan developed a style that draws on his surroundings in funeral homeless as well as folk art, Day of the Dead imagery, religion, and German Expressionism. His work has been shown in galleries throughout the United States and the United Kingdom. Lindsay Gallery in Columbus, Ohio carries his work, as does Yard Dog in Austin, Texas. Egan also sells his own work at www.mikeeganart.com

Ehn, John (1896–1981)—"Old Trapper's Lodge"—Woodland Hills, California

John Ehn worked for many years as a trapper in Michigan before moving to California in 1941. He opened a motel, and after watching a professional sculptor at work, decided he could do as well. He spent the next fifteen years filling his yard with sculptures of historical and fictional characters. He also made tombstones with tales of the West inscribed on them. The faces of many of his figures are life masks of his family. After Ehn's death, efforts to care for the environment were a hardship to his family. Much of this monumental environment was moved to the campus of Pierce College in Woodland Hills in the San Fernando Valley, not far from its original site in Burbank. There are also a few pieces at the John Michael Kohler Arts Center in Sheboygan, Wisconsin, and at the Oakland Museum.

Eiseman, Jon (b. 1965)

Jon Eiseman was born in New York City. He now lives in Atlanta, Georgia, and Miami, Florida. He has worked in design in the past and has been painting full-time since 1989. He uses markers, watercolors and crayons on paper, metal, and other surfaces to create elaborate, swirling portraits and depictions of nature. His work is in the High Museum in Atlanta.

Eldridge, John (b. 1967)

Eldridge lives in Isonville, Kentucky, and is a neighbor of artist Minnie Adkins. Eldridge carves canes with figures, using dogwood and maple. His designs are completed with enamel. He also carves and paints animals. His work is in the Kentucky Folk Art Center in Morehead and the Owensboro Museum of Fine Art.

Ellington, Kim (b. 1954)

Kim Ellington was born in Hickory, North Carolina, and after high school and some travel in Europe with the help of the army, he returned to Hickory and opened a pottery studio in 1982. He was a studio potter before learning about traditional pottery and much prefers the latter. He started making face jugs in 1988, but is slowly moving away from that form.

Elliott, Willie Leroy, Jr. (b. 1943)

Elliott was born near Mobile, Alabama, and worked for 25 years in the automotive industry in Detroit. Doing numbing, repetitive work, he looked for a creative outlet elsewhere. He bought a welder and learned to use it. Now Elliott is a sculptor who uses wood, paint, and recycled material to create his art. Many of his sculptured pieces make a strong statement on social issues and current events, as well as a strong artistic statement. In 1993 he returned to Alabama, living in Prichard near Mobile, and continues to make his art. He now paints on canvas, too. Elliott was included in the book *Revelations: Alabama's Visionary Folk Artists*.

Ellis, John Robert (b. 1939)

Ellis was born in Athens, Georgia. He began drawing during an incarceration and stopped following his release. He refers to himself sometimes as "Jesus Christ, Jr., sometimes as "The Sinner," and sometimes as "Mr. Teach." His drawings sometimes reflect historical events and major newsmakers of his day. His art was included in *Unsigned, Unsung*, an exhibition in 1993 at Florida State University Museum of Fine Arts; several drawings are in the collection of the Georgia Museum of Art.

Ellis, Vivian (b. 1933)

Vivian Ellis was born in New Orleans, Louisiana in 1933. She emigrated to Germany in the early 1980s, where she continued to paint and receive gallery recognition (e.g., a show in 2004–2005 at the Naïve-Kunst Galerie in Cologne, Germany. Pieces of her art are in the collection of the Amistad Research Center in New Orleans, which is also a repository for her papers. Her work was represented in a recent exhibition at Amistad, "Beyond the Blues: Reflections of African America in the Fine Arts Collection of the Amistad Research Center" (April 10—July 11, 2010).

Ellison, Tony (b. 1957)

Tony Ellison was born December 8, 1957, in Chicago, Illinois. He moved with his family to Tennessee in 1965. During his first eight years of school, he says, "I was doing my art. Some of it was drawing race cars. Then, when I got older, I started doing nude drawings of women." In 1972 he started high school, tried to get into an art class, but it was closed. After one year of high school Ellison went to work with his father, which he continued for four years. He joined the Army National Guard and was gone for a while, returning and again working with his father. In 1980 he was in a car wreck and was hospitalized for a year. When he got out of the hospital, Ellison went to live with his grandmother. He didn't have much to do so he started making his art again. In 1964 he met self-taught artist Jesse Mitchell who inspired him, and he has been drawing ever since. He sculpts with found objects, uses wire and steel wool for hair, and paints. He also does drawings in ink.

Ellsworth, Jack (1899–1974)— "Ellsworth Rock Garden"—Lake Kabetgama, Minnesota

Jack Ellsworth was a contractor from Chicago, Illinois, who built a summer home on a Lake Kabetgama, situated on the border between Canada and Minnesota. It included 62 terraces he built, filled with flowers that could be seen all over the lake, and accented with sculptures he created from existing rocks. There is a detailed description of the site in *In'tuit*, Winter 1996; more information is available at http://www.nps.gov/voya/planyourvisit/ellsworth-showplace.htm, the website maintained by Voyageurs National Park, which took over responsibility for the Rock Garden in 1971. The Rock Garden became part of what is now Voyageur National Park, where visitors may enjoy its many terraces and artworks.

Engelbert, Nick (1881–1962)— "Grandview"—Hollandale, Wisconsin

Engelbert was born in Austria. After a youth filled with travel and adventure as a ship's engineer, a gold prospector, and a farm worker, Nick Engelbert settled

in Hollandale, in southwest Wisconsin, to join his in-laws in the cheese-making business. He was led by his creative spirit to enhance and personalize his world. He constructed a concrete environment peopled with figures from history, myth, and his imagination, which he enhanced with inlaid fragments of stone, glass, beads, china, and seashells. His environment was restored by the Kohler Foundation and has been turned over to the PEC Foundation to maintain and make available to the public. See www.nicksgrandview.com for details, visiting hours, and directions. There is also a YouTube video, supported by the Wisconsin Art Environment Consortium and posted on September 28, 2011, accessible at https://www.youtube.com/watch?v=lG1QiPdrEq0. A related series of paintings, undertaken in later life, recount his rich memories. These paintings were included in an exhibition "Wisconsin Tales" in 1993 at the John Michael Kohler Arts Center in Sheboygan and in "Nick Engelbert and Mary Nohl: Objects and Environments," at the same institution September 20, 1997–January 4, 1998. Paintings and some sculptures, especially those too fragile to remain outdoors, are in the permanent collection at the Center in Sheboygan.

Englin, Metrius (b. 1973)

Metrius brings a strong sure line and color to her artwork. She has been drawing since her childhood, growing up in a series of foster homes. Englin takes images from television, movies, magazines, and books and produces striking paintings. One is a full-face with the lighter side becoming also a face in profile. Another appears to be three heads on the same torso: an angry god, a man, and a jackal. Englin is especially adept at portraits. She has considerable painting skill in depicting light, shadow, and reflections on water. Englin has been at NIAD in Richmond, California since 1995.

Esparza, Paul (b. 1963)

Paul Esparza is from Illinois. He grew up in a large Mexican-American family of eleven children. Developmentally disabled since birth, he is the only member of the family who has any interest in or talent for art. Esparza lives at home with his parents and works at a nearby restaurant as a janitor. He has said that his primary wish is for people to have more fun, now and in the future. Esparza often expresses his interests in futurism, transportation, and popular culture through making what he calls his "expanding paintings": adjacent canvases, which may stretch more than twenty feet when mounted side by side. His own fantastical version of bowling alleys, supermarkets, arcades, and RV parks appear in the paintings. Asked why he puts in some of the images he does, he replies "fun." Esparza also does scenes of Catholic schools and churches and likes to draw penguins. He has done a whole series on penguins at the "Super Mall" in Minneapolis. Sherry Pardee in Iowa City discovered Paul's work.

Estape, Louis (b. 1938)

Louis Estape was born in Honduras and came to the United States when he was eight years old. The artist has worked at the Creative Growth Art Center in Oakland since 1985. He has developed an extensive body of art that reflects his worldview, his community, his Honduran background, and most prominently, his vision of his relationship with God. Much of Louis' work depicts saints, angels, cherubim, and "God himself."

Esteves, Antonio (1910–1983)

Esteves was born in Rio de Janeiro and grew up on the streets of New York, after his mother died following the family's arrival in the United States. He was a building superintendent until he was seriously injured when a boiler blew up. He started to paint while recovering from the accident. He painted both religious and secular subjects, on cast-off furniture and boards. His work is in the permanent collections of the New Orleans Museum of Art and the American Folk Art Museum in New York.

Evans, Deborah *see* Perry, Deborah Evans

Evans, Minnie (1892–1987)

Minnie Evans was born in Long Creek, North Carolina, to a family with its roots in Trinidad. She was raised by her grandmother in Wilmington, North Carolina. After completing the fifth grade, she worked selling seafood on the street and later became a domestic worker. She married in 1908 and had three sons. In 1948, when she became the gatekeeper at Arlie Gardens, she started spending more time drawing. Most of the images in her art came from her dreams, and have been described as "primarily symmetrically patterned and vividly illustrated." There is a Light Saraf film, "The Angel That Stands by Me," about her life, her work, and her family. During her lifetime Evans' work enjoyed many solo shows and exhibitions — a pattern that has continued since she died. "Minnie Evans: Dreams in Color" appeared at the Green Hill Center for North Carolina Art in Greensboro in 2001 and then at the University of Missouri St. Louis in 2003. Luise Ross Gallery, which had held numerous shows for Evans before she died, has done two shows since, in 1998 and, most recently, in 2011. Also in 2003, the North Carolina Central University Art Gallery mounted "The Dream World of Minnie Evans." Numerous galleries carry her art, including Luise Ross Gallery, Marcia Weber/Art Objects, and Anton Haardt

Gallery. Her work is in the permanent collections of the Smithsonian American Art Museum, the High and Milwaukee Museums of Art, the American Folk Art Museum, and several smaller museums throughout North Carolina.

Every, Tom (b. 1938)—"Dr. Evermor and Foreverton"—Baraboo, Wisconsin

Tom Every was a businessman who had a large-scale wrecking and salvage business. He retired in 1983 and, being depressed at the time, decided he wanted to do something new and constructive, so he started creating his environment. He placed his constructions on a large park-like piece of property and numerous satellites between Baraboo and Madison (which unfortunately he did not own). The centerpiece is the "Foreverton," described by Jeffrey Hayes as the "world's largest sculpture made of scrap metal." The Foreverton is an experimental flight machine made by Every to "perpetuate oneself back into the heavens," which he made in response to being upset with the human race. Many additional sculptures adorn the property. As of 2015, Every had suffered several strokes; he does not weld any more himself, but directs numerous helpers to weld for him. His ex-wife and daughter maintain a website, www.worldofdrevermor.com, and open the sculpture park to visitors in the summer. The family has been trying for years to find a permanent home for the park, as its future is uncertain without a permanent location. Foreverton has been the subject of an "American Pickers" episode (2012, on the History Channel) and numerous newspaper articles, and maintains a Facebook page (WorldofDrEvermor).

Fama, Rocco (1926–1999)

Rocco Fama was born in Italy and was brought to the United States when he was eleven months old. He grew up in New York's "Little Italy." He later lived in SROs (single room occupancy buildings) and now lives in a nursing home. He draws extremely detailed renderings of brick buildings and urban landscapes, usually in colored pencil or oils. He says his drawings reflect visits to New York City construction sites where his father worked. He was part of the HAI program, which still offers his work for sale. In 2013, White Columns mounted a solo exhibition of Fama's art. (White Columns, originally in SOHO and now on Christopher Street, is an alternative art space offering an experimental platform for artists to exhibit their work.)

Farmer, Josephus (1894–1989)

The Rev. Josephus Farmer was born August 1, 1894, in rural Gibson Courts, Tennessee, the third of eleven children, all of whom preceded him in death. Around 1900 the family moved to Humboldt, Tennessee, where Farmer spent most of his youth. Close to the end of World War I he moved to East St. Louis, Illinois, and then across the river to St. Louis, Missouri. Farmer's first attempts at carving involved making his own toys. He became a minister in 1922 and in 1931 founded El Bethel Apostolic Church in South Kinlock, Missouri. He also maintained a secular job until his retirement in 1960. After his retirement, he once again pursued his interest in woodcarving and became well-known as a folk artist. The Reverend Farmer depicted scenes from American folklore and history, as well as from the Bible. An exhibition catalog, *The Gift of Josephus Farmer*, with an essay providing information on the life and work of the artist by Joanne Cubbs, was published in 1982.

Farmer, Michael (b. 1952)

Michael Farmer lives in Louisville, Kentucky. For years Michael suffered bouts of major depression and was in and out of Louisville's Veterans Administration Hospital for treatment. He was encouraged to paint by his friend William Miller, the cane carver. Farmer began to paint about 1990 as a way to relieve his depression and consequent headaches, and it worked. He "needed a way to communicate ideas he believed no one would hear." Farmer paints in acrylics on watercolor paper. In late 1993 he began to create sculptures from industrial "sandstone." He also carves elaborate wooden walking sticks. His work is in the Owensboro Museum of Fine Art and at the Kentucky Folk Art Center in Morehead.

Fasanella, Ralph (1914–1997)

Ralph Fasanella was born in New York City and lived in Ardsley, New York, during the later years of his life. He was a well-known contemporary folk artist who told stories in his paintings, especially about immigrant families and working-class people. He painted with oil on canvas. His work may be seen in photographs and in publications. There is one painting in the Ellis Island Immigration Museum in New York. In 1992 the (then) Museum of American Folk Art started a fund-raising effort to acquire the painting "Subway Riders," which is now installed at the subway station at Fifth Avenue and 53rd Street in Manhattan. On September 2, 2014, the American Folk Art Museum opened an exhibition, "Ralph Fasanella, Lest We Forget" to celebrate the one hundredth anniversary of the artist's birth.

Ferdinand, Roy, Jr. (1959–2004)

A native of New Orleans, Roy Ferdinand drew the people who live with poverty and violence. He said that most of his subjects were the street people he saw

every day. His drawings capture their anger, sadness, and despair. "I see people," Ferdinand said, "with faces that say they haven't got out of life what they expected." Roy Ferdinand's drawings, on poster board using ink and tempera, are not "pretty," but they are powerful and important. Not all of Ferdinand's work is about violence. He also drew a series of portraits of other self-taught artists and French Quarter "characters." Toward the end of his life he began to produce sculptured pieces made with papier-mâché. It took him a long time to make these forms because the New Orleans humidity slowed the drying process. His work is in the permanent collections of numerous museums, including the New Orleans Museum of Art, the Ogden Museum of Southern Art, the Birmingham and Mississippi Art Museums, and the Art Museum of Southeast Texas. Galleries with Ferdinand's art for sale include Barristers Gallery in New Orleans, Anton Haardt in New Orleans and Montgomery, Just Folk in Summerland, California, and George Jacobs, private dealer.

Ferreira, George (b. 1946)

Ferreira was born in Los Angeles and traveled frequently because his father was in the navy. He entered the army and did intelligence work in Vietnam and Turkey. After he was discharged he settled in Gainesville, Florida, and is a full-time artist. Ferreira's sculptures are made of found objects and wood. They are fabricated with hand tools and "exhibit a wry sense of humor." He often used epoxy on his wood pieces, and he uses leftover epoxy to paint pictures of the Florida landscape. His sculptures were included in "The Passionate Eye: Florida Self-Taught Art," in 1994. In 2002 his work was part of in a group show with a theme of works inspired by nature at the Kanapaha Botanical Gardens' Summer House Gallery in Gainesville.

Fields, "Cedar Creek Charlie" (1883–1966)

He began building projects and decorating his environment when his mother died in the 1930s. He repainted his house several times in various patterns. His favorite pattern was polka dots, especially red, white, and blue ones. He painted stoves, beds, walls, floors, and most other things. Outside, he made whirligigs, model planes with doll passengers, a suspension bridge over a creek, a Ferris wheel, and other structures; all were decorated. Fields welcomed visitors, especially on Sunday afternoons, when he dressed in a polka dot suit, shoes, and hat. The "environment" is gone. One can see his work in publications and museums, most particularly the Museum of Appalachia in Norris, Tennessee.

Filling, Dennis W. (b. 1949)

Filling was born in New Castle, Pennsylvania, and

moved with his family to Washington, D.C., before he finished high school. He was making detailed pen and ink drawings from an early age, so he enrolled in an art institute after finishing high school, but it did not suit him. He left and continued drawing in what was becoming his own distinctive style. He spent increasing amounts of time alone, wandering and hiking along the east coast and also in Washington state, always accompanied by his sketch pad and pen. His abstract drawings show organic forms, distinguished by many thousands of tiny dots, thin lines swirling across the paper—his designs fill every available space. His larger works have bright colors filling minuscule shapes or broad paths with vibrant splashes of paint. He annotates many of his pieces with detailed notes on the back side, describing steps in the development of the piece and his thinking as he made it. The Ames Gallery in Berkeley represents this artist.

Finch, Loren—"Zip Zag Zoo/ El Rancho Fincho"—Agate Beach, Oregon

Loren and Helen Finch moved to property they owned on the Oregon coast in 1968. Because Helen was quite ill and needed attention, Loren Finch stayed close to home and started decorating his home site. The result is a cheerful environment of driftwood and found object creatures. The site does not exist any more, but documentation can be found on the SPACES website, http://www.spacesarchives.org/explore/collection/environment/el-fincho-rancho-zip-zag-zoo.

Finn, Marvin (1917–2007)

Marvin Finn was born in Clio, Alabama, moved to Kentucky in 1944, and to Louisville in the early 1950s. Mr. Finn came from a family of twelve children and had five of his own. He became a widower in 1966 and had to raise his five children as a single parent. He always liked making things for himself. His sharecropper father used to whittle, and Finn watched him and "got interested that way." When he had children he made toys for them. He used scrap wood and said "I don't like to throw even a match stick away." Asked how he got started selling his work, Finn said "Man came along one day and asked, I started ... daggone chickens." His favorite thing to make was machines—but people just wanted him to "make roosters." His art was included in the exhibition "African American Folk Art in Kentucky." At the Kentucky Art and Craft Gallery in Louisville in 1999, and in "Marvin Finn: A Retrospective Exhibition" at the Kentucky Museum of Art and Craft from October 25, 2008, through January 31, 2009. More information is available at www.Marvinfinn.weebly.com. Finn's work is in the permanent collections of the Kentucky Folk Art Center, the Kentucky

Museum of Art and Craft, and the Museum of International Folk Art. Craft Gallery in Louisville carries his work.

Finster, Howard (1916–2001)

Howard Finster was born on a farm in Alabama and later lived in Summerville, Georgia. He had his first vision at age three and became a preacher at sixteen. He started making art and building Paradise Garden in 1976 in response to God's demand that he make sacred art. He believes his is the "last red light" of warning before the apocalypse. Finster is written about, exhibited, visited, and discussed more than any other contemporary American folk artist. Many complain about the quantity of his production and his use of assistants. But those are the complaints of the "art world" and were irrelevant to Finster, who saw his works as sermons that spread his message, which was his purpose in making art. Two full-length illustrated books about him are: *Howard Finster, Man of Visions* by J.F. Turner, and *Howard Finster: Stranger from Another World* by Tom Patterson. Finster's work is in many museums, and many galleries have his work for sale. A recent exhibition, with accompanying catalog (see Selected Books), "Revealing the Masterworks: The Finster Cosmology" was held at Lehigh University in 2004. Between being on the cover of *Time Magazine* and numerous television appearances, videos, and interviews, Finster has often been considered "the best known artist in America," of any variety self-taught or mainstream.

Finster, Howard—"Paradise Garden" and "Howard Finster Vision House Museum"—Summerville, Georgia

Howard Finster, the most exhibited folk artist in America, merits a second entry here for his environment. In addition to individual pieces of "sacred art," Finster created Paradise Garden, a place that is decorated by his art, shrines to his beliefs, and a "folk art church." There are sculptures around the garden, paintings on the walls of buildings, and on the Cadillac parked under a leaning shed. The sidewalks are cement embellished with found objects and mementos. Occasional chickens wander about. Finster used to greet people there every day, until he died. Summerville is in northwest Georgia, and once there, lots of people will be able to point the way to Paradise Garden. A portion of this environment has been sold to collectors and to the High Museum. There was an exhibition of pieces from the environment at the High Museum, "Howard Finster: Visions from Paradise Garden," in early 1996. It included paintings, sculpture and found object assemblages produced by Finster over the last twenty years. Maintenance and restoration of Paradise Garden is now in the hands of the Paradise Garden

Foundation (see Organizations) (www.paradisegardenfoundation.org); it may still be visited—check website for hours and directions. Alongside Paradise Garden is the Howard Finster Vision House Museum, which occupies the house where Finster lived and where he had is vision from God that inspired all of his artistic endeavors. In 2005 David Leonardis, a Chicago gallery owner, bought the house, which was severely run down, and converted it into the museum, which opened in 2007. Information is available at www.howardfinstervisionhouse.com and on the museum's Facebook page. Visits need to be arranged in advance by calling 312-863-9045.

Finster, Michael (b. 1969)

Michael Finster says he started drawing when he was five and painting by the time he was twelve. Taking the advice of grandfather Howard, he started numbering his paintings and has done more than 4,000 pieces. He supports himself full-time with his art. He paints from his imagination and from inspiration from the Bible. The designs on his own "cutouts" are done freehand with colors and patterns different on each one; he may repeat a cutout design, but not the colors or patterns. He makes a lot of monsters, birds, snakes, and other crawling things. His paintings, on the other hand, usually contain religious themes and come from dreams and visions.

Fitch, John "Jack" (1899–1994)

Jack Fitch was born on a Minnesota farm. His mother died when he was in his teens, and subsequently his stepmother put him out of the house. He harvested wheat in North Dakota, was a logger in the Pacific Northwest, worked on dam building projects, and joined the Industrial Workers of the World (IWW). He worked on the O'Shaughnessy and Hoover Dams, then 1928 he became a pile driver, joined a craft union, and moved to San Francisco to work on the Golden Gate Bridge. Fitch lost touch with his family and never married. He had no additional education after leaving Minnesota. He lived quietly on Minna Street, in a San Francisco apartment filled with his canvases, often painted on both sides, which he would not sell or give away. He painted memories, families, mothers and children, gardens, mountain meadows, and forest landscapes—things he considered "pleasant matters." He died February 27, 1994, leaving no will. His paintings were auctioned by the state. His art is now available at The Ames Gallery in Berkeley.

Fitts, Kerry

Fitts lives in New Orleans now but is originally from Mississippi. She is a college professor with many talents. She is a clothing designer and a lover of art, according to the owner of the gallery Coq Rouge, Patricia Low,

who says "Her work leans to the folk/primitive genre. Anything can be a canvas." Coq Rouge sells her work.

Flanagan, Thomas Jefferson (1896–1983)

The Rev. Thomas Jefferson Flanagan was born in Columbus, Georgia, and always lived in that area. He taught for nine years in a public school and then became a Methodist minister. "His most prolific period as a painter in oils was during the 1950s and 1960s." His work is included in *Folk Painters of America* by Robert Bishop and is in the permanent collection of the Columbus Museum in Georgia.

Fleming, Walter

Fleming is a Presbyterian minister who learned to make pottery from Burlon Craig in 1988. He makes face and snake jugs, left-handed swirl, and vessels with applied grapes. Fleming lives at 1158 Scotts Creek Road in Statesville, North Carolina. Telephone 704-872-7568.

Fletcher, Milton (1906–1992)

Milton Fletcher was born in Yazoo City, Mississippi. He spent many of his adult years working for the YMCA in St. Joseph, Missouri; in Winston-Salem, North Carolina; and finally in Shreveport, Louisiana, where he established the Carver branch of the YMCA and organized a very successful credit union. His narrative paintings portrayed scenes from life on a farm to the creation of jazz, hard times on a chain gang, boats on the Mississippi River, and experiences on the railroad (he worked summers as a Pullman porter to put himself through college). Fletcher spent his last years in a nursing home in St. Louis, wheelchair bound. A New Orleans collector of his work (Fletcher used to sell his paintings at the annual Jazz and Heritage Festival) said that Fletcher did not trust galleries—"he got the price he set on his paintings, but little recognition." His work has turned up recently in auction catalogs. The Meadows Museum of Art in Shreveport and the University Art Museum/University of Southwest Louisiana, in Lafayette, have his work in their permanent collections.

Floyd, George

During February and March of 1998, the Kentucky Folk Art Center in Morehead presented an exhibit of "The Trail of Tears," a massive sculpture by this Kentucky artist depicting the removal of the Cherokees from North Carolina and Georgia. His work remains in the Center's permanent collection.

Folse, France Marie (1906–1985)

France Folse was a painter who recorded a specific culture in the middle of the twentieth century, that of the Bayou Lafourche area of Louisiana. Folse was born in Raceland, Louisiana, and died in Houma. She painted the daily life of the people along the length of the bayou, their special events, and the commerce and industry of the region. She had an eye for detail, an aptitude for composition and use of color, and an unusual ability for painting machinery and industrial scenes with as much flair as her plantation houses. She painted sugar mills, fishing fleets, oil derricks, workers in the fields, steamboats on the river, the blessing of the shrimp boats, wedding scenes, and washing day. In early 1997 the Louisiana State University Museum of Art held an exhibition of her work, which then traveled to the Southdown Museum in Houma. The exhibition included an illustrated catalog, *France M. Folse: Bayou Lafourche Folk Painter Rediscovered*.

Ford, Clinton (1923–2006)

Clinton Ford was born in Richmond, VA, and lived there until his death. He served in World War II, parachuted behind enemy lines the day before D–Day, fought at the Battle of the Bulge, and spent time in a Prisoner of War camp. Although he won several military awards for his experiences, they caused him great emotional suffering during the rest of his life. He started painting late in life, after retiring from work as a carpenter and baker, and used his art to work through his memories. His paintings were often collages that included toy soldiers and vehicles as well as natural material such as hay, rocks, and tree branches. The Meadow Farm Museum in Henrico County, Virginia; the Miles B. Carpenter Museum in Waverly, Virginia; the Virginia State Capitol, and the National D–Day Memorial in Bedford, Virginia held one-man exhibitions of his work.

Forestiere, Baldasare (1879–1946)— "Underground Gardens"—Fresno, California

A vast underground environment started when Forestiere wanted to reach the rich soil beneath his seventy acres of land so he could realize his dream of growing citrus fruit. The trees, with large skylights overhead, thrived, and so did the environment as Forestiere spent forty years creating rooms, gardens, walkways, archways, and much, much more. After Baldasare Forestiere died, the site was opened to visitors until the early 1980s, and the Underground Gardens Conservancy was formed. The Gardens are now open on weekends with reservations; check websites for days and times. The Gardens are located just east of the intersection of Shaw Avenue and Highway 99, at 5021 West Shaw Avenue. Write to Underground Gardens Conservancy, Box 5942, Fresno, California 93755. Visit the website, www.undergroundgardens.

com and www.forestiere-historicalcenter.com, or telephone: 559-271-0734.

Fragoso, Sylvia (b. c. 1962)

Sylvia Fragoso, an artist at the NIAD Art Center since 1984, is very proud of being an artist. She paints what she sees in nature "transformed into a magic synthesis of color and design." Her art celebrates life in a joyful, playful way. She uses colored pencils, felt pens and paint; "love of color is evident in her paintings and realism has no place in her art." The National Institute of Art and Disabilities in Richmond, California, shows her work. Her art was included in the exhibition "Wind in My Hair" at the American Visionary Art Museum in Baltimore in 1996.

Franklin, Francisco "Frank" (b. 1947)

Franklin was born in Arizona but spent most of his childhood in a remote part of Mexico. He was home schooled and learned mostly from books. He liked books about artists because he could see that they had a lot of freedom—they drank, chased women, and pretty much did what they wanted. He wanted that type of unencumbered life, and has pretty much led it. He began painting when he was 15. He spent a lot of time in Europe (Stockholm, south of France, Germany, and other countries), hanging out with artists and feeling part of an art family, but eventually realized that he didn't have the training to do what they did. He says he tries to make up with feeling and color in his paintings for his lack of technique. He paints southwest landscapes and people, with a heavy concentration on women, which he says "are the best thing God made." He says that art "is the only addiction that I've had that won't kill me." He says he creates his art "to make something beautiful and trade it for money." There is an interesting YouTube video of Franklin explaining his life and approach to making art (www.youtube.com/watch?v=qJNPLyvkwGY). The Trilla Collection (www.trillacollection.com) carries his work, which is also available at Petroglyphs, a gallery in Tucson, Arizona. Franklin welcomes visitors, but call first (505–275-9987).

Franklin, Mary Mac (1908–1999)

Franklin was born in Knoxville, Tennessee, and lived the last 28 years of her life in Charlottesville, Virginia. She was a librarian and was married to a librarian. In 1974 she spent eleven months hooking a rug from home-dyed wool. The rug includes biographical references as well as symbols of meaningful moments in her life. Franklin had hooked over fifty large rugs, of which the one described was the forty-fifth. It was included in the 1997 exhibition, "The End Is Near," at the American Visionary Art Museum.

Frolich, Andrew Michael "Mike" (1922–1997)

Mike Frolich grew up in the Ninth Ward of New Orleans. According to his stories, his travels started when he hopped a steamship bound for Nicaragua at the age of twelve. His paintings often portray romantic and strange seascapes and landscapes, with an exotic cast to content and color. At another time of his life he was part of the family-owned Frolich Brothers Marine Diving business and traveled the world from corner to corner. All along the way he painted, and for years was "artist-in-residence" at the Saturn Bar just east of the French Quarter, where he painted a huge mural of "the history of the world." He had a family that fell apart because of his drinking. His son was killed at the age of seventeen in an auto accident. He met Ann and Marie Cusimano, who needed a manager for their Burgundy Street "Washateria," a coin-operated laundry. Frolich took the job and moved into a small room in the back and set up his home and "studio." Frolich soon had the walls of the Washateria hung with his colorful art. Area residents came to treat the place as an art gallery, and it was listed in a French guidebook as a "place to see" in New Orleans. Ann Cusimano said Frolich "painted like crazy, almost frantic in his application of paint, frantic to finish the work." In 1989 there was the first exhibition of his works, at the Contemporary Arts Center in New Orleans, in an exhibition called "Outta Site: Beyond Emerging." During the last twelve years when he was working at the Washateria he did not drink, but previous habits took their toll. Frolich had a stroke in 1991 and went to a nursing home in Violet, Louisiana. The Cusimanos sold the laundry business in 1992 to a man who did not like the art and was going to throw it out. The art was rescued by Richard Gasperi and sold at his now-closed New Orleans gallery. It may also be seen on the walls of the Saturn Bar (St. Claude and Clouet Streets) in the Bywater neighborhood of New Orleans.

Fryar, Pearl (b. 1940)—Topiary Garden—Bishopville, South Carolina

Pearl Fryar was born in North Carolina and moved to Bishopville around 1980 where he works for a can company. Fryar lives by the motto "one must do more than the average to rise above the average." Fryar set out to create a garden that would win a local award. With no previous knowledge of the form, he set out to create a topiary garden. The art of sculpting with live plants presented a creative outlet for Fryar's vision and imagination which has resulted in a three-acre sculpture garden surrounding his home, filled with shrubs and trees pruned into fantastic shapes; designs both abstract and figurative. Fryar's work—a living 20-foot by 18-foot Hollywood twist juniper topiary, a gift

to the museum—is now part of the sculpture garden at the State Museum in Columbia, South Carolina. Fryar's Topiary Garden is open to the public, for a small donation to help with the upkeep. It is located just off U.S. Highway 15, between I-20 and Bishopville, South Carolina. The address is 165 Broad Acres Road, Bishopville, South Carolina 29010. Telephone: 803-484-5581.

Fuller, Leon (b. 1969)

Fuller was born in Southern California. His grandfather, a graphic artist, encouraged him and provided him with art supplies. He draws heavily from the sensational in media, such as is found in supermarket tabloids. By utilizing hook lines, titillating quotations, graphic symbols, and original typography, he constructs rich dramatic compositions. He uses pencils, markers, and prismacolor in combination with his computer-generated texts. "His work can be simultaneously humorous, topical, and enigmatic." He works at the First Street Gallery Art Center in Claremont.

Gabriel, Romano (1897–1977)— "Wooden Sculpture Garden"— Eureka, California

Romano Gabriel, a skilled carpenter from Italy who moved to Eureka, California, after World War I, found the local climate inadequate to his needs so he built a garden "planted" with carved and brightly painted figures cut from fruit boxes. The garden grew to the point where his house was hidden; it contained political and religious figures, scenes from Italy, and figures from his imagination. A few of the pieces were animated. After Gabriel's death in 1977, a huge community effort spearheaded by Dolores and Ray Vellutini resulted in the installation of the wooden garden into a protected space at 305 Second Street in Eureka. Gabriel's Garden was preserved and maintained by the Eureka Heritage Society from the early 1980s through 2012, when it was presented to the Humboldt Arts Council, which now operates the site. Check out websites www.eurekaheritage.org/romano and www.humboldtarts.org/romano.

Galloway, Ed (1880–1963)—"Totem Pole Park"—Foyil, Oklahoma

Galloway built a brightly painted conical sixty foot tall totem pole as a monument to American Indians. He also built numerous smaller pieces and a museum to house his collection of fiddles. All the structures were embellished with designs and painted. The site restoration for this park was started by the Kansas Grassroots Art Association in the 1980s. Today the park is part of the National Park Service, and is open to visitors. Totem Pole Park may be viewed on Highway 28A east of Foyil, Oklahoma. Information is available at www.google.com/#q=totem+pole+park+oklahoma and by telephone (918-283-8035).

Gant, Samuel (1954–2000)

Samuel Gant, born deaf, was a gifted artist participating in the NIAD program in Richmond, California, who conveyed through his art what he could not say in words. As a child Gant enjoyed assembling model airplanes and cars. Becoming increasingly angry at not being able to communicate with the hearing world, he was kicked out of a number of special schools because of his behavior. In 1986 he found a haven at NIAD where he began to paint, spilling out "a lifetime of feeling, intelligence, emotion and expression." His paintings are abstract, with rich and dark colors and repetition of shapes and symbols that had deep meaning for him. It is said that "his painting and sculpture evoke a sense of isolation and loneliness."

Garcia, Lorrie

Garcia has lived her whole life in an area of northern New Mexico well-known for its painters, carvers, and other artists. She lives in Peñasco, New Mexico, where she shares a studio and gallery with her husband Andrew. Both Garcias worked for the local school district for many years, she as a teacher and he as a principal, taking up art only after they retired. Lorrie makes *retablos* and *bultos*, two- and three-dimensional carvings of saints and other religious figures and scenes. Andrew, who long used his carpentering skills to build their house and studio/gallery, now makes very beautiful furniture in the old Spanish colonial style. They sell their work from their home studio and as part of the annual High Road to Taos Tour every fall, during which artists in the area open their galleries and studios to visitors. The Garcias' work can be seen at the tour's website (www.highroadnewmexico.com) and at their gallery, by appointment; the Garcias can be reached by email (lorriegarcia85@hotmail.com) or phone (575-587-2968).

Garcia, José Marco (1902–1998)

Garcia was born in Cuesta de David, near the small New Mexico towns of Roy and Solano, and grew up, as one of 13 children, in La Cañada de la Pompa near Solano. He was a wood carver who created hundreds of sculptural carvings, often from one piece of wood. His works are humorous and spiritual, with subject matter including politics, pop culture heroes, historical figures, death, the devil, and religious icons. In 1923 he left the Roy area and went to work in Dawson as a mining supervisor. In the 1940s he designed airplane propellers. He left Dawson and moved to Albuquerque when the mines closed in 1950. During the 1970s and 1980s, Garcia maintained a booth at the Albuquerque

Flea Market and also sold his work at several other venues that focused on Hispanic artists. He had many enthusiastic followers, who were always interested in seeing what he had come up with recently. A show including more than 100 pieces of the artist's work opened at the National Hispanic Cultural Center in Albuquerque on February 20, 2015, and ran through August 30, 2015.

Garrett, Carlton (1900–1992)

Garrett spent most of his adult life in Flowery Branch, Georgia. His wood sculpture recreates scenes from the past and often depicts rural Georgia and folk heroes. He drew on his knowledge of mechanics to animate his work. Garrett died after a long illness on October 21, 1992. His work is in the High Museum of Art in Atlanta.

Garrison, Harold (b. 1923)

Garrison lives in Weatherville, North Carolina. He carves political and social commentaries in wood in a gun-like format with figures that move when the rubber band-operated trigger is pressed. He is famous for his images called "water-gate guns," which have been illustrated in publications. Garrison calls himself "one hundred percent American" and speaks out strongly against waste and corruption in the federal government and the people's poor representation by politicians who often provide nothing more than "bunk." Ironically, the term bunkum, today bunk, comes from the name of Garrison's home county, Buncombe County. In the early nineteenth century, when criticized for an irrelevant speech, one of the county's congressmen replied that he was "speaking to Buncombe." Pieces of his work is in the Smithsonian American Art Museum, including some complex government machines—two with a Watergate theme and one concerning the Democratic Party at its 1972 Chicago convention. Most of Garrison's wood carvings, however, are traditional Appalachian split bark work or whittled forms of animals and flowers shaved from sticks.

Gatto, Victor Joseph (1893–1965)

Victor Joseph "Joe" Gatto was born in Greenwich Village. When his mother died in 1897, his father put Joe and his four brothers into a Catholic orphanage. Gatto had a brief career as a boxer, was dishonorably discharged from the navy for desertion, and spent most of the 1920s in prison. For more information, read "The Art of Becoming Gatto," by Gene Epstein in *Raw Vision* v.4. His work is in the permanent collections of several museums, including the Smithsonian American Art Museum, the American Folk Art Museum, the Milwaukee Art Museum, the New Orleans Museum of Art, and the Noyes Museum of Art of Stockton College.

Gee, Reginald K. (b. 1964)

Reginald Gee lives in Milwaukee, Wisconsin, where he was born. Gee began drawing at the age of four, and during his school years he entertained his friends with his drawings. He has said that the thrust to do art comes from every direction, "be it curiosity, pleasure-seeking, boredom, anger, desperation—all these emotions are put to use." "My being here, blessed with the ability to make someone think, giggle, or at least smile, is genuine reward … or priceless fuel." In 1986 he got a chance to show a few of his pieces at an outdoor arts festival, and attention from galleries followed. He has been in numerous exhibitions including "Visions of Our Own," at the University of Wisconsin–Milwaukee, "Contemporary American Folk Art: The John and Diane Balsley Collection" at the Haggerty Museum in 1992, and "Wind in My Hair" at the American Visionary Art Museum in 1996. His work is in the permanent collection of the New Orleans Museum of Art.

Gehrke, Emil (1884–1979) and Veva Gehrke (1902–1980)—"Windmills"—Grand Coulee (now Electric City), Washington

Emil Gehrke made 600 windmills from material salvaged from the junkyards in about 25 nearby towns. His wife Veva painted them all. Although people from all over the world came to see them and many bought windmills to take home, there would still be more than 300 in the yard at any one time. Since her death, their work has been preserved. Some of it is in a fenced enclosure on the Grand Coulee Highway, and a few pieces are in Seattle at an electric substation at Fremont Avenue North and North 105th Street. The book *Strange Sites* by Jim Christy has color photographs of the Windmill Garden. The Windmill Garden, in its permanent home in a lakeside park in Electric City, Washington, was featured on Roadside America in 2015 and several videos showing the park are available on YouTube.

Gendron, Lorraine (b. 1938)

Lorraine Gendron was born in California and moved with her family to Louisiana when she was eleven. When her mother began suffering from arthritis, Gendron left school to take care of the younger children. Eventually she married and moved to Hahnville, where she still lives. "I married a Cajun at seventeen," she says, "and thought I'd moved to Disneyland! I love the bayous and the people. I lived someplace else long enough to know it's different here, and this is home." This love for Louisiana culture and bayou

country is reflected in her work. She has created small sculptured figures from Mississippi mud, and sculptured scenes from cutout wood—her husband Louis cuts the wood for her—but now she concentrates mostly on paintings. Her subjects include regional culture, New Orleans musicians and other local celebraties, the Mardi Gras Indians, "Second Liners," and religious scenes. Her art captures the special feeling of the very unique place that is south Louisiana. Her two-dimensional paintings and inlay painting on Masonite and poster board combine obsessive detail with overall flatness. She sells her art every month at the Arts Market of New Orleans in Palmer Park and in other venues. The Birmingham Museum of Art has her work in its permanent collection; Jeanine Taylor Folk Art in Miami carries her work. In recent years Gendron made a series of large paintings and some figures commemorating the slave revolt that took place in 1811. These are installed at the Slave Revolt Museum and Historical Research and Education Center at Destrahan Plantation in Destrahan, Louisiana, which was the site of the trial that followed the revolt. Gendron has written a book about her work, *Louisiana Folk Artists* (Lafayette, LA: University of Louisiana at Lafayette Press, 2009). She sells through her website, www.lorrainepgendron.com or you can call her at 985-783-2173.

Gentle, Ken "Blacktop" (b. c1970)

Gentle is a memory painter from Georgia, who paints people and places he remembers from growing up in Alabama—baptisms, churches, cotton fields, wildlife, the Civil Rights Movement, and other scenes of southern rural life. He says "My paintings are a process of storytelling—invoking the past." Jeanine Taylor Folk Art in Miami, which represents the artist, mounted an exhibition of his work, "Recollections of My Youth" from April 6 to 18, 2013. In addition to Jeanine Taylor, Dos Folkies Gallery in Washington and Roots Up Gallery in Savannah also handle Gentle's work. Gentle maintains his own Facebook page, and there are several videos on YouTube that feature him discussing his technique, background, and inspirations.

Gerdes, John D. (1913–2001)

Gerdes was born in Germany and was brought to the United States when he was ten months old. He had his own electronics company in Cleveland, Ohio, and moved to Maitland, Florida when he retired in 1971. His paintings are a trompe l'oeil display of countless varieties of faux wood. He made two dimensional paintings, inlay painting on Masonite and on poster board, combining obsessive detail with overall flatness. His "electronic sculptures" that move, make sounds, and light up attracted collectors. His work is in the permanent collections of the Smithsonian American Art Museum and the Mennello Museum of American Folk

Art, and was included in the exhibition "Unsigned, Unsung…Whereabouts Unknown," at the Florida State University Gallery and Museum in 1993.

Gibson, Emma (b. c1924)

Emma Gibson was born in Ohio, moved to San Francisco, then Stockton, and now resides in Lodi, California. She has been part of the program at the Alan Short Center for people with mental disabilities. She had been painting all of her life but stopped in 1984. She is now painting again. Gibson uses prisma-color pencils on paper. She paints her dreams, often of a family she never had. The Pardee Collection carries her work.

Gibson, Sybil (1908–1995)

Sybil Gibson was born February 18, 1908, in Dora, Alabama. Gibson, whose father was a prosperous coal mine operator, lived most of her adult life in poverty. Gibson was college educated, an elementary school-teacher, mother of one daughter, interested in real estate and the financial market. She began painting in November 1963 at 55 years old when she became enchanted with a piece of gift wrapping paper in a downtown Miami, Florida, store. When she picked up a brush to create her own wrapping paper with materials at hand—tempera and brown paper bags—she was seized with a compulsion to paint that lasted three decades. Her difficult years, in which she was beset by health and financial problems, pushed her to the breaking point and in 1971, just after her work had attracted the attention of the Miami Art Museum, she "disappeared" and returned to Alabama. In Birmingham she lived in a seedy hotel, continued to paint, received high praise from critics, but sold few paintings. In 1981 she moved to a home for the elderly in Jasper, Alabama. Finally she moved to a facility in Florida where she was closer to her daughter. An operation restored most of her sight, and she was able to keep working on her art. Her pictures, most often depicting people, animals, and sometimes flowers, are painted with tempera and house paint on paper bags. The subtlety of color and impressionistic quality comes from her practice of wetting the bag and painting the image before it could dry. A description in a catalog for the 1995 exhibition "Drawing Outside the Lines: Works on Paper by Outsider Artists" at the Noyes Museum in Oceanville, New Jersey, says of her art: "Although her delicate pastel colored figures have a superficial sweetness, the faces are expressionless and appear to be trying to hide from the world's cruelties." Sybil died in a nursing home January 2, 1995, in Dunedin, Florida. Her work is in many museum collections including the Birmingham Museum of Art, the Fayette Art Museum, the Montgomery Museum of Fine Art, the New Orleans Museum of Art, and the American Folk Art Museum in New York.

Gilbert, Robert E. (c. 1920–1993)

REG, as he signed himself, was a prolific contributor, from the 1950s through the 1970s, of art to science fiction fan magazines. The magazine art was done in pen and ink to show up with the inexpensive reproduction techniques, but he also did a large number of paintings in oil, pastels, and watercolors. In addition, from the 1940s through the 1980s he experimented with traditional and non-traditional styles that have nothing to do with science fiction. Artisans gallery in Mentone, Alabama, has acquired the remaining body of work from his estate. There are over 400 pieces, of which about 150 have outer space, science fiction, and future technology themes.

Gilkerson, Robert (b. 1922)

Gilkerson is from Oakland, California. He worked for many years as a mechanic, machinist, and miner in northern California's logging and mining regions. Gilkerson makes humorous assemblages and constructions from natural and manufactured cast-offs. The forms may be of people, animals, or monsters, painted in bright colors. Gilkerson says that each one has its story. His work is in the collection of the Oakland Museum of California and the Smithsonian Institution Archives of American Art, and is carried by The Ames Gallery in Berkeley.

Gillam, Charles

Charles Gillam was born in central Louisiana and moved with his family to New Orleans when he was five years old. Gillam comes from a large family of five boys and three girls. Although the family was poor, his father managed to keep them together and in school. When Gillam was ten, he discovered the artists in Jackson Square and watched them every chance he got. He finally got up the courage to approach them and ask for their old brushes and paints and would then rush home and paint until he was exhausted. Gillam left home at seventeen because he needed to support himself. He remembers seeing artist Willie White and his work and wondering at the colors. He now paints, with acrylics, peaceful, colorful country scenes that are most often of scenes on the banks of the Mississippi River, and he does woodcarving and sculpture, particularly of musicians. He has carved and painted more than one hundred heads in the last ten years including Aaron Neville, Louis Armstrong, and various blues singers. He has also been working with the Rev. Charles Smith to create a second African American Heritage Museum and Black Veterans Archive in New Orleans. His work is in the collection of the House of Blues, and is available at Kako Gallery in the French Quarter, at the New Orleans Jazz and Heritage Festival, at the annual show he puts on himself in the Algiers neighborhood of New Orleans, and at several galleries outside of Louisiana (e.g., Just Folk in Summerland, California and Jeanine Taylor Folk Art in Florida). He also sells from his home and yard environment, which he calls the Algiers Folk Art Zone. He accepts calls at 504-234-1703 to arrange a visit.

Gillespie, Russell (b. 1922)

Gillespie was born in a log cabin in North Carolina, the state where he still lives. He has been an ordained Baptist minister since 1950 and is married and has reared three children. He farms and raises tobacco on a small scale, and still preaches occasionally. He creates "peaceable kingdoms" from found wood, including roots and knots. Animals and birds made from roots, knots, and gourds are part of the scenes. Just Folk in Sommerland, California carry his work, which is also in the permanent collections of the Smithsonian American Art Museum and the Mississippi Museum of Art.

Gilley, John (b. 1929—no recent information is available)

Lives in Frenchburg, Kentucky. He is married, has two children, and grandchildren, too. For years he was a heavy-equipment operator—"anything on rubber, I can run it," says Gilley. Then he had a heart attack and bypass surgery and became disabled. Now he stays up most of every night making his art. He searches for wood that "looks right" and creates birds from pine knots sitting on various branches and "trees," often painted with WalMart paint. He also searches the countryside for small and medium-sized boxes, installs a flock of painted birds, then "shuts the door" and decorates the box itself. The contents are usually a surprise to the unsuspecting browser. Gilley works in a shed behind his house. He also makes colorful rag rugs. His work is in the permanent collections of the Kentucky Folk Art Center, the Owensboro Museum of Art, and the New Orleans Museum of Art.

Ginther, Ronald Debs (1907–1969)

Ginther lived most of his adult life in Seattle, a good part of it on the original "Skid Road." He was a union official and a member of the Industrial Workers of the World. He championed the rights of the working class and recorded their desperation in the 1920s and 1930s. He considered his art a record of the true story of the times. Eighty of his paintings are in the Washington State Historical Society in Tacoma, where an appointment is required to see them. Ginther was included in the catalog for "Pioneers in Paradise," and Wallace Stegner wrote an article about his life in *Esquire Magazine*, September 1975.

Godie, Lee (1908–1994)

Lee Godie was a well-known street artist in Chicago.

Born Emily Godee, on September 12, 1908, in Chicago, Lee Godie lived the anonymous life of a bag lady before she began selling her self-styled "French Impressionist" drawings on the steps of the Chicago Art Institute in 1968. She became a frequently collected artist but continued to live on the street. In 1989 her daughter located her, after a long search, and Godie went to live with her. "Artist Lee Godie: A Twenty-Year Retrospective," curated by Michael Bonesteel, was presented at the Chicago Cultural Center, March 13, 1993, to January 16, 1994. She died later that year.

Goe, Caroline

Caroline Goe was, and maybe still is, a classic New York bag lady. Barry Cohen "discovered" her in the 1990s at her "spot" on Avenue B. Cohen bought art from Goe whenever he traveled to New York and could find her. Since she had no telephone, Cohen would write her a card suggesting a time to meet. One can only guess, but it is quite likely that Goe's small pieces of canvas, and perhaps even her oil paint itself, were scavenged from the trashcans used by mainstream artists in the neighborhood. Caroline Goe disappeared in 1989. Cohen still has some of her work for sale.

Goodpaster, Denzil (1908–1995)

Denzil Goodpaster lived in Ezel, near West Liberty, Kentucky, a half mile from where he was born. He was a farmer, producing tobacco, corn, hay, cattle, and sorghum until he stopped at age 65 when he "got too old." He started carving his well-known walking sticks—sculptures in the round—in the 1970s when he quit farming. Frequent images carved were colorful spiraling snakes, bathing beauties, Dolly Parton, and an occasional nude. He started his pieces with a hatchet and finished them with a knife. He also made small carved figures of people and animals. There was an exhibition of his art at the Kentucky Folk Art Center in 1996. His art is in the permanent collections of the Kentucky Folk Art Center, the Milwaukee Art Museum, the Georgia Museum of Art, the American Folk Art Museum, and the Smithsonian Institution Archives of American Art.

Gordon, Theodore "Ted" (b. 1924)

Ted Gordon comes from Louisville, Kentucky, and after spending his teenage years in New York he worked as a medical clerk at Letterman Hospital in San Francisco. Now retired, he lives in Laguna Beach in Southern California. He began his self described career as a "doodler" in 1951. In 1967 his pen and ink and colored pencil markings evolved into human faces, done in symmetrical patterns of spirals and lines; unsmiling big headed men with menacing eyes. Creating thousands of portraits to date, Gordon says each drawing is a self portrait. "Whatever face appears is my face,

whatever expression is my expression at the moment of execution." Gordon has been exhibited many times, including at the American Visionary Art Museum, the Milwaukee and Birmingham Museums of Art, and the Oakland Museum of California. In 2000 the Folk Art Society of America honored him with its Award of Distinction. The Ames Gallery and Marcia Weber/Art Objects carry his work.

Gray, Earl (b. 1955)

Earl Gray lives near Glenwood, West Virginia, and grew up in this area. In 1983, he was working in his tobacco fields when he picked up a stick and carved a face on it. This started him carving on wood and later on stones. For a while he stopped woodcarving because he simply got tired of it, but then started again. His sandstone carvings he did first with a pocketknife and now uses a chisel and hammer. He treats them with a water seal so that they can be kept out of doors. The forms carved on the stones are unique, and as one walks around the carving, one finds that there is frequently a change in what one sees—multiple forms or faces are carved but they often flow from each other rather than being isolated distinct features. In about 1995, Gray started drawing. He had injured his back, could only get around with a walker, and the materials he had been using were too unwieldy. He started drawing pictures with colored pencil on birch plywood. He uses only the best grade of plywood for his drawings. He also makes his own frames. Earl says he gets his images from "inside." Most of his drawings have large heads as a prominent feature. His boards often contain a narrative image with another imposed within its own drawn frame. Many viewers believe his drawings are his most significant art. The Huntington Museum of Art and the Marshall University Graduate College in South Charleston each have Earl Gray's work in their permanent collection. Larry Hackley, a private dealer in Richmond, Kentucky, carries his art. He likes visitors at his home in Glenwood, West Virginia, but call ahead (304-762-1004). Gray also sells his work at the "Day in the Country" fair held at the Kentucky Folk Art Center in Morehead the first weekend of June every year.

Green, Homer (1910–2002)

Homer Green was born in Coffee County, Tennessee. During his working years he was at times a carpenter, blacksmith, dairyman, factory worker, and utility lineman. He began carving small objects in cedar and then decided to "try something" and started cutting larger figures with a chain saw. He made many animals including dinosaurs, alligators, turtles, and cows—and some figures strictly from fancy. At first he left them plain, but when he applied polka dots with some leftover paint, his wife Rilda really liked them, and that became his standard. When Rilda died in

1989 he stopped working for a while, but took it up again before he died. Several galleries carry his work, including Bell Buckle Crafts and Shelton Gallery in Tennessee and Larry Hackley in Kentucky.

Greene, Mark Cole (b. 1955)

Greene, born in Abilene, Texas, has always risen above the challenges in his life. When tested as a child, it was reported that he would never be able to read or to distinguish colors. Mark reads constantly, with history, nature, aliens, and Elvis Presley being his favorite subjects and makes paintings filled with vibrant colors. The artist works with inks and watercolors on board, and a few acrylic paintings on canvas. His subjects are the natural world, the theatrical world, and historic events. Greene started painting after experiencing an overwhelming number of personal tragedies. He lives in an assisted care facility and his work was included in the "Spirited Journeys: Self-Taught Texas Artists of the Twentieth Century" exhibition. The Webb Gallery in Waxahatchie, Texas carries his work.

Grgich, Anne (b. 1961)

Anne Grgich was born in Los Angeles, California, and raised in Portland, Oregon. She was the fourth of five children. She started painting when she was fifteen. She would pull the books off the shelves in her home and paint the inside pages. Or she would make collage art from basement junk, "driving my parents nuts." Her life has been challenging; she dropped out of high school, joined and retreated from a cult, married and divorced, and had a son to raise on her own. Seattle has been her home since 1987. Her art has been a constant force through all these obstacles. Now, in addition to the book paintings, she also works in oil and mixed media on canvas. She feels her art comes from the humor and tragedy of life. Two galleries, Marcia Weber/Art Objects and Barristers, carry her work, which may also be seen in the Milwaukee Art Museum. She also sells her own work through her Facebook page.

Griffin, Felecia (b. 1963)

Felecia Griffin started working at NIAD in 1985. She does printmaking, painting, collage, ceramic sculpture, fabric painting, and jewelry creation. Her abstract monoprints have the strong gestural quality of drip painting—"loose and graceful." Other prints are patterned with small circles or identical stripes that are actually outlines of popsicle sticks, which she collects. Her collages are fashioned with cardboard geometric shapes, or scraps of tissue paper and fabrics, or scraps of printed pages, with focus always on the colors. Griffin's work has been shown in many group exhibits, including one in China.

Griffin, Ralph (1925–1992)

Ralph Griffin was born in Burke County, Georgia. With his wife, Loretta, he settled in the rural community of Girard and raised six children. He worked as a janitor and at a variety of other jobs. In the late 1970s he began scavenging roots and weathered tree trunks and using black, white, or red paint to turn them into sculpture-like creatures, which he placed around his yard and later sold to collectors. Louanne LaRoche carries his work, which is also in the collections of the Kentucky Folk Art Center, Birmingham Museum of Art, and New Orleans Museum of Art.

Griffith, Wilbert (1920–2005)

Born in Bridgetown, Barbados, Griffith left school at age 13. He worked in a bakery, married, and had seven children. He came to the United States in 1996 and worked as a machinist helper in Emeryville, California. In 1995, 13 years after he retired, he bought some marking pens and began to draw "to pass the time." He later used oil paint on canvasboard, working with both brush and finger. His colors were tropical, with greens, browns, reds, and yellows predominating. He liked to paint "...blacks more in today's society than going back to slave days." Most of his paintings include figures, usually women. The Ames Gallery in Berkeley carries his work.

Grimes, Ken (b. 1947)

Ken Grimes was born in 1947 in New York City and moved with his family to Cheshire, Connecticut when he was six years old. He still lives there, residing in a supervised group living facility. He is fascinated by the paranormal, which may have been inspired by his grandfather, who was a magician. He keeps a "coincidence board" to record such occurrences; for instance the story of another Ken Grimes who lives in Cheshire, England. His themes are alien interventions, space signals, synchronicities, and government cover-ups. He paints only in black and white, acrylics on canvas. Ricco/Maresca carries his work.

Growler, Ray (b. 1965)/Growler, Ruby

Ruby Growler and Ray Growler are a brother and sister who make carved animals of aspen wood and cover them with real home-cured hides—goat or sheepskin—and attach wooden legs. Some of the animals—goats, sheep, llamas, and buffalo—are life size, and look so real that you almost expect them to nibble at you while standing next to them. Ray was the one of the first two known folk artists to begin making these animals. Ray lives in Shiprock and works with his wife Karen. Ruby lives in the family home at Sweetwater, Arizona. Their work is in the Smithsonian Mu-

seum of American Art, and available at the Twin Rocks Trading Post in Bluff, Utah.

Guillen, Jesus (1926–1994)

Jesus Guillen was born in Coleman, Texas. His father was a Mexican citizen and his mother a Latina from an old Texas family. Jesus lived in Mexico for a while as a young boy and delighted in watching his Tarascan Indian paternal grandparents make pots. Young Guillen began to paint on paper sacks, using natural dyes made from earth and plants. In 1935 his father died, the family returned to Texas to work in the cotton fields, and so began his life as a migrant. He was nine years old. He followed the crops for years, teaching himself to read and write English and Spanish— and he never stopped painting. The migrant trail brought Guillen to La Conner, Washington, in 1960 and "he knew immediately that he was home." In 1961 his wife Anita and eight children joined him there. Settled down and with a job in one place, Guillen painted more and more, and also made sculpture. His work vividly reflects the migrant's life. He has a story to tell: "It is about hard work and the desire of migrants to be recognized for their work in the fields." This story unfolds on his canvases. Guillen also made sculptured figures that he placed around his home and his yard. Twisted bent twigs and vines were stripped of bark and then soaked in water so he could shape them into abstract sculpture. His widow Anita still keeps up the art in the yard. There have been several exhibitions of his work including a solo exhibition at the Whatcom Museum in Bellingham, Washington, October 17, 1992– January 10, 1993. There are paintings in the permanent collection at Skagit Valley College.

Gulley, Boyce (1883–1945)—"Mystery Castle"—Phoenix, Arizona

Boyce Gulley abandoned his home and family in Seattle and disappeared into the Arizona desert when he discovered he had tuberculosis. He recovered while building a huge house that eventually had eighteen rooms, thirteen fireplaces, and a chapel with an organ. He built it all without blueprints, adding rooms and stairways as he went along. When he died July 27, 1945, he left "the castle" and surrounding small sculptures he made to his wife and daughter. The site is open to the public October through June. It is located in Phoenix at 800 East Mineral Road. Telephone 602-268-1581 for travel directions, hours of opening and other information.

Gunter, Alma Pennell (1909-1983)

Alma Gunter was born in Palestine, Texas, and knew as a young girl that she wanted to be an artist. However, that was not an honorable calling in her community,

so she studied and became a nurse. After her retirement, the death of her husband, and the death of her sister, she returned to Palestine to take care of her mother. She began to paint again, using acrylics and prestretched canvas, and did not stop until her own death nine years later. She painted the black community she remembered in her past. Gunter was included in the exhibition, "Spirited Journeys: Self-Taught Texas Artists of the Twentieth Century."

Hagedorn, Ricky (b. 1956)

Hagedorn lives in Connecticut, in a group home for autistic adults in Waterloo. In the 1980s he spent some time in an airport, photographing planes. Then he painted pictures of the planes from the photographs. His work was shown at the Outsider Art Fair in New York and attracted a good response from collectors. Each one of his paintings takes one month to complete.

Hall, Carolyn (b. 1950)

Carolyn Hall was born June 18, 1950, in Clarke County, Kentucky and lives now in Nada, in Powell County near Stanton. She grew up down the road from Carl McKenzie. Six months after McKenzie's wife died, Hall and her husband took McKenzie in to live with them. He was with the Hall family until he had a stroke. Before he went to a nursing home, he taught Hall to carve and gave her his carving tools. Although some of the subject matter echoes that of McKenzie, she has a style strictly her own. She carves human figures out of basswood or white pine. Her figures are generally about 16 inches tall, are painted with acrylics—including their "hair" which is made of cotton. Carolyn carves a great variety of figures including politicians and presidents, figures from popular culture, doctors, nurses, lawyers, musicians, and basketball players. Carolyn sells mostly at shows or may be reached at 606-663-2036. Happy collectors are her greatest promoters. Her work is in the permanent collections of the Kentucky Folk Art Center and the Owensboro and Birmingham Museums of Art.

Hall, Dilmus (1900–1987)

Dilmus Hall was born in Oconee County, Georgia, into a tenant farming family. At age thirteen he moved to Athens, Georgia, served in the army in Belgium during World War II, returned to Athens, and held a variety of jobs including hotel work, work for the highway department, and as a waiter. Before being stopped by arthritis, Hall made sculpture—some of the devil in various activities, and some of fanciful human and animal figures. He built his statues of metal, wood, clay, and cement. They were usually painted with house paint. After his arthritis became too painful for him to continue making sculptures, he began to make drawings.

Halozan, Bertha A. (birth year unknown–2004)

Halozan was born in Vienna, Austria, and came to the United States in 1956. She lived in New York City. In 1979 she started to paint as "therapy" after suffering a stroke and a heart attack. She was very sick and she couldn't talk, but she could walk. She often went out to the park around the Statue of Liberty and lay down in the grass and thought about getting well. She got a permit to paint outside Lincoln Center. This led to a visit from Robert Bishop, then director of the Museum of American Folk Art, who bought a painting from her. Her "Statue of Liberty" paintings are her most interesting work. On the back of every painting she pasted press reviews of her appearances as a cabaret singer. She recycled old frames, incorporating them into her work. When weather permitted, she could be found on the street at 50th and Broadway. Marcia Weber/Art Objects, Just Folk, and Yard Dog carry her work, which is also in the permanent collection of the Smithsonian American Art Museum.

Hamblett, Theora (1895–1977)

Theora Hamblett was born near Paris, Mississippi. When she was age ten, her father died. In 1939 she moved to Oxford, Mississippi, bought a big, old house and began to take in boarders. After experiencing a reoccurring dream, she began to commit her memories and visions to canvas, eventually filling the house with her works and displacing the boarders. There is one painting in the Museum of Modern Art in New York, and many are in museums in the state of Mississippi. Most of her works are at the University of Mississippi.

Hamerman, Esther (1886–1977)

Esther Hamerman was born in Poland and died in New York. From 1950 to 1963 she lived in San Francisco. Hamerman and her family fled the Nazis in 1938 and lived in the British West Indies during the war. Her daughter and son-in-law encouraged her to paint when she was in her sixties. For the rest of her life she spent most of her time painting her memories—not at all bucolic—of a childhood in Poland and Austria, experiences of war and flight, and of her new life in New York and San Francisco. The Ames Gallery in Berkeley carries her work.

Hamilton, Ray (1920–1996)

Ray Hamilton was born in Anderson, South Carolina, April 20, 1920, and died January 6, 1996, in Brooklyn, New York. The artist attended school through the tenth grade and served in the navy in World War II. After the war he lived in New York. He lived in Brooklyn in a state-run adult home. Hamilton was raised on a farm in the South, with six brothers and six sisters, and often his drawings were influenced by that period in his life. He also included "magical quasi-human figures." He painted complex compositions, involving multiple divisions of the page. Hamilton used a broad range of colors and media. He took part in the art program at HAI in New York. His art was included in the exhibition "Drawing Outside the Lines: Works on Paper by Outsider Artists," at the Noyes Museum in New Jersey in 1995. The Milwaukee Art Museum has his work in its permanent collection.

Hamm, Larry "Buddy" (1937–1996)

Larry Hamm was born in Carter County and moved to Morehead, Kentucky, in 1963. Hamm had served in the army and was manager of the Certified Oil Station in Morehead for sixteen years. He was a woodcarver who made a variety of constructions and images including small animals, models of log cabins, Noah's Ark, and "Elvis." Hamm's work often exhibited his sense of humor. Hamm died of a sudden heart attack July 16, 1996. His carvings are in the permanent collection of the Kentucky Folk Art Center.

Hamm, Louis Emil "Slingshot" (1896–1976)

Hamm came from Santa Clara, California, and died in Vallejo. His father was Paiute and his mother Spanish. He was a sharpshooter, accordion player, and carver. After he served in World War I, he and his wife were circus performers. He was in show business for 35 years, was a rider and a roper, and then went to work in a shipyard. Hamm retired at age 70 and spent his time carving. He carved wood panels, snakes, and totems. His work turns up in galleries from time to time.

Hampton, James (1909-1964)—"The Throne of the Third Heaven"— Washington, D.C.

James Hampton's magnificent creation, the "Throne of the Third Heaven of the Nations Millennium General Assembly" is the most often viewed art in the Smithsonian American Art Museum. His work has been studied by Lynda Roscoe Hartigan, appears in Hemphill and Weissman, and is written about frequently. His own writings and papers are in the Archives of American Art.

Hardin, Joseph (1921–1989)

Joseph Hardin was born in Raymond, Alabama, and lived in Birmingham, Alabama. He suffered from rheumatoid arthritis from the age of seven, which confined him to a wheelchair. A Birmingham artist, Virginia Martin, discovered Hardin's art while she was bringing him Meals on Wheels. She recognized the

talent of this individual so severely crippled with arthritis that he was unable to move except in a minimal fashion in the shoulder/arm joints. With brush or pencil pushed between the fingers of his claw-like hands, Joe Hardin kept painting until the end, having an occasional visitor thumbtack to the walls of his apartment the paintings as he finished them. Mrs. Martin began bringing Joe discarded matboard on which to work and she, and perhaps others, showed his work along with their own paintings at Birmingham arts and craft shows a few times. Much less prolific than most of the other Alabama artists of his generation, he probably made no more than a few hundred pieces. Hardin worked in mixed media on small pieces of discarded matboard or canvasboard that he could handle easily. His subject matter was primarily the female figure, often somewhat erotically posed. It has been stated that he was painting a world that he was physically unable to participate in. At one time before living in the North Birmingham apartment, Joe had lived near a ballet school and could see the young dancers come and go. This may have accounted for the dance motif in some of his work—not ballet, but a single female figure, usually, nude and dancing freely across a field. A Western motif (cowboys, Indians, cactuses, cowgirls, and the like) came from some time spent in his earlier years in the New Mexico/Arizona area. The signature he used on some of his paintings—"MJ" represents "Mexico Joe," his nickname from those years. Hardin is in the collection of the Birmingham Art Museum, has been included in exhibitions, and is written about in the book *Revelations: Alabama's Visionary Folk Artists*. Marcia Weber/Art Objects in Montgomery and Orange Hill Art in Atlanta carry his work. Most of his work available from the latter gallery was done in the last three years of the artist's life although a few pieces are certainly earlier, probably dating from as early as the 1970s.

Harper, Robert (1935–1995)—"The Fan Man"—Houston, Texas

Harper was born and grew up in Houston, Texas. Around 1980, while living in Houston's Third Ward, Harper began to decorate the entire interior of his house with phonograph records pinned to the walls and straw baskets attached, closely together, on the ceiling. After completing the interior, Harper began an outdoor environment, starting with a sitting area for himself and his friends. After he built a few more structures, he built a fence from cast off materials including old fan blades, thus earning him his nickname. His yard art was constantly being developed and added to until January 1992 when it was leveled by a fire, which also killed his stepmother. After the fire, Harper moved to a house in the Fifth Ward. He planned to design and construct a new environment, but became seriously ill with cancer and couldn't create much. His

environment was documented and pieces from it are at the Orange Show Foundation in Houston.

Harris, Alyne (b. 1943)

Alyne Harris has lived all of her life in Gainesville, Florida, with the exception of three years spent in Milwaukee when she was a child. She is a distant relative of artist Jesse Aaron. She has felt compelled to create her whole life. Even as a young child, Harris pored over whatever picture books were available to her, and her mother encouraged her interest in art. Harris has said she is driven to paint, often all night, and panics when she does not have the funds to buy more paint. Harris has always had domestic service jobs—cooking, cleaning—until recently. She is now working in a restaurant. Harris has the natural ability to choose color and plan her design as she executes her paintings. Her paintings may be on canvas, pieces of Masonite, paper, boards, or metal. The varied subject matter includes flowers; religious pictures (including "haints"); scenes of black people, nearly always at labor; and memory scenes from childhood. Her work is available from Just Folk in California and Jeanine Taylor Folk Art in Florida; several museums (Ashville Art Museum, New Orleans Museum of Art, Rockford Art Museum) include her work in their permanent collections.

Harris, Ben (b. 1945)

Harris was born in North Carolina and worked on his family's small tobacco farm. He moved to Raleigh and worked in construction and then moved to Los Angeles, California, where he worked as a welder. During the 1984 Olympics he was inspired to create his first piece of sculpture, a figure made of raw steel called "Olympic Runner." The late Larry Whiteley, a folk art dealer, discovered him and gave him his first show. His work was included in the exhibition "Contemporary American Folk, Naive and Outsider Art: Into the Mainstream?" in 1990.

Harris, Felix "Fox" (1905–1985)— Yard Show—Beaumont, Texas

Felix "Fox" Harris was born in Trinity, Texas. He eventually settled in Beaumont, where he lived the rest of his life. The last twenty or more years of his life was spent sculpting. He used a simple hammer and a hand fashioned chisel to do his artwork. His work was a result of a vision and message from God. Harris took discarded tools, machines, toys, and scraps of metal and plastic and with his native ability created his remarkable sculptures. At his death, his nephew gave 120 pieces to the Art Museum of Southeast Texas in Beaumont. Pieces have gone through numerous installation locations, de-installations due to threats of inclement weather, and subsequent long term storage. Finally in August 2007, AMSET unveiled *Somethin' Out of*

Nothin': The Works of Felix "Fox" Harris, a semi-permanent gallery and resting place for these Beaumont treasures.

Harris, Jim (b. 1958)

Harris was born in Kirkwood, Missouri, and lives in Owensboro, Kentucky. He has traveled a lot to perform construction work, and this has influenced his carving. The majority of the works by Harris are caricatures of people, but he also carves animal figures. He carves basswood and paints the figures with acrylics. His work is in the permanent collection of the Owensboro Museum.

Harte, Tom (1944–2012)

Tom Harte lived in Richmond, Virginia and attended Virginia Commonwealth University, where he studied psychology and advertising, and served in the Navy. He lived for a while in San Francisco, where he was a street musician. Returning to Richmond, he became a familiar figure riding his bicycle around the Fan district, gathering discarded recyclables. The artist's small acrylic paintings "vary in subject and technique but retain a haunted Oriental feeling." His work was included in "Folk Art: The Common Wealth of Virginia," and his paintings are in the collection of Longwood University.

Hartman, Ben—"Hartman Rock Gardens"—Springfield, Ohio

Hartman filled his relatively small yard with statues, miniature stone castles, cathedrals, and other historic buildings. There are models of the White House and Independence Hall, a scene from the Oregon Trail, boxer Joe Lewis, the Dionne Quintuplets, religious scenes, and many more. Informants say the garden still exists and may be seen at 1905 Russell Avenue (in Springfield, take Yellow Springs Street (Route 68) to McCain Street and turn right. The garden is on McCain and Russell. The Folk Art Society of America visited the site during its annual conference in 2014 and found the garden in excellent condition.

Harvey, Bessie (1929–1994)

Bessie Harvey was born in Georgia and lived in Alcoa, Tennessee. She was a profound, wise woman, who gave strength and support to her children, grandchildren, and great-grandchildren. She had visions most of her life, which, she said, influenced her root sculpture. She created figurative sculpture from branches and roots and also did drawings. Bessie Harvey's art was included in the 1995 Whitney Museum Biennial. In 1997, the Knoxville Museum of Art presented an exhibition, "Awakening the Spirits: Art by Bessie Harvey." The exhibition included her root and

branch assemblages. Galleries still carry her art (e.g., Anton Haardt, George Jacobs, Raven Arts, Outsider Folk Art), and she is included in the permanent collections of several museums, including the Smithsonian American Art Museum, the Milwaukee Art Museum, and the Birmingham Art Museum.

Hasty, Lela (1924–1995)

Lela Hasty was born near Sacramento, California. Most of her adult life was spent in an adult care center for those with mental disabilities. Essentially nonverbal, she communicated through her paintings of beautiful trees, plants, and flowers. She sometimes painted houses and small rabbit-like creatures. Her work was included in the exhibition "Tree of Life" at the American Visionary Art Museum.

Hawkes, Gerald (1943–1998)

Gerald Hawkes lived and worked in Baltimore. He made matchstick sculptures from burned matchsticks dyed with color from earth, coffee grounds, grape juice, and other natural sources. He worked with household glue and razor blades, making many geometric forms, which had symbolic significance. Hawkes was a profound early inspiration for the developers of the American Visionary Art Museum in Baltimore, and there is an exceptional piece of his art in the permanent collection there.

Hawkins, William (1895–1990)

William Hawkins was born in Kentucky to a farming family. He eventually moved north to Columbus, Ohio, where he spent the rest of his life. He is one of the best-known contemporary folk artists. He used plywood, Masonite, and found objects, painted with semi-gloss enamel, to create his spirited bold images of buildings, animals, and other scenes. He often incorporated his name and birth date into a painting. There are many written references to Hawkins, and his work is in the permanent collections of several museums.

Hay, Thomas Andrew "T.A." (1892–1988)

T.A. Hay was a Kentucky native and a tobacco farmer until the age of eighty. He served in World War I, during which he was wounded. "After his wife died, T.A. filled his final years by recreating his rural life in miniature, slowly turning the seven rooms of his house into what amounted to a museum of pre-industrial agriculture," according to James Smith Pierce. He also made small figurative paintings of birds and animals. Detailed descriptions of his art and more information about his life are included in the catalog *Folk Memories: T.A. Hay*. Larry Hackley, a private dealer in Richmond, Kentucky, sells his art.

Hay, Tom (b. 1955)

Tom Hay lives in Columbus, Ohio, in the neighborhood where he was born and grew up. He says that there are elderly people still living on his block who knew him as a little boy. The only thing that tempts him to leave is the winter cold since he has worked out-of-doors for the last "ten to fifteen years." Tom Hay is a laborer by trade. He works in the building industry, and for nine years he did demolition work. He started carving bas-relief on found-wood boards about two years ago, inspired by his friend Smokey Brown, seeing books about Elijah Pierce, and remembering the carving and whittling done by his father. Hay works on board and carves a variety of images including sports heroes, scenes from street life, and visual commentaries on his musings on such social issues as wealth versus poverty. He paints his works with acrylics, the colors sometimes determined by what he finds. Lime green, pale yellow, and "swimming pool blue" were recently available. After painting the pieces he applies Butcher's wax. Hay says he does the work "for fun" and wants to make people smile, and to date has given many of his carved boards away. He is now ready to start selling his work. His address is 96 E. Mithoff, Columbus, Ohio 43206. Telephone: 614-443-5561. Call him if you are interested.

Hayes, Herman Lee (1923–2012)

The Rev. Herman Hayes was a wood-carver; he was a Methodist minister for more than thirty years. He made intricate carvings of all sizes from small people on toothpicks and golf tees to figures six feet tall. He is best known for his carving of miniature people in various settings such as a church or a sports stadium. The tiny carved faces have individual "looks." He used basswood and buckeye most frequently, and left the carvings in their natural finish. His work may is in the collections of the Columbus Museum, the Owensboro Museum of Fine Art, and the Museum of International Folk Art.

Hedges, Jimmy (1943–2014)

Self-taught wood-carver Jimmy Hedges began carving in his 50s, being inspired by Neva Boyd, a Chattanooga artist who carved intricate birds and other wildlife. Jimmy spent the first four years of his carving life doing birds, too. He quit for a while and then about 1986 started again, doing carvings dealing with social commentary. He then quit again, immersed as he was in his business as a folk art dealer. It was while retrieving logs for Homer Green that he decided to take one home and try chainsaw carving. He started out working with basswood but later preferred cedar and white pine. His work is representational and was often inspired by the unique individuals he met while searching for folk art for his business.

Heimer, Andrea Joyce (b. 1961)

Heimer is a self-taught painter known for her exploration of the suburban experience, drawing inspiration from the neighborhood mythos of her childhood home in 1980s Great Falls, Montana. Adopted as an infant and plagued by lifelong clinical depression, Heimer struggled early on with feelings of disconnect from her family and community. Her sense of isolation continued into her teens, but by then she had found comfort in a peculiar activity: observation. Through quietly observing the lives around her Heimer was able to piece together neighborhood tales of madness, conspiracy, and love, often substituting her own theories to fill any missing pieces of the story. The result was a kind of vicarious connection to those around her—a connection that sustained her during deep depressive bouts. It is fragments of these stories that make up Heimer's darkly imaginative narrative works. Part allegory, part autobiography, her crudely rendered but tremendously detailed paintings depict scenes of heartbreak, madness, and the emotional claustrophobia that stems from living as an outsider in one's own backyard. Lindsay Gallery in Columbus, Ohio carries her work.

Henry, Donald (1966–2009)

Donald Henry was raised in Cincinnati, Ohio. A head injury in a playground accident left him severely brain damaged. Henry was easily frustrated. His sister Gina Henry said drawing was the one thing that could calm him down. Henry spent time in the Orient State Institute, a "mental asylum," and while there did not paint. After he was released he lived in group homes and began attending Visionaries and Voices, a Cincinnati art program for people with developmental disabilities. He made robot-like figures, usually with brightly painted surfaces. Lindsay Gallery in Columbus, Ohio carries his work.

Herbert, Woody (c. 1926–1994)

Woody Herbert lived in Sweetwater, Arizona. A Navajo, his carved animals were covered with a clay-like substance and painted. They may be from one to five feet tall. His legacy of woodcarving excellence is being followed by his children and grandchildren. Lulu Herbert Yazzie, Edith Herbert John, Dareen Herbert, and the husband and wife team of Laban and Kathy Herbert create their pets and family animals in fanciful carvings of chickens, geese, dogs, cows, and Appaloosa horses.

Herberta, Victoria (1939–2010)— "Pigdom"—Houston, Texas

Victoria Herberta grew up in Houston Heights, Texas, and fell in love with pigs at the age of four. She spent years collecting specially designed pig signs and

pig memorabilia to place around her purple house. Much of it was done to honor her best friend, an 800-pound pig named Jerome. She lost the pig to a city ordinance and lost much of her spirit at the same time. After her death the site tumbled into disrepair; SPACES, an organization that documents folk art environments, lists it as "threatened." Herberta and Pigdom are, however, still available for viewing on a short video to be found at www.blip.tv/weird-america/weird-america-pigdom-46779. In addition the book, *Paint the Town Orange*, published by the Orange Foundation in Houston, contains a long essay about Herberta and her site.

Herget, Dee (b. 1935)

A Baltimore "screen painter" who is one of the artists featured in the film "The Screen Painters: A Documentary of Baltimore's Unique Folk Art" and in the book *Screen Painters of Baltimore* by Elaine Eff (see "selected books since 2000"). The screens are painted in such a way that a person can see out, but passersby cannot see in. They are painted with certain customary scenes or, as in Herget's case, sometimes with designs requested by the customer. Herget became a screen painter in 1977, when she quit a civil service job because of hearing loss. Herget is very busy. You supply the screen, and patience, and she will paint it. Her telephone number is 410-391-1750, and at last check she was still in business.

Herrera, Nicholas (b. 1964)

Called El Rito Santero, Herrera lives and works in El Rito, New Mexico, where he was born and began carving. Early on he abandoned art-making to indulge in a wild and reckless youth. A nearly-fatal motorcycle accident prompted Herrera's dual conversions to a life of art making and to the *penitente* sect of the New Mexican Catholic religion. Herrera learned to carve by interacting with some of New Mexico's well-known carvers and *santeros*, including Felipe and Leroy Archuleta and Charlie Carrillo. From Carrillo, he learned to make and to use natural pigments. Whereas he once had trouble gaining access to the Indian and Hispanic Markets of Santa Fe, he is now recognized across the world. *Nicholas Herrera: Visiones De Mi Corazon/Vision of My Heart* (LPD Publishing, 2003), tells the story of Herrera's work in stories and pictures. Herrera's carved saints combine traditional with contemporary elements. His figure of death has an automatic weapon instead of the traditional Spanish bow and arrow. Herrera makes some flat pieces, or retablos, which feature such images as "low riders." An article about Herrera appeared in the *Folk Art Messenger* (Summer 1993). In 1996 he was in the exhibition "Wind in My Hair" at the American Visionary Art Museum. There was an exhibition of his work at Cavin-Morris Gallery in the fall of 1998. Herrera's work is in the permanent collec-

tions of the Smithsonian Institutions-Museum of Colonial Arts, American Folk Art Museum, Museum of International Folk Art, and the Harwood Museum in Tesuque, New Mexico. San Angel Gallery in San Antonio carries his work.

Hewell, Chester (b. 1950), and the Hewell Family

Chester Hewell (b. 1950) is from Gillsville, Georgia. His family has been making pots for one hundred years and more. His great grandfather, Eli D. Hewell (1854–1920), established the pottery about 1890. Chester uses a wood-fired kiln; the blue in his glazes is from Milk of Magnesia bottles, and he makes face jugs. His sons Matthew and Nathaniel work with him, as does his mother, Grace Matthew Hewell, who also makes face jugs. Matthew Hewell uses an alkaline glaze and burns in a wood kiln. His faces have large, round eyes and round hollow mouths with broken porcelain teeth. The bottom half of the face is generally heavy and protruding, suggesting jowls. Nathaniel (b. 1976) makes face jugs, which have pinched-looking faces. The Hewell Pottery is known for its gardenware (shipped all over the world).

"The Highwaymen"

"The Highwaymen" is a name given to a group of self-taught black artists who, since the 1950s, have been traveling throughout central and south Florida selling their paintings from the trunks of their cars. Some of these "Highwaymen" are: Curtis Arnett, Hezekiah Baker, Al Black, George Buckner, Ellis Buckner, Mary Ann Carroll, Willie Daniels, Johnny Daniels, James Gibson, Alfred Hair, Israel Knight, R.A. McLendon, Harold Newton, Lemuel Newton, Livingston Roberts, and W.C. Reagon. "The Highwaymen" have diverse backgrounds, from prisoner to preacher, outstanding citizen to drug addict and alcoholic. Their colorful lives and primitive and individual art styles make them important to folk art collectors. Jeanine Taylor Folk Art in Miami carries the work of some Highwaymen.

Hill, Kenny (b. c. 1950)—Chauvin Sculpture Garden—Chauvin, Louisiana

Little is known about Kenny Hill, who made a fantastic sculpture garden containing more than 100 pieces in a strip of land along the Bayou Petit Caillou in Chauvin. He was a bricklayer by trade, and settled along the bayou in 1988. Over time he built a small rustic house on the property. In 1990 he began transforming his yard into an incredible construction of the world as seen through his eyes. He packed the property with scenes of pain, struggle, and redemption. Many of the statues are angels, of all colors and descriptions,

many helping to elevate other sculptures. In the middle is a 45-foot tall lighthouse adorned with many figures, from cowboys to angels, including a self-portrait. The John Michael Kohler Foundation acquired the site to assure its preservation. After restoration the Foundation gifted it to Nicholls State University in Thibodaux, Louisiana, which maintains an art studio at the site (www.nicholls.edu/folkartcenter/park.html).

Hirshfield, Morris (1872–1946)

Morris Hirshfield was born in Poland and went to New York City in 1890. He worked in the garment industry, and as a young man he showed considerable talent as a carver. In 1937, because of poor health, he retired from the business he had established and turned to painting. His work is very well known, and frequently illustrated in books. Women and animals were his favorite subjects, often set off by rich painted draperies of fabric.

Hodge, Albert (b. 1941)

Hodge was born in Newton, North Carolina, and now lives in Vale, North Carolina. He had a difficult childhood and joined the army at fifteen. Albert returned, got married and began to collect old pottery. When it became too expensive he taught himself to turn, glaze, and fire his own clay works. He did not come from one of the traditional pottery families. In 1993, he moved from Newton to Vale. Hodge uses a variety of alkaline glazes and turns both single clay bodies as well as swirl jugs. He fires in an electric kiln. His bright-eyed, open-mouthed face jugs are expressively detailed with teeth, mustaches, eyebrows, and hair. He also makes jugs with animals and snakes. Decoration is his special touch. Barry Huffman says in his book, *Catawba Clay: Contemporary Southern Jug Makers* (1997), that Hodge does not want to be known as a potter—his technical skills aren't good enough—he wants to be known as a folk artist. He has his own shop, where one may call him at 704-462-1411 or email him at albert@hodgepottery.com. His work is in the permanent collection of the Smithsonian American Art Museum.

Hodge, Mack (b. 1937)

Hodge was born near Fourmile, Kentucky, and lives in Pineville in southeastern Kentucky. He worked in coal mines in Kentucky and factories in Ohio, and then moved back to Kentucky. He carves small wood sculptures of figures doing work such as farming or coal mining. He also carves animals, country churches, and canes. His work is illustrated in the *Sticks* exhibition catalog and in *Folk Art of Kentucky*. His work is in the permanent collection of the Kentucky Folk Art Center in Morehead and the Kentucky Museum of Art and Craft in Louisville.

Hoffman, Albert (1915–1993)

Albert Hoffman was born in Philadelphia. His mother was descended from a German Jewish family from Frankfurt. His father, Isaac, came to the United States from Kiev, Russia, to escape religious persecution. Hoffman left school after the sixth grade and worked at many jobs to earn a living during the difficult years of the Depression. He lived in California, married, and had a son. When Pearl Harbor was bombed, he joined the navy and was injured when his battleship was hit. His marriage dissolved sometime during the war, and when he was discharged he remarried and settled in Galloway Township, New Jersey. He established a junkyard there, never too successful because he preferred to carve. This wife died during the 1970s and Hoffman married again, to a woman who supported and encouraged his art. Hoffman carved relief and three-dimensional works, with the relief carving being the greater part of his work. His favorite wood to use was mahogany, and his subjects were memories of Jewish communities where he lived, biblical tales from the Old Testament, and Jewish religious customs. Also, his subjects extended to social commentary about contemporary events. His art was included in the exhibition "Tree of Life" at the American Visionary Art Museum in 1995. In 1997 the Noyes Museum of Art, in Oceanville, New Jersey, held an exhibition, "For the Love of Art: Folk Carvings by South Jersey Artist Albert Hoffman." His work is in the permanent collections of the Noyes and the Milwaukee Art Museum.

Holder, Frank (1931–2009)

Frank Holder lived a few miles down Highway 421 west of Winston-Salem. His yard was filled with dinosaurs, a spouting whale in a pool, a life-sized mermaid, and larger than life daffodils. Looking over all was an eagle on a tall pole. Holder worked for thirty years at R.J. Reynolds Tobacco as a welder. He always "fooled around with making things all his life," but the large pieces were what attracted him most after retirement. He made his welded sculptures out of discarded metal. He painted only a few pieces—the whale, the daffodils, a large grasshopper—leaving most in their natural metal colors. People nearly always stopped when they saw the yard. His wife liked the art, too. His work was featured in *Self Made Worlds: Visionary Folk Art Environments* (1997) and in a video accompanying the exhibition *Homegrown & handmade: Selected Works from the Huffman Collection of Southern Contemporary Folk and Outsider Art* mounted by the Hickory (N.C.) Museum of Art.

Holland, Dorothy (b. 1947)

Holland was born in Rio de Janeiro, Brazil, and has lived in many places; she now resides in Santa Fe, New Mexico. Holland began drawing in her fifties, when she found the book *Drawing on the Right Side of the*

Brain and discovered that she could do it. She says, "My partner was a watercolorist, and when she switched to acrylics I inherited her watercolor materials and equipment and discovered my passion. When I paint I drop into another world, similar to when I meditate. I love the feeling! I used to paint landscapes, my favorite subject being the beauty of the Southwestern landscape." Holland can be reached at Dorothy@bookgrrls.com.

Holley, Lonnie (b. 1950)

Lonnie Holley was born in Birmingham, Alabama, the seventh of many children, and spent most of his youth in foster homes and reform schools. He began making art by sculpting figures in industrial sandstone, later diversifying to paintings and sculptures using found objects. In the outskirts of Birmingham he filled his own yard and several adjacent abandoned lots with his art, creating an immersive art environment visited by many collectors and persons from the art world. In late 1996 he was notified that his property was going to be condemned to make way for the expansion of the Birmingham International Airport. After a court fight that netted Holley more than 10 times the airport authority's original offer, Holley, his family, and his work to a larger property in Harpersville, Alabama, east of Birmingham, where he lives with 5 of his 15 children. His work is highly thematic and centers on the human condition. Holley is written about frequently, and his work appears in numerous exhibitions. The permanent collections of numerous museums include his work (e.g., the High Museum in Atlanta, the American Folk Art Museum in New York), and his work has been exhibited at the White House. In 2003 the Birmingham Museum of Art organized a 25-year retrospective, "Do We Think Too Much? I Don't Think We Can Ever Stop: Lonnie Holley, A Twenty-Five Year Survey," which also travelled to England. Holley's work is available through several galleries, including Just Folk in California, Main Street Gallery in Clayton, Georgia, and Anton Haardt Gallery in New Orleans and Alabama. Holley also sells from his own Facebook page.

Holmes, Eric (b. 1946)

Eric Holmes lives in Miami in an adult residence for people living with mental illness. He attended college earlier in his life but did not study art. His room is filled with books and magazines. He was an honors student at the University of Pennsylvania until his illness took over. Holmes started painting in 1970 while in a Philadelphia mental hospital. He has stories for each of the paintings he does. His subject matter is wide-ranging and includes "eerily isolated heads," with names of old lovers or friends, lyrical flowers, and tortured abstractions to semi-humorous versions of the masters— Eric's Picasso or Eric's Matisse. His large painted boards are often of women, and his palette varies from bright primary colors to somber dark ones. In addition to his artworks, Eric keeps journal-notebooks filled with strong poetry. His work is in the permanent collection of the American Visionary Art Museum in Baltimore. Also, his art was included in the exhibition, "The Passionate Eye: Florida Self-Taught Art," in 1994.

Holvoet, Camille (b. 1952)

Camille Holvoet was born in San Francisco. When Holvoet entered the Creative Growth art program in 1982, she was described as a talented young woman with obsessive behavior patterns. In the following years, she has used her obsessive energy to create direct, powerful, and intensely moving images in her artwork. Holvoet has a photographic visual memory. Her drawings, paintings, and sculpture are often camera-like stills of past experiences and present perceptions. She often mixes real and dream images, light fantasy, and disturbing psychological insights in the same works. Her artwork is always vibrant, intensely colored, and compelling. Holvoet now works at Creativity Explored in San Francisco, where her art is exhibited regularly and available for sale.

Holzman, William (1903–1997)

William Holzman was a friendly, humorous storyteller who made wonderful, colorful art objects. He was born in North Freedom, Wisconsin, and moved in later years to Tucson because of the health problems of his first wife. After she died he married again, the mother-in-law of his son. Holzman worked in copper mining, shipping ore, and building company towns for mining companies. He was a union man, but unemployed about half the time. Then he was a warehouseman for twenty years, until he retired in 1972. After he quit a "retirement job" as a church custodian, he and his wife decided to spend their time fishing, but they never caught anything. One day his wife refused to go, deciding to sew instead, whereupon William went to his shop to whittle. This was the beginning of his art career. Holzman made wildly colored windmills, dollhouses, small animals, bookends, and other objects out of plywood. Holzman made chairs that took the form of a man with a hat, a woman with a crown, a wolf, or an alligator. The arms often had paws on the end and the back might have the head of a cat. Holzman started taking his creations to the outdoor market in Tucson in 1979. One day, a woman attending a convention in town bought a windmill and set it up at her hotel. Everyone wanted one, and soon he was sold out. The Shemer Art Center in Phoenix, Arizona, presented an exhibition, "Capricious Concoctions: Whimsical Furniture and Whirligigs by William Holzman," April 19–May 13, 1994. In 1997 his work was exhibited at a one-person show, "William Holzman's Fantastic Folk Art: Whirligigs, Furnishings and Whim-

sies," April 3–June 8, 1997, at Tohono Chul Park in Tucson, Arizona.

Hooper, Annie (1897–1986)

Annie Hooper was born on the Outer Banks of North Carolina into a family of twelve children plus fourteen foster children. Then she was the wife and mother of fishermen and lived a lonely existence, especially when her husband and son were in the service during World War II. To pull herself out of the resulting depression, Hooper filled her nine-room house and outbuildings with thousands of figures inspired by the Bible, work she made to fight off loneliness. Her work was saved, and the pieces are now in the collection of the Gregg Museum of Art and Design in Raleigh (formerly the N.C. State Gallery of Art and Design). In early 1995, Roger Manley, now the Gregg's director, curated an exhibition there entitled "A Multitude of Memory: The Life Work of Annie Hooper." The exhibition consisted of 2,500 pieces including biblical subjects in driftwood and concrete, angels, sheep, and scripture on Styrofoam meat trays.

Hope, Alva (1902–1993)— Environment—Stephenville, Texas

Alva Hope was an ex-cowboy and farmer who lived in Stephenville, near Waco in east-central Texas. His environment began when a plastic milk bucket flew out of a passing pickup truck and landed in his front yard. He figured he could either throw it away or "do something with it." More than three years and 200 whirligigs later, Alva Hope had created a fanciful found-art environment in which all his neighbors could participate. Children brought their old toys to adorn the plastic buckets he cut and painted. Adults dropped off everything from bandage cans to straw hats. People noted that "around Alva's place, a simple wind became an amazing phenomenon as row after row of plastic babies and cows and arrows and buckets spinning in every direction. The bright paintings on the buckets included self-portraits and occasional cryptic messages to people in Alva's life, both living and dead."

Hot, Dan (b. 1932)

Dan Hot is a Navajo carver who lives in Sweetwater, Arizona, and is the grandfather of highly regarded sandpainter Thomas Begay, Jr. He carves bulls and other animals of great character, using fabric and sheep wool over wood forms. Often his animals are anatomically complete. His figures range from one to five feet in size. Just Folk in California carries his work.

How, Shirley (b. 1959)

Shirley How does richly painted figures, inspired by Eastern art, on silk banners that have been used by the city of Richmond, California, in its beautification project; on outsized kimonos; and in a series of brightly colored paintings of Buddha as primitive, squared-off figures. She also does small linoleum prints and composes expressive poems. How was born with cerebral palsy in San Francisco, institutionalized at age three, and has lived in board and care homes since the age of ten. She has worked at Creative Growth and now is at NIAD.

Howard, Jesse (1885–1983)

Howard lived in Fulton, Missouri, and created an environment with thousands of signs expressing commentary on politicians, taxes, government regulations, and his neighbors who tried to have him locked away. His work is in the Kansas City Art Institute and the Museum of American Folk Art. He was the subject of an exhibition sponsored by the organization Intuit, "Free Thought, Free Speech, and Jesse Howard Is My Name" in May 1992. In the July 1998 issue of the newsletter *ENVISION*, John Foster wrote a detailed article about Jesse Howard, his life, and his environment of signs. Occasionally his signs will turn up for sale at auctions.

Howell, Robert (1932–2004)

Robert Howell was born May 15, 1932, in a log cabin—since burned down—in Powhatan, Virginia. It was right behind the place where he lived at the end of his life. He grew up with five brothers. He never married and "preferred the solitary life." His several acres of woodland were filled with colorful and imaginative creations he made from found wood, nails and paint, which he sometimes adorned with other discarded objects such as tennis balls, plastic pieces, hats, and plastic pipe. He liked visitors and most definitely appreciated buyers, because, as he said, he needed the money. His work is in the collections of Longwood and Hampton Universities in Virginia, and the Meadow Farm Museum in Glen Allen, Virginia. Exhibitions that featured his work include the American Visionary Art Museum's 1996–97 *Wind in My Hair* and the University of Richmond's 2001 *Point of View*.

Hudson, Walter Tiree (b. 1943)

Hudson was born in Virginia. He was formerly married, and has two sons. After dropping out of school, he served in the army. He obtained his high school equivalency degree in 1968. From 1972 to 1978 he hitchhiked over 200,000 miles, systematically covering 48 states and other points of interest. Tiree, as he is called, has been in three mental hospitals over the years, but is now living on the "outside" with the help of disability payments. He has been painting for over ten years, first with chalk on the walls of a building that his brother owned, and now on artboard, canvas, and

found materials. He says "Topography has become the object of interest in my art. Some say it is wanderlust, well, maybe so, but it is a form of 'full art' also." His paintings are filled with characters and symbols that can be "living guardians, spirits, or just a breeze or the wind, and may involve warnings and other indications." He has produced over 60 notebooks, some 1,500 pages, with more than 10,000 pencil drawings in each, describing his "full art." All this "picture writing" is part of Hudson's struggle to function and stay healthy against what he perceives to be an uncaring, hostile society. The Morris Museum in Augusta, Georgia has some of his work in its permanent collection.

Hull, L.V. (1942–2008) Yard and House Environment—Kosciusko, Mississippi

Mrs. L.V. Hull lived in Kosciusko, Mississippi. The unsuspecting visitor was in for a surprise when he or she turned down the road toward Mrs. Hull's house. Shoes in every size and color seemed to sprout from the ground. Old television sets had Hull's words of wisdom painted on the screens and on the sides. A gallery owner who visited often said, "Found objects of every description are colorfully painted and artfully arranged so densely between the flowers of her garden that the effect is more like a huge painting with yard as canvas." Hull enjoyed visitors, and would invite people in to see her house, crammed every inch with her creations including bottles and jugs with beads glued all over, crosses with homilies painted on both sides, with each word painted a different color, and painted television sets, telephones and everything else painted with advice and warnings. This site is probably gone, but there is a 2005 YouTube video in which Hull describes her site, her purpose in creating it, her neighbors' reactions to it, and images of the site itself (https://www.youtube.com/watch?v=UYOpWKQ1X-4).

Hunter, Clementine (1886–1988)

Louisiana's most famous folk artist, Clementine Hunter, did not start painting until she was 57 years old. She then produced thousands of paintings. She was born on Hidden Hill Plantation near Cloutierville, in north Louisiana. At the age of fifteen she moved to Melrose Plantation and stayed the rest of her life. She started working as a field hand and later was "promoted" to working in the house. Before painting, she demonstrated her artistic abilities in many ways. She made clothing and dolls for her children, wove baskets and made intricate quilts. The owner of Melrose Plantation, Cammie Henry, invited artists and writers to stay there while they worked on their art. Hunter found some discarded paint, painted on old window shades, and never stopped. Painting became an obsession with her. She painted on any surface she could

find. Her themes were plantation workers in the fields, recreational scenes, religious scenes, and painted flowers. She also did a few abstract paintings. Numerous written works describe her life and work. A new book containing her early drawings in notebooks was published in 2015 (see Selected Books since 2000).

Hunter, John L. (1905–1999)

The Rev. John L. Hunter was born March 17, 1905, in Taylor, Texas. His father died when he was a baby and his maternal grandparents raised him. In 1918 he and his mother moved to Dallas. He married in 1928 and started carving occasionally while still working. In 1936 Hunter received his religious calling and attended Southern Bible College in Austin. The Hunters moved to Texarkana where he was a pastor for 13 years, and then to Sherman where he pastored for eight years. The Hunters returned to Dallas in 1962, and Hunter became senior minister at True Light Baptist Church in south Dallas. In his nineties he still preached and carved regularly, usually tree branches or other found wood. He used a knife, a saw, and sometimes a drill to make his colorful sculptures. He removed only a minimal amount of the original piece of wood. The appendages for his figures were carved and attached with nails or glue. His figurative sculptures were mostly gunfighters, couples, or walking men. The figures are painted. Hunter was included in the exhibition "Spirited Journeys: Self-Taught Texas Artists of the Twentieth Century." He died June 28, 1999, at his Dallas home.

Hupenden, Ernest (mid–1800s– 1911)—"Painted Forest"—Valton, Wisconsin

The "Painted Forest" consists of murals covering the walls of a 33-foot by 60-foot lodge hall that once was the local headquarters for a fraternal insurance organization, Modern Woodsmen of America. They were painted by Hupenden beginning around 1898 and restored by the Kohler Foundation in the 1980s. Lisa Stone calls them "a brilliantly cohesive personal vision." After restoration the site was given to Sauk County and initially maintained by the Historical Society of Upper Baraboo Valley, but was returned to the foundation in 2001 when Sauk County could no longer support the site. It is now managed by the Edgewood College Art Department in Madison, which can be contacted for further information.

Hussey, Billy Ray (b. 1975)

Hussey was born in Robbins, North Carolina, near the Southern pottery area of Seagrove. He made his first sculpture at the age of ten while working for his uncle, M.L. Owens, at Owens Pottery. His first face

jugs were actually jugs turned by M.L. Owens on which he made the faces. Billy Ray is the only folk potter who works in both earthenware and stoneware. He makes humorous face jugs and figures of animals and people. Billy Ray Hussey's work is widely collected and he and his wife, Susan, head the Southern Folk Pottery Collectors Society. In 1997–98 there was an exhibition of his work, "Billy Ray Hussey: North Carolina Visionary Potter," at the Mint Museum of Art in Charlotte, North Carolina, which included a catalog. Hussey now runs the Southern Folk Pottery Collectors Society Shop and Museum in Robbins, North Carolina.

Hutson, Charles W. (1840–1936)

Hutson was an early New Orleans self-taught artist. He was born in South Carolina, fought in the Civil War, and was captured by the Yankees. He was a teacher for many years and moved to New Orleans in 1908. Hutson started to paint at age seventy when he retired from teaching. In his earliest years as an artist, he produced several hundred pastel sketches, which he "worked with great delicacy, all delicately and finely drawn." In the 1920s he turned primarily to watercolors, with some pastels and oils, using "much bolder methods of grouping shapes and gave greater attention to patterns." He became more abstract in his last years. His major subject matter was New Orleans, the Gulf Coast, and nature in Louisiana and Mississippi. There were approximately thirty exhibitions of his work, including at the Delgado (now New Orleans) Museum of Art and The Phillips Collection. Museum collections that have his work include: Lauren Rogers Museum of Art in Laurel, Mississippi; The Phillips Collection in Washington, D.C.; Montgomery Museum of Fine Arts in Alabama; and the Mint Museum in North Carolina.

Hutt, Billie (c. 1925–2007)

Billie Hutt was born in Brooklyn, New York, in 1925 or 1928. She was a painter of memories, in this case of growing up and being raised in the Flatbush section of Brooklyn. She got started painting in the 1980s when "fooling around with some leftover house paint." Hutt lived in Santa Fe, New Mexico, toward the end of her life, and added images of Santa Fe to her work.

Hych, Emitte (1909–2009)

Emitte Hych spent the first thirty years of his life living in rural Mississippi. As a young man he worked as a sharecropper picking cotton. During the 1940s he moved to the Midwest to live with his sister there. He had experience as a cook in Mississippi and this led to work in the North. In the mid–1980s he started decorating the inside of his house with stencil painted designs on the walls, polka dots on the ceiling, and old

oil drum lids painted and hung outside all over his trees and fences. He said "the Lord showed me what to do." Hych drew simple whimsical scenes of men, women, snakes, elephants, cotton, and imaginary plants. Once he retired he spent most of his time working in his large garden and drawing for relaxation in the evening. His work is available from The Pardee Collection in Iowa City.

Ignazio, Elizabeth Willeto (1926–2011)

Ignazio was a Navajo carver who lived near Nageezi, New Mexico. She made cottonwood figural carvings that were partly imaginary and partly ceremonial representations. She painted detailed designs on the figures. Her first husband was the now-famed carver Charlie Willeto. *See also* Willeto, Charlie.

Isik, Levent (b. 1961)

Levent Isik was born in Istanbul, Turkey, and grew up in Montreal. He lived in Cleveland before settling in Columbus, Ohio, where he now lives close to downtown in a loft. Isik is a self-taught artist who started painting in 1990, inspired by the works of other Columbus artists. Isik says his main influences are Elijah Pierce, William Hawkins, and Mr. Imagination. Isik says he tried to be a part of the "art scene" but never got any work done, and he says he "doesn't know how to talk about art." He paints twelve to fourteen hours a day, producing "mixed-media paintings" that often have three-dimensional qualities thanks to layers of wood and sometimes other materials. He paints cityscapes, wildly fanciful animals, superwomen, and angels, using a variety of patterns, colors, and built-up surfaces. His work has been shown in many galleries and folk art publications. He is often shown at Raw Vision Gallery in Columbus, Ohio. He maintains his own Facebook page (Facebook: "Works by Levent Isik") and sells his own work. Lisik61@yahoo.com and 614-477-2528 are contact points.

Jackson, Boosie (1881–1966)

Jackson was born in Union Springs, Alabama. He was a carpenter, tombstone maker, fix it man, and artist who, without any training or much formal schooling at all, achieved considerable sophistication and perfection in his art. He created a menagerie of brightly painted cement monsters around his house, including a ten foot high cement milk pitcher and large, foreboding creatures such as nail-toothed serpents and open mouthed alligators that appear to have had the job of "protecting his home from evil" by scaring away ill wishers. None of his work remains intact except a few isolated pieces, discovered and salvaged by Anton Haardt just a few days before the site was completely demolished. Jackson also carved walking canes and

painted on paper. One of only three of his paintings known at this time is a large enamel-on-Masonite piece entitled "This Is a French African Building," which depicts a large building supported by two oversize dogs, and is in a carved wood frame incorporating images of common Southern delicacies such as sweet potatoes, watermelon, corn, and turnip greens. The few Jackson pieces that remain may be seen (but not purchased) at the Anton Haardt Gallery in Montgomery.

Jacquez, Larry (b. 1968)

Jacques was born in a small town in northern New Mexico and went to school on the Jicarilla Apache Indian Reservation. While there he learned several skills for making art, which he put to use when he left school at the age of 16 and met David Alvarez, a famous Mew Mexico carver. He worked for and with Alvarez for several years, learning the techniques of creating traditional folk art such as bultos and retables of angels, saints, and nativities. He also learned to make coyotes and virtually any other animal, wild or domesticated. He now carves these figures using driftwood gathered from the shores of local lakes or cottonwood that grows along the Rio Grande. His work is much in demand locally, and has a widespread presence in much of New Mexico. His work is available through the Santa Fe Indian Trading Company.

Jamison, Mercedes (1933–1997)

Mercedes Jamison was born, lived, and died in Queens, New York. She had a lengthy history of mental illness. While recovering from a physical illness in a healthcare facility, she suffered a fatal heart attack. Until the onset of her physical illness she drew and painted regularly, completing some of her finest works in her later years. She used any medium that was available to her, but later works favored acrylic paint in the color yellow. Her works—landscapes, animals or faces—usually include a smiling sun. Jamison was part of HAI, Inc.

Jarrett, Alvin (1904–1993)

Alvin Jarrett was born near Rockvale, in central Tennessee, and later resided in the town itself. He carved old red cedar—a wood he called "slave wood" because it "has been around since the time of the slaves." He made many forms, including totems, walking sticks, and small jointed figures that often are seated on chairs.

Jarvi, Unto (1908–1991)

Jarvi was born in Saaksmaki, Finland. He came to the United States at the age of eleven with his mother and two sisters to join his father. He worked for fifty years in construction, in nearly every state. In 1971 he settled in Kentucky with his wife Bernice, a native of Logan County. He had first started painting in 1959 to pass time while recovering from an accident. When he came to Kentucky he began again, painting landscapes and rural activities. His most distinctive creations are shallow boxes faced with glass in which he arranged carved figures in front of a painted background.

Jennings, Harry (b. 1966)

Jennings was born in southwestern Virginia but lives today in Kentucky. He has been carving since he was about 15 years old. His first pieces were animals made from twigs, but now he carves entire figures. His small works are fully cared and depict a wide range of characters—men, women, and children—with a variety of appearances. Some of his human figures stand as high as five feet tall. Jennings' other works include distinctive caricatures of famous people and part-twig/part-carved rooster. His work is in the permanent collection of the Kentucky Folk Art Center.

Jennings, James Harold (1931–1999)

Jennings was born in Pinnacle, North Carolina. He lived with his mother until she died in 1974. She was a schoolteacher, and tutored him from the fifth grade on. This well-known North Carolina artist made wooden constructions that offer a great variety of figures and groupings. He made Indian figures, Elvis with guitar, angels decorated with symbols which reflect his religious beliefs, birdhouses, "Tuff" women beating up on men and or the devil, and some very large pieces such as his "Folk Art World" and his Ferris wheels. Jennings' artworks are very brightly colored and patterned. The artist has appeared in numerous exhibitions and his work is illustrated frequently. James Harold Jennings used to welcome visitors, but in his last years found it difficult and upsetting. Concern about his ill health and other matters led to his death by suicide in April 1999.

Jimenez, Alonzo (1949–2005)

Jimenez was born and lived his whole life in Santa Fe, New Mexico. He spent a great part of his childhood and adolescence helping his grandfather herd goats. "There were no kids to play with. My family didn't have a car or a TV, but I always had a knife in my pocket to carve with." One day Jimenez met Felipe Archuleta while hitchhiking. "Felipe right away wanted me to work…. Felipe made me laugh all the time. He spoke Spanish all day. Felipe loved me because I could stand a piece up real fast." Four productive years and a mutually beneficial relationship were the legacy of this chance encounter. In 1978, Jimenez started carving on his own, making animal woodcarvings of every size and description. He is perhaps best known for his cats, various African animals, and coyotes. His work is in the collections of the Albuquerque Museum of Art and the Museum of International Folk Art in Santa Fe and can

be purchased at Davis Mather Folk Art Gallery in Santa Fe.

John, Edith Herbert (b. 1961)

Edith Herbert John lives in Sweetwater, Arizona. Edith John, daughter of Woody Herbert, has been making cottonwood carvings since 1990. She started out for the pleasure of it, but continues because it is a good source of much needed money. She once spent time carving alongside her father, but her work is very different. John has made a whole series of rough but appealing owls in a variety of colors; another Navajo carver of "bad luck" owls that have brought economic good luck. She is written about in *The People Speak.*

Johns, Jas (1941–2003)

Johns was born in Atlanta, where he attended an Episcopal boys' school for troubled youth. He earned a master's degree in technology education and taught at a middle school. He was known for his elaborately framed and decorative paintings, *papier mâché* sculpture, and mixed media pieces that incorporated beads, buttons, and other found objects. He regularly exhibited his pieces at Folk Fest in Atlanta and Kentuck in Alabama. His work is included in *Coming Home! Self-Taught Artists, the Bible, and the American South,* by Carol Crown.

Johnson, Anderson (1915–1998)

Anderson Johnson was born in Lunenburg County, Virginia, and lived in Newport News. The son of a sharecropper, he received his first message from God when he was a small boy, but waited until he was sixteen to go and preach. He was a street preacher and had congregations in many cities before moving to Newport News in 1985 after an accident left him partially paralyzed. He converted the first floor of his house into a church which he called his Faith Mission, and where he held Sunday services. The walls of his Faith Mission were covered inside and out with hundreds of paintings, mostly of women's faces and usually done on salvaged plywood or cardboard. In 1993 his house was demolished for an urban renewal project, but his wall murals were saved. His work has appeared in the exhibitions "Folk Art: The Common Wealth of Virginia," "Virginia Originals," and "Flying Free." His work is now on permanent display at the Anderson Johnson Gallery at the Downing Gross Cultural Arts Center in Newport News, Virginia (see Museums).

Johnson, Eurelia Elizabeth "Mama" (1918–2011)

Mama Johnson was born June 21, 1918, in Tampa, Florida. Her husband Willie died in 1976. She spent most of her life doing missionary work for her church and the community, primarily taking care of the sick. Although she had only one son, Herbert Randy Harris, she was called "Mama" by dozens of others. Mama Johnson always liked to make things to give to the children, using whatever she had around the house to make her art. An empty plastic ketchup bottle became the base for a figure, a plastic milk carton was cut to form a doll with a fancy hat. She had her dolls, birds, and other art covering every room in her house. In addition to making assemblages, Mama Johnson also painted. Her favorite subjects were "people doing good." Sometimes her subjects were alter-ego aliens, which she saw everywhere. With God's direction, Mama Johnson made a special ointment that helped with memory loss, arthritis, and other ailments. People told her that she had "something in her hands" that gave her healing powers. Main Street Gallery in Clayton, Georgia and Hustontown in Fort Louden, Pennsylvania carry her work.

Jones, Clyde (b. 1938)—"Haw River Animal Crossing"—Bynum, North Carolina

Clyde Jones was born on a farm in central North Carolina and now lives in Bynum. As a teenager he moved to a company town to work in a textile mill. Ten years later he began working as a day laborer, construction worker, and part-time pulpwood logger. He injured himself severely with a chainsaw in 1979, and to pass time during his long convalescence he created animal forms from roots and stumps. The animals grouped together in his yard form an environment he has named "Haw River Animal Crossing." The house and yard are filled with incredible numbers of creatures. Clyde Jones carves large roots and stumps with a chain saw. Many are further enhanced with house paint and found objects such as tennis ball "eyes," plastic eyelashes, and artificial flowers in their "hair." They look absolutely great together in his yard, and Jones does not like to sell them. In November 1987, Jones started painting with enamels and oil paints on plywood and paneling. Jones enjoys visitors, especially children. Some of his artwork has found its way into galleries. His environment was featured on Roadside America in December 2014; several videos on YouTube depict Jones and his "Crossing." His art is available on eBay.

Jones, Frank (1900–1969)

Frank Jones was born near Clarksville, Texas. His life was filled with tragedy. His father deserted his family just after Jones was born. When he was three his mother abandoned him on a street corner. He was taken in by a woman he called Aunt Della. He had one miserable experience after another. In 1949, Della Grey was murdered, and Jones was convicted of the crime,

though it was generally believed by all but the authorities that he was innocent. Jones served a life sentence and died at the prison in Huntsville, Texas. While in prison he began drawing a series of "devil houses." There is much written discussion and information about his work.

Jones, M.C. "5¢" (1917–2003)

Jones was born in Eagle Shute, Louisiana, and lived for a good part of his life on the J.W. Lynn Plantation between Belcher and Gilliam, where he was a laborer. He later lived in Gilliam, where he enjoyed trading art with his grandchildren and great-grandchildren. He painted Bible stories and made memory paintings of plantation life, with some unusual touches—"he has been known to make the overseer black and the laborers white." Occasionally a palm tree appeared, placed there because of something Jones saw on television. His works reflect the rural life he lived and his religious beliefs; he also painted nudes and self-portraits. Marcia Weber/Art Objects in Montgomery, Alabama and Yard Dog in Austin, Texas carry his art, which is also in numerous museum collections including the Smithsonian American Art Museum.

Jones, S.L. (1901–1997)

Shields Landon "S.L." Jones was born in Indian Mills, West Virginia, and lived near Hinton, in the New River Gorge area. For 47 years he worked as a carpenter-foreman for the Chesapeake and Ohio Railway. His abiding artistic passion was the fiddle and banjo, which he taught himself to play. He also did some whittling and painting in the 1950s, before he retired. Jones retired from the railroad in 1967 and started carving in earnest. His famous carved heads were usually asymmetrical; he roughed them out with a chain saw, and then refined the sculpture with hand tools. In his later years he had a stroke and had to give up carving for painting. For awhile he recovered his strength, after the stroke, and was able to do a little carving. In his last years he did mostly drawings. Horses were one of his favorite subjects. His work has been included in many exhibitions and is in the permanent collection of the Smithsonian American Art Museum.

Jordan, John (b. 1919—no further information available)

John Jordan was born in Stamford, Connecticut, on February 16, 1919. He began sculpting by making his own toys. As an adolescent he worked with a local junkman. After World War II he had his own truck and began to search out discarded objects to use in found-object sculpture. In the 1950s he did floor refinishing and carpentry, which gave him access to fine woods, and he began to carve black walnut, cherry, and cedar.

Since he retired he works at his art full-time. He makes woodcarvings and found object sculptures. His art was exhibited in a one-person show, "Working Hard: The Art of John Jordan, Drawings, Paintings, Wood Carvings, Found-Object Art," at the College of New Rochelle [New York], curated by Dan Prince. Prince writes about the artist in his book *Passing in the Outsider Lane.*

Jordan, Tom (b. 1955)

Tom Jordan was born in Syracuse, New York, and lives in Asheville, North Carolina. He studied forestry and graduated from Cornell with a degree in natural resources in 1978. For several years he worked for the National Forest Service in Montana, then held a variety of jobs as a park maintenance man, an assistant geologist, and a house painter. Then he moved to North Carolina and painted sets for the film industry in Wilmington. Since 1990 he has worked as a wholesale produce delivery person while raising a son as a single parent. During the time he was studying forestry, Jordan began making art from materials found in the woods. After ten years of working at it, spruce cone scales, red-oak leaves, rose thorns, sycamore leaves, and many other forest "products," along with Elmer's Glue, became a large dragon, followed by other fanciful creatures. His work was in the exhibition, "Tree of Life" at the American Visionary Art Museum.

Joy, Josephine H. (1869–1948)

Joy was born in West Virginia and lived from 1936 to 1942 in Southern California. Her art was included in the exhibition "Cat and a Ball on a Waterfall" in 1986. She died in Peoria, Illinois, in 1948. Her work is in the collection of the Smithsonian American Art Museum.

Juneau, Pat (b. 1947)

Pat Juneau was born on November 2, 1947, in Alexandria, Louisiana, where he went to Catholic school for 12 years under the stern watch of the Brothers of the Sacred Heart. Although art was never part of his education, he always loved making things, probably influenced by his father, who grew up very poor during the depression in rural Louisiana. If his family needed something they traded for it or built it themselves so he became quite good at "inventing" all sorts of weird devices. He earned a degree in sociology from the University of Southwestern Louisiana, taught for a year, and realized teaching was not for him. He and his wife, Suzanne, opened a shop/gallery selling hand made things, where they met people on their way to an art show. They explained that you got to travel around the country and sell whatever you wanted to make and you didn't have to spend six days a week sitting in a shop that you had to pay rent on every month.

That sounded good to the Juneaus. At that time they both made jewelry from many different metals. They lived in the Atchafalaya basin for 15 years, and spent the better part of their days driving themselves and their kids back and forth to school and other things. Once they moved to town, Juneau acquired a much larger workshop/studio in the form of a large 100 year old cypress barn, so he started experimenting with various forms of metal sculpture until he settled on constructed steel painted in a folk art style, which he has made for the past 25 years. He cuts figures from plate steel, paints them, and then mounts them over a painted plywood background. It has been said that his images are "simply striking." Along with his wife, who makes fine jewelry, Juneau sells his art at many different art fairs around the country. Every month he is at the Arts Market of New Orleans in Palmer Park; he exhibits at the New Orleans Jazz and Heritage Festival and at the Kentuck festival in Alabama. He ranges as far afield as Michigan and Baltimore, where he has participated in the juried Baltimore Craft Show organized by the American Craft Council. One can also see and purchase his art through the website he shares with his wife and daughter, www.psjuneau.com. Or call him at 337-654-6731.

Kahler, Frederick (b. 1942)

Kahler was born in Washington, D.C. In 1942. He was adopted, an only child, and was educated through high school. He enlisted in the army a few years later, where he painted murals for the Airborne Chapel and designed and built a bell tower at Fort Benning. He was married to his wife, Mary, for 42 years, until she died in 2008. She supported his drawing, and they were very close. In the early 1970s Kahler began making minutely detailed drawings, using watercolor and ink applied with a steel-tip pen. Each drawing takes months and sometimes years to complete. He may draw for as many as 12 hours a day. His works include mythological narratives, ancient landscapes, or metaphysical themes. His drawings may give the sense of gazing at galaxies or viewing light through stained glass. He takes his inspiration for this imagery from the mythologies of many civilizations. For all his involvement with ancient worlds, though he has no formal art training and little familiarity with mainstream art. Kahler's work consists of approximately 100 ink drawings of various sizes, and some etchings. About one-third of his work is in private collections. His work has been exhibited at the Outsider Art Fair in New York and at Intuit in Chicago. He has been in several exhibitions at the American Visionary Art Museum in Baltimore, which has some of his work in its permanent collection. His work is also in the permanent collection of the Smithsonian American Art Museum. He sells his own art on the Web at www.frederickkahler.com.

Kale, Richard (b. 1960)

Richard is a Catawba County potter who worked with his father Harry (b. 1912) and turned his first face jug in 1986 or 1987. In 1992 he was diagnosed with having muscular dystrophy and left his long-time job with a cable manufacturing company to become a full-time potter. Most of his ware is alkaline-glazed, with a smaller percentage being cobalt, rose, or hunter green glazes. His wife, Jane, and son, Jamie, also make face vessels. Jamie (b. 1977) also makes other figurative pieces. Richard lives in Catawba, North Carolina, and can be reached at 828-241-3269.

Kalista, Cathey (b. 1934)

Cathey Kalista was born June 8, 1934, in New York City. She is a retired waitress and has lived in West Palm Beach, Florida, for 25 years. Although she has never had art lessons, she has been painting "ever since she was old enough to hold a paintbrush," and will paint on any surface or object she can find. She gets up early on trash day to go out and rescue other people's rejects to turn it into an art object; an old bed post becomes "the post people, with smiling, happy faces," a piece of an old drawer becomes "the home of a sweet child selling watermelon." Cathey hates to see so many things thrown away while trees continue to be cut down. Cathey Kalista has had her work shown in exhibitions and in collections in London and Ireland. Cathey signs her paintings "YEHTAC," Cathey spelled backward, stating she feels younger every day and is going backwards in age. She is featured in *Extraordinary Interpretations: Florida's Self-taught Artists*, by Gary Monroe, and is in the collection of the Polk Museum of Art in Lakeland, Florida.

Kammerude, Lavern (1915–1989)

Kammerude lived in Blanchardville, Wisconsin, and painted Midwestern rural scenes based on his memories. Starting painting late in life, he depicted the seasons of farming in oils on Masonite. His work was in the collection of the Wisconsin Folk Art Museum in Mt. Horeb but, after that museum closed, his work was moved to the Wisconsin State Historical Society in Madison.

Kane, Andy (b. 1956)

Kane was born in New York and now lives sometimes in Philadelphia and sometimes in Chicago. He used to do "very primitive work" but has changed his style of late and says he "wants to be a real contemporary artist." He did not complete high school. His art is in the collection of the American Folk Art Museum. Kane works in oil on canvas, painting with strong colors. His earlier images were said to have a "pictographic quality."

Kane, John (1860–1934)

John Kane is numbered among the earliest of the twentieth century self-taught artists of importance. Biographical information is available from many sources. He was born in Scotland and lived in Pittsburgh as an adult. It has been said that "no artist equaled John Kane in portraying the industrial scene." For detailed information about him, read *John Kane, Painter*, by Leon Anthony Arkus. Kane's work is in The Phillips Collection, the Museum of Modern Art, the Museum of Art of the Carnegie Institute, the Parrish Art Museum, the Metropolitan Museum of Art, and the Whitney.

Kapunan, Sal (b. 1932)—Taoist Environments—Florida and North Carolina

Sal Kapunan is a visionary artist who was born in the Philippines. He is very well educated in philosophy and education, but he is untrained and self-taught in art. He has created two garden environments of note, one in Cape Coral, Florida, and one in Boone, North Carolina. His many outdoor sculptures of cast-off and found objects grace his two gardens, and his piece, "Gertie," greets visitors to the Appalachian Cultural Museum. He sees himself as on a cultural continuum, no longer of the Philippines where he was born and raised, but not entirely American either. Kapunan guides his art using the philosophy of Taoism. To explain his art and his philosophy, he wrote *My Taoist Vision of Art* published by Parkway Publishers in Boone, North Carolina, in 1999. The book contains many pictures of his artwork. He as written other books with a focus on self-education, including *Surviving World War II as a Child Swamp Hermit: Transcending Illiteracy and Ignorance* (published in 2006).

Karr, William (1929–1996)

Bill Karr was born in Rochelle, Illinois. He spent most of his life on a farm in Belvidere. His only time away from the Midwestern farm life came in 1953 when he joined the army. After that he briefly tried farming again, then left to work for an industrial company. His last employment was at the Chrysler Company in Belvidere. Eventually a lifelong struggle with asthma forced him to leave on medical disability. Karr started making and selling hand-carved animals to pay for his medicine. Farm animals were among his earliest subjects. He had a strong love for animals and would not hunt, and pigs and goats became pets to him. His figures were carved wood, paint and mixed media. Examples of his art appeared in the exhibition "Within Reach: Northern Illinois Outsider Artists," at the Rockford Art Museum in 1998.

Kass, Jacob (1910–2000)

Jacob Kass was born in Brooklyn, New York and lived in a number of places before ending up in Indian Rocks, Florida. His working life was spent painting wagons and trucks, where he specialized in fine detail painting. He invented several painting techniques still in use today. After retirement he began painting on tools, mainly on old hand saws. His subject matter was scenes from rural Vermont, as well as memories of his early years in New York City. He had exhibitions in several New York galleries as well as Florida venues including the University of Miami, the Brevard Art Center and Museum, and the Mennello Museum of American Folk Art in Orlando.

Kay, Edward A. (1900–1988)

Kay was born and raised in Detroit, Michigan. His observations on nature, politics, and urban life were reflected in his art. Influenced by his fascination with Native American culture, he made totems and installed them in his yard. His political images are outstanding and irreverent. His work is in the collection of the Smithsonian American Art Museum.

Keaton, Noah (b. 1933)

Keaton was born in New Boston, Ohio and now lives in South Shore, Kentucky. He worked as a welder and boilermaker most of his life, taking up carving as a pastime only since his retirement. He started out doing welded pieces in metal along with carving axes, guns, busts, knives, and animals. He never thought anyone would be interested in what he could do, but he was encouraged to pursue his carving by fellow carver and folk artist Linvel Barker. Barker also encouraged him to visit the Kentucky Folk Art Center and show his work to museum staff. His work is now in the permanent collection of the Kentucky Folk Art Center.

Keeton, Barbara (b. 1953)

Barbara Keeton was born in Paintsville, Kentucky, and now lives in Martha. Two of her four daughters are married, and she is a grandmother. Barbara Keeton began painting in 1992, using acrylics on paper. She uses strong color and a flat presentation in the naive style. She paints her Kentucky environment—the people and places she knows. She also paints biblical stories. She sells her works directly: call 606-652-4981.

Keeton, Charles (b. 1946)

Charles Keeton grew up in eastern Kentucky, and had no education beyond elementary school. He says it has meant he has had to work very hard for very little pay. He says he would not have made the first thing without the encouragement of Minnie and Garland Adkins, but with them he "just started." Among the animals he carves are panda bears, cows with calves, a

mother dog with three puppies, horses, and skunks. He paints his woodcarvings.

Keith, Selma (1913–1999)

Keith lived his entire life in Floyd County, Virginia. He was a carpenter and construction worker before he retired. When he was a child he liked to paint and draw, but his family told him it was a waste of time. He was forced to retire because of ill health and took up painting scenes on saws, glass jugs, dustpans, and kerosene heaters, and also made snakes. Most of his painted scenes included log cabins, animals, and people in a rural setting, reflecting his live for the mountain culture of his boyhood. He was included in the exhibition "Folk Art: The Common Wealth of Virginia."

Kelley, Lavern (1928–1998)

Born and raised in Oneonta, New York. He received no encouragement from his family for his art and never thought of himself as an artist. He worked as a subsistence farmer for over fifty years. He was a wood-carver, making and painting human figures, farm equipment, trucks, and cars. Early drawings of his, made in the 1950s are sometimes available. In 1978 he had a logging accident that cost him an eye, crushed his leg, and precipitated a heart attack. Following hospital recuperation he returned to the family farm where he lived with his brother. In the summer of 1986 he was one of the state's first folk-artists-in-residence at a gallery in Cooperstown. There is an illustrated catalog of his work, *A Rural Life: The Art of Lavern Kelley*. His works are in the collections of the Smithsonian, Fenimore House in Cooperstown, and Hamilton College. He was included in the exhibition "'Twentieth-Century Self-taught Artists from the Mid-Atlantic Region," at the Noyes Museum in 1994. Kelley died suddenly of pneumonia, December 11, 1998.

Kelley, Steven J. (b. 1962)

Steven Jude Kelley is a dairy farmer from Wisconsin. Married and with three children, he has been an artist all his life. For years the artist has crafted "regenerative art" from discarded material: tree roots, machinery or wooden debris from his barnyard, old barbed wire, and rusty nails are among the recycled objects used in his art. When he uses his natural media he thinks about the tones, the lines, the focal point, and how something as simple as a tree root can bare its soul. Art is for Kelley an opportunity for creativity and for escape from the hard labor and harsh realities of farming life.

Kemplin, Bob (b. 1948)

Kemplin was born in West Liberty, Kentucky, and now lives in Newfoundland, a small community in Elliott County, Kentucky. He decided to paint in the late 1990s. He used oils on canvasboard and he didn't enjoy it, so he gave it up. About a year ago he was talking to artist Minnie Adkins and she encouraged him to try again. This time Kemplin painted with acrylics and found much more pleasure in what he was doing. His themes are country life, with a concentration on the architectural aspects of a scene. Bob has painted old houses, covered bridges, the occasional chicken, cat, or dog, and a few stick-figure people in the landscape. Bob receives telephone calls at 606-738-6139.

Kendrick, Eddie (1928–1992)

Eddie Kendrick was born in Stephens, Arkansas, was raised on a farm, and went to school through the seventh grade. He was the oldest of thirteen children. Kendrick moved to Little Rock, where he worked as a school custodian and was first recognized there by a teacher for his paintings on paper. Kendrick used pencils, crayons, watercolors, and occasionally oil paints. Kendrick, a deacon of his church, was a deeply religious man who believed he was charged by God to make religious paintings. His work was inspired by the Bible, music, and dreams. An exhibition "The Art of Eddie Kendrick: A Spiritual Journey," curated by Alice Yelen, opened in September 1998 at the Arkansas Arts Center and traveled to the New Orleans Museum of Art.

Kennedy, Janice Yvonne (b. 1941)

Janice was born the fourth of six children in Harbins, Georgia, 35 miles from Norcross. She started working in the fields as a sharecropper while still a child, after her father made her drop out of school. She says "that by the age of ten she could pick one hundred pounds of cotton in a day." Kennedy tells of a very painful and impoverished family life, and a father who was so abusive to his wife and his family that she believes he was probably "possessed." She wanted to write a book about her life, but "it would have been too cruel." Instead she "paints what's in my heart and soul," and "gets lost in the painting." She now lives in Tampa, Florida with her second husband, has three children and three grandchildren, and is "a born again Christian." In spite of the pain of severe arthritis, she works at her art every day. She says that when she starts a painting she asks, "Lord, what would you have me paint today?" Kennedy loves to make something out of items around the house. She has made quilts, painted furniture, and loofah sponge dolls. Her subject matter is the rural South where she was born. She likes best to paint with acrylics on Bristol board. She paints on her kitchen table when sunlight permits, and has been known to turn her paintings upside down "to get the best effect."

Kennedy, Leon (b. 1945)

Leon Kennedy was born in Houston, Texas, and

moved to the San Francisco Bay Area in 1965. He started drawing with pencils when he was very young. Now he paints mostly on cloth. His art frequently deals with the struggle of peoples' fight to be free. Recently it has been more spiritual than political. He uses mixed media on found objects to paint ecstatic visions, memory paintings, and black urban life portraits. The artist says "My art has a way of communicating. It brings people together." His work has been exhibited at the University of California Heller Gallery in Berkeley, at City Hall in Richmond, California, at Stanford University, and many other California venues. In 1997 the Smithsonian American Art Museum acquired a bedsheet by Kennedy as part of an acquisition of 200 works from the Rosenak collection. You can see his art and hear him talk about his art on a YouTube video posted on May 4, 2014 (https://www.youtube.com/watch?v=XY2ZQWWiJPQ).

Kent, William (b. 1919)

"Trained as a musician and self-taught as an artist, William Kent has spent his life carving giant, larger than life sculptures of everyday objects such as jackets, trousers, forks and fruit as he strives for perfection of form and substance."

Kessler, Fred

Kessler grew up in the swamps of eastern North Carolina. He built his first boat at the age of twelve, aided by his father. He later spent two decades building steel tugboats. He started cutting animal figures out of scrap steel leftover from his boat building. The steel animals and plants he makes reflect his love of nature, and range from a majestic moose to a hissing cat.

Kibbee, Dot (b. 1916)

Dot Kibbee was born in Hardwick, Massachusetts. She worked as a community nurse for many years and supported herself and her two sons. She is a painter and a "star" of the G.R.A.C.E. art program. She is very popular with collectors. Her style of painting is unique and features heavily patterned renderings of imaginary landscapes inhabited by snakes, butterflies, turtles and tiny people. Her artwork is in many private collections and has been exhibited throughout the region as well as nationally and internationally. She was the subject of a 2004 publication. *A Triumph of Spirit Dot Kibbee: Her Life and Art.*

King, Rothel (b. 1964)

Rothel King was born in Wolfe County, Kentucky, on January 13, 1964. He graduated from high school and has worked as a coal miner and in construction. He built a cabin in eastern Kentucky where he lives with his wife Marilyn and daughter Katie. King has only been carving for about four years. He said he was bored once when the electricity went out, and started carving small heads with a box cutter. His neighbor Donny Tolson saw the heads and suggested King carve the whole figure, and with a good jack knife. He took the suggestion, and also added a chisel to his tools. Another well-known carver, Earnest Patton, gave help and encouragement. King makes heads, snakes, and full figures, most often with other objects to create complex scenes, such as "Ezekiel in the Valley of Dry Bones," in which the prophet is portrayed standing, surrounded by white human bones. In addition to religious scenes, King does popular and narrative subjects inspired by neighbors and by newspaper and other articles. He usually writes an explanation on the bottom of the piece.

Kingsbury, Ida Mae (1919–1989)

Kingbury created a most wonderful paradise of flowers and shrubs crowded with fantasy characters and animals in her yard in Pasadena, Texas. The story of the last-minute rescue of this folk art environment by Orange Show Foundation director Susanne Theis, with the help of friends, is very interesting. Theis struck a deal with the rubbish hauler who was at the site to cart it all away and with the help of volunteers saved a large portion of Ida Kingsbury's art. One hundred of the best pieces (there are about 500 altogether) were shown at the Houston Children's Museum in 1990. Since about 1990, some very dedicated people who formed the organization Friends of Ida Mae Kingsbury have tried to raise the money to build a site for a permanent installation of the work. They were not successful. However, in 2005 The Grassroots Art Center in Lucas, Kansas (see Museums) acquired about 150 of Kingsbury's pieces, which are now displayed in Lucas—the Center's first acquisition of works by an artist from a state other than Kansas. There is an extensive article about Kingsbury and her garden in *Paint the Town Orange* (see Selected Books). There is also a book by Tom LeFaver, *Ida Mae Kingsbury's Fantasy Yard*, that includes many photographs as well as some articles about the garden from local newspapers. The Webb Gallery in Waxahachie, Texas has offered pieces of Kingsbury's art for many years (see Galleries).

Kinney, Charley (1906–1991)

Charley Kinney lived in Toller Hollow, Lewis County, Kentucky for his entire life. He was known not only for his art but for a lifestyle with an unbroken connection to the past. He once made clay busts of famous figures which he sold at state parks. After that he started drawing and painting, and his work proliferated after he stopped farming tobacco. His paintings told a story, often about local history, legend, and observation. He is described in many written sources, including the numerous catalogs of exhibitions in which

his work was included. "Terrors, Holy and Otherwise: Works by Charley Kinney" was an exhibition presented at the Rasdall Gallery of the University of Kentucky in 1992. Curated by Julie Ardery, it was Charley Kinney's first one-man show. His work is available from Marcia Weber/Art Objects, and is part of the permanent collections of many museums, including the Kentucky Folk Art Center, and the Birmingham, High, Huntington, Owensboro, Milwaukee, and New Orleans Museums of Art.

Kinney, Hazel (1929–2009)

Hazel Bateman Kinney was born in Mason County, Kentucky, and lived, after her marriage to Noah Kinney, in Toller Hollow, near Flemingsburg. After Noah died Hazel began painting. She made drawings on paper or any other surface she could find. Her earliest drawings were on scrap lumber. She painted with oil crayons, markers, "whatever suits the material." Hazel painted some biblical scenes, but often she painted the countryside, farm animals, and the goings-on around her. Everyone who saw her work said it got better and better the more she worked. Her work is in the permanent collections of the Kentucky Folk Art Center and the Southern Ohio Museum and Cultural Center in Portsmouth, Ohio.

Kinney, Noah (1912–1991)

Born in Toller Hollow, Kentucky, and like his older brother Charley he never traveled far from home. He was known for his carved wood figures of animals. A trip to the Cincinnati Zoo in the late 1980s expanded his repertoire of figures. Noah said, during a visit in 1991, that he "would have liked to have been a doctor but it was out of the question for a poor boy." He stayed on the family farm, was married thirty years, and in addition to entertaining visitors and neighbors with hand-carved puppets, he read a lot of history, anatomy books, and books about contemporary world events. His work is in many publications and in the permanent collections of the Kentucky Folk Art Center, the Kentucky Museum of Art and Craft, and the Southern Ohio Museum and Cultural Center in Portsmouth, Ohio.

Kirshner, Robert (b. 1955)

Robert Kirshner has lived in the Boston area all of his life. He began drawing in the 1960s after seeing the Prudential Center construction site. It is likely that his interest in drawing came about in part because it gave him a means of expression; "Bob knows what he wants to say, but no words come out, no matter how hard he tries." As he learned to read and write, he added words to his drawings to further communicate the experience of his environment. Bob's work consists of pencil and crayon, and sometimes ink drawings on paper. There

is lots of layering of these materials, and lots of erasures and smudging. His subject matter is mainly architecture and vehicle oriented. He especially likes construction sites with cranes and trucks. A reviewer of his art in *Art New England* (February/March 1996) said, "Kirshner's art rejects traditional representation, employing what appears to be minimalist abstraction to capture the essentials of the urban landscape." Kirshner began working in 1983 at Gateway Crafts, an art center for adults with disabilities. His work has been shown extensively at the Gateway Gallery and other venues in Boston.

Kitchen, Tella (1902–1988)

Tella Kitchen was born in Vinton County, Ohio, and lived in Adelphi, Ohio. She began to paint at the age of 63, when her husband died and her son gave her a set of paints. Her personal style reflected her remembrances of an earlier time in her life. Her work is in the collection of the American Folk Art Museum.

Kitchens, O.W. "Pappy" (1901–1986)

Oscar William "Pappy" Kitchens was born in Crystal Springs, Mississippi, and lived in Jackson. "Pappy" Kitchens' images are a direct and unselfconscious depiction of people and events from his personal history, as well as personal commentaries on contemporary social issues such as the Vietnam War, the women's liberation movement, and the population explosion. He used humor and narrative, along with descriptive titles, and inserted written comments. His work is illustrated in *American Self-taught*. His work is in the permanent collections of the Smithsonian American Art Museum, the New Orleans and Mississippi Museums of Art, and the Old Capital Museum of Mississippi History.

Klumpp, Gustav (1902–1980)

Klumpp was born in the Black Forest region of Germany and lived in Brooklyn, New York. He worked as a linotype operator. Klumpp retired in 1964 following a forty-year career. Klumpp discovered art at a senior center in the housing project where he lived. He painted in oils. His total output was done in about five years. In 1971 he stopped painting due to ill health. His paintings were colorful examples of a dream-like world, often with beautiful female nudes. His work is in the American Folk Art Museum and the Museum of International Folk Art.

Knight, Leonard (1931–2014)— "Salvation Mountain"—Niland, California

Leonard Knight was born in Vermont and made a living painting cars and repairing trucks. In 1970 he

had a religious experience. He first constructed a hot air balloon to carry his spiritual message. After moving to the desert near Niland, California, he started painting on a sandbar, building onto it with sand, water, putty, and paint. After thirty years working on the site, the fifty-foot mountain eventually was covered in bright colors and bore the message "God Is Love." Knight lived in his truck at the foot of "Salvation Mountain." *Salvation Mountain, The Art of Leonard Knight* was published by New Leaf Press in 1998. Salvation Mountain may be visited; information is available at www.salvationmountain.us.

Kornegay, George Paul (1913–2014)

The Rev. George Paul Kornegay was born on November 23, 1913, near Tuscaloosa, Alabama, of African-American and Native American ancestry. Starting in 1960 he began to build a two-acre narrative environment of paintings and sculpture made with found objects. Subjects for his artwork include African traditions, Indian heritage, biblical wisdom, and apocalyptic visions. He died on June 3, 2014, at the age of 101, after making art for more than 30 years. He is the subject of a video (https://vimeo.com/8680247), and the Webb Gallery in Texas carries his art.

Kossoff, Helen (1922–1994)

Helen Kossoff was born in the Bronx and died in Brooklyn. She found her subject matter, animals and people, in photographs from newspapers and magazines. After Kossoff transformed the subject of her vision, the images bore minimal resemblance to their source. Her animal and human subjects seem to have happy personalities. Kossoff filled her paintings with vibrant traditional as well as psychedelic colors. Her forms were flat. She filled the backgrounds of her works with geometric patterns. She was an artist in the HAI program.

Kowaclewski, Gregory J. (b. 1954)

Greg Kowalewski was born in the Irish Channel neighborhood of New Orleans on January 17, 1954. In 1960 his family moved to the suburb of Metairie where he eventually attended East Jefferson High School "for a while." Greg says he always did artwork, drawing and painting "as a kid," and doing murals on the walls of his bedroom. He has worked at carpentry, plumbing, and auto repair. He is now an artist, though his mother wishes he would get "a real job." He makes his unique art—metal cutouts, painted and nailed on wooden plaques in memorial tableaux or simple portraiture, accompanied by written "thought bubbles"—out of scavenged scrap metal. He used to do more religious themes but now he is inspired by popular culture, especially television news programs and science fiction. Sometimes his subject matter is "the vicious stories in the Bible." He inclines toward the gloomy view. When he gets an image in his head, he draws it first on paper, then on the tin he uses. He outlines all figures in black and fills in the figures with acrylic colors. Greg lives in New Orleans with his wife, Maureen, and his son. His work can be seen at the New Orleans House of Blues.

Kozlowski, Karol (1885–1969)

Karol Kozlowski was born in Kielce, Poland, and lived in Brooklyn, New York. He came to the United States at the age of 28. Shortly after, he moved in with the family of a friend, a fellow Pole from his army days, and their home became his for life. He held several jobs as an unskilled laborer until settling at Astoria Light, Heat and Power for 27 years. He started painting about 1920, in a small shed he shared with his collection of tropical birds. He was a "loner" about whom not much is known. What has been discovered is included in a richly illustrated book, *Karol Kozlowski*, by Martha Taylor Sarno. She says this hardworking laborer created "large, richly colored, intricate, and fanciful paintings, filled with blue skies, happy and affluent people, on a permanent holiday." The Abby Aldrich Rockefeller Folk Art Center in Williamsburg, Virginia, has several of his paintings.

Krause, Jo Neace (b. 1935)

Krause was born in Shoulder Blade, Kentucky and began painting in oils at the age of 56, when she lived in rural West Virginia. Her paintings hang in the Kentucky Folk Art Center at Morehead, Kentucky, and in various galleries. She is represented by askart.com. Her writings and essays have appeared in various literary journals such as *The Yale Review, Exquisite Corpse, Other Voices, University of South Caroline Review, Web del Sol*, and other places. After winning a creative artist fellowship she attended Ohio State University. She lives in Duck River in Hickman County, Tennessee. Krause brings her art to sell at "Day in the Country" at Morehead State every June (first weekend) and at the Wild Duck Emporium, a small gallery in Centerville, Tennessee. She lives on a farm at 7103 Old Richmond Road, Nunnelly. Tennessee. where she has an art "shack" from which she shows and sells paintings, and welcomes anyone seriously interested in art. Contact her first by email at Duckriver@wildblue.net.

Kugler, May (1916–2005)

May Kugler grew up in Reserve, Louisiana, and lived in La Place, Louisiana until her death. She was widowed twice, and had a son and daughter from her first marriage. At her dining room table, she painted scenes from her own childhood and the local customs of her part of Louisiana. Kugler said "anger" was her initial inspiration for painting. She was full of anger from her childhood: her family was so poor she only

had tops of shoes to wear to school and children made fun of her. A teacher accused her of cheating when she saw May's drawings; and when May drew in front of the teacher it only made the teacher mad because she didn't want to believe Kugler was "good enough." Kugler spoke only French when she began school and was given a very hard time about it. Her family walked miles to the nearest Catholic church "because they had no money to ride," and when they got there were "constantly chased out of the pews, because they had no money to sit," as the seats required a rental fee in those days. She said that painting her memories helped take the anger away. She usually appears in her paintings, wearing a red dress. Her memory paintings bear such titles as "I Did Not Cheat" (about her art when she was a child), "First Communion," "Bonfire on the Bayou," and "Picking Up Pecans." On the back of each painting she put its story and a prayer. Her son framed her work in old wood. May sold her own work, continuing to paint until her death even though Parkinson's disease slowed her down a bit.

Lacy, Don (b. 1922)

Lacy was born in Indiana and lives in Owensboro, Kentucky. He carves wood, which he paints, carves stone, and makes sculptures from found-metal pieces, frequently including railroad spikes. His work is in the permanent collection of the Owensboro Museum of Fine Art.

Lady Shalimar *see* Montague, Frances "Lady Shalimar"

La France, Helen (b. 1919)

Helen La France was born in the small village of Boaz in western Kentucky and lives in Mayfield. She started drawing when she was a little girl and made dolls from materials she found around the house. She made numerous carved wooden puppet figures, which are a favorite of collectors. She has also been painting landscapes, religious themes and family memories for many years. Recently she was included in the exhibition "African American Folk Art in Kentucky," at the Kentucky Folk Art Center in Morehead, Kentucky. Her work is in the permanent collection at the Owensboro Museum.

Lage, Joel (b. 1939)

Joel Lage was born in Charles City, and grew up in Osage, Iowa. He started making small sculptures out of trash retrieved from a landfill on his uncle's farm, using glass, bones, and whatever else he could find. He ran a machine shop in Iowa before moving to New Mexico in 1982, and now lives there in the village of Llano, near Taos. He makes sculptures, for which all his materials come from northern New Mexico dumps. His tools are scissors, pliers, and an ice pick. According to a critic, "there is often humor in his work, sometimes it's satirical. His best pieces are elegantly simple expressions of pathos for the human condition." It is amazing what happens to a coffee can, aspirin tins, and bottle caps in his hands. Lage likes what the elements do to his found objects—the changes in color, the patina, the rust. About his found-object sculpture he says, "That a cast-off thing, resurrected by the mind and hand, can lift a heart is a miracle." Most of his over 6,000 works are small, but not all of them. He is still making art, which was in the show "Tin Maidens" at the Parks Gallery in Taos in 2012. The Wilder Nightingale Fine Art in Taos carries his work.

Lamb, James (1926–1994)

James Lamb was born June 25, 1926, in Rockford, Illinois. He got a B.A. degree from Northwestern University and an M.B.A. from Utah State. He was married and had three children. A variety of jobs resulted in moves about the country. He worked for several years for a family-owned theater business in Illinois, moved to a middle-management position in an aerospace company in Dallas, then on to Colorado and Utah—all over a fifteen-year period. Then it was back to Beloit, to be closer to family, and a final job in Rockford. He never went after upper-management jobs because he was not a "company man," and preferred to work alone. He retired a little more than ten years after having had a heart attack at age 46. He was a self-taught but relatively sophisticated artist who used oil and acrylics to create "storyboard paintings" in which images illustrate sometimes fairly lengthy text that reflect his views on a variety of subjects. His widow says that when he retired, Lamb was going to pursue painting or music; painting was cheaper so he chose that. He read a lot about art and signed up for art appreciation classes at a two-year college in Janesville, Wisconsin. There he met his mentor, art professor Everett Scott, who encouraged him to keep painting but to not ruin his personal vision by taking classes. Everything came from his head, "whimsical, weird and irreverent." When Lamb first started he made "Grandma Moses like" small paintings that sold well, but he soon moved on to his more prominent work that "ranged from fears for his children to biblical satire." He was a naïve painter, who, according to Professor Scott, "remained quite independent and did beautiful work." His last ten years were quite productive. He did about 200 paintings. Lamb died February 13, 1994. His work is in the permanent collection at Beloit College, at Whitewater University/Crossman Gallery and in private collections.

Lamb, Matt (1932–2012)

Matt Lamb was born in Chicago. He owned and op

erated Blake-Lamb Funeral Homes of Chicago, Illinois. His career as an artist started just past his fiftieth birthday. His late arrival to art came from an extraordinary situation. In 1980 he was diagnosed as having a terminal illness, then found out it wasn't true. He became committed to sharing, through paintings, his religious views and views of the social and personal madness of the modern world. He painted in oil on canvas or plywood. His canvases are crowded with masklike faces. An illustrated catalog of his work, with an analytical essay by Donald Kuspit, was published by Fassbender Gallery in 1996. A book written by Richard Speer that details his life and work, *Matt Lamb: The Art of Success*, came out in 2013 (John Wiley & Sons).

Lamb, Tom

Tom Lamb just celebrated his sixth anniversary as a First Street Gallery artist and one of his paintings toured the country as part of an exhibition entitled "Accerate" that originated at the Kennedy Center in D.C.

Lambdin, Edd (b. 1935)

Edd Lambdin is a native Kentuckian and has supported himself as a carpenter and by doing construction work. He began making objects around 1980, both for his own amusement and for his nieces and nephews who lived nearby. Lambdin spends a lot of time in the woods, looking for the unusual natural wood formations he uses in his sculptures. He uses these found-wood pieces to make such objects as snake-handling people, monkeys, lizards, and various other critters. Often one critter is riding on the back of another. The major part of each sculpture is the found wood; some elements are turned on a lathe. Sculptures are painted with bright enamel in bold patterns of spots, stripes, and bull's eyes. Humor is always an important element in Edd Lambdin's work. His work is in the permanent collections of the Huntington, Mississippi, and Owensboro Museums of Art and the Kentucky Folk Art Center; it may be purchased from Larry Hackley, a private Kentucky dealer.

Lambdin, Sherman (b. 1948)/ Lambdin, Shirley

The Lambdins are natives of Kentucky. Sherman is Edd Lambdin's brother. He has worked in the past as a construction worker, but is now disabled. Edd Lambdin's success inspired Sherman and Shirley to start making sculptures, also. They often collaborate in their work, which is simpler than Edd's and smaller and more linear. Their most usual images are birds, peacocks, horses with riders, babies riding pigs, simple twig figures, and various other animals. The sculptures are painted with bright enamel, but with less overall patterning than is found in Edd Lambdin's work. Their

figures, with their brightly painted finishes, are usually made from twigs. Their work is in the permanent collections of the Owensboro Museum of Art and the Kentucky Museum of Art and Craft.

Lancaster, Paul (b. 1930)

Lancaster was born in Parsons, a small country town in west Tennessee and now lives in Nashville. He worked most of his life in grocery stores and all-night markets. Paul's first artistic effort was to make signs for a grocery store where he worked. Without any art education, he began painting his fantasy and nature pieces in 1959. The majority of his work is of serene, even magical or fantasy-like, forest scenes, which frequently include female figures. There is also a strong spiritual feeling about his work. He is the subject of a book, *Paul Lancaster Immersed in Nature*, that addresses his life and work through biography, his poetry, critical essays, and 112 full color pages of his art. Grey Carter/ Objects of Art in McLean, Virginia carries his work and distributes the book. Lancaster's work is in the permanent collections of the Smithsonian American Art Museum, the American Visionary Art Museum, and the Parrish Museum in Waterville, New York.

Landry, John, Sr. (1912–1986)

John Landry was a native of New Orleans, Louisiana. Shortly after his retirement he began fashioning miniature replicas of elaborate Mardi Gras floats—the King's float, the Queen's float, and a number of others depicting large butterflies, dragons, and floats from the Zulu parade. Wires and Mardi Gras beads are the major elements in construction. Landry's work is illustrated and further described in the exhibition catalog, *What It Is*, by Regenia Perry.

Landry, Lonnie (b. 1940)

Lonnie Landry, born July 20, 1940, began making art strictly for his own enjoyment. He has always shown his work in his restaurant in Morgan City, "Landry's Seafood Inn." Favorable reviews from the public are his primary reward, be he also enjoys selling his work. He started with paintings, then moved on to dioramas, and is now combining the two with three-dimensional framed paintings/dioramas and smaller individual sculpture depicting the landscape of Louisiana's bayous and swamps.

Landry, Michael (b. 1965)

Michael Landry was born May 24, 1965, in New Orleans, Louisiana, but was raised in Baton Rouge. Landry felt he needed to "break free" and experiment to create and cultivate his own style, and that he did. He broke all the rules by painting on whatever he could get his hands on: plywood scraps, cypress wood, Masonite, even glass. He throws together media, and the

result is a fresh explosion of expressionistic faces and figures "that run the gamut from nihilistic to psycho-sexual to humorous." When asked to make a statement on his work, Landry replies "My work is the statement," which means if you want to understand it you have to come by and see it. He has been exhibited at the Outsider Art Fair in New York and Folk Fest in Atlanta.

Lanning, Ralph (1916–2009)

Lanning was born in Greene County, Missouri, and lived in Republic, Missouri after returning from work with the Civilian Conservation Corps during the Great Depression and service in the Army during World War II. On his farm in Republic, he began in the early 1970s to create an environment that he called "The Lanning Garden." This he populated with concrete statues of dragons, other mythical beasts, and characters from fiction, making scenes reflective of war and love. His work was included in Intuit's exhibition, *American Self-Taught Stone Carvers*, where it was displayed alongside such artists as William Edmondson, Popeye Reed, and Tim Lewis. The Folk Art Society of America gave him its Award of Distinction in 2003. His work has appeared in *Raw Vision* and in the books *Rare Visions and Roadside Attractions* and *Detour Art*. Unfortunately this environment no longer exists.

Lassiter, Carolyn Mae (b. 1945)

Carolyn Mae Lassiter was born in Baltimore, Maryland. She moved with her family to Ahoskie, North Carolina, where she grew up picking cotton and tobacco and working in the peanut fields. According to a newspaper article in 1992, "She seemed destined to a life of backbreaking hard labor until she met and married her husband, Edmund." They first moved to New York State and then on to Cuernavaca where they lived among the Nahuatl Indians. There they interacted with several Indian artists. As a result of this encounter, Edmund began a small specialty paper business in Santa Fe, New Mexico. Carolyn Mae began to make her surreal imagery of animal and human forms, influenced by the unevenness and knots in the paper. Lassiter's work is often described as one continuous line, rendering images that blend over each other. Bright and bold colors created with oil sticks and pastels over pencil and pen are used in making her art. Lassiter's work was included in the 1988 exhibit, "Outside the Mainstream: Folk Art in Our Time" at the High Museum in Atlanta and she has been in several gallery shows since that time, including at El Zocalo in Santa Fe, NM, and the Luise Ross Gallery in New York. She sells her art through the Santa Fe Community of Artists (www.santafesocietyofartists.com/artists/carolyn-mae-lassiter) and her own website (www.carolynmaelassiter.com).

Lauricella, Robert (b. 1940)

Robert is an artist at the Creative Growth Art Center in Oakland. Usually he sculpts in clay and wood, and draws beautiful portraits, landscapes, and animals. He is known for his brilliant use of color and has a fine understanding of design and composition. Although he is not able to converse easily, it is obvious he knows when people admire his work. Robert loves to swim and is most physically free and comfortable when he is in the water. Hence it is no surprise that he often portrays people at the beach or in the water and renders other water-related subjects such as fish and boats.

Layton, Elizabeth (1909-1993)

Layton was born in Wellsville, Kansas, moved to Colorado and raised her family there and then returned to Kansas. She started painting in the fall of 1977, and this helped her with the depression she had suffered with for more than thirty years. All of her work involved portraits, nearly all self-portraits, of an amazing variety. Each painting was accompanied by a written description. Layton's life is detailed in *Through the Looking Glass: Drawings by Elizabeth Layton* (Mid-America Arts Alliance, 1984). Her work has been in shows at the Smithsonian American Art Museum (including a one-person show of her own) and the American Visionary Art Museum.

Lebduska, Lawrence (1894–1966)

Lebduska was born in Baltimore, Maryland, and then returned with his family to Europe, where he studied the family trade of stained-glass making. He came back to the United States in 1912. A year later he was working as a decorative mural painter and began to paint portraits of friends and recollections of his childhood. He "shunned museums and training," wanting only to paint to please his friends. His work is in the permanent collections of the Metropolitan Museum of Art, the Museum of Modern Art, and the American Folk Art Museum in New York, the Milwaukee Art Museum, and the Abby Aldrich Rockefeller Folk Art Center in Williamsburg, Virginia.

Lee, Richard (1933–2012)

Lee was born in Pullman, Washington, and worked his way through a few years of college as a dock worker and a dancer. Being quite successful as a dancer, he accepted a job as a dance therapist in an Alabama hospital for people with mental illness, eventually working his way back to the West Coast in the 1950s. He made his first art as a birthday card for a friend, using the technique of reverse glass painting. He attracted a large following in Los Angeles, where he had numerous shows. A friend convinced him to move to Martha's Vineyard, where he lived with his family until his

death. He made masks, opened a dessert restaurant, created wonderful gardens, and made hundreds of reverse glass paintings and cabinets. He would buy antique mirrors at tag sales, scrape off the silver, and create worlds of fanciful animal figures, with strong references to nature, highlighted in gold, silver, and bronze leaf. One of his cabinets is now in the permanent collection of the Baltimore Museum of Art. During his lifetime he sold his work from his shop, behind his wife's jewelry store, and at several galleries. The Beverly Kaye Gallery in Woodbridge, Connecticut carries his work.

Leedskalnin, Edward (1887–1951)— "Coral Castle"—Homestead, Florida

Edward Leedskalnin created "Coral Castle," a massive sculptured coral environment 25 miles south of Miami. He constructed an open-air castle out of 1,000 tons of stone, working alone. Leedskalnin was born in Latvia. At age 26 he was jilted by his 16-year-old fiancée and claimed that he built his monument to his lost love. He first built a monument in Florida City, then moved to the present location near Homestead and began again. Not long ago, with everything else falling down around it, Coral Castle was damaged not at all by a major hurricane. Coral Castle is documented in several books, including *Coral Castle: Photo Tour* (J. C. Vintner, Create Space Independent Publishing Platform, 2012) and *Coral Castle: The Mystery of Edward Leedskalnin and his American Stonehenge* (Rusty McClure, Temary Publishing, 2009. At publication time Coral Castle was still at 28655 South Dixie Highway in Homestead, Florida.

Legge, Eric (b. 1971)

Legge was born in Decatur, Illinois, the son of an accomplished wood-carver. He grew up mostly in Valdosta, Georgia. Legge worked during college at a center for severely mentally and physically handicapped people and acquired from this an appreciation for his own life. Legge paints smiling, happy people. He uses bright, bold colors to create still life and fanciful faces. He has been painting every day for the last five years and his art work now supports him. Eric lives in north Georgia in the mountains. In addition to still lifes and room scenes, his favorite subjects for painting are jazz, reggae, and blues musicians. It has been said of Eric that he has "an amazing eye for composition." Galleries carry his work (e.g., Dos Folkies in Oregon) and he attends festivals including Kentuck and Riverfest.

Leonard, James (b. 1949)

James Leonard was born in East Orange, New Jersey. After high school he joined the navy, serving in

Guam. Trained as a cabinetmaker and woodworker, Leonard started making whirligigs while living in the Williamsburg section of Brooklyn, using street life as his inspiration. Other whirligigs are influenced by his own memories and experiences. Leonard now lives on a ten-acre farm near Lewisberry, Pennsylvania. He engages in "subsistence farming" and makes flower- and fruit-based wines for family and friends. His whirligigs are elaborate and wonderful, and some are very large, with as many as 2,000 pieces. He frequently uses copper and tin. There are examples in the permanent collections of the American Folk Art Museum and the Smithsonian American Art Museum. To inquire about his work, write to him at P.O. Box 253, Lewisberry, Pennsylvania 17339, or call him at 717-938-5020.

LeVell, Michael (b. 1964)

Michael LeVell reproduces and invents intricate architectural ideas on paper and in clay. Whether in pencil, pen and ink, or marker, he draws as though each piece is a musing on architectural minutiae: sometimes fully complete buildings or pieces of furniture, or simply scores of ornate corners or scroll-work filling a single page. LeVell, who has multiple disabilities, is one of the original eight artists who helped found the First Street Gallery in Claremont, California, in 1989.

Levin, Abraham (1880–1957)

Levin has been written about frequently. He painted mostly religious works. He was included in the exhibition "Transmitters: The Isolate Artist in America."

Lewallen, Chris E. (b. 1965)

Chris Lewallen was born May 10, 1965, in Gainesville, Georgia. Lewallen works full-time as a paramedic/firefighter for Hall County Fire Department. Before this he has had many jobs such as cutting grass, selling horse and cattle feed, and working in a hospital. Sometimes his experiences turn up in his art. He has been painting and drawing as long as he can remember. Lewallen paints with enamel paint, sometimes house paint, on boards, pieces of tin, tree limbs, vines, or anything else he can find. He paints animals, people's faces, lizards and snakes. He likes to include humor, bright colors and "positive things." Sometimes he writes words on the pictures he makes. He sold his first piece in 1992; he had never let anyone see his work until he went on a family visit to see R.A. Miller, took a piece, and Miller told him it was good and to let people see it. Now, when he is not at the fire department, he is at home in Gainesville working at his art, and he likes visitors.

Lewis, Erma "Junior" (1948–1999)

Erma "Junior" Lewis lived in Isonville, Kentucky. He was a tobacco farmer and had also drilled oil wells,

worked as a carpenter, and worked for the state. He started carving around 1987; his first pieces were an Indian head and a devil head made out of blocks of wood. His interest in devil figures had grown to include "Devil Island," "Devil Boats," and a few others. He also carved biblical scenes of great beauty—especially the Last Supper—and animals common to eastern Kentucky plus the occasional lion or tiger or alligator, too. He had added more animals to his repertoire, in his last year or two, including a mother pig with babies and small chunky dogs. Junior Lewis would rough out the wood with a chain saw, then would carve and sand the rest by hand. Arms, legs, and the devil's horns were pegged on. Much of his work was painted, although sometimes he would leave his many figured pieces unpainted. Junior died suddenly and unexpectedly Friday, August 20, 1999.

Lewis, Jim (1948–1999)

Jim Lewis was born in Sandy Hook, Kentucky, where he lived his whole life. He was married to Beverly Hay Lewis, and they had two grown children. Lewis worked as a heavy equipment operator. He started carving on and off in the 1990s, and then when he was laid off he started making art full-time. Friendly with Garland and Minnie Adkins for many years, their work inspired him to try it for himself. When the company called him back to work he didn't go. He carved and painted colorful fish to sit on a table or hang on a wall, birds, forest animals, and a few fantasy creatures. One of his images was Jonah in the whale, with Jonah looking very uncomfortable. His Noah's Ark creations are large and colorful. He also carved canes. Lewis used basswood and poplar, roughing out the shapes with a band saw and finishing the pieces with a knife. He used acrylic paints and finished each piece with a coat of polyurethane.

Lewis, Tim (b. 1952)

Tim Lewis lives in Isonville, Kentucky, in a beautiful hillside home he built himself, with his wife and his daughter, Amber. He is brother to furniture maker and sometimes carver Leroy Lewis, and Junior is his cousin. Lewis was in the army and traveled around for six years. He has also done oil well digging, strip mining, and logging. Driving a runaway truck on a mountain road discouraged him from continuing his work in logging. He says his first inspiration came from seeing what Junior Lewis was doing, and then Minnie and Garland Adkins encouraged him. Tim Lewis started by making canes from the root ends of small trees. These he painted elaborately to create a face or figure. He spends more time now making stone carvings, often from chimney stones found in the woods. He also uses sandstone blocks. He carves with a hammer and chisel. Lately his work schedule has been interrupted by bouts of arthritis. However, he still comes to "Day in the Country at Morehead."

L-15 (Bernard Schatz) (b. 1950)

L-15, the former Bernard Schatz, grew up in Los Angeles in the 1950s. He was trained as a physical therapist and has worked at that, along with his art, most of his life. After a time in show business, television, and nightclubs, he moved to a small farm near Charlottesville, Virginia. He says that in 1984, during open heart surgery, an alien visited him and gave him the name L-15; a joke he concocted to amuse his staff at the clinic he owned in California. L-15 creates boldly painted sculptured figures from mostly found materials. His themes are commentary on politics, history, and world culture. His art is sophisticated, idiosyncratic and reflects the visions of a very creative mind. He is an entirely self-taught artist. An essay by Tom Patterson in *Not by Luck: Self-taught Artists in the American South* provides detailed information about the artist. His work was in the exhibition "Wind in My Hair" at the American Visionary Art Museum in Baltimore in 1996.

Librizzi, Ray (b. 1907)

Librizzi was born in Pittsfield, Massachusetts. He dropped out of school at an early age, after a fistfight with the school principal. He worked around the country, "riding the rails," and eventually returned to Pittsfield, finished school, and went to Williams College. He spent time as a newspaperman, with much of his hard luck being attributable to this being the time of the Great Depression. Eventually he started a paper of his own, but his anti-fascism offended local Italians and Germans who boycotted his paper, *The Berkshire Gazette*, which then folded. He paints in oil on canvas and includes short to-the-point titles on his paintings, most of which tell a story. His work and his life are described in detail by Dan Prince in *Passing in the Outsider Lane*. As of this writing he was still alive and living in Pittsfield, at age 107.

Lieberman, Harry (1876–1983)

Harry Lieberman was born in Poland and died in Great Neck, New York at the age of 103. Much of his painting was done in Los Angeles during the winter months he spent with his daughter and grandchildren. Details about his life, his culture, and his religion—all of which played a great part in his painting—are documented in the book *Harry Lieberman: A Journey of Remembrance*, by Stacy Hollander. Lieberman also made floral still life and clay figures. His work may be seen at the Seattle Art Museum, the Miami University Art Museum in Oxford, Ohio, the Hirschhorn Museum in Washington, D.C., the American Museum Folk Art, and in many important collections of Jewish ethnic and religious folk art.

Liggett, Myron "M.T." (b. 1930)— Yard Environment—Mullinville, Kansas

Myron Liggett was born in Mullinville, Kansas, the son of a sharecropper. The family, which included seven children, lived in an old claim shack and grew wheat. They eventually made some progress out of the poverty of their early years and moved to the far better house of Myron's grandfather. After he graduated from high school in 1948, his father "sort of shipped off my twin brother and me to the military." Liggett stayed in the military for twenty years. He lived in California for a while, had a marriage that didn't work out, and returned to Kansas. M.T. says he has always carried a sketchbook with him: "While others wait, I sit and draw." Someone may say something to him that will trigger some art. He never knows for sure what a piece will be when he starts. Liggett cuts, welds, and paints scrap metal. He has about two miles (three deep) of sculptures. These "totem poles," as he calls them, are frequently politically motivated and some are like windmills. They make a definite statement to the community whether it is local, state, or national politics. Most often the pieces have written statements on them and M.T. says some of the people in his town don't like them one bit. He also makes some sculptures of his friends that are placed along the fence line. The sculptures are mounted on metal pipes about fifteen to twenty feet off the ground. Even his house and barn are decorated in brightly colored geometric forms. They, too, have writings on them such as "Jesus Wasn't a Methodist" and "Join the Hemlock Society." Liggett says that he has read a lot in his lifetime and authors are remembered by their words. The sculptures are his "views to be remembered by." He says, he "can sell his art … but usually doesn't." Liggett lives about 35 miles southeast of Dodge City, Kansas. A new building at the Grassroots Art Center in Lucas, Kansas is under construction (in 2015) and will include a permanent installation of Liggett's "amazing metal creations." His work is documented in *Detour Art—Outsider, Folk Art, and Visionary Folk Art Environments Coast to Coast, Art and Photographs from the Collection of Kelly Ludwig* (Kelly Ludwig, Kansas City Star Books, 2007) and *Rare Visions and Roadside Revelations Coast to Coast Travel-o-Pedia* (Randy Mason, et. al., Kansas City Star Books, 2009), and can be seen at http://bestroadtripever.com/a-garden-of-goat-getting-political-satire-mt-liggetts-art-field.

Light, Joe Louis (1934–2005)

Joe Light was born on a farm in Dyersburg, Tennessee. He enlisted in the army at age seventeen but was discharged soon after. After returning home he was imprisoned twice for armed robbery, and during his second term he converted to Judaism. After getting out of prison he settled in Memphis. In 1975 he began to paint, covering the outside of his home with signs proclaiming his belief in the Old Testament. He painted mostly on boards, covering the surface with paint. His images are sparse but colorful. Light's work may be seen at the Center for Southern Folklore in Oxford, Mississippi and at the High Museum of Art in Atlanta. He had work in numerous exhibitions, including *Another Face of the Diamond* (1988), *Passionate Visions of the American South* (1993), *Souls Grown Deep* (1997), and *Testimony: Vernacular Art of the African-American South* (2000), organized by the Schomburg Center for Research in Black Culture of the New York Public Library.

Line, Marion (1919–1999)

Marion Line was born in Morristown, Tennessee, and lived in Richmond, Virginia. She always wanted to be a painter, but since there were no classes available in Morristown, she turned to music. She had a forty-year career as a music teacher. She thought about painting all those years, but believed it was out of the reach of "ordinary people." In 1976 she bought her first canvas and oil paints. She tried one art class which nearly ruined painting for her: she could not and would not do what the instructor demanded. Mrs. Line was a memory painter and painted her life. She started in 1983 and had her first solo exhibition in 1984. She divided the themes of her work as follows: memories of her family; scenery, especially the mountains around her home in Tennessee; Bible stories; paintings related to songs; and contemporary life and scenes in Virginia. Mrs. Line always said, "mainly I've had a good time. I've enjoyed my work and like to paint the 'up' side of life. Even my funerals are not that sad." Marion Line was included in the exhibition "Folk Art: The Common Wealth of Virginia." There was a one-person exhibition of her work at the Meadow Farm Museum in Glen Allen, Virginia, July 20–October 19, 1997, called "Memory and Reverie: The Contemporary Folk Art Paintings of Marion Line."

Lisk, Charles (b. 1952)

Charlie Lisk was born in Robbins, North Carolina, and now lives in Vale, North Carolina. He graduated from Appalachian State University in 1975 and returned to Moore County to work at Pinehurst Pottery. After his marriage he moved to Vale, leaving the Seagrove area, becoming part of the Catawba Valley heritage. Burlon Craig has been Lisk's inspiration. His specialties are alkaline-glazed pieces and clear glass-glazed swirlware. Face jugs and snakes are frequent forms. His face jugs are in great demand. Lisk lives at 7386 West Highway 10 in Vale. Call him at 828-462-2881.

Little, Chris (b. 1960)

Chris Little was born July 28, 1960, and lives in Bartlett, Tennessee. His yard "is peppered with his cre-

ativity, his passion and compassion." He built his three sons a colorful shelter at the end of the driveway so they would have a comfortable place to wait for the school bus. He has a 14-foot giraffe staring across the street at an 84-year-old neighbor who loves it. This giraffe was joined by a baby giraffe and a large green lizard. Many other objects—animals made from found wood and brightly painted, and designed pieces and found object assemblages fill the yard. They all come from the creative mind of Chris. "I try to use the things around me," Little says, "I see something in them and I just work with that." His recent creativity started while he was doing stone work as a side job. During the school year he works as an interpreter for the hearing impaired, a vocation shared by his late wife who was killed in an automobile accident. He is raising his three young sons who sometimes help him with his art, and he is in school working on a degree in special education. He keeps his yard critters, although he gives some away for donations to worthy causes. Recently he has been trying his hand at smaller pieces so that he might have something to sell to interested people, such as the two-foot zebra he just made. His art may be seen by driving by his home, on five acres, at 3632 Old Brownsville in Bartlett. You can contact him at rchrislittle@gmail.com.

Litwak, Israel (1868–1960)

Litwak was born in 1868 in Odessa, Russia. He lived a good part of his life in Brooklyn, New York. Litwak started painting at the age of 68 when he was forced to retire. He liked to talk about his work, which often depicted landscapes. He used pencil, watercolors, and oil, and is sometimes compared to Rousseau. Litwak is included in *They Taught Themselves* by Sidney Janis, and in *Twentieth-Century American Folk Art and Artists*, by Hemphill and Weissman. His art was included in the exhibition "Flying Free" in 1997.

Litz, James C.

James "Jim" Litz is a Vietnam veteran and self-taught artist who was born in Checktowaga, New York, and now lives in Depew, near Buffalo. He creates powerful and vibrantly colored "naive" images, including animals, houses, baseball games, biblical stories, and childhood memories. He uses both acrylic and water color. Some of his paintings mix the real and the fantastical, the present and the historical, in an unusual way. Litz' work is in the permanent collection of Fenimore House and the Musée d'Art Naif in Paris.

Livesay, Richard (1954)

Livesay was born in Louisville and now lives in West Liberty, Kentucky. He has worked as a water well driller, welder, furniture builder and refinisher, a teacher's aide, and a carpenter. He began to make art while incarcerated at Eastern Kentucky Correctional Complex in 1979. His work came to the attention of Morehead State University folk art staff during a visit to the prison in 1991. Staff bought a "Harrison Stage Wagon" made by Livesay for the Kentucky Folk Art Center's permanent collection. Livesay had sold other wagons to fellow inmates, who sent them to their families, so a number of his wagons are in private collections around the country.

His work is in the permanent collection of the Kentucky Folk Art Center.

Livingston, Calvin (b. 1970)

Calvin Livingston was born in Tuskegee, Alabama. After the family moved around a bit, they settled in Autauga County, Alabama. Calvin is the cousin of Charlie Lucas, who has encouraged him to make art. Livingston started out drawing, but now he makes constructions from found objects and uses vivid colors, textures, and bold images. Additional biographical material is included in the exhibition catalog *Outsider Artists in Alabama* (1991). Both Anton Haardt galleries carry his work, as does Marcia Weber/Art Objects in Montgomery.

Lockett, Ronald (1965–1998)

Ronald Lockett was from Bessemer, Alabama. Described as a shy, quiet man, Lockett's art was strong and forceful. His art was frequently focused on contemporary social issues. He mixed found objects and paint and created images both figurative and abstract. Entrapped deer were recurring images. His work was included in the 1996 exhibition in Atlanta, "Souls Grown Deep." He died August 23, 1998, after a long battle with AIDS-related illnesses. His friends from California were his major comfort and support at the end of his life. According to an obituary notice about him, Lockett had recently completed two series of paintings, one on the Oklahoma City bombings and the other on Princess Diana. His work was included in many important exhibitions such as *"Ashe: Improvisation and Recycling in African American Visionary Art,"* 1993; *"Tree of Life,"* 1995; *"Souls Grown Deep,"* 1996, and *"Bearing Witness,"* 1997.

Lomayesva, Gregory (b. 1971)

Lomayesva is the son of an Hispanic mother and a Hopi father. His mother, Maria Cash, is a well known local artist. From these two very rich cultures emerged a unique artistic talent that embraces painting and sculpture to success in composting music. A painter since his mid teens, Lomayesva's career began when he combined his woodworking skills with the classical imagery of his Hopi heritage into fusion artifacts that rapidly developed a strong collector base and wide acclaim. Greg's folk art styled wood objects draw from

a complete assimilation of many aspects of life and fantasy combined. His Kachina styled figures are representative of his Hopi roots but NOT representative of actual Kachina figures. The feathers used are molted parrot feathers that add rich coloration to each work. Beginning with the masks and dolls that are staples of his historical folk craft tradition, Lomayesva quickly built a recognizable visual lexicon all his own that he was eventually able to bring to large-scale works of wood, bronzes, and steel. Cars, motorcycles, scooters and wagons with wild whimsical riders make Greg's pieces truly fun with a wonderful folk art flare. His work has been in many exhibitions, some solo, and is available at Case Trading Post in Santa Fe, Rainbow Man in Santa Fe and La Mesa of Santa Fe and Bryans Gallery in Taos.

Long, McKendree Robbins (1888–1976)

Long was born in Statesville, North Carolina. He received art training as a young man, learning an academic style of portrait painting. Long was an ordained minister and gave up art for evangelism for thirty years. In his seventies, Long completed two series of paintings: one a set of illustrations interpreting the Book of Revelation, and a series called "The Woman in Red." In spite of his early training, Long has been described as an "outsider," and as an important visionary artist. These works from his later years were nothing like those he had done as a young man. His work is in the permanent collection of the Smithsonian American Art Museum and was included in exhibitions at the American Visionary Art Museum.

Long, Phyllis "Por Phyl"

Phyllis Long lives near Eden, North Carolina. She grew up one of thirteen children and is the mother of five and grandmother of six. She has had no formal art training. "Her talent is completely self-taught and God given." Her art includes painting, sculpting (with paper, "sculpty," and soap) and wood-carving. Long signs her work "Por Phyl" because she has been so poor all her life. She began painting years ago while undergoing treatments for cancer. Note: Some sources call her "Por Phil." The Gallery at Folk Art Net in Roanoke carries her work.

Long, Woodie (1942–2009)

Woodie Long was born in Plant City, Florida. He lived in Andalusia, Alabama. Long painted houses, churches, and other buildings before he became an artist full-time. He would paint pictures on the walls of houses, then quickly paint over them before the owners came home. Long painted bright colors on paper of the happier memories he has of growing up in the South. His family continues to maintain a gallery for his work that is open 3 days a week 11–5 and by appointment, the Woodie Long Art Gallery (http://www.woodielong.net). Many galleries carry his work, including Cotton Belt Gallery and Marcia Weber/Art Objects in Montgomery, Just Folk in Summerland, California, and Judy A. Saslow Gallery in Chicago.

Loose, Peter (b. 1963)

Peter Loose was born in Silver Spring, Maryland. From his earliest days he has been fascinated by nature and spent his childhood splashing in creeks and hiking in the woods. School was always a chore but it led eventually to a job as a state park naturalist, and as a naturalist for the Audubon Society. In 1986 he moved to Athens, Georgia, to work at the Sandy Creek Nature Center. When there, he tried using watercolors to do a guidebook for the Center, but "decided it was too hard." Then during a period of emotional stress and physical illness, he tried again. This time he began to create strange little paintings dominated by splotches of color, on typing paper. Encouraged by friends, he soon switched to acrylics and canvasboard. Self-taught and painting now since 1987, Peter Loose builds and paints whimsical portraits of animals both real and imagined. His style, bright colors and bold imagery, is gaining attention from collectors. He lives in Hull, Georgia, with his wife, Sandy, and shares their five acres with formerly abandoned animals. His current work includes his paintings, birdhouses, and sculptural musical instruments, his trademark being snake-shaped dulcimers. Marcia Weber/Art Objects in Montgomery and Ginger Young, private dealer, carry his art. He also sells from his own website, home.fuse.net/looseart, or call him at 706-548-6596.

Lopez, Ricardo

Ricardo Lopez is the son of carver José Dolores Lopez and is the recipient of the 1977 "Master's Lifetime Achievement Award" at Spanish Market in Santa Fe, New Mexico. He makes chipped carved depictions of saints. His daughter Sabinita Lopez Ortiz is a well-known santera. Montez Gallery in Santa Fe carries his work.

Lott, Jesse (b. 1943)

Jesse Lott was born in Simmesport, Louisiana, and now lives in Houston. He calls himself an urban folk artist. He says his sculptural technique is directly related to the urban environment: "a combination of the natural resources of the urban community with the skill of an artist and the attitude of the primitive." He says his "forms and images express ideas found in the urban environment," and that he "collects, categorizes, and reassembles materials which provide evidence of the area and situation where they were collected."

Louis, Rosemary Roberts (b. 1942)

Rosemary Louis was born in New Orleans on August 8, 1942, and was raised in Lutcher, Louisiana, a small town on the Mississippi River. She is self-taught and started making art as a child. She made paper dolls and gave them to friends as presents. She is now a painter and frequently the subjects are people she remembers from her hometown. Most of these people, including her mother and stepfather, have passed away. She often paints on objects found in thrift shops. Rosemary Louis now lives in New Orleans.

Louque, Barbara (1928–3013)

A self-taught artist, Barbara Louque lived in Lutcher, Louisiana. Louque used oil, pastel, watercolor, cypress knees, and clay to create the images of her beloved southern Louisiana. Plantation homes, sugar cane, and cotton fields were among her favorite subjects to paint. Her works are filled with detail. Barbara had a deep fondness for southern Louisiana which she tried to express in her paintings. She sold her work at numerous local art shows, including the annual Spring Arts Show of the Terrebonne Fine Arts Guild.

Lowe, George (b. c. 1958)

George Lowe lives in Atlanta, Georgia, and Lakeland, Florida. Lowe has always enjoyed road trips. Since he was a child in Clearwater, Florida, two-week annual family vacations left visual impressions that later found there way into his art. Now forty, Lowe's visual vocabulary is complex and varied, including crop circles, aerial topography, railroad tracks, three-dimensional cityscapes, collage, and military intelligence references. The iconography is cryptic, commanding, and beautiful. Lowe draws his map-like works on large sheets of brown wrapping paper with colored pencil, never planning in advance but letting each drawing evolve on its own terms. When he is not working on his art, Lowe is an animation voice actor. Robert Cargo Gallery carried his work before it closed; it is now in the permanent collection of the Birmingham Museum of Art.

Lucas, Annie Lykes (b. 1954)

Annie Lucas lived in Pink Lily, Autauga County, Alabama, with her former husband, Charlie. Though her hands were full with their six children, Annie still wanted the opportunity to paint. "Art was God's answer to my prayers." Annie had been doing cleaning work at a hospital and a nursing home. After she started painting she never went back. Her work was included in the exhibition "Outsider Artists in Alabama." She combines paint and needlework on stretched cloth to interpret Bible stories. Cotton Belt Gallery and Marcia Weber/Art Objects in Montgomery carry her work.

Lucas, Charlie (b. 1951)

Charlie Lucas was born in Birmingham, Alabama, and lives in Prattville, Alabama and has an additional studio in Pink Lily. Charlie ran away from home when he was a teenager and learned to support himself as a construction worker, truck driver, and handyman. He began making scrap metal sculpture while recovering from a back injury. His house is easy to identify because of the scrap metal creatures in place everywhere. He bends, welds, and twists aluminum wire into larger than life people and animals. He also paints on boards. Charlie Lucas is included in many exhibitions and museum collections; and numerous galleries carry his work, including Anton Haardt and Marcia Weber/Art Objects.

Lucas, David (b. 1948)

David Lucas lives near Whitesburg, Kentucky. He is a self-taught painter who is documenting life in Kentucky, particularly in Letcher County. His series of coal mining scenes is now in the museum of the University of Kentucky. In addition to coal mining scenes, he paints the countryside, towns, and houses. His narrative paintings are done in subdued, autumn-like colors. Not long ago, he painted a series of feuds in his county, being tired of "all the attention given to the McCoys and Hatfields." The Kentucky Folk Art Center in Morehead presented an exhibition, "Paintings by David Lucas" in April–May of 1994, and featured him in another exhibition in September 2013. A solo exhibition featuring his work was mounted at the Appalachian School of Law in February 2014. A video including interviews with the artist and images of his work may be viewed at the Appalshop archives (https://archive.org/details/2304DavidLucas).

Ludwiczak, Ted (b. 1926)

Ted Ludwiczak was born in Poland and lived in India, Egypt, Greece, and Rome before moving to the United States in 1956. Ludwiczak lived within the village of Haverstraw, New York, for twenty years and has lived along the river on the edge of the town for about thirty-five years now. He has two daughters, a son, and a grandson. He started making stone heads after retiring from his job of making contact lenses in 1986. His stone heads have a great variety of faces. He uses simple tools, his favorite being an old lawnmower blade. His "studio" is in the midst of his head-filled yard overlooking the Hudson River; it can be seen from the street, and is the subject of a DetourArt piece that calls his yard "Easter Island on the Hudson" (http://www.detourart.com/easter-island-on-the-hudson-ted-ludwiczak). He says he "works and looks, works and looks" at the beautiful view. "He has created an environment of mystery and drama with his hillside of monumental heads." Ludwiczak lives on Riverside Avenue in Haverstraw, New York. From the direction

of Haverstraw, take Westside to Highway 9W and turn left—then take the hard diagonal left onto Short Clove Road; right turn again onto Riverside Avenue, through the quarry (still on Riverside), and look for the small house on the left (river side) with the yard full of stone heads. Outsider Folk Art carries his sculptures, as does American Primitive Gallery in New York City.

Lunde, Emily (1914–c. 2007)

Lunde lived in Grand Forks, North Dakota. She grew up in Minnesota and painted memories of her childhood there. Lunde raised her four children and then started working outside the home. When she retired in 1974 she began to devote more time to her art. She is known for documenting the lives of Swedish immigrants at the turn of the century. Her work is in the American Folk Art Museum and in the New York State Historical Society collection in Cooperstown, New York.

Lusch, Birdie (1903–1998)

Lusch was born in Columbus, Ohio. She lived with her family in Illinois and Michigan as a child, living on farms. At the age of twenty she returned to Columbus, where she stayed. Lusch's interest in the natural world "turned her into a true ecologist … drawing upon almost everything she encountered in daily life much as a painter selects colors from a palette." Her work ranges from fairly conventional paintings, to painted assemblages incorporating found objects, and to collages using printed images from magazines. Gary Schwindler, in the exhibition catalog *Interface: Outsiders and Insiders* (Ohio State University, 1986), calls her art "remarkable, sharply observant, and highly literate." He says further that Birdie Lusch and her art conform most nearly to the criteria presented in the catalog's introductory essay for defining outsider art. Lusch died November 19, 1998, at age 95.

Luszcz, Bronislaus (1893–1960)— "Black Madonna Shrine"—Eureka, Missouri

Brother Bronislaus Luszcz came to the United States from Poland in 1927 with a group of Franciscan brothers. In 1937 he built a small chapel to house a copy of an icon cherished by Poles, Our Lady of Czestochowa, popularly known as the Black Madonna. This first shrine was burned down by vandals in 1958. After constructing the chapel, Brother Bronislaus spent 22 years clearing the woods and building grottoes "dedicated to Mary and the saints." The grottoes are constructed of Missouri tiff rock. Into the grotto frames he molded intricate designs and sculptures. He incorporated all the trinkets left behind by visitors. There are seven grottoes altogether. The Franciscan brothers maintain this shrine, which is located at 100 St. Josephs Hill Road in Pacific, Missouri, eight miles from Interstate I-44. Telephone: 636-938-5361. See www.franciscan caring.org/blackmadonnashri.html.

Lyons, Charlie

Charlie Lyons lives in South Carolina and makes airplanes out of scraps of tin and found objects. He uses wheels from old toys and makes the propellers from tin. Mary Praytor Gallery in Greenville, South Carolina, has his work.

Mackey, Sam (1898–1992)

Sam Mackey has been described as an American "outsider" artist. He did drawings, pastels, and watercolors. Mackey was the grandfather of Detroit community artist Tyree Guyton and worked with Guyton on the Heidelberg Project. His work was exhibited at the Detroit Institute of Arts in 1990and is in the Collection de l'Art Brut in Lausanne, Switzerland.

Mackintosh, Dwight (1906–1999)

Mackintosh was born in Hayward, California, and lived in Berkeley. He was institutionalized at the age of 16 and spent the next 56 years in mental hospitals. According to records he suffered from brain damage and possible mental illness. In 1978 he was introduced to the Creative Growth program in Oakland, California, where he worked hour after hour, day after day, drawing obsessively on plain white paper with a felt-tipped pen. His subject matter was the human figure, usually men, and vehicles. His work also contains what looks like writing, but it is not intelligible. His art was included in the exhibition, "Flying Free," and is in the permanent collections of the Smithsonian American Art Museum, the High Museum of Art in Atlanta, and the Milwaukee Art Museum. Mackintosh, who was labeled an "outsider artist," died March 27, 1999, just before his ninety-third birthday. The Ames Gallery in Berkeley, Creative Growth Art Center in Oakland, and Judy A. Saslow Gallery in Chicago carry his work.

Mains, Arlee (b. 1935)

Arlee Mains is a native of the Appalachian mountains of North Carolina. She was born in Beech Creek on May 3, 1995. She attended school in a one-room schoolhouse for five years. After high school she married Carl Mains, a local boy, and they have one son, Kenny. All reside in the mountains of North Carolina. She was from a community that was strong and self-sufficient and lived with the old traditional values of the Appalachian people. Her first creations were the toys with which she and the other children around her played. Arlee paints her memories from the 1930s through the 1950s of the isolated, rural poor outside of Boone, North Carolina. As a child she asked many

questions and listened attentively to the family story-tellers about her family and her region. Now Arlee includes handwritten stories about the scenes in her art. As a child she drew pictures on everything she could find, her family not being able to afford real drawing paper. Sometimes she just drew her pictures in the dirt with a stick. For awhile other responsibilities consumed her time but now she draws nearly every day and all day long. She paints with acrylics on watercolor paper. Occasionally she will paint on a found canvas. Arlee is also well-known for her doll crafts including corn shuck dolls, fabric witches, fairy godmothers, angels, and pilgrims. She was discovered by Pamela Bundy McKay who carries her work at the Art Cellar Gallery in Banner Elk, North Carolina.

Makiki (Geraldo Alfonso) (1920–1998)

Makiki lived in Key West. He served in the U.S. Navy, and worked as an entertainer, playing drums and maracas and dancing. He began making art after his mother died, transforming his home into a shrine to his mother, using pieces of glass and mirror to create alter-like structures. His work incorporated photos, flowers, dolls, lights, and other pieces of memorabilia and painted surfaces. Eventually he was encouraged to sell some of his art objects, and he began making paintings similar to those of his neighbor, Mario Sanchez. He sold his paintings from his home and sometimes in local Key West galleries. Skot Foreman Gallery in New York carries his work.

Maldonado, Alexander A. (1901–1989)

Alex Maldonado was born in Mazatlán, Mexico, and immigrated to San Francisco with his family in 1911. His father died when he was in his teens, and Maldonado had to go to work. Later he worked in shipyards, as a professional boxer, and at a can company. His sister Carmen encouraged him to take up painting when he was sixty. Maldonado painted fantasies of the future; space travel and astronomy were among his fascinations. His work is in the permanent collections of the Smithsonian Museum of American Art, the American Folk Art Museum, and the Oakland Museum of California. He was honored by the San Francisco Board of Supervisors. The Ames Gallery in Berkeley carries his work.

Malone, Ronald (b. 1946)

Malone was born near Gallup, New Mexico, and lives in Sweetwater, Arizona. As a child he always loved cars and would make his own out of wood. He cuts out sandstone figures of cars and trucks and paints them bright colors with poster paint. Malone has exhibited at the Wheelwright Museum of the American

Indian. His work is illustrated and described in the book, *The People Speak: Navajo Folk Art.*

Manning, Zelle (b. 1938)

Zelle Manning lives in Morton, Mississippi. She has four children and four grandchildren and began painting in the early 1990s. She is described as a "primitive" painter who captures the landscape and spirit of her part of the South; she is also known as the "cotton patch" painter. A curator at the Museum of Fine Arts in Houston has said of her art that she "takes the Southern landscape as a point of departure, successfully playing memory against cliché." She started painting in about 1984. Her paintings have won awards at the Mobile Arts Fair and at the Museum of the Mississippi Delta (formerly Cottonlandia Museum) in Greenwood, Mississippi, where one of her paintings is on permanent display. She also has three paintings in the Morris Museum of Art in Augusta, Georgia. Manning sells her own work with the help of her daughter, Roxanne S. James, who manages the selling while Manning does the painting. To visit, call 601-732-6631 to arrange a visit to her home in Morton, Mississippi.

Mansur, Ben (1951)

Mansur was born in Waukesha, Wisconsin and now lives in Cynthiana, Kentucky. He has been working with wood most of his life, including his work as a custom doormaker/craftsman and his carving of figures great and small. He carves animals of all kinds and sizes. Some people know him for his crows, but he is equally likely to create giant sculptures featuring a favorite horse, Naika. He makes one enormous sculpture a year, usually with complicated imagery. One that the Mennello Museum in Orlando bought some years ago he calls "Almost Had Him." In it, Naika pulls a wagon through a forest during a solar eclipse, chasing "Bluebird 2000," a version of the bluebird of happiness, which remains just out of reach. The Edenside Gallery in Louisville and the Kentucky Artisan Center at Berea College carry his work, which is also sometimes available through the Kentucky Folk Art Center. Mansur also sells his work from his home; he asks that people call him to arrange a time to visit (859-954-0119).

Mantel, Fryma

Mantel was born in Frankfurt, Germany, and raised in Duluth, Minnesota. After spending her early adulthood in New York City, she decided to head west "to find a more peaceful living environment." In childhood, Mantel showed little artistic ability or interest. In the 1980s, after a visit with a psychic channeler, the artist decided to try painting. She decided to experiment with art by enrolling in several workshops with a more spiritual than technical approach. "The emotional light." The "psychic portraits" she paints, using

oil and acrylic on canvas, are "the subliminal energy that flows from her subjects."

Marcile, Stanley (1907–1991)

Stanley Marcile worked in New York, Connecticut, and Vermont, where he settled in North Troy in 1944. There he worked for a plywood mill until it closed in 1971. He did not like being idle, felt he couldn't go hunting any more, and when he saw some colored pencils in a store, he started drawing. The subject matter of Marcile's drawings, mostly in ballpoint and felt pen on paper, are fantasy houses, churches, and farms. His work is brightly colored and decorative. In 1982, Marcile's work was in "*Images of Experience: Untutored Older Artists*," organized by Pratt Institute in New York City. In 1997, he was included in the exhibition of Flo and Jules Laffal's collection in Connecticut at the Lyman Allyn Art Museum.

Marino, Robert J. (1893–1973)

Marino was born in Blacksher, Alabama. He created large sculptures carved or constructed from local woods. Some of his carvings are painted and some are decorated with Mardi Gras beads. His art is in the permanent collection of the Mobile Museum of Art in Mobile, Alabama.

Marsh, Harry C. (1886–1983)

Marsh was born in St. Cloud, Minnesota. His father bought a tract of land in Florida in the 1890s, and the family moved there in an ox-drawn wagon. He worked on the railroad as a young man, then worked raising racehorses on a ranch in Texas and eventually moved to Tennessee. During the 1940s he was a sign painter for the Mid-South Fair. He painted recollections of the past events of his life, and religious themes, using oil on canvas or canvasboard (earlier works were sometimes on Masonite). One of his paintings was used in the UNICEF calendar in 1976, when it featured "primitive art." Marsh and Theora Hamblett were the only two American artists represented.

Marshall, David (b. 1936)

David Marshall was born in Nassau County, New York, spent his childhood first in Virginia, and then near Kingston, New York. He left school at sixteen and became a field hand. He worked on and off as a paperhanger, painter, dairy-farm laborer, mink farmer, and factory hand, and put in several years in the navy. Marshall carves individuals and groups—human and animal figures—from soft, water-shaped rocks. He uses more than forty knives, shaping the stones to a generally rounded conformation with details of clothes and faces. "Some of these pieces are humorous, some poignant, but each has a mysterious inner vitality of its own." The Ames Gallery in Berkeley sometimes has works by Marshall for sale.

Marshall, Inez (1907–1984)— "Continental Sculpture Garden"— Portis, Kansas

Marshall created 450 sculptured pieces using Kansas limestone and hand tools. All of these pieces were displayed in her very own sculpture museum. Her inspiration came from "voices" and childhood memories. Marshall died at age 77 in 1984. Her work was auctioned off to pay her debts. At some point, around 1990, someone bought the pieces obtained at auction by Florida collectors and returned them to Kansas, where they are now installed at the Grassroots Art Center in Lucas, Kansas.

Martin, Eddie Owens see St. EOM

Martin, John (b. 1963)

John Martin was born February 24, 1963, in Marks, Mississippi. He has been at the Creative Growth Center in Oakland, California, since 1987. His art presents vibrant colors and images that reflect moments in urban life. Fish are a favorite image because he likes to go fishing from the Oakland and Berkeley piers, and he likes to eat his catch.

Martin, Sam, Sr. (1926–1998)

Sam Martin was born September 3, 1926, in Straven in Shelby County, Alabama. He was a third-generation carver of exceptional ability, from an Alabama coal-mining family. He carved small animals and walking canes, usually from a single piece of wood, using a pocket knife. He used sourwood, bay, maple, and various other woods, sanding them smooth once he had finished carving and then gave them a coat of paste wax that gives the completed work the rich appearance of antique ivory. The animal figures on his canes seemed to emerge and flow with the wood. His father was a carver, as are his sons, Sam Jr., and Tim. His work is shown in Lavitt's *Animals in American Folk Art*. His work is part of the bequest that Robert Cargo made to the Birmingham Museum of Art.

Martin, Tim

Tim Martin was born in Alabama and is a fourth-generation carver, the son of Sam Martin. He carves Indian heads, realistic, detailed pieces approximately eighteen to twenty-four inches high, occasionally larger, of cedar wood. He leaves them unpainted. His work is also part of the collection of the Birmingham Museum of Art, a gift from Robert Cargo.

Martinez-Augustine, Guillermo (b. 1944)

Guillermo was raised on a state work farm in Colorado. He spent the first six years of his life in a cage in a basement and has many memories of horrible experiences, not only personal but those about others he watched being hurt. He has been self-employed for most of his life, resisting any regimentation or regulation of his life by the state. He did serve in the U.S. Marine Corps in 1961. He now lives in New Mexico. Guillermo enjoys the friendship of many famous people, having been involved with Amnesty International in Los Angeles. His motto, which is the same as Amnesty's, is "There are no lesser people." He paints with acrylics on canvas or paper and does some drawings. His art is part of his healing process.

Maruki, Jennie (1917–2002)

Maruki, an artist of Hospital Audiences, Inc., showed a fondness for the color blue. She painted delicate female figures usually standing and stylized, reminiscent of flat, frontal Egyptian art. When Maruki broke her right, dominant arm, she immediately switched to using her left hand. Her work retained its distinctive style, but became considerably emboldened. Once she returned to painting with her right hand, the same boldness sometimes surfaced, distinct from her paintings of gentle women placed in simple landscapes with trees, flowers, or grasses. A Japanese-American who was interned during World War II, Maruki moved to New York from California after the war. After being hospitalized for mental illness for many years, she lived in a group residence in the community until her death. One of her pieces, a portrait of a woman, was selected to grace the cover of the October 1998 *American Psychologist*, from among the more than 80 works by 15 HAI artists then forming an exhibition at the American Psychological Foundation offices in Washington, D.C.

Marzan, Gregorio (1906–1997)

Marzan was born in Vega Baja, Puerto Rico, where he worked in sugarcane fields and as a carpenter, and moved to New York City in 1937. He worked in New York for a toy manufacturer. After he retired, he made imaginative sculptures from found objects. Some of his images are quite fanciful, and others are realistic enough to be recognizable. His Statue of Liberty is a popular figure, an image he made frequently. He also made small houses. His pieces are very colorful, with the color coming from the materials he used; he did not paint them. His last figures were mostly birds and mammals, "in relief and in the round." He was included in the "Cutting Edge" exhibition at the American Folk Art Museum in 1990 and "*Works of Art ... Worlds Apart*" in 1992 at the New York State Historical Association

in Cooperstown. His work is in the permanent collections of the Smithsonian American Art Museum, the American Folk Art Museum, and the Fenimore House Museum in Cooperstown, New York.

Mason, John Robert (1900–1997)

Mason was born in North Carolina and lived in Suffolk, Virginia. He worked on the railroads before retiring. Mason did pictures using colored pencils and felt markers on paper or cardboard. His pictures are distinguished by images of stylized birds, moons, trees, suns, and "Mongolians." His "studio" was the Hardee's restaurant in Suffolk, where everyone knew him. He was included in the exhibition "Folk Art: The Common Wealth of Virginia."

Massey, Willie (1906–1990)

Willie Massey was born in 1906, in Salem, Kentucky. He worked as a tenant farmer and learned to make things to meet practical needs and to satisfy his creative energy. He was married for more than twenty years. Massey created many different art forms and images using found objects and materials. He is possibly best known for his much-decorated birdhouses complete with wingless birds, and sometimes a snake or two. He died as a result of burns suffered in a fire in his home. His art was included in the exhibition "African-American Folk Art in Kentucky" in 1998. Just Folk in Summerland, California, At Home Gallery in Greensboro, North Carolina, and Larry Hackley, private dealer in Richmond, Kentucky carry his work, which is also in the permanent collections of several museums including the Kentucky Folk Art Center, and the Birmingham, Huntington, Morris, and New Orleans Museums of Art.

Mast, Mae—Environment—Webster Township, Michigan

Mae Mast is the family matriarch, and in her eighties. She graduated from college in 1921 or 1922. She has decorated her home in Webster Township, catty corner from Webster church, just northwest of Ann Arbor. As in many old Midwestern homes, the center of the house is a log cabin to which other rooms have been added. Every inch of the interior is covered with decoration, as are all the exterior surfaces of the house and outbuildings. The house is listed on http://abita mysteryhouse.com/folkartworlds.htm as available to be seen (scroll down until you get to "Michigan").

Mastroni, Sandy (b. 1954)

Mastroni lives in Connecticut. She has been making art from an early age, drawing fantasy figures from her dreams that she began to sell when she was 20. For about ten years she switched her creative talents to re

finishing furniture, but came back to her fantasy figures, which she began creating as dolls as well as in paintings. The dolls are meant for an adult audience, but children also find them intriguing. Articles about her fabric art have appeared in *House and Garden*. Her paintings have illustrated covers of two books for the Antrim House Press and have won awards from juried shows at several galleries. She is currently represented by Beverly Kaye Gallery and also sells her own work at www.etsy.com/shop/sandymastroni and smastroni. blogspot.com.

Materson, Raymond (b. 1954)

Raymond Materson was born March 14, 1954, in Milford, Connecticut, and grew up in the Midwest. He went to college and got a degree in education but drugs took over his life; he was caught trying to rob a store and went to prison in 1988. He was sentenced to fifteen years, and to keep himself sane—remembering the serenity of his grandmother's embroidery—he taught himself to embroider, using the threads from unraveled socks and selling his work for cigarettes. His embroidered pictures are fully conceived works of art with a complexity and depth that is enhanced by their miniature size. He is now married, has a son, and lives in New York State where he relates his story to at-risk youth in an effort to help them avoid prison.

Matthews, Gabriel (b. 1970)

Gabriel Matthews was born in New Orleans, March 15, 1970, and now lives in a suburb of that city. He is a clerk in a drugstore. He makes constructions, from medieval castles to spaceships that are stunning in concept, very imaginative, and demonstrate a sharp humor. All the pieces are made from cardboard, including toilet paper rolls, paper towel rolls, and shirt boards, plus plastic from hobby shops. Matthews started making such objects, though in simpler form, when he was a child in a family too poor to purchase toys, and so made them himself. Although their creator would like for some manufacturer to see them as prototypes for toys, any folk art collector would want to put one on a shelf or table. The working parts are amazing, the figures introduced into the interiors of the planes, spaceships and other objects are even more so. The weapons on a period piece vessel are tiny crossbows, and they really work. The "armor" for battle is made from tin can metal. Matthews likes "flight" machines but doesn't much like guns. He loves adventure books, and *A Wrinkle in Time* is a favorite. He carries a notepad with him at all times; he draws designs wherever he is, and maps out a plan. A junior high school dropout, Gabriel Matthews has been fighting depression all his life. He prayed for relief and got the designs in his mind. This took his attention away from his troubles.

Matthews, Mary Mayfair (b. 1938)

Mary Matthews lives in Memphis, Tennessee. She was born in Chulahoma, Mississippi, to a family of sharecroppers. She had to drop out of school in the third grade to help her family in the cotton fields. At age 28 she moved her family to Memphis to escape the cycle of poverty. She worked there as a domestic worker, and eventually was able to earn her G.E.D. In the fall of 1991, following the violent death of her only son, she started to make art full-time to ease her sorrow. Her first creative efforts were quilted wall hangings and soft sculpture. Her daughter, who had earned her B.F.A. degree, took her to art exhibits. Noticing her mother's interest and excitement, she bought her mother canvas and paints. Now Ms. Matthews paints, sculpts, and quilts daily. Her works reflect her own upbringing and memories, as well as the dreams of a life she never got to experience. Her work is pictured in the book by Roland Freeman, *A Communion of the Spirits*.

Mattingly, Lloyd E. "Hog" (1923–2003)

Lloyd "Hog" Mattingly lived in Lebanon Junction, Kentucky, and created a variety of art. He built miniatures of all the buildings as they were in Lebanon Junction when he was growing up, not stopping with the exteriors. Lift the roof of any of his pieces and you will find them furnished on the inside, too. Mattingly also made creatures and critters, inspired by the imagination of the artist, from roots and other found wood that he painted in bright flat colors. Mattingly recalled hearing the older men gathered at his father's grocery store tell stories about "things in the woods." He thought that is where he picked it up, "I guess they're sort of like spooks," he said. Toward the end of his life he started making models of the riverboats once common in his area, which are outstanding.

Maughan, Ryan (b. 1980)

Ryan Maughan was born in Phoenix, Arizona, on April 25, 1980. As a very young child he took everything and anything apart. He also began to show signs of being different from other kids. In hopes of turning his compulsive activity into something positive, family and friends donated unwanted small appliances and he contributed to this collection with objects found in alleyways and garbage cans. He soon began to create things from his collection. At age five, he built himself a life-size boy out of planks of wood and dressed him in his own clothes. Maughan also built the boy a dog out of the same wood and other objects to furnish his life. At about the same time he made articulated puppets and his first robot-like figure. He has made more complicated ones with more movable parts as he has grown older. By age sixteen he had made a robot with a motor that moved the fingers. Maughan has made

many prototype robots out of tin cans that are ten to eighteen inches tall. He also makes many clay sculptures and drawings.

Maurey, Clyde (1899–1995)

Clyde Maurey lived in Columbus, Ohio. He was a retired electrician who did not think of himself as an artist but as more of a "tinkerer." He played the organ—a large one—at home. He once made himself a pipe organ with sixty keys, making the pipes and whistles himself. He made whirligigs that incorporate people and animals in action, such as an alligator with movable jaws, and painted them with bright, attractive colors. Maurey died March 2, 1995, at the age of 96.

Maxwell, Lenville (b. 1944)

Maxwell was born in Ritner Kentucky, one of nine children. He still lives in Whitley City with his wife, Brenda. He was a meat cutter by trade until he went to work in a factory in 1976. He began carving around 1980, but it was not until his work was noticed by folklorist Lynn David that he considered his work of value or note. He has carved individual pieces including groups of figures, but mostly focuses on making walking sticks. He sometimes markets his work under the pseudonym "Bee Bow Albert," which he uses as a memorial to his sister Jennifer, who had Down syndrome. She passed away at the age of 33, but Maxwell remembers her fondly. She loved hair bows and called them her Bee Bows. Also, she struggled pronouncing Maxwell's first name, but could say Albert, so he uses the name for his art. Maxwell has been pastor of a local church since the early 1980s. His work is in the permanent collection of the Kentucky Folk Art Center, and he sells it through is website, www.lenvillemaxwell.com. He can also be reached by phone at 606-310-0638 or email at lenvillemaxwell@gmail.com.

Maxwell, R.G. (b. c1947)

Maxwell lives in Natrona Heights, in the Pittsburgh, Pennsylvania, area. He does pen and ink drawings and makes collages from photocopies from books. His works are allegorical pieces, things from outer space. Maxwell has worked on his art all the time, since the mid 1980s when he started staying home to take care of his parents. In September 1992 his work was exhibited for the first time, at the Turmoil Room in the Pittsburgh area.

May, Thomas (1922–2009)

May was a Kentucky carver of small figures, and canes decorated with heads and sequins. A teacher for 32 years, May became interested in cane making during his retirement. He carved only in the winter, saying that he devoted his summers to working the land and caring for his garden, horses, turkeys, and geese. He lived with his wife, Lucille, in a house that was his father's in Langley, Kentucky. Characteristic of his tall, brightly colored walking sticks are the incised diamond-patterned shafts highlighted by the addition of plastic beads. At the top of the cane, May carved a variety of personalities, including kings, soldiers, or an Uncle Sam. He used yellow poplar, sassafras, maple, and dogwood with acrylic paint. May's work is in the permanent collection of the Kentucky Folk Art Center in Morehead, Kentucky.

Maya, Chris (b. 1961)

Chris Maya was born in El Paso, Texas. He is a self-taught artist whose artwork reflects the Spanish Colonial styles and regions of the Southwestern United States. From the shoreline of California to the adobe missions of New Mexico, the lifestyle, landscape, and culture of the great southwest are reflected in his paintings, woodcut prints, and *santos*. Maya spent his young adult life traversing the highways and back roads of Arizona, New Mexico, and California. Along the way he rediscovered the woodcarving tradition he originally learned from his father. In his high school days he was known for being a painter, and continues to work in that medium today. In the early 1990s an art collector and mentor introduced him to the art of woodcut printmaking. Chris Maya's woodcut prints have continued to expand both in number and popularity. San Angel Folk Art in San Antonio carries his work.

Mayer, Maurice

Mayer lives and paints in Wyoming. He liked art as a child in elementary school but lost interest in high school having been consumed by football. He married after a year and a half of junior college. About thirty years later, after his two children were grown, he started painting again. His son and daughter-in-law gave him his first set of oil paints and some pre-stretched canvas. Mayer says "it took more years than I care to mention before I was putting down something I liked. It was a joy for me so I stuck with it." His art depicts his region and its history. His work has been in exhibitions in Riverton, Casper, and Cheyenne, Wyoming, and in Pueblo, Colorado.

Mayfield, M.B. (1923–2005)

Mayfield lived in Ecru, Mississippi. He was one of twelve children, five of whom died of tuberculosis as did his father and stepfather. He had a twin brother, L.D. He dropped out of school in the eighth grade to work in the cotton fields, but he loved to paint. He had a yard full of paintings when an art professor, the late Stuart Purser, drove by and introduced himself. The art department at the University of Mississippi was new, and the hiring policies loose, so Purser was able to hire Mayfield as a janitor, and hide him in the closet

during his art classes so Mayfield could hear the lectures. The students knew he was there and helped, too, giving him art supplies. Mayfield notes that he was "the first black student at Ole Miss," although unofficially so. He painted scenes from his rural Mississippi childhood, popular figures, and sometimes self-portraits, including images of William Faulkner, Oprah, Elvis, and others. At one time Southside Gallery in Oxford, Mississippi handled his work, which is mostly now in private collections.

May-Miller, Zephra (b. 1943)

May-Miller lives in Louisville, Kentucky. She is called "Bag Lady of Louisville" because she creates figures from plastic bags and found objects. She also does paintings, using gourds as her canvas, and does pictorial needlework. She has been making art, the inspiration for which she gives credit to a religious experience, for several decades. She gives a helping hand to the street people in her Louisville neighborhood. Her work was exhibited at the Kentucky Folk Art Center in 1998 in "African-American Folk Art in Kentucky" and is in the Center's permanent collection.

Maynard, Mark (b. 1968)

Born in Lexington, Kentucky, Maynard now lives in Ypsilanti, Michigan. He has created artworks since childhood, beginning with sculptural dioramas using empty television sets and discarded objects. While studying for a degree in American Studies at the University of Michigan, Maynard began suffering with migraine headaches and started having trouble in some classes. He became a patient at Michigan's Anxiety Disorder Clinic where he was diagnosed as having several health and learning problems. Upon graduation he moved to Atlanta, Georgia, where he received encouragement for continuing his artwork from such artists as Howard Finster, Frank Pickle, Leroy Almon, and others. Maynard's art includes both sculpture and paintings. They often include many words communicating his thoughts, philosophy, dreams, and visions. His work is colorful, well-crafted and often highly personal. At one time Smith Creek Art in Oconomowoc, Wisconsin, carried his work.

Mayo, Everett (b. 1959)

A former heavyweight boxer known as *The Tornado*, Everett Mayo was born in Roanoke, Virginia in 1959. Mayo began boxing in the army and continued boxing in a professional capacity after leaving the military, but his career was cut short by a construction accident that left him legally blind in one eye. After retiring from boxing, Mayo returned to his love of art and started producing folk art using pieces of driftwood found on riverbanks. Looking for shapes in the wood, Mayo paints birds, fish, and other animals as well as human figures, which he then paints with house paint. Basically, he uses the wood as it is found rather than carving it. His pieces range from small figures to a six-foot tall giraffe and a seven-foot long shark. He collects driftwood and allows the natural shape to influence his images. The first showing of his work was in 1993; he has since exhibited in several museums. He participated in the Virginia Art Residency program and also provided art workshops for children in Central and Western Virginia as well as St. Helena, South Carolina. His work was included in the exhibition, "Folk Art: The Common Wealth of Virginia," in 1996. He maintains his own Facebook page (https://www.facebook.com/LordOfTheWood), participates in Folk Art Nation (www.folkartnation.ning.com/profile/EverettMayo), a site where folk artists can post pictures, videos, discuss art, chat, and just come together and is the subject of a YouTube video (www.youtube.com/watch?v=y-jfxBqMWPc).

McCaffrey, Wayne D. "Mad Mac" (1924–1993)

"Mad Mac" was born in Akron, Ohio. He lived most of his life in and around the area and was "a sometime preacher, country music guitarist, folk artist, and gadfly extraordinaire." McCaffrey drove trucks, painted houses, sold vegetables door-to-door, scrapped copper wire, and drank. His father was an alcoholic and got Mac started in gin joints when he was ten or eleven. He drank for the next 25 years and would never have stopped had it not been for AA. His mother, whom he dearly loved, hung herself when he was seven, and he was the one who found her. His younger brother died as a child, when Mac was just twelve. A patron of his art, Chuck Auerbach said, "Life started hard for Mac and stayed hard." His son and daughter-in-law were brutally murdered in his house in front of his grandchildren who have a daily struggle with that memory. Mac persevered, though. He believed in visitations by aliens who he found mostly benevolent. He made wire-sculpture art of great distinction out of telephone wires and plastered paper. Objects ranged from realistic alligators and other creatures to political portraits—none too flattering (some look rather like the devil himself). Some of his last works were allegorical picture boards which are wire-work landscapes with images and warnings of destruction. His work is illustrated in the catalog *New Traditions/Non-Traditions: Contemporary Folk Art in Ohio*. After a long battle with cancer, Mr. McCaffrey died July 26, 1993. Many of his pieces are in private collections. The Akron Museum of Art includes some of his pieces in its permanent collection.

McCarthy, Justin (1892–1977)

McCarthy grew up in Weatherly, Pennsylvania, where he spent most of his life. He came from an afflu-

ent family, with whom he moved to Paris after a more favored brother died. He was left on his own a lot, and spent time at the Louvre. His father committed suicide in 1907. He failed at law school, had a breakdown, and "drew to recover." After his family lost their money, he supported himself and his mother by raising and selling vegetables. After she died in 1940, he had a series of menial jobs. McCarthy began painting in the 1920s, but was not "discovered" until 1962. He worked in many media and had a tremendous range of subjects, but his most frequent were current entertainment personalities, particularly movie stars and sports figures. He died in Tucson, Arizona. Many galleries and dealers carry his art, including Marcia Weber/Art Objects, Fleisher/Ollman Gallery, Just folk, Galerie Bonheur, Outsider Folk Art, Grey Carter, and Barry Cohen, private dealer. His work is in the permanent collections of many museums, including the Smithsonian American Art Museum; the Birmingham, Milwaukee, Philadelphia, and New Orleans Museums of Art; and the American Folk Art Museum.

McClusky, C.T. (fl. mid–1900s)

C.T. McClusky was a circus clown who spent his winters in an Oakland, California, rooming house in the 1940s and 1950s. Fifty-three of his collages were found in a suitcase at a swap meet in 1975. The daughter of the woman who owned the rooming house remembers him as a nice man who drank too much, and spent hours poring over old *Life* magazines, looking for pictures to use in his art. His art was featured in an exhibition at the San Francisco Craft and Folk Art Museum in 1996, "C.T. McClusky: Visions of the Circus."

McCord, Jake (1945–2009)

Jake McCord was born and lived in Thomson, Georgia. He lived and worked on the family farm for more than thirty years. McCord and the whole family, including Jake and his eleven brothers and sisters, worked planting and picking crops. In the 1970s he started working for the city, cutting grass in the summer and driving a truck in the winter. McCord started painting around 1984 or 1985. The sources of his art were television — he owned six sets, a least two or three of which were on at all times — and his childhood. His favorite subjects were farm animals, house pets, women, and houses. He painted in bright colors on plywood. The work was "just for fun." His art was included in the exhibition "Flying Free" in 1997. Marcia Weber/Art Objects, Main Street Gallery (Clayton, Georgia), Red Piano Too Art Gallery (St. Helena Island, South Carolina), and Louanne LaRoche, private dealer, carry his work, which may also be seen at the Morris Museum of Art in Augusta, Georgia and the House of Blues in New Orleans.

McCormick, George Ray, Sr. (1944–2009)

McCormick was born in Vicksburg to sharecropping parents. He moved to Milwaukee with his mother and stepfather in 1950, as part of the post-war movement of African-Americans out of the deep south. After his early dream of becoming a painter was dashed by a high school teacher who told him that "black men did not become professional artists," he joined the Navy and later held menial jobs in industrial plants. In 1984, after a number of setbacks, McCormick attended Milwaukee Area Technical College to study tailoring and cabinetry. While using these skills his interest in making art returned. He started making dolls, then paintings, prints, woodcarvings, and welded metal sculpture. He is best known for his "flat people"—portraits of prostitutes, hustlers, and other street people. He also made richly colored and inscribed relief carvings of Biblical scenes. His work has been part of the Smithsonian's National Folk Art Festival in 1998, the Kentucky Festival over many years, and many group exhibitions across the Midwest. One of his most notable accomplishments was the 2008 exhibition at the Charles Allis Art Museum, "Journey from the Secular to the Spiritual: Works by George McCormick Sr." In 2009 the Museum of Wisconsin Art mounted the exhibition "One from Wisconsin: George Ray McCormick Sr." featuring 15 of the artist's pieces, which was still up when the artist died suddenly.

McCrane, Ruth Mae (1929–2002)

McCrane was born in Corpus Christi, Texas, where her family had migrated from Louisiana. McCrane taught school, and did not start to paint until some time after her retirement in 1985. Her paintings are based on her experiences from 1937 through the beginnings of integration and on into the present time. Although her paintings have little scale or depth, they demonstrate great energy and activity. The people who fill her populated canvases are busy, actively involved in church affairs, childhood games, juke joints, parties with music and dance, baptisms, storytelling, and family chores. She usually painted with acrylics on canvas board or plywood. Each piece is highly detailed. Raven Arts Gallery in New Orleans sells her work, and it can be seen at the House of Blues in New Orleans.

McDonald, Eric Calvin (b. 1925)

Born in Brooklyn, New York, McDonald now lives in the metropolitan Washington area. A former musician and cab driver, he had a stroke several years ago that left him unable to speak and paralyzed his legs and right arm. Prior to his stroke, McDonald did not make art. Now he draws with ink and felt tip on paper. Most of his themes come from popular media. McDonald's art is in the collection of the Smithsonian American Art Museum.

McDonald, Guillermo (1928–2001)

McDonald lived in Albuquerque, New Mexico. He was born in Peru and was of Scottish-Peruvian descent. He pursued his interest in painting from the time he was a little boy. He incorporated religious imagery in most but not all of his "jewel-like paintings." His work is illustrated in the exhibition catalog *Visions*.

McDonald, Marjorie (1898–1995)

McDonald was born in Akron, Indiana, and moved with her family to Portland, Oregon, when she was young. In her later years she lived in Corvallis, Oregon. She studied languages and history at Reed College and the University of Oregon, and followed her father in becoming a teacher. She spent forty years as a teacher, married and lost her husband, and helped institute the first high school–level Russian language curriculum in the United States. After she retired she did volunteer work, but began to suffer from headaches. She started to pursue art at the age of 72, at the suggestion of a friend who thought it might take her mind off her pain. (It did not help; she still had migraines.) She made collages of dyed rice papers, which she shaped and to which she attached figures—often whimsical animals, dinosaurs, plants, birds, or people, simplified to flat shapes and touched with fantasy. They stand out against the rice papers dyed in the soft colors of the Oregon coast. Her work appears occasionally at galleries in the Northwest. Slides of her work are in the research library at the National Museum of Women in the Arts in Washington, D.C. Images of her art, along with more detail about her life, appear at http://marjorie-mcdonald.com/story.html.

McEwen, Mary France (1866–1958)

Mary France McEwen learned doll making, wax-head display figures for store displays, at her family's factory in Milwaukee, Wisconsin. The factory failed when composition materials replaced wax and the family moved to Seattle in 1910. It was there that McEwen began making her wax dolls. At first they were blue-eyed blondes. When this reclusive artist died at age ninety-two, her collection of black dolls was found. The heads with brown glass eyes and expressive faces were made of wax, as were the hands. The bodies were of wood with cloth and arms and legs covered with cloth. These dolls engendered great enthusiasm at shows and at the Ames Gallery in Berkeley when they appeared there.

McGee, James Hagan (b. 1927)

McGee was born near Springfield, Kentucky. He is a self-taught artist who paints his memories of what he calls "a more spiritual epic." His themes are based upon his childhood memories of rural Washington County. His technique is a rich, textural handling of paint. His memories are a child's memories for he moved to urban Louisville with his family in 1939. He started painting after retirement from being a maintenance worker at Holy Cross High School in Louisville. His art is about connections between people and animals, and people and the land. His paintings now number in the hundreds, mostly of Kentucky barns, covered bridges, country churches and farm scenes of the early 20th century. Many of his works are in the hands of collectors. Louisville's Brown-Forman Corporation commissioned his painting of the historic Woodford Reserve Distillery and has purchased more than 100 of his barn scenes for its collection.

McGrane, Claudia

McGrane assembles dolls from found objects that "are delightful, fun, and have a little bit of a creep factor." Heads, arms, and legs are made of clay while the bodies may be old tin boxes, drink shakers, lunch boxes, or oil cans. The Green Eyed Gator Gallery in New Orleans carries her work, which she also sells through her Facebook page and website (www.claudiamcgraneartdolls.com).

McGriff, Columbus (1931–1991)

Columbus McGriff crafted figures of animals and machines out of wire for almost 25 years. He was born on a tobacco farm in the Havana, Florida, area where as a child of nine he first began to sculpt with scrap wire he found on the farm. He was a farm worker for much of his life, although he worked in a shoe shine parlor in New York City for several years. He moved to Cairo, Georgia, in the early 1970s, to help his sick mother. "Ingenious and spritely," McGriff's cars, trains, pigs, ducks, and dinosaurs have been hailed as inspired examples of naive art. In 1990 his work was featured as part of the Black Heritage Week exhibition at the Thomasville Cultural Center. McGriff never enjoyed more than brief flashes of public acclaim, and subsisted with the help of a small shoe shine and candy store that he operated in his house.

McGuigan, Frank (b. 1952)

Frank McGuigan lives in New Hope, Mississippi. He has been painting since 1991, and he says he "uses the painting experience as a means of communication and expression." He started out after seeing a set of watercolors for sale at a Wal-Mart and became obsessed, painting all the time. He now works at his art full-time. His small studio is filled with his work. His chosen medium is gouache. He paints portraits and landscapes featuring blues people, musicians, animals, and land-

scapes. He likes the work of Picasso, Chagall, Matisse, and children. He says, "Ultimately, I just look to myself for my own inner vision." Marcia Weber/Art Objects and Primitive Kool Gallery, among others, carry his work.

McKay, Kenny (b. 1941)

Kenny McKay was born October 8, 1941, in Mt. Vernon, New York. The earliest source of inspiration for McKay was the coffee cup, which he drew in endless variations. He also paints a blue and somewhat demonic bird regularly. McKay takes an interest in the Renaissance and paints related subjects. He also paints contemporary popular icons such as Mickey Mouse, Bugs Bunny, and Marilyn Monroe. McKay's transparent, overlapping forms are a result of his technique of drawing fluid outlines, followed by scrubbing watercolor onto the page. This results in the blurring of the final images. McKay, who spent 25 years in a mental institution, has a fine intellect and a creative sense of humor. He incorporates his humor into his paintings by writing puns, jokes, and word plays on them. McKay lives in a group residence and is a regular at HAI. His art was included in the exhibition "Flying Free."

McKee, Larry (b. 1941)

Larry McKee was born in McCreary County, Kentucky, and now lives in the south-central area of that state. He has carved and whittled since he was a child, following the example of his father. McKee spent many years employed in logging and now is disabled. He carves walking sticks and adds paint and shellac. His favorite wood is cedar. His images include skeletons, birds, animals, reptiles, flowers, cards, and dice. His work was in the exhibition "Sticks: Historical and Contemporary Kentucky Canes" in 1988, and in the exhibition "Flying Free" in 1997. The Craft Gallery in Louisville carries his work.

McKenzie, Carl (1905–1998)

Carl McKenzie was born on June 4, 1905, near Pine Ridge in Wolfe County, Kentucky. His father, George, worked as a logger and was killed by lightning in 1912, and his mother died in 1918, leaving Carl on his own when he was thirteen. He lived and worked on small farms in the area when he was in his teens. He married his first wife in 1927 and worked in a tile factory in Cincinnati. They had two children and separated. During the Depression he worked in the coal fields of Perry County. He married Edna Spurlock in 1938. He worked for awhile for Armco Steel in Ohio, and finally moved to Powell County permanently in 1944. He worked for seventeen years trucking lumber, a job he loved, and when poor health forced him to retire he started carving. He lived in Snakey Hollow, near Slade, Kentucky, and his wife worked at nearby Natural Bridge

State Park. She died in 1989. After retirement he carved all kinds of figures, animals, and birds—but mostly women. He painted his figures with bright colored patterns. McKenzie used homemade twig brushes to apply acrylic house paint. Often he would then carve into the painted surface to expose the wood, "enhancing the hair or gouging a pattern into clothes," explained Larry Hackley who met McKenzie in 1977 and brought his work to the attention of many collectors. His Statue of Liberty figures are quite popular. McKenzie spent his last years in a nursing home after having suffered a stroke in 1992. His work is in numerous museums, including the Kentucky Folk Art Center; the Birmingham, Huntington, Morris, and Owensboro Museums of Art, and the Smithsonian Archives of American Art. Just Folk in Summerland, California, the Craft Gallery in Louisville, the At Home Gallery in Greensboro, and Larry Hackley, private dealer, carry his art.

McKesson, Malcolm (1909–1999)

McKesson lived in New York City. From a background of privilege and accomplishment, he withdrew from social commitments to a private place where he devoted himself to meditation. According to a description of his work written by the American Visionary Art Museum staff, "McKesson has produced huge numbers of highly detailed drawings expressive of inner obsessions which he explains are 'powerfully sexual but always beautiful.'" He was a highly regarded outsider artist whose works are in the permanent collection of the American Visionary Art Museum in Baltimore and the Collection de l'Art Brut in Lausanne. His illustrated book, *MATRIARCHY: Freedom in Bondage*, was published in January 1997. Grey Carter Objects of Art carries his work.

McKillop, Edgar (1879–1950)

McKillop was born in North Carolina, in Henderson County. He was a self-taught and very well-known carver who is included in illustrated books and museum collections such as those at the Henry Ford Museum in Dearborn, Michigan, and the Abby Aldrich Rockefeller Folk Art Center in Williamsburg, Virginia.

McKissack, Jeff (1902–1980)—"The Orange Show"—Houston, Texas

Jefferson Davis McKissack was born in Ft. Gaines, Georgia. He earned a college degree in commerce, then moved to New York to work for a Wall Street bank, attending graduate school at Columbia. When the stock market crashed in 1929, he returned to Georgia and traveled the state selling oranges. After World War II he moved to Houston and worked for the post office. His Orange Show is a work of folk architecture located in Houston's East End. Jeff McKissack built it

with found objects over a 25-year period to illustrate his philosophy of good health and nutrition. McKissack's life and his environment are described in many writings and in a film. The Orange Show has evolved into the Orange Show Center for Visionary Art and since 1980 is a non-profit organization designed to preserve and present works of extraordinary imagination and provide people the opportunity to express their personal artistic vision. As a form of folk art, The Orange Show captures a segment of late 20th Century American culture. Programming at the Orange Show is for both children and adults and includes hands-on workshops, music, storytelling and performance, the Eyeopener Tour program and Houston's most popular public art event, the Houston Art Car Parade. The foundation has grown to take in other folk art icons and now possesses and runs the Beer Can House. In addition, it developed and maintains Houston's first folk art inspired green space, Smither Park, in the land adjacent to the Orange Show Monument. It is located at 2401 Munger Street in Houston. See chapter on Organizations for details of visiting, tours, and events.

McLaws, Donald (b. 1931)

Don McLaws is a retired guard who once worked on a towboat in St. Louis. He lives in Baton Rouge, Louisiana, with his stepdaughter. He paints imaginative scenes in acrylic paint with such titles as "Dancing Grandma"and "Armageddon," historic scenes from Louisiana, and nudes. He says he does nudes "real good, not pornographic, just like they did in the old days." His themes come from his memories, historical events, and his vivid imagination. He also makes canes and wooden musical instruments to supplement his meager retirement income, and he makes small figures from the roots of toppled cypress trees. His paintings are acrylics that have been watered down, and look very much like watercolors. He never paints an image more than once. The size of the paintings is determined by the size of his briefcase, which he uses to transport his work. His step-daughter drives him to downtown Baton Rouge in the morning; he walks the street selling his work until about 4 p.m., when she picks him up again. Gilley's Gallery in Baton Roouge carries his work.

McMillan, Sam (b. 1926)

Sam McMillan lives in Winston-Salem, North Carolina. He was born in Robeson County. He used to buy and sell furniture door-to-door until the racial turbulence of the 1960s made it too dangerous to continue. He has made and repaired furniture, worked in tobacco warehouses, and worked as a handyman. He runs "Sam's Handcraft Shop." McMillan finds all kinds of furniture and household effects and paints them with colorful backgrounds and primitive figures. He paints furniture with images, dots, lines, and his name

"Sam" all in bright colors. Sam works sells his art at Kentuck and many other folk festivals and at his home at 701 Northwest Boulevard in Winston-Salem. Telephone: 336-724-1597. His work can be seen at the House of Blues in New Orleans, and is in the permanent collection of the African American Museum of Dallas.

McNellis, Laura Craig (b. 1957)

Laura McNellis was born in Nashville, Tennessee. Her father is a retired postal worker and her mother, a homemaker. She has three older sisters. McNellis is mentally retarded. It became apparent early on that she loved to paint and that it provided her with a much-needed means of expression. She paints with tempera and, with a keen sense of observation, frequently records in her paintings the people, objects and events in her day. Her work is illustrated in the book *American Self-taught* by Maresca and Ricco; Ricco/Maresca Gallery in New York City carries her work.

Meaders Family, North Georgia Potters

The Meaders family, many of whom are listed separately below, have been making commercial and folk pottery in White County Georgia and surrounding areas since 1893. They have been featured in several films (*The Meaders Family: North Georgia Potters* produced in 1978 by the Smithsonian Institution and *Clay in the Blood* by Eyeball Productions in 1996) and books (*Brothers in Clay* and *Raised in Clay*, among others). Work by many members of the family are in the collections of the Museum of Arts and Sciences in Macon, the Folk Pottery Museum of Northeast Georgia in Sautee-Nocoochee, and the Southern Folk Pottery Collectors Society Shop and Museum in Seagrove, North Carolina. Many Meaders potters are featured in an impressive exhibition, "*Pottery of the U.S. South: A Living Tradition*," at the Museum of International Folk Art in Santa Fe, New Mexico (October 24, 2014, through January 3, 2016), which also includes a video of Cheever and several other family members working in their pottery. The work of many Meaders family members is available at www.folkpottery.com (rgh@folkpottery.com).

Meaders, Alva Gusta "A.G." (1923–1993)

A.G. was the son of Cleater James Meaders (1880–1934) of White County, Georgia, and became a full-time potter after retirement. He worked for the most part with his brother, Cleater James (C.J.) Meaders, Jr. (b. 1921). A.G. was an accomplished potter who had started producing face jugs before his death.

Meaders, Cleater "C.J." (1921–2003)

C.J. Meaders was born and raised in Mossy Creek, Georgia. His father, Cleater, Sr., was the son of John M. Meaders, who "started the dynasty when he opened the Meaders pottery in 1893." C.J. is Lanier Meaders' cousin. He moved to Mobile and went to work at Warner Robbins and returned to pottery full-time after retiring in 1978. His pottery was in Byron, Peach County, Georgia.

Meaders, Cleater, III (b. 1956)

Clete Meaders is part of the Meaders family that has been making pottery for well over one hundred years. He makes his pottery using completely traditional methods. Clete turns out all of the traditional pots, jugs, churns, and other pottery made by his ancestors, but he is best known for his face jugs. Most of his face jugs have poetry on them. His work has been displayed at the Smithsonian Institution, the Atlanta Historical Society, and the Museum of Arts and Sciences in Macon. C.J. Meaders Pottery is located in Braselton, Georgia, at Exit 49 of High-way 53 and I-85.

Meaders, David (1951)

The son of Reggie Meaders, David's introduction to pottery came at the shop of his grandfather, Cheever Meaders. David drifted away from pottery but returned in 1984 with the help of his Uncle Edwin Meaders. David and his wife Anita, also from a family of potters, have a pottery shop in north Georgia. They each make face jugs in addition to other ware.

Meaders, Edwin (b. 1921)

Edwin Neil Meaders is the youngest son of Cheever Meaders, and the only one still alive. Edwin worked full-time at a lumber mill but always helped at his father's pottery from his earliest years. In 1969, Edwin built his own shop. He still works, in Cleveland, Georgia, making only two items; the best known are his blue and green roosters.

Meaders, John R. (1916–1999)

John is the oldest of the four sons of Cheever Meaders, Lanier being the second, Reggie Meaders the third, and Edwin Meaders the fourth. Neither of them worked at pottery until after their respective retirements. John was a farmer and "the Great Depression and World War II took Reggie away from pottery." John made jugs and pitchers and specialized in a very unusual shallow chicken bowl. Reggie made face jugs that are quite distinctive, with somewhat small, recessed faces in "a style that is very much his own."

Meaders, Lanier (1917–1998)

Quillian Lanier Meaders was born in 1917 in Mossy Creek, Georgia. His family was in the pottery business, started by his grandfather in 1892. He was one of four sons of Arie and Cheever Meaders who had taken over the family pottery in 1920 and was "the keeper of the family homestead and pottery." Lanier took over the family pottery at his father Cheever's death when Lanier was fifty, combining his father's stubborn adherence to the old ways with the artistic vision of his mother, potter Arie Meaders. Lanier's face jugs have character, power, and vitality. Some were portraits of famous people. He used porcelain for teeth and a variety of glazes. By the late 1960s traditional folk pottery in Georgia was declining. Lanier continued with the traditional alkaline-glazed stoneware tradition and this made him an important link between the past and future of Southern folk pottery; his success inspired others. There was a memorial exhibition of his work at the Mint Museum of Art, Charlotte, North Carolina, in the summer of 1998.

Meek, Cora (1889–2001)

Born on a farm in east-central Illinois and has lived in the area until she died in 2001 at the age of 111. She quilted for many years, but did not become a celebrated folk artist until the age of 93. She received a grant from the Illinois Arts Council when she was 101. Her work is now in museum collections around the country, including the Smithsonian American Art Museum. When widowed as a young woman, she used the sewing skills she had learned as a child to support herself and her three children. Meek collected all sorts of materials and made them into drapes for her windows, furniture for her home, and rugs for her floors. "Inside and out," says Lisa Stone in a biographical note about the artist, "Meek's house was a reflection of her tenacious creativity." Cora Meek is represented in the folk art collection of the Tarble Art Center in Charleston, Illinois. Curator Donna Meeks says "Although working in the quilt tradition, Meek's quilting style is that of an outsider artist." Her designs include pure abstractions and Lisa Stone likens them to the intuitive line drawings of Paul Klee. In October 1995 an exhibition of her work was presented by Intuit, which she attended, in Chicago.

Mello, Alipio (1898–1987)— Environment—Napanoch, New York

Alipio Mello was born in Portugal and worked for years as a mason in the waterworks of the Catskill Mountains in New York State. After retiring, Mello began to work on his water powered circus of Ferris wheels and whirligigs made of wood, aluminum, Styrofoam, and recycled materials. The environment worked from a system of rain gutters, hoses, and tributaries, which he controlled from a nearby stream. The

waterpower turned wheels and paddles that would animate characters such as a woodchopper, a mother rocking her baby, a boy lifting a bucket out of a well, and a bicycle rider. There were also numerous open-work spheres, structures, and towers that would spin from the force of the water. Mello began building the site in 1975, and continued until his death. After he died, the environment was left unattended. Trees fell on and creeping vegetation grew over the structures, and the flooding stream began to erode the figures. Nothing remains of this wonderful environment.

Menard, Edmond (b. 1942)

Menard was born in Barre, Vermont, November 20, 1942, and now lives in Cabot, Vermont. He carves unique, small fantailed birds carved from a single piece of cedar. An artist friend has described his work as "more art than craft." He learned to carve from an elderly man. Call him if in the area, at 802-563-2877. In the summertime, if you are traveling on Route 2 between Montpelier and St. Johnsbury, you will see his signs ("The Birdman") along the side of the road.

Menna, Gaetana (1912–1997)

Menna Gaetana was born in Brooklyn, New York, September 12, 1912, of Italian parents. He worked in two distinctively different styles. He created a primitive male figure, whose nude body is visible under a conservative suit. Points of focus, seen as dots on his drawings, represent skeletal joints such as ankles and knees. Shoelaces fly about. Menna also created finely detailed interpretations of paintings by Old Masters. These interpretations display technical virtuosity and intense use of color. His sister remained devoted to him throughout his life. He is described as a man who was cheerful but quiet. His work was included in the exhibition "Flying Free." He was a part of the HAI program and died in Brooklyn in April 1997.

Mercier, Anna (b. c1924—no further information available)

Anna Mercier is from New Orleans. She has lived in Chicago for more than 25 years. She uses markers on file folders to make her art. She saves everything and incorporates it into her work. Sometimes she uses bags and rings from soda bottles. She makes big fluffy constructions "like a memory vase," and also draws on fabric. At first she was very decorative, but after her first show she has become more non-figurative. In 1994 she collaborated with actress Tekki Lomnikki to produce a play, "When Heck Was a Puppy," written by Lomnicki, Michael Blackwell, and Nancy Neven Shelton and based on a compilation of life stories by Lomnicki, Mercier, and other southern folk artists. Mercier did the scenery and some of the props. She has been described as "an incredible colorist." She was included in the exhibition "Outsider Art: An Exploration of Chicago Collections," in 1996–1997.

Merritt, Gene (b. 1936—no further information available)

Gene Merritt was born in South Carolina and works in a restaurant. He makes drawings that record a personal world of people and things "that just come into my head." He watches a lot of television and this has influenced his art. Merritt does ink and pencil drawings on paper. His work was included in the exhibition, "Visions of Self-taught Artists: Nine from South Carolina," at Piccolo Spoleto in Charleston, South Carolina, in 1995 and in a solo show at Brandt Gallery in Cleveland in 1999. He is included in the *New Encyclopedia of Southern Culture, Vol. 23: Folk Art* (see Recent Books).

Messenger, Morris (1936–1997)

Messenger was born in Gila Bump, Arizona, four miles west of Brice, and lived in Phoenix. Messenger is part Navajo and part Cherokee. He was raised on a farm but worked at 37 different trades in his life. Morris made full-sized figurative stone and wood-carvings, and worked with tin. He also painted figures and landscapes. When he died in December 1997, his wife gave his remaining carvings to family members.

Metten, Ferd (1893–1977)

Metten has 27 works in the collection of the Tarble Arts Center in Charleston, Illinois. These exceptional works include complex dioramas of many carved and painted elements, figures, and moving parts made of walnut shells, assemblages, and wood-carvings. Themes focus on rural scenes and subjects from the early part of the century. Others involve religious subjects, and there is one political diorama called Watergate (circa 1974). Metten was a farmer and self-taught woodcarver. He began assembling his carvings into dioramas during the early 1940s.

Meyers, Kenneth Lee

Meyers started carving at a very young age. He learned by watching his father who made whimsical art objects. He can carve any image from a photograph. His wife, Elizabeth, helps with the painting of his sculptured pieces. The Meyers have five children, from ages seven to fourteen, and all of them can carve. Folk Art Net in Roanoke, Virginia, has his work.

Michel, Christian (b. 1949)

Christian Michel was born in Cadouche, Haiti. He immigrated to Philadelphia in 1989. For years Michel

worked in bakeries, "packing bread and cakes for a living while dreaming of the day he could put aside pastries for his paintbrush." A series of grants has made it possible for him to stop working in bakeries to paint full-time. "He paints vivid portrayals of Haitian villages and colorful market women, colorful scenes of Philadelphia block parties, and works of religious salvation." His art has been included in several group shows at the Noyes Museum in New Jersey including, in 1966, "Family in Focus: Cultural Diversity and the Family." In the catalog for that exhibition it says that Michel frequently paints narrative family scenes based upon experiences with his eight brothers and sisters, and his own five children.

Middleswart, Lee (b. 1947)

Middleswart was born in Oakland, California. She moved about several times after her father's death in 1961, and at age seventeen left home and went to Iowa. She "felt at home" there and has lived in Iowa ever since. She divorced and became a single parent at age 22. Middleswart painted signs and garbage trucks to support her two small sons. In 1991 when her youngest son was killed, she went into a severe depression and "mostly stayed in bed" for three years. In 1993 she began to use her art ability as therapy. She began to experience something she identified as "the spirit of life," and started doing art that reflected those feelings. Lee uses old objects and collectibles found in Iowa for her pieces. The painting is done using techniques that duplicate aged pieces. Lettering is frequently used to express the message of the pieces. Pieces are also carved, wood-burned, sanded, and stained. Many of her pieces have a Santa Claus theme.

Milestone, Mark Casey (b. 1958)

Milestone was born in Jacksonville, Florida, and lives most of the time in North Carolina. His work takes many forms, from simple, whimsical whirligigs to spiritually inspired paintings. He also makes toys with moving parts and larger than life robots made from found material such as scrap metals and salvaged wood. Art Cellar Gallery in Banner Elk, North Carolina, and Gray Carter/Objects of Art in McLean, Virginia carry his work. In addition, he sells from his own website, www.markcaseymilestone.com.

Milkovisch, John (1912–1988)—"Beer Can House"—Houston, Texas

John Milkovisch retired from his job as an upholsterer in 1976. In the 1960s he spent his free time in laying thousands of rocks, marbles, brass figurines and metal pieces in concrete blocks and redwood. These he used to make patios, fences, and so on. He claimed this was done because he hated to cut grass. Then he started, after retirement, using beer cans—tops, bottoms, sides, and pull tabs—to make curtains, mobiles, fences, sculpture, windmills, and wind chimes. He wired the beer can bottoms in long chains and hung them from the eaves of the house and all around the sides. He made a very attractive front gate with beer cans laid on their sides filling a "regular" gate frame. The house glistens in the light and tinkles in the breeze. It is possible to see the house easily from the sidewalk, but it is important to note that the house is occupied by the creator's family and one should not walk around the yard itself. The house has its own website, www.beercanhouse.org. It is at 222 Malone in Houston, where it can be visited, or called at 713-926-6368. The Orange Show Foundation in Houston has extensive documentation of the site.

Miller, Anna Louisa (1906–death date unknown)

Anna Louisa Miller was born January 12, 1906, in Glenbeulah, Wisconsin. She married Lynn Miller, and moved with him to Milwaukee in the early 1940s. It was then that she started painting. Miller occupied her time, while her husband worked as a night watchman, painting large, detailed oil paintings. After World War II and their return to their farm home near Augusta, Wisconsin, Miller produced a collection of portraits, landscapes, and fantasy paintings. She stopped painting after her husband died in 1971. In 1976 she was institutionalized and lived in a health care center in Eau Claire until her death. Her paintings have been described as possessing a visionary quality. In early books, for instance *Grass Roots Art: Wisconsin* (1978), she is referred to as "Lynn Miller," her husband's name. The bulk of her work was given as a gift to Viterbo College in La Crosse, Wisconsin. There are pieces also in the collections of the Milwaukee Art Museum—the first piece of twentieth century self-taught art acquired by that institution—and the John Michael Kohler Arts Center in Sheboygan, Wisconsin.

Miller, Bill (b. 1962)

Miller makes his art from discarded linoleum and vinyl flooring. He creates an effect that lies somewhere between collage and stained glass; his innovative use of the linoleum's pattern and color is his signature style. Miller's work has been recognized for rendering narrative moods and a sense of common memory. His unexpected use of patterns taps into the medium's nostalgic familiarity striving to impart a sense of history and story within each piece. Miller's work has been in exhibitions across the United States over the past 15 years. Initially showing paintings in oil and acrylic, Miller began working with recycled materials as a founding member of Pittsburgh's Industrial Arts Coop, constructing large scale sculptures made of scrap materials in abandoned industrial sites. San Angel Folk Art carries his work.

Miller, Dan (1961)

Miller was born in Castro Valley, California. His artwork reflects his perceptions. Letters and words are repeatedly overdrawn, often creating layered ink masses hovering on the page and built up until one cannot see the ground. Each work contains the written recording of the artist's obsession with objects, light bulbs, electrical sockets, food, and the names of cities and people. In 2007 Miller had a solo exhibition at White Columns, New York, and has participated in group shows including at The Armory Show in New York. He works at Creative Growth in Oakland, California, where in 2013 he was one of two artists featured in that studio's 40th anniversary celebration. His art is available through Creative Growth and Andrew Edlin Gallery in New York.

Miller, Dan Robert (1918–1991)

Dan Robert Miller was born in St. Matthews, South Carolina. He was a self-taught wood sculptor who began making his art—he never called himself an artist until others did—when a severe illness made him give up his work as a truck driver. Miller's art came from his dreams and visions. "The good Lord showed me some things…. I'd see them in the night … the next day I'd go in the woods, and then I would carve out of the wood." The intensity of his inspiration lasted for about ten years from 1969 to 1979. During that time Miller created his unique, highly personal sculpture. In 1987, four years before his death, the South Carolina State Museum purchased his works.

Miller, Janice (b. 1939)

Miller was born in Garrard County, Kentucky and now lives in Lancaster, Kentucky. She grew up doing all the work it takes to farm. She drew most of her life, using cake coloring at home. In the fourth grade she found she could get attention for her drawing and coloring, which she feels is a gift and a passion. She now paints with acrylics on Masonite and uses found or recycled frames. She mostly paints animals that she knew on the farm. Her work is in the permanent collection of the Kentucky Folk Art Center.

Miller, R.A. (1912–2006)

Miller was raised in the rural South, in Gainesville, Georgia, on the land where he was born. He said that he had a lifetime of dull jobs. He became a preacher at a nearby Free Will Baptist Church and made whirligigs—with figures of flags, animals, people, devils, angels, and even neighbors such as the often immortalized "Oscar"—out of cut and painted tin. Miller also painted pictures on paper and board. R.A. Miller's son, Robert, is now doing some artwork too. Miller produced an amazing number of works, and has been included in most major shows of folk art, including *Pas-*

sionate Visions of the American South, organized by the New Orleans Museum of Art in 1993. A retrospective exhibition of his work, *R. A. Miller: A Tribute*, was organized by the Simmons Visual Arts Center at Brenau University in Gainesville shortly before his death, which published as an exhibition catalogue. Many galleries in North Carolina, Georgia, Alabama, and elsewhere carry his art for sale; it may also be viewed in many museums, including the Birmingham and Georgia Museums of Art. Miller's papers are in the Smithsonian Archives of American Art.

Miller, William (1962–2008), and Rick Bryant (b. 1963)

William Miller was born in Louisville, moved to a farm when he was young, and then returned to Louisville. Rick Bryant was born in Denver, Colorado, moved to Indiana and then, eventually, to Louisville. Bryant carved his first canes to help Miller walk after a disabling accident. When they started, Bryant would carve the sticks and Miller would paint them. Once they discovered that their carved sticks and figures were considered "art," they became frequent faces at folk art events. Miller served a jail sentence during which he continued to paint and draw, and died shortly after his release. Bryant has returned to Colorado. The themes of their art are mostly loss of freedom and salvation through religion. Examples of their work are in the collection of the Kentucky Folk Art Center.

Minchell, Peter (1889–1984)

Peter Minchell was born in Treves, Germany, and came to the United States in 1906. He settled in New Orleans. He worked in construction until his retirement in the 1950s, when he moved to Florida. Minchell is thought to have begun drawing around 1960 and to have continued on into the mid–1970s. His first works were unusual floral and arboreal scenes that did not resemble the real world. He was a devout Roman Catholic and considered painting a spiritual act. Minchell painted watercolors on paper depicting the natural surroundings of the Gulf Coast and religious works influenced by stories in the Bible. He died in West Palm Beach in 1984. His art is in the permanent collection of the Smithsonian American Art Museum. It was included in the exhibition "Flying Free" in 1997.

Minshew, Roy (b. 1950)

Minshew was born in southern Georgia and lives in Fitzgerald. Prior to a stint in the air force, he worked variously as a fireman, sheet metal fabricator, trucker, machinist, and shoe repairman. The custom leather work involved in repairing shoes was the catalyst that gave initial shape to Minshew's creative energy. In 1981,

when his job at the shoe repair shop ended, he decided to pursue art as a career. He set up shop, hired employees, and began doing production carvings to ship all over the world. After two and a half years of production work, he became frustrated because he felt he was no longer doing anything creative. From 1989 on, Minshew has been home in his studio creating the kinds of pieces that give shape to his philosophy of life and art. He works in wood, and also does occasional small acrylics on canvas. He carves many animals, including dogs, goats, horses and pigs, ranging in size from one to five feet. They are done with great imagination, exaggerating physical characteristics to create a mood and emotional reaction in the observer (e.g., a dog with a too-large head, open mouth and big teeth seems to say "watch out," while another dog with an oversize red tongue lolling out and an anticipatory stance appears eager to greet all comers). Minshew also does carvings and paint-carving combinations on religious and political themes. Marcia Weber/Art Objects in Montgomery, Alabama and Jeanine Taylor Folk Art in Miami carry his work.

Mirelez, Samuel (1928–2008)

In the 1990s, Samuel Mirelez of San Antonio, Texas, found himself without enough money to buy his wife an anniversary present. He took some old coffee cans, cut them up, and made them into a replica of one of the old Spanish missions in the city. His wife loved it so much, Mirelez made others. After his wife died and he retired, he filled his yard with missions, castles, the White House, the Alamo, a Mississippi riverboat and the Eiffel Tower. He is also well-known for his birdhouses. He got aluminum siding scraps (which won't rust) from a contractor, then used history books, magazines, postcards—any pictorial source—to find structures of which he made birdhouse copies. Although Mirelez experimented with paint, he left most of his constructions the original color of the siding, white being by far the most common color. Once finished, Mirelez mounted them atop metal poles, screwed them onto the flat portions of his roof, hung them from tree limbs, from the eaves of his house, or attached legs to them and set them in the yard around his house. Sam passed away in 2008; his yard was still intact as of 2010. Yard Dog Art in Austin carries some of his birdhouses.

"Mr. B" *see* Beverland, Jack

Mr. Imagination (1948–2012)

Mr. Imagination (Gregory Warmack) was a native of Chicago. He took a new name when he survived a near-fatal shooting in 1978. He was a self-taught artist who used simple tools and material that was free for the finding. He reclaimed materials such as paint brushes, bottle caps, brooms, and old chairs. From chunks of discarded sandstone foundry molds, he carved fantastic figures, monuments, and block-lettered text. In the 1970s he sold handmade crafts and jewelry on the streets. He embellished some of his stone masks with found objects and made faces on paintbrushes, the bristles supplying the hair "like a new crew cut." He also made huge thrones of bottle caps. Mr. Imagination lived on the North Side of Chicago, and liked to interact with collectors. He was a mentor for many children in various Chicago neighborhoods. Just Folk in Summerland, California, Jeanine Taylor Folk Art in Miami, Judy A. Saslow Gallery in Chicago, and Raven Arts in New Orleans carry his work; which many be seen in many museums, including the Smithsonian American Art Museum, American Visionary Art Museum, Intuit, the Museum of International Folk Art, the Longwood Center for the Visual Arts, and the Milwaukee Art Museum.

Mitchell, Jesse (Jessie) Lee (b. 1958)

Jesse Lee Mitchell was born in Dyersburg, Tennessee, on September 18, 1958. His father was in the United States Navy and his mother worked hard to help support the family. He was the youngest of three children. The family moved frequently and when Jesse was eleven his parents split up. His mother moved to Chicago and his father to Taunton, Massachusetts. He spent his childhood running away from either or both places. He never finished school and is himself the father of two sons. He is divorced and living in Louisiana. His children live in Tennessee with their mother. Mitchell has created a variety of objects using clay, paper, acrylic, pen and ink, and other materials. At present he is primarily a painter. He paints self-portraits and a friend named Maria; often with the theme of love gone seriously awry. His work is sad and disturbing, though Mitchell is quick to assert that life is sweet. Shelton Gallery in Nashville carries his work.

Mitchell, Reginald "Reggie" (b. 1960)

Reggie is a native of New Orleans, Louisiana. He has a learning disability, is fatherless, poor, black—and lived most of his pre–Katrina years in one of the meanest projects in the town—yet he still paints. Reggie loves to paint even though the neighbors mock him and his family is not particularly supportive. His architectural images and street scenes of New Orleans capture, in a most refreshing manner, the very essence of the city. "In bold color," according to a local art reviewer, "he evokes New Orleans life from jazz funerals and streetcars to the Superdome and cemeteries." After Katrina, Reggie and his family fled to Houston, where he has had less opportunity to paint. Cotton Belt Gallery in Montgomery, Just Folk in Summerland, California, Jeanine Taylor Folk Art in Miami, and Yard Dog Art in Austin still carry some of his work, which may also be seen in the New Orleans House of Blues.

Mohamed, Ethel Wright (1906–1992)

Ethel Wright Mohamed was born in Webster County, Mississippi, and lived in Belzoni, Mississippi. She was married to Hassan Mohamed, from Lebanon, for 41 years and they had eight children. Her family was the center of her life. She is noted for her colorful stitchery pictures of family memories. Her home in Belzoni is open as the Ethel Wright Mohamed Stitchery Museum (www.mamasdreamworld.com) and is directed by family members. Her work may also be seen in the Old Capitol Museum of Mississippi History in Jackson.

Mohammed, A.J. (b. 1937—no further information available)

A.J. Mohammed was born in Yazoo City, Mississippi. He enjoyed making art from childhood and started selling his work in the late 1960s. He was a construction worker and lived in Maryland and Tennessee. When he returned to his hometown in 1977, he was blinded by a shotgun blast. When he started making art, he was a painter. After being blinded he switched to carving. He carves human heads, snakes, animals, and walking sticks. He was included in the exhibition "Folk Art: From the Collection of Sally M. Griffiths" in 1994; he is a featured artist in *Light of the Spirit: Portraits of Southern Outsider Artists* (1998, by Karekin Goekjian and Robert Peacock). His work is in the permanent collections of the Rockford (Illinois) Art Museum, the Mississippi Art Museum, and the Old Capitol Museum of Mississippi History in Jackson.

Mollett, Mark Gregory (b. 1973)

Mollett was born in Tomahawk, Kentucky, where he still lives. He attended local schools and earned a bachelor's degree from Morehead State University. He began carving when he was 20, to recreate something he remembered from his grandfather, who was a carver also. Mollett's family had a tradition of hanging a simple carved cross by the fireplace or on the mantle during a period of mourning following a death. Mollett carved several of these simple crosses, which he decorated by burning a variety of patterns into their flat unpainted surfaces. His work is in the permanent collection of the Kentucky Folk Art Center.

Monceaux, Morgan (b. 1947)

Monceaux was born in Alexandria, Louisiana. His mother was a blues singer and he hoped to be an opera singer but ended up in the navy during the Vietnam War. After four years in the service, he moved around the country doing a variety of jobs. He was for a time jobless and homeless in New York City. Then he found a janitor's job on Long Island, took up residence in a vacant farm shack, and began painting to pass the time. His art work was discovered and first exhibited in 1992, thanks to a passing conversation between the artist and a well-known East Hampton art dealer Morgan Rank. At the time, Monceaux was living nearby in a migrant shack by the railroad and working as a janitor at a bar. Walking by Rank's gallery, which specialized in primitive American art, he decided to look inside. "I can do this," he said. Mr. Rank was skeptical: "No one out here can do this." So Mr. Monceaux said, "I can prove it" and later brought Mr. Rank back to his shack and showed him the 40 presidential portraits he had done. A few weeks after that Mr. Rank held an exhibition of his work, which Adam Gopnik in *The New Yorker* called "a unique meditation on history." Using materials he found in the town dump and along the street, Monceaux had done a series of presidential portraits that included researched material about each subject. He then did a series about black cowboys, and finally a series of jazz musicians. This last series has been published in a book, *Jazz: My Music, My People.* Now the artist is living in Baltimore, where he has been given a number of shows. In 2009 he had a solo show, "Divas," at New Door Creative. Monceaux also has three works in the permanent collection of the National Portrait Gallery in Washington. He has a Facebook page, https://www.facebook.com/THeMorganMonceauxArtistTrust.

Money, Lonnie (b. 1949) and Twyla (b. 1952)

Lonnie Money was born in East Bernstadt, Kentucky. He has been interested in wood-carving all of his life. He believes he inherited his talent from his Swiss great-grandfather, who was a wood-carver. After leaving the business of dairy farming, Money found more time to pursue his carving skills, producing animal figures and canes. He uses some power tools, but prefers carving knives. He works mostly in pine, which he paints, but also carves unpainted objects from cherry or walnut wood. He makes walking sticks out of dogwood. Now his wife Twyla works with him. Their work, done mostly in pine, is painted in bright colors with their characteristic "dotted" finish. Their work is in the permanent collections of the Kentucky Museum of Art and Craft and the Kentucky Folk Art Center. Main Street Gallery in Clayton, Georgia carries their wok, which is also available through their website, www.moneysfolkart.com.

Montague, Frances "Lady Shalimar" (1905–1996)

Frances Montague was born January 26, 1905, in Paris, France. In Montague's paintings, she depicts herself in various opera, ballet, and circus roles on the stages of three continents. Her paintings are similar to costume renderings and usually present female performers. Occasionally she painted circus animals or

ships. She embellished her work with glitter, tiles, sequins, even straight pins. Montague spent her final years in a health care facility and had no visitors, except through HAI. At the age of ninety she continued to paint regularly. She rarely went out, fearing the out-of-doors. She did attend, with enthusiasm, exhibits of her paintings. She died January 27, 1996, in Brooklyn, New York. Her art was included in the exhibition "Flying Free" in 1997. HAI still carries her work,

Monza, Louis (1897–1984)

Louis Monza was born in Turate, Italy, and came to California as a teenager. He traveled in both the United States and Mexico. A socialist and pacifist, he had no desire to fight in any war. However, he was drafted into the U.S. Army during World War I and served in Panama. After the war he moved to New York, where he was a house painter. Monza began to devote serious time to his art in 1938, while recovering from a serious fall from a painter's scaffold. He moved to Redondo Beach, California, where he married his wife, Heidi, in 1947. She worked to support them both. They traveled a lot, especially to Mexico. His subjects were varied, from landscapes to political allegories and social criticism. He made some spiritual paintings, though he disliked organized religion. He also made bronzes, terra cotta sculpture, and lithographs. His work is in the permanent collections of the Smithsonian American Art Museum, the American Folk Art Museum, the High Museum in Atlanta, and the Oakland Museum of California.

Moore, Earl, Sr. (b. 1927—no further information available)

Moore is from Rock Lick, Kentucky. He makes unpainted wood-carvings of small animals and biblical scenes. His work is in the museum at the Kentucky Folk Art Center in Morehead, Kentucky.

Moore, Eddie (b. 1913—no further information available)

Deacon Eddie Moore was born in east Texas and now lives in Dallas. He was attracted to cemetery art, moved to Dallas in the 1940s and tried to take art lessons, but was not accepted because of segregation. He served as a police officer in California in the 1950s, and retired fifteen years ago. He now serves as a deacon in his Baptist church. Eddie Moore uses wood and other found objects to convey images that appeal to him. He carves scenes from rodeos, hunting and fishing trips, and religious figures. Most of his work is under two feet tall, and painted with acrylics. Moore is a realist who tries to carve things as they appear. His work is in the permanent collections of the Mississippi Museum of Art and the Art Museum of Southeast

Texas. Raven Arts in New Orleans has some of his work.

Moore, Kelly

Kelly Moore is a self-taught artist who has no formal training or education in art. His very interesting work has been referred to as Outsider Art, Art Brut, Raw Art and Visionary Art. His intuitive style and technique reflects a raw, primitive quality that is frequently juxtaposed with a startling innocence. He is also a poet and a blogger. He maintains his own website, www.kellymoore.net, on which he posts almost daily with poems, commentary on the world, and images of his art. He has published a book, *Absurdity Is My Friend: Art and Stories from the Desert*, with much the same content as his website—paintings and poems. There is a YouTube video about him from 2009 (www.youtube.com/watch?v=dKFtipjtYUw). He sells his art at the Tusuque Pueblo Flea Market every Friday, Saturday, and Sunday from March through November.

Moore, Mildred "Gentle Rain" (c1935)

Moore is a master potter of the Pamunkey tribe in Virginia. She received her Indian name, "Gentle Rain," because a gentle rain was falling at the time of her birth. The Pamunkey have the distinction of being one of the tribes east of the Mississippi that has practiced the art of pottery-making continuously since aboriginal times. Among the Pamunkey, women are the traditional potters. They sustain two distinct pottery traditions: the traditional coil-method black ware that is as old as the community itself, and a glazed Southwestern style they started making during of the Great Depression. Moore has been making pottery since she was a small child, beginning with turtles, canoes, and other small birds and animals. As her gift progressed, she was recognized by the Smithsonian Institution in the 1980s as a Master Traditional Powhatan Potter. Her expertise has led her to be a repeat demonstrator at the National Museum of the American Indian in Washington, D.C., recipient of a Community Service award from the Commonwealth of Virginia, recognized as a Master Potter with the Virginia Foundation for the Humanities, and a highly respected traditional artisan highlighted in *American Indian Magazine's* Winter Edition 2008. In 2011 she took part in a symposium featuring Virginia artists held by the Folk Art Society of America at its annual conference.

Moore, Steven (b. c. 1957)

Steven Moore is originally from Texas, and now lives in Diamond Bar, California. He incorporates his memories of rodeos into his drawings and paintings of longhorn steers, cowboys, horses, and dogs. Moore has been working at First Street Gallery and Art Center

in Claremont since 1998, where his work is available for sale.

Moran, Barbara (c. 1950)

Moran has spent most of her 60+ years in Topeka, Kansas. She was placed in a mental institution there when she was ten, diagnosed with autism and schizophrenia. Years later, when autism was better understood, the schizophrenia label was removed. Moran always drew, using colored pencils on whatever came to hand at first, and now on cardstock. She says "I see human traits as objects ... certain things, like stoplights and airplanes and radios, are just beautiful to me. Boeing jet airliners have six omnidirectional eyes, and each has a smile in it." Art saved Moran's life in many ways. She was sometimes allowed to draw in the institution, but often they took her materials away because they thought that her drawing was detaching her from reality and making her sicker. She says "they treated imagination like substance abuse." After the institution, Moran worked in a nursing home kitchen for 22 years. She is now retired, receives Social Security, and lives in a one-bedroom apartment in Topeka where she "is free to live and create as I please. It's my life and my imagination and I'm living both." Moran's work is available through Visionaries and Voices in Cincinnati, and through the website for KindTree, an organization that "serves and celebrates" people on the autism spectrum (www.kindtree.org/marketplace/artists/barbara-moran).

Moretti, Vida (1941–c. 2010)

Moretti discovered art at age 43 when she first came to NIAD in California. Among her best works are flat, multicolored landscapes with harmonious gatherings of various animals. Other works are of farm lands or small towns with multicolored hills, water, and skies. Moretti started working at NIAD when she came to live in a board and care home after living in a state hospital for the mentally retarded since age 15. Although she died recently, NIAD still has some of her work for sale.

Morgan, Bob (b. 1949)

Morgan creates intricate sculptures from old radios and collected objects. Each piece reveals a part of his life story and takes months to complete. The objects—broken toys, jewelry, and other cast-offs—are carefully chosen. One of five children, Morgan was born in Kentucky. The child of alcoholics, he learned as a youngster to find comfort in his radio as an escape from his family's violent outbursts. Having made art since he was a child, Morgan finds the process of building his radio "temples" healing, and enables him to explore and deal with his painful memories. Morgan also creates small delicate figures wrapped in layers of cloth, threads, sequins, and trinkets which he calls "Venuses." Morgan lives in Lexington, Kentucky. In 1995 there was an exhibition of his work in Jackson, Kentucky, presented by the Kentucky Folk Art Center called "Daughter of Cain: Art by Bob Morgan" which included assemblages of old radios and other found materials.

Morgan, Donald G.—"Jamaica"—Washington, D.C.

Donald G. Morgan has created a 56-foot long, 14-foot wide model of the island of Jamaica in his front yard in northwest Washington, D.C. Built over the past twenty-five years as a way to educate the public about his homeland, Morgan's model is a "superb example of urban folk art." The model depicts Jamaica's rugged coastline, mountains, rivers, underground lakes, waterfalls, white sand beaches, and tropical vegetation. It is contoured in concrete, surrounded by water and tropical fish. It has winding roads and a railway, industrial sites, historic towns, and valleys. In 2015, Mr. Morgan was continuing to add to the environment, often with figures depicting important figures in the political environment such as President Reagan and, most recently, President Obama. "Jamaica" is at 1201 Kalmia Road N.W., Washington, D.C. 20012. Much of it can be viewed from the street, but there is a fence. If you call, Mr. Morgan is likely to invite you in to tour the site—202-726-8292.

Morgan, George (1870–1969)

Morgan started painting when he was in his nineties while confined to a rest home. The subjects of his works were Randolph, Gardner, Hallowell, and Augusta, Maine. Details about his life and art with its unique, primitive, unusual perspective were included in an illustrated article by Chippy Irvine in *Folk Art*, Summer 1998. An exhibition of his art, "George Morgan: Self-taught Painter of Maine," was at the Farnsworth Art Museum in Rockland, Maine, in July 1998, curated by Susan C. Larsen. A one-man exhibition of his work was mounted in Chicago by Intuit, February 5–10, 1999. Steven S. Powers Works of Art and Americana in Brooklyn, New York, carries his work (www.stevenspowers.com/paintings_gallery).

Morgan, Sister Gertrude (1900–1980)

Sister Gertrude Morgan was born in Lafayette, Alabama, and spent her childhood in Columbus, Georgia. In 1934 it was revealed to her that her mission was to preach the Gospel. She preached on the streets of Mobile and Montgomery, and then went to New Orleans in 1939. She opened an orphanage with two other women, and began to preach. Her spiritual expression included painting, gospel singing, and music. In 1957

she "became the bride of Christ," and white began to dominate her home and clothing. Her brightly colored paintings and painted objects were soon discovered by the art world, and much has been written about her. Morgan is in the permanent collection of several museums and has been written about frequently. On April 7, 1997, thanks to the efforts of William Fagaly of the New Orleans Museum of Art, a marker was placed on her grave during a dedication ceremony at Providence Memorial Park in Metairie, Louisiana. Her work has been included in, or the subject of, several recent exhibitions, including *Great and Mighty Things: Outsider Art from the Sheldon and Jill Bonovitz Collection*, at the Philadelphia Museum of Art in 2013; *Ashe to Amen: African Americans and Biblical Imagery*, at the Reginald F. Lewis Museum of Maryland African American History and Culture, Baltimore in 2013; *The Museum of Everything*, the Pinacoteca Giovanni e Marella Agnelli in Turin, Italy in 2004, and *Tools of Her Ministry: The Art of Sister Gertrude Morgan*, at the American Folk Art Museum, New York in 2004; traveling to the New Orleans Museum of Art in New Orleans. Many museums have her work in their permanent collections, including the Smithsonian American Art Museum, The High Museum, the New Orleans Museum of Art, the Museum of International Folk Art, and the Birmingham Museum of Art. Her work is also available from many galleries, including Cotton Belt Gallery, Arte del Pueblo, Dean Jensen Gallery, Fleisher-Ollman Gallery, other galleries, and several private dealers.

Morgan, Ike (b. 1958)

Ike Morgan lives in the state hospital in Austin, Texas. He has been institutionalized for more than half of his life because of his schizophrenia. Art seems to be his main interest. His life is described in detail in other sources, as is his art. Most often, he makes portraits of people who, according to art dealer Leslie Muth in Santa Fe, "always look a little troubled." Muth still carries his work, as does Larry Hackley, private dealer, Yard Dog Art, Marcia Weber/Art Obects, At Home Gallery, and Webb Gallery in Waxahachie, Texas. It is also part of the permanent collections of several museums, including the Smithsonian American Art Museum, the Birmingham and New Orleans Museums, of Art, and the Milwaukee Art Museum.

Morrison, Bennie O. (1941–2013)

Morrison was born and spent most of his life in Oglethorpe County, Georgia, except for serving in the Navy in Vietnam. He painted minutely detailed rural scenes from his childhood on practically anything, including old bricks and pressed and dried magnolia leaves. He sometimes used a magnifying glass and a brush with a single hair to apply the acrylic paints he used. Marcia Weber/Art Objects carries his work.

Moses, Anna Mary Robertson "Grandma Moses" (1860–1961)

Moses lived most of her life in upstate New York—except for twenty years spent in the Shenandoah Valley of Virginia, where Moses would have been happy to stay had her "homesick" husband not torn up the family and transported them back North. According to gallery owner Randall Morris, "she may be seen as a bridge from the nineteenth century to the twentieth century." She painted from her own experience. Many books have been written about her, including one she wrote herself. Zibby Oneal, in her biography *Grandma Moses: Painter of Rural America*, says Moses spent the last six months of her life in a nursing home in Hoosick Falls, New York. "She hated it. They wouldn't let her paint." Her work is in many museums.

Moses, James Kivetoruk (1900–1982)

James Moses was born on Seward Peninsula at Cape Espenberg, Alaska. He turned to painting in 1954 after being seriously injured in a plane crash, which ended his successful career as a trader of furs and dogs in Cape Espenberg and Siberia. In 1978 he was living in Nome. His works are in ink and colored pencil on paper, and usually depict Eskimo legends or rituals, showing many versions of a story. His work does not resemble traditional native art. Pieces are in the permanent collection of the Alaska State Museum in Juneau. He is included in *Twentieth-Century American Folk Art and Artists* by Hemphill and Weissman. His work is reproduced in several recent books, including Ellanna and Sherrod's *From Hunters to Herders: The Transformation of Earth, Society, and Heaven Among the Inupiat of Beringia* (2013) and Suzi Jones' *Eskimo Drawings* (2008), the latter featuring a painting by Moses on the cover.

"Moses House"—Florida

This "environment" in Florida is the work of Taft Richardson, Harold Richardson, and Kenny Dickerson. Taft Richardson's bone sculpture, Kenny Dickerson's canes, and the gardens cultivated by Harold Richardson come from a religious calling. They created Moses House to be a cultural center for inner city children. Their work is meant to be "spiritual," and not done for aesthetic reasons. There work was included in the exhibition "The Passionate Eye: Florida Self-taught Art" in 1994. Moses House has moved its base of operations back to its original Sulphur Springs neighborhood, where it operates as a nonprofit organization that continues the work begun by its founders. It maintains its own website, www.moseshouseinc.wordpress. com.

Mosley, Dan (1906–1991)

Daniel Joseph Mosley was born September 2, 1906,

in New Orleans, Louisiana. His father, one of the first black Americans to fight in the Spanish-American War, died of a heart attack while loading a barge on the Mississippi, when Dan was just a few months old. Mrs. Mosley was left alone to raise their twelve children. In his late teens Dan made barrels for wine and mattresses of moss, cotton, and shuck. But his love was cooking and he knocked on the doors of St. Charles Avenue mansions until he was hired. Later he became the houseman for May Curtis Godchaux who lived on Dumaine Street, in the French Quarter. Dan lived in one of her houses in the 900 block of New Orleans. After her death he moved to Dumaine Street and worked for two doctors who lived on that street. Dan knew everyone on the block, and looked after one and all—neighbors and visitors alike. He was called "The Mayor of Dumaine Street." With urging from a neighbor, Page Moran, Mosley started painting when he was eighty years old. He was very proud of his black heritage and painted contemporary black events such as freedom riders and other civil rights themes, French Quarter architecture, and family portraits from photographs. He used felt-tip pens and markers. He died in New Orleans in December 1991.

Moss, Emma Lee (1916–1993)

Emma Lee Dunlop Moss was born in central Tennessee and lived in San Angelo, Texas, until advancing years made it necessary to return to her family in Tennessee. Her first paintings were done in the 1950s using the paints that belonged to the children of her employer. Emma Lee married Tucker Moss in 1956. She stopped painting after her own marriage and children, and started again during the long terminal illness of her husband. She moved to San Angelo with her second husband. Her paintings are called "bright and optimistic" and there is a lot of action going on. There are always lots of people included in her work. Her work is illustrated in *Animals in American Folk Art* by Wendy Lavitt, and she was included in the exhibition "Spirited Journeys: Self-Taught Texas Artists of the Twentieth Century." Paintings and her papers are in the San Angelo Museum and the Robert Cargo Collection given to the Birmingham Museum of Art.

Mullen, Marlon (b. 1963)

Mullen is able to hear but he cannot speak. "It is most fascinating to watch him paint," say the people at the National Institute of Art and Disabilities. "He puts his whole body behind each brush stroke, almost dancing to an inner rhythm as he paints." He has an intense painterly quality which he achieves through swift brush strokes, overlaying color upon color. His images range far, from bridges to television sets to ice cream cones. Sometimes his paintings are abstract, sometimes not. His colors vary with his conception. "At times they are rich and dark, while at other time

he achieves a luminosity of delicate opalescence." The National Institute of Art and Disabilities Gallery in Richmond, California, carries his work.

Mulligan, Mark Anthony (b. 1963)

Mark Anthony Mulligan is a self-taught artist who was born in Louisville, Kentucky, and whose works convey his joyous love and detailed knowledge of the sites and streets of his city. He is a very cheerful person and likes to share his art. His sketches and paintings, mostly Louisville scenes, are dense with images of urban streets, mostly signs—street signs, directional signs, commercial signs, railroad crossing signs. He paints with acrylics, often on large panels, and uses very bright colors. Mulligan's work was included in the exhibition "African-American Folk Art in Kentucky" at Morehead in 1998. His work is in the permanent collections of the Birmingham Museum of Art, the Kentucky Folk Art Center, and the Milwaukee Art Museum.

Mumma, Edward "Mr. Eddy" (1908–1986)

Mumma was born in Milton, Ohio. He traveled around the country a lot, doing odd jobs until he married and settled on a small farm near Springfield, Ohio. Then he started an antiques and junk business. After his wife died he moved to Gainesville, Florida, around 1966, to be closer to his daughter. Mumma suffered from diabetes, which eventually cost him both legs. "Mr. Eddy" painted mostly round-faced portraits of a man, though he occasionally did other images, including sailboats. Mumma painted with acrylics on plywood or Masonite. He would not sell his paintings. The day Mumma died, according to information in the Rosenaks' *Folk Art Encyclopedia*, a folk art collector happened by and "arranged to buy between 600 and 800 of the artist's works. The family considered Mumma an eccentric and had no use for his paintings." Marcia Weber/Art Objects in Montgomery and George Jacobs, private dealer, carry his work, which may also be seen at the Milwaukee Art Museum and the New Orleans House of Blues.

Munro, Janet (b. 1949)

Janet Munro was born in Woburn, Massachusetts, and now lives in Portlandville, New York. Munro says that her paintings "come from two places in my mind, some from out of my life experiences and some from the ideas and philosophies I cherish." She paints her dreams, but her dream paintings are "not about memories but about a belief or thought." Munro says she worked a variety of jobs—waitress, baby-sitter, housekeeper, window-washer—because she never took a job she couldn't quit. "I always knew that I was really

a painter." Her work is in the Fenimore House Museum collection. She also maintains her own website, www.jlmunro.com.

Murray, Donnell (1984)

Murray was born in Far Rockaway, New York, When he was 16 his family got cable television and he became fascinated with the way people looked on TV shows—what they wore, their "polished" look, their adventures, and their happy moods. He wanted to be like them, and to interpret the way they were for himself; he says that making art was the best way he had to express this desire. He feels he can express himself better in drawings than in words. When he first started drawing, with colored pencils, all he had was lined notebook paper. He used that, and found that the lines helped him in drawing his characters. The hundreds of these drawings he has done serve as references for the larger works he produces on rag paper. Murray works at HAI, which represents his work.

Murray, Valton (b. 1953)

Valton Murray was born February 14, 1953, in Mesena, Georgia. He grew up in a large, loving family. He left school before completing the seventh grade because he was so unhappy having to deal with birth defects. His parents and family became his teachers. He never received any art training. But painting and creating are a major part of his life, and his family has been very supportive of this activity. Despite the orthopedic and neurological problems that have handicapped him since birth, Murray works very hard to support himself and his two small sons with his art, which he believes is a gift from God. He specializes in genre painting recalling his childhood in the South, and has been an active participant in programs and exhibitions sponsored by Very Special Arts Georgia. Murray lives at 1907 Long Dale Drive in Decater, Georgia; one may call him at 706-595-3879. He also maintains a Facebook page, from which he sells his art.

Murri, Nathan

Nathan has been with the art program at First Street Gallery for barely a year. His art has already developed a collector base at the First Gallery and two others including the Santa Monica Art Studios and Modest Fly Gallery in Tujunga.

Murry, J.B. (1908–1988)

Murry was born in Glascock County, Georgia, and remained in that vicinity all of his life. He worked as a sharecropper and tenant farmer, marrying Cleo Kitchens, with whom he had eleven children. When he died in 1988 he had three great great grandchildren and quite a few family members of the generations in between. Murry began making art after he had a vision

in the late 1970s which made it possible for him to "write in the Spirit" and "read through the water." He completed hundreds of vibrant, colorful paintings and drawings which incorporated his improvised script "Spirit writing," with or without other images that tend to be very "watery"—elongated, wavy, and graceful. His work is in many museums; Gray Carter/Objects of Art and Phyllis Kind Gallery carry his work. He is the subject of a recent book by Mary Padgelek, *In the Hand of the Holy Spirit: The Visionary Art of J.B. Murray*(Macon, GA: Mercer University Press, 2000).

Muth, Marcia (1919–2014)

Marcia Muth lived in Santa Fe, New Mexico, and was a self-taught painter whose work should be better known. Born in Indiana, she was an English teacher, writer, publisher, and librarian. After moving to Santa Fe, Muth and her partner Jody Ellis started Santa Fe's first literary magazine, *The Sunstone Review*. Muth started painting in 1975; her themes were the ways in which ordinary people in the 1920s and 1930s lived and worked. Her paintings, acrylics on canvas or acrylics and inks on paper, are in a flat, linear style. Her stores, factories, tea parlors, corner groceries, and living rooms are well-furnished with objects of the time. These narrative paintings record memories of life beyond the rural. Two books are available about her work: *A World Set Apart: Memory Paintings* (2007) and *Words and Images* (2004). In 2008, Teddy Jones published a biography, *Left Early, Arrived Late: Scenes from the Life of Marcia Muth, Memory Painter*. All three books were published by Sunstone Press. Marcia Muth's work is in the permanent collections of the Museum of Fine Arts in Santa Fe, the Museum of Naive Art in Paris (France) and the Jewish Museum in New York City.

Naranjo-Morse, Nora (b. 1953)

Naranjo-Morse is a Native American potter and poet with an unusual world view, though she lives a traditional life at Santa Clara Pueblo. Her pointedly satirical figures that play on Anglo and Indian lore and huge conceptual installations make her one of the most exciting Indian artists of her generation. She currently resides in Española, New Mexico just north of Santa Fe and is a member of the Tewa tribe. She is the daughter of potter Rose Naranjo, and grew up surrounded by her mother, aunts, and other pueblo women all of whom worked in clay. Her work can be found in several museum collections including the Heard Museum, The Albuquerque Museum of Art, the Minneapolis Institute of Art, the Wheelwright Museum, and the Smithsonian's National Museum of the American Indian, where her hand built sculpture piece, *Always Becoming*, was selected from more than 55 entries submitted by Native artists as the winner of an outdoor sculpture competition held in 2005. In 2014, she was

honored with a NACF Artist Fellowship for Visual Arts and was selected to prepare temporal public art for the 5×5 Project by curator Lance Fung. Naranjo-Morse is the author of the poetry collection *Mud Woman: Poems from the Clay* (1992), which combines poems with photographs of her clay figures.

Nash, Carl (b. 1951)

Nash was born in Lubbock, Texas, and then moved to Fort Worth. He is a self-taught artist and homeless man who says that God came to him in a dream and told him to make art. He and his first wife had four children. Now he is married to another woman and has eight additional children. Nash has been homeless in Fort Worth, and in Lubbock, too. Wherever he makes a home, whether in an abandoned building or a public housing project, the family is eventually evicted. And wherever he is, he makes his art from found materials. He creates objects from six inches to 25 feet tall, made with whatever he has on hand. He says, "With art I started putting two and two together and instead of getting four I got six." Nash does paintings of animals and people, as well as wire sculptures, some of which resemble space creatures. He works a lot from dreams. He also makes penny boxes, designs, and space weapons from coins. His work has ranged from a whole environment to individual sculptured pieces. He was included in the exhibition "Spirited Journeys: Self-Taught Texas Artists of the Twentieth Century." Webb Gallery in Waxahachie, Texas carries his art.

Needham, Ricky

Ricky Needham was born in Winston-Salem, North Carolina. He was one of seven children and close to his family, although he and many of his siblings spent time in foster care. The family noted early on that Needham was learning disabled, but encouraged him to be a part of a normal community and family life. No matter how difficult for him, he always worked hard to learn. He was, though, according to an older sister, subject to verbal and sometimes physical abuse from other young people. When he finished high school, Needham had a series of blue-color, low-level jobs. All during this time, he kept at his early passion for drawing. In 1995 he became an artist resident at Signature House in Morganton, North Carolina. A description of Needham's work says "Ricky's fantasy paintings reflect his vivid imagination and represent his vision of a perfect world, a vast peaceful, sunshine-bathed, multi-racial nudist colony where the cars and the architecture are dazzling, and where all the people are happy, slender and beautiful, and they all love each other." He maintains his own website, www.ricky needham.com, from which he sells his art, posts blogs, and offers news of himself and his family.

Nelson, Ellis (1928–2015)

Ellis Nelson was born in Iowa County, Wisconsin, and lived in Muscoda, Wisconsin until his death. He dropped out of elementary school because teachers told him he was stupid. He was a mechanical genius and has invented many things, particularly machine shop tools. He held several jobs, and between 1960 and 1988 he ran two service stations and repaired cars. In 1985 he decided to build a large metal dinosaur based on the Sinclair Oil Company logo from auto-body scraps lying around the station. It drew so much attention and so many people wanted his artwork, that he quit working a few years later to work full-time as a sculptor. His early work, mostly large figures, are by far the best, but demand for his work pushed him toward producing smaller objects. He had two of his figures depicting "The Grim Reaper" at the American Visionary Art Museum exhibition, "The End Is Near." His son Tom also welds and has been working out of Ellis' studio; the studio still offers work for sale, but now is by other family members.

Nelson, John Olaf (1951–1997)

John Olaf Nelson was born August 4, 1951, in Tulsa, Oklahoma. He moved to Kentucky in 1987 to pursue his dream of becoming a well-known carver. Known in the art world as J. Olaf Nelson, he lived in Lexington with his wife, Sandi, and son, Christian Olaf. Christian was six when his father died. Nelson had fought a long hard battle with diabetes, always showing great courage in the e face of his illness. He was a member of the Kentucky Arts and Crafts Foundation. In his fine carving he used fir and white pine to create his figures, painted them with watercolors, and then coated them with polyurethane. His work was very "clean" and finely finished. His figures—all tall and thin—included Uncle Sam, a farmer, a man in a suit, and a man sitting on a box with a fiddle in hand. Nelson's art was described, on the occasion of an exhibition of his work, as "primitive yet sophisticated." He said he could only carve what was in his mind, even when people asked him for something special. His art is in the permanent collection of the Owensboro Museum of Fine Art.

Newman, Morris Ben (1883–1980)

Newman's work was included in the exhibition, "Pictured in My Mind," and in an earlier exhibition, "Contemporary American Folk, Naive, and Outsider Art: Into the Mainstream?" in 1990. Newman worked in Ohio in the 1970s but claimed to be from Ethiopia. Newman was discovered by Lee Garrett, a Columbus artist. He worked in house paint, tempera and oils, and had a limited palette of neutral colors over a white background with an occasional touch of color. His painting surface included canvas, bed sheets, window shades—whatever he could find. Yard Dog Art in Austin carries his work.

Newmarker, John H. (b. 1927)

Newmarker was born in Nevada and moved to California in 1954. He makes human figures, and sometimes animals, out of found objects and wood. His figures from tin cans and jar lids are among his best. Many of his figures represent special events or people in different occupations. His work may be seen at the Oakland Museum.

Newsom, Bennett (1886–1973)

Newsom was born in Oakland, California. As a 17-year-old cadet he traveled to China aboard a steamer. This experience, plus travels with his wife and printed materials, was the source for his prolific output of carved and painted sculptures. The felling of a neighbor's apricot tree provided his first material. Newsom died in Oakland. His work was part of the exhibition "Visions from the Left Coast: California Self-Taught Artists."

Newton, Harold (1934–1994)

"The Highwaymen" is a name given to a group of self-taught black artists who have been traveling throughout central and southern Florida, selling their paintings from the trunks of their cars. Their story begins with Harold Newton, a migrant worker and now deceased, who is considered the "grandfather" of this group of artists. Born in Gifford, Florida, in the early 1950s, Newton began to paint Florida's landscapes to sell. Painting on board, he used house paint and made his own frames from window and door molding. He started selling his paintings door-to-door, and never returned to the migrant labor force. He was able to support himself and his family with his art up to his death in 1994. He is the subject of a recent book by Gary Monroe (*Harold Newton: The Original Highwayman*) (see Selected Books—Monroe has written two other books on The Highwaymen also). Newton's art, which has become highly sought after in recent decades, along with the work of other Highwaymen, may be seen at www.floridahighwayment.com and www.floridahighwaymentpaintings.com.

Nickens, Bessie (1906–2004)

Bessie Nickens was born in Sligo, Louisiana, the daughter of sharecroppers. She moved north eventually and worked for a dry cleaners, retiring when she was 80 years old. She demonstrated a determined interest in making art since she was a little girl. At first, she traced pictures from the Sears Roebuck catalog, then drew with crayons and eventually painted with oils on canvas. After working nearly all her life and rearing a family, too, Nickens started painting full time when she retired. Nickens' paintings are narratives, telling the stories of her life, especially the times when she was young. She also wrote a book, *Walking the Log:*

Memories of a Southern Childhood. An exhibition of her work, "My Southern Childhood, A Look Back 90 Years Ago: Bessie Nickens," took place in Newport News, Virginia, at the Newsome House in early 1996 and a book, *Bessie Nickens' Fervor for Folk Art*, by Delores Edwards, was published in 1994 (Rizzoli).

Nipper, J.L. (b. 1935)

J.L. Nipper was born in Whoodoo, Tennessee and now lives in Beech Grove. Nipper is a chain saw carver who makes large birds and animals from tree stumps. He paints his work with solid colors and polka dots. For a time his work was very similar to that of his teacher and mentor Homer Green, but later took its own direction, especially after Green's death. One of his most interesting forms is his tree branches with crows. He makes some very large pieces that require a crew to install. Main Street Gallery in Clayton, Georgia, carries his work.

Nohl, Mary (1914–2001)—Yard Art—Milwaukee, Wisconsin

Mary Nohl had training as an artist, but she is included in the folk art pantheon because the environment she created at 7328 Beard Road, in the Fox Point area of Milwaukee was considered a "must see." Attached to the surface of the house were cutout figures; hanging throughout the trees were white, ghostlike figures, probably of painted wood. Two interim "fence" sections, upon closer examination, were an arrangement of cast concrete faces. Many human and animal figures were placed throughout the garden—some of this world and some not. The figures seem "melancholy" and somewhat poignant. A catalog for the exhibition, "Mary Nohl: An Exhibit of Sculptures, Paintings, and Jewelry," gives details about her life, her art, and the pleasure it used to give when people stop to look. Her work was included in an exhibition with environmental artist Nick Engelbert at the John Michael Kohler Arts Center in Sheboygan in 1997. Nohl gifted the house and environment to the John Michael Kohler Art Center upon her death; it remained intact at its original location until 2014, with the Art Center going to great lengths to preserve it in its original site. Irreconcilable differences between the Art Center and the house's affluent neighbors finally forced the Center to move the house and its surrounding yard and art to Sheboygan. Starting in spring 2014 the house was dismantled piece by piece and reassembled at its new site, where it again may be seen and enjoyed.

Norberg, Virgil (1930–2013)

Virgil Norberg was born in Galesburg, Illinois. He remembers being fascinated by weathervanes as a child. He served in the navy and worked throughout his life as a welder and maintenance mechanic. These

skills were easily transferable to his uniquely designed weathervanes. His themes were taken from Bible stories, circus performances, and military life, and were often a commentary on modern life. The finest pieces are welded steel, painted with enamels of brilliant oranges, greens, blues, and yellows. Norberg lived in Davenport, Iowa until his death. His son, Randy, also builds sculptures and is especially noted for his wooden vintage cars. Virgil's work is in the Mennello Museum in Orlando.

Notzke, Bill (1891–1991) "Jubilee Rock Garden"—Jubilee, Illinois

William Arthur "Bill" Notzke was an Illinois dairy farmer, born in Jubilee Township, Peoria County, Illinois. His first major construction was a brick and glazed tile dairy barn, an Art Deco vision built around the usual wooden dairy. His next project was a rock-studded plaza, and then arches—one a memorial to his wife who died in 1963. He described his building techniques to a reporter in 1979 and told her his were inspired by the 1933 Chicago World's Fair. Notzke inlaid his constructions with rocks and stars and crescent moons of rose quartz. When Notzke was alive his garden was planted with pink petunias. The Jubilee Rock Garden is very large, impressive, and visible from the road. To see it, drive down Highway 150 near Brimfield, fifteen miles west of Peoria. Images are available at http://www.detourart.com/jubilee-rock-garden-2. After Notzke died, his daughter sold the property to Cheryl and John Becker, who have been caretakers ever since. Though parts deteriorated beyond repair, they've maintained the spread as created. Visitors are invited to stop by. The Beckers ask that visitors pull alongside Route 150 and look from there. Please do not pull into the driveway, knock on their door or otherwise trespass.

O'Brien, Kellianne (b. 1965)

O'Brien was born in Columbus, Ohio. She grew up there and in Andover, Massachusetts. She graduated from college in Ohio, moved to Madison, Wisconsin, and began painting in June of 1994. The following year she had a series of emotional breakdowns which taught her more than she had ever wanted to know about mental health systems. Three years after a successful recovery, O'Brien became the first person hired by the State of Wisconsin as an advocate for persons with mental illness. She now resides and paints in Madison, Wisconsin. She frequently paints in an abstract style with acrylics, oil, or watercolors on an assortment of flat surfaces. HUSTONTOWN in Fort Louden, Pennsylvania carries her work.

Oden, Antjuan (b. 1971)

Born in Birmingham, Alabama, in 1971, Oden has been painting since he was a kid. "I have to paint, I can't stop. It's an obsession," he tells us. He has traveled a bit, and has lived in Atlanta, Philadelphia, and Birmingham, among other places. He paints on found objects, paper and wood, and often writes on his art. Antjuan Oden was featured in the 1998 edition of *Art Papers*. He has been an Artist in Residence at the Tacoma Art Museum; a YouTube video (https://www.youtube.com/watch?v=VuZrs3xE-b0) documents this time in his life. He also maintains his own Facebook page.

Odio, Saturnino Portuondo "Pucho" (1928–1997)

"Pucho" was born in Santiago de Cuba in Oriente Province, and worked in Cuba as a carpenter, barber, and member of the merchant marine until he came to the United States, via Canada, when he was 35. He moved to New York City where he once again became a barber. Eventually his knowledge of carpentry provided the opportunity to start carving and soon he became a full-time artist. He used found wood to create people, animals, birds, and other figures, and then finished the pieces with latex house paint. His work is in the collection of the American Folk Art Museum and the John Judkyn Memorial in Bath, England.

Oebser, Frank (1900–1990)— "Little Program"—Menomonie, Wisconsin

In 1973 when he retired, Frank Oebser, who had a dairy farm near Menomonie in rural Wisconsin, started building fantastic yard art around his house and barn. Most of the pieces were mechanized. He also had an extensive collection of working antique farm machinery in his barn, peopled with life-sized figures stuffed with hay and dressed in cast-offs. Thousands of people visited his site until it was dismantled in 1989. It may be seen in the film, 'And So It Goes…' *Frank Oebser—Farmer/Artist, 1900–1990*, produced by Karla Berry and Lisa Stone. Oebser's work was included in the exhibition "Wisconsin Tales" at the John Michael Kohler Arts Center in Sheboygan in 1993. His art remains in the collection of the Arts Center, but may or may not be on display at any given time. Oebser's work was included in the book *Sublime Spaces and Visionary Worlds Built Environments of Vernacular Artists* (Umberger, 2007, see Selected Books). The SPACES website (http://www.spacesarchives.org/explore/collection/environment/frank-oebser), has quite a bit of information about Oebser and his environment.

O'Kelley, Mattie Lou (1908–1997)

Georgia memory painter Mattie Lou O'Kelley lived in Decatur, Georgia. Her landscapes and memory

paintings are well-known. She labored for months over each painting, striving to capture detailed scenes of her youth. She spent half of her life working on the family farm, in rural Bank County, and did not begin to paint until she was almost sixty years old. She wrote and illustrated several books. There was an exhibition of her art at the Abby Aldrich Rockefeller Folk Art Center. Her work is in the permanent collections of the High Museum in Atlanta, the New Orleans Museum of Art, the American Folk Art Museum, and the Museum of International Folk Art in Santa Fe.

Okun, Morris "Mo" (1903–1995)

Morris Okun was born in Pinsk, Russia, one of six children. In 1912, his father left for the United States with the intention of earning money to bring the rest of the family to join him there. However, the onset of World War I prevented this and Okun had to become the support of his family. The family was able to reunite in 1920, in Springfield, Massachusetts. In Springfield, he progressed from being a hardware clerk to owning his own furniture company. When he retired in 1979, his involvement with his synagogue became his paramount interest. In 1990, on a trip to Santa Fe, Okun became intrigued by the work of Navajo artist Mamie Deschillie. Returning home, without enough to fill his time, he started making his art. He would draw a sketch on paper, then draw on a piece of corrugated cardboard. Next he would cut and shape them with a kitchen knife and paint them with acrylic or poster paint. Okun drew on childhood memories and his life experiences for his images. All of his artwork was accomplished in the last three and one-half years of his life. In 1996, the University of Missouri–St. Louis presented the first solo exhibition of Okun's art, "The World of Mo," which was accompanied by a catalog with color illustrations of the art.

Oleksa, William (b. 1956)

Oleksa was born in New York City and is of Polish decent. He had no interest in art until his brief participation in a hospital art class in the 1980s. Starting in 1987 and continuing for the next two years, he painted large, cartoon-like images composed of zones of primary color and inspired by people and objects from his own life. Around 1994 he stared working again, this time fashioning cut and glued constructions from foam core which are then painted. His work was included in the exhibition "Twentieth Century Self-Taught Artists from the Mid-Atlantic Region," at the Noyes Museum. His work is in the permanent collection of the Milwaukee Art Museum; the website FreshArt (http://www.freshartnyc.org/bo.html) carries his work.

O'Lone-Hahn, Karen (b. c1968)

Karen lives in Upper Darby, Pennsylvania. She started painting in 1985 when her mother was dying of cancer. She painted from old family photographs as a way to hang on during her mother's illness. At the time, she could afford only black and white paint. In 1991 she began to experiment with color in landscapes. She watched a program on PBS to learn how to mix colors. Instead of continuing with landscapes, however, she started painting memories and visions of her childhood. Now she paints family, friends and events from her life. Her work is available through HUSTONTOWN in Fort Loudon, Pennsylvania, through her own website (www.karenolonehahn.com), and on her Facebook page.

Olson, David

Olson lives in Stockton, California, and participates daily at an art center for adults who have developmental disabilities. He produces two-sided drawings that document the day-to-day events of his life influenced by his playful imagination. David's pencil and crayon drawings range from pure image to text-heavy compositions. They most often include David himself, always wearing a mysterious cone-shaped hat. His work is available through the Mary Short Gallery in Stockton, California.

Orr, Georgiana (b. 1945)

Georginna Orr was born in Gridley, California, and now lives in Gilchrist, Oregon, with her husband David. About twenty years ago she stated painting, illustrating passages from the Bible. Her first exhibition of her work was in 1981 in Portland, Oregon. She painted twelve paintings based on Revelations from the Bible. She paints in very bright colors, using acrylics on canvas paper. Her work has appeared in several recent auctions.

Ortega, Joe (b. 1966)

Ortega was born in Santa Fe, New Mexico, where he still lives. He has spent his lifetime close to many wood-carvers; his brother-in-law is David Alvarez, and his father Ben and brother Michael are well-known carvers of santos. So Joe has been surrounded by both santeros and carvers of wooden animals. At the age of twenty, Joe began to carve his own work, which includes small coyotes, little rabbits, and other animals. Over time he is producing larger works. Davis Mather Folk Art Gallery in Santa Fe carries his work, as does El Potrero Trading Post in Chimayó, New Mexico (www.potrerotradingpost.com/JoeOrtega).

Orth, Kevin "King" (b. 1961)

Orth was born in Cleveland, Ohio, grew up in Akron and earned a B.A. degree from Ohio State University, Columbus in 1983. He lived in Chicago for a while, then traveled widely, including a ten year stay

in Oaxaca, Mexico. Upon his return he settled in Austin, Texas, where he creates remarkable bottle shrines, paintings, and all kinds of decorated objects with intricate designs and stylized imagery in very bright colors. Orth was one of the artists in the exhibition, "Reclamation and Transformation: Three Self-Taught Chicago Artists," at the Terra Museum in Chicago. Tom Patterson wrote a detailed essay about Orth for the exhibition catalog. His work has appeared at the American Visionary Art Museum and was acquired by the Smithsonian American Art Museum as part of the Waide Hemphill Collection. As of 2015, he blogs and shows his work at (www.kingorth.com). He may be contacted at kingorthy@gmail.com or through his Facebook page. You may also find him on the road with the King Orth Fancy Man Road Show, selling his work from his truck.

Ortiz, Sabinita Lopez (b. 1938)

Sabinita Lopez Ortiz was born in Cordova, New Mexico, and continues a family tradition of carving santos—her grandfather was José Dolores Lopez and her father is George Lopez. She wanted to walk in their footsteps. She makes unpainted, chip-carved biltos. Her works are often available at the Lopez and Ortiz Woodcarving Shop in Cordova, New Mexico on the High Road from Santa Fe to Taos, between Chimayó and Truchas. You can write to her at P.O. Box 152, Cordova, New Mexico 87523. She is usually at the annual Spanish Market in Santa Fe. Her work is included in the permanent collections the Smithsonian American Art Museum, the Owensboro Museum of Art, and the Taylor Museum in Colorado Springs. El Potrero Trading Post in Chimayó, New Mexico, carries her work.

Ortman, Howard (1894–c. 1970)

Ortman was born in April 1894, in Pennsylvania, and moved to San Francisco when he was about twenty years old. He became a jeweler, married in 1923, and had no children. In his early seventies, working in a garage with tools provided by a friend, Ortman began carving his intricate, polished figures of mixed woods and marrow bones. The highly polished and detailed carvings are especially remarkable because he had lost most of the sight in one eye. His entire collection of over one hundred pieces was carved as therapy in a seven-year period, and never exhibited in his lifetime. Howard Ortman died in the early 1970s, leaving all his artwork to a close friend who brought it to the attention of The Ames Gallery in Berkeley, California. It was first shown in 1989. The gallery still has some of his pieces.

Ott, Edward "E.B." (1914–1997)

Ott lived in Massillon, Ohio, and then retired after a career as a self-employed contractor and lived in Lakeland, Florida. Ott painted scenes of Florida nature and wildlife. He liked to paint people in groups—family and community scenes. Among his favorite subjects for his paintings were farm scenes with black people and Amish people. Ott died August 4, 1997. His work is available from Graves Country Gallery (www.gravescountry.com/selartist1.php?id=154&artist=Artist—Edward.B.+Ott).

Oviedo, Hector (b. 1972)

Hector Oviedo was born in Los Angeles. His clean and stylized drawings reveal an array of images in often complex designs. His favorite themes are animals and religious figures. His favorite medium is prismacolor although he occasionally paints with watercolors. He also makes ceramic pieces. He works at the First Street Gallery and Art Center in Claremont, California.

Oviedo, Marco A. (b. 1948)

Oviedo is a New Mexico native of Basque descent. He is a visionary woodcarver and sculptor who lives and works in Chimayó, New Mexico. Since the early seventies he has interpreted New Mexico religious folk art styles and southwest designs in his creations, using pine, aspen, and cottonwood for his carvings of santos, other religious figures, and animals. His family helps with the fine sanding, and when his figures are painted, his wife, Patricia Trujillo Oviedo, does that work. His work may be found at the Oviedo workshop in Chimayó (www.oviedoart.us).

Owen, Ben, III

Ben Owen is one of the seventh generation of potters in his family. It is said he has many of the skills and influences of his grandfather, master potter Ben Owen, Sr. The younger Ben had intended to become an engineer until he became fascinated with what his grandfather was doing. The elder Owen, who died in 1983, worked in Jugtown for 36 years and then operated his own shop, The Old Plank Road Pottery, for another 13 years. Ben III reopened this pottery to continue the family tradition. His work is in the permanent collection of the Ackland Art Museum at the University of North Carolina. It is available through the Hambidge Center Gallery in Rabun Gap, Georgia, and www.folkpottery.com (rgh@folkpottery.com).

Owens, Charles A. (1922–1997)

Charles A. "Charlie" Owens was born to an opera singer and a saxophone player. He received his first artistic recognition at age seven when he won a cash prize in a school competition for a full-color map of the United States. Visits to the Cincinnati Zoo, swimming in the Ohio River, and attendance at church camp meetings were part of his youthful experiences. Owens moved, with his wife and children, from

Maysville, Kentucky, to Columbus, Ohio, in 1949. He worked in his life as a delivery person, baker, chef, ice cream maker, construction worker, truck driver, bootlegger, and mechanic. He served, too, as a U.S. Marine. Always he had a strong drive to make art. His work depicts the essence of the world he knew just before he died and his memories of his past experiences. He is quoted as saying, "I just paint what I've seen. I like to paint history and the Bible." Owens' art is available from Lindsay Gallery in Columbus. Pieces have been included in recent art auctions.

Owens, Janice Harding (b. 1952)

Janice Harding Owens lives in Mt. Vernon, Rockcastle County, Kentucky, where she has always lived. She "fooled around with drawing like all kids do" but got serious about painting, which she had always wanted to do, in the winter of 1989. Her husband, Ron, made woodcrafts—he is now known for his bent willow furniture—and Janice had painted them for him. Her first painting was of a landscape and she continues to paint local farms and vistas. Her first exhibition took place in Lexington, Kentucky, in 1991. She paints with acrylics on canvas and prefers bright, pure, clear colors. Most of her paintings are of things she has seen, some come from what she imagines—like the ocean which she has yet to visit. Mrs. Owens has seven children. Ann Tower Gallery in Lexington has her work, and she maintains her own Facebook page. To call her direct about her art: 606-256-2355.

Owens, M.L. (1917–2003)

Owens was born and lived all his life in Seagrove, North Carolina. He was the son of James and Martha Owens who began Owens Pottery there in 1895. As a young man, M.L. Owens began to guide the family pottery business. He "partially retired" in 1978. His son Boyd now runs the pottery, along with his sister Nancy. Owens used feldspar alkaline glazes on his face jugs, which had a round-eyed, bared teeth look often compared to the look of Mayan images. His face jugs came in two sizes. Well-known potter Billy Ray Hussey is his grandnephew. Owens Pottery continues to produce useful and artistic ware (www.originalowens pottery.com, 410-464-3553), following the family tradition.

Owens, William (1908—no further information available)

Born December 20, 1908, William Owens lives in Poplar Branch, North Carolina. Owens worked as a farmer and at various other jobs until he became a sign painter in 1941. In the early 1970s, he took up wood carving. He made "bathing beauties," Uncle Sam statues, angels, and other figures—carved and painted in bright colors. He continued to paint and carve until

1989, and stopped partly because of failing health and partly because of harassment from local authorities. His work was included in the exhibition "Signs and Wonders: Outside Art Inside North Carolina." The Robert Lynch Collection of Outsider Art at North Carolina Wesleyan College in Rocky Mount includes Owens' work in its permanent collection. His work is occasionally available through art auctions.

Paddock, Morrow (b. c. 1975)

Morrow is a young man from Indiana. He went to college, where his interests were biology and languages. Upon graduation he set up a studio space in his parent's garage and began to paint daily. For a while he lived and painted in New York City while working full-time as a security guard at the Metropolitan Museum of Art, but subsequently moved back to Indiana and now lives in Indianapolis. He still makes art, including art cars, which he displays annually at an event in Indianapolis. He is represented by HUSTONTOWN in Fort Loudon, Pennsylvania.

Paioff, Sidney (1919–2001)

Sid Paioff, called "Sonny" by friends, was born in the Bronx. He was always artistic and creative but stopped doing anything of that nature when he married and had a child. In 1993 he started making art full-time when his wife had a stroke and was hospitalized, never to come home again. His art "occurred" to him "independently." He started using the thin aluminum from soda cans and paint to make intricate topiaries with every part of the plant accurate and the whole, colorful and beautiful. He makes creatures, too, including a most unique and captivating green turtle. After tiring of soda can art, he taught himself to sculpt. He has made some appealing heads with interesting faces. He worked for many years as a toy industry salesman. After twenty years as a New York taxi driver, Paioff retired and lived in New York City until his death.

Palladino, Angela (b. 1929)

Angela Palladino came from Sicily to the United States in 1958 and lives in New York City. During recovery from surgery she began to sketch, and her husband bought her some paints and urged her to try them. Her paintings are often images of nude women. Her work is in the permanent collection of the Smithsonian American Art Museum, and occasionally comes up in art auctions.

Papio, Stanley (1915–1982)

Papio was born in Canada. After working at welding all over the United States, he settled in Key West, Florida, where he bought a small lot on Route 1 and went into business as a welder. He encouraged people

to leave their oil cans and appliances on his property so he could use the junked metal for his welding. Then came the developers and upscale neighbors who hated him and his junk, and tried to get rid of him. He retaliated by welding parodies of them and putting the finished work on his front lawn. He turned his welding shop into a museum. Papio got a lot of positive attention from the art world, but not from his neighbors. He died suddenly at the age of 67. Pieces of his environment may be seen at the East Martello Gallery and Museum in Key West. It was included in the exhibition "The Passionate Eye: Florida Self-Taught Art" in 1994, curated by Claudia Sabin.

Pardo, Rosita (b. 1936)

Rosita Pardo paints and sculpts figures in the naive tradition, drawing from such sources as the Bible, early American Indian lore, the boxing and entertainment worlds. In her paintings and drawings she places her subjects in a context and integrates them with a quiet harmony of colors. Pardo started working at the NIAD center in 1987. Her work may be seen at the National Institute of Art and Disabilities Gallery in Richmond, California.

Partelow, Karen (b. 1950)

Karen Partelow was born in the Catskill Mountains of New York. As a young girl she spent many afternoons drawing scenes of her town. At other times, she and her brother would organize ball games and circuses for the whole town in their backyard. For a time she was the wife of a preacher at a black church and became acquainted with black culture. Recently she has begun painting "those good times and good friends" on roofing tin. "Her flamboyant work overlaps outsider and pop art," according to the dealer, Antique Buyers Consortium, who carries her work. She also sells her own work at karen-partelow-folkart.20m.com/index.html.

Patton, Earnest (b. 1935)

Earnest Patton was born in Holy Creek, Kentucky, and lives in Campton. He is a master of carved and painted figures. His broad range of subject matter includes folk heroes, religious figures, and figures from daily life. His favorite wood to carve is linwood, and he also uses poplar. He goes off in the woods and cuts his own wood with a chain saw. He roughs it out with a "chopping hatchet" and finishes with a carving knife, then paints them with machinery paint. He has appeared in many exhibitions, including "Flying Free" in 1997. His work is in the permanent collections of the Kentucky Museum of Art and Craft, the Kentucky Folk Art Center, the Owensboro Museum of art, and the Milwaukee Art Museum. Just Folk in Summerland, California and Larry Hackley, private dealer in Richmond, Kentucky, carry his work.

Patton, Paul W. (1921–1999)

Born in Alliance, Ohio, Patton lived in Maple Heights. He was an elementary school principal and started painting in 1985, two years after he retired. Patton's paintings document the Ohio village of Rix Mills where he grew up. He was especially motivated after he found that the town as he remembered it had been mostly destroyed by strip mining. Patton had an eye for design in the intricate patterns and placement of people and structures in his paintings. On the back of each, Patton identified each building and each human figure he had included. Gary Schwindler, in a review, said of Patton "the paintings of Paul Patton are outstanding. The juncture between recalled experience and the selective, intensified depiction of it is seamless. I find Patton's art totally convincing; I would not hesitate to call him a master of the genre." Paul Patton died January 6, 1999. His work is in the permanent collection of the Huntington Museum of Art; Lindsay Gallery in Columbus carries his work.

Payne, Leslie J. (1907–1981)—"Airfield"—Greenfield, Virginia

"Airplane" Payne, as he liked to be called, built an environment where he lived on the Eastern Shore of Virginia. He constructed large, painted airplanes and made a few other sculptures, mostly of boats and of patriotic themes. His airplane constructions and airfield environment were not saved, but is documented in the SPACES archives. One plane, restored in 1991, is in the permanent collection of the Anacostia Museum, Smithsonian Institution. One of his fishing boats is in the Smithsonian American Art Museum. Some of his sculpture pieces are in private collections. About the only access to his work is in photographs, many taken by Jonathan Green, director of the California Museum of Photography, and his colleagues. Green mounted an exhibition, Leslie Payne: Visions of Flight," in fall 1991. He was included in the exhibition "Passionate Visions of the American South." In the exhibition "Wind in My Hair" at the American Visionary Art Museum (1996–1997), a photographic environment recreated his place and his work.

Peck, B. Eugene (b. 1941)

Peck was born in Mariba, Kentucky, and lives now in Bybee. He works as an electronics technician for the telephone company. In 1975 he hurt his back and could not work for a long time. His doctor told him to take long walks, but Peck could not stand to look at all the trash along the roadside, so he started whittling. Soon he was carving intricate faces and small carved heads. Sometimes he makes other figures, too. He does not plan what the image will be; he "takes what comes out." He leaves his carvings unpainted, but his wife paints a few of them. The Kentucky Folk Art Center in Morehead carries his work.

Peckler, Dacelle (b. c. 1960–65)

Peckler is a practicing large animal veterinarian who lives in Paris, Kentucky. She works at many different horse farms in the Lexington area. Peckler combines her love of horses and her respect for the environment by recycling used bailing wire into intricate horse sculptures. She gathers the wire from the farms she visits, cleans and straightens it, and shapes it into specific breeds of horse, using only gloved hands and a pair of pliers. Many come from her imagination, but she also makes sculptures to represent specific horses, and will accept commissions to immortalize your horse in wire. She also makes various breeds of dogs, wolves, tigers, deer, moose, ferrets, lions, llamas, alpacas, giraffes, hippopotami, and other animals. Her creatures range in size from under half an inch to life size. She financed her veterinary education with her art, the proceeds of which now go to supporting the rescue horses that live on her farm until they have recovered from illnesses and injuries and are ready to go to good homes. Images of her work have appeared on the cover of the *Journal of American Veterinary Medicine* and were featured on a 2005 episode off HGTV's "Offbeat America." Her art is available at the Kentucky Artisan Center at Berea College, through her company, Equestrian Wireworks (Walnut Grove Farm, 115 Butler Street, Paris, Kentucky 40361, 859-236-9690), her Facebook page, and by email (wirehorselady@yahoo.com).

Pecot de Boisblanc, Mary Anne (b. 1925)

Mary Anne Pecot de Boisblanc was born October 1, 1925, in the small bayou town of Labadieville, Louisiana. As a teenager she moved with her mother to New Orleans. Like many others, Mary Anne found painting a pleasant diversion and spent her spare moments away from family duties painting, usually making careful copies of pictures that appealed to her. A friend kept trying to convince her to paint what was in her own mind. The serious illness of a son accomplished what her friend had not been able to do. The need to keep on opened the floodgates of memory, and she began painting her Bayou Lafourche childhood. This was in 1974. "I had my paint set with me when I was in the hospital, staying by the side of my son. It was just like an angel tapped me on the shoulder and said 'okay let's get to work.'" She finds herself trying to capture the whole south Louisiana Cajun culture, "a way of life that is fast disappearing," she says. She has had no lessons, but paints "from the heart, from my own inspirations." Mrs. Pecot de Boisblanc is a "primitive" painter and uses acrylics. Often she will "glaze" the paintings with fifteen to twenty coats of varnish. Her themes are scenes from her childhood memories, games, and frequently told local folklore and legends. She writes the story that goes along with the painting. As of 2015, Pecot de Boisblanc lives in a nursing home, where she

still enjoys meeting collectors. One may call her granddaughter Jenna at 504-875-2530 to arrange a visit. Her art is also available through her website, www.deboisblancart.com, managed by her granddaughter (jdeboi@gmail.com).

Pelner, Greg (b. 1968)

Greg was born January 14, 1968, in Los Angeles. He is autistic, has epilepsy, and great artistic talent. He carries about large sketch pads and draws people and buildings mostly, working very quickly. His art is unique and captivating. He also does sculptures of clay and aluminum foil. Greg lives with his mother in Los Angeles, his father having died a few years ago. Just Folk in Summerland, California and Berenberg Gallery in Arlington, Massachusetts represents this artist.

Pennic, Matilda (b. 1956)

Matilda Pennic was born in Pike Road, Alabama, in a family home filled with music and a lot of children. Her truck driver father played the guitar and the harmonica. Her mother was a singer, "rarely without a song." Pennic loved working with her hands. She attended high school and nursing school. She had a very stormy marriage to an abusive military man. She left him, and she and their two children went to Montgomery, Alabama, where she had to struggle to raise her two children. After working with the elderly in nursing homes, she became the housekeeper for an artist. She saved thrown away art supplies of her employer and tried painting. The memories of her childhood flooded back, and Matilda began painting, first only two works during four years of trying. Then after encouragement to paint full time, she made the break from other work and now creates memory paintings every day. Marcia Weber/Art Objects in Montgomery carries her work.

Perates, John W. (1895–1970)

One of the more famous twentieth century self taught artists, Perates was born in Greece and lived in Portland, Maine, at the time of his death. His carved, polychrome icons are definitely a reflection of his heritage. His work is written about and illustrated frequently. It is in the permanent collections of the Smithsonian American Art Museum, American Folk Art Museum, Milwaukee Art Museum, the High Museum, and the Columbus Museum of Art.

Perkins, Benjamin "B.F." (1904–1993)

B.F. Perkins was born in Vernon, Alabama, and eventually started his own little country church in Bankston, Alabama. Perkins was a painter and created an environment of painted and decorated buildings on his property. He used red, white, and blue paint to depict patriotic and religious themes. These colors and

themes may also be found on smaller-scale artworks such as gourds, boards, and canvas. Two of his famous images are the "King Tut Treasure" and the "Cherokee Love Birds." Some of these works display bright yellows and oranges, or the colors of a peacock's tail. Brother Perkins died of heart failure the morning of January 13, 1993. He was included in the book *Revelations: Alabama's Visionary Folk Artists.*

Perkins, the Reverend Seymour (b. 1931)

Perkins was born in 1930 in Halletsville, Texas and now lives in San Antonio. He is a prolific artist whose work addresses the struggles and accomplishments of African Americans in South Texas and the nation at large. Called by God to preach and bear witness through art on the day his daughter Debbie Jo Christi was killed, the Reverend Seymour began making works that address the blight of his community—drugs, alcohol, and prostitution, among them—and remind his Eastside San Antonio community of its proud African-American heritage. Perkins works on discarded objects, including wood furniture, cardboard, window shades, and clay. He carves, paints, scores, and forms and fires his work—depending upon the material and how he is called by God to work with it. He often works in themes and series. Project 2010 depicts the path of the Underground Railroad, which Perkins believes was a physical space of sanctuary. A series of cowboy paintings aligns the actors who played cowboys in Hollywood westerns with the stories of African-American soldiers. In another series dedicated to the popularity of Harry Potter, Perkins expresses his displeasure with the occult. San Angel Folk Art carries his art.

Perrin, Gilbert (1944–2005)

Perrin was born in Grayson, Kentucky. After moving around quite a bit during his working life, he later settled in Isonville, Kentucky, where he lived until his death. He began making art at an early age, and drew for his own enjoyment. When he moved to Isonville he met Minnie Adkins, who encouraged him to show his work, as did Larry Hackley, folk art collector and private dealer. He used colored pencils to draw stylized wooded mountain landscapes. His work was included in an exhibition at the Craft and Folk Art Museum in Los Angeles, and is in the permanent collection of the Kentucky Folk Art Center.

Perry, Deborah Evans (b. 1953)

Deborah Perry was born November 29, 1953, in Middletown, Ohio. She has two brothers and a sister and has lived in Ohio and Florida as well as West Liberty, Kentucky, where she is now. She is a high school graduate and has raised three children on her own.

Debbie Perry says she has loved making art all her life. She started by making gifts for her children and other relatives. Realizing she had a talent for working with wood, she continued her carving along with her regular work. When collectors began purchasing her work, her sculptures proved to be a source of much-needed extra income. Debbie credits Minnie Adkins with encouraging her to pursue her art, and counts Minnie as her most important artistic influence. Her work is in the permanent collections of the Kentucky Folk Art Center in Morehead and the Huntington Museum of Art in Huntington, West Virginia. She sells her art from her website, www.debsfolkart.com.

Perry, Virgil (b. 1930)

Virgil Perry grew up in West Blocton in rural Bibb County and now lives in Bessemer, Alabama. He spent 21 years in the U.S. Air Force and then went to work for Continental Can Company from which he retired in 1990. In 1986 he started carving when his son-in-law brought him a small cypress stump from a flea market. His granddaughter asked him to carve a unicorn for her, and he could not do it. Then "I asked the Lord to reveal the unicorn. As I held the wood, I saw nothing but the unicorn." He started by carving owls, unicorns and cats. Now he carves people and many birds. He paints his figures with acrylics and varnish. Cypress is still his wood of choice. His creatures are not standard and the forms are quite unique. They have very original and often humorous touches. His work is illustrated in the exhibition catalog *Outsider Artists in Alabama,* and was part of the exhibit, "Deep Fried Kudzu: Alabama Folk Art Exhibit" organized by the Birmingham Museum of Art in 2007. It is permissible to contact him directly at 205-491-1118.

Person, Leroy (1907–1985)

Leroy Person spent his entire life in eastern North Carolina in the small town of Occhineechee Neck. He worked as a sharecropper, shoveled coal, and was retired as a sawmill worker when he took up carving and painting. He made numerous small sculptures including birds, fish, snakes, and people. Some of his sculptures are mysterious, more abstract than representational. Person's work ranged from incised and painted furniture to drawings which he did in his later years. His work was included in the exhibition, "Signs and Wonders" (1989), and in "Self-Taught Artists of the Twentieth Century," (1998). Over 200 pieces of his were in the Lynch Collection at North Carolina Wesleyan College, until they auctioned them off, but some still remain, according to the collection's website. George Jacobs, private dealer in Newport, Rhode Island, has some of his work for sale.

Peterson, Oscar (1887–1951)

Most often thought of for his beautiful fish decoys,

Peterson also made colorful and fine carvings of other creatures, however, as well as wood plaques. This latter work may be seen in illustrations in *Animals in American Folk Art* by Wendy Lavitt, and also in a book about Peterson, *Michigan's Master Carver*, by Ronald J. Fritz. His work is in the permanent collection of the Smithsonian American Art Museum.

Peterson, Rasmus (1883–1952)— "Peterson's Rock Garden"— Redmond, Oregon

Rasmus Peterson came to the United States from Denmark in 1906. A farmer, Peterson had trouble growing produce in rocky east-central Oregon. So, according to his stepdaughter, he planted a rock garden from his huge collection of Oregon agates, obsidian, petrified wood, malachite, and jasper. These are mortared into miniature buildings, lagoons, and bridges. The Peterson Rock Garden is open to visitors daily. It is located between Bend and Redmond, Oregon, on U.S. Route 97, then about a half-mile west; its official address is 7930 SW 77th Street, Redmond, Oregon. The Rock Garden is also documented in the SPACES archive of folk art environments.

Phelps, Nan (1904–1990)

Phelps was one of eleven children born to a poor family near London, Kentucky. She later fled her home and husband, and settled in Hamilton, Ohio. Her early works resembled that of nineteenth century portrait painters. In her later years she did totally different work, creating strong original paintings with contemporary subject matter. Her work is in the permanent collection of the Cincinnati Art Museum and, in 1998, a gift of 26 of her paintings was received by the Kentucky Folk Art Center in Morehead. The Center mounted an exhibition of her art March 7–June 13, 1999. On January 17, 2015, the 25th anniversary of her death, Alfalfa Studio in SOHO, New York City, mounted an exhibition of 16 of her works.

Phelps, Rick (b. 1956)

Phelps is from New Mexico. He has found a way to recycle paper in a way like no other artist. Phelps makes baskets and flower arrangements, fantasy figures, and sculptures from paper that has been mâché'd, folded, layered, and lacquered. The works are often decorative, functional, or even mechanical. The results are both fascinating and beautiful. In 2004 and 2005, Phelps received a "Best of Show" award at the International Recycled Art Show in Santa Fe. San Angel Gallery in San Antonio carries his work.

Phillips, Irene (1925–1997)

A prolific painter, Phillips' subjects frequently came from her imagination. She also painted animals and people she knew. Her later work reflected an interest in Native Americans and the American West. She worked instinctively, painting with bold, spontaneous strokes in a free-flowing style that was matched by an equal daring in palette selection. Phillips was an HAI artist. She was born in Virginia and died in 1997 in Far Rockaway, New York. Her work is in the permanent collection of the Milwaukee Art Museum.

Phillips, Samuel David (1890–1972)

The Rev. Samuel David Phillips was a minister of the Progressive Pentecostal Church of Chicago. Born in Georgia, Phillips was of African-American and Cherokee parentage. Inspired by biblical stories and with some attention to contemporary issues, Phillips began to create "charts" as visual aids for his sermons. He drew on the back of oilcloth with pencils, crayons and water-based paints. His subjects include Satan, angels, war, temples, animals, beasts, bombs, saints, and sinners. Many include references to the scriptures. He created approximately sixty charts. April 19–June 20, 1998, Intuit presented an exhibition of his work in Chicago. There is an article about the artist by Cleo Wilson in *The Outsider*, Summer 1998. Lindsay Gallery in Columbus, Ohio carries his work.

Philpot, David (b. 1940)

Philpot was born in Chicago and still lives there, on South Bishop Street. Philpot has been carving his elegant staffs, from ailanthus trees, since about 1971. He says he got the idea for carving staffs from the movie *The Bible*. He asked God for the talent and got it "with no instructions." To make the staffs he "listens to what the tree or wood says." Philpot was one of the artists in the exhibition "Reclamation and Transformation: Three Self-Taught Chicago Artists" at Intuit in 1994. He was one of the artists who created a life-sized cow for the famous 1999 Chicago city arts "Cows" campaign; his cow was adorned with thousands of gold beads, buttons and shells — and covered in Swarovsky crystals. Intuit offered it at its fund-raising auction, where Oprah Winfrey won it on a bid of many thousands of dollars. Philpot maintains his own website, davidphilpot.wordpress.com, where one can see his work and link to Vimeo and other videos in which he discusses his art.

Piacenza, Aldo (1888–1976)

Piacenza came to the United States from Italy at the age of fourteen and went to Chicago. While becoming successful in business, he remembered his roots by constructing cathedral birdhouses which he put in his garden, and by covering the interior and exterior of his home with his painted recollections of Italy. His work is in private folk art collections and in the collections of Intuit and of the Milwaukee Art Museum. There is

an article about the artist by Bill Brooks in *In'tuit*, Winter 1996. His work is also documented in Ann Parker and Don Krug's *Miracles of the Spirit: Folk, Art, and Stories from Wisconsin* (2005-see Selected Books).

Pickering, Audrey (1924–1995)

Everything—people, animals, houses, skies, trees, water, and the land itself—seemed to vibrate with life in Audrey Pickering's color drawings and prints. Perspective, scale, placement, and color were purely arbitrary. People and animals can stand right side up or upside down in the same picture; "but no matter—they all seem to be enjoying themselves." Pickering's drawings were memories woven into a dreamlike tapestry. Pickering's drawing recorded her childhood, visits to Wisconsin farmlands, courtship and marriage, friends and picnics in the park, and other happy scenes. Pickering did not paint until she went to NIAD in 1980. She had been suffering from grand mal seizures and depression at the time of her death. NIAD still has some of her work.

Pickett, Joseph (1848–1918)

A self-taught artist of great importance, he bridged the nineteenth and twentieth centuries. He lived in New Hope, Pennsylvania, and took up painting late in life. Often his subjects were historical, or depicted the countryside around New Hope. Sometimes both of these themes converge, as in "Washington Under the Council Tree, Coryell's Ferry, New Hope, Pennsylvania," which belongs to the Newark Museum in New Jersey. The Whitney Museum of American Art and the Museum of Modern Art in New York have paintings by Pickett.

Pickle, Helen (1914–2002)

Helen Pickle was born in Texas and moved to northern Mississippi after her marriage to Reuben Pickle in 1933. When her only son died in 1972, she suffered a series of strokes, which immobilized her left arm and leg. She took up painting at the urging of friends, to fight depression. Her paintings of the rural South, including tiny figures with outstretched hands, have a delicate, lacy quality. She used acrylics on Masonite; her husband made her frames. Her work is included in the catalog for the exhibition, "Made by Hand: Mississippi Folk Art," and in the permanent collections of the Mississippi State Historical Museum and the Mississippi Museum of Art. Helen Pickle's work was included in the exhibition "Twentieth-Century Folk Art from the Collection of Flo and Jules Laffal," at the Lyman Allyn Art Museum in Connecticut in 1997.

Pierce, Elijah (1892–1984)

Pierce is one of the most famous contemporary American folk artists. He was born in Baldwyn, Mississippi, traveled throughout the South and Midwest, and eventually settled in Columbus, Ohio. He was a barber for over half a century. In the late 1920s, he renewed his boyhood interest in carving. By the 1930s he began making his religious art. His painted wood reliefs have been called "sermons in wood." Pierce has been exhibited and written about frequently, and numerous publications have illustrated his work. A large collection of works by Elijah Pierce is in the Columbus Museum of Art, and there was an exhibition of his work there in 1993 called "Elijah Pierce: Woodcarver." Many galleries carry his work, including The Ames Gallery in Berkeley, Marcia Weber/Art Objects in Montgomery, Just Folk in California, and several Ohio galleries. His work is also in the permanent collections of many museums.

Pierce, Warren H. (b. 1929—no further information available)

Warren Pierce was born in Fairfax, Louisiana, and was the youngest of four children. He entered the army in 1946, was discharged from Letterman Hospital in 1949, and stayed on in San Francisco, where he works in a vinegar factory. He is divorced, has children, and lives in a small apartment which serves as both studio and home. He started painting in 1976 when, in response to a dream, he went to his window one night and "a beam of light entered his forehead." Pierce makes images of the trials and tribulations of contemporary life, using oil on canvas. He adds salad oil to his paint and uses the handle of his brush to create hard edges and smooth pools of paint. Pierce calls his technique "swaving." His flat images, rendered in unnatural colors with precise edges, are a curious mixture of the real and the surreal. Disturbing images are presided over by Pierce's personal iconography of eyes, pyramids, and a glacial moon-embryo. His art was included in the exhibition "Visions from the Left Coast: California Self-Taught Artists."

Pioche, Dennis (b. 1965)

Pioche was born November 25, 1965, in the Blanco Canyon area south of Bloomfield, New Mexico, and lives in Aztec, New Mexico. He started carving when he was two, and by the time he was four he was making his own toys. His carved figures are of cottonwood and acrylic paint mixed with water. His best work is of Navajo people in a stoic pose, traditional style and wrapped in a trading blanket. Case Trading Post at the Wheelwright Museum of the American Indian in Santa Fe carries his work; which may also occasionally be found at the Twin Rocks Trading Post in Bluff, Utah. His art is also in the permanent collection of the Smithsonian Museum of American Art.

Pippin, Horace (1888–1946)

Horace Pippin was the most famous black artist of his time, and one of the greatest of any time. He

painted his own memories and experiences, including growing up in West Chester, Pennsylvania, and serving in World War I, where he was severely wounded. Pippin has received much attention from the art world, and there are numerous sources for reading about him and seeing his work. Pippin was included in the "Masters of Popular Painting" exhibition at the Museum of Modern Art in 1938. His work is in many collections, including the Gallery of Art at Howard University, The Phillips Collection, Oberlin College, the Metropolitan Museum of Art, the Museum of Art of the Carnegie Institute, the Pennsylvania Academy of the Fine Arts, the Whitney Museum, the Baltimore Museum of Art, Museum of Art of the Rhode Island School of Design, and the Hirshhorn Museum. The Archives of American Art has his "life story of art" and three separate memoirs of his military service. In 1994 there was a major traveling exhibition, "I Tell My Heart: The Art of Horace Pippin," organized and circulated by the Pennsylvania Academy of the Fine Arts in Philadelphia.

Pitt, Paul (1951–2012)

Pitt created scenes with a strong sense of community and extended family, even though these scenes were not part of his personal experience. His work was often populated by as many as 250 people. He gave up a football scholarship to paint, working during the day and painting at night and on weekends. He compulsively repainted each scene up to six times before he was willing to pronounce it complete. Within each painting, many small stories unfolded, each with its own considerable charm and humor. Four of his works appeared on the cover of *Craft Magazine*. Baron and Ellin Gordon, folk art collectors, gifted one of Pitt's works to their new museum at Old Dominion College in Norfolk. Many of Pitt's paintings can be seen in the permanent collection of the Museum of Art and Whimsy in Sarasota, Florida.

Plople, Harold (1946–2012)

Plople was born on a farm in South Bend, Indiana. He drew from an early age, and began painting at 14. He was a jet engine mechanic in the Air Force during the Vietnam War, and worked as a cartoonist afterward for several college newspapers, while attending classes. During this time he was diagnosed with depression and schizophrenia. He ended up homeless, staying in Los Angeles' Skid Row for eight years. Ultimately he was able to move into Harbor View House in San Pedro, where he took part in its art program, Living Museum Art Center. Plople spent the next seven years doing art. He died of cancer in 2012. His work was included in several gallery shows throughout southern California during his lifetime, and is now available from Just Folk in Summerland, California. His paintings reflect his life experiences, using washes of color

overlaid with bold figures, and finished with his titles written across the work.

Podhorsky, John (fl. mid–1900s)

Podhorsky was active in California about 1950, and little is known of his life. According to the information in the catalog for the "Pioneers in Paradise" exhibition, "His body of extant work is extraordinarily small though quite fascinating. It consists of drawings and paintings on paper, generally of architectural fantasies, bridges, small machines, which are occasionally accompanied by animals and trees. His style is a curious blend of heavily labeled geometric blueprint, full of eccentric descriptions, and playful, curvilinear counterpoint which allows the artist free rein to embellish certain details and define his flowers, animals and foliage. It is likely that Podhorsky had an interest in building, woodworking or carpentry, so evident is his concern with structural details." Cavin-Morris Gallery in New York has his art, which is also in the permanent collection of the Smithsonian American Art Museum.

Polhamus, Melissa (b. 1957)

Melissa Polhamus was born in Ludwigsburg, Germany. This Virginia Beach artist began painting in 1990. She uses subtle tones of watercolor and black ink to create energetic, vivid, detailed visions of people, animals, and insects interacting with one another, with food, and with the geometrical patterns that surround them unrelentingly. Using primary colors mixed with earthy hues, Polhamus outlines in black ink the subjects of her work: a pink pig wrapped in lines and shapes, a green face overcome by vegetation, a huge insect working on a bright orange carrot, a woman with a fish-filled aquarium. In the catalog for the exhibition "Folk Art: The Common Wealth of Virginia," her art is described as being "filled with anguished, jagged-edged figures reflecting her tortured mental state as well as her compulsion to create." She was also included in the exhibition "Flying Free" at the Abby Aldrich Rockefeller Folk Art Center in 1997. George Jacobs, private dealer in Newport, Rhode Island, carries her work, which is also in the permanent collection of the Smithsonian American Art Museum.

Polk, Naomi (1892–1984)

Born in Houston, where she lived all her life, Naomi Polk was forced to give up formal education around the sixth grade, a fact she regretted. She had three children to raise alone after a white policeman murdered her husband. She worked hard to support her children and keep her dignity, refusing to accept the ill treatment common to a servant's life. She was ingenuous in searching out ways to make a better living. Polk considered herself a poet first and a painter second. Painting on found objects, she did a series of paintings with

religious subjects, and another called "Lonesome Road" which expressed her view of life. Her art was included in the exhibition "Spirited Journeys: Self-Taught Texas Artists of the Twentieth Century" in 1998. Her life and work is included in Daniel J. Frye's *African American Visual Artists: An Annotated Bibliography* (2001).

Polster, Kendall (b. 1967)

Kendall B. Polster was born in Milwaukee, Wisconsin, where he lives now. He attended college at the University of Wisconsin in Oshkosh and then transferred to the University of Georgia and obtained degrees in microbiology and zoology. He is athletic and has placed well in powerlifting and running. He attended medical school for awhile and then left to pursue his art, or as he says, "to weld junk." He learned to weld from his brother, Craig, who is an auto mechanic. All his life he has built things and made furniture. He started "diligently sculpting" when he was "feeling a bit depressed." At this time he welded his first dog, and has made many more for people since that time. Now he makes sculpture full-time. He was in the exhibition "The End Is Near" at the American Visionary Art Museum," and his art is available from Instinct Gallery in Milwaukee. He maintains his own website, www.weld guy.com.

Ponder, Braxton (1915–2001)

Braxton Ponder lived in Nauvoo, Alabama. He and his wife had to give up the house they owned in Jasper, Alabama, when an "18-wheeler caused an accident that landed a truck right in our living room" with the bumper inches from where they were sitting watching television. Ponder was born in Lester, Arkansas, and attended school in that state. He served in the U.S. Army from 1940 to 1946, and married Mary Lou O'Mary in 1942. They were "active members of their Baptist church." He was a self-taught wood-carver who was in the grocery business until his retirement in 1986, after which he began carving. He used a pocket knife to carve his figures, which he then painted. He made animals, religious figures, and Noah's Arks. Shelton Gallery in Nashville carries his art.

Poore, Eugene (1938)

Poore was a policeman in Portsmouth, Virginia, and returned to his hometown of Saltville, Virginia, when he retired. Now he works for a correctional facility as a prison guard and creates finely made and whimsical birdhouses. His birdhouses are often such forms as a school bus, a police car, a tank, or a helicopter. His work was in the exhibition "Folk Art: The Common Wealth of Virginia." His work was exhibited also at the Reynolds Gallery in Richmond during the summer of 1998. His work may be seen at the Meadow Farm Museum in Glen Allen, Virginia.

Potts, William E. "Bill" (b. 1936)

Bill Potts, the grandson of a former slave and the son of a janitor, was born March 22, 1936, in Des Moines, Iowa, and now lives in Denver, Colorado. He attended Drake University for a short time, majoring in sociology and psychology, and traveled widely during twenty years with the U.S. Army. While he carved during those years, he has only been able to work full-time at his art since his retirement from the service in 1978. He makes detailed narrative wood-carvings with themes from black history, the Bible, and Western history. He also does full-sized figures of people and busts made from railroad ties. He uses any wood he can find, often discarded lumber, and paints his figures with house paint after carving them. He was commissioned to do a carving of Bill Clinton, and also received a major grant to carve eight children with books in their hands, which he gave to the Denver public schools. Galerie Bonheur carries his work. Mr. Potts may be contacted directly: 5556 Worchester Street, Denver, Colorado 80239. Telephone: 303-371-5328.

Powell, Christopher Dalton (b. 1967)

Dalton was born in the Midwest but moved to the San Francisco Bay Area at a young age. He studied photography at the San Francisco Art Institute, and continues to do photography as well as sculpture and painting. But it is his self-taught work n collage that is currently gaining him recognition. His precise, crisp, and finely detailed ink-drawn lines give shape to the often playful pieces of old books and other ephemera that he cuts and pastes together to further define his images. Some retain a child-like element, using pieces of jigsaw puzzles and old paper dolls. Other work is mainly drawn on elements as diverse as the insides of book covers and old prints and paintings. Powell says, "as a kid I always had a make-believe story running in my head all the time; now it's being played out as an adult." Powell's selection of tools is very important, as the array of materials he uses in a piece become an integral part of the story the piece is telling. His work has been shown on the east and west coasts of the United States, and in France. The Ames Gallery in Berkeley carries his work.

Powell, Clarence M.

Clarence M. Powell was a tailor. He lived in DeSoto, Wisconsin, and created a "Temple of Carved Art" to house his dioramas of biblical and historical scenes. Powell carved his pieces with a pen knife and used old window shades, cotton balls, twigs, and wire to fashion hundreds of figures. He did his work in the 1930s and early 1940s. Nearly all of his works are now part of the permanent collection of the John Michael Kohler Arts Center in Sheboygan. See www.jmkac.org/index.php/artist-environment-builders/clarence-m-powell.

Powers, Susan (b. 1954)

Born in Glen Cove, New York, Susan Powers lives with her husband in New York City. Powers is fascinated with old objects, a carryover from her childhood at her grandparents' farm in Vermont. She paints tightly woven compositions of these objects that are often colored in rich dark hues appropriate to their age. She works in oils on canvas. Her paintings are in many permanent collections, including the Smithsonian Institution in Washington, D.C., and the American Museum in Bath, England. Her works have been exhibited in numerous museums. Over the years, Powers has been represented by several well-known galleries, including Jay Johnson American Folk Art Gallery in New York, its successor the Frank J. Miele Gallery, and Gallerie Je Reviens in Westport, CT. Her art is part of the permanent collection of the John Judkyn Memorial Museum at Freshford Manor in Bath, England. She also sells her work through her own website, www.susanpowers.us.

Pressley, Daniel (1918–1971)

Daniel Pressley was born in Wasamasaw, South Carolina, and lived in New York from 1943 on, after spending time in Ohio where he had married and had a family. In the 1960s a disabling illness prevented him from working full-time, and he began to make art. His work was discovered at a sidewalk art show in Greenwich Village. He was included in an exhibition "New Black Artists" at the Brooklyn Museum in 1969. Mostly known for his wood bas-relief carvings, he also drew and painted. He is in museum collections and a piece appeared in the exhibition "Personal Voice" in 1997. His work is in the permanent collections of the Smithsonian American Art Museum, the Milwaukee Art Museum, and the Diggs Gallery at Winston-Salem State University.

Price, Janis (b. 1933)

Janis Price was born in Nashport, Ohio. At age 16 she quit school, eloped with her sweetheart, Ulysses, and bore and raised three children. She did not start painting regularly until her children were almost adults. In 1978 she read an article about the Museum of American Folk Art (now the American Folk Art Museum) and, unsolicited, sent it some photographs of her work. Jay Johnson, a New York art dealer, saw them and asked her to send him an actual painting. When he got it, he called again and said "send me all you have." By the time her husband died in 1982, she was able to earn a living with her art. She now lives and works in Newark, Ohio, and frequently works seven days a week. She paints bucolic oils on canvas and creates complex pictures composed of sewn-together pieces of cut fabric. Home life and observations of the life and ways of the Ohio Amish have inspired her work. In her mind, Price is often back on the bucolic farm of her youth that her grandparents owned, which has inspired hundreds of her paintings. Her work has been displayed in Isreal, Japan, Switzerland, and at the Smithsonian Institution. It is in the collection of the John Judkyn Memorial Museum in Bath, England. Lindsay Gallery in Columbus, Ohio carries her work.

Prisbrey, Tressa (1896–1988)— "Bottle Village"—Simi Valley, California

Tressa "Grandma" Prisbrey was a collector, especially of other people's cast-offs. Her collections grew to such dimensions that they could no longer be contained in her trailer, so she set out to build something to house them. First she sought cinder blocks, but they were too expensive, so she started collecting bottles from the dump. A friend of her second husband, Al Prisbrey, says she used bottles to shame him into quitting drinking. Bottle Village was created between 1955 and 1972, but most of the major construction was finished by 1961. In those first six years, Prisbrey completed thirteen bottle houses, two wishing wells, a water fountain, several planters, two shrines, and a mosaic walkway embedded with all kinds of objects. Tressa Prisbrey died in 1988; many books and articles have been written about this woman of tremendous creative ingenuity. The village is closed to all but volunteers and researchers until certain code requirements are met. From the sidewalk, however, one has good views of the exteriors: Take Highway 118E and exit at Tapo Canyon Road, turn right. When you reach Cochrane, turn left. Bottle Village is at 4595 Cochrane. There is a preservation group at work, listed in the chapter on organizations (www.bottlevillage.com), and also at least one YouTube video.

Proctor, "Missionary" Mary (b. 1960)

Mary Proctor was born July 11, 1960, in Jefferson County, Florida, just outside of Tallahassee. She is married to Tyrone Proctor, and they have four children. In February 1995, while grieving for her grandmother, aunt, and uncle who died in a house fire, she received a vision which began her career as an artist. A sweet voice spoke to her and told her to "paint the door." Since that time, Proctor has painted so much that she sometimes wonders what is wrong with her. Anything from her junkyard, which is The Noah's Art Flea Market, is a potential surface for her powerful and poignant images. She glues pebbles, sticks, buttons, or broken pieces of glass, mirror, or plates to her paintings. The broken pieces which she assembles represent the broken pieces of her life, and the rejoining of them is, for her, a mending process. Proctor writes messages across her paintings that she wants the world to know. She sees herself as a missionary and the

people who buy her work as the deliverers. Mary Proctor currently lives in Tallahassee. Many of the galleries listed in the Galleries chapter carry her work, which is also in the permanent collections of the Montgomery Museum of Fine Arts, the Morris Museum of Art in Augusta, Georgia, and the New Orleans House of Blues.

Proffitt, Ruth Clide (1910–1961)

Ruth Proffitt, everyone agrees, had a very hard, sad life. Born in Goochland, a small central Virginia farming community, she was the middle one of five children. When she was a youngster, her mother fell into the fireplace and was burned to death. The family was split with the two youngest children going to live with an aunt and uncle, and the not quite six-year-old Ruth left to take care of her two brothers and her father. She eventually married a man who was referred to as "the meanest man in the county." No one knows when she started to make art. The work, painted with oils on canvas and any other materials the artist could find, is based on happy, lively scenes from life in the 1930s and 1940s—obviously based upon the fanciful wishes of this self-taught artist, and not on her own life. There was no sadness or poverty in her scenes. Rather, her paintings portrayed perfect family holidays, beautiful women at parties, idyllic country scenes, and also religious and historical scenes and portraits. Proffitt died suddenly of a heart attack in 1961. Her art was abandoned and rescued from an old barn and her executor gave the lot to the art department at Virginia Commonwealth University in Richmond to be used by students in their art conservation program. The restored work is now in the permanent collection of the Anderson Gallery at VCU. Her paintings were exhibited at the Anderson Gallery in 1997 in an exhibition (also at Virginia Tech and at William King Regional Art Center) "Ruth Clide Proffitt: An Unrecognized Artist" curated by Loretta Cooper.

Pry, Lamont "Old Ironsides" (1921–1987)

Born in Mauch Chunk, Pennsylvania, Pry left home at age seventeen to join the circus, just as his father had done. He spent most of his working life as a clown. His personal experiences are a central theme of his work. He got his nickname, "Old Ironsides," when he survived an air crash during World War II. He was in a daredevil show after the war, but had to retire because of a heart condition. He started to paint when he entered a nursing home around 1949. He painted circus scenes, patriotic themes, and personal experiences. Little was known about it until it was shown to art patron Sterling Strauser who began exhibiting it at local fairs. Pry's work is in numerous museum collections and is frequently included in exhibitions.

Pugh, Dow (1906–1993)

Dow Pugh was born in Monterey, Tennessee. At the age of sixteen he left his Cumberland Mountain home to find work. Thirty-five years later, after his wife had died and his son was killed in an accident, he returned home and rebuilt his mother's old log house. John R. Irwin is quoted as saying "Pugh started whittling while waiting for firewood to dry out." He spent years digging up Indian artifacts. Later he made carved busts of famous people, along with birds, fish, and snakes. He also painted pictures, made heads from gourds, and decorated all his outbuildings with carved life-sized figures. The Museum of Appalachia in Tennessee has a permanent exhibition of his work. Pugh died December 27, 1993. The Smithsonian Archives of American Art has some of his papers and other archival material.

Queen, Ruby (b. 1925)

Ruby Queen was raised in Lawrence County, Kentucky, and now lives in Carter County. She and her husband, a farmer and retired factory worker, live on a ninety-acre farm on the edge of the village of Hitchins. Queen, who raised two children and worked at home, started painting about nine years ago, inspired by a friend who was a painter. She paints in oil and watercolor. Queen's work was included in "Images from the Mountains: A Traveling Exhibit of Appalachian Artists," November 1991—December 1991, sponsored by Appalshop. The exhibition sponsors said, "Her work captures the essence of days gone by in rural eastern Kentucky. She has won numerous awards and many of her paintings are in private collections and on exhibit in surrounding states." Ruby Queen will sell her paintings from her home, where you may write to her at P.O. Box 146, Hitchins, KY 42246, or call 606-474-5638.

Quinlan, Bobby

Quinlan lives in the northern Kentucky–Ohio River Valley area. He started carving totemic pieces with intense symbolism about five years ago, after he had a heart attack. He uses a single piece of wood for each piece and carves with hand tools. He will occasionally use a chain saw to make single animals but does not like to do it because it is "too noisy." He has the designs for his work strictly in his head, and does not draw them first. He makes carvings that are very complex in their symbolism, as well as birds, animals, and intricate birdhouses. Quinlan's work is in the permanent collections of the Huntington Museum in West Virginia and the Kentucky Folk Art Center.

Quinn, Norman Scott "Butch" (b. 1939)

Butch Quinn lives in Oil City, in western Pennsylvania. He has a difficult life because of poverty, isola-

tion, and a bit too much drinking. He is a loner, but likes to talk to people, first about art, then about hunting, and then about anything you are willing to discuss. He lived at the Brown Hotel until it shut down. About his paintings he says "I set out to work in colors and the images just come to me. I start art with a line on canvas and I just keep adding to it. I like polka dots." He works with wall paint, markers, and acrylics when he can afford them. He also creates works out of found objects such as bottle caps, tin cans, springs, and coils. Some of the resulting assemblages are interesting critters. He also uses feathers in his work. His work was included in the 1997 exhibition "Flying Free." It is in the permanent collections of the Smithsonian American Art Museum and the New Orleans and Huntington Museums of Art.

Rabin, Charles (1900–1986)

Charles Rabin was a Jewish immigrant who began painting at age seventy. An exhibitor at the popular boardwalk show in Atlantic City, he won awards and media recognition as a local naive painter of note. He died in New Jersey at the age of 86. Barry Cohen, private dealer in Alexandria, Virginia, carries his work.

Radoslovich, Matteo (1882–1972)— "Whirligig Garden"—West New York, New Jersey

Born on a small island in the Adriatic, Matteo Radoslovich came to the United States in 1914. In 1947 he began to create whirligigs entirely out of wood. Later he incorporated other materials and soon the backyard garden was filled with moving and stationary figures and constructions such as boats, soldiers, dancing girls, and other characters. When he died, they were about to be thrown out. Fortunately a folk art "picker" came along at the right time and the pieces were sold to collectors. Some are now in the American Folk Art Museum.

Rae, Helen (b. 1938)

Helen Rae was raised in the Claremont, California, area and attends First Street Gallery and Arts Center five days per week. She is a painter whose expressive strokes and keen sense of observation produce works of striking intensity. She paints with tempera or acrylics and makes classical portraiture to seeming random images taken from newspaper advertisements. Recently her palette has moved from Matisse-like colors to a series of black, white, and grey paintings still created with the same expressionistic brush work. Helen Rae was invited to show three drawings as part of a group show at Acme Gallery in Los Angeles with the title "About Face." First Street Gallery and the Good Luck Gallery in Los Angeles carry her work.

Rakes, Sarah (b. 1955)

Sarah Rakes was born in the Ozark Mountains of Arkansas. Now she lives in an isolated area of Georgia near Tallulah Falls, where she and her husband built their home by hand. Throughout her life she has been influenced by the natural world. Her first exposure to art came when she was a young child and a traveling museum exhibition sponsored by the Rockefeller Foundation came to her town. Rakes left Arkansas in 1976, after working at a series of jobs, moving about until she had to stop to find a job and earn some money. Then she met Mike Esslinger, married, and had three children. She tried twice to study art but neither time did it work for her. In 1986 she began to devote her time to painting. She paints with oil on canvas, acrylic on wood, oil pastels, gouache, and other mixed media. She uses bold colors and bold images. She believes we are "all in touch with the primal," and some of her paintings reflect this belief, such as "Lizard Pets at Night," "Lunar Babies," and her female nudes. She also does great cat images. Her work is available through many galleries, including Cotton Belt and Marcia Weber/Art Objects in Montgomery, Gilley's Gallery in Baton Rouge, Jeanine Taylor Folk Art in Miami, Main Street Gallery in Clayton, Georgia, and from private dealers Ginger Young and George Jacobs.

Ramírez, Martín (1895–1963)

Ramírez was born in Jalisco, Mexico and died in Auburn, California. It is believed he crossed the border into the United States to find a better life; he found the opposite. He secured work with a railway construction crew but the hard and heavy work was too much for the diminutive man. He is said to have become "confused, disoriented and delusional—characteristics of schizophrenia." These can also be characteristics of cultural dislocation and extreme fatigue. Diagnosed as "chronic paranoid schizophrenic," Ramírez was institutionalized at a mental hospital for the last thirty years of his life. About 1948 he began to make drawings. His tragic life, his discovery, and his art have received much attention. There are many written sources about his life and his art. Ramírez may have been the victim of the mental health establishment and a hostile culture rather than a mental illness. His work is in the permanent collection of the Smithsonian American Art Museum and many other museums.

Randolph, Kevin (b. 1966)

Kevin Randolph was born in New York City. After graduating from a special school, he came to Richmond, California, to live with his father and stepmother in 1987. He now resides in a board and care home. He enjoys painting and printmaking, especially the latter. Randolph's artwork resonates with the translucent quality of layered colors. Overlapping veils of color seem to float on the surface of his collage prints. In his

lino-prints a dark ground imparts a depth to his other colors. His forms are abstract, often suggestive of plant life, fish, and birds. Randolph has "a strong sense of composition and is now refining his imagery." His work may be seen at the National Institute of Art and Disabilities Gallery in Richmond, California.

Rascoe, Willie (b. 1950)

Willie Rascoe was born in rural Christian County, Kentucky. He lives in Cerulean. Rascoe graduated from high school and started college but was drafted into the army. After the army he earned an associate degree in general studies and then went to work in construction. Both he and his father are carpenters. Rascoe has been sculpting pieces from found objects for 24 years. He chooses pieces that reveal to him their hidden forms and faces. Rascoe makes his art entirely from found objects; these can be wood, stones, paint, animal bones, copper wire and paint. He presents many programs for schoolchildren. His work has been in many exhibitions, including "African-American Folk Art in Kentucky" in 1998 at Morehead, another at Morehead in 2002. He has been in recent exhibitions at the Art and Craft Foundation in Louisville. Rascoe is well known throughout Kentucky for his work in schools and as an arts educator. He conducts workshops and serves as artist in residence, where he encourages his students to push themselves to use their own unique gifts. Rascoe has exhibited at the Kentucky Folklife Festival in Frankfort, the Kentucky Museum of Art and Craft in Louisville and the Kentucky Folk Art Center in Morehead where he was featured in the African-American Folk Art exhibit. His pieces are in the permanent collection of the Kentucky Folk Art Center and the Kentucky History Center as well as private collections. His art has been exhibited in France and Thailand. There is a YouTube video that depicts him and his work (www.youtube.com/watch?v=jlFFj2FRyd0), produced one year at the Bowling Green International Festival, where he was doing a woodworking workshop—one of many he has done at numerous universities and festivals.

Ratliff, Dottee "Dot-Tee"

Dot-Tee as she is usually called lives in Chauvin, Louisiana. She is a retired school teacher who came to art later in life. She uses glass as her canvas, painting on both sides to create depth. She uses several different types of acrylic paint, from craft paint to puffy T-shirt paint. Most of her glass works are set in reclaimed wood frames made by her husband, Willy. Her art tells stories of the bayou she lives next to and lives of the people in her community. Her signature series includes mischievous pink alligators. Driven by the idea of "you use what you got," she also paints on antique muskrat boards. These pieces are full of history, as the boards date back to the fur trade in New Orleans. Her e-mail

is artgecko@charter.net and her telephone is 985-594-5997. Coq Rouge Gallery in New Orleans also carries her work.

Ratliff, Tim (b. 1959)

Tim Ratliff, whose parents were from Menifee County, Kentucky, was born in Middleton, Ohio, and now lives in Pomeroyton, Kentucky. He was trained as a bookbinder and worked in a printing company. He first started making production craft pieces and now makes individual art pieces. Early sculptures were unpainted, wooden assemblages portraying traditional scenes from rural life. He then went on to paint desert scenes and colorful exotic birds. Ratliff has since expanded his subject matter to include humorous depictions of rock musicians, harlequin-like circus performers, and much more. Ratliff works at home in rural Menifee County, Kentucky, where he lives with his wife, Sheila. His work is in the permanent collections of the Kentucky Folk Art Center in Morehead and the Owensboro Museum of Fine Art, Owensboro, Kentucky.

Ratto, John (1928–2003)

John Ratto was born in March of 1928 and lived most of his years in sheltered environments. When he was in his early fifties, with the encouragement of a northern California art center for people with disabilities, he began to draw and paint his methodical, deliberate, repetitive images within a given painting, of people and animals. While virtually without expressive verbal language, John Ratto had an impressive ability to communicate and has a great talent for use of stunning color.

Rawlings, David E. "Dave" (b. 1917)

Dave Rawlings was born in Washington, D.C., graduated from the University of Maryland, and worked with the Maryland Forestry Service for thirty years. When he retired in 1979 he began carving animals and walking sticks with images from his work in forests and along the Chesapeake Bay. He and his wife lived in Roanoke, Virginia for a long time, but moved to Richmond to be near relatives due to failing health. His art was included in the exhibition "Flying Free." The Gallery at Folk Art Net carries his work, but the owner has not heard from Rawlings in several years and does not know if he is still alive.

Rawlings, R.W. (1912–1998)

Rawlings was a self-taught Kentucky memory painter who documented the early days of his hometown of Gravel Switch, Kentucky. He had an incredible memory for the details of the scenes and activities of his youth, and this he painted—the one-room school, the main streets of his small town, the local bank, and the

daily activities in the town and on the surrounding farms. Larry Hackley, private dealer, has his work.

Reed, Ernest "Popeye" (1919–1985)

"Popeye" Reed was born in Jackson, Ohio, in 1919. Reed was self-taught, but definitely considered himself a professional artist. His favorite material for carving was sandstone, but he also used limestone. He became a full-time carver in 1968. Subjects included people, animals, and figures inspired by Greek mythology. He died in Fort Jackson, South Carolina. Reed's art was in a number of exhibitions including "New Traditions/Non-Traditions: Contemporary Folk Art in Ohio" and "Personal Voice." His work is still available through several Ohio galleries (Bingham's, Kenny, Lindsay), HUSTONTOWN, and two private dealers, Larry Hackley and Barry Cohen. In addition, it is in the permanent collections of many museums—Akron and Columbus Museums in Ohio, the Birmingham and New Orleans Museums of Art, and the Morris Art Museum. Reed's papers are available through the Smithsonian Institution-Archives of American Art.

Reed, Tim

Reed is from Alabama. He makes whimsical, satirical whirligigs that are brightly painted. His work is in the Birmingham Museum of Art.

Regensburg, Sophy (1885–1974)

Sophy Regensburg was born and lived in New York City. A sophisticated woman who was used to doing a lot of volunteer work, she took up painting when her doctor told her to slow down. Her work is illustrated in *Twentieth-Century Folk Art and Artists* by Hemphill and Weissman. Her work is in the Miami University Art Museum.

Reich, Lori Jae (b. 1946)

In 1979, Reich was the survivor of a small plane crash in Green Bay, Wisconsin. As a result of this experience she suffers from post-traumatic stress syndrome complicated by agoraphobia. In 1991 she began to pursue painting as a form of therapy. Her technical knowledge of painting technique has come from intense personal study and her friendship with painter Norbert Kox. Reich's early paintings were impasto abstracts. Since 1995 her work has become luminescent figural scenes that declare her thoughts and opinions on political and social issues. Reich lives in Green Bay, Wisconsin; her work may be viewed on the Artesian Art website, www.artesian-art.org/lorijaereich.htm.

Reinhardt, Joe (1942)

Reinhardt was born in Catawba County and moved to Vale, North Carolina, when he was two years old.

His family had made pottery for generations. Working for more than thirty years as a brick mason, he didn't start until he had to quit masonry because of a serious heart attack. He has been a full-time potter since the early 1990s. According to Barry Huffman in her book, *Catawba Clay: Contemporary Southern Face Jug Makers*, Joe has a vivid imagination as his vessels prove with their various and diverse faces, animals, and serpents. His pottery is included in the collection of the North Carolina Pottery Center in Seagrove, and may be available from shops and dealers in North Carolina specializing in folk pottery.

Reinhardt, Minnie Smith (1898–1986)

Minnie Reinhardt was a self-taught artist who started painting her own memories when she was age 72. Her paintings included about a dozen basic scenes of her homeplace in the Vale, North Carolina area: Hog Hill School, Possum John Rudisill's cabin, Wade Smith's Pottery and Jugtown Pottery. Reinhardt was married and had one son and five daughters. Her very colorful works were in an exhibition, "Mine's My Style: The Paintings of Minnie Smith Reinhardt," at the Hickory Museum of Art in Hickory, North Carolina. The exhibition was curated by Charles Zug III, and took place in early 1996. The museum has some of her work in its permanent collection.

Rembert, Winfred (b. 1946)

Winfred Rembert was born in rural Cuthbert, Georgia, in the southeastern part of the state. His father abandoned him, and his mother gave him away. He was raised by his great-aunt Lillian. He started working in the fields at a very young age and was only able to attend school two or three days a week. He dropped out of school altogether in the tenth grade. Living in the poor, black, segregated South, he had his family and friends but nothing much in the way of material goods. And in the area where he lived there was always the danger of lynching. The Civil Rights Movement attracted him, but he got into trouble and was sentenced to serve 27 years on a chain gang. Another convict saw Rembert's aptitude and helped him learn to survey roads, read blueprints, and use a transit, all skills which became valuable to prison officials. Winfred Rembert learned to tool designs in leather while in prison. When he first got out of prison he stopped working on art. He married, worked hard on heavy equipment as a longshoreman, and at many other jobs. He and his wife of 23 years have eight children. They live now in New Haven, Connecticut, and open their home to other children who need a safe place. His wife kept encouraging him to take time for his art, and he started doing his pictures again. He first sketches his pictures on paper and then hand tools them onto cured

leather. After tooling, he uses leather dyes to produce the strong colors that characterize his work. He often writes his thoughts about his picture to provide context. Rembert says he has so many pictures waiting in his head, he doubts he will ever get them all on leather. His subjects come from his life. He is the subject of a documentary, "All Me: The Life and Times of Winfred Rembert" (www.allmethemovie.com), which has been shown in many film festivals in the United States and Abroad. The Hudson River Museum gave him a solo show (January 21 through May 6, 2012), "Winfred Rembert: Amazing Grace," and has his work in its permanent collection. He has also had exhibitions at Cavin-Morris Gallery in New York City (2002), with Georgia artist Hale Woodruff at Yale University Art Gallery, and a recent exhibition, Indelible Images, at the Hand Workshop in Richmond, Virginia.

Rendon, Enrique (1923–1987)

Rendon worked in the southwestern santero tradition. He carved and painted saints made from aspen and cedar, using only a pocketknife and chisel. He gave his carvings special touches that lend them a contemporary quality. His work is frequently exhibited and discussed in writing. It may be seen in the catalog for the exhibition "A Time to Reap" and in other sources.

Rhoads, Jessie DuBose (1900–1972)

Jessie DuBose Rhoads was born in Coffee County, Alabama. She was descended from French Huguenot immigrants who first settled in North America near the Santee River in South Carolina in the late 1600s. She was a memory painter, depicting Alabama in the early years of the twentieth century. In 1961 she moved to Phenix City, Alabama, and started painting in an attempt to recover from a serious illness. She continued painting until shortly before her death. Her works are in the Columbus Museum in Georgia and also in the book *Memory Paintings of an Alabama Farm* by Fred Fussell.

Rhule, William (b. 1955)

William Rhule was born in Belifield, St. Catherine, Jamaica. He came to Houston in about 1988, when his mother and sister sent for him. In Jamaica he "worked for a white man from the U.S., entertaining foreigners from all over the world, until business fell off due to a hurricane." This "bossman" told him he had talent and must paint. Most of his work displays religious themes, his first painting being of a nativity scene. He uses sharp bright colors with a very flat perspective. Rhule is very poor but believes "God will make a way for me." He has been exhibited in Jamaica, Canada, the U.K. and the U.S. In March 2014, after 25 years in Houston, Rhule returned to Jamaica, participating before he left

in a big going-away party and fundraiser for Downtown Houston at which he played Reggae music and contributed paintings to an auction.

Rice, James Russell (1919–2012)

A native of East Point, Kentucky, Russell Rice lived a half-mile from where he was born. He had a lifelong fascination with wood but did not find the time to devote to carving until his retirement in the 1990s from the Kentucky and West Virginia Gas Company. Rice said that stick-maker Thomas May convinced him to start making canes, which he did from about 1990. He found most of the wood on walks near his home. He selected lengths wrapped with vines because the twists and deformities they caused were an integral component of his carvings. Coiled segments became snakes, and jagged roots were developed into animal antlers and free-form designs. His carving and painting of the completed canes was done with extreme care. He welcomed visitors during his later years. His work is in the permanent collections of the Kentucky Folk Art Center and the Owensboro Museum of Fine Art.

Rice, Roger (b. 1958)

Roger Rice was born in Crawford, Mississippi. He is a visionary artist who, in his younger days, was ordained as a fundamentalist minister. In the fall of 1994, he began serving a life sentence at the Parchman Prison in Mississippi. He is obsessed with the notion of the evil nature of man, and his depiction of that nature is powerful. Any drawings inspired by man's goodness are rare. His major themes in his art are religion and, in a few cases, social conditions. For a time during 1997 he did a great series devoted to prison life. These may not have been acceptable to prison authorities, and Rice does not seem inclined to do any more. Roger Rice works slowly. He does drawings at the rate of about one per week. Between 1987 and the fall of 1994 he produced 42 works. At first he was allowed to make only black and white drawings in prison. Now he is allowed to use colored pencils, but it is doubtful that he will ever again be allowed to use oil paints. The drawings are done on acid-free paper and measure 11" × 14"—the largest size that will fit in his locker. Orange Hill Art in Atlanta sometimes has his work.

Rice, Sandra (b. 1949)

Sandra Rice was born in Birmingham and lives in rural Woodstock, Alabama. For a long time she sculpted people or groups of people that reflected the sadness she experienced as a counselor. Around 1993, Rice gave up making clay sculpture and started doing welded metal sculptures which she continues to do. Her work is in the Birmingham Museum of Art.

Rice, W.C. (1930–2004)—"Cross Garden"—Prattville, Alabama

After being "saved," Rice covered his front yard and close to three acres of surrounding property with homemade whitewashed crosses of various sizes. Some are huge and required a backhoe to install them, and others are tiny and hang from trees on string. He has also filled the grounds with signs, junk, old appliances, and rotting lumber, all painted with warnings and instructions for "visiting sinners." Students, folk art people, and the curious come to visit and enjoy it. The neighbors hate it. The Cross Garden is located in Prattville at 1330 Indian Hill Road, Route 43. It is documented in SPACES and, according to that organization, was still there in 2015.

Richard, Rodney, Jr. (b. 1955)

Richard Jr., was born in Rangely, Maine, and now lives in the town of Pownal, Maine. He carves animals of the Maine woods, using a chainsaw and also a jackknife for smaller pieces. His most frequent animals are bears and loons; he says he can carve most other animals too, but he has to "practice a bit" to get them right. Richard Jr., paints his carved figures, which his father did not. He sometimes takes his work to local fairs and festivals, but mostly sells from his own house, where he can be reached at 207-688-2249 to arrange a visit.

Richard, Rodney, Sr. (1929–2015)

Richard Sr., lived in Rangeley, Maine, near the Canadian and New Hampshire borders. His father, William Richard (1900–1993), came to Maine in 1918 from New Brunswick, Canada. They are Acadian French. William Richard was well-known for his beautiful carved cedar fans. Rodney Richard was an independent logger; very conservation-minded, he would not clear-cut any area. He got out of the business when he realized it would just be a matter of time before he was injured. He founded the Rangeley Lakes Region Logging Museum in 1979. The Museum has collections that include artifacts from regional logging operations and traditional art by western Maine lumbermen including Rodney Richard, Sr., and Jr. The Museum is still functioning, but is no longer in the hands of the Richard family. Richard used a chain saw and could "make anything I can see in my mind." He was designated a master carver by the Maine Art Commission, and had a shop next to his house in Rangeley where he sold his work. By the time of his death, all of his art had either been sold or was not for sale, but many pieces are still in the Museum.

Richardson, Taft, and Harold see "Moses House"

Riddle, Morton (1909-1992)

Morton Riddle was born in Kentucky, where he first demonstrated an interest and talent for wood-carving. He moved to Southern California in 1946, and lived in Whittier. He worked there, until retirement, as a clockmaker and repairman. Riddle carved wooden figures and painted signs and pictures. He is best known to the art world for his carved wooden dolls with jointed limbs and eerie faces.

Riley, Euple (1929–2004)/Riley, Titus (1927–2006)

The Rileys were potters working in Mantachie, in northeastern Mississippi. Each was a native of Peppertown—Titus was born September 3, 1927, and Euple was born July 29, 1929—were neighbors since childhood, and married as teenagers. They work together with equipment Titus put together from old machinery. They were not from a traditional potting family. The Rileys had their first firing just before Christmas in 1982. In addition to utilitarian objects, Euple liked to make small animal and human figures, and Titus made face jugs. They renewed a former Itawamba County custom of making ceramic grave markers. Peppertown Pottery, named after a small community south of Mantachie on Route 363, was established around 1983. The Riley's granddaughter, Tab Boren, carries on the Peppertown Pottery but moved it in 2004 from its original location in Peppertown to Mantachie and calls it Clay Art. Her work has evolved from being mostly sculptural to wheel-thrown pots and platters, which are decorated with seashells, clusters of grapes, figs and her trademark dragonflies.

Rittenberry, Harold, Jr. (b. 1938)— Home and Garden—Athens, Georgia

Harold Rittenberry, who lives in Athens, Georgia, makes sculptures out of scrap metal. He worked for many years as a lawnmower repairman. When he was younger he worked for a plant where he learned welding. Fascinated by art for most of his life, Rittenberry did not begin sculpting until 1990, when he bought welding equipment for his own and began experimenting with it. He salvages metal from the roadside and turns it into heavy, textured figures of people and animals, with which he fills his yard and house. He also makes fish, birds, robots, and other whimsical forms. In January 2014, at the age of 75, Rittenberry took on an assistant to do the welding on his large sculptures recently a commission for a 12-foot centerpiece for Atlanta's Susan S. Butler Park. He is widely known for his sculptures, which may be seen at his house at 268 Colima Avenue in Athens. His work is documented on SPACES.

Rizzoli, Achilles G. (1896–1981)

Rizzoli was born in northern California to Italian-Swiss immigrants. In 1915 the family relocated to the East Bay, and his father killed himself. Later A.G. and his mother moved once again to a small home in San Francisco, where he remained for the rest of his life. Rizzoli made visionary architectural drawings. "Rizzoli's buildings," according to Bonnie Grossman, who found the work and has been searching for facts about the artist and his life, "infinitely detailed in the Beaux Arts style, are representations of people that the artist knew. These imaginary buildings are conceived of as 'heavenly homes' or designated as 'symbolic sketches.'" Another portion of Rizzoli's work is the plot plan for a fantasy community. All were done between 1935 and 1945. His later work (1958–1977) was a collection of writings, illustrations, and architectural renderings. The artist's works are featured in the exhibition "A.G. Rizzoli: Architect of Magnificent Visions" which was organized and circulated by the San Diego Museum of Art. It opened at the American Folk Art Museum in January 1998. Ames Gallery in Berkeley carries his work.

Roberg, Robert (b. 1943)

Roberg was born in Spokane, Washington, and now lives in Florida. Roberg has spent years in a personal struggle over his desire to create and its relation to his religious beliefs. From this have been born paintings filled with his personal proclamation and faith, which are said to be quite powerful condemnations of evil, as he sees it. His artwork was included in the exhibition "The Passionate Eye: Florida Self-Taught Art" in 1994. His work is in the permanent collection of the Smithsonian American Art Museum; he sells his art through his own website, www.robertroberg.com.

Robertson, Royal (1930–1997)

Royal Robertson lived in Baldwin, Louisiana. A former sign painter, he traveled to the North and to the West before returning to Louisiana to care for his mother, and then he married. His marriage, to Adele, ended after some nineteen years; she took their children and moved to Texas where she became a minister. Robertson's visionary paintings, often two-sided, generally have two themes—futuristic worlds with images of aliens and spacecraft, or vicious attacks on women in general and or Adele in particular. In August 1992 Hurricane Andrew totally destroyed his home and property. Two collectors helped Robertson file papers with the federal government and otherwise helped him recover from his losses. Sadly, just as he became reconciled with two of his children, Robertson died suddenly. There was an exhibition of his art, "A Desperate Intensity of Vision: The Drawings of 'Prophet' Royal Robertson," curated by Sal Scalora, at the Atrium Gallery of the University of Connecticut April 19–May 14, 1993. His work is in the permanent collections of many museums, including the Smithsonian American Art Museum, the Birmingham, New Orleans, and Mississippi Museums of Art, the Art Museum of Southeast Texas, and the African American Museum of Dallas. In addition, a number of galleries carry his work, including Yard Dog and Web Gallery in Texas, Anton Haardt and Raven Arts in New Orleans, Marcia Weber/Art Objects in Montgomery, and Arte del Pueblo in Connecticut.

Robinson, Mary Frances (b. 1943)

Mary Frances Robinson was born December 19, 1943, in Chattanooga, Tennessee, and was raised in Ohio by her grandmother. She always enjoyed the afternoons when her grandmother would be working at piecing together her latest quilt, especially on Wednesdays when her grandmother's friends would come over to help. Robinson always liked art, and began to teach herself to paint by trying to copy the Old Masters in the Cleveland Art Museum. Her paintings had "no resemblance to the 'Old Masters,'" she says, but with her grandmother's advice to "persevere" she kept on until she developed her own style. After years of marriage and spending her time raising her children, she has started once again devoting herself to her art. Robinson chose to work in oils because of the brilliant colors. She and her husband travel around the South taking pictures of old farmhouses, usually falling down. When she gets home, she "builds them back up and puts families back in them." Robinson has been in many gallery and other exhibitions, both juried and non-juried. She lives in San Antonio, Texas and welcomes visitors, but please call ahead (210-521-1190).

Robinson, W. Earl (b. 1950)

The Rev. Willie Earl Robinson was born in Yazoo City and now lives in Clarksdale, Mississippi. The paintings of this artist focus on cotton and on family scenes. He uses acrylics in such a way as to create a three-dimensional quality and uses vibrant colors. His attention to detail is especially attractive and, "for many Delta residents, they bring back strong memories." Formerly an upholsterer, and currently an artist and minister, Robinson's talents are gaining recognition throughout the Delta area. His work is in the permanent collections of the Clarksdale Museum, the Delta Blues Museum, and the Museum of the Mississippi Delta (formerly Cottonlandia Museum). The Turnrow Gallery in Greenwood, Mississippi carries his work.

Rodia, Simon (c. 1874–1954)—"The Watts Towers"—Los Angeles, California

Simon Rodia, known to his neighbors as Sam Rodilla and to his mother as Sabato, immigrated with his

family to the United States in the 1890s and settled in Pennsylvania. Eventually Rodia moved to the West Coast and worked in rock quarries, logging, and railroad camps, as a construction worker, and as a tile setter. In 1921 he bought a small triangular lot in Los Angeles and spent the next 33 years building his towers by hand, using a tile-setter's simple tools and a window-washer's belt and buckle. Rodia adorned the towers with a mosaic of broken glass and pottery, tiles, sea shells, and ceramics. The tallest tower measures 99 feet, a center column and spire reach a height of 38 feet, and another spire is 28 feet tall. There is also a gazebo with a circular bench, three birdbaths, and a 140-foot long "south wall" decorated with tiles, pottery, glass, and hand-drawn designs. After many battles to save it and changes of jurisdictional hands, Rodia's Towers are now administered by the City of Los Angeles Cultural Affairs Department and has a website, www.wattstowers.us. The site is heavily documented, and has at least one video on YouTube (www.youtube.com/watch?v=CcpJFawYZlY). The towers may be visited by the public and are located at 1765 East 107th Street in Los Angeles, not far from Century Boulevard or Wilmington Avenue.

Rodriguez, Miguel "Mike" (b. 1948)

Mike Rodriguez was born in Santa Fe and lives in Rowe Mesa, New Mexico. His father was a carpenter and a cabinet-maker, exposing Rodriguez to woodworking at an early age. He has worked as a plumber, carpenter, actor, and gas station attendant. He started carving in 1978. "Just being born in Santa Fe influenced me a lot in being an artist," says Rodriguez. Like many Hispanic men from the region who started carving, Rodriguez started with religious saint figures. His mother asked him to carve her a santo, and he continued to carve and paint both the bultos and retablos of his heritage. He soon realized that he couldn't make a living at this kind of work. He had sold some pieces through the Davis Mather Folk Art Gallery, but realized that carved and painted animals sold better than santos. Although he never worked with Archuleta, his work seems to be closest to Archuleta's animals in spirit, vitality and tough ferocity, which made his work exciting and appealing. "When I am doing a carving it attracts me like a magnet. If I find a piece of weed in a river bed, I sometimes see something in that wood. It drives me wild to get it done." His work is in the permanent collection of the American Folk Art Museum. Galleries such as Just Folk in Summerland, California sometimes have his work available for sale.

Rodriguez, Ron Archuleta (b. 1968)

Ron was born in Santa Fe and lives there now. He is the grandson of Felipe Archuleta and has helped his grandfather and his uncle, Leroy Archuleta, at their workshop in Tesuque since he was an elementary

school student. He makes bottle-cap snakes with cottonwood for heads and rattles, which he subsequently paints. More recently he has concentrated on painted wood-carvings of reptiles and animals. His work was included in the exhibition "Flying Free." Just Folk and Rainbow Man carry his work, which is also in the permanent collections of the American Folk Art Museum, the Mississippi Museum of Art, and the Art Museum of Southeast Texas. He maintains his own website (www.rodriguezfolkart.com/page8631.htm), from which he sells his art.

Roeder, John (1877–1964)

Roeder was born in Luxembourg and moved to Richmond, California, were he lived until his death. He worked as a gardener. His first artwork was in filling his own garden with a miniature village, life-sized cement figures, and a chapel. "Couple with Umbrella," painted concrete, is illustrated in the catalog for the exhibition "Cat and a Ball on a Waterfall." After retirement, Roeder began to paint more, often including the words of some of his own poetry. Religion was an important part of his life and his art. Some of his earliest paintings were oil paint and sand on glass. His work is in the Oakland Museum.

Rogers, Angela (b. 1969)

Angela Rogers uses a wheelchair and has the free use of one arm. She paints, draws, cuts linoleum prints, and sculpts with papier mâché and clay. Her painting has developed from static childlike depictions of human figures and faces to vivid abstractions composed of swirls and waves of color that seem at play with each other. In spite of her disabilities from cerebral palsy, she has made art that has been well-received by collectors. She came to the NIAD center in Richmond, California, in 1991. Her work is available from NIAD and also from the Gallery at HAI.

Rogers, Juanita (1934–1985)

Juanita Rogers was born near Montgomery, Alabama. Rogers began making mud sculpture as a child. She used cast off materials and objects found in her surroundings in rural southern Alabama, where she lived the last years of her life. She also made drawings based upon what was on television. She has been written about many times, most recently in the book *Revelations: Alabama's Visionary Folk Artists*. Anton Haardt Gallery has her clay figures on display. Her work is in the permanent collections of the Smithsonian American Art Museum; the High Museum; The Milwaukee Art Museum; and the Mississippi, Birmingham, and Meadows Museums of Art.

Rogers, Marie Gooden (1922–2010)

The only woman folk potter in the country who op-

erated entirely on her own, Rogers lived in Meansville, Georgia. She was descended from potters and was married to the son of the last Georgia Jugtown potter, the late Horace Rogers. Rogers turned her ware on an old treadle wheel. "My husband's daddy had it in Upson County. It has been in our family over one hundred years and was made in a blacksmith's shop," she said. Marie Rogers made face jugs and other forms. Her work is in the permanent collections of the Museum of International Folk Art in Santa Fe and the Museum of Arts and Sciences in Macon, Georgia. Cotton Belt Gallery in Montgomery, Shelton Gallery in Nashville, and Larry Hackley, private dealer in Kentucky, carry her work.

Rogers, Sulton (1922–2003)

Sulton Rogers was born near Oxford, Mississippi, and learned carpentry skills at an early age, with the help of his father. He started carving small animals as a child, and attended school for "a few years." In 1941 he married, went on to have ten children, and then left his family. He traveled a lot and then settled in Syracuse, New York, where he worked for Allied Chemical. He took up carving again when he needed to have something to keep him awake during night shifts at the chemical plant. His carvings reflect "things he saw at night," fashioning snakes, vampires, "haints," bodies in coffins, twisted-looking faces, two-headed divas, dog boys, ghouls, and some religious matter. He retired in 1984 and moved back to the Oxford area in the late 1990s. His work is in the collection of the University of Mississippi Art Museum and was exhibited in *Black Art-Ancestral Legacy"* in 1989 and *Passionate Visions of the American South* in 1993. His work is available through Just Folk, Arte del Pueblo, Shelton Gallery, and Yard Dog. It is in the permanent collections of many museums, including the Smithsonian American Art Museum; the Birmingham, Georgia, New Orleans, and Mississippi Museums of Art, the Ogden Museum of Southern Art, the Fenimore House Museum, the Art Museum of Southeast Texas, and the African American Museum of Dallas.

Romain, Max (b. 1930)

Max Romain was born in Port au Prince, Haiti. He studied dance and performed in a folklore troupe, before moving to the Bronx in 1957. He worked as a doorman and security guard before he retired in 1988. He began painting his visionary images in 1989. His first show was at the Donnell branch of the New York Public Library in 1991. He paints and draws intricate images that remind some people of the work of Minnie Evans. In theme, his paintings can be religious or sexual. He remains deeply attached to the spiritual beliefs of his native home, as his works evidence. He often includes elements of voodoo culture in his paintings— "Voodoo is strong in New York," he says. There is a

Haitian element in his artworks, but they are not really Haitian. His art has been shown in several museums including Collection de l'Art Brut in Lausanne, Switzerland. American Primitive Gallery carries his work, which is in the permanent collection of the Smithsonian American Art Museum.

Root, Ed (1867–1959)— Environment—Wilson, Kansas

Ed Root was born in Naperville, Illinois. He drifted about the West and then married a Kansan, Lydia, raised ten children, and farmed what had been his father's homestead. He built hundreds of concrete monuments and plaques embedded with small objects and broken colored glass. There were a few figurative pieces, but most were abstract assemblages. The Wilson farmland was flooded by the construction of a new dam soon after Root's death. Hundreds of concrete yard pieces were relocated to high ground by two of Root's sons. Most of the art is now at the Grassroots Arts Center in Lucas, Kansas, and will be housed in a new building.

Roper, Timothy Andrew (b. 1961)

Tim Roper was born in North Carolina and lives in Louisiana. He is married to a native New Orleanian. He is new to art and has only been making his miniatures for about four years. Tim says he likes to replicate what he sees in everyday life into miniature. He loves boats, which many of his pieces reflect. A few of the other pieces that he has made are a plane and "a cabin that has to be seen to be believed." His work was featured in a 2015 exhibition at the Alexandria (Louisiana) Museum of Art, "Artists Among Us: Faculty and Friends."

Rosebrook, Rodney (1900–1994)— Environment—Redmond, Oregon

Rod Rosebrook was born in Colorado, and moved with his family to eastern Oregon when he was ten. He went to high school for a while, then quit to work on cattle drives. For over 30 years he collected old tools and salvaged metal objects for his "Old Time Museum." Eventually he produced hundreds of constructions made from garden gates, which enclosed careful arrangements of tools. Some of the tools hung on his barn and others made up a fence along his property. The tools in the "Old Time Museum" and those hanging on the barn were sold to a museum, and the original fence was sold to a New York gallery. He made a new fence and new creations to hang on the barn. After his death, Rosebrook's art could not be preserved in its original environment. It is included in the permanent collection of the Smithsonian American Art Museum and is illustrated in several books. Pieces are occasionally available through auctions.

Roseman, William (1891–1994)

Roseman was born in New York City and taught vocational training in the public schools of Brooklyn. He painted mostly biblical scenes and antiwar themes, and worked at his art eight to ten hours a day. Starting with oils and then moving to acrylics, he painted during the years 1957 to 1992. He was discovered by art dealer Gene Epstein.

Ross, Margaret Hudson (b. 1908—no further information available)

Ross is a native of Owensboro in western Kentucky. Her paintings reflect experiences and memories of her life growing up there. She was a math teacher and started painting after her retirement. The majority of her paintings portray city life. Her work is in the permanent collections of the Owensboro Museum of Fine Art and the Morris Museum of Art.

Rothbort, Samuel (1882–1971)

Rothbort was born in Russia and came to the United States with his family in 1904. A self-taught artist, he received early recognition for his paintings, nearly all of which were self-portraits. In 1925 he taught himself to sculpt with hammer and chisel. "Using stone from demolished buildings and wood from felled trees, he created an astounding array of images based on allegorical, religious and personal sources." Although he had an extensive exhibition history, he remained always an outsider to the New York art establishment. Giampietro Gallery in New York had a solo exhibition of his work and published the accompanying catalog. His art is in many permanent collections including The Museum at Stony Brook, The Montclair Art Museum in New Jersey, the Rutgers University Art Gallery, and the Smithsonian American Art Museum.

Rotter, Rudy (1913–2001)

Rudy Rotter was born April 23, 1913, in Milwaukee, Wisconsin, the son of Russian-Jewish immigrants. He was a self-taught wood carver who made art for more than forty years. Monumental relief carvings depicting biblical themes and Rotter's pervasive themes of love, humanity, and family were the core of his creativity. It is estimated that he did more than 15,000 works. He worked as a dentist, raised a family, and rented a warehouse in Manitowoc, Wisconsin, where he lived, to create an environment/museum of his work. His Museum of Sculpture in Manitowoc is closed, but his wife and son are tending to his legacy and will sell pieces of his art, which is in storage. Interested people should contact Randy Rotter at randyrotter@msn.com. A book containing extensive material about the man and his art, along with many photographs, is *Rudy Rotter's*

Spirit Driven Art by Anton Rajer. His art is included in the permanent collection of the American Visionary Art Museum.

Rowe, Nellie Mae (1900–1982)

One of the country's most highly regarded folk artists. She was a visionary artist who believed her art was a gift from God. Inspired by her religious visions, dreams, and daily life, she created paintings and sculpture. In 1999 there was a one-person exhibition of her work at the American Folk Art Museum in New York, accompanied by a catalog written by Lee Kogan. She is in the permanent collections of the Smithsonian American Art Museum, the High Museum and several other Georgia museums, the New Orleans Museum of Art, the Ogden Museum of Southern Art, the Museum of International Folk Art, and several other museums. Marcia Weber/Art Objects; private dealers John Denton, Ginger Young, and George Jacobs; and Raven Art carry her work.

Ruley, Ellis (1882–1959)

Ellis Ruley was born December 3, 1882, in Norwich, Connecticut. He worked in construction and earned a modest living. He was struck by a lumber truck in 1929 and received enough in damages to buy a car and three acres of land. His neighbors were both amused and annoyed at an African-American who dared to have land and property. It didn't help either that his wife was a white woman. He died in 1959 in what may or may not have been an "accident" near his home. He had started painting around 1939. He used housepaint and poster board, working on an easel he built himself. His themes reflect dreams of peace and beauty, harmony with nature, and isolation and estrangement from the outer world. In addition to painting what he saw and felt, he painted from magazine sources, popular culture, and Hollywood films. An exhibition, "Discovering Ellis Ruley," traveled around the United States. It was organized and circulated by the San Diego Museum of Art and was at the Corcoran Gallery of Art in the summer of 1995. There is a video on YouTube about his life and art (www.youtube.com/watch?v=i8mLTzRnAmI). In October 2014, Ruley's body along with that of his son-in-law, whose death also may not have been an accident, were exhumed to determine whether the two were deliberately killed. California filmmaker and writer Glenn Palmedo-Smith is making a documentary of Ruley's life. He has spent years working with the family, including planning for the exhumation. Smith is the author of a 1993 book on Ruley, *"Discovering Ellis Ruley."* His film is scheduled to appear on PBS in early 2016, during Black History Month. Ruley's work is in the permanent collections of the Smithsonian American Art Museum and the Philadelphia Museum of Art.

Rusch, Herman (1885–1985)— "Prairie Moon Sculpture Garden and Museum"—Cochrane, Wisconsin

Herman Rusch created a two-acre garden and called it Prairie Moon Park. It contains more than forty objects ranging from birdhouses and planters to twenty-foot high "sun spires" crowned with mirrors to catch the sunlight. A large concrete cactus is "planted" in a garden plot. There is a colorful arched fence. In 1979 the site was sold. Rusch's art was kept intact, but the new owners did not like visitors and kept dogs in the site area. The site was purchased by the Kohler Foundation in 1992, restored by the Foundation, and then given to the town of Milton. There are photographs in several publications, and a taped interview with Rusch is on file at the Archives of American Art in Washington, D.C.

Ruth, John D. (1914–1995)—"Bible Garden"—Woodville, Georgia

The Rev. John D. Ruth was born in Woodville, Georgia, and died there. In between he graduated from college and was a musician in Athens, Georgia. He had a visionary experience, came to believe music was the devil's work, and returned to Woodville where he became the preacher in a Pentecostal church. He also created a 23-acre garden filled with statues and paintings covered with messages and teachings from the Bible. After he died, even though the site had attracted many visitors from all over the United States, the environment was dismantled. Photo documentation of the environment plus a little history is available on the SPACES website.

Saholt, Richard (b. 1924)

Saholt was born in Minneapolis, Minnesota. He served overseas in World War II and since then has been diagnosed as having paranoid schizophrenia. He makes collages by using official papers sent to him, or pictures from magazines that are used to express his grievances against the government. He often photocopies the originals and sells the copies. His work is in the permanent collection of the American Visionary Art Museum. Examples of his work may be seen at www.dougsmock.com/richardsaholt.

Saine, Charlie (b. 1922—no further information available)

Saine was born in rural Rutherford County in western North Carolina. He was one of eight children, sharing his happy, but poor childhood with four brothers and three sisters. His father, Ed Saine, was a sharecropper and a good provider, planting early and late gardens, raising hogs, chickens, milk and an occasional beef cow. Fishing and hunting supplemented their table and the father made many handicrafts. Saine dropped out of school in the ninth grade to help support the family. He spent ten years with the Civilian Conservation Corps, then worked for the Southern Bakery Company in Charlotte. After 24 years in food service, including eight years managing a restaurant, he switched to equipment sales. Saine's first artworks were carvings on fishing rods. He carved fish, animals, birds, and snakes on the handles and painted them with enamels. Prior to his retirement in 1985, he had made about a dozen rods and walking sticks. Now he makes walking sticks only. Two distinctive styles characterize the sticks: they may be intricately carved from a plank of wood, or made from a found wooden stick. Hickory, dogwood, maple, sourwood, locust, and other woods found at his Lincoln County home are used. It often takes a year for the wood to dry completely. Testor's enamel is still his preferred paint, followed by a coat of clear varnish. Each cane is signed and dated. Saine frequently adds messages of hope and encouragement. Creatures of land and sea ornament each stick. His work is in the permanent collection of the Hickory Museum of Art.

St. EOM (1908–1986)—"Pasaquan" —Buena Vista, Georgia

The creator of this site, St. EOM (Eddie Owens Martin), was a unique visionary artist who created a brilliantly colored and patterned assemblage of buildings, shrines, gates, and walls at his Georgia home. After 35 years in New York, "where he was a hustler, transvestite, model, dancer, artist, and fortune teller," St. EOM, born Eddie Owens Martin to a poor family of sharecroppers, built this Marion County art environment on four acres. He also produced paintings, sculptures, drawings, ceremonial costumes, and ritual objects. Initially an organization formed to assure the site's preservation, and Tom Patterson wrote a book about it. The Kohler Foundation took over the restoration, and the 7-acre compound is now fully functional and open to the public at 238 Eddie Martin Rd, Buena Vista, GA 31803. Visit the website, www.pasaquan.com or call 229-649-9444 for more information and details about visiting.

St. John, Linda (b. 1949)

Linda St. John is a native of Saline County, Illinois, and moved to New York City in about 1983. Linda is described by many as a storyteller, using her art to describe the poverty, the dirt, the drudgery, the drunkenness that threatened to engulf her as a child. Art critic Stuart Servetar described her work thus: "Using a very simple child's drawing technique, St. John lays down a field of bright color, orange more often than not, and then covers it over with black, then toiling away with a tiny seam ripper, until something shines

through again … she struggles on behalf of her characters, their dazed eyes show the strain of trying to hold it all together, and persistently ask the viewer for love and some sort of explanation for their existence. Linda speaks for all those for whom the forces of poverty, ignorance and despair are overwhelming." She also makes dolls "made of cloth, sticks and nerves." St. John has been exhibited in one-person shows at galleries. One of the first, "White Trash Carnival," drew much favorable attention, as have all of her subsequent shows. Her work was in the exhibition "Outsider Art: An Exploration of Chicago Collections," 1996–1997. In September 2001, a New York Times article by Alex Witchel, "The Not-So-Buried-Child," describes her painful life and the influence on her art in his review of her book, "Even Dogs Go Home to Die" (Harper-Collins, 2001). The book tells the harrowing story of her impoverished childhood in southern Illinois, where she, her brother, and two sisters were raised by an abusive alcoholic father and a self-absorbed, sadistic mother. In January 2015 her work was part of an exhibition at The Metropolitan Pavilion in New York. A piece by St. John, "Where's My Gun," was the cover art for the 2000 edition of this book.

Saldaña, Martin (1874–1965)

Martin was born in San Luis Potosi in Mexico and eventually settled in Denver, Colorado, in 1912. In Mexico he was a cowboy. In Denver he worked as a cook. He started painting when he was seventy and continued up to the time of his death. His love of animals—he painted bullfight scenes where all the sympathy is for the bull—and his memories of Mexico appear in his work. It has been said that his work has the feel of Mexican tapestries. His work is in the Museum of International Folk Art.

Salvatore, Anthony Joseph (1938–1994)

Often referred to as "Tony Joe," Anthony Joseph Salvatore lived in Youngstown, Ohio. A self-taught painter, he was deeply religious and received much of his inspiration from the Bible. He combined acrylics, wax crayons, and oil pastels rubbed to a shiny finish to create jewel-like works. His work was included in the exhibition "Flying Free." His work is in the permanent collections of several Ohio museums (Akron, Columbus, Springfield, and Miami University), the Smithsonian American Art Museum, the American Folk Art Museum, and the Milwaukee Art Museum. Cavin-Morris Gallery in New York and Lindsay Gallery in Columbus, Ohio, have pieces of Salvatore's for sale.

Salvucci, Carmella (b. 1951)

Salvucci was born in Brighton, Massachusetts, and began attending Gateway Crafts in 1975. It soon became apparent that she had a special talent, and an endless stream of pictures began to flow from her imagination. As a young child, Salvucci would draw and color to the amazement of those around her. The facility she has for reproducing images in great detail from life and photographs was evident even then. In addition, many of her images come from her imagination. Salvucci has become well-known for her architectural paintings in watercolor. She has developed a technique of layering the paint to achieve an amazing amount of detail. These works read as cityscapes composed of color patterns. The artist's ability to express through art her interior world of houses, flowers, trees, animals, and birds has helped her through the more difficult times in her life. Her work has been exhibited frequently throughout the Boston area, her work was featured in an exhibition at the Fuller Museum of Art in Brockton, Massachusetts, called "From the Outside In." In 1997 her work was included in the Boston exhibition "Pure Vision: New England Artists with Disabilities." Gateway Arts Gallery handles her work.

Samuels, O.L. (b. 1931)

Ossie Lee "O.L." Samuels was born in Wilcox County, Georgia, and worked in the Georgia pine tree industry until he was crushed by a falling tree in 1982. He had left home at the age of eight and worked as a pine raker and on Georgia farms. He worked in Florida and New York City and returned to the South in 1960. Samuels fell into a deep depression after his illnesses. The words his great-great-grandmother (a freed slave) told him long ago finally pulled him out of his sadness. She had told him that when a person would become depressed he would carve on a spool. Samuels took her advice and picked up some wood and started carving. "It started out to be a duck, turned into something else, and then turned into a mule head," he said. "I just start and let it turn out like it wants to." Although Samuels is color-blind he paints his carvings. He uses different colors and he said they seem to match up. "They ask me why I use so many colors and I say I want to be sure I get the right one." The artist's subjects include some people, a whole menagerie of animals (real and imagined) such as mules, alligators, snakes, dogs, and imaginative automobiles, his favorite form, which look as if they belong in a science fiction movie. O.L. Samuels lives in Moultrie, Georgia. His work is in the permanent collections of the Smithsonian American Art Museum, the Georgia Museum of Art, and the Arkansas Arts Center. Just Folk, Arte del Pueblo, and Ginger Young, private dealer, handle his art.

Sanchez, Mario (1908–2005)

Sanchez was born and raised in Key West, Florida, and is a wood carver and painter of Old Key West. His life and his art document the history of the Cubans of

Key West, descendants of cigar makers who came in the 1860s. The people and the places he portrays are "authentic." His wood reliefs are painted with bright colors. In 1981, the book *Mario Sanchez: Painter of Key West Memories* by Kathryn Hall Proby was published. His art was displayed at the November 8, 2012, opening of the South Street Seaport Museum in New York City. The East Martello Museum in Key West has his art in its permanent collection; it is also for sale at the Gallery on Greene in Key West.

Sandoval, Alejandro "Alex" (1896–1989)

Sandoval was born in Santa Fe, New Mexico. He lived on his grandfather's farm, chopping wood for railroad ties. Later he worked in Arizona copper mines. Sandoval stated carving animals and religious figures after he retired in 1960. His work was included in the 1985 exhibition "A Time to Reap" at Seton Hall University in New Jersey. His work is in the permanent collection of the American Folk Art Museum.

Sandoval, Christian *see* Wainwright, Donald

Santoro, Theodore (1912–1981)

Santoro was the son of Italian immigrants from Naples. Born and raised in Cleveland, Ohio, he moved to Oakland, California, when he was in his mid-twenties and became a mechanical engineer. Santoro became mostly housebound in 1956 because of illness. He began carving then, using simple hand tools and scraps of wood people brought him. He made animals, people, and religious and popular figures from the wood. Sometimes he emphasized details with paint, such as the whiskers on a cat or the hair on a person's head, and sometimes eyes are made from upholstery tacks or beads. During his lifetime, only his family saw his work except at Easter and Christmas, when he would create elaborate displays on his lawn. His work is in the Oakland Museum. The Ronjehu Fine Art and Antiques Gallery in San Francisco mounted a one-person show of his art, in cooperation with The Ames Gallery in Berkeley, in the late fall of 1998. His work is in the permanent collections of the Oakland Museum of California and the Milwaukee Art Museum.

Savitsky, Jack (1910–1991)

Jack Savitsky was born in Silver Creek, Pennsylvania, and lived in Lansford. He left school after the sixth grade to follow in his father's footsteps as a coal miner. When the mines he worked closed in 1959, he began to paint and draw, at the suggestion of his son. Within two years, he had joined the circle of self-taught artists gathered around patron/artist Sterling Strauser.

He painted in oils until 1984, when he was told by his doctor that the fumes were aggravating his "black lung" disease. He tried acrylics for a while, but did not like their fast-drying quality, so he switched to pencils, prismacolor, and markers on paper. He is renowned for his colorful depictions of life around the hard coal regions of Lansford. His work is in the permanent collections of the Smithsonian American Art Museum, the Birmingham Museum of Art, the Kentucky Folk Art Center, the American Folk Art Museum, and the Milwaukee Museum of Art. The Smithsonian Institution-Archives of American Art has his papers. Several galleries, including Marcia Weber/Art Objects, Galerie Bonheur, Arte del Pueblo, the Art Cellar Gallery, and Grey Carter/Objects of Art carry his work.

Schatz, Bernard *see* L-15

Scheffley, Walt

Walt Scheffley was born in Pennsylvania, studied industrial design, and was an architectural draftsman. He moved to Underhill, Vermont. He started painting in the mid–1980s when he had to take care of his invalid wife. At first he painted all the surfaces of his house with family portraits and Vermont scenes. His work, oils on Masonite, always has an unexpected twist. At first glance they are only pleasant, carefully detailed scenes of a village, house, or shed in Vermont. Then if you look closely, there will be "a surreal blend of new and old, real and unreal." For instance, there is a painting of a village home with the expected family grouping on the front porch—and a UFO landing in the backyard. Sheffley and his family lived in Underhill from 1953 to 1999, when Sheffley moved to Minneapolis to be near his son. On November 9, 2014, the Underhill Historical Society sponsored an exhibit of Walt Scheffley art at the Deborah Rawson Library in Jerico, Vermont, attended by Sheffley's three daughters, who offered stories of their father and his art. A video of the event is available on Vimeo (vimeo.com/113424538). While living in Vermont, Scheffley was represented by the former Webb & Parsons Gallery in Burlington.

Schlosser, Art Paul (b. 1960)

Art Paul Schlosser was born January 4, 1960, in Chicago, Illinois. Schlosser came to Madison, Wisconsin, with his mother, after his parents divorced. Schlosser says he started drawing as a child, encouraged by his sister who is an artist. He has been making a living as a street musician in Madison for the last twenty-five years. He has also played at some of the local coffeehouses and has at least one CD, and some tape recordings. He started painting again to illustrate the covers of his recordings. Schlosser also received attention for cartoons he did that were published in the *Daily Car-*

dinal for about two years. He started doing T-shirt designs with a fabric marker. When he put a design on the bowling ball bag he used to carry his CDs in, somebody bought it. "So my sister gave me these paints for Christmas and I started painting everything." Now he is doing oil and acrylic paintings on canvas. He has a Facebook page and has made a video for YouTube (https://www.youtube.com/user/artpaul) in which he describes his music and art.

Schuette, Jay (b. 1964)

Jay Schuette was born in Oxford, Ohio. Living as a child in a small town on the Ohio-Indiana border, he would often ride his bicycle into the Indiana countryside. One day he discovered an abandoned, run-down farmhouse containing the discarded belongings of its former inhabitants and a barn filled with rotten corn and cobs already eaten. It gave him a creepy feeling and a memory that has stayed vivid. Schuette went to college, traveled in the United States, and Europe. While living in Florida, he spent his time painting the haunting, eerie elongated characters he imagined in that Indiana farmhouse. He now lives in the Hollywood Hills, where he paints canyons, coyotes, hookers and celebrities both ghastly and ghostly. Jay Schuette was included in the exhibition "The Passionate Eye: Florida Self-Taught Art," curated by Claudia Sabin in 1994. His work is available at Main Street Gallery in Clayton, Georgia, which has given him numerous solo shows. He has also had art in solo and group shows from New York to Miami to California. These are listed on his website, www.jayschuette.com.

Scott, Darrell Loy (b. 1946)

Scott was born in eastern Oklahoma and grew up in northern California. In 1968 he enlisted in the Air Force and served in Laos and Thailand during the Vietnam conflict. Following his discharge from military service, he moved to Kentucky and Puerto Rico. He finally settled in Louisiana where he worked as a carpenter for thirty years. He now lives in Hot Springs, Arkansas, in the house where he spent summers with his grandparents. The Historic Arkansas Museum's Trinity Gallery for Arkansas Artists mounted an exhibition of his art from January 28 through March 27, 2005. An intuitive painter, Scott brings his life experiences and travels to his art making. His carpentry skills have enabled him to build his own cedar frames as well as the wooden surfaces for his acrylic paintings. His keen interest in aboriginal art is reflected in his use of bright colors, high contrast, and semi-pointillism in his paintings and graphics. Scott is best known for his "folk" paintings, stylized figurative acrylics on hard board, depicting the rural gentility of African Americans in the South. His older works of oils on canvas show his true love of the landscape. His work is available at American Folk Art and Framing in Asheville,

North Carolina and has had a painting selected for the permanent art collection at the Arkansas Governor's Mansion.

Scott, George Washington "Baby" (1871–1945)

George Washington Scott, known as "Baby" Scott to everyone in his hometown, was a black folk artist who carved in wood, limestone, shale, and soapstone. Scott lived most of his life in Clifton Forge, Virginia. He was a section hand for the C & O Railroad. He got his nickname because he was a very friendly person and called everyone, black or white, "Baby." His carving followed the contour of the stone or wood and he "let out" what he saw there. Among the figures he carved were alligators, frogs, lizards, bears, monkeys, and a variety of birds. Some of his pieces were meant to be utilitarian objects such as match holders, walking sticks, bookends and doorstops. His work was featured in a one-person exhibition, "Baby Let Me Out: The Work of Black Folk Sculptor, George 'Baby' Scott," at the Allegheny Highlands Art and Crafts Center in Clifton Forge, Virginia, November 17–December 22, 1992. A piece of Scott's—a juvenile bird carving—was sold at auction in 2010.

Scott, James "J.P." (1922–2003)

James "J.P." Scott was born in Orina, Louisiana, and lived in Lafitte, south of New Orleans, until his death. He started working when he was fourteen years old, on the water, in construction, and as a boat builder. He had a wife and four children, but his family broke up when he inherited a small house in Lafitte. His family refused to live there and moved to New Orleans. He started making his fanciful boats in the 1980s after his retirement. All his materials were found objects. He picked up logs when they floated by in the river. He went to the local dump to find other materials to add on the wood. He made boats, houses, and some whirligigs. He liked to make larger pieces because, he said, "you can hurt your hands on small pieces." His work is in many museums.

Scott, Judith (1943–2005)

Judith Scott was born in Columbus, Ohio. She did her art at the Creative Art Center in Oakland, California, beginning in 1987. She was a visual artist isolated from outside influences because of deafness and Down syndrome. She was very independent and self-directed and never repeated a form or color scheme. She produced a remarkable body of wrapped sculptures made with armatures of bamboo slats or other discarded materials, wrapped with knotted cloth or yarn. She was been included in many Bay Area exhibitions and is in the permanent collection of L'Aracine Musée d'Art Brut in Paris, France. Her work is described in "Meta

morphosis: The Folk Art of Judith Scott: The Outsider Artist and the Experience of Down Syndrome" by John Monroe MacGregor (Creative Growth Art Center, Oakland CA: 1999). Her work is in the permanent collections of the Oakland Museum of California, the Kentucky Museum of Art and Design, and the American Visionary Art Museum. In addition to Creative Growth, Ricco/Maresca Gallery and Stephen Romano, private dealer, both in New York, carry her work.

Scott, Lorenzo (b. 1934)

Scott lives in Atlanta, Georgia. He paints houses for a living and is a self-taught artist. Much of his work is a result of visionary experiences and audible conversations with God. He paints with oil on canvas or board. He makes his own frames with built up Bondo and gold leaf for a classical look. His works feature biblical themes or popular culture images. They are usually large and very colorful. The Morris Museum of Art mounted a solo exhibition of Scott's paintings, "Beyond This World: Paintings by Lorenzo Scott," from July 14 through September 9, 2007. His work is in the permanent collections of the High Museum, the Morris Museum of Art, The Rockford Art Museum, the Springfield (Ohio) Museum of Art, and the New Orleans House of Blues. Jim Farmer, private dealer, has an extensive collection of Scott's art for sale; Louanne LaRoche, private dealer, also carries his work.

Serl, Jon (1894–1993)

Jon Serl was born in Olean, New York, and at the end of his life lived in Southern California. He was a child vaudeville performer, dancer, female impersonator, and Hollywood voice-over actor. He did not start painting until he was fifty. He painted expressionist figures drawn from his own experiences and imagination. A reviewer has said "Some painters paint with paint. Serl thinks with it … conjures with it." He produced over 1,200 paintings and had his first one-man show in 1971. There are many written information sources about this great painter. His art is in the permanent collections of the Smithsonian American Art Museum, the Milwaukee and Akron Art Museums, the Philadelphia and New Orleans Museums of Art, and Fenimore House Museum. Ames and Cavin-Morris Galleries and George Jacobs, private dealer, often have Serl's art for sale.

Sesow, Matt (b. 1966)

Matt Sesow grew up in Lincoln, Nebraska and now lives in Washington, D.C. When Sesow was eight years old, a landing airplane hit and severed his left arm, forcing him to become right-handed. The physical and emotional pain of that trauma has left a clear mark on Matt Sesow's artworks. In 1994, at the age of 28, he began painting. As his dealer Beverly Sue Kaye says, "His titles, such as 'Painting by Remembers,' 'Lost Luggage,' 'Alone in Death,' 'Sucker Punch,' and 'Waiting for Coagulation,' are more than subtle hints of the turmoil he has experienced." Bloodred backgrounds, orange averted eyes and heavily outlined figures are his hallmark. He paints all day, using oil on canvas and cardboard. His subject matter is always the human form in some sort of sorrowful state. He has been in many solo and group shows throughout the United States, and some abroad. A documentary about Sesow's life and paintings, "Join Hands," is available at movie. sesow.com. Beverly Kaye, Jeanine Taylor Folk Art, and the At Home Gallery handle Sesow's work. In addition, he maintains his own website from which he sells his art, www.sesow.com, and Facebook page.

Seven, Robert Frito

Seven was born and raised in the foothills of North Carolina. His first job was in the cotton mills there. He has a high school education. He has been making things with his hands as far back as he can remember. He says he won an award for one of his drawings when he was seven years old. In high school he made leather items for friends and started painting. He also learned to carve and made a chess set, which he still has, from an old two-by-four. His mother taught him to sew on her old pedal machine. He has made "a lot of furniture and a little bit of music." He started making a full-time living from silverware assemblages in the fall of 1991, after being laid off from two consecutive jobs. He says art has transformed his life and given him back his soul, and he tries to "express and celebrate this transformation in all that I do." He lives in Asheville, North Carolina. He made an "art car" ambulance that recently appeared in a show at Gallery O on H in Washington, D.C. His work was featured in the exhibitions "High on Life" (2006) and "All Things Round" (2012) at the American Visionary Art Museum. He is also a musician, and appears at various music festivals.

Shaffer, "Dr. Bob" (b. 1952)

Robert Lawrence "Dr. Bob" Shaffer was born in Witchita, Kansas. He is half Crow Indian and half French-German. He has had a number of jobs including working for the U.S. Forestry Service in central Louisiana, building houses, maintenance work on spotter planes for a fishing company, and eventually a union carpenter. He started carving while working on a building project for a nuclear power plant to pass time. He stopped carving for fifteen years. Then a collector offered him money for some of his pieces. He quit his job and became a full time artist. Raised a Catholic, he says he loves pageantry and icon, vestments and candles. Shaffer came to New Orleans in 1958 and now lives and works in the Bywater neighborhood, on Chartres Street. Shaffer hunts, fishes, and

crabs. In the process he has become very familiar with alligators, which often appear in his work. He uses only found objects for his art assemblages, so sometimes it takes years to complete a picture. He is represented by galleries (Gallery O on H, The Attic Gallery) and can be found selling his art at the Jazz and Heritage Festival in New Orleans. He sells from his website (www. drbob.net) and also from his shop, so call 504-840-3614.

Shaffer, Cher (b. 1947)

Cher Shaffer was born in Atlanta and raised on a farm outside Fairburn in rural south Georgia. She has had a long residence in West Virginia. A self-taught artist, her work combines the mystical quality of her vivid and unique imagination with influences from the experiences of her childhood. Her work is included in the book *O, Appalachia*. An exhibition of her work, "Visions and Dreams: The Art of Cher Shaffer," was at the Owensboro Museum of Fine Art in early 1993. Her work is in the permanent collections of the Kentucky Folk Art Center and the Owensboro Museum of the Arts; Fust Folk and Jeanine Taylor Folk Art carry her work.

Shaffer, "Pop" (1880–1964)—"The Shaffer Hotel and Rancho Bonito"— Mountainair, New Mexico

Shaffer was born in Harmony, Illinois. At the age of thirteen he left school and entered the family blacksmithing business. He moved with his first wife and two children, first to Oklahoma and then to Mountainair. He later married for a second time and had one more child. He made his living as a blacksmith. While rebuilding his shop after a fire, he decided to add a second story and make it a ho*Phone*: He decorated the interior and exterior walls and furniture with painted designs. Then he added a collection of "critters" carved from tree limbs. The hotel is still open as a bed and breakfast on Main Street; see www.chaffer ho*Phone*: com, or call 505-847-2888. He later added to his holdings and built a red, white, and blue cabin, Rancho Bonito, which served as his workshop and hideaway. Rancho Bonito is a mile south of Mountainair. Seven of his wooden figures are in the Museum of International Folk Art. The hotel and Rancho Bonito are on the National Register of Historic Places. For tours of Rancho Bonito write to Dorothy Cole, RR 1 Box 4, Mountainair, New Mexico 87036. Mountainair is southeast of Albuquerque, on U.S. 60 at Route 55.

Sharlhorne, Welmon (b. 1952)

Sharlhorne was born August 17, 1952, in Houma, Louisiana. He dropped out of school in the third grade, lived with his "mamma and daddy" until age sixteen.

In 1968 he went to reform school for the first time. Sharlhorne has been convicted for burglaries, armed robbery, and extortion. He is mostly a street hustler, which lands him in jail with some frequency. He began making art in prison, using Bic pens on manila envelopes. His primary art images involve architecture and cars. He says he was inspired to make art to escape the reality of incarceration. His work is in the permanent collections of the Smithsonian American Art Museum, the Ogden Museum of Southern Art, the Mississippi Museum of Art, the Art Museum of Southeast Texas, and the African American Museum of Dallas. Marcia Weber/Art Objects carries his work. He also maintains his own Facebook page.

Shell, Inez (1922—no further information available)

Inez Shell left rural South Carolina over fifty years ago and moved to Baltimore, Maryland with her husband, who was seeking work there. Her later works, done in wax crayons and watercolor, depict religious or historical subjects, and vivid recollections of scenes from her family's life as sharecroppers. It was while attending activities in a senior citizens center that Mrs. Shell decided to try her hand at painting. In her paintings she recounted memories of her South Carolina upbringing, including farm work, church suppers, and family celebrations. It is believed that she is now deceased. The Birmingham Museum of Art has her work in its permanent collection.

Shelley, Mary Michael (b. 1950)

Shelley was born in Doylestown, Pennsylvania, and now lives in Ithaca, New York. She carves and then paints scenes of upstate New York life, using subject matter as diverse as diners and farms to comment on the themes of hunger, waiting, and nurturance. The people carved in her works portray emotions and feelings—a skill this artist has more of than do most relief carvers. Shelley's pieces are carved on white pine. Once carved, Shelley paints the pieces with acrylics, applies gold leaf to an inner border, and coats the entire piece, front and back, with an acrylic varnish to prevent warping. Her work is in the collections of the American Folk Art Museum, the New York Historical Society, the Fenimore House Museum, and the Museum of Women in the Arts in Washington, D.C. Shelley demonstrates her carving technique in a YouTube video (www.youtube.com/watch?v=nYPsvHOJtME) and sells directly from her website, www.maryshelley folkart.com.

Sholties, Robert (b. 1952)

Robert Sholties is from Jeanette, Pennsylvania. While in college at Pennsylvania State University he started painting on the walls of his room and liked the

results. He has continued painting ever since, turning out three to four surrealistic paintings a year. "The artist develops his paintings by spontaneously applying blobs and swirls of paint onto cardboard, and staring at the results until images swell up from his unconscious mind." Graduating from college in 1975, he held a number of factory jobs before landing a job with the post office, where he still works. His paintings have been included in the exhibitions "Sacred Waters: Twentieth Century Outsiders and the Sea" at the South Street Seaport in New York in 1996, "Wind in My Hair" at the American Visionary Art Museum in Baltimore in 1996–1997, and "Mindscapes: Extending the Limits of Reality" Noyes Museum of Art of Stockton College (October 5, 1997, to January 4, 1998). His work is in the permanent collection of the Smithsonian American Art Museum. He sells his work through the Local Artists website, http://local-artists.org/users/robert-sholties.

Short, Bob (b. 1925)

Bob Short was born in Como, Mississippi, and now lives in Monteagle, Tennessee. He is a self-taught artist and began painting in 1991. He says, "I farmed for twenty years, I was a lawyer for twenty years, and plan to paint for twenty years." Short paints to communicate his views. He wished "to paint truth and create thought." He uses bright colors to attract the eye, with every painting an interpretation of British romantic poetry or biblical scripture. He writes messages on his paintings and uses a set of recurring symbols. His work is in the Owensboro Museum of Fine Art.

Shoup, Wally (b. 1944)

Born in Charlotte, North Carolina, Wally Shoup began painting in the 1970s in Colorado after a decade of living in Atlanta. Wally Shoup is an "investigator of mediums." His paintings have a dexterous quality, multilayered in oils, acrylics, and spackle. "I've been fascinated with textures since I lived in Colorado and would just stare at the rocks. To me, that's when they are refined and beautiful, not when someone comes along and takes a chink out and carves or polishes it." After Colorado, he moved to Birmingham and became involved in the improvisational music community that thrived there. Wally is an accomplished saxophonist, and the techniques of improvising are reflected in his art. Wally has been in Seattle since the mid–1980s, where he was still playing and painting as of 2015. Garde-Rail Gallery gave him two shows in 2007 while it was still in Seattle (it has since relocated to Austin), and may occasionally has his work for sale. He has his own website, speakeasy.org/~wallyshp/wshoup, which mostly has his music but includes images of many art pieces and has an email for getting in touch. He does a lot of the art for his album covers himself, as can be seen on the website.

Simmons, Charles (b. 1939)

North Carolina artist Charles Simmons was born in Big Creek Township and moved in 1969 to Mount Airy. He went to school to the ninth grade and then just quit. He worked for R.J. Reynolds Tobacco for 33 years. Before that he had worked at farming. He carves soapstone as did his neighbor, friend, and mentor, the late Raymond Coins. Simmons says, "I carve whatever comes into my mind." His subject matter covers a broad spectrum from animals to religious imagery. Some of his favorites are frogs, dinosaurs, and angels. A self-taught carver, he began by carving wooden dolls in 1977 for family and friends. His interest in sculpting figures and relief carvings in fieldstone and soapstone came later. An image of a "waterboy" was a frequent theme because when he was a child because it was his job to get the water for his mother, Gallery owner Jimmy Hedges was a friend and he enjoyed Simmons and his family. After he was injured in a truck accident that left him brain-damaged, Simmons stopped carving, and soon after disappeared with his family. Cotton Belt Gallery and the Gallery at Folk Art Net still list him as among the artists they carry.

Simmons, Earl Wayne (b. 1956)

Earl Simmons was born and lives in Bovina, Mississippi. Since childhood, he knew that if he wanted something he would have to make it. First he made toys, the cars and trucks with which kids like to play. Now he makes large colorful trucks from found wood and metal that folk art collectors like to buy. He paints them in flat, rich colors. He also makes paint images of houses, motorcycles, fire trucks, cars, and other forms onto cardboard, and then cuts them out. These were made originally for the purpose of decorating his rooms. Then visitors wanted to buy them, so he added these to his repertoire. His home is an art creation, Earl's Art Shop, a handmade art environment where he lives and produces his art. He built it, adding rooms as needed, and now there are at least twenty rooms including a store, museum, nightclub, disco booth, and workshop. His shop burned a few years ago, and he is rebuilding it His work is in the permanent collections of the Mobile and Mississippi Art Museums, the Old Capitol Museum of Mississippi History, the African American Museum of Dallas, and the New Orleans House of Blues. The Attic Gallery in Vicksburg carries his work. He lives at 6444 Warrior Trail in Bovina and enjoys visitors, but call first: 601-636-5264.

Simon, Tamara (b. 1971)

Tamara Simon works on word puzzles at home and on paintings and prints at NIAD in California. Playing around on the computer she found a way to bring words and pictures together. On the computer Simon composes rhyming nonsense verses to accompany prints of her linoleum cuts. Since coming to NIAD in

1993, Simon has been painting, sculpting, and making costumes and collages. She lives with her parents and comes to NIAD several times a week.

Simons, Barry (1943–2009)

Simons grew up in Southern California in the San Fernando Valley with two sisters, boxed at age sixteen, and for a while wanted to be a heavyweight champion. In the early sixties, after abbreviated careers in the army and in junior college, he hitchhiked through Europe, the Middle East, and Mexico. He started painting in 1976. While some of his pieces were single color ink-on-paper works, Simons usually applied vivid colors with pen or brush, and he often used collage, which added another dimension of texture and depth. Simons also used text in some pieces. He drew intimate, dreamy portraits of the life of his mind. Most often figurative, the mood could be angry or joyous. His art was included in the exhibition, "Visions from the Left Coast: California Self-Taught Artists," in 1995. His work is in the permanent collections of the Milwaukee Art Museum and the Oakland Museum of California. Anyone interested in Simons' work should contact his family at barrysimonsart@gmail.com.

Simpson, Vollis (1919–2013)—Wind Sculptures—Lucama, North Carolina

Simpson grew up in eastern North Carolina, in Lucama where he was born and lived to the end of his life. After serving in World War II, he returned home to design and build house-moving equipment. Around 1985 he began making giant windmills and installing them on the corner of the family farm. Some were as tall as forty feet, brightly painted, with reflectors attached. It was easy to see the windmills from the side of the road, and the environment was quite a sight at night, when the huge pieces were illuminated by reflectors attached to the whirligigs. A very tall and imposing Simpson windmill is in the garden of the American Visionary Art Museum in Baltimore, right outside the museum entrance. In addition to AVAM, Simpson's work is in the Gregg Museum of Art and Design in Raleigh, the Robert Lynch Collection of Outsider Art at North Carolina Wesleyan College, and the Cameron Art Museum in Wilmington, North Carolina. The At Home Gallery in Greensboro has some of Simpson's art for sale.

Simpson, Vollis—Whirligig Park— Wilson, North Carolina

As with Howard Finster's Paradise Garden, Vollis Simpson receives two entries in this chapter because of the importance of the park being created to preserve his work and keep it available to the public. Vollis

Simpson created his whirligigs, some as tall as 50 feet, in a pasture near his home in Lacoma, North Carolina. The pieces eventually wore down and some rusted over time. A project to preserve Simpson's art began before his death, as a partnership among Wilson Downtown Properties, Inc., the City of Wilson, Wilson Downtown Development, and the North Carolina Arts Council. The group created the Vollis Simpson Whirligig Park. The park is being constructed in three phases. Phase 1 was completed in 2013 and included storm water structures, infrastructure work, water and electrical, footings for all thirty-one Whirligigs, and rough grading, plus installation of ten of Vollis Simpson's whirligigs, including the 55' long and 40 some feet high *V. Simpson* whirligig … to give the community a preview of what is to come in the later phases. Phase 2 involves installing the plaza, amphitheater, shade structure, and more Whirligigs. Phase 3 will follow by installing the interactive water feature, lighting and controls, signage, trees, shrubs, benches, bike racks, and the final Whirligigs. Twenty-one of the planned thirty-one whirligigs have been moved from the Simpson Farm into the warehouse space at Repair and Conservation Headquarters in Historic Downtown Wilson to be conserved. At the corner of Douglas and Barnes Street, a team of specially-trained community members, including former mechanics and engineers, are working on both mechanical repairs and surface conservation of the pieces. When a new whirligig comes in, the preservation team evaluates its condition to decide the best course of action, profiting often from the advice of many national art conservation experts. This often involves completely removing reflectors, sometimes as many as 2000 per piece, replacing bearings, re-engineering Vollis' mainly ad-hoc welding and mechanics, repainting surfaces, and re-attaching reflectors. Through this process, fresh coats of epoxy and paint are being applied daily and many of the formerly immobile and rusted whirligigs have now been brought back to seamless spinning shape. New protocols for conservation of outdoor folk art and vernacular artist environments are being established through this project's pioneering process. Visitors may stop by Park anytime or the Conservation Headquarters, Monday through Thursday 9–5 at 305 Barnes St in downtown Wilson. The park has a website, www.wilsonwhirligigpark.org, through which interested parties can keep up with developments.

Sims, Bernice (1926–2014)

Bernice Sims was born in the south Alabama community of Hickory Hill and then moved to Brewton. She was the eldest of ten children, and grew up mostly with her grandmother. Sims herself married at sixteen and had six children. After her children were grown, Sims went back to school to get her high school diploma at age 52. During class excursions to museums,

she was inspired to paint by a visit to Mose Tolliver, something she had not done since she was eight years old. She was a memory painter, capturing the activities and events of her life and community in Brewton, Alabama. She paints scenes of farming, church activities, cotton picking, and making cane sugar. She also painted compelling images of struggle, including the police turning dogs and hoses onto people in the streets of Birmingham; and the Selma, Alabama, march during Civil Rights struggles. She did a chilling and significant painting of being chased by the KKK after attending a workshop on how to register voters. Sims' memory paintings present strong color, movement, and energy; her people seem to be interacting. Her subject matter is far more interesting than that of many memory painters. There is detailed information about her background and her art in the book *Revelations: Alabama's Visionary Folk*. Color illustrations also appear in the brochure for the exhibition curated by Micki Beth Stiller, *A Brush with the Past: Memory Paintings of Bernice Sims*, which took place at Alabama State University in 2008. On August 30, 2005, the U.S. Postal Service issued 10 stamps commemorating the 40th anniversary of the Voting Rights Act and honoring the Civil Rights Movement's most historic milestones and people. One of these stamps reproduces Sims' painting of the start of the Selma to Montgomery March that took place on the Ed Pittus Bridge in March 1965. Toward the end of her life, Sims wrote a book, *The Struggle: My Life and Legacy* (Black Rose Writing, 2014). She died three weeks after to book was released. Three weeks later she died on October 23, 2014. She lived to see her paintings accepted into the collections of Atlanta's High Museum and the Wiregrass Museum in Dothan, Alabama. They are also in the Montgomery Museum of Fine Arts, the New Orleans Museum of Art, and the Milwaukee Art Museum. Marcia Weber/Art Objects and Main Street Gallery carry her work.

Singleton, Herbert (1945–2007)

Singleton was born in New Orleans and lived in Algiers, the part of New Orleans across the Mississippi River. He went to school through the sixth grade and has spent time in Angola Penitentiary. He started carving wood when the snakes he made from Mississippi mud "would just fall apart." He made staffs and stools, carved from stumps and painted in bright enamel colors, mostly for his neighbors. He also carved beautiful canes from ax handles, until one was used to kill somebody. Singleton carved deeply complex relief narratives on discarded doors, hardwood boards, and sometimes tree stumps "about his perception of the self-destructive course of African-American life." His themes included the Bible, "the duplicity of the church and its ministers," and the "falseness of women." The combination of his sure hand as a carver, his symbolic vocabulary,

and his brightly painted surfaces made him one of the very best of the contemporary carvers. His work is in many museums, including the Smithsonian American Art Museum; the Birmingham, Mississippi, Philadelphia, and New Orleans Museums of Art, the High Museum, the Ogden Museum of Southern Art, the Owensboro Museum of Fine Art, and the New Orleans House of Blues. His work is available through the Cotton Belt, Primitive Kool, Barrister's and Shelton Galleries, Just Folk, and George Jacobs, private dealer.

Singleton, Wendell (b. 1961)

"Wendell Singleton's lively modular paintings are so popular they are often sold before completion. His geometrical paintings lead the eye on a merry chase of kaleidoscopic patterns of intersecting and overlapping circles, triangles, squares—like drafting forms—each in turn broken into precise segments of color. But the whole equals more than the sum of its parts. In all this complexity there is a larger order and a masterful balance of form, color and rhythm." Singleton also makes flat, colorful works featuring fish, birds, animals, children, flowers, and landscapes. Singleton is unable to read, write, or speak very much. He started at NIAD in 1986 at age 25. The staff says he presents an enigma: "He enjoys and is able to work in a most complex artistic manner with a great variety of shapes, colors, and images, but is unable to read or write. He cannot measure, yet creates the most complex abstract geometric shapes with great artistic sensitivity." He uses acrylics for his paintings, which include some with flowers and animals. The National Institute of Art and Disabilities Gallery in Richmond, California, shows his work.

Skyllas, Drossos P. (1912–1973)

Skyllas was born on the Aegean island of Kalymnos, Greece. As a young man he worked as an accountant for his father's tobacco business. After World War II, he went to the United States and settled in Chicago. With encouragement from his wife, Iola, and free from his father's prohibitions, he began to make art there. He never held a job during his years in America, and his wife supported the household. He sold no paintings during his lifetime. At his death in 1973, Skyllas left a legacy of 35 highly detailed paintings including nudes, portraits, landscapes, still life, and religious figures. It is said that he wished to paint "only pure, realistic paintings." However, his work is usually described as "a romanticized medieval style." Intuit: The Center for Intuitive and Outsider Art sponsored an exhibition of his work, "*Self: The Paintings of Drossos P. Skyllas*," in May 1995 in Chicago. His work is in the permanent collection of the Milwaukee Art Museum.

Sloan, Ronald (b. 1932)

Sloan is in his 80s. His work has been described as

"beautifully painted" with "horrifying subject matter." He will not talk about his many years of painting, why there are so many images of mothers, why so many people are attempting escape, and why so many images of cages are included in his art. He is a very compulsive painter. Beverly Kaye in Connecticut represents this artist.

Smedley, Ellen (b. 1957)

Ellen Smedley works in a playful narrative style to create colorful line drawings. Her subjects are cats, other animals, and sometimes family and friends. She also draws birds, angels, and airplanes. Smedley also works well with clay, paints, and puppet making. Since coming to NIAD in 1995, she has been included in many shows. Born with Down syndrome, Smedley graduated from high school special education classes in 1976 and lives with her sister's family and their cats.

Smith, Charles (b. 1940)—"African American Heritage Museum and Black Veterans Archive"—Aurora, Illinois, New Orleans and Hammond, Louisiana

Smith started building his outdoor environment and home museum at his house in Aurora in 1986. He filled his house and yard with hundreds of sculptures composed of cement, wood pulp, discarded items and house paint. These sculptural portraits depict important African-American people and events from the past to the present. His purpose is to provide and promote knowledge and pride among black people, and to promote healing between the races. In 2002, Dr. Smith bought a small home at 701 E. Louisiana Street in Hammond, Louisiana and continues to spread his message of remembrance, hope, and vision with this second site. He also started a similar project in New Orleans with self-taught artist Charles Gillam. These environments are dedicated to the turbulent history of African-Americans. Smith hopes to inspire and educate today's youth so that they will never forget, and to build upon the vision set forth by leaders and martyrs of Black America: Harriet Tubman, Frederick Douglass, Emmett Till, and Martin Luther King among them. In addition, he includes memorials to the thousands of Black Americans who died in Vietnam, to victims of the Rwanda tragedy, as well as to whites that helped with the Underground Railroad. His Aurora house is located one hour west of Chicago: take Highway 290 from Chicago; exit at Farnsworth, exit south. Turn right (west) when you reach North Avenue, one block to Kendall, and the house is on the corner of North and Kendall. The Aurora site is included in Roadside America and Detour Art, and documented in *Sublime Spaces and Visionary Worlds* (Umberger, 2007). His environments are represented in the col-

lection of the John Michael Kohler Art Center, which is dedicated to preserving folk art environments. Smith maintains a website, www.aahm-bva.org, describing his environments, his purpose, and the latest developments. It includes images of his latest works. Jeanine Taylor Folk Art in Miami has Smith's work for sale.

Smith, DeVon (1926–2003)

Smith was born in Ellwood City, Pennsylvania. He frequently skipped school to hitchhike to the next town over and watch movies all day. Sci-fi and horror movies were his favorites. Smith quit high school worked briefly casting tank turrets in Pittsburgh, was drafted in 1944, and served until the end of World War II, earning three battle stars. He later worked at a hotel owned by relatives, but wanderlust struck, and he took off. By 1972 Smith was listed in *The Guinness Book of World Records* for the most miles ever hitchhiked—more than 500,000 documented miles. His record stood until 1983. When he got too old to hitchhike, he settled in Wampum, Pennsylvania, very close to where he grew up, and made a living trading and selling junk. Because he was lonely, he created his own "World's First Family of Robots" from 100 percent recycled material. His work came to the attention of the American Visionary Art Museum, and in June 2000 he officiated at an elaborate Robot Wedding held at AVAM, complete with champagne for the adults, ginger ale and wedding cake for the children, and featuring a remote control robot dog as ring bearer.

Smith, Ernest Archer "Frog" (1896–1993)

Smith got his nickname during the Depression when he went frog hunting to feed his family. He was born in south Georgia, and moved to the pinewoods of north Florida as a boy. He lived in every part of the state. His memory paintings are full of action and the color is true to the place. His paintings reflect his other known talent as a storyteller and writer of anecdotes about life in Florida. He was an invited storyteller at the Folklife Festival in Washington, D.C., and he self-published a book, *The Tramp's Heritage*, that is a semi-fact, semi-fiction adventure story of life in an early Florida town. In his later years he lived in North Fort Myers. Jeanine Taylor Folk Art carries his work.

Smith, Fred (1886–1976)—"Concrete Park"—Phillips, Wisconsin

Fred Smith was a lumberjack, tavern owner, farmer, and dance hall musician. He began building his Concrete Park in 1950, when he was 65. The roadside park environment of over 200 embellished sculptures represents history, mythology, and local lore. Built over a fourteen-year period, his statues include, among many others, Ben Hur, the Lincolns, a double wedding party,

an itinerant cowboy beer drinker, Sacajawea, Mabel the Milker, and Paul Bunyan. After Smith died in 1976, the Wisconsin Concrete Park was purchased by the Kohler Foundation in order to preserve Smith's visionary environment. Restoration was completed in 1978, and the site was turned over to Price County for use as a public art park. Wisconsin Concrete Park is located on Highway 13 at the south edge of Phillips, Wisconsin, and is clearly visible on the east side of the road. It is always open to the public free of charge, though donations for upkeep are appreciated. One can also join the organization Friends of Fred Smith, which maintains the website providing all manner of information about the park (www.friendsoffredsmith.org; 715-339-7282) and sponsors a variety of events at the park. In 1997 Lisa Stone and Jim Zanzi published the second edition of the book *The Art of Fred Smith: The Wisconsin Concrete Park, a Brief History and Self-Guided Tour,* which is available from the Friends group.

Smith, Geraldine (b. mid–1950s)

Smith started painting more than a decade ago after seeing a television show about an artist. Born and raised in North Carolina, she now lives in Columbia, South Carolina. Her work draws on personal knowledge and experience. She weaves together memories of people and events with scenes of daily life. Her art was included in the exhibition "Visions of Self-Taught Artists: Nine from South Carolina" in Charleston at Piccolo Spoleto in 1995. Red Piano Too Gallery on St. Helena Island carries her work, which was also available recently through Stonegate Antiques in Glastonbury, Connecticut.

Smith, Isaac (b. 1944)

Smith was born in Winnsboro, Louisiana, south of Monroe. He spent a lot of time wandering in the woods as a child, and developed an interest and admiration for animals. An interest in wood-carving began when he was young. After quitting school in the eighth grade, Smith went to work for a pipeline company in Mississippi. In 1961 he moved to Dallas and went to work for an aerospace company. In 1975 he spent more time carving while he was laid off from work. He was laid off again in 1978, and this time decided to start carving full-time to make a living, without having to depend on others. He has been carving full-time since 1978, using found wood as his medium. He gets his ideas for his animal figures from his experiences as a child in Louisiana, from *National Geographic* and "from divine inspiration." His work was included in the exhibition, "Spirited Journeys: Self-Taught Texas Artists of the Twentieth Century." His work is in the Art Museum of Southeast Texas and is available through the Craighead-Green Gallery in Dallas and the San Angel Folk Art Gallery in San Antonio.

Smith, Lewis (1907–1998)

Lewis Smith lived near Maximo, Ohio, in the woods on what had once been a farm before he let the trees grow back. He dropped out of school at a young age. His father had worked on the railroad and had often taken Lewis with him. There are railroad tracks along the back of what had been his property. After his mother's death he began to build or refurbish many small outbuildings on the property, creating facades that looked like railroad stations, an old western town, and many other recognizable structures. Each one was filled, stacked to the roof, by the salvage he found; sorted and categorized by type: one building contained stacks of cardboard, one contained metal, one contained scrap wood. He has been described as "obsessive/compulsive" and "very meticulous." Smith lived the life of a hermit but was found in the 1980s by a small-town attorney who was working as a census taker and was told, "I know an old guy who lives in the woods and does drawings." Toward the end of his life he moved into his sister's house. Visitors would be asked where they were from, and Smith could then tell them the name of their hometown newspaper and the call letters for their radio station. There was a photograph taken of Lewis Smith and his bicycle which appeared in the *Louisville Herald* April 26, 1979. In 1997 a visitor said he was then wearing the exact same articles of clothing. His environment has been vandalized and is mostly deteriorated. Some of his crayon and pen drawings were 4' × 4' and many others were on brown paper bags and boxes. A frequent image was of women wrestling. The artist claimed he didn't know there was any such thing, he just thought it was a way they could make money. Viewers have said the art has "an erotic feeling," without anything explicit. Other subjects in his drawings include lunch counters and interiors of diners, early trains, and other memories of places he visited during his travels; he had a lifetime train travel pass because of his father's work. His drawings have found their way into galleries. American Primitive Gallery, Artisans, and Robert Reeves, private dealer, carry his work.

Smith, Mary T. (1904–1995)

Mary T. Smith was born in Brookhaven, Mississippi, and moved to Hazlehurst in the 1970s. She had spent most of her adult life as a tenant farmer and a cook for other families. In 1980 she took tin panels her son had intended to use to build a shed, painted them with images of animals and figures and hung them on her fence. When her fence was finished she started painting on boards and putting the images about her yard. Although she created a one-acre environment with her art, there is very little evidence of it left. She is in the permanent collections of many museums, and many galleries carry her paintings.

Smith, R.D. (1923–2008)—"Land of Broken Dreams"—Liverpool, New York

Smith built an environment, with careful and deliberate planning, on three acres of wetlands in New York, just west of Syracuse. Smith was raised on a farm nearby and served in World War II. He ran a septic removal service for many years before he retired. Smith worked on his environment for more than forty years. He surrounded the property with large fences made of willow logs, which take root in the wet soil, and decorated them, using an incredible array of found objects, root sculptures, figural and fantastic assemblages, and live birds. He changed the pieces around until the arrangement met his approval. Smith did not build his environment to be isolated from the world. He built it facing toward the New York State Thruway, at exit 38, to attract and enjoy attention. It is not clear whether the environment has survived, but pictures of it may be seen on the Roadside Architecture website, www. roadarch.com/h/bobsmith.html.

Smith, Robert E. (1927–2010)

Robert Eugene Smith was born October 14, 1927, in Saint Louis, Missouri. He served in the army but was discharged because of a heart problem. When the drugs prescribed caused side effects, his mother had him committed to a state institution where he remained for 25 years. After he was released, he continued to work for the hospital for another seven years. He started painting while in the hospital. After leaving the hospital he lived in Springfield, Missouri, where he held odd jobs, played musical instruments, and worked at his art. He was discovered selling his paintings at a Missouri State Fair. Smith painted visions of his world, describing his daily life, his dreams, and his nightmares. In his paintings he showed Apollo rockets, local bars, army life, and monkeys drinking beer. He wrote descriptions of each painting which, though they have no punctuation or structure, provide insight into his thoughts. His art was included in the exhibition "Flying Free" in 1997. There is a website, roberteugene smith.blogspot.com, dedicated to the artist, to which anyone who knew him may make contributions. At the time of this writing, it included a video from his memorial service, links to newspaper stories about him, images of his art, and an announcement of a forthcoming book about him. His work is documented in the Smithsonian Institution's Archives of American Art. Marcia Weber/Art Objects has examples of his art available.

Snipes, James "Buddy" (b. 1943)

One of twelve children, Buddy Snipes was born in Macon County, Alabama, and still lives nearby. As a child, he made toys for himself and the other children out of whatever he could find. He also made wagons and wheelbarrows out of tree limbs and scrap lumber which he sold to neighbors. Later Snipes worked as a pulpwooder, a logger, a farmhand, a dishwasher, and he fixed things for people—broken furniture, sagging doors, and fences. About ten years ago he stated to make assemblages from roots, tree limbs, vines, scrap lumber, and anything else he can find around that triggers his imagination. He also draws pictures on scrap lumber and frames them with some of his found objects. Snipes lives in Pittsview, Alabama. His work may be seen at the New Orleans House of Blues, or purchased through Main Street Gallery, Dos Folkies, Orange Hill Art, and Ginger Young, private dealer.

Sommer, Isador "Grand Pa" (1881–1964)

Sommer was born in Galatz, Romania. At the age of sixteen he came to America and began a number of successful business ventures, among them pocketbook manufacturing, real estate, farming, and running a country hotel in Saratoga Springs, New York. When he was 64 he set his hand to painting landscapes and was hailed by the director of the American-British Art Center, Ala Story, as among the finest she had ever seen. Sommer's earliest paintings were dated 1945 and 1946, and were signed "I. Sommer" or "Isador Sommer." He did not sign them "Grand Pa" until later, and on some paintings that appellation was added in a different color at some time after the work was completed. An art critic of the *New York Times* described his work as "A theme of naive quaintness." His work occasionally comes up for auction.

Sorrento, Lamar

Sorrento, whose real name is James Eddie Campbell, has been painting since 1991. He is a musician and a native of Tennessee, now living in Memphis. He has a number of albums to his credit. He began to paint to celebrate his obsession with Gypsy jazz legend, Django Reinhardt. He has a flat colorful style and most of his subjects are musicians, including Robert Johnson, B.B. King, Johnny Cash, Flat and Scruggs, Bob Dylan, and others. His work is part of the House of Blues collection and is available from Primitive Kool Gallery in San Diego, The Arts Company in Nashville, and Yard Dog Art in Austin. In addition, you can see his art and find email and phone contact information his website, www.lamarsorrento.com.

Sparks, Arnold "Sparkplug"

Sparks is from Irvine, Estill County, Kentucky. He created hundreds of clay figures that were never fired (before 1993), which he traded for food and necessities. His work was discovered by Kentucky folk artist James Bloomfield at the Irvine trading post. At the

time he was doing this work, he was homeless, sleeping under bridges, in an abandoned bus, on the street in boxes, sometimes in cars or with friends, and sometimes in the woods. A collection of the early unfired pieces is in the collection of the Huntington Museum of Art. Now he has the luxury of firing for permanence and stability and creates multi-faced and multileveled figures. His images come from within his mind and imagination. His work was in the exhibition "Inside the Outsiders" at the Art Academy of Cincinnati in February 1992. The Huntington Museum of Art has his work in its permanent collection.

Sparks, Nina (b. 1955)

Nina Sparks was born in Ravenna, near Irvine, Kentucky. She was raised in the same two-room cabin, at the foot of Iron Mountain on the banks of Cow Creek, where she now lives with her husband, Arnold. Her childhood had its difficulties but was always filled with her mother's love and the serenity of the nearby creek, which is reflected in her paintings. She began painting in earnest in 1992. Unlike the earth tones of Sparky's clay work, she uses a broad palette of colors she can find in a variety of media. Often repeated elements in her art include the beauty and nurturing of females and the frequent presence of animals, especially birds and cats, sometimes portrayed with human faces. She was included in the "Inside the Outsiders" exhibition in Cincinnati. The Huntington Museum of Art has her work in its permanent collection.

Sparno, Rosemary (b. 1942)

Sparno was born in Westchester County, New York, and currently resides in Santa Fe, New Mexico. She has been making art for more than 40 years, first developing her skills by making scrimshaw (carving on whale teeth, which is now illegal) and visiting maritime museums in New York. Sparno holds a master's degree in special education and has been an educator for many years. She has focused her artistic effort on making objects from gourds, many of which she grows herself. She makes masks, rattles, dippers, storyteller dolls, katsinas, and mixed-media construction, each hand-painted wood-burned, etched, and then polished and finished with horsehair, buckskin, and sometimes feathers and pieces of coyote or buffalo bone and deer antler. Sparno looks to the gourd itself to suggest what it will become. When making objects that use Native American symbols or are derived from Native American ceremonies, she is careful to change the content into something from her imagination. Sparno sells her work through her website (www.santafegourdart.com), through the Eldorado Arts and Crafts Shows (spring and fall), the High Road Gallery in Truchas, the Collaboration Gallery in Madrid, and Anna's Home and Garden Center in Eldorado, all in New Mexico.

Sparrow, Simon (1925–2000)

Simon Sparrow was born in West Africa and went to school in North Carolina where his parents were sharecroppers. At the age of twelve he ran away to Philadelphia, where a Jewish family took him in. He enlisted in the army, was a housepainter in New York, and in 1969 moved to Madison, Wisconsin, where he was a street preacher. He was a familiar figure on the UW-Madison campus, where he could be found preaching on the Library Mall or painting in the Memorial Union. He did some drawings but is best known for his collages of thousands of small found objects. His work was inspired by his religious visions. He was hospitalized toward the end of his life and stopped doing his art. His work is in the permanent collections of the Smithsonian American Art Museum, the Akron and Milwaukee Art Museums, and the Philadelphia Museum of Art. The Smithsonian Institution's Archives of American Art has his papers and documents.

Spelce, Fannie Lou (1908–1998)

Spelce was born in Dyer, Arkansas, the oldest of five children. She left Dyer at eighteen to take nurse's training, and worked for forty years, the last eleven at a school in Austin, Texas. She married and had two sons. While working in Austin, summers free from school gave her time to sign up for an art course, but she did not do well at it. When she tried an oil painting from memory, her instructor told her to drop out of the class "but never stop painting." During her productive years in Austin she produced more than 300 detailed paintings of her memories, mostly of small-town life in the early twentieth century. She painted remembrances of her childhood: family activities, country fairs, farms. She has been in many solo exhibitions, and also in group shows. Spelce died in Austin. Four of her paintings were included in the exhibition of Texas folk artists "Spirited Journeys: Self-Taught Texas Artists of the Twentieth Century."

Speller, Georgia (1931–1987)

Georgia Speller was born in Mississippi and lived in Memphis, Tennessee, from the early 1940s until her death. She was married to Henry Speller. She made watercolor paintings on paper, "including quite a number of intriguing erotic pieces." Her work is in the permanent collections of the Birmingham and Rockford Museums of Art and the African American Museum of Dallas.

Speller, Henry (1900–1996)

Henry Speller was born to a family of sharecroppers in Rolling Fork, Mississippi, dropped out of school early to help his family plant cotton, and continued doing farm work until 1941 when he moved to Memphis. He started to draw regularly after moving to

Memphis. Speller incorporated his experiences into his work, and his television watching inspired many of his images. His work is in the permanent collections of the Smithsonian American Art Museum; the Birmingham, Mississippi, and Rockford Museums of Art; the Old Capitol Museum of Mississippi History, the High Museum, the Hudgens Center for the Arts, the Virginia Union University Museum, and the Milwaukee Art Museum. Anton Haardt Gallery and George Jacobs, private dealer, carry his work.

Spellman, Charles (b. 1938)

Spellman was born in Baton Rouge, Louisiana, but moved a lot in childhood as his father's work as a civil engineer took the family to many places. He liked to draw from an early age, but began painting regularly in his late 40s. Spellman has a Ph.D. in psychology, working in community mental health centers for many years after finishing his degree. In 1977, following the death of his first wife, he went into private practice, which he continues to do. Since moving to Arkansas, he has lived in a rambling property that he built himself with lumber saved from tearing down old houses and barns, situated above the backwaters of the White River in the Arkansas Delta, one of the least populated places in the American South. Spellman paints clear scenes of ordinary people in the South. As Adrian Swain writes in the catalog for an exhibition featuring Spellman's work at the Kentucky Folk Art Center in 2011, "these are character studies of people around kitchen tables, in honky-tonks, amid conversations, in churches. Looking at Spellman's work you can feel like you're intruding on a conversation that you're not supposed to be a part of. It's that moment when you walk into a room and everyone stops talking, that moment just before they look up at you. Without reference to personal visions, folk tradition, art history, or coded religious iconography, Spellman creates works that inspire insights into aspects of the broader American experience that are otherwise largely obscured from view. His work asks us to slow down, to observe, to pay attention. It encourages us to explore the nuanced expressions of the real people we encounter in daily life." Spellman's work is in the permanent collection of the Kentucky Folk Art Center; he sells his work at Day in the Country, the first weekend every June at the Center. Galleries have offered exhibitions of his work, such as Gallery 55 in Natick, Massachusetts did in fall 2006.

Spencer, Oscar Lipscomb "O.L." (1908–1993)

O.L. Spencer lived in Blue Ridge, Virginia, and had been carving wood since he was twelve years old. He worked as a coal miner until he lost a leg in an accident and then became a painter of buildings. The majority of Spencer's artwork consisted of snakes carved from vines, roots, or branches, which he painted with extreme care. He became especially interested in snakes, he said, when a copperhead bit him, right on his artificial leg. His work was included in the exhibition "Folk Art: The Common Wealth of Virginia." His work is in the permanent collections of the Meadow Farm Museum, the Milwaukee Art Museum, the Taubman Museum of Art, and the Owensboro Museum of Fine Art.

Sperger, Hugo (1922–1996)

Sperger was born in Merano, Italy, to German parents who moved to the United States in 1929. After living in upstate New York, he moved to Kentucky in 1955 and settled in his wife's homeplace, Salyersville, Kentucky. He was a painter, carver, and toymaker. His subject matter varied, ranging from religious paintings to erotic carvings. His paintings teemed with figures: people, animals, angels, devils. He used bright-colored acrylics. Sperger's art is in museum collections. His work is in the permanent collections of the Smithsonian American Art Museum, the Kentucky Folk Art Center, the Owensboro Museum of Fine Art, the Taubman and Milwaukee Museums of Art, and the Lehigh University Art Gallery. Outsider Folk Art has his work available for sale.

Staples, Marcus J., Jr. (b. 1936)

Staples was born in Reading, Pennsylvania, one of six children. His father died when he was two, and his mother died one year later. Of American Indian, black, and white lineage, he has been on his own since the age of fourteen. "When I look back," he says, "I see myself alone, drawing pictures, scenes of people where they were not—faces on rocks, in the trees, in clouds. No one else could see them there but myself." He began to paint seriously after a brush with death, when he went into a diabetic coma. He supports himself by selling used furniture, collectibles, and his art. "His work, images of farms, slaves, religious and historical figures, seems familiar at first glance but upon closer scrutiny they come alive with spirit." Barry Cohen, private dealer, carries his work.

Starday, Jewell (b. 1938)

Jewell Starday was born in Bessemer, Alabama, with the name Betty Jean Washington. When she started painting and finding a new and better life, she dropped her birth name. She grew up very poor in Alabama and in New York City. She was a high school dropout, endured a bad marriage, cleaned houses for rich people, and watched five of her twelve children die of accidents or illness. Returning to Birmingham in 1993, she went to work in the law office of her son Lonnie. She accumulated a stack of doodles on her memo pads, took them home, and with the encouragement of a daugh-

ter, began coloring the images with acrylics and watercolors. She painted everything from swirling abstracts to glittery portraits of African kings and queens. She says the painting made her feel so good it erased the ugly things inside. Her paintings have attracted collectors now and she was included in the publication *Revelations: Alabama's Visionary Folk Artists*. Her work is in the Birmingham Museum of Art.

Staub, Leslie (b. 1957)

Leslie Staub lives in New Orleans. She was born June 10, 1957. While she was in college, Leslie lived in a small wood-frame cabin she built herself in the woods near Puget Sound and Olympia, Washington. She lived there close to nature "with the sounds of birds and the words of poets." Staub paints with oil on wood. Her frames, an important element in her works, are incised plaster or carved wood painted gold and encrusted with faux gems. The subject matter is mostly portraits of musicians, politicians, or literary figures, usually with a touch of irony. The frontally posed figures, the style, and the frames give the work the look of icons. Her work can be seen at the New Orleans House of Blues; LeMieux Galleries in New Orleans represents her.

Steen, Lee (1897–1975) and Dee (1897–c. 1972)—Environment— Roundup, Montana

Lee and Dee Steen, twin brothers, were born in 1897 in Kentucky. They were raised in Roundup, Montana, and spent all of their adult lives in the Pacific Northwest. These men lived on the edges of society and created a fantastic and elaborate environment from natural objects and discarded refuse; local folks referred to the figures as "tree people." The Steens also kept tamed wild animals scattered throughout the yard art. Lee Steen made wonderful human and animal figures from broken pieces of trees. The environment is no longer extant, but an extensive collection of the brothers' work is archived in the Paris-Gibson Square Museum of Great Falls, Montana. The environment is documented in the catalogs *Lee Steen*, published by the Yellowstone Art Center, and *Yard Art*, published by the Boise Art Museum. Roadside America did a story of the Steens and their work.

Steinberg, Sam (1896–1982)

Steinberg was born in Manhattan and grew up in the Brownsville neighborhood of Brooklyn, New York. The family, from Russia, was very poor and life was a struggle. As an adult Steinberg lived in the Bronx and worked always as a street vendor. He came to painting at an advanced age and was for many years a "presence" on the campus of Columbia University, selling his art, and was often called "artist in residence." He painted surrealistic portraits of famous people but was best known for his portrayals of mermaids, snakes, dogs, birds and, most especially, cats. In 2015, the Columbia College Class of 1975 sponsored a retrospective exhibition of Steinberg's artistic career as part of its 40th Reunion.

Stenman, Elis (c. 1974–1942) "The Paper House"—Pigeon Cove, Massachusetts

Starting in 1922, Elis Stenman and his wife (whose name is never mentioned in any articles) built and furnished a house completely of used newspapers. The walls and roof are thick layers of folded and pasted paper. The furniture is made of rolled tubes. Each piano, bookcase, and floor lamp can be unfolded, perused, and reassembled. Many furnishings are thematic. The grandfather clock is veneer with rolled newspapers from the capital cities of 48 states; the fireplace is faced with rolls of the Sunday *Boston Herald* and the *New York Herald-Tribune*; a desk is assembled from newspapers describing Lindbergh's flight. Since Stenman's death in 1942, the house has been preserved and is open to visitors. The house was still intact in 2015. It has its own website (http://www.paperhouserockport.com), was the subject of a 2012 YouTube video (www.youtube.com/watch?v=5XIsDnz_xmI) and was written up by Roadside Architecture (www.roadarch.com/h/paperhouse.html). It is located at 52 Pigeon Hill Street in Pigeon Cove, Massachusetts, north of Gloucester on Route 127 near the New Hampshire border.

Stephens, Wilma (b. 1933)

Wilma Stephens was born in Isonville, Kentucky. Like so many others in the area, she and her husband had to move to Ohio to make a living. He worked for an aviation company in Columbus and as a sheet-metal worker. In 1978 they sold their Ohio home and moved to Florida where they ran a park for RVs. They moved back to Isonville in 1992. Wilma started carving when she was small. She still does carving with a pocketknife and makes animals and heads of people. She paints her carvings with acrylics. About two to three years ago she started doing paintings on canvasboard with acrylics. Most of her themes come from the Bible. Wilma Stephens is first cousin to well-known carver Minnie Adkins. A piece appears about her at www.intuoutsiderart.com/wStephens.html.

Stephenson, Q. J. (1920–1997)— "Occoneechee Trapper's Lodge"— Garysburg, North Carolina

Stephenson, known as "Q.J.," lived all his life in Garysburg, North Carolina, except for a time during

the Depression when he worked in the redwoods of northern California. He was a dragline operator for a construction company for forty years, and also a trapper. He retired in the mid–1970s, and began building an environment called Occoneechee Trapper's Lodge. He made the Lodge by covering the interior and exterior walls of his house with cement, into which he embedded petrified wood, fossils, Civil War relics, Indian artifacts, and other finds from his trapping days. In 1981 he began making free-standing sculptures using the same methods and materials and developed the museum for displaying his art and found objects. The museum is still there, but whether or not it will be opened again to visitors has not been determined. Numerous pictures are posted on the SPACES website, and several comments as late as August 2014 on Roadside America give evidence that the Lodge continues to exist and that one can walk around the property, and also confirm that a "for sale" sign is still posted for the property.

Stewart, Wesley (b. 1916—no further information available)

Wesley Stewart was born in Columbia, South Carolina, and moved to Jacksonville, Florida, with his family in 1926. For the last 40 years he has been creating unusual sculpture and paintings by gluing together thousands of toothpicks and painting them. His work was in the "Tree of Life" exhibition at the American Visionary Art Museum in Baltimore and it is in the permanent collection of the Carl Van Vechten Gallery of Fine Arts at Fisk University in Nashville; Just Folk in Summerland, California, carries his work.

Stone, Henry "Squirrel" (1938–2007)

Stone was born in Sand Hill, South Carolina, and lived in the country near Hemingway outside of Andrews. He lived in a house trailer at the end of a long dirt road, easy to identify because at the beginning of the road Henry had nailed to the trees many of his paintings. He worked as a farmer and a housepainter for many years and then his health began to deteriorate. He began to paint around 1982, and painted obsessively, on anything he could. If there were no boards or pieces of tin about he would paint on Coke bottles, Coke cans, cereal boxes, pieces of wood—whatever was at hand. During a winter when Henry was house-bound after major surgery, he painted every surface, food container, and box in the house. His brother, with whom he lived, was afraid "Henry might start next on the dog." His subject matter was mainly architectural; naive paintings of barns, log cabins, farm buildings, houses. He did a few portraits, but there were no people included in the drawings of buildings. Often, while sitting in the sweltering South Carolina heat, he would paint his usual buildings covered with snow in

a winter scene, though it is not likely that he had ever seen deep snow. Visionary Art in Alabama and Ginger Young, private dealer, still have some of his art for sale.

Stone, James "Squeakie" (b. 1951)

Stone was born in Georgetown County, South Carolina, in 1951. When he was growing up, the family moved every few years or so because his father was a sharecropper and carpenter, and they moved where the work was. Squeakie started work at "handing" tobacco (passing the leaves on to a worker who strung it for drying) when he was just five or six years old. As he got older, he was involved in all aspects of tobacco farming. He also picked cotton, worked in a few factories and grocery stores over the years, and then began working as a house painter about thirty years ago. He began painting art to sell when his uncle, Henry "Squirrel" Stone (1938–2007), who had been painting folk art for nearly twenty years at the time, suggested that Squeakie try his hand at painting a picture of a church from a photograph, which was for a woman who'd commissioned it. Squeakie had always felt that there was something else that he was meant to be doing, but had never worked out what it was until that day. When he painted that first picture, he knew this was it. That day, in 2002, he became a folk artist, although he admits now that he didn't know what he was doing back then. Fran Oxner, from Cuz-I-Got-To-Have-It Gallery at Pawleys Island, South Carolina., came to collect some of his Uncle Squirrel's work; when she saw Squeakie's paintings she promptly took those, too. It was to be another five years before Squeakie was able to give up his day job, but since 2007 he has done nothing but paint full time. His naive, down-home pictures of people working in the fields, making baskets, doing household chores, working in the tobacco fields, and other local scenes are bought by collectors from as far away as England. His work is available from Red Piano Too Gallery, The Attic Gallery, Roots Up Gallery, Around the Back at Rocky's Place, Possum County Folk Art, and other locations. He also sells from his website, www.squeakiestone.com.

Stovall, "Queena" (1888–1980)

Grew up in the backcountry of Piedmont, Virginia, and was a mother of eight children. A Southern memory painter, she often portrayed her black neighbors as well as her own family. She started painting at age 62, when she was already a great grandmother. She has been written about, and a film has been made about her life. In March 1994 she was one of the artists in an exhibition "Grandma Moses' Southern Sisters: Queena Stovall and Clementine Hunter" at the Theatre Art Galleries in High Point, North Carolina. She was honored by the Library of Virginia's "Virginia Women in History" project (www.lva.virginia.gov/public/vawomen/2010/honoree.asp?bio=4). The col

lections of Lynchburg College, the Virginia Museum of Fine Arts, Fenimore House Museum, and the New York State Historical Association hold examples of her work, which is also available through a website maintained to feature her work, http://artofqueenastovall.com.

Strasberg, Anne

Born and raised in Paris, Anne always wanted to be a painter. When her parents refused to buy her paper, she painted the walls of her room. She started painting in earnest when she met her now former mother-in-law, a painter, and painted with her in the countryside of Normandy. Anne creates primitive narrative paintings, inspired by what she sees and reads and by her many travels. The colors and textures are very personal and are influenced by the nature of the subjects, real and or imaginary, which she is painting. She now splits her time between Paris and New York. Galerie Bonheur in Saint Louis has her work, which she also sells through her website, www.annestrasberg.com. In addition, she has a gallery of her own, La P'tite Gallerie 555, 555 8th Avenue, Suite 2310, New York, NY 10018 (between 37th and 38th Streets, www.laptitegalerie 555.com.

Streeter, Vannoy (1919–1998)

Streeter began working with wire to make his own toys as a child in Tennessee. A boyhood fascination with wagons and machinery gave rise to the creation of model vehicles, and growing up around many local stables inspired him to depict his other favorite subject, Tennessee walking horses. His horse models replicate the conformation and spirit of particular champions and challengers in the local show ring of his Shelbyville hometown. Using only pliers, his own imagination, and self-taught techniques, Streeter had practiced this art form all his life which earned him the nickname "Wire Man." He mostly used coat hangers, but also used about every kind of wire he came upon. He sculpted many objects, from trucks, fishing boats and airplanes to hunting scenes, guitars, hats, and a life-sized horse. He also did people, such as Elvis Presley and Tina Turner. Often his works have movable parts and whimsical details. Streeter was exhibited in "Visions of My People: African-American Art in Tennessee" at the Tennessee State Museum in 1997. His work is in the permanent collections of the Birmingham Museum of Art, the Museum of International Folk Art, and the Carl Van Vechten Gallery of Fine Arts at Fisk University. The Arts Company in Nashville has his work for sale.

Streetmyer, Walter (1908–1985)

Streetmyer was born to a farming family in Hartsburg, Illinois, and grew up working with farm machin-

ery. After World War II he settled in Columbia, South Carolina, where he operated a car and truck repair shop for 31 years. When he retired he spent time making miniature models of the farm machines he had once worked with, using old Crisco cans and a soldering iron. At his death in 1985, his widow donated his works to the South Carolina State Museum.

Strickland, David (b. 1955)

David Strickland was born in Dallas and now lives in Red Oak, Texas. He learned to weld after being sent to a trade school. He has worked as a welder, carpenter, plumber, and general laborer. In the late 1980s Strickland began collecting metal, including old farm equipment and auto parts. While repairing farm equipment to earn additional money, he noticed that some metal pieces looked like parts of animals. Working with these pieces of metal, in 1990 he created his first art piece, "Big Bird." He makes welded metal sculptures of animals, people, and abstracted figures using found objects. His figures range from three inches to nine feet tall. His artwork was included in the exhibition "Passionate Visions," at the New Orleans Museum of Art, and in "Spirited Journeys: Self-Taught Texas Artists of the Twentieth Century." His work is in the Art Museum of Southeast Texas.

Sudduth, Jimmy Lee (1910–2007)

Jimmy Lee Sudduth was born March 10, 1910, in Caines Ridge, Alabama. He had jobs as a gardener and in highway construction, but mostly worked on farms. Jimmy Lee lived in Fayette, Alabama, near where he was born. He worked for years as a farm hand. His wife, Ethel, whom he married in the 1940s and who is the subject of some of his paintings, died during the summer of 1992. Self-taught, Sudduth was an artist for many years. He painted on plywood boards and used natural materials, including mud, as well as paint. His subjects include people, animals, and buildings. His neighbor, Jack Black, was a major influence on his art career. He founded the Fayette Art Museum, which houses many of Sudduth's works. Sudduth was the only self-taught artist to receive the State of Alabama's Governor's Art Award (in 2005). His work was featured in the Smithsonian Institution's 1976 Bicentennial Festival of American Folklife in Washington, D.C., and has been included in many exhibitions such as *Passionate Visions of the American South (1993)* and *Flying Free* in 1997. For many years he sold his work at the Kentuck Festival, where he was regarded as an institution. His work is in the collections of the Smithsonian American Art Museum, the American Folk Art Museum, the High Museum, the New Orleans Museum of Art, and the Montgomery Museum of Fine Arts, among other museums. It is also available through many galleries and dealers.

Sullins, Maurice Legrand Lesueur (1911–1995)

From Joliet, Illinois, Sullins painted over 1,200 works from 1970 to 1986, but stopped after his wife died in that year. He was a self-taught artist who worked at the Joliet Municipal Airport waxing planes by day and painted at night. He was the subject of an Illinois State Museum retrospective exhibition in 1988. Descriptions of his art include such comments as "unique images," "sophisticated composition," "bold use of color," "exuberance of visionary expression." His work was included in the exhibition "Outsider Art: An Exploration of Chicago Collections" in 1996–1997. He and his paintings are the subject of a 1988 book, *Maurice Legrand Lesueur Sullins: Paintings, 1970–1986* (Illinois State Museum) that accompanied the retrospective exhibition. He began selling his work only after he stopped painting.

Sullivan, Patrick J. (1894–1967)

Patrick Sullivan was born in Braddock, Pennsylvania, and lived in Wheeling, West Virginia. His father died when he was two, after which he lived in an orphanage until the age of fifteen when he rejoined his mother. He held a series of low-paying jobs including being a housepainter. Though his work was discovered by Sidney Janis and received critical acclaim, he never was able to support himself with the sale of his art. It is said that he made his allegorical paintings "to make people think." His work is in the permanent collections of the Museum of Modern Art, the Smithsonian American Art Museum, and the Oglebay Institute's Mansion Museum and the Sacred Heart Church in Wheeling.

Suter, Michael "Catfishman"

Michael Suter was born in England and brought to the United States by his father. He spent a long time wandering around, often homeless. He is now living in Greensboro, Georgia. Suter paints very bright colors on boards, images that have a fanciful look but at the same time resemble "something familiar." His work is available through Linda Matley Gallery in Williamsburg, Virginia.

Swearingen, Johnnie (1908–1993)

The Rev. Johnnie Swearingen was born in the black community of Campground Church near Chappell Hill, in Washington County, Texas. He was called to preach at an early age and then fell away from his calling and got into a lot of trouble as a young man. He traveled west and worked at a variety of jobs. Eventually he returned to Texas and settled in Brenham. He painted religious scenes inspired by the Bible, and memory paintings inspired by his own life in rural Texas. He started painting when he was about twelve years old. He would paint on anything, but preferred

Masonite. He seldom cleaned his paintbrushes, which explains why some of his pictures are bright and clear while others look quite muddy. He would use shoe polish and house paint when he couldn't afford anything else. His art was included in the exhibition "Spirited Journeys: Self-Taught Texas Artists of the Twentieth Century." His work is in the permanent collections of the New Orleans Museum of Art, the African American Museum of Dallas, and The Menil Collection. Webb Gallery carries his work.

Swift, Herman (1899–1992)

Swift was born in Clarksville, Tennessee. He had a great love of horses which he acquired while growing up and training Tennessee walking horses. He was also involved in breeding Morgan horses. He lived most of his life in Rockford, Illinois. When he retired in 1967 his carving hobby became his passion. His biggest project was a twenty-foot long carved replica of the Borax twenty-mule team. He made many carvings of horses and people. His works were finely carved and finished. His work appeared in the Rockford, Illinois, art exhibition "Within Reach: Northern Illinois Outsider Artists" in 1998.

Swike, Roger (b. 1962)

Roger Swike was born in Boston and at an early age was diagnosed as being autistic. He attended a number of schools for students with special needs and as an adult was placed in an assembly-work day program. Swike now lives in a residence in Revere, Massachusetts, and attends Gateway Crafts in Brookline. His works are drawings on paper. He uses pens, pencils, and markers. There are grids and lists of words, often clever and filled with puns. He is obsessed with television and pop culture. Drawing for him is a way to communicate with the world. His work was included in the exhibition "Pure Vision: New England Artists with Disabilities" at the Federal Reserve Bank of Boston in the fall of 1997. It is available through the Gateway Arts Gallery.

Szwarc, Stanley (1928–2011)

Szwarc was born in Poland and emigrated to the United States in 1977, settling in Illinois. He worked as a welder, and brought home from work the small metal pieces that otherwise would have been thrown away. These he crafted into decorative objects—boxes, bookends, candle sticks, vases, and similar pieces making elaborate patterns of the leftover metal. He often gave his pieces away to friends. Several pieces of his were included in the show, "Outsider Art: A Survey of Chicago Collections," sponsored by Intuit with the Chicago Cultural Center. The Folk Art Society of America presented Swarc with its Award of Distinction at its annual meeting in 2005. He is the subject of a

Detour Art posting in 2009; his work is often available through the web.

Talpazan, Ionel (b. c1956)

Talpazan escaped from Bucharest, Romania, in 1987. He swam across the Danube River to Yugoslavia where he lived and worked for several months until the American government gave him political refugee status. Talpazan now lives in New York City. Talpazan has said at times that he first became interested in outer space when he came to the United States. After seeing a television program on UFOs, he began making his first drawings of outer space and spaceships. Other sources claim that he has had a lifelong interest in UFOs which began after a childhood experience of witnessing a whirling blue energy in the sky. He currently paints on canvas and also on oak tag, using acrylics, oils, pastels, glitter, and nail polish. Talpazan depicts UFOs in other planetary worlds and flying saucers hovering above New York City. In 2008, American Primitive Gallery gave him a solo show, "Ionel Talpazan—UFO: Art and Science." He is well-known in Britain, where the Henry Boxer Gallery carries his work and the BBC has done pieces on Talpazan and his work. Marcia Weber/Art Objects carries his art.

Tapia, Luis (b. 1950)

Tapia was born in Agua Fria, New Mexico, and now lives south of that city in La Cienega. He began carving both traditional and non-traditional santos in the 1970s. His style looks different than that of old traditional santeros and when he first displayed his work he was criticized for it. The critics were mostly Anglos "because Tapia himself has pride in his traditions and did research to learn more about culture, tradition, and evolution in Hispanic art." He received a National Endowment for the Arts grant in 1980. His carved wood santeros are painted. His work is in the permanent collections of the Smithsonian American Art Museum, the Milwaukee Art Museum, and the Owensboro Museum of Fine Art. There is information of interest about Tapia in *Crafting Devotions* by Laurie Beth Kalb.

Taplet, Alfred "Big Al" (b. 1936)

"Big Al" lived on St. Bernard Avenue in New Orleans with his twin brother Alvin, "Little Al," until Hurricane Katrina forced them to move to Houston, where they remain. During the day he shone shoes for a living around Jackson Square in the French Quarter. He made signs with drawings and slogans to attract people to his shoe shine stand. People were interested in the signs and began to buy them from him. For a while he had to stop selling his signs because other Jackson Square artists complained he didn't have a license to sell art. He has continued to make his signs since moving to Houston, where he had a show of his art as re-

cently as May 2014. His work is in the New Orleans House of Blues collection and is available through Just Folk and Jeanine Taylor Folk Art.

Tarrer, Tom (b. 1927)

Will Tom Tarrer is from Corsicana, Texas, and moved to Dallas as a young man. He was inspired by chalk carvings he saw for sale by the side of the road, and decided to try his own hand at carving. He started with limestone, soon switched to wood, and eventually started painting his figures. He made carvings off and on through the years, either packing them away in boxes or giving them to friends. He recently started carving again. His themes include Western history, American history in general, and religious scenes from the Bible. In addition to painting the carvings, he paints a base and background for them, turning the work into a three-dimensional tableau. Tarrer was included in the exhibition "Spirited Journeys" in 1998. In 2002 Houston's Redbud Gallery mounted a solo show of his work, "Texas Visions"; his work is in the collection of the Art Museum of Southeast Texas.

Tarver, Willie (1932–2010)

Willie, born in Bartow, Georgia, lived with his wife Mae in a small Georgia town called Wadley near Augusta. As a young man he worked with his father as a sharecropper, worked in a lumberyard and served in the Korean War. For 25 years he worked as a refrigerator repairman. He was also a goat farmer and made headstones for graves. Tarver started making art in the late 1960s. He used concrete and paint to form and decorate animal and human figures. Most figures stand about two to three feet tall, but many are smaller, and a few are very large. His work is in the collection of the New Orleans Museum of Art, and is available through Jeanine Taylor Folk Art and Roots Up Gallery.

Tawana, Kea (b. 1935)—"Kea's Ark"—Newark, New Jersey

Tawana built an ark sixty feet long from castaway materials and gutted buildings on a rubble-strewn weedy lot in central Newark, New Jersey. She worked by herself. Then, of course, officials noticed and eventually decided to destroy it. In spite of many supporters from the community and the art world, the city prevailed. Unable to secure a new site, Tawana destroyed the *Ark* in the summer of 1988, rather than face the humiliation of City destruction. There is a beautiful photograph of the ark in Time-Life's *Odd and Eccentric People*. Photographer Camilo José Vergara called Tawana "the only folk artist in the Eastern United States to have built a work comparable in scope and conception to the famous Watts Towers of Los Angeles. Tawana maintained a Facebook page as recently as 2013. The SPACES website provides links to much

documentation and a few pictures, as do the Rutgers University Libraries (libguides.rutgers.edu/content. php?pid=158675&sid=2811271).

Taylor, Lanell G. (1930–1997)

Lanell G. Taylor was born January 6, 1930, in Chicago, Illinois, and grew up on its far south side. She graduated from Carver High School and was employed after graduation as a secretary. Later she studied interior decorating and custom drapery making, after which she opened her own drapery shop. While making draperies, she became interested in folk art. She began making miniature dolls and this led to the creation of her story boxes. The story boxes were made of brown paper, hand painted, mounted on wooden panels which are sometimes stained, and enclosed in Plexiglas. The story box figures depicted different periods of the past. Taylor lived in Hazel Crest, Illinois. Her work shows up occasionally in auctions.

Taylor, Sarah Mary (1916–1997)

Taylor was born August 12, 1916, in Anding, Mississippi, a small rural community near Yazoo City where she lived until her death. She is best known for her quilts, but she also made drawings. Among her favorite images for her paintings was the Statue of Liberty. Her style is primitive and her colors are bright. Her work is in the permanent collections of the Birmingham and Mississippi Museums of Art, the Kentucky Folk Art Center, the Carl Van Vechten Gallery of Fine Arts at Fisk University, and the Art Museum of Southeast Texas. It is available for sale through the Cotton Belt Gallery, Mason Murer Fine Art, and Larry Hackley, private dealer.

Tellen, James (1880–1957)— Woodland Sculpture Garden— Sheboygan, Wisconsin

Tellen built a beautiful site with garden and buildings in Sheboygan, Wisconsin, filled with an impressive group of concrete sculptured figures and buildings. It has been restored by the Kohler Foundation in Sheboygan, Wisconsin, and is located in the Black River community on the road which runs along the lake. There is link to the site on the Foundation's website (www.kohlerfoundation.org/preservation), information and images on Roadside America (www. roadsideamerica.com/tip/17172), and a video on YouTube (www.youtube.com/watch?v=erDFU98UzMg).

Terrillion, Veronica (1908–2003)— Environment—Indian River, New York

Starting in 1953, Veronica Terrillion filled her garden and a pond with life-sized figures of human and animal figures and religious scenes. The Lady of Fatima is her favorite. There is also a log house, a garden of natural plants, and handmade sculpture. The pond has two stone islands occupied by cement figures. Terrillion said, "The Garden means my whole life. I worked not only by the sweat of my brow but the sweat of my blood to get everything I got. I had to burn the brush, and I had to dig out dirt, stones myself. I tell you, I done some work here. I sit down at night and wonder how I did all of it." This and more information can be read in an article in *Heritage: The Magazine of the New York State Historical Association* (Winter 1993). Terrillion's environment is still there, and can be seen next to the road, Highway 12, at Indian River, Lewis County, New York. SPACES has extensive documentation for the site, including pictures; Roadside America documents it; and the local community supports it and considers it a local asset (www.northcountryfolklore.org/rvsp/veronicasgarden.html).

Thal, Ben (b. 1932)

Ben Thal, M.D., was born in Vancouver, British Columbia, and was raised in Bellingham, Washington. He is a recently retired physician and has lived for a long time in Edmonds, Washington. For the last fifteen years he has been making very detailed, one-of-a-kind whirligigs. Each whirligig has hundreds of mechanical pieces to make it run. They are very complicated, with multiple actions, and each one takes months to make. Thal says he has always been "a very mechanical person," and this is definitely reflected in his art. The subject matter varies, with humor a frequent element in each work. Thal's work has appeared in many museum and gallery exhibitions, including the national traveling exhibit, "Whirligigs and Weather Vanes," sponsored by Visual Arts Resources in Eugene, Oregon, and accompanied by an illustrated catalog. Thal has posted brief videos of his work on YouTube (www.youtube. com/user/whirligiger32).

Thibodeaux, Carol (b. 1950)

Thibodeaux was born in Virginia and lived in nearly every state south of the Mason-Dixon Line before her family moved to Louisiana when she was 16. After college, at Northwestern State University in Natchitoches, Louisiana, she moved to California to work in Silicon Valley. She also traveled a lot, mainly in Asia. Thibodeaux returned to Louisiana in 1984 and now lives in a 100+ year old house near the banks of the Amite River between Baton Rouge and New Orleans. Thibodeaux feels that when she slowed down upon returning to Louisiana, "art caught her." She found a box of art supplies on the side of the road one day and discovered her passion inside. She makes sculptures from gourds, does paintings on wood panels or plywood, and has developed a method of painting on window screen that she calls Cajun Stained Glass and for which

she obtained a copyright in 2012. She serves on the Board of Directors of the Louisiana Crafts Guild and the Louisiana Gourd Society. Sans Souci Gallery in Lafayette and Adorn/Le Jardin Gallery in New Orleans carry her work, and she exhibits and sells at various art shows and festivals. She can be found in her booth at Palmer Park in New Orleans on the last weekend of every month. She accepts commissions, and can be contacted through her website, www.carolart. net, and by phone (225-751-0827).

Thomas, James "Son" (1926–1993)

James "Son" Thomas was born October 14, 1926, in Eden, Mississippi, and moved to Leland, Mississippi in 1951. He died in a nursing home in Greenville, Mississippi, on June 26, 1993. Thomas was survived by his wife, eight daughters, and five sons. He was a leading exponent of traditional Delta blues music and known for his handcrafted clay figures. Thomas had the distinction of being the only blues artist to appear at the Annual Delta Blues Festival every year since it began in 1978. He appeared in the films *Mississippi Delta Blues*, *Give My Poor Heart Ease*, and *Delta Blues Singer*. In his art he is especially known for his skulls and skull-like heads, which often have real teeth. He started making art full-time in 1971. His work is in many museums, including several in Mississippi, several in Louisiana, the Smithsonian American Art Museum, the American Folk Art Museum, and the Rockford Museum of Art. Anton Haardt Gallery, Cotton Belt Gallery, American Primitive, and Webb Gallery has pieces of his for sale.

Thomas, L.T. "Thunderbolt" (1904–1995)

The Rev. Lilion T. Thomas was born October 9, 1904, in Calvert, Texas. He became a cotton farmer, and then a preacher, serving as the pastor of a number of country churches around Calvert. In the 1940s he began drawing in his spare time to keep busy. The subjects of his drawings were the outlaws Clyde Barrow, Bonnie Parker, and Pretty Boy Floyd. He used pencils, ballpoint pen, and occasionally crayons. Sometimes his figures are shown riding horses or primitive planes. His later pieces were done in profile. His art was included in the exhibition, "Spirited Journeys: Self-Taught Texas Artists of the Twentieth Century." His work is occasionally available through auctions.

Thompson, William Thomas (b. 1935)

Thompson lives in "the old Gassaway Mansion" in Greenville, South Carolina. He went to Hawaii to access his life after the collapse of his business of thirty years and the onset of a nerve disease that had paralyzed him below the knees and partially crippled his hands. In 1989 while in church in Hawaii he had a vision of the world on fire, what he calls "an anointing of the Lord." After seeing his vision, Thompson bought paints and brushes and began to work immediately. He filled his house with "apocalyptic canvases." He now paints some landscapes and still life, his primary inspiration is the Bible, particularly Revelation. He sells his art through his website, www.arthompson. com, which also includes his journals.

Thornblad, Rodney (b. 1959)

Thornblad was born January 4, 1959, in the Bronx, New York. His subjects range from historical and biblical scenes to contemporary views of prisons, all on a large scale but worked in minute detail. Hundreds of tiny primitive figures populate tableaux, usually surrounding a large central subject. Listening to rock and roll music and going to church are Thornblad's sources of inspiration. He expresses how he feels through his art. He is part of the HAI program.

Thornton, Gerald (1925–2014)

Thornton was a poor, inner city man who painted black life in Connecticut. New Haven was the first city to have a black Masonic group, and Thornton liked to paint people dressed to attend these events. He did very political paintings and jazz funerals also. Thornton lived with his children and grandchildren and earned money as a sign maker for community groups. He watched television to get ideas for his work. His beautiful painting "Flag Funeral" was part of the American Visionary Art Museum's exhibition "Life, Liberty and the Pursuit of Happiness." Beverly Kaye in Connecticut carries his work.

Thunder-Sky, Raymond (1950–2004)

Thunder-Sky was born in Hollywood, California but lived much of his life in Cincinnati, Ohio, where he was a cultural icon. Among the last Mohawk Indians in the Cincinnati area, his father was a chief of the Mohawk Nation. Thunder-Sky wandered the city of Cincinnati, taking as his subject matter buildings slated for destruction. He drew these buildings with magic markers, documenting urban blight and destruction, which he compared in his drawings to his vision of heaven on earth. His work is represented by Visionaries and Voices, a Cincinnati studio-gallery for artists with mental disabilities. Recently, Thunder Sky Inc. (www.raymondthundersky.org) was founded in Cincinnati to preserve the legacy of Raymond Thunder-Sky through exhibits and programs, and to provide an exhibition space, workspace, and ongoing support for other unconventional artists in the area.

Todd, Carter (1947–2004)

Carter Todd was born in Indianapolis, Indiana, and now lives in Madison, Wisconsin. He started drawing

while in a center for alcohol treatment. Never having learned to read and tired of television, Todd started to draw to overcome boredom. He asked a center worker for a pencil and some paper. "Once I started drawing, I couldn't stop," said Todd. "It calms me. It makes me feel good." His formal education ended in the ninth grade, and he worked at a variety of jobs such as short-order cook and gas station attendant. He also suffered from epilepsy and other health problems. He made drawings, always of buildings of various kinds, done with painstaking detail using colored pencil, ink, and graphite. Todd's work was included in the exhibition "Contemporary American Folk Art: The John and Diane Balsley Collection" at the Haggerty Museum in 1992. Dean Jensen Gallery in Milwaukee still carries his work, which is also in the permanent collection of the Milwaukee Art Museum.

Toepfer, Daniel (b. 1949)

Daniel, his friend Barbara, and their dog Bambi drive around the country in their van collecting "stuff" from curbsides, flea markets, countless stalls, the Salvation Army and Goodwill—the "amusing" mass-produced materials, post–World War II, to sell in their shop called Dullsville, in New York's East Village. They also maintain a large house and church in rural, south-central Pennsylvania. In moments between travels, Toepfer assembles his creations in his church basement studio. He transforms disparate pieces into new objects—"fragments become whole; the popular, esoteric; the useless, useful; the many, one; and, aesthetic order, attained." The resulting assemblages are very colorful and available at HUSTONTOWN Internet Gallery based in Pennsylvania.

Tolliver, Annie (b. 1950)

Annie Mural Tolliver Turner is the daughter of artists Mose Tolliver and Willie Mae Tolliver. She remembers drawing in the dirt of Sternfield Alley outside the house where she was born in Montgomery, Alabama. She went to high school until the tenth grade, when she dropped out to take care of her son Leonard, and to marry artist L.W. Crawford. She has been married and divorced twice, and has three children. She worked for a long time cleaning hospitals, hotels, and restaurants. She says her father was the first to influence her art: "I was very interested in my daddy's work. He would often show us how he painted things and encouraged all of us in the family to try painting also." She and her brothers Charles and Jimmy took the most interest in his work. For about five years she worked with her father and signed his name to her work. In 1990 she started signing her work with her own name. Her work has definite differences from that of Mose Tolliver's. Annie's is more colorful, with brighter and more varied colors. Her shapes are her own, with more muscular bodies and many more details such as

tiny white teeth, trim on the clothing, polished fingernails, and so on. Her paint has a flat, hard-edged look, and she seldom mixes her colors. She says her paintings are about what makes her smile—her children, her family and funny animals. "I enjoy painting and now I know I'll never give it up. It's in my blood." Her work is in the permanent collections of the New Orleans House of Blues and the Virginia Union University Museum. Anton Haardt Gallery, Cotton Belt Gallery, Marcia Weber/Art Objects, Main Street Gallery, and Dos Folkies carry her art.

Tolliver, Charles (b. 1962)

Charles is the son of painter Mose Tolliver. He was born when the family lived in an urban housing project in Montgomery. Charles is married and has two sons and a daughter. He works hard to support his family, six days a week for the city sanitation department. He does not have as much time to paint as he would like. He loves to paint. "When I start out painting," he says, "I'm not sure what it will be. The picture paints itself." He works in a space behind his house and tries to paint every day. He says he feels "driven to it." He started painting in 1983, encouraged by his father at Sunday evening family gatherings. His work is influenced in material and technique by his family, but his own unique style is developing. Black and gray dominate in his paintings; he is not a colorist like his sister Annie. He paints a variety of images such as birds and other creatures and also African themes. He writes titles on the backs of his work. Both titles and imagery reflect influences from his personal life and from his imagination. His work is in the permanent collection of the New Orleans Museum of Art; Marcia Weber/Art Objects has his art for sale.

Tolliver, Mose (1920–2006)

Mose Tolliver was born near Montgomery, Alabama, on the Fourth of July 1924, to a family of tenant farmers; he was one of twelve children. Mose Tolliver married in the early 1940s and had a large family. He had to go to work at an early age and received very little formal education. In the 1960s while working for a furniture manufacturer his legs were crushed in a work-related accident. Soon after the accident, Mose Tolliver taught himself to paint. He used wall or exterior house paints rather than artists' colors. His figures are flat, only partially representational, and sometimes explicitly erotic. His works are in major museum collections including the Smithsonian American Art Museum, the American Folk Art Museum, the Montgomery Museum of Art (which gave him his first solo exhibition in 1981), and the Birmingham Museum of Art. Many galleries have his work for sale. Check the index and the Galleries and Museums chapters for specifics.

Tolson, Donald Lee (b. 1959)

Donny Tolson, as he is always called, was born in Campton, Kentucky, one of the many children of the internationally famous wood-carver/sculptor Edgar Tolson. Danny is the only one who followed in his father's footsteps and is also an accomplished wood-carver. He is considered by some to be a better carver than his father. Donny has produced more than 200 carvings, most of them, like his father's, based upon Bible stories. He often carves out of poplar. He started carving as a young boy. His work is in the permanent collections of the Kentucky Folk Art Center and the Huntington Museum of Art; archival and oral history material on Tolson is in the Library and Archives of the University of Kentucky. Larry Hackley, private dealer, carries his art for sale. Tolson was in jail for a number of years for killing his brother, but is now out and participating in at art-related events. In September 2010 Tolson together with folk art historian and collector Larry Hackley presented a gallery talk at the Kentucky Museum of Art and Craft. In June 2013 Tolson was selling his art at Day in the Country at the Kentucky Folk Art Center in Morehead.

Tolson, Edgar (1904–1984)

Edgar Tolson was from Campton, Kentucky, and is considered by some to be the most important of the Kentucky wood-carvers. Edgar Tolson's work has been exhibited frequently and is included in a number of publications. In August of 1998, The Hopewell Museum in Paris, Kentucky, had an exhibition, "Edgar Tolson and The Campton School of Carvers." This exhibit included examples of the work of Edgar Tolson, Carl McKenzie, Donny Tolson, Earnest Patton, "and emerging artists showing the influence of the Campton School." His work and place in the field of contemporary folk art is the subject of a book-length study by Julie Ardery: *The Temptation: Edgar Tolson and the Genesis of Twentieth-Century American Folk Art.* Tolson's work is in the permanent collections of many museums, and can be purchased from Marion Harris, Fleisher/Ollman Gallery, and Larry Hackley, private dealer.

Toney, John Henry (b. 1929)

John Henry Toney lives in Seale, Alabama. A deeply religious man, he lives in a house trailer on the edge of a swamp. He is a neighbor of folk artist Butch Anthony who has encouraged him to pursue his art. Toney had been drawing a lot since he was very young, but when he was working in a cotton mill he drew a picture of his boss, and the boss didn't like it and fired him. With that discouragement, he quit until about 1994. Toney makes drawings and paintings in marker and paint that feature simple images embellished with recurring outlines and intriguing color combinations.

Marcia Weber/Art Objects, Orange Hill Art and Dos Folkies carry his work.

Townsend, Parks L. (1909–1991)

Townsend was born near Beech Mountain in North Carolina. He was a farmer who married and raised a family of ten children. In the early 1960s he went to Alexandria, Virginia, to work in construction for ten to twelve years. He then retired and returned to farming in Elizabethton, Tennessee, near Johnson City. When in his sixties, he suffered a broken hip in a car accident and was not able to do much physical work thereafter. Wood-carving became not only a pastime but a passion, and he created hundreds of items both functional and whimsical. Among his works are canes, walking sticks, weather vanes, pipe racks, religious symbols, farm, exotic and prehistoric animals, mythical creatures, ornaments, and his much loved "jumpin' jacks" (hand operated acrobats). Townsend's work was included in the book *By Southern Hands* by Jan Arnow.

Travers, Philip (b. 1914)

Travers was born in and still lives in New York City. He began drawing as a child. Travers tried a class at the Art Students League but found the watercolors used "too messy." He has created hundreds of detailed drawings with dense text. In 1984 he began producing a series of meticulously drawn and annotated stories he calls "The Tut Project." Sometimes the story seems random, but Travers says it isn't and is determined by astrological relationships. Throughout the chronicles, main characters such as Alice (as in "Wonderland") and King Tut appear frequently along with others representing Mistaire (Travers' French alter ego) and Disney characters Pinocchio and Jiminy Cricket, as well as biblical characters, mythological figures and characters drawn from popular culture. Travers produces most of his work at a senior center in New York. His art was included in the 1997 exhibition "Flying Free."

Traylor, Bill (1856–1949)

Bill Traylor was born into slavery on the George Traylor plantation near Montgomery, Alabama. He spent the later years of his life in Montgomery. The first record of his residing in Montgomery is dated 1936. His famous drawings, which have been described in great detail in many sources, were discovered by artists connected with the New South School and Gallery. Although the date "1947" is usually given for his death, compelling information from his living family members, discovered by Miriam Fowler of the Alabama State Council on the Arts and Marcia Weber, Montgomery gallery owner, indicates that the correct date is 1949. His work is in the permanent collections of many museums, and a surprising number of galleries

still carry his work. Check the index and the Galleries and Museums chapters for specifics.

Treiber, Beverly (1921–1996)

Treiber took up painting at age 65. Working with the staff at the National Institute of Art and Disabilities, he created stunning abstract collages and collage prints from all manner of odds and ends: scraps of floral printed fabric, yarn, textured paper and cardboard, cigarette packs, envelopes, postcards, discarded paintings, magazines, newspaper pages, and colored tissue paper. Like the overlapping layers of colored tissue on his collages, the layers of colored ink he applied to his prints give a luminosity and depth to his abstract forms. Treiber came to NIAD in 1986 after having been in institutions for people with developmental disabilities most of his life. He lived in a board and care home until his death, and liked attending church on Sundays and walking around town to chat with friends he made in various stores. He wore hats of various vintages and adorned himself with advertising and political buttons which he pinned in great quantity to his hats, shirts, and jackets. "The effect is rather like a walking collage." NIAD still has his work for sale.

Tripp, Billy (b. 1955)

Tripp lives in Brownsville, Tennessee, where he was born and where he has lived his whole life. When he was young, Tripp used to sit in the fields behind his house, letting his mind wonder and think of many things, stimulated by the fields and sky. This activity prompted the name he has given his installation—a massive and still growing structure of steel girders, fire towers, a cotton tanker, parts of a drive-in movie, metal banners with text that Tripp sees as his epitaph, and much more. Tripp's family owns several properties on one of Brownsville's main streets, which includes a narrow lot for which there wasn't much use. His father gave Tripp this lot to create an installation, which Tripp began in 1989. In keeping with one of the family businesses, which was welding, Tripp developed his enormous installation out of steel, as a memorial for his parents and, ultimately, himself. One side of the site includes wooden signs bearing some information about the site, thoughts for the day, comments on current events, and similar things. Mindfields has been written up in *Roadside America* (http://www.roadside america.com/tip/7403). Tripp has also written a book, *The Mindfield Years*, a novel in which he depicts his life through the voices of three main characters and their efforts to find meaning, purpose, and contentment in the existence to which they were born. Written in stream of consciousness style, the novel contains elements of short story, poetry, philosophy, and psychology intermingled into a multi layered yet deceptively simple tale.

Tumlinson, Matt (b. 1988)

Matt Tumlinson is a self-taught artist currently residing in San Antonio, Texas. Growing up in the small town of Early, Texas, Tumlinson constantly practiced his skills with whatever medium happened to be handy. It was only after a sojourn on Nantucket Island that he began to pursue his artwork fulltime. His pieces are a direct reflection of his Texas upbringing, historical sentiment, and an artistic eye. His latest project features what he calls "Brass Canvas." Each piece is composed of several thousand spent 9mm and .40 caliber pistol cartridges. Each casing must be positioned and secured before the final image is painted on the base. Tumlinson's idea to create artwork from used bullet casings was the result of few summers spent working at his uncle's gun range in South Texas. The topic of firearms elicits much debate in our society, he says, and the idea that a small piece of metal is capable of invoking such a deep emotion is very intriguing to him. A spent casing is the punctuation of a whole story preceding it. Tumlinson intentionally pairs these casings with images that have a very symbolic and provocative, nature. These images are capable of encompassing a whole idea, frame of time, way of life, and a story that would take up volumes to express in writing. They beg viewers to add their own understanding to their response to the piece. Tumlinson's work is available through San Angel Folk Art in Santa Fe, and through his website, Tumlinsonart.com. One may also call or email him (325-647-9247, matt.tumlinson@ yahoo.com).

Turner, Cleveland (1935–2013)— "The Flower Man"—Houston, Texas

Cleveland Turner was born near Jackson, Mississippi. His parents were farmers. He was raised by his aunt, who taught him to be a gardener. At the age of 23 Turner moved to Houston and found work at a sheet metal fabricating plant. He also found wine and drank himself out of a job and almost out of a life. After a severe bout of alcohol poisoning, Turner made a pact with God: if God would help him stay sober, Turner would use his time to make a place of beauty. After turning one place into a "magical garden," vandals set fire to his house. Turner destroyed what was left of the garden in a powerful rage and cried for days. Then he moved a mile or so away and eventually was able to start over again. Turner's new garden covered every inch of his 700 square foot yard, spilling out into the ditch in front and to the street beyond, and he packed every conceivable flower into an incredibly small space. Pictures of personal heroes, shapes and colors he liked, and mementos of his boyhood in Mississippi dot the side of the house. The Houston Chronicle published an article, with photographs of "A final goodbye to the Flower Man" (Sunday February 6, 2015). James Rob

bins rides the bicycle of Turner in a parade of artists and friends of the artist to celebrate the life of the Houston folk artist. His colorful house was razed Saturday, February 8, 2015. The Orange Show Center for Visionary Art, which makes every attempt to restore and preserve Houston's unique folk art environments, sadly agreed that the house and garden could not be saved. The house was ruined by Hurricane Ike, and the garden would have needed the constant care and attention that Turner lavished on it. The Orange Show Center has extensive documentation of the site in its heyday.

Turrell, Terry (b. 1946)

Turrell was born in Spokane, Washington, and now lives in Seattle. He attended North Idaho College for two years before moving to San Francisco to work as a laborer from 1966 until he moved to Seattle in 1976. At that time he began making leather handbags and batik wall hangings to sell at the Pike Place Market. He sold his own hand-painted T-shirts at the public market, too. He began to pursue his art in 1986. He taught himself to sculpt and paint. He creates art that is part wood sculpture, part painting. He uses paint, materials used to fill in dents in cars, Bondo, metal, cheesecloth, and dirt. A writer has called Turrell's work "reminiscent of prehistoric or tribal art." Recently he has been concentrating on paintings. His work is available from American Primitive Gallery, Garde-Rail Gallery, and Mason Murer Fine Art.

Tyler, Valton (b. 1944)

Tyler is a self-taught artist from Texas City, Texas, who now lives in Dallas. He has been referred to as "an unconscious surrealist." His paintings often contain strange creatures stalking about in very bright colors. Others are machines with no known use. Sometimes the machines have wheels and sometimes they wear hats or sprout hands. He has received much positive critical attention. There is a YouTube video about him (www.youtube.com/watch?v=wwwppmOSjUA); his work is available from Valley House Gallery in Dallas.

Tyler, William (b. 1954)

William Tyler was born in Ohio and has worked at Creative Growth Art Center since 1978. The staff there says, "Tyler is a reflective dreamer and wonderer with a prodigious memory for significant dates, events, and symbols. He is very interested in magic and illusion as well as the uncertain boundary between make-believe and reality." Tyler's artwork has been included in many exhibitions throughout California. He works in many different media. "His pieces are ordered and precise, and demonstrate his measured control over the materials. Tyler's art draws liberally on his personal experiences and his fascination with illusion. In his work

Tyler creates a symbolic place where make-believe and reality are equally powerful, but order reigns over emotion." His work is available at Creative Growth Gallery in Oakland, California.

Van Maanen, Gregory (b. 1947)

Van Maanen was born in Paterson, New Jersey, the son of a working-class family. He was drafted right out of high school in 1968 and wounded in Vietnam in 1969. He returned to the United States a committed pacifist. He began to paint and sculpt in 1971. His large pieces, often monochromatic and dominated by skulls, are quite powerful. He has developed a personal and powerful visual vocabulary. His small paintings, intimate in scale, are "suffused with a strength that belies their size; there are evocations of sorrow and death," according to his dealer Cavin-Morris in New York. His work is in the permanent collections of the New Orleans Museum of Art and the Milwaukee Art Museum.

Van Savage, LC (b. 1938)

Van Savage was born on Staten Island, New York, and lives in Brunswick, Maine. She began to paint as a child, but was ridiculed by her parents for her primitive style and funny paintings. Her serious attention to painting did not begin until she married and left home. Van Savage paints scenes of everyday life but with a humorous touch. Her style is childlike and naive, but her message is strong and mature. She paints on Masonite with primary and bright colors. Subject matter is generally people in situations that sometimes seem normal and mundane, but she brings out the human emotion, humor, and joy possible in each, presenting her unique views of human life. "She is a delightful person whose love of life, joy, and wonderful sense of humor show through in her work. She is self-conscious about it because of the early criticism she received." Van Savage maintains her own Facebook Page. In addition, her work may be ordered through Galerie Bonheur.

Van Wie, Carrie (1880–1947)

Born and died in San Francisco. She made sketches and paintings, mostly of architectural landmarks of San Francisco at the turn of the century. Her works have great appeal and may be seen in the book *The Wonderful City of Carrie Van Wie: Paintings of San Francisco at the Turn of the Century*, by Edwin Grabhorn (San Francisco: Grabhorn Press for the Book Club of California, 1963). Her art was included in the exhibition "Cat and a Ball on a Waterfall." Thirty-eight of her paintings are in the collection of the Oakland Museum of California.

Van Zandt, Frank *see* Chief Rolling Mountain Thunder

Varick, Louis "Thai" (1941–c2006)

Varick was born in Manhattan and grew up in Brooklyn, New York. Varick makes "intricately rendered wire sculpture" that are "lacy evocative horses, fish, whales, dinosaurs and unicorns out of tenacious wreaths of steel." His signature piece is his horse figure, in a variety of poses. Within each figure is usually a heart. He lived on the street and his "substance abuse" made it hard for him to maintain relationships with those willing to promote his art. His work has been compared to that of Alexander Calder. It "has sophistication, but at the same time it's innocent, naive, compelling," says Jay Potter, a collector in New York and the foremost expert on Mr. Varick's work. "The strands of wire he uses are like his stream of consciousness. There's a rawness to it, maybe indicative of his struggle on the streets." His work is in many private collections and is documented in the High Museum book, *Let It Shine: Self-Taught Art from the T. Marshall Hahn Collection.* Those interested in Varick's work should contact Jay Potter, jayspotter@gmail.com, who still has quite a bit of it available.

Virgous, Felix (b. 1948)

Virgous was born in Woodstock, Tennessee, and now lives in South Memphis. Virgous, known as Harry, grew up and lived across the street from the prolific Vernacular artist, Joe Light. Inspired by Light's brightly decorated house and yard, Virgous decorated an old shed in his backyard with his collages, paintings, and carvings, and called it the "Harry Club." Most of his images are stories from the Bible, in which Virgous depicts flat figures using vibrant, saturated colors. Virgous was discovered by artist Lonnie Holley in 1987 and has shown his work around the country. He combines images from biblical stores with images from black popular culture. He draws with pencil and markers and paints with acrylics on paper and plywood. His flat figures and limited numbers of very bright colors gives his work a "graphics" look. Virgous was included in the exhibition "Fundamental Soul" at Rockford Art Museum in Rockford, Illinois, in 1996, and in the book *Souls Grown Deep.* Anton Haardt Gallery carries his work, which is also in the permanent collections of the Birmingham Museum of Art, the Columbus Museum, and the Virginia Union University Museum, in addition to the Rockford Art Museum.

Vivolo, John (1886–1987)

John Vivolo was born in Acri, Italy. When he was fourteen his father had managed to save enough to send him to America. He was a baker, a butcher, mason, and dynamiter. He built his own home and designed a crude windmill to provide electricity and running water for his growing family. The death of his wife in 1931 left him with seven children to raise alone. In 1950 he bought land in Bloomfield, Connecticut, and built the house he was to live in for the rest of his life. Vivolo retired in 1957 and started carving because he couldn't stand being idle. Soon the wooden figures he called his children filled his house. He painted some figures, which progressed from dull in tone to very bright. He also made large whirligigs that were meant to be placed out-of-doors. In 1976 Ken Laffal published *Vivolo and His Wooden Children.* The Smithsonian American Art Museum has his work in its permanent collection.

Von Bruenchenhein, Eugene (1910–1983)

Von Bruenchenhein was born in Marinette, Wisconsin, but lived the greater part of his life in Milwaukee. His mother died when he was seven. His father was a sign painter and his stepmother painted on canvas. It is speculated that he may have learned from them at an early age. For about forty years he worked obsessively in virtual isolation, producing thousands of artworks including paintings, sculpture, and photographs. An excellent source for information about his life and work is *Eugene Von Bruenchenhein: Obsessive Visionary,* by Joanna Cubbs. In 1998 the Fleisher/Ollman Gallery in Philadelphia published *Ceramic Sculptures: Eugene Von Bruenchenhein,* a catalog with many color plates that accompanied their exhibition of his works in clay. His work may be seen at the John Michael Kohler Arts Center in Sheboygan, Wisconsin, which has more than 250 pieces of his work including paintings, chicken-bone towers and thrones, ceramic crowns, photographs, and huge, tinted concrete heads. The Smithsonian American Art Museum, Akron and Philadelphia Museums of Art, and the Milwaukee Art Museum also have his work in their permanent collections. Andrew Edlin Gallery in New York, Fleisher/Ollman Gallery in Philadelphia, Carl Hammer and Karen Lenox Galleries in Chicago, and Dean Jensen Gallery in Milwaukee have his art for sale.

Vuittonet, Louis (b. 1943)

Vuittonet was born in Texas and calls himself French-Mexican. He moved to California in the early 1960s, and now lives in Fresno. He has "dabbled in art for as long as I can remember." He uses acrylics, oils, ink, layers of newspaper, tape, house paint, spray paint, and a wide variety of other elements, on all types of materials. His finger tips are his main brushes although he does use brushes for detail. He sells his art through his website, www.louis-vuittonet.com, and at is house, 7804 E. Hammond, Fresno, California 93737. He may be contacted through his website, his email (s4-3art@yahoo.com), or by phone (559-360-8909).

Wagner, Albert (1924–2006)

The Rev. Albert Wagner was born in Arkansas and

lived in Cleveland, Ohio, where he moved with his mother and brothers at the age of seventeen. Wagner was a self-taught artist and preacher living in the inner city, where he worked to change the lives of those living in the community. "I had wanted to paint since I was five years old, but there was nothing, not even an old piece of cardboard, to work on … but I could not be bitter with anyone because what seemed to have been lost has all come to pass at its proper time." His paintings and assemblages done over the last twenty-five years of his life address the human condition, his difficult life, and the struggles of African Americans. His work is in the permanent collections of the American Visionary Art Museum in Baltimore and the Museum of Contemporary Art in Cleveland.

Wagner, Jerry (b. 1939)

Wagner was born in South Providence, Rhode Island. His father was a tailor and had a great influence on Wagner's life. As a child Wagner loved radio programs and became deeply inspired by the music of Fats Domino, Little Richard, and Elvis Presley. He became a musician himself, performing at various venues in Greenwich Village in the late 1960s as an acoustic blues guitar player and singer. He studied the Torah seriously in 1971 but, deciding he "didn't have what it took to be a rabbi," he left the yeshiva and started walking—from Maine to Connecticut, from Miami to the Mississippi Delta, and from San Diego to Monterey. In 1977 he became very ill and underwent several major operations. He began to keep detailed journals and used his art as a means of self-control, never intending to show it. He maintains the pattern of daily activities begun in those days, going to a favorite spot alone, where he observes, meditates, writes, draws, carves, composes collages, and practices t'ai chi chuan. He says his art "allows me to integrate my thoughts and to be critical and deliberate. I take the scenes from earlier drawings and let them evolve. I move to new styles as the drawings seem to move me. I do things over and over. It takes years for me to finish things." But he has finished things—hundreds of drawings, annotated collages, wood carvings, and assemblage sculptures. His compositions are often abstract and enigmatic; many are intended to be viewed from multiple angles. Over the years his art has been featured in numerous shows, including at Intuit (2011), Cavin-Morris Gallery (2006), and Island Arts (1997). Wagner's work is available through George Jacobs, private dealer.

Wagner, Father Philip J. (1882–1959)—"Grotto and Wonder Cave"—Rudolph, Wisconsin

Father Wagner built a Grotto Wonder Cave with a maze of walkways and a series of biblically inspired scenes made of sheets of tin with proverbs spelled out in pin-holes, backlit by colored lights. The "cave" is not real, but is rather a conceptual representation. After Wagner's death, his coworker and fellow builder Edmund Rybicki, once a young student of Wagner, continued with renovation and building until his own death in 1991. The grotto is on the parish grounds of Saint Philip the Apostle Church in Rudolph, Wisconsin; it is still thriving, and may be visited. The site is described in *Sacred Spaces and Other Places* by Lisa Stone and Jim Zanzi. The SPACES website has extensive documentation of the site, and archival materials may also be found in the Museum of Wisconsin Art and the John Michael Kohler Art Center. There is also a piece about the Grotto on Detour Art.

Wainwright, Donald

Donald Wainwright, also known as Christian Sandoval, was born on the East Coast sometime in the late 1920s. Friends whom he met when he lived in California in the 1960s are his family. He lives now in an isolated area in the mountains near Taos, New Mexico. In the early 1970s he began to create "slab figures" to surround his home. These were abstract constructions created from discarded pieces of wood, layered and nailed together. "His nearly life-size constructions of horses, musicians, checker players, and birds in flight reflect his humor and artistic efforts to create an environment for his own company and entertainment," according to an announcement for the Intuit-sponsored exhibition "Christian's People," which opened in the fall of 1998. The whole environment was purchased and resold to dealers. For a time the creator was called Christian Sandoval, to protect the reclusive artist. Later his true name became known. He no longer makes the sculptures.

Walker, Arthur (1912–1995)

Arthur Walker was born and raised in Sullivan, Illinois, along with six brothers. A builder and carver, he created over 1,000 works. Walker was an avid traveler, and many of his works are inspired by what he saw far from home. He made many different images including fish, horses, wagons, merry-go-rounds, pigs, owls, Indian families—all done with style and craftsmanship. His work may be seen at the Tarble Art Center in Charleston, Illinois.

Walker, Donald (b. 1953)

Donald Walker was born in California and has lived in the San Francisco Bay Area all his life. He spends most of his time enthusiastically drawing and painting, using whatever paper comes to hand, from computer paper, to menus and schedules, to scraps of cardboard—often using both sides of the page. He will use any drawing materials that are available: pencil, oil pastel, marker, or watercolor. Faces and truncated figures

are Walker's most frequent images—the lower torso or legs never seem to be part of the drawing. He also draws an occasional building, animal or car, and sometimes fills the paper with boldly colored, segmented shapes. Walker frequently uses letters and numbers as part of his imagery—sometimes a single letter ("A" is a favorite) is repeated many times to form a compact mass around a profile or shape; at other times "splashed" as if by the bold stroke of a brush. Whether using cursive or printed letters, Walker's placement of them seems quite deliberate. In addition to the letter "A" the numerals "4" and "5" are favored, but rarely does any recognizable word or pattern appear. The Ames Gallery has represented Donald Walker since his introduction in 1992 and still has some of his pieces available.

Walker, Inez Nathaniel (1911–1990)

Walker was born into poverty in Sumter, South Carolina. She eventually moved to New York State and spent most of her life as a migrant farmworker. Imprisoned for killing a man who abused her, she began to draw while in the Bedford Hills Correctional Institution. Her drawings are in pencil, colored pencil, and felt-tip marker. The subjects are usually women. The heads are large, with bodies proportionally smaller. The hair is elaborately detailed, and the drawings include lots of patterning. Numerous detailed accounts have been written of Walker's sad life. Her work is in the permanent collections of the Smmithsonian American Art Museum, the High Museum, the Museum of International Folk Art, the Milwaukee and Miami University Art Museums, and the Columbus Museum of Art. The Ames Gallelry, Marcia Weber/Art Objects, Ridgefield Gallery, Raven Arts, and Larry Hackley, private dealer, have her work for sale.

Walker, Milton (1905–1984)—"The Walker Rock Garden"—Seattle, Washington

The Walker Rock Garden, at 5407 37th Avenue, S.W., Seattle, Washington, was created by Boeing mechanic Milton Walker and his wife Florence between 1959 and 1982. The Garden is a series of towers, walls, miniature mountains, lakes, paths, fountains, a patio, and fireplace, all built with semi-precious stones, rocks, crystals, geodes, and chunks of glass. Walker worked nonstop until 1982 when Alzheimer's disease made work impossible. His wife, Florence, had noticed he was beginning to have problems, "but when he told me he didn't know how to make an arch, then I knew what was wrong." Mrs. Walker, during a visit in 1997, said the inspiration for the work was to entertain the young people in the family. The garden has been available to visitors, but its future is in doubt. The property was sold in 2011, without stipulation that any buyer

maintain the garden. Even before the sale, the bank behind the gardens was collapsing and sliding down the hill, consequently city officials roped off the back of the garden. Blog posts indicate that the garden was still there in late 2013, but that it had fallen into disrepair and also that it was again on the market (for about $200,000 more than the 2011 sale price). It may or may not still be there.

Wallis, Josephine (b. 1959)

The artist, known as "Wallis," was born in the Outback of Australia and raised on a 600-acre farm. She and her six sisters were members of a family musical group. Beginning with church socials, the "Wallis Sisters" went on to national prominence, performing weekly on television. Eventually they came to the United States and toured the country with their aunt who was a star of the musical *Oliver!* Along with her musical talent, Wallis always liked to draw. These two talents have merged in recent work. Wallis paints austere and arresting portraits of blues musicians on found objects and old cabinet doors. The artist loves to travel about the country on the Greyhound bus, stopping to live when she finds a place she likes. She has lived in the South and in Mexico on and off for many years, and now considers Oaxaca, Mexico her home base. She sells her own art through her email, wallisjoart@hotmail.com. The House of Blues has a number of her pieces.

Walters, Hubert (1931–2008)

Walters was born in Jamaica, immigrated to New York in 1970, and later moved to Troutman, North Carolina. He was a commercial fisherman for 25 years and built his own boats. He and his wife were also textile workers. Later he was in business for himself, operating a small concession. Walters sculpted people, animals, or boats which he sometimes embellished with found objects. His scrap material boats are constructed of wood, string, plastic and Bondo. He usually painted them white, black, and red. He used sheet metal, wood, and auto body filler, painted with waterproof paint, to make other objects such as heads, clocks, horses and cows. He later added yellow, brown, and blue to his palette. In addition to his sculpture he painted pictures of boats, bridges, buildings, landscapes, and often solitary people. His work was included in the exhibition "Signs and Wonders." In 1997 there was a one person exhibition of his work at the Diggs Gallery in Winston-Salem, North Carolina. His art is in the permanent collections of the Birmingham and New Orleans Museums of Art, the House of Blues, the Cameron Art Museum, the Art Museum of Southeast Texas, and the African American Museum of Dallas. Cotton Belt Gallery and San Angel Folk Art have his work for sale.

Walunga, June (b. 1949)

Walunga was born in the Eskimo village of Sivuqaq (Gambell) on the western edge of St. Lawrence Island in the Bering Sea. Her father, a member of the Avatmii Clan, rode in the great skin boats between Siberia and western Alaska just before the U.S. border with the U.S.S.R. was closed. Her mother's traditional design work and artistic expression have appeared for years in sewing and beading craft, and drawings on bleached skins. Walunga was raised in a traditional Siberian Yupik culture until the time when she left the island for schooling. Walunga is a woman of two worlds. She mastered the traditional skills and customs of her people when she was quite young, and as someone with a spirit for adventure and knowledge, she has enjoyed years of sport parachuting and has traveled extensively outside the United States. She has worked in many facets of Alaskan life, including staff work with the Alaska legislature, hairstyling, apprenticeship as an electrician on the Alaska pipeline (as one of the first women apprentices), and, throughout her career, as an accomplished artist. Walunga's natural artistic talents, evident since childhood and self-developed, are expressed in her oil paintings and drawings that depict the marine environment in which her people have prospered for more than 10,000 years. She paints animals, sea creatures, birds, and landscapes. Interested persons may write to her at P.O. Box 193, Gambell, Alaska 99742.

Ward, Velox (1901–1994)

Ward was born on a farm in Franklin County in eastern Texas. He was named after his mother's German-made sewing machine. He began painting in 1960 at the request of his three children. Many of his canvases are based on remembrances of his early years, recollections of his childhood, and photographs. He often made paper cutouts, which he then traced on the canvas before painting "in order to obtain the perfection he sought." He was included in the exhibition, "Spirited Journeys: Self-Taught Texas Artists of the Twentieth Century." His work is in the permanent collections of the Museum of Modern Art in New York and the Art Museum of Southeast Texas, and is available through the Valley House Gallery and David Dike Fine Art, both in Dallas.

Ward, William "Wibb" (1911–1984)— "Bear Park"—Sand Lake, Oregon

William "Wibb" Ward created a five-acre environment populated by bears which he carved from pine logs using a chain saw. Many of the bears were used to illustrate his personal beliefs, especially that government should stay out of the way of private business. The bear park is maintained by Ward's daughter. Visitors are welcome; vandals are not.

Warfel, Floretta Emma (1916–1993)

Born in Dushore, Pennsylvania, Warfel began painting around 1952 at the suggestion of a neighbor. Using ballpoint pens, tubes of embroidery paint, and often cloth instead of canvas, she constructed vibrant colorful landscapes, which are usually quite cheerful. The *American Folk Art Museum Encyclopedia of Twentieth-Century American Folk Art and Artists* provides details about her personal history and her art. Outsider Folk Art has pieces of her art for sale.

Warhola, Paul (1922–2014)

Andy Warhol's last surviving brother, Paul Warhola, was the first of the three Warhola brothers, each birth separated by three years: John born in 1925, Andy in 1928. Paul was also their parents' first child to live beyond infancy, born in Pittsburgh within a year of their mother's arrival from the village of Mikova in what is now the Slovak Republic. With Andy's untimely passing in 1987, Paul began to take up painting, and showed silkscreened images of a photo of himself and Andy in their youth, as well as images of Heinz Baked Beans cans, riffing on Andy's subjects and techniques. He also invented a novel means of applying paint, using chicken's feet rather than a brush; their stamped impressions evoke his semi-retirement to a farm in Fayette County. His son James also used him as a model for characters in several of his children's books.

One of Paul's stories of their childhood is perhaps apocryphal, but bears telling. During the disastrous St. Patrick's Day flood in 1936, the Warhola boys heard the rumor that the Clark Candy Company's factory on the North Side of Pittsburgh was underwater, and crates of their sweet stuff were floating away. As the flood receded, the boys walked from their home in South Oakland to downtown. As they crossed the 7th Street Bridge, Andy began to complain that his feet hurt. Paul promised they would rest when they reached the other side, and they sat on the steps of the Frick & Lindsay Company at 117 Sandusky Street, where Andy removed his shoes and rubbed his sore feet. In 1994, that building became The Andy Warhol Museum (one of four Carnegie museums in Pittsburgh), and the bridge is now the Andy Warhol Bridge. In 1943 Paul married his wife Anne, and then served in the Navy in World War II; after 71 years of marriage their family counted seven children (one of whom, James, followed in his famous uncle's footsteps as an illustrator of children's books), twelve grandchildren, and seven great-grandchildren. Warhola and his extended family have been supporters of the Andy Warhol Museum and its programs, especially the Carpatho-Rusyn days celebrating the family's ethnic heritage. Paul Warhola's own art may be seen at the Westmoreland Museum of American Art in Greensburg, Pennsylvania, the Washington County Museum in Hagerstown, Maryland, and the Castellani Museum in Niagara University, New York.

Warmack, Gregory *see* **Mr. Imagination**

Warren, Henry (1883–1978)—"Shangri-La"—Prospect Hill, White Rock, North Carolina

With the help of neighbor Junius Pennix, Henry Warren converted a corner of his large yard into a miniature village. They built 27 white quartzite buildings and decorated the pathways from the miniature village to his house with arrowheads embedded in cement, creating a mosaic-like pattern. After Warren died, his wife and sister continued to maintain the environment in White Rock, North Carolina. It is well documented on the SPACES website and was featured on Roadside America. The environment still exists (as of 2015) but has been deteriorating since Warren's wife died, but is still viewable from old Route 86, about 3 miles south of the intersection of Route 119 in Prospect Hill.

Watford, Arliss (1924–1998)

Arliss Watford was born in Winton, North Carolina. He was a bricklayer and a worker at a shipbuilding dry dock in Newport News, Virginia, before he opened a repair shop and junk store in eastern North Carolina after World War II. In the early 1980s he began to concentrate on carving, what had been just a pleasurable pastime before. Watford always credited the late collector Robert Lynch for encouraging him to create art. He made wood-carvings, often from cedar. He created a variety of figures, all very precise and clean. His three major themes were hard times during the Depression, religion, and likenesses of famous people. Sometimes the works were painted and other times not. He lived in Ahoskie, North Carolina, and his work appears in the catalog *Signs and Wonders* (1989) and in *Black History and Artistry* (1993). Mr. Watford died July 1, 1998. His work is in the permanent collections of the Robert Lynch Collection of Outsider Art at North Carolina Wesleyan University and at the Diggs Gallery at Winston-Salem University.

Watson, Willard (1905–1994)

Willard Watson was born in Deep Gap, a mountain community near Boone, North Carolina. He spent his work life doing many hard tasks such as coal mining, logging, stonemasonry, and carpentry. He retired at age sixty and started carving wood, using curly maple, black walnut and black cherry. He made miniatures of pre-mechanized farm implements, furniture, and toys with movable parts. He also carved animals and chickens. Watson was first cousin to musician "Doc" Watson, and his wife Ora was called "one of the great quilters of the mountains" by Charles Kuralt. The Watsons'

lives included the knowledge of how to make everything you need, roots and herbs that were about as good as anything chemical companies have invented, and the importance of neighbors and community. Willard Watson is included in *Signs and Wonders* and Jan Arnow's *By Southern Hands*. He and Ora are written about in *Charles Kuralt's America*. His work is in the permanent collection of the Museum of International Folk Art, and his papers and other documents are in the Smithsonian Institution Archives of American Art.

Watson, Willard "The Texas Kid" (1921–1995)—Environment and Art—Dallas, Texas

Willard Watson called himself "The Texas Kid" and frequently dressed in cowboy hats, boots, and fancy shirts. He began decorating his Dallas yard in 1970; his front yard was a forest of found objects and sculpture. He also made objects to sell. His initial constructions offended his wife, Elnora, and the neighbors, who circulated a petition to get rid of the mess. He says, "at first they wouldn't speak to me at church on Sunday, but now everybody comes by and takes pictures and appreciates the yard." Watson attributes his unique design sense to his background of Choctaw, French, and African. Elnora Watson helped with the work, saving chicken bones (an important material in his artwork) and sewing clothes for some of the more risqué sculpture. Watson made a distinction between the yard decorations and his artwork (with the chicken bones). Watson eventually became a celebrity with lots of attention from movie stars, musicians, and the Dallas art scene. After his death, the yard was dismantled and the pieces sold at auction. There are photographs in books such as the catalog for the exhibition "Spirited Journeys: Self-Taught Texas Artists of the Twentieth Century." Watson was included in the Rosenaks' *Contemporary American Folk Art: A Collector's Guide*. His work was in many exhibitions in Texas and elsewhere, as documented by the African American Visual Arts Database (aavad.com/.artistbibliog.cfm?id=1532). It is occasionally available through auctions.

Watt, Bob (1925–2012)

Bob Watt started out his adult life as an "underground poet." Watt lived in Wisconsin and was described as "very eccentric." His first ventures into art were constructions of doll figures that stretched from floor to ceiling, which he made from trash found while searching through people's trash cans. His house was filled with them. He also did "about 500" paintings. All of this was lost in a house fire. He moved to a house on Dousman Street—that already had a yard filled with paintings and sculpture—and started over. He found old paintings at garage sales and painted Amer-

ican Indian images over what was there. In addition he made books filled with collages of his paintings, which he cut into pieces for the purpose, and photographs of women holding the paintings with the photographs cut into pieces, too. Those who knew him described him as a "very original person." It is unclear what is happening with his remaining work and the contents of his home. There is a blog about him that includes a short video at outsidersandintuits.blogspot.com/2009/07/bob-watt.html and various newspaper articles that mourn his passing.

Way, Melvin (b. 1954)

Melvin Way is from South Carolina. He moved to New York City with his family when he was young. In his early years he expressed his creativity playing music. He played woodwinds and percussion in jazz and rhythm and blues bands. He later worked as an industrial machinist and as a chauffeur before entering a program for homeless people in New York City. Way creates his drawings on scrap pieces of paper that he works intensively, usually in ballpoint pen. Carrying the papers in his pockets, he often folds and tears the drawing. His drawings recall chemical formulas, hieroglyphics, or unique languages that appear to be forms of cryptic communication. Way takes part in the HAI program, which carries his work. Way's art is also available from Just Folk in Summerland, California.

Webb, Mona (1914–1998)

Born Nevelle Ruth Boyce in Houston, Texas, Mona grew up in a cultured, middle class family of African, Apache, Portuguese, and Scottish ancestry. Mona's mother was a teacher and concert pianist and her father was the founder and pastor of Houston's first black Presbyterian Church. As the firstborn of eight, Mona was given a boy's name, "Nevelle," and raised as a tomboy until she grew into a graceful and intellectual beauty, determined to become a medical doctor. She attended what is now Hampton University in Virginia and there met and married a prominent professor and author, Marcus H. Boulware. The birth of their first child interrupted her studies, but even without a degree, Mona went on to teach biology, ballet, and to serve briefly as dean of women at St. Augustine's College in Raleigh, N.C. She liked to say "I never go the M.D., but as an artist I did fulfill my dream of becoming a brain surgeon!" She lived the life of a respected professor's wife and gave birth to three more children. After hearing headline news of the brutal, racially-motivated killing of young Emmett Till in 1955, Mona left her husband and gathered her two sons and two daughters and moved with them on her own to Mexico City. There, she felt free from the confines of academia and quickly became a major force in a very international and more kindred circle of creative free thinkers that included Krishnamurti and Aldous

Huxley. Mona was also inspired by the vibrancy of Mexican culture, its textiles, and the revolutionary paintings of Diego Rivera and Orozco. In the early 1960s, Webb returned to the United States to settle in Madison, Wisconsin. Divorced from Boulware, Mona briefly married a far younger man who was an heir to the Vanderbilt fortune. She soon founded and opened "The Wayhouse of Light" in an historic, three-story building. For the next thirty-plus years, Mona poured her creativity into every inch of this structure, filling her house with creative people, music, discussions, and her very particular spiritual and artistic vision of God and Goddess as expressed in many forms. Niels Nielsen's award-winning documentary, *The Gods of Beauty*, captures Mona in her Wayhouse, surrounded by her art. In 2010, Edgewood College mounted an exhibition of Webb's work, "Treasures from the Mystic Wayhouse Gallery," which presented 28 of Webb's paintings. The exhibition explored how her gestural style was expressed in her portraiture. She left behind an impressive collection of portraits when she died. These portraits document the faces of important contributors to the vibrancy of Madison's creative community, as well as express an urgency and power noteworthy among many untrained artists. Examples of her work are in the permanent collection of the American Visionary Art Museum, which included her art in several of its exhibitions. Webb's daughter Cookie Martin Smith is the "keeper of the flame" of her mother's legacy and still has numerous examples of Webb's paintings and sculptures. She may be contacted for further information.

Webb, Troy (1926–2000)

Webb lived in Hamlin Town, Tennessee, just across the border from Kentucky. He started working in the coal mines when he was fourteen and did not stop until he was nineteen when he lost his right leg in an accident. Though they told him his days in deep mines were over, eighteen months later he returned and continued to work another twelve years. He started carving during the time he was recuperating from the loss of his leg. Although he once made animal shapes, he was later known more for his human forms—"coal miners and their wives," he said. He mostly used buckeye and carved with a knife. The sales shop of the Museum of Appalachia in Norris, Tennessee, carries his work. Many other family members make the "Webb Family Dolls," too.

Webster, Derek (1934–2009)

Webster was born in Porto Castillo in Honduras and came to the United States in 1964 to visit his sister, then decided to stay. He had a wife and a daughter. He started working as a maintenance man, producing no artwork of any kind until 1978 when he bought a house. This sparked an urge to decorate the house and

yard with creations from his imagination. He used pieces of wood and objects thrown away by others to make elaborate constructions. In addition to his imaginary creatures, Webster also carved small animals. His work was included in *Black Art: Ancestral Legacy—The African Influence in African-American Art* that originated at the Dallas Museum of Art. In 2004 he had a one-person show at Chicago's Intuit: the Center for Intuitive and Outsider Art, for which there is a catalogue: *Vibrant Spirits: The Art of Derek Webster*. His work is in the permanent collections of the Smithsonian American Art Museum, the Birmingham Museum of Art, the Milwaukee Art Museum, the African American Museum of Dallas, and the Baron and Ellin Gordon Galleries at Old Dominion University. Marcia Weber/Art Objects, Main Street Gallery, Judith Racht Gallery, San Angel Folk Art, Webb Gallery, and Raven Arts carry his work.

Webster, Fred (1911–1998)

Webster was a retired high school principal who lived in Berry, Alabama. He had whittled for many years but in later years he had to work at a far faster pace because his work was in such demand for collectors. He especially enjoyed visiting primary schools to show his work to children. Webster's sculptures are hand carved with a pocket knife and painted with ordinary house paint. The wood is mostly southern pine drawn from scrap pieces in his shed. He constructed painted carved-wood pieces mostly assembled to tell biblical and other stories. He is written about in the book *Revelations: Alabama's Visionary Folk Artists*. His work is in the permanent collections of the Birmingham and Taubman Museum of Arts, the Fayette and Mississippi Art Museums, the Columbus Museum, the Art Museum of Southeast Texas, and the Montgomery Museum of Fine Arts. Anton Haardt Gallery, Cotton Belt Gallery, Marcia Weber/Art Objects, Just Folk, and Mason Murer Fine Art carry his work.

Wegner, Paul (1864–1937) and Matilda (1867–1942)—"Grotto"—Cataract, Wisconsin

The Wegners and their son, Charles, left Germany in 1886 and settled in Wisconsin. Years later, being much inspired by the Dickeyville Grotto of Father Wernerus, they built over thirty freestanding sculptures, a garden for meditation, a church, and a roadside pulpit during the 1930s. Their environment was surrounded by a decorative fence. All of the constructions were made with concrete, many of them decorated with pieces of glass and crockery in interesting designs. The small church has symbols honoring all religions. After the death of Paul Wegner in 1937 and Matilda Wegner in 1942, the site was purchased and restored under the sponsorship of the Kohler Foundation and

given as a gift to Monroe County in 1987. It is now open to the public. Take Highway 71-27 north out of Sparta for nine miles; Highway 71 turns west to Melrose; the Wegner Grotto is 2/10 mile west on Highway 71. Telephone: 608-269-8680.

Wellborn, Annie G. (1928–2010)

Wellborn was born in Oglethorpe County, Georgia, and was living in Bishop, Georgia when she died. She had "never been out of Georgia but one time"—as a child she went with the family lumber business to "the edge of North Carolina." In a vision she had in the late 1980s, the Lord revealed to her that "she would paint and He would be known through her." He said she would be well-known; when she replied that she did not want to be well-known. "He said, 'Yes, but I do.'" She felt "very humble that God gave me this talent." Wellborn had to survive surgery seven times. She lived in a small mobile home with her husband and a retarded brother-in-law. Her subjects were often family life, but she also painted the visions she had, especially those she had in the hospital and also the angels that flew over her bed for more than 25 years—some of whom she recognized as close relatives. She painted using acrylics on board, tar paper, wallpaper, and canvasboard. She used "anything I can paint on and with." Her work is in the permanent collections of the Owensboro Museum of Fine Art and the Fenimore House Museum. Gallery O on H and Dos Folkies carry her work.

Wells, Della (b. 1951)

Wells, a native of Milwaukee, began drawing and painting seriously at age 42. Pastels are her favorite medium. Wells receives encouragement in the use of pastels from her artist friend Evelyn Terry. She has created works in a variety of other forms including handmade dolls, painted bottles, and hand-crafted quilts. Much of her work displays a strong feminist overtone, with motherhood also being a dominant theme. She has had several exhibitions of her work in the Milwaukee area and has also shown at Atlanta's Folk Fest and at the Kentuck in Alabama. Marcia Weber/Art Objects, Red Piano Too Gallery, and Main Street Gallery carry her work.

Wentworth, Perly Meyer "P.M." (d. 1960)

P.M. Wentworth is an artist about whom very little is known. He worked in the San Francisco Bay Area in the 1950s, but spent most of his life in Southern California. His art was based on "visions in the sky." The inscriptions Wentworth wrote to accompany his images reveal a deep concern with Christian theology, the future, and life on other planets. It is believed he died around 1960. His work is in the permanent col

lection of the Smithsonian American Art Museum; Cavin-Morris Gallery in New York and Fleisher/Ollman Gallery in Philadelphia have examples of his work for sale.

Wernerus, Father Mathias (1873–1931)—"Holy Ghost Park/Dickeyville Grotto"—Dickeyville, Wisconsin

This environment has been described as "perhaps the most spectacular grassroots environment in Wisconsin." The park consists of two large grottoes and two major shrines, as well as small niches for statues. Building materials were concrete and rock, with colored glass and "treasures" from people in the local parish embedded to decorate the concrete surfaces. Father Wernerus and his parishioners worked on Holy Ghost Park from 1925 to 1930. Wernerus died in 1931 before he could complete the additional shrines he had planned. It is maintained by the church and may be visited. The grottoes are "dedicated to the Mother of God and the Holy Eucharist; the shrines to the Sacred Heart and patriotism." Father Wernerus was born in Germany and was ordained a priest in Milwaukee in 1907. Dickeyville is on Route 151 north of Dubuque, Iowa. The SPACES website has much documentation of the park, and Roadside America has a story on it.

West, Myrtice (1923–2010)

Myrtice West was born in Cherokee County, Alabama. "The Bible story of Revelation manifested itself in my life," according to West, and she devoted much of her time to telling through paintings the whole story of Revelation, as she saw it in visions. She also made memory paintings of when she picked cotton and was involved with riverboats piled high with bales of cotton. Her only daughter was killed by an abusive husband and she said "I put my hurt in my paintings." West worked with found cloth stretched around found window frames, which she then gessoed and painted with oils. She occasionally applied glitter to her work. Many of her works are extremely detailed and it could take her over six months to finish one. The University of Memphis exhibition of her paintings, "Revelation: The Paintings of Myrtice West," December 16, 1995–January 26, 1996, was the first solo exhibition of her work. The exhibition was curated by Carol Crown of the art faculty and a catalog was published. Her work is in the Birmingham Art Museum. Marcia Weber/Art Objects and Dos Folkies have examples of her work for sale.

White, Billy (b. 1962)

Arstanda "Billy" White weaves stories through the scenes he paints and around his "portraits." He says stories form in his head while he is drawing. He often has several pictures in progress and will spin a separate tale for each one. White draws everywhere he goes. When he rode Bay Area Rapid Transit to and from NIAD, he drew people on the train. He attracted several collectors to NIAD in the process. His subjects range from such casual encounters to people he knows, television and radio characters, and celebrities. His portraits are not likenesses nor or his scenes realistic, but they arouse viewers' curiosity as to what is going on in them. He started at NIAD in 1994 when he was 32. The Achenbach Foundation Collection, Palace of the Legion of Honor, San Francisco, has bought one of his prints.

White, George W., Jr. (1903–1970)

Born in Cedar Creek, Texas, and lived in other places including Petersburg, Virginia, and Washington, D.C. In 1945 White moved to Dallas and stayed there until his untimely death from a minor foot infection. He was a jack-of-all-trades—cowboy, oil field worker, veterinarian's assistant, barber, deputy sheriff, and homemade liniment hawker. He gave it all up the morning he had a dream of becoming an artist. He painted and made sculpture, some of which he mechanized. He also made wood reliefs. The subjects were scenes representing his life experiences and the Southern black experience. His art was included in the exhibition, "Spirited Journeys: Self-Taught Texas Artists of the Twentieth Century."

White, Mike "Ringo" (b. c1948)

Mike "Ringo" White lives in Milwaukee, Wisconsin. He travels by bicycle and he examines the shores of Lake Michigan to collect beach refuse in order to make collages. Frequently he makes his collages on a flat piece for which he then makes a colorful frame. Another frequent form is to stack many lids from jars on wire, which are then hung from his ceiling. He is a hardworking artist who is very serious about making things and filled his home with so many of his creations that it could best be called "an art environment." White discusses his materials, inspirations, and practices in a 2009 YouTube video (www.youtube.com/watch?v=Th6gaA7BGEE). In 2009 he had a show at The Portrait Society Gallery in Milwaukee.

White, Willie (1908–2000)

Willie White was a self-taught Louisiana artist. Born in Natchez, Mississippi to sharecropper parents, he left Natchez at age 21 to work on riverboats as a porter; he also repaired river levees. He arrived in New Orleans at age 39, where he worked as a waiter for twenty years then briefly as a janitor in a Canal Street bar. He began to draw following the example of one patron, an artist, who sat and sketched as White watched. White's next

job, as a sign painter, solidified his commitment and contributed the idea of bright colors and bold images to his style. White hung around artists in the French Quarter, watching them work, and one befriended him and offered to teach him. White accepted the encouragement but rejected guidance, preferring his own ideas instead. He settled on felt pens on poster board for his art. His subject matter was "inspired by God and movies of faraway places" seen on his television. His work is prized for its bright colors and naïve renders of numerous subjects: religious images, houses, tomatoes growing, prehistoric creatures, rocket ships, watermelons, birds, crosses, donkeys, and cacti. His shapes are simple and the colors are strong and bold. White drew obsessively for twenty years, then suffered a stroke in early 1989 that some thought would stop him. In less than two years, though, he was drawing again, and went on to create art for another six years. White's work is in the permanent collections of the Birmingham, Morris, and New Orleans Museums of Art, the Fayette Art Museum, the Ogden Museum of Southern Art, and the New Orleans House of Blues. Marcia Weber/Art Objects, Arte del Pueblo, Gilley's Gallery, and Anton Haardt have his work for sale.

Whiteside, Clyde (b. 1917—no further information available)

Whiteside lives in the mountains of western North Carolina, where he created a beautiful home environment that one may see in the pages of O, Appalachia. After he married in 1936, he began converting a four-acre lot into a landscaped garden. For years he worked as a laborer and was finally able to retire in 1980. Then he started working full-time on his house and garden, decorating it with carved animal heads, whirligigs, and cutout tin birds and fish. He is the subject of a 1988 book by Jan Oliver Alms, *Clyde Whiteside: Folk Artist* (Cullowhee, NC: Western Carolina University, 1988), which includes a biographical essay by Tom Patterson.

Whitfield, Mary (1947)

Mary Frances Latham Whitfield was born in Birmingham, Alabama, on April 14, 1947. She spent her early years with her grandmother who took her to Civil Rights meetings and church services. When her mother remarried and settled in New York she went to live with her. After high school she married David Whitfield, a hardware salesman, and moved to Great Neck, Long Island. She began to paint when her children were small, using old house paint and scrap plywood. She attended business school and went to work. In 1990 she started painting again, often portraying the stories her grandmother had told her. Some stories are of pleasurable events, such as dances, and other images are of such horrors as lynching. Her colors, compositions, and images are very powerful. Mary Whitfield is included in the book *Revelations: Ala-*

bama's Visionary Folk Artists. She is represented in the permanent collection of the Birmingham Museum of Art and was included in the exhibition "Tree of Life" at the American Visionary Art Museum. Marcia Weber/Art Objects and Galerie Bonheur carry her work.

Wickham, Enoch Tanner (1883–1970)—Memorials—Palmyra, Tennessee

In Buckminster Hollow, Palmyra, Tennessee, Enoch Tanner Wickham built fifty statues made of concrete and painted with enamel. These statues were of national heroes, religious scenes, and local people and ranged in size from six to thirty feet tall. Wickham began his project in 1952 when he was 69 years old. Soon after his death, vandals began to strike with some regularity and savagery. In his article "Giants of Tennessee: The Primitive Folk Sculpture of Enoch T. Wickham," Daniel Prince speculated about the reasons for the physical abuse of these statues and described the background of Wickham and efforts to save the art. In 1991 Jonathan Williams wrote of a 1988 trip to Palmyra in which he describes the site as "ruinous, but absolutely thrilling: an arcade of sculpture lining a rural road. Daniel Boone, the Kennedy brothers, Patrick Henry, Estes Kefauver, local soldiers, local doctors … very moving, even with no heads and with all the graffiti." A few of Wickham's pieces were removed to the Austin Peay Museum. The story has a good ending, however, as Wickham's work is now an established roadside attractions with 22 restored statues and its own website, www.wickhamstonepark.com. The website gives visiting hours and directions, images of all statues, and the history and meaning of each one to Wickham. So visitors may again wander among the sculptures scattered in the loblolly pines that Wickham planted to enhance a once-barren hill for his sculpture garden.

Wiener, Isidor "Pop" (1886–1970)

Born in Russia and immigrated to the United States in 1901. He lived in the Bronx and ran his own grocery store from the 1920s to his retirement in 1950. His wife died soon after, and Wiener was encouraged by his son to paint to overcome his sorrow and loneliness. He painted his memories, Bible stories, and scenes of life in New York. He also carved and usually made animals. He is said to have painted with good humor and spirit. His work is in the Fenimore House Museum in Cooperstown, New York.

"Wiili" (b. 1956)

Wiili B. (Bobalink) Summer was born in Lansing, Michigan, in August of 1956. He lived in Pennsylvania and then West Virginia until he left home at age

sixteen. Since then he has lived in several eastern states, in and out of institutions, on and off the streets. Wiili is a left-handed artist. Several years ago he threw a man through a plate-glass window and pieces of glass tore the ligaments and tendons in his left forearm. He taught himself to paint right-handed but produced only one artwork during that time. Two surgeries and considerable therapy later, Wiili taught himself to paint again with his left hand and continues to use it to this day. He has been in the Dorothea Dix Hospital twice and also voluntarily to several smaller ones. Wiili has been labeled a manic-depressive with paranoia and currently is battling agoraphobia. Although extremely outspoken and intelligent (he tested at 163 I.Q. at age six), he cannot handle a crowd or strangers in a normal fashion. Wiili hopes to be able to find a place where he can live and collect the trash and throwaways of society in order to create a large mound of art always in progression. "Wiili prefers to paint en masse, climbing from level to level of experience, changing his mind, moving from color to color and in the end, surprised to find a painting." His love of birds and butterflies comes from a veterinarian father. The angels, "she-germs become angels," are the muses guiding his painting. The women in his pieces are modeled on previous girlfriends. The Art Cellar Gallery in Banner Elk, North Carolina has his work.

Wikle, Barbra

Wikle lives near Clarksville, Georgia. A self-taught artist, she works in oils on canvas nearly ten hours a day. She paints memories of her childhood days on a farm in rural DeKalb County. She also paints stories from the Bible. Sometimes she puts the canvas aside and paints on all kinds of furniture. She concentrates on "the beauty she sees in everything." In 1983 she opened a small shop in an abandoned garage built by her husband's family sixty years ago. Her art is available there, Art Barbra's Folk in Clarksville. Wikle's work is in the collection of the Museum International in Rio de Janeiro, Brazil.

Wilkerson, Lizzie (1895–1984)

Born the youngest of 21 children to a black family in rural Georgia, Lizzie moved to Atlanta after getting married, where she worked in factories and as a domestic worker. She started painting at the age of 77, while attending a senior center. She worked for six years before her death, and created fewer than one hundred paintings. Her bright, lively paintings represent rural Georgia, biblical scenes, and angels. She often filled the entire background of the painting from edge to edge with a background of floral patterns and animals. Her art was included in the exhibition "Women Folk" at Wesleyan College in Macon, Georgia, in the spring of 1998. Her work is in the Smithsonian Museum of American Art and the High Museum.

Wilkinson, Knox, Jr. (b. 1954)

Knox, whose full name is Wallace Knox Wilkinson, Jr., lives in Rome, Georgia, and is a self-taught artist. He is developmentally disabled, but with the help of his loving and supportive family and his "God-given talent," he has managed to create his well-received art. Knox Wilkinson is best known for highly patterned, vibrant works on paper. Among his best known images are singers, room interiors, fantasy animals, Loretta Lynn, and Elvis Presley. His colorful creature images include rabbits, turtles, cats, and fish. Wilkinson's work was included in a number of exhibitions, especially in Georgia, and it is in the permanent collection of the High Museum in Atlanta and the Polk Museum of Art in Lakeland, Florida. He appears to have stopped working at present.

Willeto, Alfred Charlie (1906–1964)

Charlie Willeto was born in the eastern region of Navajo country in New Mexico. He was a sheep- and goat herder and a medicine man. He carved figures of Navajo men and women, owls and half-fanciful animal figures. He was the first to break the Navajo traditions and taboos around carving. His work gained fame when it traveled with an exhibition of works from the Hemphill Collection. These pieces are now in the Smithsonian American Art Museum. *See also* Ignazio, Elizabeth Willeto.

Willeto, Harold (b. 1959)

Harold, a son of Charlie Willeto, makes painted pine and cottonwood sculptures. His figures are nearly life-size. He paints them with housepaint and traditional Navajo designs. His work is in the Smithsonian American Art Museum, and is available for sale through Twin Rocks Trading Post in Bluff, Utah. He also has his own Facebook page.

Willeto, Leonard (1955–1984)

Leonard, a son of Charlie Willeto, made carvings of Navajo figures, either non-representational or small doll-like figures, in elaborate costumes. His work is in the Smithsonian American Art Museum.

Willeto, Robin (b. 1962)

Robin Willeto, a son of Charlie Willeto, is the more prolific carver of the two living brothers. He does very imaginative carvings based upon his dreams. His work is in the Smithsonian American Art Museum and is available at Rainbowman Gallery in Santa Fe and Twin Rocks Trading Post in Bluff, Utah.

Willey, "Chief" (1889–1980)

"Chief" Philo Levi Willey was born in Falls Village, Connecticut. He worked at many jobs in lumber

camps, saw mills, farming, the automobile business, and circus work. The job he enjoyed most was driving an eight-horse team for the Barnum & Bailey Circus. He served in World War I and eventually ended up as chief of security for the New Orleans Water Board. Willey had moved to New Orleans when the Chevrolet agency he worked for in St. Louis relocated there and then went to work for the New Orleans Water Board in 1932. He retired in 1966 as head of the Board's police force, hence the name "Chief." He started painting in the 1960s and sold his colorful work, filled with tiny figures and great detail, along the fence at Jackson Square, a New Orleans artist tradition. His subject matter was the many sights and sounds of New Orleans. His work is in the permanent collections of the New Orleans Museum of Art, American Folk Art Museum, and the Museum of International Folk Art. Gilley's Gallery in Baton Rouge still has some of his pieces for sale.

Williams, "Artist Chuckie" (1957–1999)

"Artist Chuckie" lived in Shreveport, Louisiana, and started drawing when he was a child. He used found materials such as cardboard, plastic board, and plywood. He painted mostly celebrity figures, and added glitter to the images. Michael Jackson, Janet Jackson, Elizabeth Taylor, and Dolly Parton were among his favorite subjects. His inspiration came from television. His work is in the permanent collections of the Birmingham Museum of Art, the African American Museum of Dallas, and the New Orleans House of Blues. Anton Haardt Gallery and Webb Gallery carry his work.

Williams, Ben (1928–1996)

Ben Williams lived in the same Montgomery, Alabama, home his parents bought before he was born. He dropped out of school in the sixth grade because he wanted only to draw. In his teens Williams moved to Cincinnati where he shined shoes, drawing his pictures between customers. When his father's health failed, he returned to Alabama. He married in 1947 and had six children. He and his wife separated after the children were grown. He moved to Washington, D.C., and then back to Alabama. In 1985 a broken leg suffered in an automobile accident left him disabled but with time to devote to his art. The figures in his paintings are frequently of grotesque proportions, with clawlike hands, anguished faces, and accentuation of physical flaws. The women in his paintings exhibit sexual poses as if for sale. Williams attributes the inspiration for his images to God, pointing a finger skyward and saying "He give 'em to me. My ideas come from the Lord," adding "I always liked drawing the ladies." He said that some of his inspiration came from magazine advertisements. In contrast to his overtly sexual

images, the other frequent subject of his work is the weeping Christ, either in crucifixion or portraiture. Artist and gallery owner Anton Haardt says "this contrast suggests the artist's struggle, which has led him to destroy all his work until recently. It is as though creation is the sin, and salvation lies in destruction." He worked on a lap board, sometimes drawing in near darkness. "His rudimentary collages of cutout figures drawn on brown paper bags relieve the stark white surfaces of poster board. The detailed drawings evidence the considerable time he takes with each piece, which is first sketched in pencil and then traced and retraced with ballpoint pen until the pressure carves deep furrows in the paper." When his work began to attract an appreciative audience, Williams started to save his pictures. Anton Haardt Gallery in Montgomery, Alabama, which supplied this information, and carries some of his work.

Williams, Bettye (b. 1935)

Bettye Williams was born July 22, 1935, in Jefferson County, Florida, near the Georgia line. She now lives in Bartow, Florida. She is a self-taught artist who started painting in 1982 after retiring from her government job. Williams paints scenes of the rural Georgia and Florida that she remembers from her childhood. Her paintings are finely detailed but retain a fresh, naive quality. She says, "It was by the grace of God that I was born and raised in a time and place that was unpretentious, where we did not know that we were unsophisticated or lacked worldliness, and where simple things and appreciation for them were the rule, not the exception … and everything I paint I've lived." She sells her art through her website, www.bettyewilliams.com.

Williams, Charles (1942–1998)

Williams was born in Blue Diamond, Kentucky, a now defunct coal camp. He was raised by his grandparents until he joined his mother in Chicago during high school. He returned to Hazard, Kentucky, after high school, and then joined the Job Corps in western Kentucky. He moved to Lexington in 1970 where he worked at a variety of jobs. Along the way he took some art classes "but was encouraged to retain his own aesthetic." Williams typically made use of found and recycled materials in his sculptures. His art was included in the exhibition, "African American Folk Art in Kentucky," at the Kentucky Folk Art Center in 1998 and is included in the permanent collection there as well as in the collection of the Rockford Art Museum. His work is available at the Institute 193 in Lexington, Kentucky.

Williams, George (1910–1997)

George Williams grew up in Clinton, Louisiana, where he was born; he was living in Fayette, Missis

sippi when he died. He started carving wood sculpture to stay awake when he worked the late shift at a lumberyard. He is well-known for his carved male and female figures, which are sometimes dressed and sometimes not. He painted them with enamel and then varnished them. He also did a few other images, including the Statue of Liberty. His work was included in the exhibition, "Passionate Visions of the American South." His work is in the permanent collections of the Smithsonian American Art Museum, the Birmingham and Mississippi Museums of Art, and the Old Capitol Museum of Mississippi History.

Williams, Joe (b. 1948)

"Indian Joe" Williams was born in Jefferson, Georgia, and received his nickname from his mother. A truck driver by profession, Williams hauls fertilizer all across the Southeast. On the long hauls, he usually does not play the radio but instead passes the time trying to think about his next creations. The ideas change constantly and take shape as he assembles the work. "I just start cutting and I end up with what I end up with. Working with wood is relaxing and I get a lot of satisfaction watching it all come together." Williams makes heaven/hell devil boxes with various images. A favorite is "Hell's Alley" where "the devil is a bowler and the pins are the sinners." Indian Joe lives in Jefferson, Georgia. He sells his work at the Kentuck festival in Tuscaloosa, Alabama.

Williams, Oliver (b. 1948)

Oliver Williams lives in Iowa and has been painting for about the last 25 years. The rather eerie quality of his work is explained by the artist as an attempt to portray "man's inner fears in mundane, everyday settings." Five years ago Williams began making terra cotta sculptures. In his "animal revenge" series, animals get even with humans. The Pardee Collection carries his work.

Williams, Ruby C. (b. c1930)

Ruby Williams grew up in Bealsville, Florida—a community formed by freed slaves in the 1860s—and went to nearby Plant City High School. She married and then separated from her husband David Williams. After the separation she went to New Jersey to be with her sister. She intended to stay only a little while but ended up being there for 28 years. She founded a mission and became an evangelist in New Jersey. In 1983 she returned to Bealsville and opened a fruit and vegetable stand. Her colorful, bold signs were what first attracted folk artist Rodney Hardee from nearby Lakeland. He wanted to know if she painted pictures, too. She hadn't for a long time but decided to give it a try. Using paint left over from her sign making, Ruby painted on an old table top Hardee supplied. Since then she has developed a very personal art vocabulary. Using acrylic paint straight out of a can or tube, Wil-

liams creates areas of flat color. She then applies a black outline that delineates figures and gives them the same poster quality as her signs. She also uses an expressive dotting technique. She paints on canvasboard, plywood, and unstretched canvas. Her early works contain animal imagery—real and imaginary. Now there are more figures of people. Most have messages included. Williams paints images that come to her mind; recurring ones have developed names and "personalities." In 1997, there was a one-person exhibition of her work at the Polk Museum of Art in Lakeland, Florida, "Casting Her Bread Upon the Waters: The Folk Images of Ruby C. Williams," curated by Jane Backstrom. A video of Williams, her art, and her produce stand is available on Vimeo (https://vimeo.com/63546506), posted in 2013. She sells her art at her produce stand just off Florida State Highway 60 near Plant City and at FolkFest. Cotton Belt Gallery, Dos Folkies, and Jeanine Taylor Folk Art carry her work.

Williams, Russell

A retired barber from West Liberty, Kentucky, Russell Williams makes whimsical simple sculptures and birds from pine knots. Other works include heads of men, sometimes carved as bottle stoppers, and handles for canes. The carvings are left unpainted. His work may be seen at the Kentucky Folk Art Center in Morehead.

Williams, Ruth Russell (1932–2010)

Ruth Russell Williams was born in 1932 in the Vance County community of Townsville, North Carolina. Her parents were sharecroppers. At age eight she began picking cotton to earn enough money to go to the State Fair. Later, her paintings would portray scenes from this early work and from many other childhood experiences, including memories of going to work with her grandmother to the home of a plantation owner. She developed her talent along a path that took her from these humble beginnings to beauty salon owner and cosmetologist to national recognition as a self-taught artist. In 1948 she married Odell Russell and they had four children but would later divorce. In 1974 she married building contractor Samuel Williams. Initially drawn to ceramics, she taught ceramics at Vance-Granville Community College. When her children were mostly grown, she began painting, although she initially thought her paintings lacked merit. At an art exhibit at Kerr Lake in 1985, Williams was quite satisfied showing her work to laymen and women, but when she learned that North Carolina A & T art professor James McCoy was nearby, she grabbed her paintings and hid behind bushes, fearful of presenting her work before a professional. McCoy, however, immediately recognized Williams' unique aesthetic sensibility. He told Williams that she was a gifted folk artist and predicted that she would one day become widely recognized. For the next two decades, Williams pro-

duced hundreds of paintings, each one telling a story of life as she saw it, in a simple, straightforward—and vividly colorful—way. Her work is now prized by collectors and museums throughout the United States and Europe. One of her best-known works, "Baptism," appeared on the cover of Smithsonian magazine in 1993. The North Carolina Central University Art Museum in Durham showcased over fifty of her original works of art at the exhibit, "Ruth Russell Williams: Master Storyteller," in 2009. On March 28, 2015, the Warren County Memorial Library hosted a symposium and exhibition, "Celebrating the Legacy: Art Perspectives on Ruth Russell Williams (1932–2010)." Her work is available through the African American Art Store (www.avisca.com/Ruth_Russell_Williams_Gallery_Avisca_com_s/57.htm).

Williams, Todd W. (b. 1971)

Todd Williams was born in Magee, Mississippi, and lives in New Orleans, Louisiana. Todd began making art as a child. He had to hide it under his bed because his parents didn't approve of this activity. He started with drawings and then watercolors, which he says didn't suit him. Then he tried oils and moved on to acrylics on canvas, which he says he likes because of the vibrant colors, and because it is possible to see the results faster. He works on the floor and does all of a work in one sitting "even if it takes hours and hours." If he stops in the middle he won't finish the work. His subject matter comes from dreams, "sudden thoughts," and his Southern heritage. He frequently repeats images of ladders descending in space, black angels, free-floating suns, and pots of flowers. He says he doesn't know what they mean; they were in a dream that affected much of his work. Although he is white, his figures are frequently black. The only people who cared for and comforted him when his parents broke up during his early childhood were a black couple. His best friend and earliest supporter, Melanie, who continues to collect his work, is also black. He believes this has influenced the choice of subjects of his artwork. He was "discovered" in 1995 when he gave away paintings as Christmas gifts, including one to a gallery owner and friend who admired his work and encouraged him to pursue art. His art has been selling well ever since and he has been represented in many shows and galleries. Recently the prominent Historic New Orleans Collection acquired a Todd Williams painting. His two most recent art projects are paintings based upon old family portraits and becoming one of the proprietors of a folk art gallery in the French Quarter.

Williamson, Clara McDonald (1875–1976)

Williamson was born in the small Texas frontier town of Iredell and raised in a rural community "filled with hard work, family responsibilities, and simple pleasures." Her life consisted mostly of maintaining a household for her husband and three children. At the age of 68 when she was widowed, she moved to Dallas and began painting. She was a memory painter, recording the domestic history of early Texas life. Her art was included in the exhibition, "Spirited Journeys: Self-Taught Texas Artists of the Twentieth Century." It is also part of the exhibition "Texas Folk Art" held at the Amon Carter Museum of American Art in Ft. Worth (September 12, 2015–September 19, 2016). The Valley House Gallery in Dallas has some of her art for sale.

Williford, Bobby (b. 1959)

Bobby Williford was born in North Carolina and now lives in Nashville, Tennessee. One of thirteen children, Williford ran away from home with a friend when he was ten to escape his mother's beatings, which started after his father abandoned the family. After doing endless odd jobs to support himself, getting involved in drugs and alcohol, and suffering a number of blows to the head while living on the streets, he had to get away from North Carolina. As he tells it, "When everything started closing in, I had to get away. So I just started walking." No one picked him up and several days later he arrived in Nashville on foot. Williford was encouraged to draw at a Nashville homeless shelter where he ended up in the early spring of 1995. He works with colored pencils on paper to create a highly personal commentary on his life. His drawings are powerful, intense, and kaleidoscopic. They are loaded with images that reflect his fascination with the exteriors of buildings, windows, and doors. Winding stairways and crooked walls are often studded with floating body parts and muscular superhuman figures, jet-powered flying saucers, and cars and guns. His process of composition is precise and painstaking. In February 1996 he had a one-person show at Cheekwood Museum. Shelton Gallery in Nashville carries his work.

Willis, Luster (1913–1990)

Luster Willis was born near Terry, Mississippi. He developed an interest in drawing at an early age, and though his teachers were not encouraging, he never stopped. After serving in France and Austria during World War II, he returned to his family's sixty acre farm. His themes were friendship, morality, and racial justice. He also drew portraits of his friends. His works were made with whatever materials were available—pencil, tempera, pen, watercolors, shoe polish, glitter. Willis' work has been shown in many important exhibitions. His work is in the permanent collections of the Smithsonian American Art Museum, the Kentucky Folk Art Center, several Mississippi museums (Mississippi Museum of Art, Old Capitol Museum of Mississippi History, University of Mississippi Museums), the Rockford Art Museum, and the African American Museum of Dallas. Raven Arts has his work for sale.

Willis, Pauline (1946–2006)

Pauline Marcantel Willis was born on December 11, 1946, in Lake Arthur, Louisiana at the home of her maternal grandparents. She executed her first oil painting while visiting her aunt and uncle in the summer of 1957. Willis graduated from high school in 1964 and married J.E. Willis in 1965. She drew pictures all her life, painting her first "oil picture" at the age of eleven. Over twelve years following her marriage she had five children. In 1977, only one month before her last child was born, Willis' ten-year-old eldest child died, a tragedy that affected both her life and her art. In 1993 she did a whole series of what she called her "birth paintings." She explained these paintings by saying, "I am the oldest of nine children, the mother of nine and the grandmother of two. So birth has always been a big part of my life." The resulting images are unique. Willis' work, even in her own words, has been called "Outsider Art," although she did have a background in art, studying at the Commercial School of Art in Baton Rouge and McNeese State University, Lake Charles, LA. She is in the collection of the Asheville Art Museum.

Willis, Wesley (1963–2003)

Wesley Willis was born in Chicago and lived there until the end of his life. He sat in public places, often in the Loop-area subway, where he talked to people and drew. He used colored pens to make large appealing drawings of Chicago scenes, mostly buildings and trains. He "drew Chicago," but not the people. From 1983 to 1986 he lived in the Robert Taylor Homes, one of Chicago's most notorious public housing projects, with his mother and a brother or two. He was befriended by several Illinois Institute of Technology faculty, who let him "hang out" there. After several moves, Willis seemed to have gotten a place of his own toward the end of his life, and continued to work on the streets and sell his art in the subway. His work is in the permanent collection of the New Orleans Museum of Art.

Willi/Willie (William Holladay Armstrong, Jr.) (1957–2003)

Willi/Willie, as he called himself, was born in Baton Rouge, Louisiana. He was a lifelong resident of Ascension Parish, brought up in a rural community six miles north of New Orleans and "a stone's throw" from the Mississippi River. Today in this area big industry operates side by side with sugarcane fields. "We now live in the middle of this industrial corridor commonly known as Cancer Alley," he said. Willi/Willie worked in these plants for over twenty years. He got inspired to use their discarded material, including big iron pipe that he converted into bold, brightly colored masks. Inspired by "the food, the religion, the blues, the bayous and the deep-south landscape, the diverse people, I make my art full-time now." He sold his work at the New Orleans Jazz and Heritage Festival during his lifetime; Gilley's Gallery in Baton Rouge now has it for sale.

Wilson, Allen (b. 1960)

Wilson lives in Summerville, Georgia, and is the son of Howard Finster's daughter Gladys. He worked in a local cotton mill until he was 26, and began pursuing art full-time about ten years ago. Allen Wilson's creations are most unusual. He carves large figures such as clowns, devils, prehistoric creatures, and other figures from rings of wood, which he fits over bottles to make a torso. Then he carves and paints details and adds the head (which comes off, so the bottles are usable). His work is very individual and not at all like his grandfather's work or the work of any other family members. He is a talented artist in his own right. In 1992 he created and installed a sculpture out of concrete, metal, glass, marble, tile, and paint in Atlanta's Folk Art Park (Courtland St. NE & Ralph McGill Blvd. NE), titled "Homage To Reverend Howard Finster." Wilson lives next door to the Howard Finster Vision House Museum in Summerville, which in turn is next to Paradise Garden.

Wilson, Genevieve (1935–2008)

Wilson was born April 18, 1935, in Casey County, Kentucky, and now lives near Russell Springs. She moved to Cincinnati with her family during World War II and then back to Kentucky following the war. Wilson dropped out of school in 1950 and married the following year. Many of her paintings portray contrasts between the city life of Cincinnati with the rural calm of her Kentucky home. Her memory paintings are done with acrylics. She also finds wood and paints it, creating animals, birds, and fantasy creatures. Her work is in the permanent collections of the Kentucky Folk Art Center and the Owensboro Museum of Fine Art.

Wilson, George (b. 1946)

George Wilson is a man of few words, usually offering only a whispered comment as he moves through the studio at the Creative Growth Art Center where he has been working on his art since 1985. His eyes and hands are always in motion and this is reflected in his art. His drawings of dogs, horses, people, and places swirl in front of the viewer's eyes, charged with brilliant color and kinetic energy. His work was included in the exhibition "Wind in My Hair" at the American Visionary Art Museum in 1996–1997 and in "Visions from the Left Coast: California Self-Taught Artists" in Santa Barbara in 1995. Creative Growth carries his work.

Wilson, Mack (b. 1931)

Mack Wilson was born in Cumberland, Kentucky, where he has spent most of his life. As a young man

he served in the U.S. Army and fought in the Korean War. After the service, he worked as a mechanic in a garage, had a body shop, and later became a service technician for Sears. After retiring in 1983, he began growing gourds and then started making strange and imaginative figures, critters and animals, combining the gourds with other dried plant material. Wilson and his wife have had serious health problems and he has said that making his art has helped relieve the resulting stress. His work is in the Hackley Gallery.

Wince, Charles (c. 1955)

Wince is a self-taught artist who moved to Columbus New Wave music/art scene from rural Ohio in 1983. His website includes the following information about him: He began hanging his artwork in bars, trendy clothing stores, and writing and illustrating articles in local music fanzines. This led to his participation in the small number of independent galleries around the Ohio State University Campus area. In 1985 he was "discovered" by Whitney Museum of Modern Art curator Barbara Haskel, who had come to Columbus to O.S.U. to curate an exhibit. From that point on he began to be acknowledged in the academic art world and the media, and a growing interest started to build around both him and his work. However, his career did not develop as he had expected. The underling dark themes of his work were much more personal than he cared to admit, even to himself, and a crippling depression began to sabotage not only the production of new artworks, but his state of mind as well. Over the next 10 years Wince produced some interesting artwork but only in periodic bursts.... While art critics have recognized Wince favorably since the 1980s, the artist's career has experienced a series of starts and stops. Long dry spells were brought on by bouts of clinical depression as well as a rather hedonistic lifestyle. Earlier paintings reflect this, the canvases dominated and driven by a cacophony of subject matter where humorous touches battled it out with bizarre, tightly wound bombastic creatures and creations.... Currently there is renewed interest in the artist and his work. It's as if he has gone from being the "hot young artist" in the '80s to "What ever happened to...?" in the '90s, to "sort of a legend" in 2010, where we find the artist surprisingly well adjusted and downright happy with his lot in life. He sells his art through his Facebook page; his work is often on view at Alana's Fine Food restaurant in Columbus and at The Hive Gallery and Studios in Los Angeles.

Winkelman, Jane "In Vain" (1949–2012)

Jane Winkelman was born on March 31, 1949, on Long Island, New York. In 1963 her father moved his clothing factory and his family to Miami Beach. After high school, Jane went to college in Washington, D.C.,

and then headed off to San Francisco to study drama and filmmaking. She joined a commune in 1971, lived a hippie lifestyle, dreaming of a better world. She returned to Miami Beach and did a series of menial jobs there. Her mother's death in 1986 was devastating to her. She returned to San Francisco and after living off a small inheritance, went on welfare, sweeping the streets. Very depressed, she went to Hospitality House, a shelter providing a free art studio that homeless people could use, which opened up a whole new world to her. Her style sprang from emotion and vision, depicting her concerns: homelessness, politics, sexuality, and major world events. Winkelman created six posters reflecting some of the issues facing homeless people in San Francisco for the San Francisco Arts Commission: Market Street in Transit project. The posters appeared in 24 kiosks along Market Street in 1997. She signed her paintings Jane "In Vain" because of her failure to ever please her family. Her work exhibits remarkable technical skill and presents powerful imagery. Her work is in the collection of the Smithsonian American Art Museum and was included in the exhibition "Eros and Error: Love Profane and Divine" at the American Visionary Art Museum in 1998.

Wise, Tony (b. 1954)

Born at North Carolina's Cherry Point Marine Corps Air Station, Clarence Antonio Wise currently resides in Durham. While visiting Miami in 1987, he became the victim of a drive-by shooting and was left paralyzed below the neck. After several years of physical therapy, he regained partial use of his arms. He says that in 1995, while struggling with depression, he experienced a vision of Moses on the same day his mother gave him a gift of art supplies. He felt the two incidents on the same day were "prophetic." He now paints, mostly religious themes, for countless hours each day. He paints with the brush clamped between his teeth. Wise's paintings have an ethereal and fluid quality, and a shimmering color palette derived from his use of colored bronzing powder mixed with oil. His work was included in the exhibition "The End Is Near!" at the American Visionary Art Museum.

Wiseman, Harriet

Harriet Wiseman "is a uniquely evocative painter who portrays internal murals of a life deeply lived." Autobiography motivates her work. Her faces are often masklike, frequently naive, and sometimes painful. Wiseman turned to painting when her children were grown, and she was alone.

Wolfe, Sabra Jean (b. 1951)

Wolfe lives on Coosaw Island, South Carolina, near Beaufort. She shares an eight acre tract of land with her ex-husband, Will Thorp, a painter and fisherman.

Wolfe has been painting off and on since she was eighteen. Her vibrant portraits, landscapes, and depictions of animals are painted on tin, fiberboard, or whatever else is at hand. The images are inspired by the people and things on the island. Red Piano Too Gallery has sometimes carried her work.

Wong, Bohill (b. 1934)

Bohill Wong was born in Hong Kong. He began attending Gateway Crafts in Massachusetts in 1979, after being discovered in a nursing home drawing on any scrap of paper he could find. "His transformation from institutionalized individual to independent person living in his own apartment is truly amazing. He travels about the city, sketchbook in hand, entertaining people with his unique and sometimes zany artworks, which range from cute and funny to sexy and sophisticated." Wong works on paper using ink, markers, and watercolors. His imagery is provocative, depicting women in fantastic fashions, or animals which have been humanized, or objects with legs and high heels. He loves to draw snakes: kissing, on the toilet, in the shower, or in bed. His work has a "fun" aspect and is very colorful and unique. Recently Wong was featured on the television program *Greater Boston Arts* and his segment was awarded a New England Emmy. In addition to Gateway, Just Folk in Summerland, California carries his work.

Wood, Peter (b. 1948)

Peter Wood was born in Cleveland, Ohio, and spent his first eight years in a housing project there, the third son of a struggling artist father who believed one should never compromise his art. His mother, on the other hand, was more interested in the well-being of her children, convinced the father to get a job and move the family out of the projects. This vision of the "pure artist" who makes no compromise with commerce maintained a strong hold on Peter, who dropped out of high school in the mid–1960s and began the life of an artist-adventurer. He avoided any attempt to make money from his art for years and got by doing odd jobs and moving from town to town. Some of his "hundreds of jobs" have included waiter, steelworker, chauffeur, cook, and soil technician. Wood is proud of the fact that he has circumnavigated the globe, hitchhiked many times across the country, and backpacked hundreds of miles in the Southern mountains. More recently he prefers the comfort of the Greyhound bus. He considers the New Orleans French Quarter one of the only places in America he likes to live. He loves jazz and the blues. Wood first exhibited his work in 1964 and since then has shown in galleries and exhibits around the country. His colors and compositions are very bold. The work is figurative and the subjects reflect his interests and travels. One of his main themes

involves musicians. He paints with his hands mostly and uses six tubes of paint, thus has no need for a studio. The first portrait of his to be accepted in a juried show was one of Charlie Parker, in the Cleveland Museum of Art's Annual May Show in 1996. He has made many strong portraits of Delta blues musicians. He spends most of his time now in Oaxaca, Mexico. He can be contacted about his art through email, oaxacamouth@hotmail.com.

Woodard, Onis (b. 1926)

Onis Woodard was born in Elkhart, Texas, and raised in nearby Palestine. He quit school after the ninth grade to work picking cotton and raising hogs. Woodard remembers that when he was a child he watched his grandfather make walking sticks and whirligigs. Woodard himself started carving around 1941 when he entered Tuskeegee Air School hoping to become a pilot. He was not accepted because he was "too tall," and became a mechanic and guard instead. Woodard has carved mostly animals and figures, usually under two feet in height. His favorite wood for carving is catalpa. He paints his figures with bright, glossy enamels. Woodard has lived in Dallas since 1959, is married and has a son. He is a deacon in the True Light Baptist Church. The Rev. John Hunter, a well-known carver in his own right, is the pastor of his church and encouraged Woodard to carve more. Woodard was included in the exhibition "Spirited Journeys: Self-Taught Texas Artists of the Twentieth Century," and in San Angel Folk Art Gallery's 2003 exhibition, "Big, Bad Broad: A Celebration of the Statue of Liberty." His art is in the permanent collection of the Art Museum of Southeast Texas.

Woodrum, William (b. 1943)

Woodrum learned to whittle about forty years ago from a gypsy who worked on his aunt's farm in Savage Branch in eastern Kentucky. "We would sit around after the farm work was done and he would tell me and my sister stories, and at the same time he would be teaching me how to carve items in wood," said Woodrum. Woodrum is a retired U.S. Marine whose tours of duty took him to Japan, Korea, Vietnam, Okinawa, and the Philippines. He is a native of Lexington, Kentucky, and he and his wife now live in Winchester. Woodrum had a second career after retiring from the military but a series of heart attacks forced him to give it up. Not one to sit around, he took up carving again, and writing poetry. He is an outgoing person with a wonderful sense of humor that has helped him through the hard times. Most of his art pieces are accompanied by writing. He has carved Noah's Ark, musical instruments, figures, and flowers. One of his most popular pieces is a spacecraft carving inside a bottle. The bottle is then placed inside a decorated wooden box. Most of these boxes also include small lights.

Woods, Elizabeth (b. 1928)

Elizabeth Woods is a memory painter living in Minot, North Dakota. Her subject matter includes farm and ranch life. She was born in Connecticut and lived in Salt Lake City, Utah, for 11 years before moving to North Dakota in 1983. Her responsibilities of working and raising a family of three by herself delayed her interest in art until she was 66. She paints her childhood memories in oil. She also paints images inspired by music and whatever else she feels like painting, especially current happenings in North Dakota. Elizabeth Woods realized a lifelong goal and earned a college art degree, long after she had begun painting, but it did not change her own style of painting. At the age of 87, Woods is still painting and selling her art, and has recently completed her second children's book. She can be reached at 701-838-4494; Folktique Gallery in Philadelphia carries her work, which was in a 2012 exhibit at the Taube Museum of Art in Minot.

Woods, John (b. 1929)

John Woods was born in Iowa and moved to the Los Angeles area in 1954 to work in the aerospace industry. When the lake in MacArthur Park was drained in 1973 and 1978, Woods began to collect the objects found at the bottom in layers of mud. The collection of over 100,000 items includes toys, tools, cosmetics, dice, rings and padlocks, as well as guns, knives and brass knuckles. He collates many of these into assemblages of found objects, both board mounted and freestanding. Woods calls himself a folk archeologist. He was included in the exhibition, "Visions from the Left Coast: California Self-Taught Artists" in 1995. Pieces of his art are on display at the Grassroots Art Center in Lucas, Kansas.

Woodyatt, Lyle (1914–2006)

Lyle Woodyatt was born in Sterling, Illinois, and lived in Dixon. Woodyatt did not start painting until the age of 65, after working 25 years as a civil engineer. The drafting and designing that were so much a part of his work made Woodyatt aware that he wanted to be an artist. Occasionally, when out on a survey site, he would sketch the local scenery that caught his eye. In his retirement he finally found time to pursue his art and express his fascination with the wonders of nature. Rainbows were a recurrent image in his art. Other paintings were of places and scenes that he experienced such as a view from a hospital bed, scenes from vacations taken, and scenery along the Rock River. His work has been exhibited at the Rockford Art Museum in Illinois.

Woolsey, Clarence (1929–1987)/ Woolsey, Grace (?–1988)

Clarence Woolsey was born in Houghton, Kansas, and toured on the rodeo circuit until injuries forced him to quit. He married Grace in 1947 and the couple moved to Iowa to work as farmhands. In the winter, to pass the time, they started collecting bottle caps and saving them in a gallon jar. One snowy night in 1961, when the jar was full, they started to make their first small sculpture with the caps. From there, things just went uphill with one astounding bottle cap creation after another: a bicycle, life-sized animals, and entire bottle cap buildings built to scale. About ten years after they started their artwork, the Woolseys started displaying their pieces in a roadside bottle cap menagerie called "The World's Largest Pioneer Caparena"—Caparena was their word for an arena of caps. Admission was just 25 cents. The Woolseys soon became discouraged because of the lack of response at the two shows they staged and they abandoned their hobby. After their deaths, their unique creations were newly "discovered"—and the whole lot was sold off at auction for $57 from where they had been stored in an old barn belonging to Grace's brother. Today, Woolsey sculptures have sold individually for $5,000 and more. Their art is recognized among the most significant pieces in American outsider art. Their legacy is more than 200 sculptures created or covered completely with bottle caps. Pieces of their work are in the permanent collections of the American Visionary Art Museum and the Milwaukee Art Museum. Their work is available through Just Folk in Summerland, California.

Wooton, Clarence (1904–1996)

Clarence Wooton was born in Cutshin Creek, Kentucky, and grew up in Hell-For-Certain. In later years he lived in Noctor. Wooton painted a lot in the 1930s and early 1940s. He worked in the WPA artist project and assisted in the work on several public murals. His first exhibition was in Long Beach, California, and he has had others all over the country, including Rockefeller Center in New York. Wooton quit painting during World War II and started painting again in 1987. He painted every day. He would take a walk with his sketchbook, then come back and paint what he had sketched. He called himself a "regional painter," preferring to paint what he saw outside his house and in the mountains. He made his own frames for his paintings. Another favorite "hobby" was making his homemade wines. His work was exhibited at Berea College and as part of an exhibition at Appalshop. Wooton died February 27, 1996. Most of his art is with family members.

Worcester, Barbara

Barbara Worcester, a woman in her fifties with developmental disabilities, has been a regular participant of the G.R.A.C.E. workshop at Howard Community Services in Burlington, Vermont. While she had never done artwork prior to joining the workshop, her very personal vision and style were there from the begin

ning. Barbara uses colored markers and spends many hours completing each piece.

Work, Jim (b. 1944)

Jim Work likes to draw the vernacular architecture of the Midwest where he lives: water towers, two story brick buildings, barns, and windmills. He then colors them in with crayon and uses popsicle sticks as his straight edge. Once he has colored his buildings he rubs the surface with the side of a popsicle stick to smooth it out. The effect of this technique transforms ordinary crayon into a lustrous surface. Jim is mildly retarded and lives with his father in the rural countryside on the family farm. He does odd jobs for the neighbors such as mending fences and painting. Most of his buildings come from his imagination, yet reflect the common structures of small towns in the Midwest. Sherry Pardee in Iowa represents the artist.

Wright, Artis (1912–2002)

Wright lived in Rockford, Alabama, where he took up art while in his 80s. He made "creatures" from wood scraps, feathers, yarn, and paint, following images that he said he saw in his dreams at night. He covered most surfaces with bright dots on equally bright backgrounds. After a number of years making objects, he began to apply his painting approach to his house and surrounding trees, eventually creating quite an extensive local environment. His work was included in the 2000 exhibition, "Celebrating the Vision: Self-Taught Artists of Alabama." The Attic Gallery and Marcia Weber/Art Objects sells his work.

Wright, George

Wright is a self-taught wood-carver who began to carve at age fourteen. He prefers to carve cowboys and Indians. Most of his figures are life-sized. He also carves wonderful realistic animals such as dogs, alligators, owls, rabbits, and sometimes birds. In the past, he has carved Civil War figures to sell at the Appomattox Civil War Battleground in Appomattox, Virginia. Mr. Wright lives in a trailer located in Franklin County, Virginia. The Gallery at Folk Art Net carries his work.

Wynia, Clyde (b. 1938)—"Jurustic Park"—Marshfield, Wisconsin

Clyde Wynia was born and lived in Iowa through grade school, moving subsequently to Wisconsin. After practicing law in Marshfield for 38 years, he retired and began to create "a wild, rusted, menagerie of fossils" from things he finds in scrap yards and dumpsters. He started building his park in 1992. He creates "scientific" stories about the origins and characteristics for his handmade fossils and is said to have a great sense of humor. Some of the creatures have eye sockets filled with melted sticks of colored glass from the work

of his wife Nancy. There are about twenty large creatures in the park, and Clyde Wynia has no intention to sell any of them. He does make smaller creatures that visitors may take away with them. A video on YouTube (www.youtube.com/watch?v=cKqfCKDUTko) documents the site and includes a guided tour by Wynia. Jurustic Park is three miles north of Marshfield, in central Wisconsin, off County Trunk E and west on Sugarbush Lane. Visit the park's website (www.jurustic.com), or call 715-387-1653 for more information and to arrange a visit.

Yazzie, Lulu Herbert (1959–2011)

Lulu Herbert Yazzie, daughter of Woody and Anne Herbert, lived in Sweetwater, Arizona. With her husband, Wilford, she made standing cottonwood carvings of barnyard animals. Chickens, chickens with chicks, roosters, sheep, and black crows were common subjects—the crows were done only by Wilford, as it is considered bad luck or improper for a woman to do this animal. The pieces stand twelve to twenty inches high, are relatively primitive in style, and are painted with acrylics. The Penfield Gallery of Indian Arts in Albuquerque carries her work.

Yazzie, Wilford (b. 1946)

Wilford Yazzie lives with his wife in Sweetwater. In addition to the figures they carve together (see entry under Lulu Herbert Yazzie), Wilford makes standing pieces of the Navajo holy men, or "Yei" figures. These are rather finely done, and average 30 to 48 inches in height. They are generally carved from a single cottonwood log and have a white base, a blue shirt with painted jewelry, and a painted face. They are adorned with beaded earrings, white fur, and an occasional eagle feather.

Yeomans, Brooks (b. 1957)

Edmund Brooks Yeomans was born March 28, 1957, in Shelby, North Carolina. The son of a doctor, he had three sisters. A mentally challenged artist, he went to live in an institution in 1991 after his mother died. He paints his memories and experiences of events, "like a journalist," soon after they happen. It is said he remembers every detail, down to the kind of buttons on a figure's clothes. In addition to actual happenings in his life, he also paints rooms and other scenes from his imagination. Yeomans always liked to draw, and did so as a child. He paints in acrylics on canvas and is a resident artist at Signature House in Morganton, North Carolina. He has been described as "a man of few words and a thousand brushstrokes." In January 1999 his work was the subject of an exhibition at Collection de l'Art Brut in Lausanne, Switzerland.

Yoakum, Joseph (1886–1972)

Yoakum was born in Arizona. Soon after his birth,

his family moved to Missouri. According to his own account, Yoakum ran away at age fifteen to begin his career as a hired hand, hobo, stowaway, and with many traveling circuses. When Yoakum settled in Chicago in 1962, he began to draw, following a dream. He made carefully titled landscapes from around the world. Yoakum was a powerful influence on contemporary Chicago trained artists. At the "Altered States/Alternate Visions" symposium in Oakland, California, in April 1992, Gladys Nilsson describes the "strength, directness, and simplicity" of Yoakum's work. From 1962 to 1972, "the length of his art life," says Nilsson, "he made from 1,500 to 2,000 drawings." His art was included in the exhibition "Flying Free" in 1997. His work is in the permanent collections of many museums, including the Smithsonian American Art Museum, the High Museum, Chicago museums (Art Institute of Chicago, Museum of Contemporary Art), the Milwaukee Art Museum, the Philadelphia and Akron Museums of Art, and the Museum of International Folk Art. Many galleries still carry Yoakum's work, including Carl Hammer and Karen Lennox Galleries in Chicago, Cavin-Morris and Ricco/Maresca in New York, Fleisher/Ollman Gallery in Philadelphia, and Stephen Romano, private dealer.

Yoder, Claude (1904–1991)

Claude Yoder was one of seventeen children of an Amish farm family in the mountains of western Maryland, near Grantsville. As is Amish custom, he went to school only to the eighth grade. He was frequently disciplined at school for drawing pictures. He married outside his community and became, as she was, a Mennonite. His wife encouraged his creativity, and Yoder carved wood in his basement studio whenever he could find the time after his work and farm chores. In 1972 he participated in the folklife festival in Washington, D.C. The Allegheny Museum in Cumberland, Maryland has Yoder's wooden folk sculptures in its permanent collection, as does the American Visionary Art Museum, which included pieces of his art in its recent exhibition, "The Visionary Experience."

York, Henry (1913–1995)

Henry York was a retired tenant farmer who lived in south-central Kentucky. He carved off and on all of his life. He made mostly walking sticks, animals, and articulated figures. He used to drive a station wagon topped by a large set of oxen with riders. His wood of choice was cedar, found in old fence posts and rails. York carved with a pocketknife and then accented the figure with paint, although sometimes he would paint the whole object. He shellacked his pieces when they were finished. Some of his canes have handles that represent horses with riders, and snakes are a frequent subject on his canes. The articulated figures are "usually erotic," men with exaggerated penises attached

with a spring. York is included in the *Sticks* catalog and the book on canes by George Meyer. His work is in the permanent collection of Intuit, in Chicago.

Yost, Gary

Yost is a North Carolina artist who makes large carved figures, from a single piece of wood, with carved faces and arms added. The work is in the Menello American Folk Art Museum in Florida. His work is in the permanent collection of the Menello Museum of American Folk Art

Young, Ned (1873–year of death unknown)

Young was born in a small town in Vermont. As a boy he drew cartoons and took up woodworking as a hobby. Young played the cornet in the town band but abandoned the horn after rupturing his lung. He was also considered a musical prodigy and at the age of 17 he went to Boston and became a professional violinist. While playing in orchestras at resort hotels in northern New England, he met his wife Effie and taught her to play the cello. They formed their own string ensemble and eventually took up residence in St. Johnsbury where he taught music at an academy. All the while he continued woodworking, producing accomplished and elaborate pieces. At some point he gave up the violin and became an antiques dealer, expertly repairing pieces with broken or missing parts. From 1989 to 1817 he produced a set of carvings from roots he found on the banks of a nearby river. The Ames Gallery in Berkeley carries his work.

Young, Purvis (1943–2010)

Purvis Young was a self-taught artist who was born and lived all his life in Miami, Florida. Young started to paint when he was in prison for armed robbery. He did paintings, often surrounded by found wood, street murals, and mixed-media works. It was said "his subjects are his life." Many museums include Young in their permanent collections, and a large number of galleries still carry his work.

Young, Willie (b. 1942)

Willie Wayne Young was born into a poor family in Dallas, Texas. At age fifteen he signed up for an art course by mail. At sixteen he spent time in a juvenile home where a counselor encouraged him to draw. In the next few years he was in and out of juvenile detention centers for criminal offenses. He attended a Dallas high school where his art talent was recognized and he received a scholarship to a Saturday morning art class at the Dallas Museum of Art where he was encouraged to follow his own course. Young is basically illiterate and has worked his whole life shining shoes

in a barber shop. He has never shown much interest in selling his work. For thirty or more years he has made meticulous drawings in pencil on brown wrapping paper or on sketchpads. The subjects of his drawings are reflections of organic matter such as roots, bird and small animal bones, seed pods, and other forms from nature. He does not, however, render them in realistic form. Rather his drawings are inspired by natural objects, which evolve in his drawings into something else. An art dealer has noted that "a crack in the sidewalk may manifest itself in a Grand Canyon of an image." Willie Young's art was included in the exhibition "A World of their Own: Twentieth-Century American Folk Art" at the Newark Museum in 1995. His work was in a 2009 exhibition at the African American Museum of Dallas. The Tanner Hill Gallery in Chattanooga sometimes has his art for sale.

Zeldis, David (b. 1952)

David was born in Israel. He is the son of well-known naive painter Malcah Zeldis. In 1957 the family moved to New York City where he continues to live and work. He began drawing in colored pencil and graphite when he was nineteen, simple but psychologically probing surreal works rooted in his imagination. In addition to making art, David Zeldis also writes poetry and stories. His work is in the permanent collection of the Noyes Museum of Art of Stockton College. Marcia Weber/Art Objects, Hirschl & Adler, and Marion Harris carry his work.

Zeldis, Malcah (b. 1931)

Malcah Zeldis was born in the Bronx and now lives in Manhattan. Shortly after her birth, she moved with her family to Detroit. In 1948 she moved to Israel to work on a kibbutz. While there she married, and she began to paint. She returned to New York in 1958. Her husband actively discouraged her from painting. In 1974 Zeldis obtained a divorce and began painting in earnest. Her paintings are an expression of her own life, her experiences, her feelings, her religion and her environment. With her flat style and bold colors, Zeldis creates works of art which have great appeal. She does not concern herself with academic rules of painting; she follows her own rules. Zeldis is written about, and her work is in the permanent collections of many museums around the world including the American Folk Art Museum, the Smithsonian American Art Museum, the Jewish Museum, the Milwaukee Museum of Art, the Noyes Museum of Art of Stockton College, the Akron Museum of Art, the Fenimore House Museum, and the International Folk Art Museum. In the last few years her work has illustrated a number of well-received children's books. Marcia Weber/Art Objects and LouanMarcia Weber/Art Objects and Louanne LaRoche, private dealer, carry her work.

Zerda, Lino (b. c1945)

Lino Zerda, a native of Argentina, came to the United States in 1981. He had an apartment on Manhattan's West Side and worked as a bicycle messenger—until he was struck by a truck which broke nearly every bone in his body and caused him to lose his memory. The good part, if one can call it that, is that Zerda had a powerful vision that he saw God and was given another chance at life and a new talent. At first, when he left the hospital, he could not work and he could not stay in his old room. Although he was getting workmen's compensation, he was living as a homeless person. This lasted for two years, until December 1991, when two policemen came to where he was sleeping by the East River and said that since the temperature was expected to go down to zero, he had to go to a shelter. The shelter had an art program. Zerda said that before then he had never drawn anything, though he did eventually remember that in the past he had written poetry in Spanish. The first month he was drawing with pencil, then charcoal, then acrylics, and then oil. He became a part of the Art Program for the Homeless, started by Tina White, and soon his art was selling well and he was able to buy a boat at City Island where he lives and works. Zerda paints portraits, landscapes, still lifes, and narrative paintings. His work is in the permanent collection of the Noyes Museum of Art of Stockton College.

Zets, Jeff and Mark (b. 1963)

Jeff and Mark Zets were born January 1, 1963, in Washington, Pennsylvania, and now live in Pittsburgh. Jeff and Mark are identical twins. They each received bachelor of science degrees in parks and recreation from Slippery Rock University in Pennsylvania. Since 1987 they have been working independently and in collaboration to create collages which are scenes of contemporary life. These self-taught artists use cutouts and pieces of magazines, menus, photographs, ticket stubs, food stamps and other materials, as well as hand-painted fragments "to depict their subjects of the circus of life. Their works tell stories, sometimes directly, often indirectly, about relationships, society and politics." Their work was in and exhibit at the Pittsburgh Center for the Arts in 2008, and the Street Art Project in Cleveland in 2011.

Zimmerman, Kurt (b. 1925)

Zimmerman was born in Plochingen, Germany, and he now lives in Florida. His family moved from Germany to Schenectady, New York, when he was four years old. He was drafted into the U.S. Army during World War II and flew 35 bombing missions over his native Germany. After serving in the Korean War, he attended Hudson Valley Technical Institute, graduating with a degree in electrical technology. He worked for General Electric on a secret NATO project in Ger-

many, and while there he had an emotional breakdown and was hospitalized. When he returned to the United States he was assigned to the Cape Canaveral Apollo Moon Project. After a second breakdown he quit his job to do art full-time. Zimmerman says, "My work is a direct expression of entities in contact with me from other dimensions. By bringing them into this world through my art, I hope to make viewers aware of the greater dimensionality of life—a view very different from the 'normal' day-to-day reality we perceive." His work is in the permanent collection of the Mennello Museum of American Folk Art; Jeanine Taylor Folk Art and Main Street Gallery carry his art, and he has his own Facebook page.

Zirbel, Frank Joseph (b. 1947)

Zirbel, as he is called, is from Green Bay, Wisconsin, but has been living in Chicago since 1977. His first group show dates back to 1973 in Door County, Wisconsin. He started drawing as a child, and has continued to this day; he is primarily self-taught. In 1978 he began etching and fell in love with the process. There are more than sixty images in his catalog. In 1985 he started showing his work in East Village galleries and continued through the rest of the 1980s. In 1985 he also started oil painting and working in color. In 1995 he abandoned his day job to be a full-time artist. He has been called a "figurative-expressionist." Zirbel is also an accomplished rock musician. Under the moniker Mental Insect, he has released three projects. Information about him is in the Chicago Artists' File at the Chicago Public Library.

Zoettl, Joseph (1878–1961)—"Ave Maria Grotto"—Cullman, Alabama

Zoettl, the builder of the miniatures at the Ave Maria Grotto, was a Benedictine monk born in Bavaria. When he came to the Abbey in Cullman he was appointed to run the power plant. While there he started building his miniature shrines. He worked for over forty years on the reproductions of famous churches, shrines, and buildings from all over the world. He built his last model, of the Basilica at Lourdes, at age eighty. The site covers over three acres and is located at the St. Bernard Abbey, 1600 St. Bernard Drive, S.E., Cullman, Alabama 35055. Telephone: 205-734-4110, website: www.avemariagrotto.com.

Zoratti, Silvio Peter (1896–1992)

Zoratti lived with his wife in Conneaut, Ohio. He was born to a farming family in northeastern Italy. He left for Austria at the age of nine, apprenticed to a stonemason uncle. In 1916 he was drafted into the Italian army, and spent a year as a prisoner of war of the Germans. He came to the United States in 1919 and worked for a farm tool manufacturer. In 1923 he went to work for the Nickel Plate Railroad where he stayed until he retired in 1961. During his working life he had no time to work on art, with one exception—in the 1950s he made large cement animal sculptures, which he placed in the yard behind his house for the amusement of his grandchildren. His daughter Alvera Terry says he went to his basement workshop the morning after his retirement and worked on art all day, every day, into the 1980s when he could no longer see. His art has been described as "bursting with energy and excitement." His figures are people, children, politicians, animals, figures from popular culture, and American icons such as the Statue of Liberty and Uncle Sam. The sculptures filled the deep yard behind his house. He received media attention in the 1960s, but was largely ignored by art collectors—perhaps because he lived far away from art centers. Silvio Zoratti and his wife, Beatrice, eventually moved to a nursing home near Conneaut. He and his art were the subject of a recent blog, creeksideartgallery.com/blog/tag/silvio-zoratti.

Zwirz, Jankiel "Jack" (1903–1991)

Zwirz was born in Poland and immigrated to Belgium where he was a Resistance hero. He suffered in World War II at the hands of the Germans, but lived to migrate to the United States in 1950 when he settled in Memphis. He was a painter whose subject matter ranged from Jewish life in Europe and the horrors of concentration camps to futuristic visions of spaceships. His work is in the permanent collections of the Milwaukee Art Museum and the Ogden Museum of Southern Art.

Zysk, George—Environment— Grand Haven, Michigan

Zysk covered his house with signs, usually written in response to something in the newspaper he didn't like. His work reminded many of Jesse Howard. There is an article by Susan Craig in the Fall 1992 issue of *In 'tuit* about his yard and house, and what he accomplished. His environment no longer exists, but documentation may be found at SPACES and in the In'tuit archives.

BIBLIOGRAPHY

Very few published books or periodicals contain information relevant to the task of updating the 2000 edition. The exceptions were:

Sellen, Betty-Carol, and Cynthia Johanson. *Self-Taught, Outsider, and Folk Art: A Guide to American Artists, Locations, and Resources.* Jefferson, NC: McFarland, 2000. The second edition of this guide (the first published by McFarland) was the starting point for all updates and edits.

Books Used for Birth and Death Years

Laffal, Florence, and Julius Laffal. *American Self-Taught Art: An Illustrated Analysis of 20th Century Artists and Trends with 1,319 Capsule Biographies.* Jefferson, NC: McFarland, 2003.

Raw Vision. *Raw Vision Sourcebook: The Essential Guide to Outsider Art, Art Brut, Contemporary Folk Art & Visionary Art from Around the World.* Radlett, Herts., UK: Raw Vision, 2002.

Raw Vision. *Raw Vision Sourcebook: The Essential Guide to Outsider Art, Art Brut, Contemporary Folk Art & Visionary Art from Around the World.* Radlett, Herts., UK: Raw Vision, 2009.

Periodicals Used to Find Obituaries, Exhibitions and Recent Books

All issues of *Folk Art Messenger*, the publication of the Folk Art Society of America, starting with the 2000 volume.

Many issues of *Raw Vision*, starting with the 2000 volume.

Other Sources

Other sources of death dates were the Smithsonian American Art Museum's complete list of the self-taught/folk artists in its holdings (birth dates, and death dates if the person was dead), supplied by Leslie Umberger; information by telephone for many Kentucky artists from the staff of Kentucky Folk Art Center; phone and email conversations with gallery owners who once represented now-deceased artists; calls to artists' families; and extensive Internet searches.

Sources of information on galleries, museums, organizations, publications, and auctions came from the owners, directors, curators, editors, and websites of the relevant entities.

Information on artists not included in Sellen and Johanson (2000) came from gallery owners, gallery websites, artist websites, phone conversations with artists or their relatives, and Internet searches.

INDEX